China's Terracotta
WARRIORS

THE FIRST EMPEROR'S LEGACY

China's Terracotta
WARRIORS
THE FIRST EMPEROR'S LEGACY

Liu Yang

WITH CONTRIBUTIONS BY

Edmund Capon
Albert E. Dien
Jeffrey Riegel
Eugene Wang
Yuan Zhongyi

MINNEAPOLIS
MIA INSTITUTE
OF ARTS

This book was published in conjunction with the exhibition
"China's Terracotta Warriors: The First Emperor's Legacy."

MINNEAPOLIS INSTITUTE OF ARTS
October 28, 2012–January 20, 2013

ASIAN ART MUSEUM, SAN FRANCISCO
February 22–May 27, 2013

Editors: Elisabeth Sövik and Laura Silver
Designer: Jill MacTaggart Blumer
Digital image production: Joshua Lynn
Indexer: Enid L. Zafran
Publishing and production management: Jim Bindas,
Books and Projects LLC, Minnetonka, Minnesota

© 2012 Minneapolis Institute of Arts
2400 Third Avenue South
Minneapolis, Minnesota 55404
www.artsmia.org

Printed in Canada by Friesens

Library of Congress Control Number: 2012945028
ISBN: 978-0-9800484-9-0

Distributed by the University of Washington Press
P.O. Box 50096
Seattle, Washington 98145-5096
www.washington.edu/uwpress

"The Discovery and Excavation of the Terracotta Army," by
Yuan Zhongyi, is reprinted by permission of the Art Gallery of
New South Wales from *The First Emperor: China's Entombed
Warriors* (Sydney: Art Gallery of New South Wales, 2010).

"Five Decisive Events in the Rise of the State of Qin," by Jeffrey
Riegel; "The First Emperor: His Life, Achievements, and Vision,"
by Liu Yang; "The First Emperor's Tomb Complex," by Liu Yang;
and "The Making of the Terracotta Army," by Liu Yang, are
revised and expanded from essays that appeared in *The First
Emperor: China's Entombed Warriors* (Sydney: Art Gallery of
New South Wales, 2010).

"Inheritance and Innovation: Qin Bronze, Gold, and Jade,"
by Liu Yang, is revised and expanded from "Inheritance and
Innovation: An Archaeological Perspective of Qin Culture,"
published in *Arts of Asia* 41, no. 1 (January/February 2011),
pp. 80–93.

Rows of light infantry in Pit 1 at the First Emperor's tomb complex

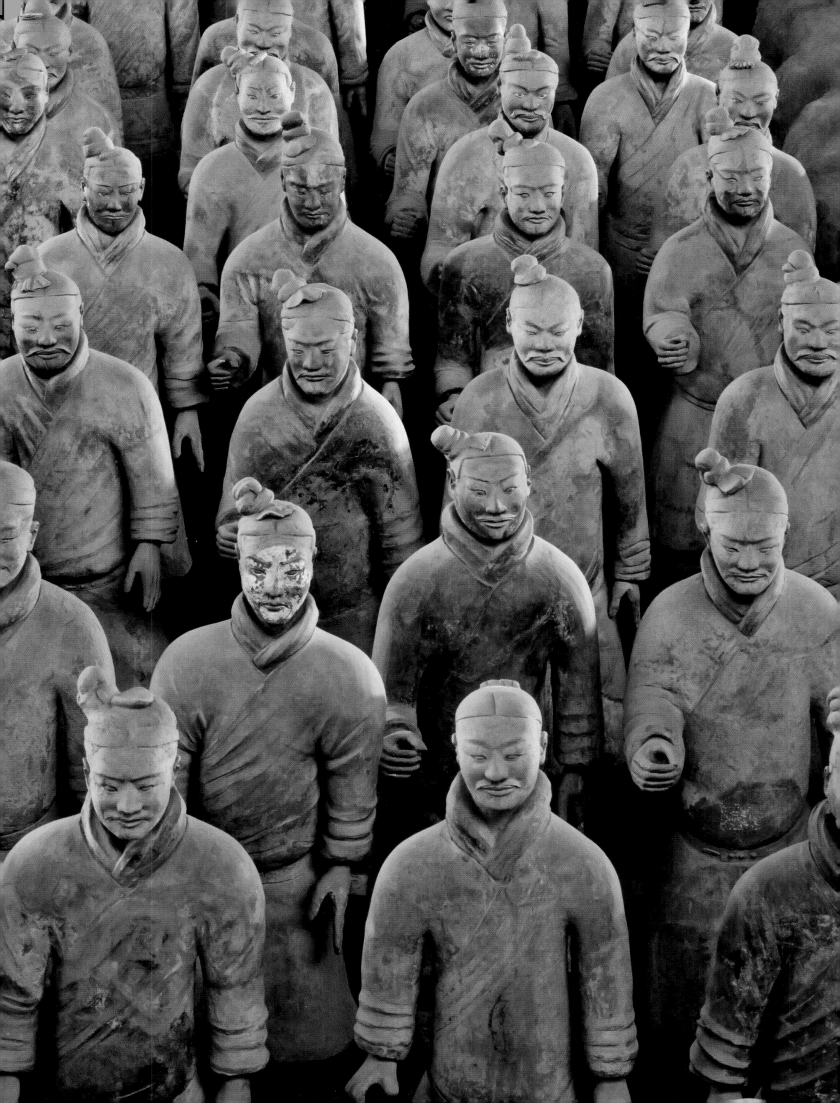

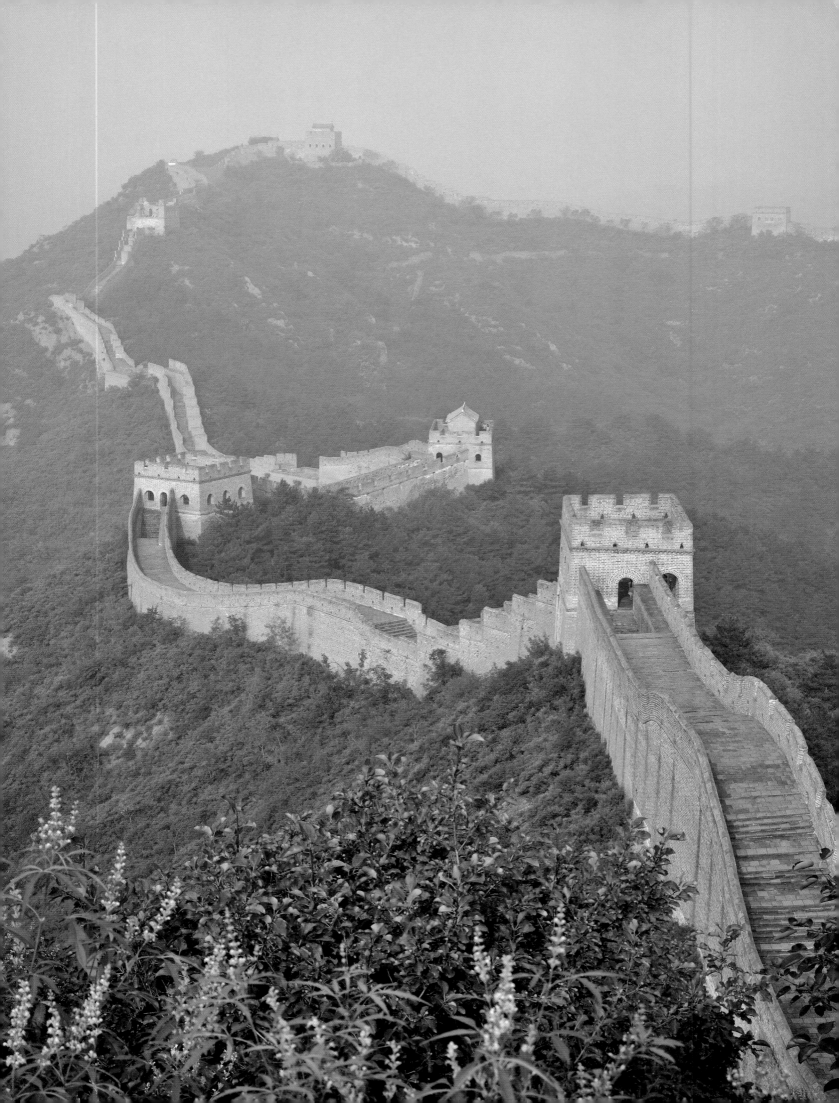

Contents

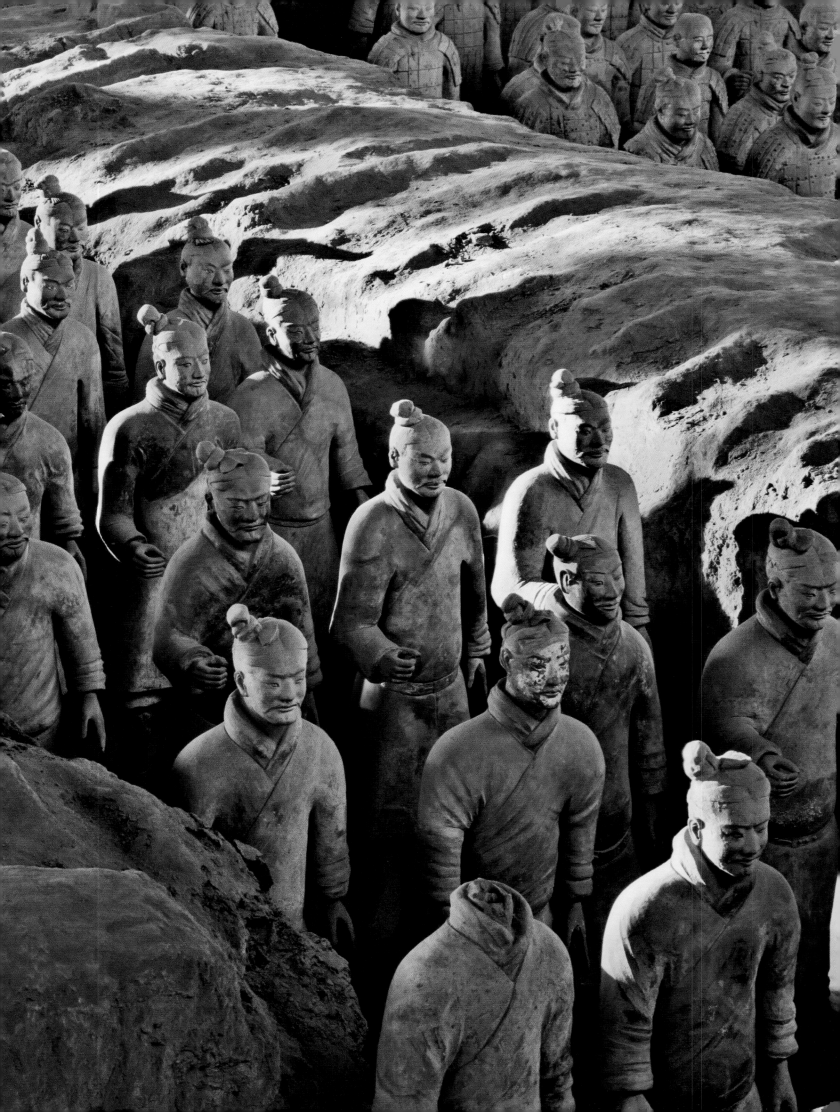

Foreword

ZHAO RONG

*Director, Shaanxi Provincial
Cultural Relics Bureau*

In 1985, to commemorate the third anniversary of the sister-state relationship established between Shaanxi Province and Minnesota, the Shaanxi Provincial Cultural Relics Bureau and the Minneapolis Institute of Arts collaborated on a small exhibition of the terracotta warriors. Its success promoted friendly dealings and exchanges in trade relations, tourism, and cultural education between Shaanxi Province and Minnesota. Even before this, in 1975, the Asian Art Museum of San Francisco had worked with China's State Administration of Cultural Heritage to hold "The Exhibition of Archaeological Finds of the People's Republic of China." These two successes helped bring about many exhibitions of Chinese art organized by the Minneapolis Institute of Arts and the Asian Art Museum, which played a positive role in furthering relations and cultural exchanges between China and the United States. To celebrate the thirty-year anniversary of Shaanxi Province and Minnesota's sister-state relationship, and to promote Shaanxi's relationship and exchange with Minnesota and California, at the invitation of the Minneapolis Institute and Arts and the Asian Art Museum we collaborated to organize the current exhibition, "China's Terracotta Warriors: The First Emperor's Legacy."

The province of Shaanxi, in northwest China, is the cradle of Chinese civilization. More than a million years ago, human activity was evident in Shaanxi. For two thousand years, from the eleventh century BCE to the tenth century CE, more than fourteen dynasties, including the Zhou, Qin, Han, and Tang, had their capitals in the region. The Qin and Han period was a crucial phase in Chinese history. China's core territory was established, a centralized system of government was instituted, and the nation was unified. The essential Chinese nationality and culture began to take shape then, and cultural exchange between China and the outside started to gain momentum. The systems established by the Qin and Han have remained for over two thousand years in the areas of politics, economics, sociology, and culture. From the time of the Qin and Han onward, Chinese civilization has been a force on the stage of world history. China's is the only culture to have continuously developed from an ancient civilization.

The core of this exhibition is drawn from recent important archaeological excavations in Shaanxi. The 120 sets of objects selected from thirteen museums and archaeological institutions in Shaanxi are precious cultural relics that comprehensively reflect the splendor of Chinese history and culture from the Spring and Autumn period through the Qin dynasty. These two-thousand-year-old markers of Chinese civilization are also significant constituents of the world's cultural heritage.

I believe this exhibition is sure to become a favorite with the American public, while also strengthening Shaanxi's exchange and cooperation with Minnesota and California.

I wish "China's Terracotta Warriors: The First Emperor's Legacy" great success!

Left: Rows of light infantry in Pit 1 at the First Emperor's tomb complex

Previous: View of the Great Wall of China today

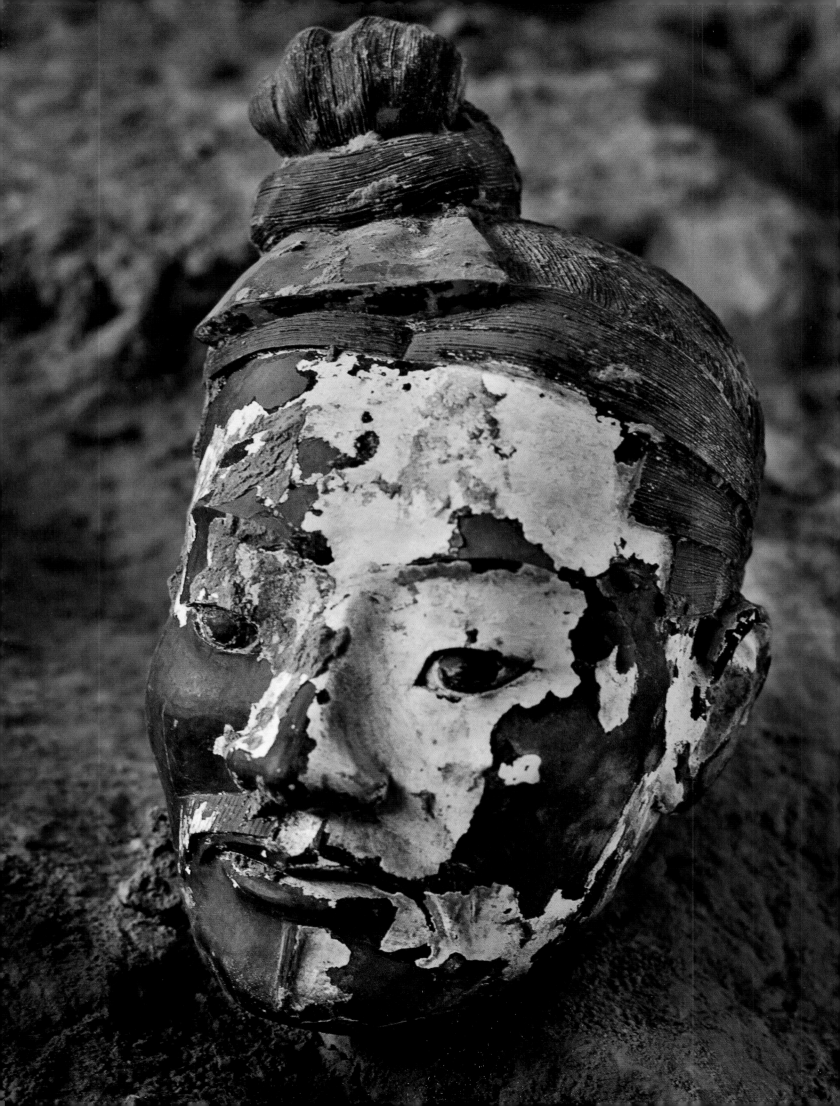

Director's Foreword

KAYWIN FELDMAN

*Director and President,
Minneapolis Institute of Arts*

In the third century BCE, when Rome was battling Carthage for supremacy in the Mediterranean, another pivotal war was intensifying on the other side of the earth. In China, the rising state of Qin was vanquishing neighboring states, bringing to end the Warring States period and unifying the country. Zheng, the future First Emperor, was born in this time of turmoil. At the age of twenty-one, in 238 BCE, he took control of all state affairs and conquered the remaining independent kingdoms, declaring himself emperor in 221 BCE. Like Rome's victory over Carthage, Qin's triumph over the other states had long-lasting results. The First Emperor abolished the old system of feudal investiture and instituted a centralized, bureaucratic form of government that would continue through successive dynasties over the next two millennia.

Both these ancient civilizations, Roman and Qin, left remarkable physical evidence of their achievements. The long-held Chinese belief in and desire for an afterlife in which earthly pleasures and activities continued, inspired the practice of burying artworks and other objects with the deceased. Underground treasures hidden for nearly two thousand years and accidentally revealed by local farmers in 1974 have elicited worldwide fascination with one man's quest for immortality.

Minnesotans were among the earliest Westerners to see some of these important archaeological finds in 1985, when the Minneapolis Institute of Arts organized a small display of three figures: a general, a small stableboy, and a horse. Twenty-seven years have passed since that exhibition, and every day Chinese archaeologists discover new artifacts from the wealth of China's ancient past. It is therefore fitting that the MIA should revisit the remarkable legacy of the First Emperor. The new exhibition presents over 120 objects, including 10 of the world-renowned warriors and horses, together with recent finds from the First Emperor's tomb complex and from his capital Xianyang, both located near modern Xi'an in Shaanxi province, central China. Equally significant, the exhibition explores the period of Chinese history preceding the Qin dynasty. Through carefully selected objects such as bronze ritual vessels and jade artifacts, gold and silver ornaments, architectural fixtures, and ceramic works, "China's Terracotta Warriors: The First Emperor's Legacy" tells a story of turmoil and change, the emergence of the Qin state, and the material cultural of the First Emperor and his court.

Thanks to generous and visionary donors such as Alfred F. Pillsbury and Ruth and Bruce Dayton, the MIA has a long and distinguished history of collecting and exhibiting Chinese art. As evidenced by this exhibition, the museum's commitment to enhancing the understanding and appreciation of Chinese art, history, and culture is stronger than ever. I am grateful to Liu Yang, Head of the Asian Art Department and Curator of Chinese Art at the MIA, for enthusiastically organizing "China's Terracotta Warriors: The First Emperor's Legacy." When Dr. Liu joined the museum staff one year ago, he arrived with numerous exciting exhibition ideas and a passion to publish the museum's great collection. With

Head of an infantryman from
Pit 2 at the First Emperor's
tomb complex

generous funding from Ruth and Bruce Dayton, he quickly organized a symposium to coincide with the opening of the exhibition, inviting an impressive roster of international scholars to explore new perspectives on Qin culture.

This exhibition was organized by the MIA in partnership with the Asian Art Museum, San Francisco, and the Shaanzi Provincial Cultural Relics Bureau and Shaanxi Cultural Heritage Promotion Centre, People's Republic of China. It opens at a time when Minnesota and Shaanxi celebrate the thirtieth anniversary of their sister-state relationship and is one of many events commemorating our important ties. We are indebted to our colleagues in Shaanxi, China, for their support and cooperation in realizing this exhibition. I would particularly like to thank Zhao Zhengyong, Governor of Shaanxi; Zhao Rong and Liu Yunhui, Director and Deputy Director of the Shaanxi Provincial Cultural Relics Bureau; Cao Wei, Director of the Qin Shihuang Terracotta Warriors and Horses Museum; Pang Yani, Director of the Shaanxi Cultural Heritage Promotion Centre; and the Project Manager, Zhang Zheng, and his colleague, Wang Chunyan. In the United States, I express my thanks to Mark Dayton, Governor of Minnesota; Jay Xu, Director of the Asian Art Museum, San Francisco; our presenting sponsor JPMorgan Chase; lead sponsors Fredrikson & Byron P.A., the Carlson Family Foundation and Carlson Companies; our additional supporters Christie's and the E. Rhodes and Leona B. Carpenter Foundation; our media partner Star Tribune; major sponsor Thomson Reuters; and our official airline Delta Air Lines.

Acknowledgments

LIU YANG

*Head of the Asian Art
Department and
Curator of Chinese Art,
Minneapolis Institute of Arts*

A project such as this relies on the support and commitment of many people. Above all, I would like to thank MIA Director and President Kaywin Feldman and Deputy Director and Chief Curator Matthew Welch for making it possible for me to engage in this challenging and meaningful endeavor. Without their support, this exhibition could not have happened. I wish also to express my gratitude to the following individuals for their contributions.

In China: Zhao Zhengyong, Governor of Shaanxi; Zhao Rong and Liu Yunhui of the Shaanxi Provincial Cultural Relics Bureau; Cao Wei, Wu Yongqi, Yuan Zhongyi, and Xia Juxian at the Qin Shihuang Terracotta Warriors and Horses Museum; Pang Yani, Zhang Zheng, and Wang Chunyan of the Shaanxi Cultural Heritage Promotion Centre; Zhang Tianen, Jiao Nanfeng, and Xiao Jianyi at the Shaanxi Provincial Institute of Archaeology; Wang Hui at the Gansu Provincial Institute of Archaeology; and Duan Qingbo at Northwest University.

In Australia: Edmund Capon, Anne Flanagan, Analiese Cairis, and Michelle Andringa at the Art Gallery of New South Wales, and Jeffrey Riegel at the University of Sydney.

In the United States: Ruth and Bruce Dayton for their financial support of the symposium and the publication of the symposium proceedings; Mark Dayton, Governor of Minnesota; Jay Xu and Li He of the Asian Art Museum, San Francisco; Albert E. Dien of Stanford University; and Eugene Wang of Harvard University. At the Minneapolis Institute of Arts: Kristin Prestegaard, marketing and communications, design and editorial; Garnette Kuznia, brand communications; Mike Dust, Web site production; Anne-Marie Wagener and Tammy Pleshek, public relations; Julianne Amendola and Mary Mortenson, sponsorship; Charisse Gendron, foundation relations; Susan Jacobsen and Alex Bortolot, public programs; Sheila McGuire and Amanda Thompson Rundahl, audiotour coordination; Jennifer Starbright and Brian M. Kraft, registration; Roxy Ballard, exhibition design; Elisabeth Sövik, catalogue and exhibition editing; Jill Blumer, catalogue and exhibition graphic design; Dan Dennehy, visual resources; Joshua Lynn, digital image production; Laura DeBiaso and Rayna Olson, exhibition administration; Erin Threlkeld, Rachel Turner, and Mona Wang, curatorial and administrative assistance. And Laura Silver of Minneapolis.

And finally, I thank our sponsors and supporters: our presenting sponsor JPMorgan Chase; lead sponsors Fredrikson & Byron P.A., the Carlson Family Foundation and Carlson Companies; additional supporters Christie's and the E. Rhodes and Leona B. Carpenter Foundation; our media partner Star Tribune; major sponsor Thomson Reuters; and our official airline Delta Air Lines.

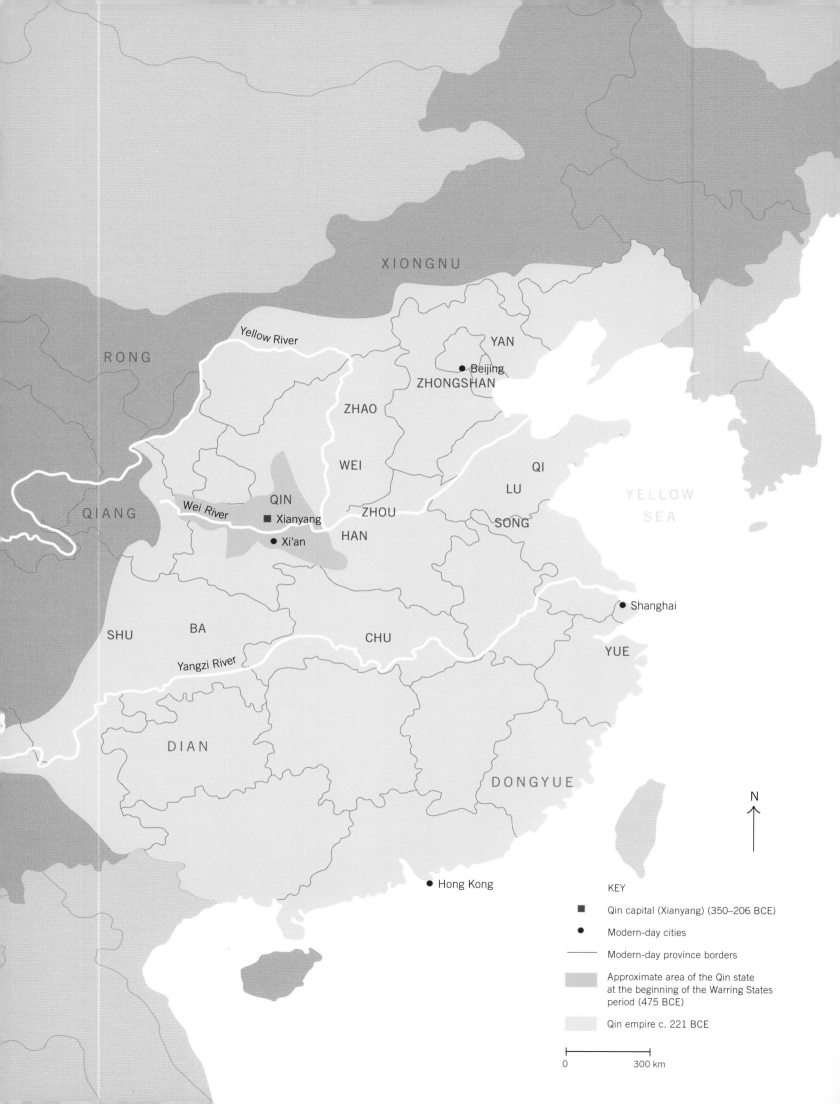

XIONGNU

RONG

Yellow River

YAN

● Beijing

ZHONGSHAN

ZHAO

WEI

QI

QIANG

LU

YELLOW
SEA

QIN

Wei River

■ Xianyang

ZHOU

● Xi'an

SONG

HAN

SHU

BA

● Shanghai

CHU

Yangzi River

YUE

DIAN

DONGYUE

N

● Hong Kong

KEY

■ Qin capital (Xianyang) (350–206 BCE)

● Modern-day cities

— Modern-day province borders

 Approximate area of the Qin state
 at the beginning of the Warring States
 period (475 BCE)

 Qin empire c. 221 BCE

0 300 km

Chronology

NEOLITHIC PERIOD	c. 10,000–c. 2000 BCE		
SHANG DYNASTY	c. 1600–c. 1046 BCE		
ZHOU DYNASTY	c. 1046–256 BCE		
WESTERN ZHOU	c. 1046–771 BCE		
EASTERN ZHOU	770–256 BCE		
Spring and Autumn period	770–476 BCE	770 BCE	Zhou ruler moves capital to Luoyi, in present-day Luoyang, establishing Eastern Zhou dynasty; history of Qin as a vassal state of Zhou begins
		c. 762 BCE	Duke Wen moves Qin capital eastward from present-day eastern Gansu to the area of present-day Baoji, Shaanxi
		c. 677 BCE	Duke De relocates Qin capital to Yong, at present-day Fengxiang, Shaanxi
		659 BCE	Duke Mu (one of the Five Hegemons of the Spring and Autumn period) begins 39-year reign
		c. 570 BCE	Birth of Laozi, founder of Daoism
		551 BCE	Birth of Confucius
Warring States period	475–221 BCE	383 BCE	Duke Xian moves Qin capital to Yueyang, at present-day Lintong, Shaanxi
		372 BCE	Birth of the Confucian philosopher Mencius (Mengzi)
		356 BCE	Shang Yang takes charge of Qin's military and political affairs and begins Legalist reforms
		350 BCE	Duke Xiao relocates Qin capital to Xianyang, Shaanxi
		325 BCE	Duke Huiwen adopts the title "king"
		260 BCE	General Bai Qi of Qin defeats army of Zhao state, killing 400,000 surrendered soldiers at the battle of Changping
		259 BCE	Birth of Ying Zheng (later Qin Shihuang, the First Emperor)
		256 BCE	King Zhaoxiang attacks Eastern Zhou, ending Zhou rule
		249 BCE	King Zhuangxiang begins reign; Lü Buwei appointed prime minister
		246 BCE	Ying Zheng begins his reign as king of Qin at age 13, following King Zhuangxiang's death in 247 BCE
		238 BCE	Ying Zheng takes personal control of state affairs of Qin at age 21, suppressing a coup
		237 BCE	Lü Buwei is removed as prime minister (commits suicide two years later); Li Si replaces him
		227 BCE	Jing Ke attempts to assassinate Ying Zheng
		223 BCE	Qin army conquers Chu state
QIN DYNASTY	221–206 BCE	221 BCE	Ying Zheng conquers Qi state, beginning the Qin dynasty; proclaims himself Qin Shihuang, the First Emperor
		220 BCE	Qin Shihuang's first inspection tour; construction of Chidao roadway begins
		215 BCE	Building and consolidation of Great Wall by Meng Tian begins
		213 BCE	First Emperor orders the burning of books across the empire
		212 BCE	First Emperor orders the execution of 460 necromancers and scholars
		210 BCE	First Emperor dies of illness and is buried in present-day Lintong; succeeded by his son Huhai
HAN DYNASTY	206 BCE–220 CE	206 BCE	Liu Bang seizes Xianyang, establishing (Western) Han dynasty
		89 BCE	Sima Qian completes *Shiji* (Records of the Grand Historian)

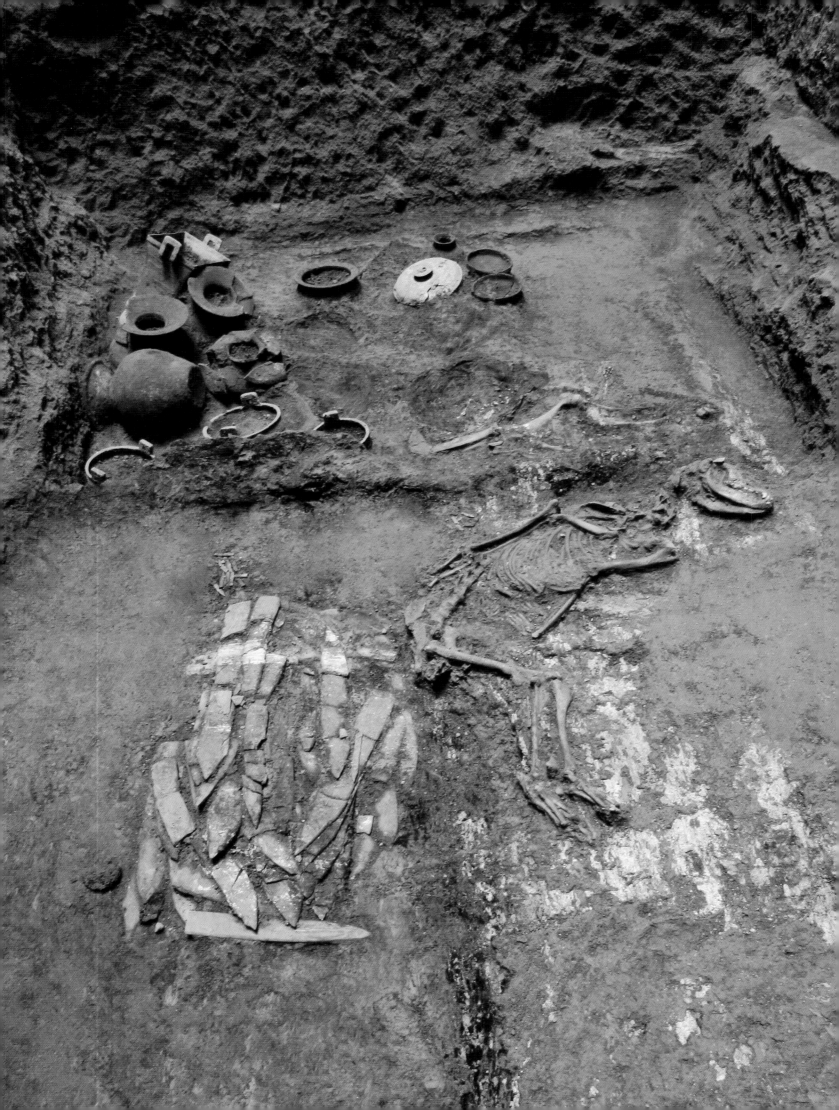

Before Empire:
Qin in the Spring and Autumn
and Warring States Periods

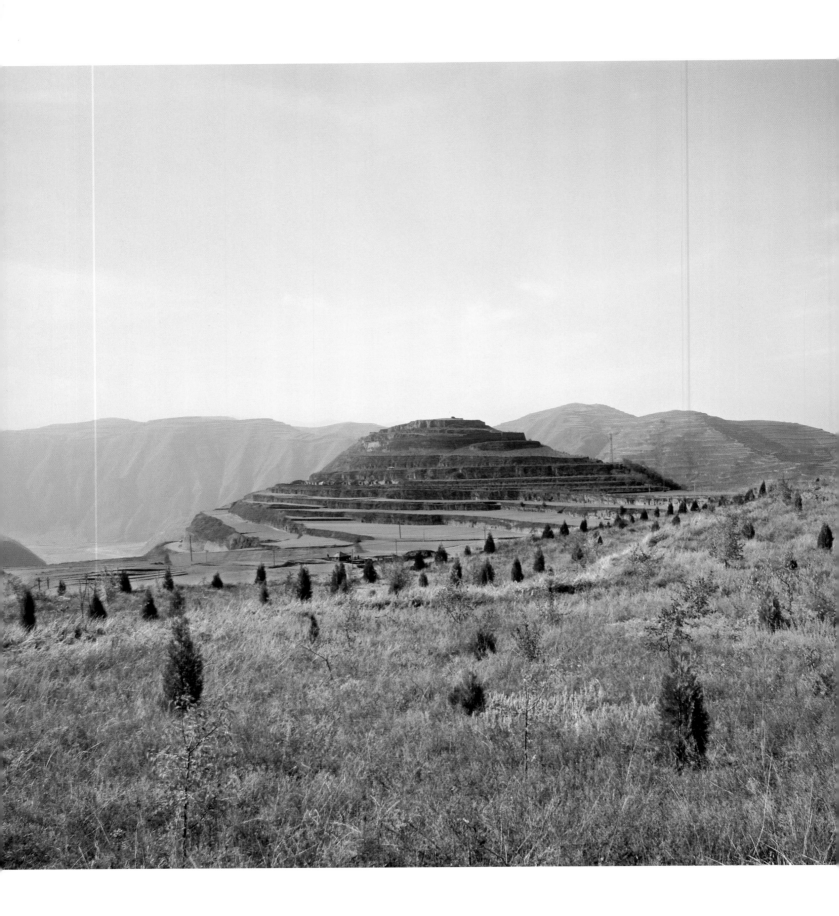

Five Decisive Events in the Rise of the State of Qin

Jeffrey Riegel

The forebear of Qin was Lady Xiu, granddaughter of a remote descendant of Emperor Zhuanxu. Once when Lady Xiu was weaving, a dark bird dropped an egg. The lady swallowed it and gave birth to Grand Undertaking. Grand Undertaking took as his wife a child of Shaodian named Lady Hua. Lady Hua gave birth to Grand Expenditure who assisted Yu the Great in regulating the lands and rivers.[1]

Thus opens the account by the Han dynasty grand historian Sima Qian (c. 145–c. 86 BCE) of Qin's beginnings and rise to prominence. As with this opening passage, the historian's account is marked by both genealogical detail and mythic romance, the latter added not merely for the sake of literary embellishment but to make significant claims about the origins and nature of Qin's rulers and people. The myth of the miraculous birth of Daye, or Grand Undertaking, is strongly reminiscent of the tale of Qi, the founder of the ancient royal Shang lineage, whose birth was also the result of his mother's having swallowed an egg dropped by a "dark bird," that is, a swallow.[2] Sima Qian's point may have been to show that the Qin were somehow destined for power since their lineage was founded in the same divine way as the Shang royal line. However, the Qin elite may very well have regarded the similarity between the two origin myths as proof that their ancestors came from the civilized Shang territories in the east rather than the barbarian lands in the west.

That Lady Xiu's father is not named in the text is perhaps meant to suggest that the early Qin people traced descent through their mothers rather than their fathers. The association of Dafei, or Grand Expenditure, with the famous labors of Yu the Great places this early Qin ancestor in the ranks of the culture heroes of antiquity. Because of Grand Expenditure's accomplishments and his skill in "subduing and training birds and beasts," the legendary emperor Shun granted him the surname Ying (Abundance), the family name of Qin's ruling house down to the end of the imperial dynasty. The grand historian may have repeated this and related myths to show that the Qin people and rulers were from earliest times recognized as fierce fighters and pastoralists capable of subduing even wild animals.

The Qin Move Eastward

In Sima Qian's narrative, a few pages and some seventeen generations after Grand Expenditure we encounter Feizi of Dog Hill. Feizi's nearer ancestors included famous charioteers in both the Shang and Zhou courts—one of whom "had the body of a bird yet spoke human language"—and others who had lived among the Rong people of the west, pastoralists admired for their knowledge of animals and feared as fierce warriors. It is likely that the Qin were related to the Rong.

Left: View of Mount Dabuzi in Lixian, Gansu

Previous: View of Tomb IM25 at Mount Dabuzi under excavation

The Han dynasty historian Sima Qian (c. 145–c. 86 BCE), author of *Shiji* (Records of the Grand Historian), portrayed in a woodcut of 1609

While living at Dog Hill, in the southeastern corner of Gansu not far from the border with Shaanxi province, Feizi had gained a reputation as someone "skilled at rearing and breeding" horses and other domestic animals.[3] King Xiao of Zhou (r. 872–866 BCE) therefore employed him to take charge of the horses on the high tableland between the Qian and Wei rivers in western-most Shaanxi. For his service in breeding horses, Feizi was given the walled city of Qin, located in the vicinity of Dog Hill. The accounts of these early centuries of the Qin mention other walled cities named Qin, also situated in western Shaanxi. One was slightly to the northeast of modern-day Baoji; another was near the confluence of the Qian and Wei rivers, about ten miles east of Baoji.[4] It is possible that between the ninth and seventh centuries BCE the Qin were migrating eastward more or less along the course of the Wei River, and they probably shifted their capital city several times.

The Qin thus had their origins in what is the northwest of modern China. But their destiny lay farther to the east. In the early seventh century BCE, Duke De of Qin performed a divination that foretold the future of the state: "Your descendants will water their horses at the Yellow River!"[5] Over the course of five centuries, the Qin moved their center of power 110 miles eastward from Gansu, establishing their last capital in 350 BCE at Xianyang, about 12 miles northwest of Xi'an.

It is with Feizi—called Qin Ying by King Xiao—that we can say the reliable history of the ruling house of Qin begins. Starting with his son, the Marquis of Qin (r. 857–848 BCE), the rulers of Qin are referred to by the feudal titles used during the Western and Eastern Zhou dynasties.[6] And from this point forward the histories of Qin and of the royal Zhou court and the other feudatories are tightly interwoven. Sima Qian says that Feizi's great grandson was given the posthumous title Duke Zhuang of Qin (r. 821–778 BCE) and that it was only with the reign of the latter's son, Duke Xiang (r. 777–766 BCE), that the rulers of Qin were ranked among the "feudal lords," that is, recognized officially as vassals and supporters of the Zhou king. A total of twenty-four Qin rulers were given the posthumous title "duke" between the years 771 and 338 BCE. In 337 BCE, Qin rulers adopted the title "king," a usurpation of the prerogative of the royal Zhou house already enacted by the rulers of the southern state of Chu two centuries earlier. Four Qin rulers held the title of king between 337 and 247 BCE. Then Ying Zheng came to the throne in 246 BCE as the king of Qin, until he adopted the title First Emperor after conquering the last of Qin's enemies in 221 BCE.

For the early state of Qin, the eighth century BCE was characterized by two significant trends. The first was the growing involvement of the Qin court in the affairs of Zhou and the Zhou feudatories. For example, in 771 BCE, when the Rong attacked King You of the Zhou and the feudal lords turned against him, forcing the royal court to move, it was Duke Xiang of Qin who escorted King Ping of Zhou east to the city of Luoyi, between the Luo and Yellow rivers, in what is now Henan province. One suspects that maneuvering by the Qin contributed to the Zhou decision to abandon their old domain in the valley of the Wei. Escorting the king may have been intended both to protect the court and to force it to go. Sima Qian tells us that after his departure King Ping invested Duke

Xiang not only with the old Zhou capital of Feng, but also with all the lands west of Mount Qi, celebrated in the canonical *Book of Songs* as the place where the Zhou progenitors had dwelt.[7] The investiture should no doubt be regarded simply as Zhou's post facto recognition that by the eighth century BCE it was Qin that wielded actual power in the region. For public consumption, the Zhou king issued a statement justifying his action as a necessary defense against the Rong: "The immoral Rong have invaded our lands of Mount Qi and Feng. If Qin can attack and drive off the Rong they should of course possess these lands."[8]

Once the Qin took possession of these former royal Zhou lands, Duke Wen of Qin (r. 765–716 BCE) and his successors set about making the area into a holy land by building numerous shrines and altars to the ancestors they credited with their military success and prosperity. This was the second major trend. In 756 BCE, having dreamt that an enormous yellow serpent descended from the sky and kissed the earth at Fu Marsh, Duke Wen built a shrine there and sacrificed an ox, a sheep, and a pig as offerings to his ancestors. In 747 BCE, Duke Wen built a temple to house the Chen Treasure, a magical stone (perhaps a meteorite) said to resemble a chicken or pheasant, which had fallen fiery to the earth. The old Shaanxi town of Baoji, or Treasure Chicken, grew up around this temple where people worshiped the spirit of the stone, which "some years did not visit and some years came several times."[9]

The Reign of Duke Mu of Qin

The most famous and important of the pre-imperial Qin rulers was Duke Mu (r. 659–621 BCE). The high regard in which he was held, not only in Qin but throughout the other states and fiefdoms of Zhou times, was reflected in a widely popular myth. Impressed by Duke Mu's virtue, the supreme deity God-on-High extended the duke's preordained lifespan by nineteen years, ensuring that he could bring about everlasting strength and prosperity for the house of Qin.[10] The myth was in effect a mandate from Heaven for the Qin ruling lineage to overcome all enemies and flourish. Duke Mu's reign was marked by intense competition and occasional warfare between Qin and its great neighbor to the east, Jin. By personally

leading his armies into battle and taking other strategic measures, Duke Mu made certain Qin got the upper hand. So successful was he that it is little wonder people thought he enjoyed divine blessings. Early in his reign he forcibly combined twelve other states to extend Qin territory in the west. In 645 BCE, through war with Jin, he expanded Qin's domain to include all the lands west of the Yellow River.[11] In recognition of the de facto power that he wielded beyond his own borders, he became Bo, or Uncle to the King and Lord-Protector of the Realm, to the reigning Zhou king, one of only five men in the history of the Zhou dynasty to gain such status.[12]

So great was Duke Mu's influence that he was able to place on the Jin throne—apparently without opposition from other Jin nobles—the "noble scion" Chong'er, a famous figure in Eastern Zhou history who had spent many years in exile. Chong'er became Duke Wen of Jin (r. 636–628 BCE), and though his reign was short it was illustrious. He even succeeded his patron Duke Mu of Qin as Uncle to the King and Lord-Protector of the Realm. This is but one example of how Duke Mu brought Qin to the center stage of Eastern Zhou political action, a position it would occupy for the next four hundred years. Indeed, it can be argued that Duke Mu's strategic moves—along with, of course, the Qin military conquests of the Warring States period—helped pave the way for the First Emperor's success in overcoming all of his neighbors and creating his unified empire.

Another of Duke Mu's contributions to the Qin tradition of governance was his willingness—unprecedented in the "Qin Basic Annals"—to demean himself or pay large sums to secure worthy advisers for his court. The story of how he managed to acquire Baili Xi and, through persistence, win his confidence and loyalty is legendary. Similarly famous is the tale of how Duke Mu then used lavish gifts to employ the services of Jian Shu, a man he had never met but whom Baili Xi had highly recommended.[13] Since these stories relate to a ruler of whom the grand historian Sima Qian approved, they are perhaps more formulaic than factual; nevertheless, they appear to reflect the practices by which Qin rulers won the loyalty of worthy advisers.

Duke Mu is also remembered as a great builder of impressive architecture in the capital of Qin. When

sometime around 626 BCE he showed his palace to an envoy from the king of the Rong, the obviously over-awed envoy observed: "If one employed spirits to make these sort of things, it would be toilsome for them."[14] Summarizing generally, we can see in Duke Mu's life precedents and harbingers of what the First Emperor would accomplish. But it would probably not be right to see Duke Mu as a model for the First Emperor; the political circumstances of the seventh century BCE were still a far cry from those of the third century. More direct models and actual momentum for the First Emperor would come with Duke Xiao of Qin (r. 361–338 BCE).[15]

When Duke Mu died he was buried in grand fashion in Yong. According to Sima Qian, 177 people were buried with him to serve him and keep him company in the afterlife.[16] The Qin practice of sacrificing people to accompany the dead goes back to 678 BCE, when an earlier Qin ruler was buried with 66 people who had served him in life. Sima Qian notes that this was "the first time" the Qin had buried living humans with the dead.[17] According to the figures given by Sima Qian in the "Qin Basic Annals," the number of people thus sacrificed grew as time went on, climaxing with the burial of Duke Mu. The practice is said to have been banned by Duke Xian of Qin in 384 BCE.[18]

The Conquest of Shu and Ba

The history of warfare and political intrigue in the fourth century BCE is fascinating and complicated. The great states at the time were Qin, Han, Wei, Zhao, and Qi. They stretched more or less from west to east along the valley of the Yellow River, with enormous and mighty Chu dominating the south, and Yan the northeast. The most ambitious state was Wei, which along with some of its neighbors attempted to check the rise of Qin. States that were pro-Qin formed what was termed a "horizontal" alliance, while the states that opposed Qin joined with Chu and formed a "vertical" alliance. The crucial political figures of the period were the rhetoricians who traveled from state to state attempting through the force of their logic and argumentation to persuade rulers to join one alliance or the other. Their rhetorical skill became legendary, and accounts of their exploits filled a manual

of political intrigue that survives today under the title *The Intrigues of the Warring States*.[19]

Perhaps Qin's greatest victory during this period was its conquest in 316 BCE of the large ethnic entities Ba and Shu, in the eastern part of what is now Sichuan province—after a campaign of almost 130 years. Though the center of a rich culture in the late second millennium BCE,[20] ancient Sichuan appears to have subsequently been something of a backwater until roughly the middle of the fifth century BCE, if the sparse accounts of Ba and Shu in the Chinese historical records mean anything. But I see the lapses in Sima Qian's account as little more than lacunae due to ignorance. More likely the culture of the Shu and Ba was quite high, if alien and exotic to the Xia or Hua populations of the Yellow River's drainage basin. As Edward Schafer points out:

> Just as high but "barbaric" cultures, characterized by leisure and urbanity, grew up among the aborigines of the American tropics, so unique and substantial cultural complexes developed among the pagans south of the true Hua-men, the ancestral Chinese. So the Pa and Shu peoples (akin to tigers, although the Chinese gave reptilian signs to their names) in what is now Szechwan, were accepted as civilized men by the Chinese at the end of the fourth century B.C. and gradually absorbed.[21]

By the fourth century BCE, the mineral wealth—primarily copper and gold—of Ba and Shu was coveted by Chu, their great neighbor downstream on the Yangzi River. Perhaps drawn by Chu's interest, Qin became greedy for other resources possessed by Ba and Shu: land, people, cattle, salt, weapons, and, above all, grain and other food supplies.[22] Caught thus between two great powers, the Shu and Ba populations could not retain their independence. To prevent their falling into the Chu sphere, "Qin armies occupied Shu, the upper Han valley, and what was left of Ba in north and east Sichuan."[23] As noted by Michèle Pirazzoli-t'Serstevens, Qin's colony in Sichuan not only provided the wealth and manpower required to realize Qin's imperial ambitions, it also served as a "laboratory" in which to test measures for integrating alien peoples into the Qin social and cultural order.[24]

The "Reforms" of Shang Yang and Fan Ju

It is almost commonplace in early historical records to vilify the rulers and native population of Qin as violent and uncivilized. As late as 266 BCE, a nobleman from the neighboring state of Wei said:

> Qin has the same customs as the Rong and the Di. It has the heart of a tiger or a wolf: greedy, violent, keen for profit, and untrustworthy. It knows nothing about traditional etiquette, proper relations, and virtuous conduct. If it sees something profitable before it, just like a wild animal it will disregard relatives and brothers.[25]

Even contemporary scholars refer to Qin's backwardness compared to other states, using as proof the custom of forcing the living to accompany the dead into the netherworld.[26] Though Qin may have been culturally undeveloped compared to the other ancient states, few could accuse it of being backward with respect to governance and warfare, especially after the mid-fourth century BCE. It was then that Shang Yang (d. 338 BCE) left his native state of Wei to serve Duke Xiao of Qin (r. 361–338 BCE) as chancellor. In this position he initiated a series of economic and legal reforms that are said to have greatly increased Qin's agricultural productivity and enhanced the already fearsome performance of the state's soldiers on the battlefield.[27]

Shang Yang put in place a detailed code of laws concerned not only with the administration of the Qin government but also with people's behavior and conduct. Corporal punishments were introduced for a wide variety of activities, even minor crimes, in an effort to deter disobedience. To enforce these penal laws, the population was divided into small units of five or ten households for purposes of surveillance and to ensure mutual responsibility. But Shang Yang also created an elaborate set of titles to reward those who served the state, especially in the military. As noted by Mark Lewis, an authority on the history of violence in early China, "military success measured by the number of heads of slain enemies was rewarded with promotion in rank."[28] Shang Yang is also credited with agrarian reforms that resulted in more provisions for the army and an improved economic basis

for the Qin state. Those reforms may very well have laid the groundwork for the series of military victories of the fourth and third centuries—including the conquest of the Shu and Ba people—that decimated Qin's enemies and made inevitable the triumphant establishment of the Qin empire.

Finally, it was Shang Yang who built Qin's last capital, Xianyang, "the Confluence of Yang Powers," so named because of its propitious location north of the Wei River and south of the mountains forming the northern limit of the Wei River basin. While designing what would become the seat of Qin's imperial power, Shang Yang put in place the military strategy that enabled the Qin to extend their territory beyond the seemingly impassable boundary of the Luo River and eventually conquer the states to the east "outside the passes."

Yet in spite of—or indeed because of—all his accomplishments and contributions to Qin's greatness, Shang Yang was doomed. When Duke Xiao died in 338 BCE, his relatives and heirs, long resentful of Shang Yang's power, had Shang Yang executed in the cruelest way possible, his body torn limb from limb. Shang Yang's life and death illustrate the most vexing issue facing the rulers and political philosophers of the period: How can a state secure the long-term survival of its ruling lineage against internal political threats and at the same time win the loyal and devoted service of wise advisers not related to the throne? Answers fill the political tracts of the Warring States period. But the question would continue to perplex the Qin and many of the imperial dynasties that followed.

After the conquest of Shu and Ba, Qin was fortunate to have King Zhaoxiang (r. 306–250 BCE) come to the throne. Zhaoxiang is remembered not merely because he was the First Emperor's grandfather but because he was the king who employed as his chief minister the great political theoretician Fan Ju (d. 255 BCE).[29] Fan brought about a revolution in Qin's thinking and policies. The last of the rhetorician "persuaders," he convinced King Zhaoxiang to fashion an "alliance with distant states and attack those nearby," putting Qin on an irreversible path of territorial expansion at the expense of those who shared its borders. Another of Fan Ju's radical doctrines taught that when attacking neighboring territories Qin should utterly destroy their defending armies. Previously it had been

accepted practice to spare the lives of defeated soldiers, because having a large population under one's command was regarded as an asset. Fan Ju's policy of mass slaughter resulted in the destruction of armies on such a scale that enemies lost the will to fight.[30]

The Founding of the "Qin Academy" by Lü Buwei

Qin's cultural backwardness was addressed by the remarkable statesman Lü Buwei. According to the grand historian Sima Qian, Lü Buwei was a wily merchant native to another state who bought access to the ruling house of Qin during King Zhaoxiang's waning years and engineered the succession that led to the enthronement of Ying Zheng as king and eventually as First Emperor. Lü Buwei became chancellor of Qin in 247 BCE and set about making the state a center of intellectual activity and philosophical debate. Popular opinion held that his control of Qin surpassed, at least briefly, even that of Fan Ju. In his otherwise unflattering biography, Sima Qian relates that Lü Buwei was ashamed that Qin did not compare well with other states in its treatment of scholars. He therefore "recruited scholars, treating them generously so that his retainers came to number three thousand."[31] Eventually the scholars he gathered about him helped Lü in his attempt to encompass the world's knowledge in a great encyclopedia, the *Lüshi chunqiu* (Annals of Lü Buwei),[32] compiled in 239 BCE. It was intended as a philosophy for the empire Lü Buwei knew Qin was destined to become, a philosophy that would, I believe, be considered enlightened no matter the place or time. Lü's text asserted the following:

- What qualifies one to rule is the equanimity he brings to his family and the tranquillity to the world through the cultivation of impartiality in himself.

- The practice of hereditary rule is based on stupidity, grounded in selfishness, and reinforced by flatterers and sycophants.

- The fundamental principle on which all government must rest is that in all his undertakings the ruler "must first determine the wishes of the people and only then act."

- Education is crucial to the individual as well as to both society and government. Therefore teaching "is

the most important of our moral duties, and learning is the culmination of wisdom."

But the text also contained a controversial attack on Qin practices. This had elements in common with Confucian thinking and other early schools of thought and hence was not unique. However, the particular formulation in *The Annals of Lü Buwei* was directed against the school of Shang Yang, which remained dominant in Qin right through the third century BCE. According to Lü, in resorting to severe punishment Qin showed that it "lacked the proper Dao" when it merely "multiplied severity." The harshness of Shang Yang's government, military practices, and penal sanctions is nowhere to be seen in Lü's compilation.

His protégé, the First Emperor, eventually cast Lü Buwei and his philosophy aside in favor of the teachings and policies of the Legalist heirs of Shang Yang, which he put into full effect in 221 BCE when he created the Qin empire. Perhaps he genuinely regarded Lü and his philosophy as an irrelevant aberration in the march of Qin history, with its grand legacy of military conquest, mass slaughter, triumphant expansion, political reform, and cultural ascent.

Notes

1. These are the opening lines of the "Qin benji," or "Qin Basic Annals," *Shiji* (Beijing: Zhonghua Shuju, 1959), pp. 173–221. For complete translations, see William H. Nienhauser, Jr., ed., *The Grand Scribe's Records*, vol. 1 (Bloomington: Indiana University Press, 1994), pp. 87–125, and Burton Watson, *Records of the Grand Historian: Qin Dynasty* (New York: Columbia University Press, 1993), pp. 1–34. For more details on pre–221 BCE Qin history and the limitations of the *Shiji* as a source for Qin history, see Derk Bodde, "The State and Empire of Ch'in," in *The Cambridge History of China*, vol. 1, ed. Denis Twitchett and Michael Loewe (Cambridge: Cambridge University Press, 1986), pp. 20–102.

2. The Shang origin myth is found in the poem entitled "The Dark Bird" in the canonical *Book of Songs*. See Arthur Waley, *The Book of Songs* (New York: Grove Press, 1996), song 303, p. 320.

3. For the location of Quanqiu or Dog Hill, see Lin Jianming, *Qin shi gao* [A draft history of Qin] (Shanghai: Renmin Chubanshe, 1981), p. 33n16. Based on my reading of the passage in the "Qin Basic Annals" I equate Dog Hill with the location identified as "West Dog Hill." See the map in Tan Qixiong, *Zhongguo lishi ditu ji* [Collection of historical maps of China] (Shanghai: Ditu Chubanshe, 1982), 1:22.

4. See Tan Qixiong, *Zhongguo lishi ditu ji*, 1:22.

5. "Qin Basic Annals," *Shiji*, p. 184.

6. The title *hou*, often translated "marquis," literally means "target." It may have indicated that the holder was one of the Zhou king's trusted marksmen, or that he had been subdued (perhaps willingly) by the arrows of the Zhou archer kings. Possibly Feizi's son was given the title *hou* posthumously by his descendants, to commemorate his father's contributions to the family. The title and rank of the Marquis of Qin's son and grandson are uncertain. See Jeffrey Riegel, "Early Chinese Target Magic," *Journal of Chinese Religions* 10 (1982): 1–18.

7. Waley, *Book of Songs*, song 300, p. 314.

8. "Qin Basic Annals," *Shiji*, p. 179.

9. The reference to Duke Wen getting the "Chen Treasure" is found in "Qin Basic Annals," *Shiji*, p. 179. The description of the spirit is found in Sima Qian's "Fengshan shu," *Shiji*, p. 1359.

10. The myth is preserved in the fourth-century BCE *Mozi*. See Jeffrey Riegel, "Kou Mang and Ju Shou," *Cahiers d'Extrême-Asie* 5 (1989–90): 55–83. The number 19 was significant in ancient calendrics because approximately every nineteen years the day of the new moon coincides with the winter solstice.

11. Bodde, "State and Empire of Ch'in," pp. 33–34, provides more detail on the political accomplishments of Duke Mu. The claim that by 645 BCE Qin dominated all the lands west of the Yellow River is an exaggeration. In fact Qin's eastern border was confined by the southeasterly course of the Luo River until the successful campaigns undertaken by Shang Yang in the middle of the fourth century BCE.

12. Some sources name five, rather than four, others: Duke Huan of Qi, Duke Wen of Jin, King Zhuang of Chu, King Helu of Wu, and King Goujian of Yue.

13. "Qin Basic Annals," *Shiji*, p. 186.

14. Ibid., p. 192.

15. This was the judgment of Li Si, the First Emperor's prime minister. See Michael Loewe, "The Heritage Left to the Empires," in *The Cambridge History of Ancient China*, ed. Michael Loewe and Edward L. Shaughnessy (Cambridge: Cambridge University Press, 1999), p. 974.

16. "Qin Basic Annals," *Shiji*, p. 194.

17. Ibid., p. 183.

18. Ibid., p. 201.

19. Mark Edward Lewis, "Warring States Political History," in Loewe and Shaughnessy, *Cambridge History of Ancient China*, pp. 632–34, provides more detail on the alliances and the persuaders of the period 350–250 BCE. For a translation of the *Intrigues*, see J. I. Crump, Jr., *Chan-Kuo Ts'e* (Oxford: Oxford University Press, 1970).

20. I am referring to the "lost civilization" represented by the archaeological sites at Sanxingdui and Jinsha. See Jay Xu, "Sichuan before the Warring States Period," in *Ancient Sichuan: Treasures from a Lost Civilization*, ed. Robert Bagley (Princeton, N.J.: Princeton University Press, 2001), pp. 21–37.

21. Edward H. Schafer, *The Vermilion Bird* (Berkeley: University of California Press, 1967), p. 13.

22. Michèle Pirazzoli-t'Serstevens, "Sichuan in the Warring States and Han Periods," in Bagley, *Ancient Sichuan*, p. 39.

23. Ibid., p. 40.

24. Ibid.

25. Quoted in the "Hereditary House of Wei," *Shiji*, p. 1857. Along with the Rong, the Di were a pastoralist and warrior people regarded as barbarians by the population of the old Central States of Zhou dynasty China.

26. See for example Zhang Zhengming, "Chumu yu Qinmu de wenhua bijiao" [A cultural comparison of the tombs of Chu and Qin], *Huazhong Shifan Daxue xuebao* 42, no. 4 (July 2003).

27. The philosophy behind Shang Yang's reforms is thought to be preserved in the *Shangjun shu*, or *Book of Lord Shang*, though the book seems to have been compiled in the third century BCE. See J. J. L. Duyvendak, *The Book of Lord Shang* (London: Probsthain, 1928). For a much more detailed discussion of Shang Yang's reforms than that presented herein, see Bodde, "State and Empire of Ch'in," pp. 34–38.

28. Lewis, "Warring States Political History," p. 612. In parts of the concluding paragraphs of the present essay, I have borrowed from Lewis's learned historical account.

29. Fan Ju's name has from quite early times been mistakenly given as Fan Sui, because the Chinese graphs for *ju* and *sui* are similar in appearance. As a result, Fan Ju is better known as Fan Sui, especially in Western scholarship on Qin history. For example, Lewis, "Warring States Political History," pp. 638–41, refers to Fan Ju as Fan Sui.

30. "Here we find enunciated as policy the mass slaughters of the third century." Lewis, "Warring States Political History," p. 640.

31. "Lü Buwei liezhuan," *Shiji*, p. 2510.

32. For a complete translation of the text see John Knoblock and Jeffrey Riegel, *The Annals of Lü Buwei* (Stanford, Calif.: Stanford University Press, 2000).

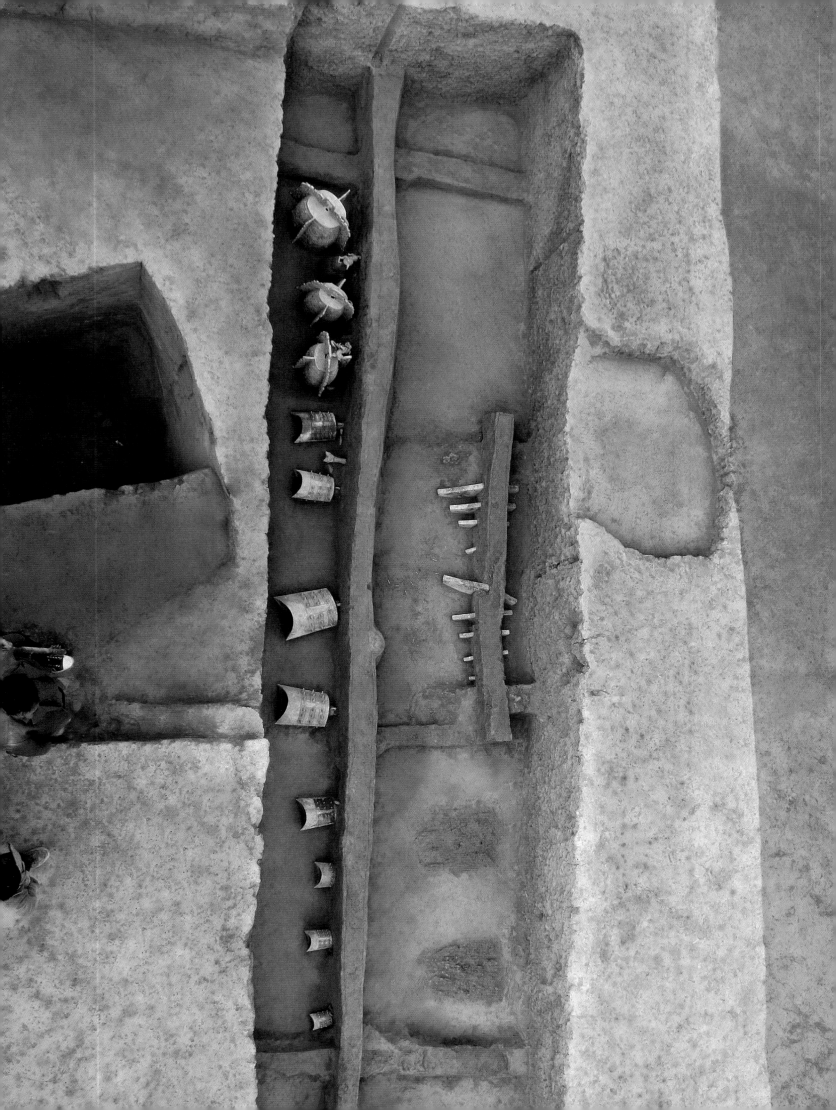

From the "Barbarian" Land: Recent Discoveries in the Archaeology of the Qin in Gansu

LIU YANG

One of the great puzzles of Chinese history is the ethnic origins of the Qin clan. The historian Sima Qian (c. 145–c. 86 BCE), writing in the first century BCE, stated that the Qin were descendants of the legendary sovereign Zhuanxu, a grandson of the Yellow Emperor.[1] He seemed to suggest they were the offspring of Dongyi (Yi of the East), thus advancing the earliest theory linking the Qin to east China. Dongyi was a collective term for the people of east China, in present-day Shandong and eastern Henan provinces. They were the offspring of the legendary overlords Taihao and Shaohao, as were the ancestors of the Shang, whose dynasty (c. 1600–c. 1046 BCE) is verified by rich archaeological finds and important genealogical information discovered on oracle bones.

Other views of Qin's beginnings were voiced throughout history, attracting more attention in the 1920s and 1930s. The renowned historian Wang Guowei (1877–1927) challenged Sima Qian's authority with a theory that the Qin came of primitive and barbaric origins associated with the Rong or Quanrong, nomadic tribes from the northwest frontier.[2]

In the 1980s, this theory of the Qin's western origins gained support from new archaeological activity. Scholars noted several significant differences in mortuary practice between the early Qin and other states of the Western Zhou dynasty (c. 1046–771 BCE). For instance, Qin corpses were generally placed in a flexed position on their sides (see p. 32), whereas corpses unearthed in early tombs from other regions lay supine and straight. The Qin commoners' tomb known as *dongshi mu* (catacomb tomb) differed structurally from such tombs in other regions: the coffins or bodies were placed in a lateral chamber adjacent to a vertical shaft. And a type of pottery vessel (*li*) known as *chanjiao daizu li*, with three plump legs, each ending in a foot resembling a shovel, was often buried in early Qin tombs but not seen in the Central Plains. All of these distinctive customs were associated with the culture of the Rong and another ethnic group, the Qiang.[3] Yet another burial custom suggesting a western origin to some scholars was the east-west orientation of Qin tombs, with the head of the corpse toward the west,[4] while most other Western Zhou tombs had a north-south orientation. As further evidence, an inscription carved on a bronze bell of the Warring States period (475–221 BCE), unearthed from a Chu state site at Dangyang, in present-day Hubei province, refers to the Qin as "Qin-Rong."[5] So it would seem that early in the Warring States period the Qin were already perceived as originating from the family of Rong.

On the other hand, arguments in favor of Sima Qian's suggestion of an eastern origin have also been heard since the 1930s[6] and have been particularly strong in modern scholarship. They are supported by the following points: (1) The Qin's totemic worship resembled that of the ruling class of the Shang dynasty, who

Musical Instrument Pit at Mount Dabuzi under excavation

according to popular theory were the offspring of Dongyi,[7] and Qin and Shang had a similar genealogical myth about the origins and nature of their rulers and people (Lady Xiu swallowed the egg of a dark bird and gave birth to Grand Undertaking, the ancestor of Qin; the mother of Xie, the founder of Shang, was impregnated by devouring an egg dropped by a black bird). (2) The family name of the Qin ruler was Ying, and clans with this name were mostly from the east, such as the ruling classes of the small states Xu, Jiang, Huang, and Yan. (3) When the state of Jiang was conquered by Chu in 623 BCE, Duke Mu of the Qin wore a livery of grief,[8] perhaps mourning the loss of a state ruled by his blood relations. According to Sima Qian, not only were the Qin descended from Zhuanxu, but Duke Xiang (r. 777–766 BCE) of the Qin state worshiped Shaohao, another legendary eastern tribe overlord.

In recent scholarship, the genealogical origin of Qin's rulers and people is intermingled with the culture of Qin. Both arose in eastern China but developed in the west.[9] Scholars favoring Qin's eastern origin have assumed that several epic migrations of the Qin people from east to west took place during the early Shang, late Shang, and early Western Zhou periods.[10] They argue that recent archaeological evidence makes clear that Qin's characteristic *dongshi mu* tomb structure and use of the *chanjiao daizu li* pottery vase did not appear in the early Qin until the Warring States period. Current archaeological data show that Qin aristocrats were usually buried in a stretched position; the flexed position is seen mainly in burials of commoners. This seems to suggest that Qin aristocrats wished to show their ancestral eastern lineage but that Qin commoners had adopted the barbarian Rong custom.[11]

The heated debates continue, but there is now broad agreement that it was in western China, in present-day Gansu province—more specifically the Tianshui district of eastern Gansu—that the Qin arose and developed. This is consistent with Sima Qian's record—the ancestors of the rulers of Qin dwelt among the barbarians in Xichui, or Xiquanqiu, as early as the late Shang and early Western Zhou—and is supported by substantial archaeological data.

Since the early 1980s, many Qin-type funerary sites and settlement remains have been found in the Tianshui area,

including Dongjiaping, Xishanping, Fangmatan, and Maojiaping in Gan'gu county, excavated in 1982–83.[12] Archaeologists compared three groups (A–C) of remains from Maojiaping, including settlement and burial sites, with Qin materials excavated earlier in the Guanzhong area (present-day central Shaanxi, between Baoji on the west and Xianyang on the east) and concluded that Group A belonged to the Qin culture, dating from the late Shang to the late Warring States period.[13]

By extending our knowledge of the Qin people into the late Shang and early Western Zhou periods, the excavations at Maojiaping provide an earlier and more reliable starting point for the study of Qin culture. The archaeological finds also prove that Sima Qian's account of early Qin's settlement in the west is not legendary hearsay. According to Sima Qian, from the time of King Taiwu of the Shang dynasty, some Qin chiefs had won merit generation by generation by assisting the Shang ruler. In the late Shang dynasty, a Qin chief known as Zhongjue "lived among the Western Rong people and guarded the western border."[14] Many generations later, a Qin chief known as Feizi was given the title Qin Ying and the land of Qin (in present-day Tianshui, Gansu) by King Xiao of the Western Zhou for his service of pasturing the royal horses. From then on (around the last decade of the ninth century BCE), the history of the Qin becomes much clearer.

The finding of house remains and pottery cooking vessels of *li, pen, dou,* and *guan,* and also *yan* and *zeng* steamer sets at the Maojiaping site shows that agriculture was important to the society's livelihood. It complemented what Sima Qian asserted was Qin's traditional way of life, a nomadlike existence dependent on hunting and herding. The similarity of many of the pottery forms to those used by the Western Zhou people also suggests that during this period the Qin had encountered and assimilated many aspects of the Zhou culture.

By the mid-1980s Chinese archaeologists had identified three grand necropolises or mausoleums of Qin rulers, all in the northwestern province of Shaanxi: Yong (in present-day Fengxiang), Dongling (near present-day Xi'an), and the First Emperor's tomb complex in Lintong. Yet the whereabouts of the tombs of the early Qin rulers remained a mystery. The breakthrough came when the necropolis on Mount Dabuzi, or Great Fort Mountain

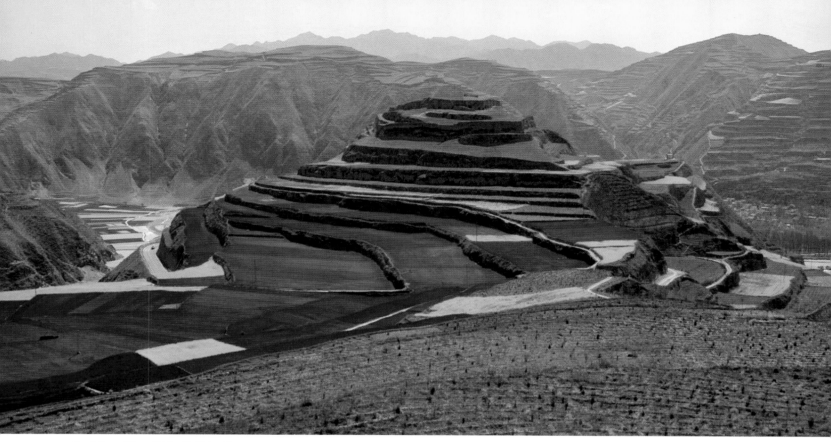

Fig. 1. View of Mount Dabuzi in Lixian, Gansu

(named for a fort built on its summit in the Qing dynasty), was revealed.

Mount Dabuzi is some eight miles east of present-day Lixian, in eastern Gansu province (fig. 1). In the 1980s, a number of ancient tombs were accidently opened when local farmers were digging for "dragon bones," or fossils, which people believed could cure sickness. Theft and serious damage to the tombs ensued in 1992–93. The mountain was torn open by grave robbers who stole numerous valuable cultural relics until security forces and archaeologists stepped in. The subsequent archaeological excavation from March to November 1994 revealed a graveyard extending some 250 meters (275 yd) east to west and 140 meters (155 yd) north to south. Further excavation within an area of about 35,000 square meters (8½ acres) uncovered more than two hundred tombs of various sizes, all with east-west orientation (fig. 2). Most of them had been looted. Chinese archaeologists so far have excavated two large tombs (M2 and M3) in the shape referred to as *zhong* 中, one of two chariot-and-horse pits (K1), and nine medium-size tombs.[15]

Both literary records and archaeological excavations verify that a sophisticated burial system was practiced in the Shang and Western Zhou sphere long before the Qin state was founded. The deceased's social status was signified not only by the tomb's scale, but also by its

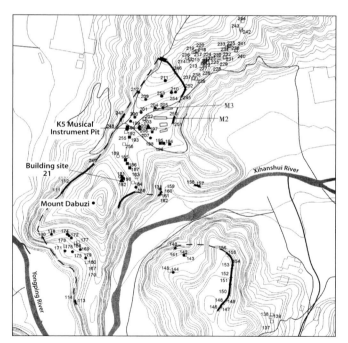

Fig. 2. Topographical drawing of Mount Dabuzi showing the positions of the tombs

structure and the number of entrance ramps leading into the main chamber. In general, the tomb for the Son of Heaven had four ramps, giving it the shape of the Chinese character *ya* 亞. The tomb of a ranked aristocrat such as a duke could have two ramps (a *zhong* shape) or just one (a *jia* 甲 shape). A commoner's tomb was simply a rectangular vertical shaft, without any entrance. The

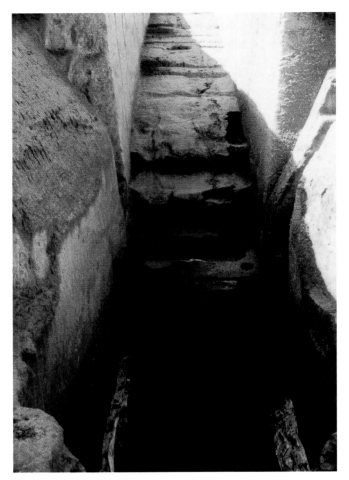

Fig. 3. Mount Dabuzi Tomb M2 under excavation

Fig. 4. Lacquered leather box in Mount Dabuzi Tomb M2

zhong-shaped tombs found on Mount Dabuzi reinforce the idea that the Qin had close ties to the Shang and Zhou tradition. Such burial structures became standard in later Qin mortuary practice and were found in the royal cemeteries established at Yong and Xianyang and in the First Emperor's tomb complex.

One of the *zhong*-shaped tombs on Mount Dabuzi, Tomb M2, is a trapezoidal shaft that contained a wooden chamber (*guo*) with an inner lacquered coffin (*guan*) at the bottom, a sacrificial pit called a *yaokeng* (literally, "waist pit") beneath the chamber (containing a slaughtered dog and a jade *cong*), and a shelf known as an

ercengtai (literally, "second-layer terrace"), formed by packing earth into the space between the chamber and the shaft walls (fig. 3). The entrance ramp on the east side measured 37.80 by 6 meters (124 x 20 ft) and that on the west 38.20 by 4.50 meters (125 x 15 ft). The main chamber was 12.10 by 11.70 meters (40 x 38 ft) at the mouth and 6.80 by 5 meters (22 x 16 ft) at the bottom and was 15.10 meters (50 ft) deep. The tomb's occupant was positioned east to west, his head to the west.

Nineteen human sacrifices were found in the grave. Seven, in the *ercengtai*, were laid supine and straight, some in lacquered wooden coffins and many with jade ornaments, suggesting they were of noble status. The remaining twelve, in the western entrance ramp, were in a flexed position on their sides. From their positioning and signs of physical injuries, it is apparent that they were slaves. Although the tomb had been robbed, gold plaques embellishing the lacquered coffins remained. Archaeologists also unearthed a rotted lacquered leather box decorated in black and red with a stylized phoenix motif (fig. 4).

The chariot-and-horse pit (K1) excavated near Tomb M2 is L-shaped, with an entrance ramp on the east measuring 21.85 meters long and 9.5 meters wide (72 x 31 ft). The main chamber has a vertical shaft 14.65 meters long, 12.95 meters wide, and 5.4 meters deep (48 x 42 x 18 ft). Although this pit had suffered serious damage, archaeologists were able to determine that it originally contained an array of four rows of chariots and horses. There were three chariots per row, making a total of twelve, each with four horses.[16] Only a handful of bronze chariot fittings were found, and a number of ornamental gold plaques were stolen from this pit. It was a common mortuary practice throughout the Western Zhou cultural sphere to include chariot-and-horse pits in burials of high-ranking aristocrats. The presence of such pits next to the grand tombs at Mount Dabuzi suggests that the tomb occupants were persons of high status. It is also an indication of the Qin's adherence to Western Zhou ritual customs.

Each of the nine medium-size tombs is a rectangular shaft, oriented east to west, approximately 2 to 5.2 meters (6½ to 17 ft) long, 1.4 to 2.7 meters (4½ to 9 ft) wide, and 3.6 to 7.6 meters (12 to 25 ft) deep. The deceased were laid supine and straight and were buried with bronzes, potteries, jades, stone objects, and, in

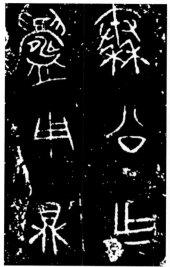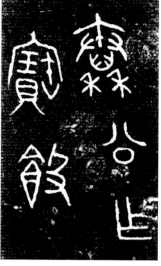

Fig. 5. Inscriptions cast on a bronze *ding* and a bronze *gui* from Mount Dabuzi showing the character for "Qin" (top right on each) written two ways

some cases, human and animal sacrifices. Ceramic substitutes for bronze vessels were also used.

Although Chinese archaeologists found few valuable objects in the looted large tombs, a group of bronze *ding* cauldrons and *gui* vessels confiscated by the local police in 1993–94 were identified by the tomb robbers in custody as being stolen from Tomb M3. A comparison of their decorative patterns with those on bronze fragments excavated from M3 supports that assertion. In addition, a number of ritual bronzes and gold ornaments that emerged during the 1990s in overseas markets and ended up in various collections were shown by scholars to be from Mount Dabuzi.[17]

Han Wei, former director of the Shaanxi Provincial Institute of Archaeology, studied a group of gold plaques and sculptures in the form of owl-like mythological birds, tigers, and geometrical shapes, formerly in the collection of Christian Deydier Oriental Bronzes in London, and concluded that all were from the cemetery on Mount Dabuzi.[18] Lending support to his opinion, seven gold plaques excavated by Chinese archaeologists from Tomb M2 have a double-loop pattern almost identical to that on plaques in the Christian Deydier collection.[19]

A number of the bronze vessels bear inscriptions such as "Qingong zuozhu yong ding" (The Duke of Qin had this *ding* made for his use) or "Qingong zuozhu yong gui" (The Duke of Qin had this *gui* made for his use). So it is certain that the two grand tombs belonged to early Qin rulers. One view is that these were the tombs of Duke Xiang (r. 777–766 BCE) and his wife, since Xiang was the first on

whom the Zhou king bestowed the title *gong*, or duke.[20] However, because the character for "Qin" is written in two ways (fig. 5), it has been suggested that there are two groups of bronzes, possibly made for Duke Xiang and his successor, Duke Wen (r. 765–716 BCE).[21] Ancient tradition called for burying rulers on high ground, and the cemetery on Mount Dabuzi, encircled by rivers—the Xihanshui to the south and the Yongping to the west— meets the general requirements of a rulers' cemetery of the period.

In 2006, thirteen years after the excavation of the two grand tombs on Mount Dabuzi, archaeologists discovered another significant burial about 20 meters (65 ft) south- west of Tomb M2. Now known as the Musical Instrument Pit, this untouched find contained important bronze and stone musical instruments used for ritual ceremony (figs. 6 and 7). These included three huge *bo* bells 53.3 to 66 cm (21 to 26 in) high, together with three tigers sculpted in the round, which probably were part of the *bo* set; eight *yongzhong* bells 23.4 to 53.7 cm (9 3/16 to 21 1/8 in) high; and ten pieces of *qing* hanging chime stone.[22] The largest *bo* bell bears an inscription identifying it as made for Qinzi (fig. 8). Although opinions differ as to who Qinzi was—Duke Wen's son Duke Jing (d. 716 BCE) or Duke Chuzi (r. 703–698 BCE)—Chinese scholars all agree that these bronzes can be dated to the early Spring and Autumn period (770–476 BCE).[23] The number of *bo*, three, is mentioned in the inscription, and a group of three *bo* was also excavated at Taigongmiao village in Baoji, Shaanxi province. It seems that a grouping of three was standard in the Qin ritual system. Also in 2006 on Mount

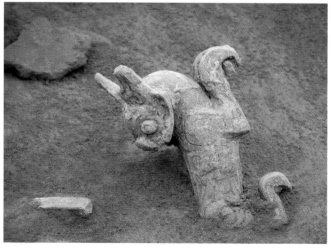

Fig. 6. The Musical Instrument Pit in Mount Dabuzi under excavation

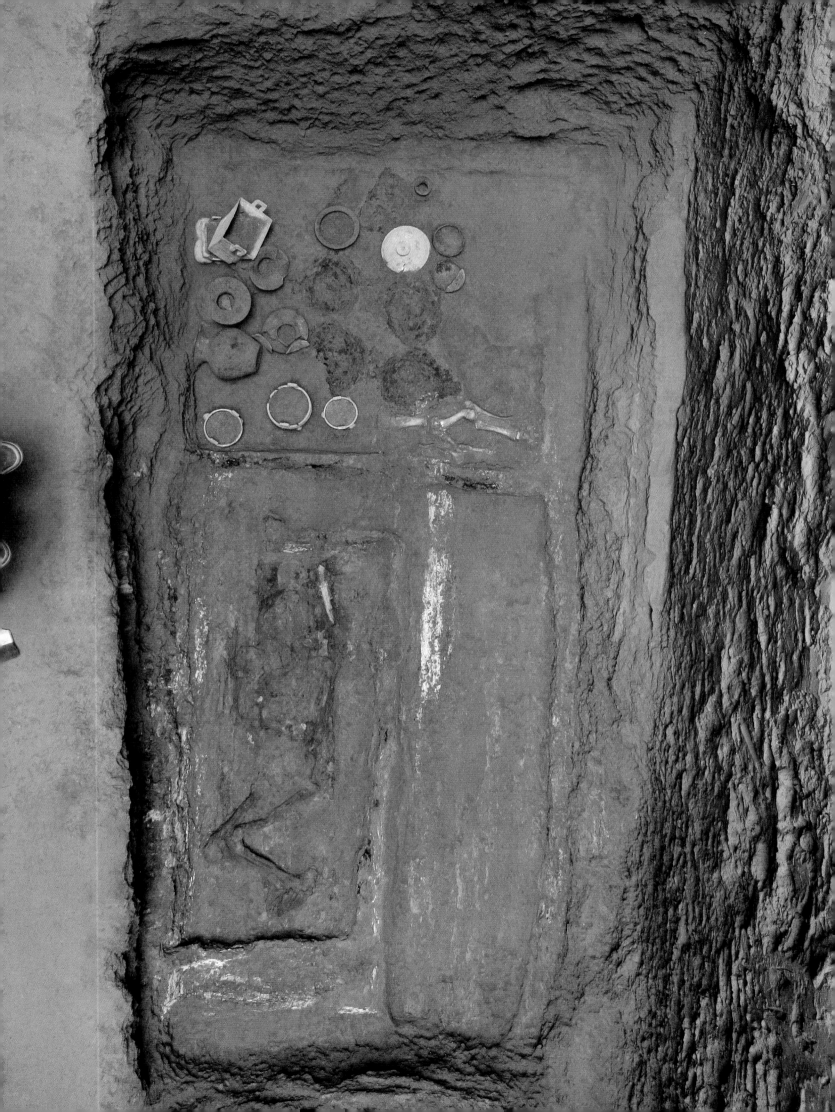

Fig. 7. Drawing of the Musical Instrument Pit viewed from the top and from the side

Dabuzi, archaeologists excavated nine small-scale tombs of Qin aristocrats (IM21–25, IIIM1–2, IIIM11–12), dating from the mid to late Spring and Autumn period, that yielded important information about the early mortuary practices of Qin officials of lower and middle ranks (fig. 9).[24]

In the late 1990s and early 2000s, another significant excavation was made, this one on Mount Yuanding, nearly two miles from Mount Dabuzi, on the opposite side of the Xihanshui River. As at Mount Dabuzi, robbers had raided a number of the ancient tombs in the 1990s, and archaeologists then intervened to save some of the graves. The preliminary archaeological work revealed the northern slope of Mount Yuanding to be a vast cemetery of Qin aristocrats and commoners, with graves dating from the early Spring and Autumn period up to the beginning of the Warring States period.[25]

Fig. 8. Inscription cast on a *bo* bell

The first excavation, carried out from February to June 1998, uncovered three tombs (98LDM1–3) and one chariot-and-horse pit (98LDK1) (fig. 10). The second, conducted from May to July 2000, unearthed another grave (2000LDM4). Although these tombs were once raided, the harm done was minimal; the relatively high groundwater level kept the grave robbers from venturing very deep. Authorities acted quickly to prevent further deterioration, and archaeologists found a vast number of funerary artifacts. Some eighty-three ritual bronzes were unearthed, along with thirty-eight jades and numerous potteries and stone objects. Interestingly, cinnabar red was scattered on all four tombs.

Tomb 98LDM2 is typical and yielded the largest group of objects (figs. 11 and 12). It is the most extensive of all the tomb configurations in the Mount Yuanding cemetery. A rectangular shaft 6.25 meters long, 3.25 meters wide, and 7 meters deep (20½ x 10½ x 23 ft), oriented east-west, it had the familiar structure of *ercengtai* and *yaokeng* and contained one outer chamber 5.50 meters long, 2 meters wide, and 1.60 meters high (18 x 6½ x 5 ft) and an inner coffin, both painted in lacquer. Seven human sacrifices in lacquered coffins were placed around the *ercengtai*. Found with them were jade ornaments (*jue* rings, *huang*

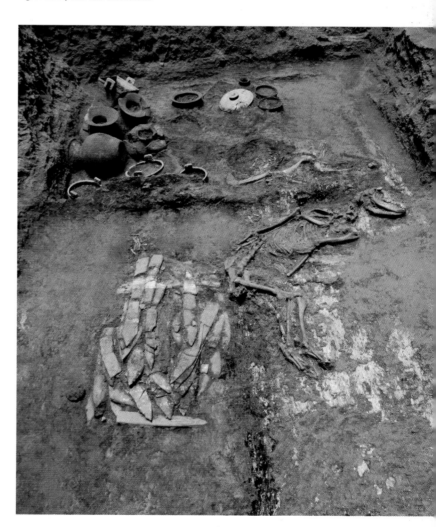

Mount Dabuzi Tomb IM25, later view of excavation shown in fig. 9

Fig. 9. View of Mount Dabuzi Tomb IM25 under excavation

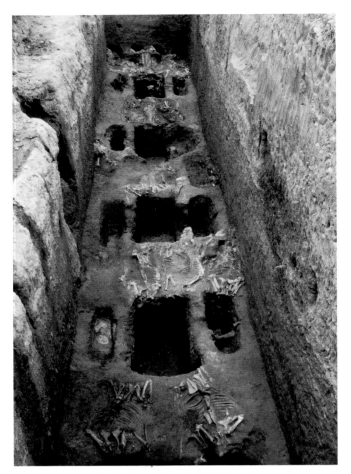

Fig. 10. Mount Yuanding chariot-and-horse pit (98LDK1) under excavation

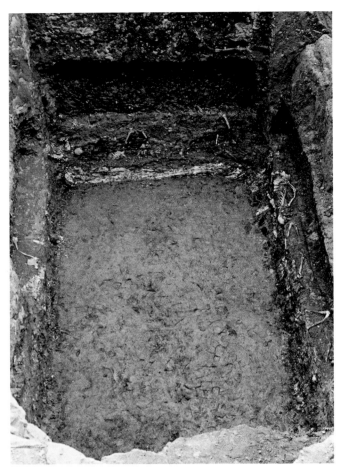

Fig. 11. Mount Yuanding Tomb 98LDM2 under excavation

pendants, beads, etc.). A total of thirty-eight ritual bronzes were unearthed from the tomb, including five *ding* tripods, six *gui* vessels, two *fanghu* vases, a *he* kettle, a *xu* covered vessel, a *yi* water vase, a *pan* basin, a dagger, and three swords, and also thirty-two jade ornaments.[26]

Judging from the bronze styles, the Qin burials on Mount Yuanding span the Spring and Autumn period (770–476 BCE). This suggests that after Qin was promoted to a vassal state (around 770 BCE) and moved into the former heartland of the Western Zhou (in present-day Shaanxi), some Qin aristocrats continued to live in Xichui, guarding the ancestral temples and lands. Strategically, this enabled the Qin to exert control over the various barbarian tribes in the west and to extend their influence to the southwest, in Ba and Shu (present-day Sichuan province). Therefore, the Mount Dabuzi and Yuanding cemeteries remained in use, although the burials there do not incorporate all the features befitting rulers of a vassal state.

The excavation of these early Qin burial sites in Lixian sheds further light on questions concerning the Qin identity. It seems that the Qin people subscribed fundamentally to the culture of the Central Plains, especially

that of the Western Zhou. This is reflected in their mortuary practice: the *zhong*-shaped tomb with two long entrance ramps; the *yaokeng* sacrificial pit and *ercengtai* shelf, both of which derive from Shang dynasty burials and were adopted by the succeeding Western Zhou;[27] the use of inner and outer coffins; and human sacrifices. Moreover, the manner of grouping various objects, the form and decoration of the ritual bronze vessels, the expressive mode and script style of inscriptions, the pottery types and their grouping, the use and craftsmanship of jade objects, the presence of chariots and horses, and the form of the bronze chariot fittings and weapons—all demonstrate strict adherence to the Shang and Western Zhou tradition.

If the Qin people were in fact of eastern origin, they would have migrated west very early. But when and why would they have done so? A recent finding provides an explanation. In 2008 Tsinghua University in Beijing was given 2,388 bamboo slips bearing important early Chinese texts written in ink, dating to the Warring States period around the fourth to third centuries BCE. They had been illegally excavated from an unknown location in the ancient Chu region (in present-day Hubei and Hunan) and brought to

Musical Instrument Pit at Mount Dabuzi under excavation

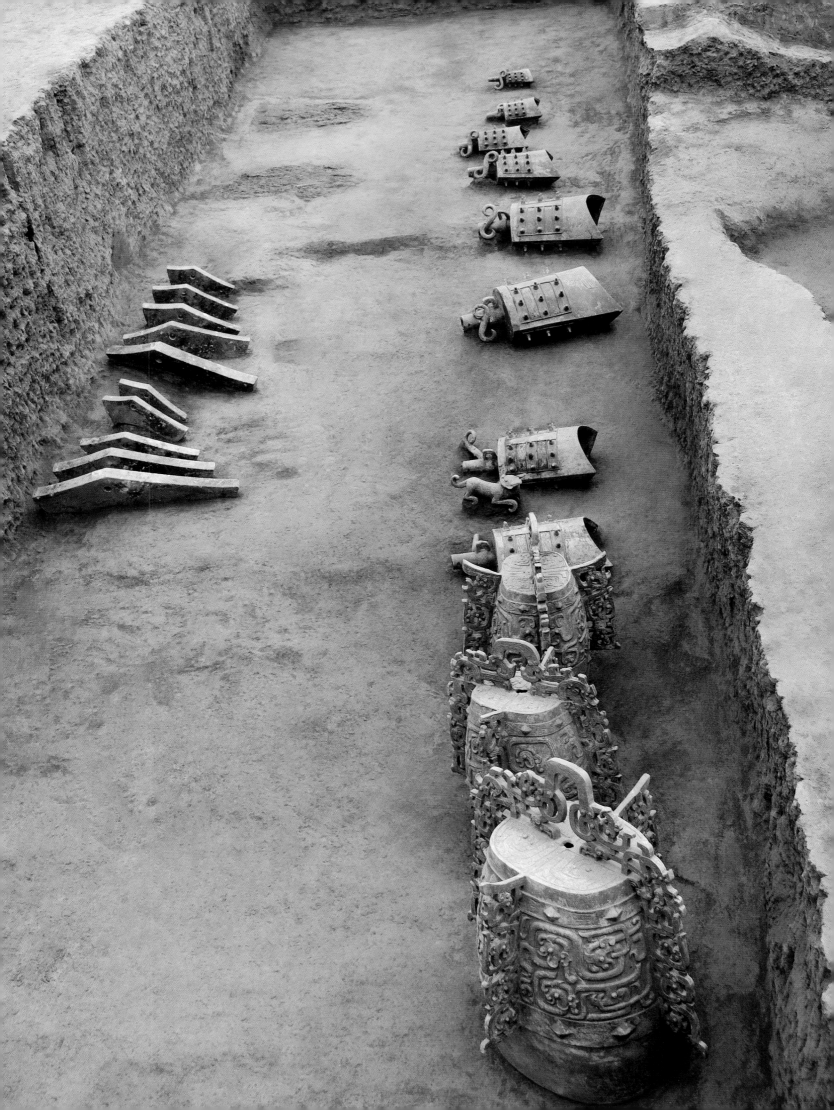

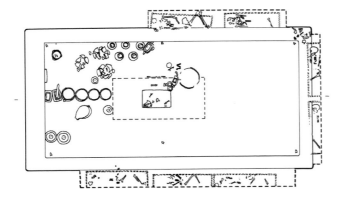

Fig. 12. Drawing of Mount Yuanding Tomb 98LDM2, viewed from the top and from the side

Hong Kong. They were then acquired and donated to the university by an alumnus. The very large size of the collection and the significance of the texts for scholarship make this one of the most important discoveries of early Chinese texts to date.

The trove includes an annalistic history (138 strips, divided into 23 chapters) of events from the beginning of the Western Zhou (mid-eleventh century BCE) through the early Warring States period (mid-fifth century BCE), which mentions the early history of the Qin. Recounted in chapter 3 are these events: When King Wu died two or three years after the conquest of Shang around 1045 BCE, his three brothers formed an alliance with other regional rulers and Shang remnants and rebelled against the young King Cheng. One of the early Qin chiefs, Feilian, joined them. King Cheng's regent, the Duke of Zhou, stamped out the rebellion, and Feilian and his followers fled to the Yan state in the east (in present-day Shandong), which joined the rebel alliance. The Duke of Zhou led his forces against Yan and conquered it. He then ordered the relocation of numerous householders from Yan, including Feilian's people, to a place in present-day Gan'gu in Tianshui, Gansu province, where they were to guard the northern frontier from attack by the Rong tribes. The text claims, "These people are the Qin ancestors."[28] Feilian was the son of Zhongjue, who Sima Qian said had lived among the Western Rong and guarded the border. Perhaps Sima Qian confused Zhongjue with Feilian's people.

The various explanations given by historians of the Warring States period for Qin's migration to the western frontier need further archaeological validation. But one thing is quite clear: while becoming reestablished on the western frontier, the Qin people must have absorbed aspects of the local cultures through interactions with their neighbors. Indeed, receptiveness to other cultures appears to have been characteristic of the Qin. The archaeological evidence shows that early Qin culture was a mixed bag, with elements taken even from the "barbarians." This is especially evident in Qin's distinctive burial custom of interring aristocrats laid out straight and commoners in a flexed position on their sides. The bent position and the placement of the deceased facing west reflect the practice of the ethnic Rong and Qiang cultures rather than the burial customs of the Central Plains. Nonetheless, the main influence on the Qin would clearly have been the dominant culture of the Central Plains, the Western Zhou culture.

Notes

1. Sima Qian's "Basic Annals of Qin," in *Records of the Grand Historian: Qin Dynasty*, trans. Burton Watson (New York: Columbia University Press, 1993), p. 1.

2. Wang Guowei (1877–1927), "Qin duyi kao" [A study of the Qin metropolis], in *Guantang jilin* [Selected essays by Guantang] (Shijiazhuang: Hebei Jiaoyu Press, 2001), pp. 335–38; Meng Wentong, "Qin wei rongzu kao" [A study of Qin's origin being Rong], in *Meng Wentong wenji* [Collected essays by Meng Wentong] (Chengdu: Bashu Shushe Press, 1987), 2:71–75.

3. Yu Weichao, "Gudai xirong he qiang, hu kaoguxue wenhua guishu wenti de tantao" [On the cultural description of the ancient western Rong, Qiang, and Hu from an archaeological perspective], in *Xianqin lianghan kaoguxue lunji* [A collection of essays on pre-Qin, Western and Eastern Han dynasties] (Beijing: Wenwu Press, 1985), pp. 180–92.

4. Ye Xiaoyan, "Qinmu chutan" [A preliminary study of Qin tombs], *Kaogu*, 1982, no. 1: 65–73.

5. Yu Weichao, "Gudai xirong he qiang, hu kaoguxue wenhua guishu wenti de tantao," p. 187. Vassal states in the Central Plains were already referring to the Qin as "Qin-Rong" during the late Spring and Autumn period, according to information in the *Guanzi* (an encyclopedic collection of historical and philosophical materials compiled in the late Warring States period). See *Guanzi jiaozhu* [Annotated *Guanzi*] (Beijing: Zhonghua Press, 2004), chap. 8, p. 425.

6. Wei Juxian, "Zhongguo minzu de laiyuan" [The origin of Chinese ethnicity], in *Gushi yanjiu* [Studies on ancient history], vol. 3 (Shanghai: Shangwu Press, 1934), pp. 1–92.

7. See Wang Guowei, "Shuo shang" [On Shang] and "Shuo bo" [On Bo], in *Guantang jilin*, pp. 327, 328.

8. *Zuo Zhuan* [Chronicle of Zuo], compiled during the fifth to fourth centuries BCE, "Fourth Year of Duke Weng." See Yang Boda, *Chunqiu zuozhuan zhu* [Annotated *Chunqiu* and *Zuozhuan*] (Beijing: Zhonghua Press, 1990), 1:534.

9. Lin Jianming, *Qin shigao* [The History of Qin] (Shanghai: Shanghai Renmin Press, 1981), chap. 2, pp. 14–20; Huang Liuzhu, "Qin wenhua eryuan shuo" [On the theory of two origins of Qin culture], *Bulletin of Northwest University*, 1995, no. 3: 28–34.

10. Duan Lianqing, "Guanyu yizu de xiqian he qinying de qiyuan, zushu wenti" [On Yi people's western relocation, the origin of Qin Ying genealogy], *Renwen zhazhi* [Journal of humanities], special issue on the history of pre-Qin, 1982, pp. 166–75; Wang Xueli and Liang Yun, *Qin wenhua* [Qin culture] (Beijing: Wenwu Press, 2001), pp. 122–26.

11. Liu Junshe, "Guanyu chunqiu shiqi qinguo tongqimu de zangshi wenti" [On the issue of the deceased's positions in the Qin tombs of the Spring and Autumn period which contained bronze vessels], *Wenbo*, 2000, no. 2: 37–42; Teng Mingyu, "Lun qinmu zhong de zhizhi zang ji xiangguan wenti" [On the question of *zhizhi zang* in Qin tombs and related issues], *Wenwu jikan*, 1994, no. 4: 72–80.

12. For investigations of the early Qin burials and settlements in Gansu, see Gansu Provincial Institute of Archaeology et al., *Xihanshui shangyou kaogu diaocha baogao* [An archaeological investigation report on the region of the upper course of the Xihanshui River] (Beijing: Wenwu Press, 2007); Gansu Provincial Cultural Relics Team and Archaeological Department, Beijing University, "Gansu gangu maojiaping yizhi fajue baogao" [A report on excavating the site at Maojiaping in Gan'gu, Gansu], *Kaogu xuebao*, 1987, no. 3: 359–95.

13. Zhao Huacheng, "Gansu dongbu qin he qiang rong wenhua de kaogu xue tansuo" [A discussion of the cultures of Qin, Qiang, and Rong in the east of Gansu from the archaeological perspective], in *Kaogu leixingxue de lilun yu shijian* [Theory and practice of the archaeological pattern theory] (Beijing: Wenwu Press, 1989), p. 152.

14. Watson, *Records of the Grand Historian*, p. 2.

15. Dai Chunyang, "Lixian dabuzi shan qingong mudi ji youguan wenti" [The cemetery of the Dukes of Qin in Mount Dabuzi, Lixian, and related issues], *Wenwu*, 2000, no. 5: 74–80; Zhu Zhongxi, "Qin xichui lingqu" [The Qin necropolis at Xichui], in *Qin xichui lingqu* [The Qin necropolis at Xichui], Lixian Museum and Lixian Qin Xichui Cultural Research Association (Beijing: Wenwu Press, 2004), pp. 1–29.

16. Dai Chunyang, "Lixian dabuzi shan qingong mudi ji youguan wenti," and idem, "Lixian dabuzi shan qin guo mudi fajue sanji" [A note on the excavation of the Qin necropolis in Mount Dabuzi in Lixian], in *Qin xichui wenhua lunji* [Collected essays on the Qin culture at Xichui], Lixian Museum and Lixian Qin Xichui Cultural Research Association (Beijing: Wenwu Press, 2005).

17. Li Chaoyuan, "Shanghai bowuguan xinhuo qingongqi yanjiu" [A study of the newly acquired bronzes of the Dukes of Qin by the Shanghai Museum] and "Shanghai bowuguan xincang qinqi yanjiu" [A study of the newly collected Qin bronzes by the Shanghai Museum], in *Qin xichui wenhua lunji*, pp. 510–20 and 521–33; Li Xueqin and Sarah Allan, "Zuixin chuxian de qingonghu" [The most recently published Duke Qin vessel], in *Qin xichui wenhua lunji*, pp. 489–90.

18. Han Wei, "An Important Cultural Discovery: Pure Gold Decorative Plaques from Lixian, Gansu Province," in *Qin Gold* (London: Christian Deydier/ Oriental Bronzes, 1994), pp. 21–32.

19. Han Wei, "Lun gansu lixian chutu qin jinbo shipian" [On the Qin gold plaques unearthed in Lixian, Gansu], *Wenwu*, 1995, no. 6: 1–11.

20. Dai Chunyang, "Lixian dabuzi shan qingong mudi ji youguan wenti," p. 79.

21. Li Chaoyuan, "Shanghai bowuguan xinhuo qinggong qi yanjiu," pp. 510–20; Chen Zhaorong, "Tan Gansu lixian Dabuzishan qingong mudi ji wenwu" [A discussion on the Dukes of Qin cemetery and cultural relics excavated at Mount Dabuzi in Lixian, Gansu], in *Qin xichui wenhua lunji*, pp. 348–55; and Wang Hui, "Yetan lixian Dabuzi shan qingong mudi jiqi tongqi" [Another discussion on the Dukes of Qin cemetery at Mount Dabuzi in Lixian and the related bronzes], in *Qin xichui wenhua lunji*, pp. 356–61.

22. Joint Archaeological Team on Early Qin Culture, "2006 nian gansu lixian dabuzi shan jisi yiji fajue jianbao" [A brief report on the excavation of the sacrificial remains at Mount Dabuzi in Lixian, Gansu, in 2006], *Wenwu*, 2008, no. 11: 14–29; Joint Research Team on Early Qin Culture, "Gansu lixian dabuzi shan zaoqi qin wenhua yizhi" [The early Qin cultural site at Mount Dabuzi in Lixian, Gansu], *Kaogu*, 2007, no. 7: 38–46.

23. Joint Archaeological Team on Early Qin Culture, "2006 nian gansu lixian dabuzi shan jisi yiji fajue jianbao," pp. 14–29; Zhao Huacheng, Wang Hui, and Wei Zheng, "Lixian dabaozi shan qinzi yueqi keng xianguan wenti tantao" [A discussion of the Qinzi "musical instrument pit" in Mount Dabuzi, Lixian, and the related issues], *Wenwu*, 2008, no. 11: 54–65.

24. Joint Archaeological Team on Early Qin Culture, "2006 nian gansu lixian dabuzishan dongzhou muzang fajue jianbao" [A brief report on the excavation of the Eastern Zhou tombs at Mount Dabuzi, in Lixian, Gansu, in 2006], *Wenwu*, 2008, no. 11: 30–49.

25. Gansu Provincial Institute of Archaeology and Lixian Museum, "Gansu yuandingshan 98LDM2, 2000LDM4 chunqiu mu" [The Spring and Autumn tombs 98LDM2, 2000LDM4 on Mount Yuanding at Lixian in Gansu], *Wenwu*, 2005, no. 2: 4–27.

26. Gansu Provincial Institute of Archaeology and Lixian Museum, "Lixian yuandingshan chunqiu qinmu" [The Qin tombs of the Spring and Autumn period in Mount Yuanding, Lixian], *Wenwu*, 2002, no. 2: 4–30; idem, "Gansu lixian yuandingshan 98LDM2, 2000LDM4 chunqiu mu" [The Qin tombs 98LDM2 and 2000LDM4 of the Spring and Autumn period in Mount Yuanding, Lixian, Gansu], *Wenwu*, 2005, no. 2: 4–27.

27. The use of *yaokeng* and a sacrificial dog was especially prevalent in the Western Zhou capital districts Feng and Hao, both located in the southwest of present-day Xi'an. See also Teng Mingyu, "Fenghao diqu xizhou muzang de ruogan wenti" [On several issues relating to the burial practice of the Western Zhou at Feng and Hao district], in *Kaogu xue wenhua lunji* [Selected essays on archaeology and culture], vol. 3 (Beijing: Wenwu Press, 1993), pp. 204–29.

28. Li Xueqin, "Qinghua jian guanyu qinren shiyuan de zhongyao faxian" [An important discovery on the origin of the Qin people as revealed by the Tsinghua bamboo slips], *Guangming Daily*, September 8, 2011.

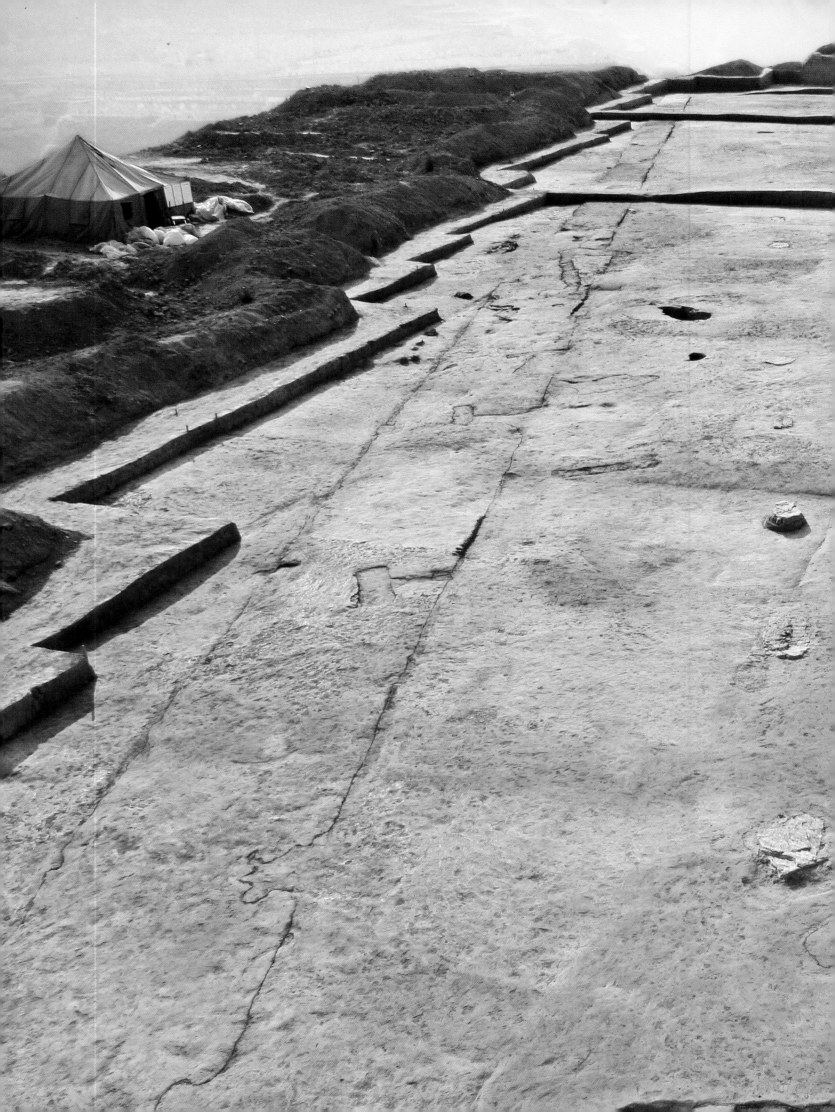

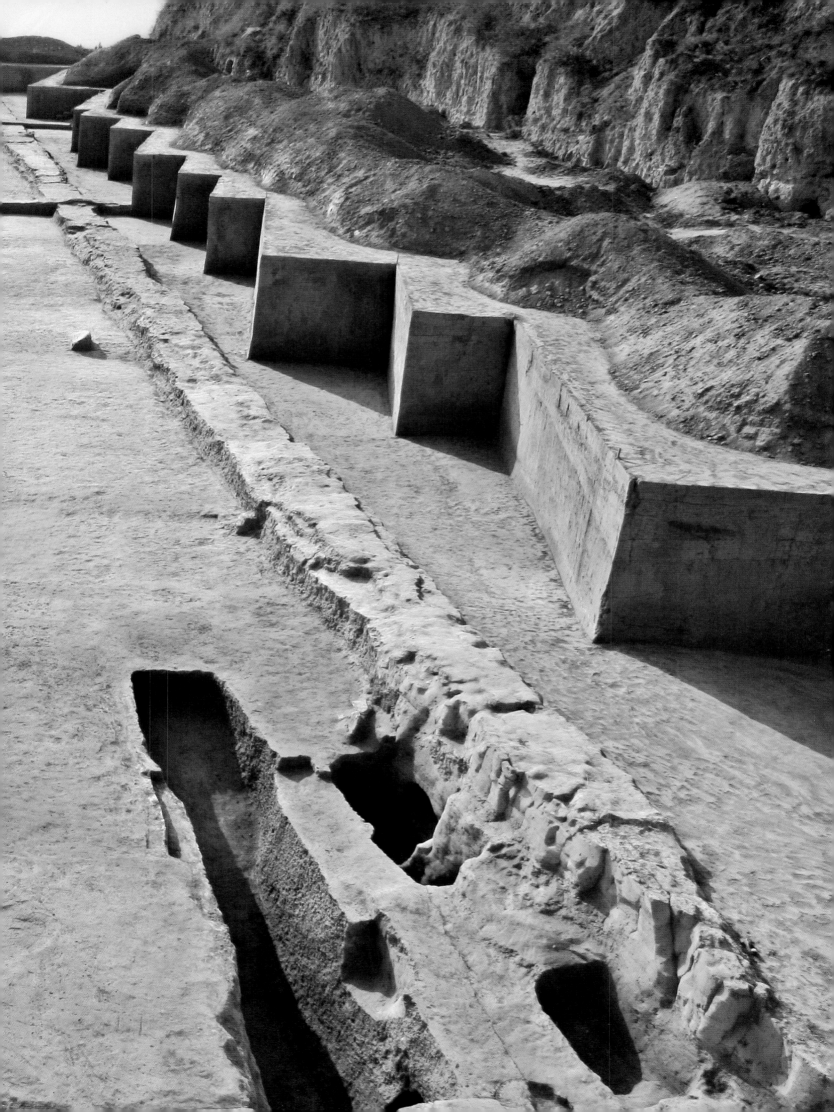

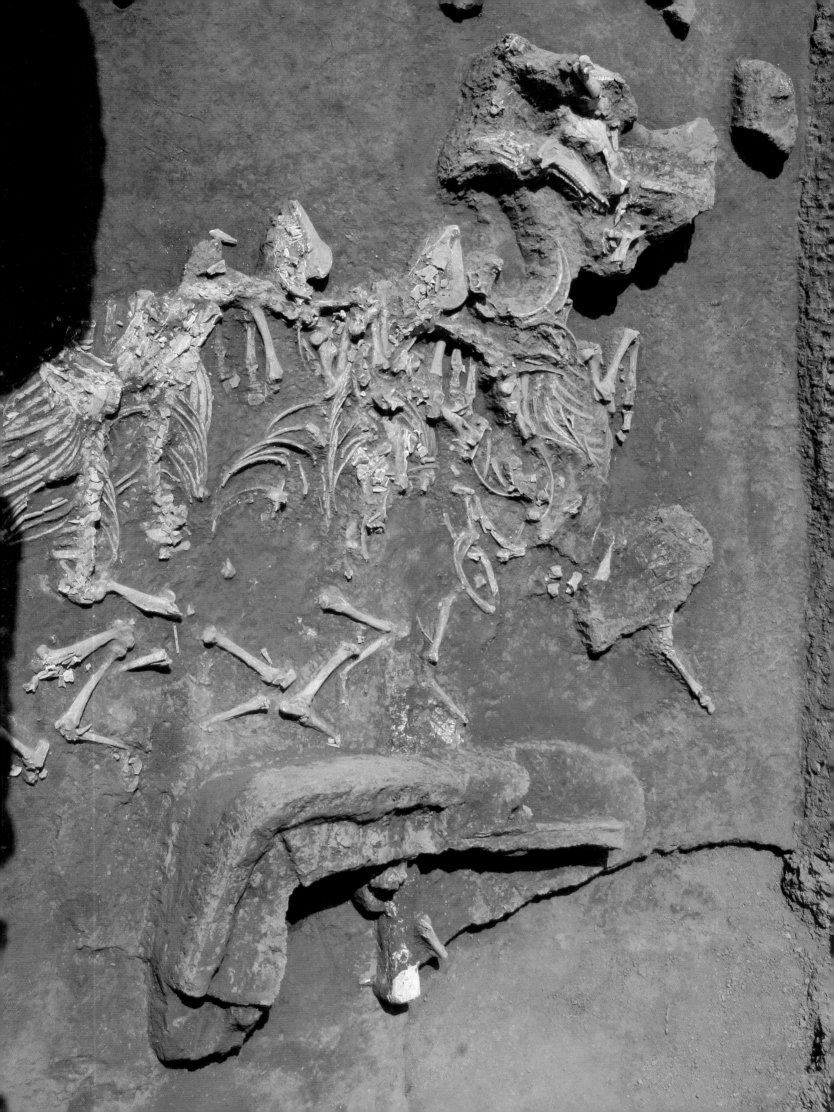

City, Palace, and Burial: An Archaeological Perspective on Qin Culture in Shaanxi

LIU YANG

Qin's Eastward Expansion

In 771 BCE the capital of the Western Zhou, Haojing, southwest of present-day Xi'an, was sacked by "barbarian" Rong tribes from the west. King Ping of the Zhou (r. 770–720 BCE) was forced to move eastward, and Duke Xiang of Qin (r. 777–766 BCE) sent troops to escort him to Luoyi, in present-day Luoyang, Henan province, which became the capital of the Eastern Zhou dynasty (770–256 BCE). For this show of loyalty to the Zhou king, Duke Xiang was made a feudal lord and promised a large area of land west of Mount Qi (near modern Baoji, in Shaanxi) that was still controlled by the Rong tribes. Thus begins the history of Qin as a vassal state of Zhou.

According to the great historian Sima Qian (c. 145–c. 86 BCE), the Qin capital was relocated several times after the Qin ruling class moved into what is now western Shaanxi province.[1] The general tendency was to go toward the east, which was a more developed and affluent area, though there were many back-and-forth movements during the Qin's clashes with the Rong.

The first of the relocations was conducted by Duke Xiang, who moved his political center to Qian, somewhere along the modern Gansu-Shaanxi border. This remained the Qin base for the next fourteen years. After Duke Xiang died in an attempt to reclaim land from the Rong, his successor, Duke Wen (r. 765–716 BCE), retreated to Xichui (in present-day Lixian, Gansu). Xichui was the Qin capital until 762 BCE, when Duke Wen began another eastern campaign. An inscription on a bronze vessel from Duke Wen's ancestral temple in Xichui confirms the historical account.[2] This explains why the Qin rulers' necropolis from this period is in present-day Lixian. Not until the reign of Duke Wu (r. 697–678 BCE), after four generations of fighting, did the Qin finally drive the Rong out of the region and firmly establish their reign in the former Western Zhou heartland.

Archaeological excavations carried out in modern Longxian county, in the far west of Shaanxi, have provided clues to the whereabouts of Qian, Duke Xiang's capital.[3] Between 1977 and 1986, a number of aristocrats' tombs excavated at Bianjiazhuang revealed a very sophisticated use of ritual bronzes. These tombs were usually large rectangular vertical shafts with a chamber measuring over four meters (13 ft) in length. Normally they contained a double coffin (in some cases several nested coffins) and a typical set of ritual bronze vessels, including *ding* tripods, *gui* food vessels, *hu* wine vessels, *pan* and *he* water vessels, and *yan* steamers. The grouping of five *ding* and four *gui* seen in some tombs suggests that the deceased had been high-ranking officials. In Western Zhou ritual custom,

Left: View of Pit K10 at Shenheyuan under excavation

Previous: Building site no. 21 at Mount Dabuzi under excavation, 2006

the quality and quantity of bronze vessels and paraphernalia accompanying the dead tallied closely with their social status.[4]

Other important archaeological excavations, in Dianzi and other places outside of Longxian, are extensive too and include neighboring counties such as Changwu.[5] In addition to the tombs of Qin aristocrats, a number of tombs of middle-class people were found in these areas. They typically contain pottery replicas of bronze vessels, which, like the bronzes, are buried in sets. Commoners' tombs at these sites, reflecting the lower social status of the deceased, contain only pottery meant for daily use.[6]

This border area has yet to be investigated in a planned series of archaeological excavations. So far, the unearthing of tombs there has often been the result of "rescue" activities. However, the presence of a large number of high-ranking aristocrats' tombs in a small area and the unusual richness in burial objects, particularly the bronze vessel groupings, suggest there may have been a political center nearby.

In 762 BCE, Duke Wen moved his capital farther eastward, to the confluence of the Qian and Wei rivers. Chinese archaeologists conjecture it was located in present-day Chencang, Baoji, where some stunning artifacts were excavated in recent years.[7] But to establish this region as Duke Wen's political center requires more substantial archaeological data.

According to Sima Qian, in the second year of Duke Ning's reign (r. 715–704 BCE) the Qin capital was once again relocated, this time to Pingyang. Although the name "Pingyang fenggong" (Pingyang Palace) appears in the inscription on Duke Wen's ritual bronze vessels,[8] the whereabouts of the Qin capital during this period is still a topic of scholarly discussion. Rich archaeological finds support speculation associating Pingyang with the present-day Baoji area.[9] In 1978, Chinese archaeologists excavated a set of three *bo* and five *zhong* bronze bells at a location north of the village known as Taigongmiao (Taigong Temple), in Chencang, Baoji.[10] The lengthy inscription engraved on the bells revealed that they were important musical instruments used in the ritual ceremony in which the Qin ruler presented offerings to Heaven and to ancestors during the time of Duke Wu.

The Qin Capital at Yong

The most important capital of the Qin state from the mid–Spring and Autumn period to the mid–Warring States period was Yong, south of present-day Fengxiang, in Shaanxi. According to Sima Qian's *Shiji*, nineteen dukes (out of thirty-six rulers in the Qin sovereign lineage) reigned for some 294 years, from the first year of Duke De (r. 677–676 BCE), to the second year of Duke Xian (r. 384–362 BCE). The geographic and strategic importance of the new capital was perfectly understood by the sovereign. When Duke De had just ascended the throne, he sacrificed three hundred animals and performed a divination that foretold the future of the state: "By taking Yong as residence, your descendants will water their horses at the Yellow River!"[11] The implication was that with Yong as a base the Qin could expand their territory beyond the Yellow River to conquer the other vassals in the eastern Central Plains.

Duke De died after a two-year rule. His son Duke Gong succeeded him, but in 659 BCE he was replaced by his brother Duke Mu (d. 621 BCE). The sustained forty-year reign of Duke Mu did much to elevate the status of Qin among the vassal states and to expand Qin territory. Duke Mu became known as one of the Five Hegemons of the Spring and Autumn period. Before him, the Qin's engagement with other vassal states in central and eastern China had been minimal. The state of Jin, directly to the east, across the Yellow River, was the most powerful state at that time, and some modern scholars also claim that its culture was the most advanced. To consolidate a good relationship with Jin and create an alliance, Duke Mu married the daughter of Duke Xian (r. 676–651 BCE) of the Jin state. He also married his own daughter, Huaiying, to Duke Wen of Jin (r. 636–628 BCE). Duke Mu campaigned hard against the east to gain a better foothold on the Yellow River plain. In the fifteenth year of his reign, in a war to subdue the Jin state, the Qin established their superiority and forced Duke Hui of Jin (r. 650–637) to cede Jin's territory west of the Yellow River. Later, Duke Mu supported the return of the exiled Jin prince Chong'er, who ascended the throne as Duke Wen of Jin.

The connections with Jin and the ascendancy of the Qin over the Jin (though it did not last long) opened a good channel for trade. Qin's cultural exchange with Jin and other states in the Central Plains accelerated, with fruitful

results, as recent archaeological excavations have revealed. Many bronze vessels with styles characteristic of the Jin, for instance, were found in the tombs of Qin aristocrats (see cat. nos. 16 and 18). The influence from the Central Plains on Qin ritual bronze casting must have been tremendous. It was during this period that Qin bronze vessels underwent a transformation, from a style following the Western Zhou model to one distinctively Qin.

After years of vigorous growth, Yong had developed into a prosperous city. Even during Duke Mu's time, it was full of palatial buildings decorated with sculptures and murals. Arriving in Yong and witnessing its magnificence, Youyu, the ambassador from the western region of Xirong, sighed, "If it was done by ghosts, then it would have exhausted their energy; yet if it was done by people, then it certainly caused them suffering."[12]

Archaeological excavations carried out since the 1960s have gradually unveiled the layout and structure of this long-lost metropolis.[13] Occupying some 51 square kilometers (20 sq mi), the site of Yong comprises a city, the rulers' necropolis, the citizens' cemetery, and a suburban architectural complex.

The city covered more than 10 square kilometers (4 sq mi) south of the Zhifang River and north of the Yong River. It was surrounded by a large wall, whose remains stretch 3,300 meters east to west and 3,230 meters north to south (about 2 miles in each direction). The wall on the western side, which is the best preserved, is 4.3 to 15 meters (14 to 49 ft) wide and still stands 1.65 to 2.05 meters (5½ to 6½ ft) high. The rivers to the east and south would have formed a natural barrier. Outside the western wall, a moat 5.20 meters (17 ft) deep and 12.6 to 25 meters (41 to 82 ft) wide has been revealed.

Archaeologists have discovered that there were three gates on each side. A gate in the middle of the western wall is estimated to have been about 10 meters (33 ft) wide. In the main avenues, which were as wide as the gates, chariots and carts had worn ruts 2.1 meters (7 ft) apart, suggesting the size of the common vehicles of the time. Four parallel avenues intersected by four avenues running the other direction divided the city into twenty-five districts. These avenues were 8 to 10 meters (26 to 33 ft) wide and 3,000 meters (1¾ mi) long, with an

estimated 400 to 800 meters (¼ to ½ mi) between them. Scattered within this grid were buildings ranging from small houses of 10 square meters (110 sq ft) to huge halls of 100 to 200 square meters (1,100 to 2,200 sq ft).

Three complexes consisting of palaces and ancestral temples formed the city's center. Those in the area of the present-day villages of Yaojiagang and Majiazhuang were built and used during the Spring and Autumn period; the area around present-day Tiegou and Gaowangsi became fashionable during the Warring States period.

The Yaojiagang area of 20,000 square meters (5 acres) is slightly west of the central axis and only 600 meters (660 yd) from the western wall. An investigation carried out in the 1970s revealed palace remains and bronze architectural fixtures. Speculation is that Duke De's residential palace, Dazhenggong, was built here and that Duke De's successors, Duke Kang (r. 620–609 BCE), Duke Gong (r. 608–604 BCE), and Duke Jing (r. 576–537 BCE), all lived in this complex. In late 1973 and early 1974, sixty-four bronze structural fixtures with magnificent reliefs were unearthed in three separate storage pits. Adorned with stylized dragon or serpent designs current during the early Spring and Autumn period, they served both a decorative and a functional purpose, as attested by remnants of wood within them (see cat. no. 60).[14]

On the northwest side of the palace site, some 100 meters (110 yd) west of the pits containing the bronze fixtures, an icehouse (lingyin) was excavated in 1977. The aboveground building was gone without any trace, but underneath was a shaft 10 meters long, 11.4 meters wide, and 2 meters deep (33 x 37½ x 6½ ft), narrowing toward the base and lined at the bottom with rocks, with an estimated capacity of 190 cubic meters (250 cu yd). On the west side, a drain ending with five sluice gates allowed water to be discharged into the nearby river through pottery drainpipes. Vestiges of a large quantity of humus were found, assumed by archaeologists to be the rotted remains of straw used to maintain the proper temperature in the icehouse.[15] Icehouses are mentioned in an ode collected in the Shijing (Book of Songs, c. 800–600 BCE): "In the days of [our] second month, they hew out the ice with harmonious blows; And in those of [our] third month, they convey it to the ice-houses, [Which they open] in those of the fourth, early in the morning, Having offered in sacrifice a lamb with scallions."[16]

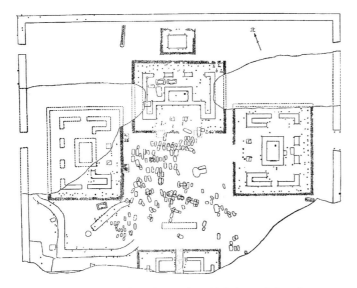

Fig. 1. Layout of the ancestral temple complex at Majiazhuang, in Fengxiang

The ancestral temple, located slightly west of the central axis and to the north of Majiazhuang, is a separate compound within another complex of clustered palaces (fig. 1). The oblong compound was enclosed by walls 84 meters long north to south and 90 meters long east to west (280 x 300 ft), with a total area of about 7,560 square meters (2 acres).[17] The whole layout was arranged on a north-south axis, with the main gate at the southern end. Opposite the gate was the *zumiao*, or Primogenitor Temple, a 凹-shaped main hall with a hipped roof, measuring 20.8 meters east to west and 13.9 meters north to south (68 x 45½ ft). Between the *zumiao* and the entrance, on either side of the central axis, stood two other temples: the *zhaomiao*, for the ancestors of odd-numbered generations, on the east; and the *mumiao*, for the ancestors of even-numbered generations, on the west. They were the same size and built in the same style as the *zumiao*. Surrounding the temples, verandas 2 to 2.8 meters (6½ to 9 ft) wide allowed visitors to walk through.

The three temple buildings and the southern gate face a rectangular atrium 34.5 by 30 meters (113 x 98 ft), called the *zhongting* (central courtyard). Since the atrium shows no traces of trampling, Chinese archaeologists have suggested this was not an ordinary courtyard but rather a sacrificial ground designed in accordance with ritual regulation. Their speculation is supported by some 181 sacrificial pits uncovered on the south, west, and north of the *zhongting*. Cows were found in 86 of the pits, goats in 55, and humans in 8; the contents of 2 were mixed, and 28 were empty. *Bi* disks made of jade or animal bones and pottery vessels accompanied the sacrifices in some of these pits. Another 2 pits each contained a chariot (but no horses), together with gold and bronze chariot fittings.[18]

The architectural remains at Majiazhuang are the largest and best-preserved Qin ancestral temple complex so far discovered. There is even a sophisticated system of underground drainpipes. The layout follows the established order for temples of patriarchal clans and meets the ritual requirements of Western Zhou temples of similar design.[19] The use of animal sacrifices also accords with Western Zhou ritual practices.[20] Like Western Zhou temples, the buildings are in a closed compound and surrounded by roofed verandas.

The ancestral temple was essential to rulers during the Western Zhou. It was the focus of urban planning, and everything in a city was built around it. A Western Zhou ancestral temple was both a religious and a political center. It was a place for holding ceremonies and a site of administration. As Herrlee Glessner Creel described it:

> All of the most important activities of the state took place in the ancestral temple of its ruler. Here the new heir assumed his position. Military expeditions set out from the temple, and returned to it to report and celebrate victory upon their return. The business of diplomacy, and state banquets, took place there. Officials were appointed to office and given rewards, and vassals were invested with territories, in this same hall.[21]

From the Spring and Autumn period on, vassals no longer submitted to the Zhou ruler's authority or received their mandate through royal investiture. The decline of the large clan-lineage network-based Western Zhou social and political systems led to the division of the archaic temple into twin centers: a temple for religious functions and a palace serving administrative purposes.[22] The divorce of the palace from the lineage temple and the growing importance of the palace reflect a significant social transformation. As Jacques Gernet has observed, political power was trying to free itself from the family and religious context that had imprisoned it.[23]

Such change is reflected in the layout of the city of Yong. Here the ancestral temple is separated from the palace, but the two were given equal importance by placing them

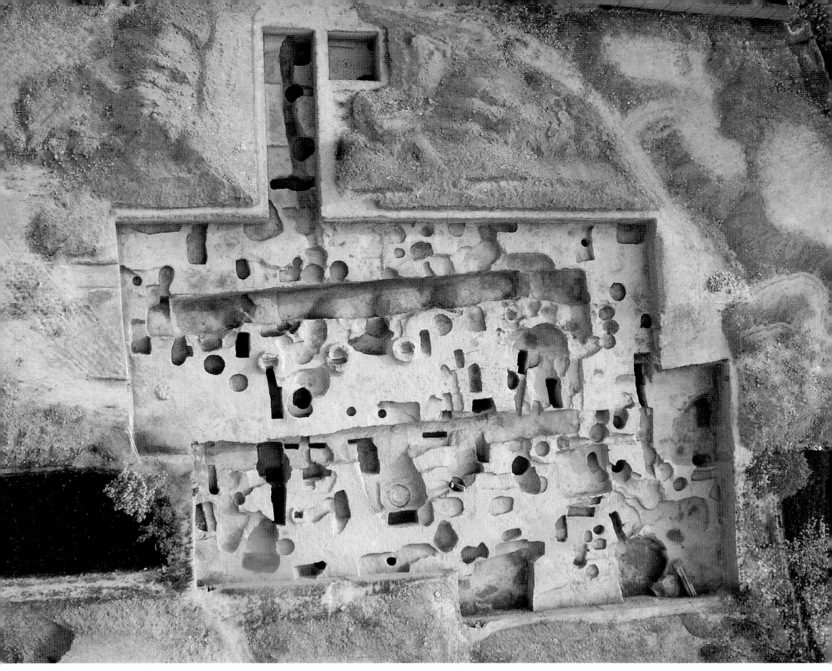

Fig. 2. Aerial view of kiln sites at Doufucun village, in Fengxiang

in the central part of the city, to the north of present-day Majiazhuang. In the capitals of some other states, the ancestral temple was moved outside the city, as in Houma, Henan, where the capital of the Jin state once was.[24]

In addition, the impressive scale of Yong contravenes the traditional hierarchical building code, which required that a vassal capital be only one-third the size of the Western Zhou capital. During this period, however, cities in vassal states were increasingly built on an impressively grand scale, generally exceeding 10 square kilometers (4 sq mi).[25] Yong was apparently one of the largest cities of the time.

The palace complex in the vicinity of present-day Tiegou and Gaowangsi, north of the Yong site, seems to have been established during the Warring States period.

Although a clearer picture of this compound requires further excavation, a rich find of architectural remains and a bronze-storage pit unearthed in 1977 at Gaowangsi village suggest that Duke Zao (r. 442–429 BCE) might have lived there.[26] Twelve bronze vessels date from the late Spring and Autumn and early Warring States periods. Many vessels were evidently manufactured in other states but ended up in the hands of Qin aristocrats, suggesting intensified cultural contact between Qin and other states in the Central Plains during this period.

The excavations conducted in the Yong area were not restricted to the city itself but also extended beyond it. An archaeological survey carried out during the 1980s and 1990s revealed palace building remains in the southern part of the Yong site. In 1982, a number of roof tile ends were excavated at Sunjia Nantou village, at the Qin

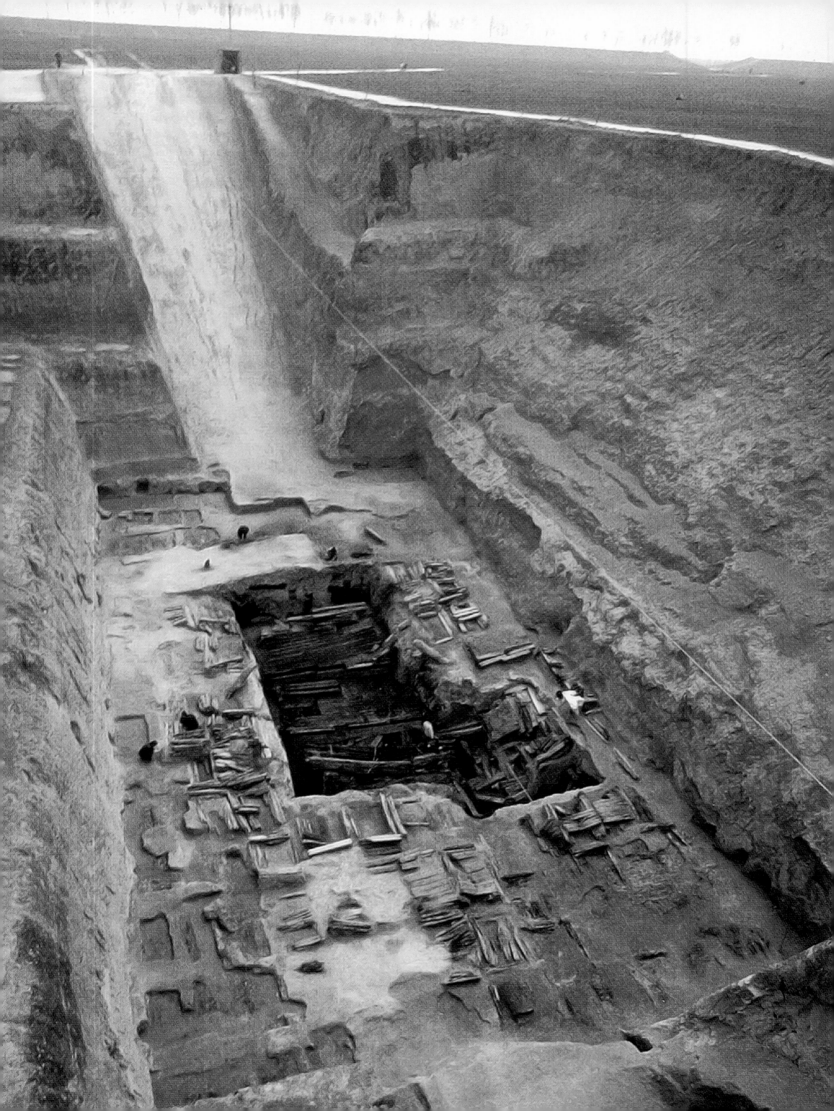

cultural stratum. Many of them were decorated with cloud and animal motifs, and some bore the four molded characters *Qinian gongdang* (tile end of Qinian Palace), providing evidence for the existence of the famous Qinian Palace during Duke Hui's reign (r. 399–387 BCE).[27] When Duke Xiao (r. 361–338 BCE) came to the throne, this palace was integrated with a new compound, Tuoquangong, and many tile ends belonging to that building were also collected (see cat. no. 71). It was here that the future First Emperor, Ying Zheng, held his coronation ceremony in 238 BCE and later quashed a coup plot masterminded by Lao Ai, his mother's lover.

The palaces were in continual use for several hundred years, through the Han dynasty. An excavation conducted in 1997 yielded more roof tile ends, with other palace names: Laigugong, Zhuquangong, Yuyanggong, and Niangong.[28] Yuyanggong, where the First Emperor jailed his mother after he suppressed the rebellion of Lao Ai, was traditionally located in present-day Fufeng, about thirty miles east of Fengxiang. Some of these palaces are not mentioned in any historical record, so these discoveries offer important information for the study of Qin history.

Excavations in the Yong area, both inside and outside the city, covering over 20,000 square meters (5 acres), also revealed a number of handicraft industry sites, including bronze and iron foundries and kilns.[29] In 2005 to 2006, an excavation carried out in Doufucun village, within Yong city, yielded some two thousand pottery architectural components and identified some kiln sites (fig. 2). From this evidence of a comprehensive process of tile making, archaeologists surmised that the architectural materials necessary for building the city were made locally. Behind the palace complex to the north, archaeologists also unearthed a walled area of some 34,030 square meters (8½ acres), which they assume had served as the trade center. It was in use from the Warring States period through the Qin and Han dynasties.[30]

The city of Yong displays various characteristics of urban planning and palace construction that are distinct both from traditional practice and from the contemporary practice of other states. The palace and the lineage temple became separate but equal centers, signaling a transition

Fig. 3. View of the Duke of Qin Tomb 1 at Fengxiang under excavation

from a kingdom united by kinship ties to an empire controlled by a central government. There was no constellation of towns surrounding the city of Yong, whereas metropolises in other states had towns clustered around them. Yong's well-planned core of gridded streets was also unprecedented, and this plan was perpetuated in the building of Yueyang, the next Qin capital.

The Qin Necropolis at Yong

During the Eastern Zhou period, a common mortuary practice among the vassal states was to situate the royal burial compounds within the boundaries of the city. This was done in the states of Zheng, Han, Zhongshan, Yan, Qi, Lu, and Chu and in the Eastern Zhou capital, Luoyi.[31] The urban planner of Yong, however, broke with tradition and placed the cemetery outside the city. This revolutionary innovation was followed in successive Qin capitals, including Yueyang and Xianyang, and also set a norm for the dynasties that followed.

The Qin royal burial complex was located south of Fengxiang in an area known in ancient times as Nanyuan. According to the *Shiji*, from the reign of Duke Mu (r. 659–621 BCE) to that of Duke Chu (r. 386–385 BCE), some sixteen dukes and a crown prince were buried there. A series of excavations beginning in 1976 revealed that the cemetery, which covers more than 20 square kilometers (7½ sq mi), was defined by a moat 2 to 7 meters (6½ to 23 ft) wide and 2 to 6 meters (6½ to 19½ ft) deep, with ditches dividing the area into separate graveyards.[32] The moat and ditches were a distinctive feature of the Qin necropolis during the late Spring and Autumn period and the Warring States period. Besides functioning as a boundary and protective barrier, they signaled the presence of dignitaries and royalty—the same purpose served by the tomb mound and protective walls of later burial complexes.

So far, archaeologists have found fourteen enclosed burial compounds containing some forty-nine tombs. The tombs are laid out in either a *zhong* 中 or a *jia* 甲 shape, generally with east-west orientation, and most have chariot-and-horse pits associated with them. The so-called Duke of Qin Tomb 1 is the largest ruler's tomb known to us from this period (fig. 3); it is almost three times the size of any of the known tombs of the Shang kings at Anyang. Oriented

east-west, zhong-shaped, with two tomb passages, the tomb is 59.4 meters long, 38.8 meters wide, and 24 meters deep (195 x 127 x 79 ft). Including the sloping entrance, it measures 300 meters (328 yd) long and occupies 5,334 square meters (over an acre).

In the center of the tomb is a main chamber constructed of wooden timbers. This was divided into two compartments, the back one functioning as charnel house. The structure thus resembled a qianchao houqin, with a palace in front and a residential chamber at the back. There was another lateral chamber housing valuable belongings. Surrounding the tomb's main chamber, 166 human sacrifices were buried in accordance with their rank: the more prominent were placed in coffins close to the main chamber; the lower-ranking, in coffins of inferior wood farther away; and those ranking even lower were deposited in the fill, without coffins. From the pillar-holes and remains of architectural materials, archaeologists inferred that buildings once stood upon the tomb, serving either as shrines where ritual ceremonies were conducted or as shelter where the spirit of the dead could dwell.[33]

Although the tomb had been exhaustively plundered in the past (around 300 holes burrowed by robbers were detected), archaeologists were still able to gather about 3,500 objects of bronze, iron, gold, pottery, jade, lacquer, and textiles, which demonstrate how luxurious were the personal belongings buried with the occupant. The wooden chamber is thought to be the earliest known example of huangchang ticou construction,[34] being built entirely of stacked timbers of the yellow-colored wood of the Oriental arborvitae, preferred for its denseness and resistance to rotting. The scale of this tomb surpasses anything seen elsewhere in the Spring and Autumn period; it took ten years for Chinese archaeologists to complete the excavation. For the ruler of a vassal state subordinate to the Zhou king to have such a tomb certainly constituted a breach of the Zhou rule. The Qin also changed other existing funeral practices in significant ways. Tombs found in eastern Gansu and western Shaanxi show that the Qin had complied with the rites of the Western Zhou and buried their dukes and aristocrats in a double coffin. The Duke of Qin Tomb 1, however, has a coffin chamber, subdivided into main and minor chambers.

An inscription on a piece of qing chimestone provides a clue to the tomb's occupant: "The Son of Heaven [of Zhou] hosted a feast, the heir of Gong and Huan was invited to attend. Blessed by the spirit of Gaoyang, four cardinal directions enjoy the peacefulness."[35] From this it is apparent that Duke Jing (r. 576–537 BCE), the successor to Duke Gong (r. 608–604 BCE) and Duke Huan (r. 603–577 BCE), had a set of qing chimestones made to commemorate a feast hosted by the Zhou king. The inscription also proves that the Qin rulers considered themselves heir to the legendary monarch Gaoyang, also known as Zhuanxu, the overlord of the eastern tribe.

Although the Duke of Qin Tomb 1 is by far the largest tomb of the period, its zhong shape, with only two sloping entrances, rather than the four seen at the Anyang royal tombs of the Shang kings (no Western Zhou royal tombs have been found so far), suggests that the Qin rulers still saw themselves as territorial rulers, not overlords.

The Yong necropolis provides our most detailed information about early mortuary practices of the Qin ruling class. Unlike royal burial compounds in other states, which were situated within the capital cities, the Qin necropolis was located outside the city. There are no mounds marking the tombs, but there is evidence of shrines having been built upon them, serving as the abode of the spirits or as tang, where ritual ceremonies dedicated to the deceased were performed.[36] Finally, the Qin used moats and ditches to enclose the entire cemetery and to define the individual tombs within it, practices that were carried on by successive Qin rulers, as seen in the Dongling cemetery and the First Emperor's mausoleum, and that were also copied by commoners.[37]

Yueyang, a Capital in Transition

In 383 BCE, the Qin capital was moved farther eastward to Yueyang, north of present-day Lintong.[38] For the next thirty-three years, from the second year of Duke Xian (r. 384–362 BCE) until the twelfth year of Duke Xiao (r. 361–338 BCE), in 350 BCE, Yueyang remained the Qin capital. A series of excavations conducted by Chinese archaeologists from the 1960s to the 1980s revealed a lost city of 4.2 square kilometers (1½ sq mi), extending 2,500 meters (1½ mi) east to west and 1,600 meters (1 mi) north to south. It had six main avenues running east to west

and seven roads north to south.[39] Yueyang was built on a much smaller scale than Yong, and its palace buildings were modest in comparison. However, Yueyang was significant because it served as a transitional capital, allowing Qin to conserve its strength for future advances.

It was in Yueyang, beginning in 356 BCE, that the outstanding statesman and legalist Shang Yang (390–338 BCE), with the support of Duke Xiao, enacted numerous reforms. These helped Qin develop from a peripheral state to a militarily powerful and strongly centralized kingdom; they laid the foundation that would enable Qin to conquer all of China. Shang Yang's reforms doubtless enhanced the strength of the Qin military, as Yueyang became one of the Qin state's centers for making weapons and military equipment. Inscriptions such as "Yueyang gong" (workers of Yueyang) or "Yueyang gongshi" (supervisor of Yueyang workers), cast or engraved on dagger-axes and spearheads dating from King Huiwen's reign (r. 337–311 BCE) until the late Qin, substantiate the historical accounts.

As noted earlier, Qin rulers seem to have established a tradition of building their necropolises outside their capital cities. Thus, Duke Xian and his descendant Duke Xiao were likely buried on the outskirts of Yueyang, though their burial sites have not been located. Interestingly, the tomb configuration customary for hundreds of years, with no mound above the grave, may now have been replaced by a new fashion of building a mound atop the burial. Evidence of this comes from literary records. On bamboo slips found at Shuihudi in Yunmeng county, Hubei province, which record Qin legal systems of the time, the tombs of Duke Xiao and Duke Gong are referred to as *zhong*, or tumulus.[40] A later book, *Shuijing zhu* (Commentary on the Waterways Classic), by Li Daoyuan (d. 527 CE), refers to Duke Xiao's tomb as *ling*, or mausoleum with mound, and locates it in the north of Yueyang.[41] Both *zhong* and *ling* stand for a tomb with a mound or architecture. Although the tumulus had already appeared and had gradually become prevalent in the Central Plains during the late Spring and Autumn period, the tombs of Duke Xian and Duke Xiao, if indeed they had tumuli, heralded a new tradition in Qin history: the building of an impressively grand mound of rammed earth on top of the tomb, a tradition that reached its apogee in the First Emperor's mausoleum.

Xianyang, the Last Capital of Qin

The Shang Yang political reforms accelerated Qin's rise from an ordinary state to a superpower and stimulated the ruler's ambition to exercise control over other states. To accommodate to realities of the time, in 350 BCE Duke Xiao moved his capital to Xianyang, about twelve miles northwest of present-day Xi'an. In 221 BCE, after Ying Zheng forged the seven warring states into one nation and transformed himself from king of the Qin state to First Emperor, Xianyang naturally became the Qin dynasty's capital.

Located on the north bank of the Wei River, Xianyang is in the center of the fertile Guanzhong Plain, a vast area stretching nearly two hundred miles from west to east. It was an important transportation hub in central Shaanxi, serving traffic along the middle reaches of the Yellow River. From a military perspective, Xianyang was invulnerable thanks to natural barriers: the Yellow River on the east, the Qinling range to the south, Mounts Long and Yan on the west, and Mount Qi and others to the north. This geographic advantage guaranteed a strategic upper hand over the vassal states downstream. Thus the shifting of the capital to Xianyang revealed the ambitions of the Qin ruler.

Under King Zhaoxiang (r. 306–250 BCE), Xianyang's expansion began. As the city gradually spread beyond its original confines on the river's north bank, it was linked by a bridge to the south bank, where some splendid new palaces were built, including Zhangtaigong, Xinglegong, and Liuyinggong.

While conducting his war of unification, Ying Zheng, the future First Emperor, ordered replicas of the famous palaces of the conquered states to be built along the north bank of the Wei. These were filled with treasures and beautiful women captured from the other states. By 221 BCE, all six states had been vanquished, and Zheng had established China's first centralized empire. He then began transforming Xianyang from the capital of a vassal state into an imperial center of politics, commerce, and culture. By forcing 120,000 rich and influential families from the former six states to move to the capital, he simultaneously increased the city's prosperity and kept these powerful families under surveillance.

Fig. 4. Model of Palace 1 at Xianyang

The First Emperor continued to expand the palaces on the river's south bank. In Xinglegong, in 220 BCE, he built a high terrace known as Hongtai, or Terrace of Wild Swans, where he could stand and shoot wild swans.[42] This was possibly the inspiration for the casting and interment of life-size cranes, swans, and ducks at his tomb complex (cat. nos. 82–85). In the same year, he began to build Xingong, a complex designed to correspond with the celestial realm. The emperor resided in the northern palace, Beiling, the earthly equivalent of the Purple Palace of the supreme heavenly deity in the pole star. Soon renamed Jimiao, or Temple of Heaven, this was where the First Emperor held grand ceremonies paying homage to the heavenly deities.[43] It was here in 213 BCE, during an imperial audience, that courtiers debating the political system triggered the calamity of burning books and burying scholars and necromancers alive.

The First Emperor continued with the theme of earth as the mirror of heaven, building a network of palaces, imperial gardens, temples, government offices, and transportation and defense facilities in the Wei valley—all connected by elevated roads. And just as urban design needed to be correlated with heavenly phenomena, so too did the First Emperor's world in the afterlife. He ordered a lavish mausoleum to be built near the capital, complete with his terracotta army. According to Sima Qian, the grave was arranged inside so that "above it contained the heavenly phenomena, and below it held all geographic features."

In 212 BCE, the emperor began to build the enormous palace complex Chaogong within the imperial Shanglin Park on the south bank of the Wei. It is estimated that

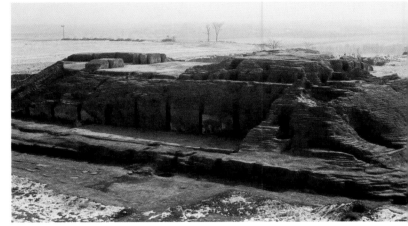

Fig. 5. Tamped-earth terrace of Palace 1 at Xianyang

more than seven hundred thousand people worked on the project. According to Sima Qian, the first section undertaken was the front hall, the famous Epang Palace, whose grandeur he describes: "It measured 500 bu or paces [759 m, or 2,500 ft] from east to west, 50 zhang [116.5 m, or 380 ft] from north to south; the upper part could seat 10,000 people, and in the lower part flagpoles of five zhang [11.65 m, or 38 ft] high could be erected." The emperor died in 210 BCE, but work continued under his son and successor. Then, three years after the First Emperor's death, Xianyang fell to a rebellious army, and General Xiang Yu and his soldiers set the city's palaces on fire. According to Sima Qian they burned for three months before falling to ashes. When archaeologists in Shaanxi conducted a preliminary excavation of Epanggong in 2002 and 2003, they found a tamped-earth foundation 12 meters (39 ft) high, measuring 1,270 meters east to west and 426 meters north to south (4,170 x 1,400 ft). However, the lack of burned traces suggests Epanggong was not among the palaces burned by Xiang Yu (perhaps because it had not been completed).[44]

To resolve the many questions about Epanggong, a more exhaustive archaeological survey is needed.

Though Epanggong may be shrouded in mystery, a clear picture has emerged of the Xianyang palace complex on the north bank of Wei River (fig. 4). Oriented north to south, Palace 1 was built on a tamped-earth terrace 6 meters (20 ft) high (fig. 5) and extended 60 meters east to west and 45 meters north to south (200 x 150 ft). In the center above the terrace was a two-story pavilion. Surrounding this main structure was a cluster of other buildings connected by verandas and paved with hollow bricks decorated with dragons, phoenixes, or geometric motifs (see cat. nos. 113–16). Amalgamating individual pavilions and buildings into an integrated compound was an unprecedented innovation in Chinese architecture.

The main hall on the top of the tamped terrace measured 13.4 meters east to west and 12 meters north to south (44 x 39 ft). It is assumed this was where Qin Shihuang confounded an assassination attempt by Jing Ke in 227 BCE. A pillar 64 centimeters (25 in) in diameter in the center of the hall supports Sima Qian's account of the drama: when Jing Ke's first strike with a poisoned dagger missed, he chased the king around a pillar in the audience hall.[45] The walls were plastered with many layers of wattle and daub, and the surface was painted in red and white or with colorful murals or decorated with pictorial bricks. The floors were painted red or gray or, in some cases, were lacquered or paved with bricks. Fireplaces were installed in some areas. The doors were fitted with bronze hinges and animal-mask ring holders (see cat. no. 87). Under the eaves were pebble-lined drainage aprons connected to ditches; funnels at the four corners led to underground water mains.[46] A long veranda at ground level skirted the tamped terrace and its clustered buildings.

Flanking Palace 1, Palaces 2 and 3 were tall structures. Palace 2 is 127 meters east to west and 32.8 to 45.5 meters north to south (415 x 100 to 150 ft). Palace 3, not yet completely excavated, appears to be a grand oblong building. All three palaces were connected by verandas, suggesting that they formed a large complex, the Xianyang Palace compound. A great many fragments of painted murals and hollow tiles and bricks decorated with various motifs were unearthed at the site. The murals are the only evidence of painting from the Qin

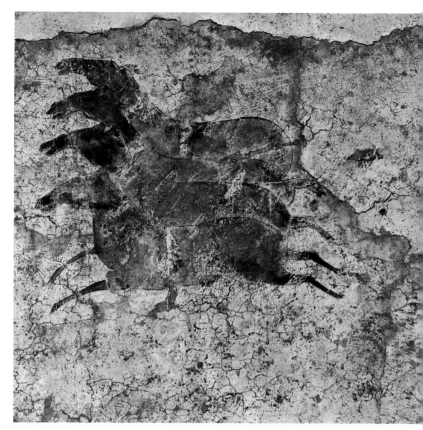

Fig. 6. Chariot procession, detail from a mural fragment excavated at Palace 3 at Xianyang in 1979, Xianyang Municipal Conservation Center for Cultural Relics, Shaanxi BH001

dynasty; those from Palace 3 are the best preserved. Their discovery substantiates historical accounts of the splendor of the Qin palaces. The painted scenes depict galloping horses and chariots (fig. 6), ceremonial processions, buildings, *zhidao* highways, human figures, plants, and geometrical patterns, among other themes.[47]

Palace buildings such as these represent a radical departure from earlier standards of architecture. The old architectural style, characterized by single-story halls of various sizes, with multiple compounds or courtyards—exemplified by the Qin ancestral temple at Majiazhuang in Yong—was out of favor. The Qin ruler now preferred his palaces to be built on a high terrace in multistoried clusters that extended the space both vertically and horizontally. This development emerged from the First Emperor's ambition to manifest his power in monumental buildings of opulence and eminence. The shift in architectural style had already begun in the late Warring States period when vassal dukes in many states (Chu, for instance) competed by building palaces on towering *tai*, or terraces.[48] A lavish and public display of wealth was one way for a ruler to assert his prestige before his allies and rivals, and the First Emperor pushed such extravagance to a level far exceeding that seen in previous

structures. Skilled craftsmen from the captured states helped summon the architectural luster of the conquered metropolises. The splendor of his palaces displayed the strength, wealth, and advanced technical skill at the Qin emperor's disposal, showing off and glorifying the political achievements of this omnipotent ruler.

Ongoing archaeological surveys show that Xianyang grew swiftly to cover a walled area roughly 7,200 meters east to west and 6,700 meters north to south (4½ x 4 mi).[49] Thus, under the mighty Qin empire, this surprisingly large city, with its full-fledged infrastructure and majestic palaces, became a miracle of ancient Chinese architecture and experienced unparalleled prosperity.

Royal Burials in Xianyang

After the Qin political center was shifted to Xianyang, a new Qin rulers' necropolis was established by King Zhaoxiang (r. 306–250 BCE) at Zhiyang, to the east of present-day Xi'an. The large enclosed burial complex was known during Qin times as Dongling, or East Mausoleum. According to Sima Qian, the three dukes (or kings, as they styled themselves) who preceded the First Emperor, along with their families, were buried there.[50] To date, at least four tomb compounds have been located but not excavated. They occupy 720,000, 150,000, 50,000, and 480,000 square meters (180, 37, 12, and 120 acres), and each has a moat around the perimeter, serving as a boundary and protective barrier.

Archaeological data show that the Qin retained many of their early mortuary customs during this period. For example, the tombs in Dongling cemetery, and also the First Emperor's mausoleum and 80 percent of the medium to small tombs of the commoners, all face east, with the primary axis running east to west. However, changes are apparent: whereas in the Yong cemetery there were no burial mounds, the four grand tombs at Dongling (in compounds 1, 2, and 3) all had impressive tumuli over the burial shafts.

The building of tumuli did not begin until the late Spring and Autumn period (770–476 BCE). Extant royal Shang dynasty tombs, such as that of Fu Hao (d. 1200 BCE), the wife of King Wuding, had no tomb mound.[51] No royal

Zhou tombs have been excavated to date, but the lack of any visible trace of a tumulus or its remains from the Zhou dynasty is reason to assume mounds were not made during that time.[52] One of the earliest tombs of the late Spring and Autumn period excavated in 1979 at Gushi, in Henan, had a mound 7 meters (23 ft) high and 55 meters (180 ft) in diameter.[53]

The practice of building tumuli became widespread in the Central Plains.[54] However, it was not until the late Warring States period that the Qin rulers began to adopt the custom. As mentioned earlier, the tombs of Dukes Xiao and Xian might have had tumuli. According to a Han dynasty historian, their successors King Huiwen, King Wu, King Zhaoxiang, King Xiaowen, and King Zhuangxiang all built impressive tumuli, which survived to exemplify the grandiosity of their time.[55] The practice culminated in Qin Shihuang's tomb complex, where the tumulus resembles a hill.

Architectural remains surrounding tomb compound 1 in Dongling, dating to the late Warring States period, suggest that sacrificial halls once stood in the complex, which was unprecedented. More significant, however, is the change in tomb structure. Three of the tombs in compounds 1 and 4 have four entrance ramps, giving them a shape resembling the Chinese character *ya* 亞. Earlier tombs of Qin rulers had only two entrances, forming a *zhong* 中 shape.[56] In the Shang and Zhou ritual system, the *ya*-shaped tomb was reserved for the Son of Heaven. So the adoption of this structure by the Qin rulers suggests that they no longer conceived of themselves as territorial rulers but as ready to rule the whole country.

The trend is evident also in two other necropolises. In 2004, archaeologists excavated a burial site of the late Warring States period or Qin dynasty in Shenheyuan, a southern suburb of Xi'an. Again, the mausoleum was demarcated by a rectangular wall—extending in this case 550 meters (600 yd) north to south and 310 meters (340 yd) east to west—surrounded by a moat. The area encompassed here is about 170,500 square meters (42 acres), making this the second largest mausoleum of the times from the Warring States period to the end of Qin rule. The southern part contains architectural remains, while a grand tomb with four entrance ramps (a *ya*-shaped tomb) is located in the north of the walled area (figs. 7 and 8). The tomb measures

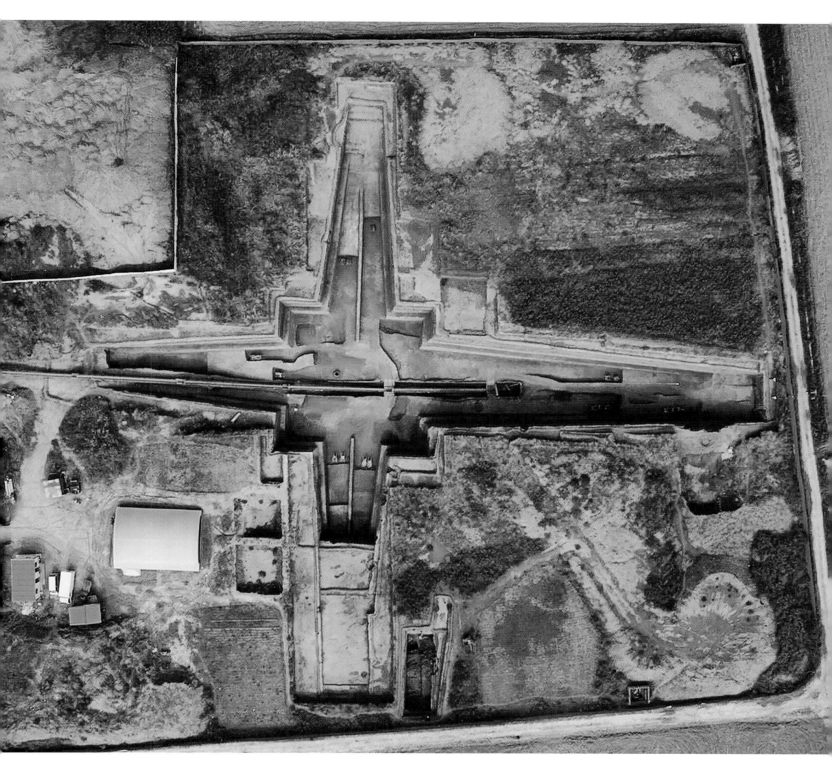

Fig. 7. Aerial view of the grand tomb at Shenheyuan

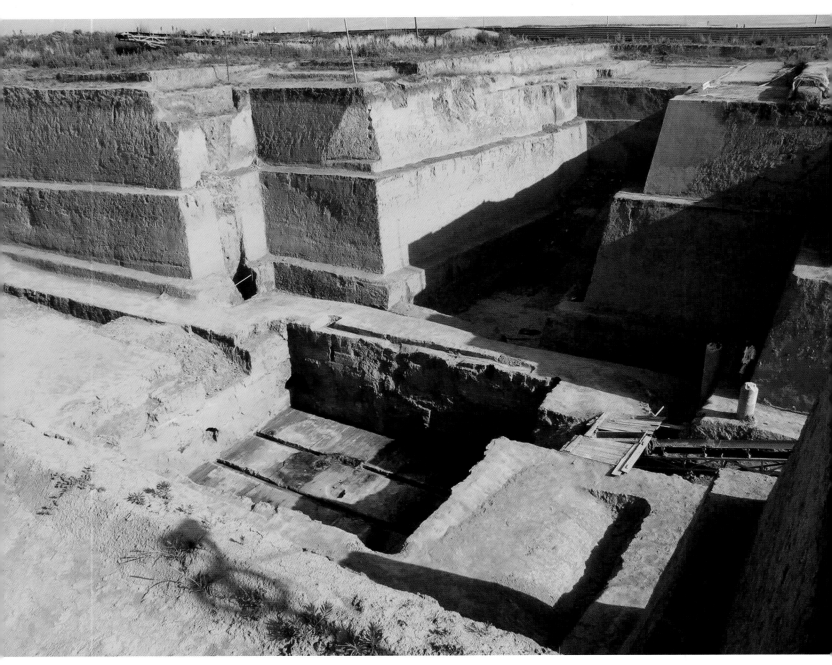

Fig. 8. Shenheyuan tomb under excavation

10.5 meters wide and 12.1 meters long (34½ x 40 ft); including the ramps, it is 135 meters long and 110 meters wide (443 x 361 ft). Although the tomb had been badly looted and suffered fire damage in the past, archaeologists were still able to collect nearly one thousand artifacts, including bronzes, gold and silver ornaments, jades, and pottery (see cat. no. 106).[57]

Surrounding the tomb are thirteen burial pits. Pit K12 housed sixteen animals, including a leopard, bear, gibbon, goat, and crane. They apparently had been kept in captivity by the ruling house, as some were leashed with iron chains or locked in cages. In ten of the pits horses were buried, one hundred in total. Pits K8 and K10 contained six chariots apiece, each drawn by six horses abreast (fig. 9). Along with the chariots were many gold and silver harnesses and jades. While many Qin aristocrats' tombs have chariots and horses associated with them, the finding here of chariots drawn by six horses abreast clearly indicates that this is a royal tomb, since according to Western Zhou ritual norms only the king was entitled to a chariot drawn by six horses. Clues to the deceased's identity are found in inscriptions carved on bronze and ceramic vessels and stone chimes: "beigong" (northern palace) and "siguan" (private courtier), referring to a queen's chamberlain.[58] Based on historical and archaeological evidence, the tomb is assumed to be that of Lady Xia, grandmother of Zheng,

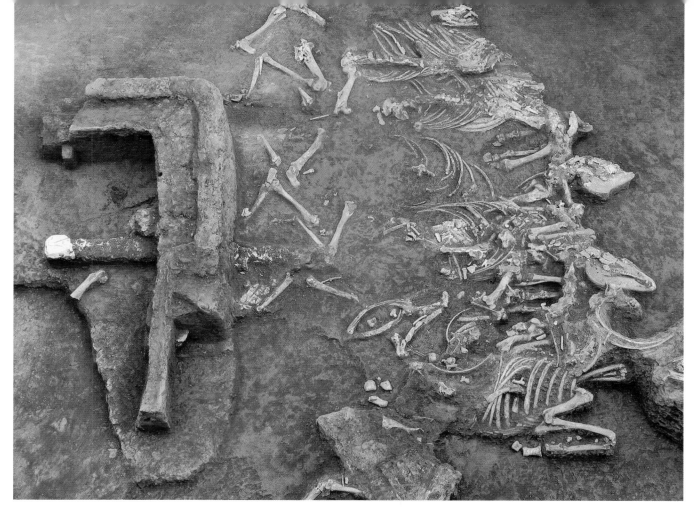

Fig. 9. View of Pit K10 at Shenheyuan under excavation

the future First Emperor. She died in 240 BCE, when King Zheng was nineteen years old.[59]

In 2007, Chinese archaeologists conducted a survey at a necropolis traditionally known as Zhouwangling, the Mausoleum of Zhou Kings, about five miles north of Xianyang.[60] Their work shed new light on the identity of these tombs. Archaeologists now believe this is the Qin royal mausoleum, although they did not ascertain which rulers were buried there. The mausoleum is still marked by two imposing mounds, 14 meters (46 ft) and 17.5 meters (57 ft) in height (fig. 10). Whether these tumuli are those of King Huiwen and King Wu or of one of these kings and his wife must be determined by future excavations.[61]

The burial site is circumscribed and protected not only by a double moat, but also, which is most unusual, by a double wall (fig. 11). The inner wall, encircled by a moat, forms an enclosure 422 meters long and 236.5 meters wide (462 x 259 yd), with two doors on the east, two on the west, one on the south, and one on the north. The rectangular outer wall is 833 meters long and 528 meters wide (911 x 577 yd), oriented north-south. Doors in the middle of each side mark the four cardinal directions. Some 30 to 46 meters (100 to 150 ft) beyond this wall is the outer moat. A preliminary examination revealed that the

two grand tombs were constructed with four ramps, making them *ya* shaped. So far, some twenty-seven burial pits have been detected, nine in the inner enclosure and eighteen between the inner and outer walls. There are also five architectural remains and 168 accompanying tombs.

The Qin mausoleums near Xianyang, unlike the Qin royal tombs at Yong, have impressive mounds with four entrance ramps. The development of a plan with two separate walls enclosing the grand complex apparently echoed the layout of the capital Xianyang, where the imperial palace was enclosed by the city walls, themselves encircled by other walls. This arrangement was followed by the planner of the First Emperor's mausoleum, a monument associated with an event of universal significance: the unification, in 221 BCE, of Chinese territory into a centralized state under an absolute monarch.

∴ ∴ ∴ ∴ ∴ ∴ ∴ ∴

We may today view the history of Qin through the extraordinary exploits and burial of the First Emperor, but his reign was in effect the culmination of centuries of history, which only in recent years has been revealed through a series of remarkable and often accidental

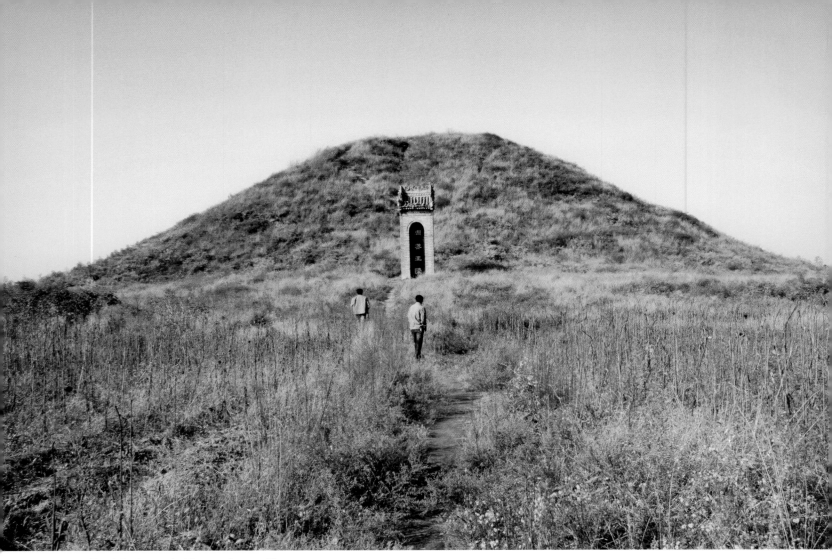

Fig. 10. Tomb mound at Zhouwangling, near Xianyang

discoveries of ruins of cities, palaces, and temples, as well as tombs and burials of early Qin royals and aristocracy. In the absence of substantive and reliable written sources, it is archaeological evidence that provides clues to the history and evolution of the state of Qin. Important archaeological discoveries from present-day Gansu and Shaanxi provinces have reshaped our understanding of the origins of the pre-imperial state of Qin, the rise of Qin culture, and the political and military reforms that led to Qin's position of prominence during the late first millennium BCE and served as the foundations for empire. During the course of its development, the rulers of the Qin state played their indispensable parts in its transformation from a small kingdom into a superpower. The numerous discoveries associated with the burials of Qin rulers have shed new light on our understanding of early craftsmanship, early mortuary practices, conceptions of the netherworld, and the great lengths to which the Qin sovereigns, above all the First Emperor, went to protect their eternal sleep and ensure their never-ending rule over the universe.

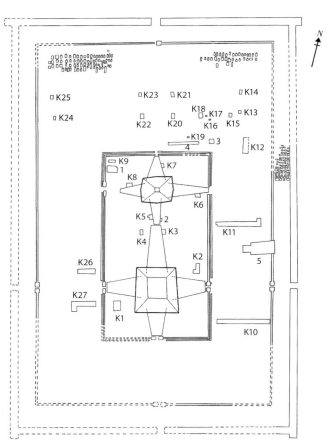

Fig. 11. Layout of the Qin mausoleum at Zhouwangling

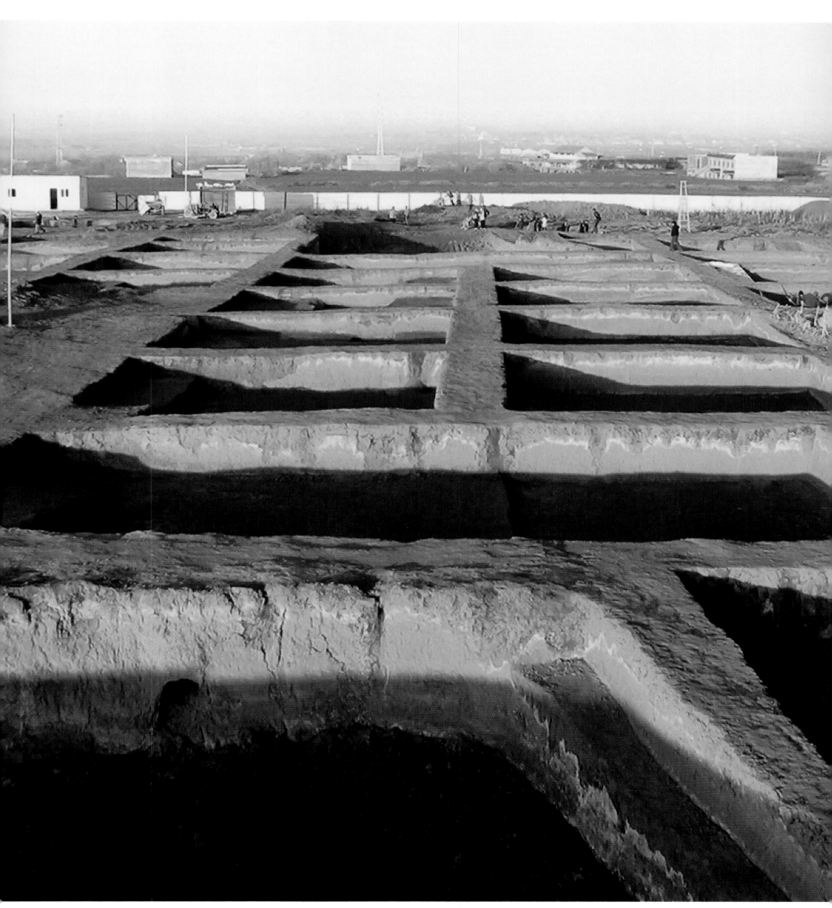

The grand tomb at Shenheyuan under excavation

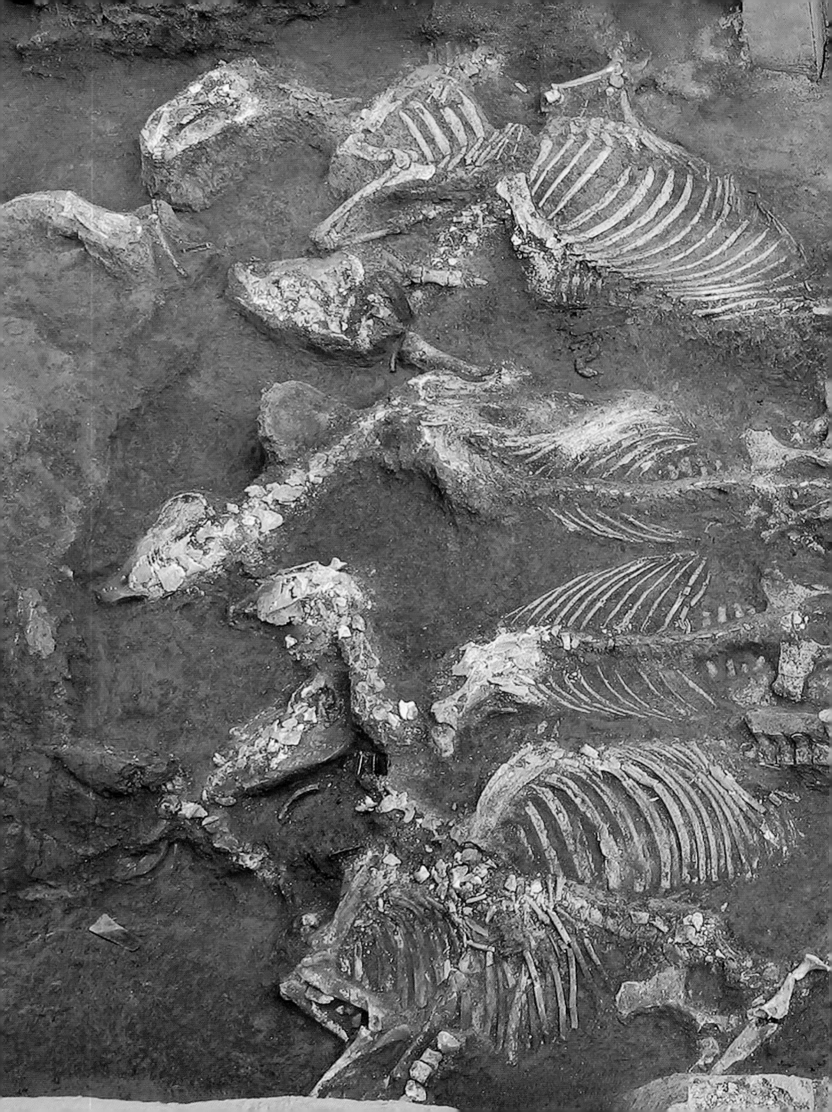

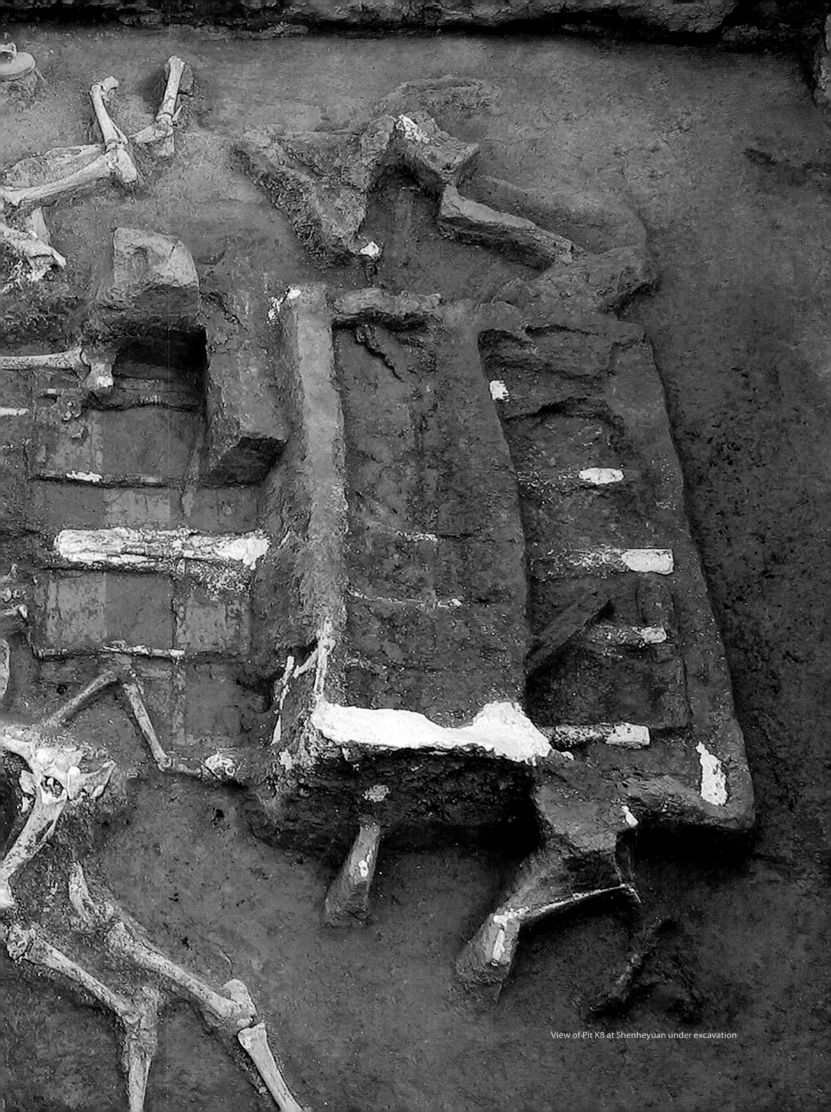

View of Pit K8 at Shenheyuan under excavation

Notes

1. Sima Qian's *Shiji, juan* 5, "Basic Annals of Qin," in *Records of the Grand Historian: Qin Dynasty*, trans. Burton Watson (New York: Columbia University Press, 1993), pp. 5–6.

2. Guo Moruo, "Liangzhou jinwenci daxi, kaoshi" [Collection of the bronze inscriptions of the Zhou dynasty: An interpretation] (Shanghai: Shanghai Shudian Press, 1999). See also, Lin Jianming, *Qin shigao* [The history of Qin] (Shanghai: Shanghai Renmin Press, 1981), p. 88.

3. Shang Zhiru, "Qindu baqian yu buju jiegou zhi tantao" [A discussion of the eighth relocation of the Qin capital city and its urban plan], in *Zhou qin wenhua yanjiu* [Research on the Zhou and Qin culture], Editorial Committee for Research on the Zhou and Qin Culture (Xi'an: Shaanxi Renmin Press, 1993), pp. 572–82.

4. Yin Shengping and Zhang Tianen, "Shaanxi longxian bianjiazhuang yihao chunqiu qin mu" [Qin Tomb 1 of the Spring and Autumn period at Bianjiazhuang in Longxian, Shaanxi], *Kaogu yu wenwu*, 1986, no. 6: 15–19; Baoji Branch of the Shaanxi Provincial Institute of Archaeology and Baoji Municipal Archaeological Team, "Shaanxi longxian bianjiazhuang wuhao chunqiumu fajue jianbao" [A brief report on the excavation of Tomb 5 at Bianjiazhuang in Longxian, Shaanxi], *Wenwu*, 1986, no. 11: 14–23.

5. See Shaanxi Provincial Institute of Archaeology, *Longxian dianzi qinmu* [Qin tombs at Dianzi in Longxian] (Xi'an: Sanqin Press, 1998), and idem, "Shaanxi changwu shangmengcun qinmu fajue jianbao" [A brief report on the excavation of the Qin tombs at Shangmeng village in Changwu, Shaanxi], *Kaogu yu wenwu*, 1984, no. 3: 8–17.

6. See Teng Mingyu, *Cong fengguo dao diguo de kaoguxue guancha* [Qin culture from an archaeological perspective: From a feudal state to the great empire] (Beijing: Xueyuan Press, 2003), pp. 25–27.

7. Watson, *Records of the Grand Historian*, p. 7. See also Li Ling, "Shiji zhong suojian qin zaoqi duyi zangdi" [The early Qin necropolises as seen in the record of *Shiji*], *Wenshi* 20 (1983): 15–23; Wang Xueli et al., eds., *Qin wuzhi wenhua shi* [History of the Qin material culture] (Xi'an: Sanqin Press, 1994), pp. 68–69; Chen Ping, *Guanlong wenhua yu yinqin wenming* [The culture of Guanlong and the civilization of Qin] (Nanjing: Fenghuang Press, 2004), pp. 261–87.

8. The Qing scholar Ruan Yuan (1764–1849) recorded a bronze vessel bearing the inscribed name "Pingyang fenggong." See *Jiguzhai zhongding yiqi kuanshi* [Bronze inscriptions in the collection of Jiguzhai] (Beijing: Shangwu Press, 1937), chap. 9.

9. These are from excavations carried out at Doujitai, Lijiaya, Fulinbao, Qinjiagou at Yangping, Jiangchengbao, Rujiazhuang, Xigaoquan, etc. See Su Bingqi, "Doujitai dongqu muzang" [Burials at the eastern section of Doujitai], in *Su Bingqi kaoguxue lunshu xuanji* [Selected essays on archaeology by Su Bingqi] (Beijing: Wenwu Press, 1984), pp. 3–58; He Xinyun, "Baoji lijiaya qinguo muzang qingli jianbao" [A brief report on excavating Qin tombs at Lijiaya in Baoji], *Wenbo*, 1986, no. 4: 5–9; Baoji Excavation Team of the National Archaeological Institute, "Shaanxi baoji fulinbao dongzhou muzang fajueji" [Report on excavating the Eastern Zhou tombs at Fulinbao in Baoji, Shaanxi], *Kaogu*, 1963, no. 10: 536–43; Shaanxi Provincial Administration for Cultural Relics, "Shaanxi baoji pingyang zhen qinjiagou cun qinmu fajueji" [Report on excavating Qin tombs at Qinjiagou in Yangpingzhen, Baoji, Shaanxi], *Kaogu*, 1965, no. 7: 339–46; Wang Guangyong, "Baoji shi weibingqu jiang chengbao dongzhou muzang" [Eastern Zhou tombs at Jiangchengbao in the Weibing district in Baoji], *Kaogu*, 1979, no. 6: 564; Baoji Municipal Museum, "Shaanxi baojishi rujiazhuang dongzhou mu" [Eastern Zhou tombs at Rujiazhuang in Baoji, Shaanxi], *Kaogu*, 1979, no. 5: 408–11, and idem, "Baojixian xigaoquan cun chunqiu qinmu fajueji" [Report on excavating Qin tombs of the Spring and Autumn period at Xigaoquan village in Baoji], *Wenwu*, 1980, no. 9: 1–9.

10. Lu Liancheng and Yang Mancang, "Shaanxi baojixian taigongmiao cun faxian qingong zhong, qingong bo" [The *bo* and *zhong* bells of the duke of Qin found in Taigongmiao in Baoji, Shaanxi], *Wenwu*, 1978, no. 11: 1–3.

11. Watson, *Records of the Grand Historian*, p. 8.

12. Ibid., p. 15.

13. Han Wei and Jiao Nanfeng, "Qindu yongcheng kaogu fajue zongshu" [A summarization of the excavation and research of Yong, the Qin capital], *Kaogu yu wenwu*, 1988, nos. 5–6: 111–26; Shaanxi Provincial Yong Archaeological Team, "Qindu yongcheng zuantan shijue jianbao" [A brief report on the preliminary excavation at Yong, the Qin capital], *Kaogu yu wenwu*, 1985, no. 2: 15–26.

14. Fengxiang Museum and Shaanxi Provincial Administration for Cultural Relics, "Fengxiang xianqin gongdian shijue jiqi tongzhi goujian" [The preliminary excavation of the early Qin palaces and the bronze architectural fittings], *Kaogu*, 1976, no. 2: 121–28; Yang Hongxun, "Fengxiang chutu chunqiu qingong tonggou—jingang" [Jingang—The Qin palace bronze fittings of the Spring and Autumn period excavated at Fengxiang], *Kaogu*, 1976, no. 2: 103–8.

15. Shaanxi Provincial Yong Excavation Team, "Shaanxi sheng fengxiang chunqiu qinguo lingyin yizhi fajue jianbao" [A brief report on the excavation of the Qin *lingyin* site of the Spring and Autumn period at Fengxiang in Shaanxi], *Wenwu*, 1978, no. 3: 43–47.

16. *Shijing*, "Qiyue" [July], in the section *Binfeng* [The odes of Bin]. See *Shijing yizhu*, annotated by Zhou Zhenfu (Beijing: Zhonghua Press, 2002), p. 217. Bin is located in the north of Yong.

17. Han Wei, "Majiazhuang qin zongmiao jianzhu zhidu yanjiu" [A study on the architectural system of the Qin ancestral temple], *Wenwu*, 1985, no. 2: 30–38.

18. Shaanxi Provincial Yong Archaeological Team, "Fengxiang majiazhuang yihao jianzhuqun yizhi fajue jianbao" [A brief report on the excavation of building complex no. 1 at Majiazhuang in Fengxiang], *Wenwu*, 1985, no. 2: 1–29.

19. For instance, it is similar to the basic structure of the Western Zhou building complex unearthed at Fengchu village in Qishan, Shaanxi province.

20. Shaanxi Provincial Yong Excavation Team, "Shaanxi sheng fengxiang chunqiu qinguo lingyin yizhi fajue jianbao," pp. 43–47; idem, "Fengxiang majiazhuang yihao jianzhuqun yizhi fajue jianbao, pp. 1–29.

21. Herrlee Glessner Creel, *The Birth of China: A Study of the Formative Period of Chinese Civilization* (New York: Reynal and Hitchcock, 1937), p. 336.

22. See Wu Hung, *Monumentality in Early Chinese Art and Architecture* (Stanford, Calif.: Stanford University Press, 1995), pp. 88–89.

23. Jacques Gernet, *A History of Chinese Civilization* (Cambridge: Cambridge University Press, 1972), p. 62.

24. See Shanxi Provincial Archaeological Institute, Houma Branch, *Jindu xintian* [Xintian, the Jin capital] (Taiyuan: Shanxi Renmin Press, 1996).

25. National Institute of Archaeology, *Chinese Archaeology: Western Zhou and Eastern Zhou* (Beijing: China Social Science Press, 2004), p. 227.

26. Shaanxi Provincial Yong Archaeological Team, "1982 nian fengxiang yongcheng qinhan yizhi diaocha jianbao" [A brief report on a survey of the Qin and Han site in Yong, Fengxiang, carried out in 1982], *Kaogu yu wenwu*, 1984, no. 2: 1–13; Han Wei and Cao Mingtan, "Shaanxi fengxiang gaowangsi zhanguo tongqi jiaocang" [The bronze hoard of the Warring States period found at Gaowangsi in Fengxiang, Shaanxi], *Wenwu*, 1981, no. 1: 15–17; Jiao Nanfeng and Ma Zhengzhi, "Qinian, Yuyang, and Niangong kao" [A discussion of the palaces of Qinian, Yuyang, and Niangong], *Kaogu yu wenwu*, 1983, no. 3: 25–35.

27. Jiao Nanfeng and Ma Zhengzhi, "Qinian, Yuyang, and Niangong kao," pp. 25–35.

28. Ibid.

29. Xu Weimin, *Qin ducheng yanjiu* [A study of the Qin capitals] (Xi'an: Shaanxi Renmin Jiaoyu Press, 2000), chap. 5, pp. 74–86; Zhao Congcang, "Shaanxi fengxiang faxian chunqiu zhanguo qingtongqi jiaocang" [The bronze storage pit of the Spring and Autumn and Warring States periods excavated in Fengxiang, Shaanxi], *Kaogu*, 1986, no. 4: 337–43; Fengxiang County Cultural Relics Bureau, "Shaanxi fengxiang tiefeng zhanguo taoyao" [Kiln of the Warring States period found at Tiefeng in Fengxiang, Shaanxi], *Kaogu yu wenwu*, 2007, special issue on pre-Qin archaeology.

30. Wang Xueli et al., *Qin wuzhi wenhua shi*, pp. 91–92.

31. Shang Zhiru, "Qindu baqian yu buju jiegou zhi tantao," p. 579; Shang Zhiru and Zhao Congcang, "Qindu yongcheng buju yu jiegou tantao" [A

discussion on the layout and structure of the Qin capital Yong], in *Kaoguxue yanjiu: jinian shanxisheng kaogu yanjiusuo chengli sanshi zhounian* [Studies in archaeology: Essays celebrating 30th anniversary of the establishment of the Shaanxi Provincial Institute of Archaeology] (Xi'an: Sanqin Press, 1993), pp. 484–85.

32. Shaanxi Provincial Yong Excavation Team, "Fengxiang Qingong lingyuan zhuantan yu shijue jianbao" [Report of a preliminary excavation of the cemetery of the Qin Dukes at Fengxiang], *Wenwu*, 1983, no. 7: 30–37.

33. Two opinions are presented in Yang Hongxun, "Guanyu qin yiqian mushang jianzhu de wenti" [On the issue of the houses built upon tombs], *Kaogu*, 1982, no. 4: 402–6, and Yang Kuan, "Xianqin mushang jianzhu he lingqin zhidu" [The system of spirit shelters and the houses built upon tombs], *Wenwu*, 1982, no. 1: 31–37.

34. In *Lüshi chunqiu* [The Spring and Autumn Annals of Mr. Lü], Lü Buwei (c. 290–235 BCE) recorded an ancient custom of burying nobles in a tomb chamber known as a *huangchang ticou* structure. See Xu Weiyu, *Lüshi chunqiu jishi* (Annotated *Lüshi chunqiu*) (Beijing: Zhonghua Press, 2009), p. 223, and also John Knoblock and Jeffrey Riegel, *The Annals of Lü Buwei: A Complete Translation and Study* (Stanford, Calif.: Stanford University Press, 2000), p. 229.

35. In Chinese, the inscription reads: 天子郾喜，龚桓是嗣，高阳有灵，四方以鼏. For the excavation of the Qin necropolis at Yong, including the Duke of Qin Tomb 1, see Wang Xueli et al., *Qin wuzhi wenhua shi*, chap. 7, pp. 254–73.

36. See Yang Kuan, "Xianqin mushang jianzhu he lingqin zhidu," pp. 31–37; Yang Hongxun, "Guanyu qin yiqian mushang jianzhu de wenti," pp. 402–6.

37. Qin tombs of medium and small scale with such features were excavated recently in the eastern suburb of Xi'an by the Shaanxi Provincial Institute of Archaeology, but the reports are yet published; see Zheng Hongli, "Qin shangzang zhidu yanjiu" [A study of the Qin burial system] (master's thesis, Northwest University, 2002), p. 13.

38. Watson, *Records of the Grand Historian*, p. 22.

39. Tian Xingnong and Luo Zhongru, "Qindu yueyang yizhi chubu kantan ji" [A preliminary survey of the Qin capital Yueyang site], *Wenwu*, 1966, no. 1: 10–18; Yueyang Excavation Team of the Institute of Archaeology of China Academy of Social Science, "Qinhan yueyang cheng yizhi de kantan he shijue" [An investigation and preliminary excavation of the Yueyang city of the Qin and Han period], *Kaogu xuebao*, 1985, no. 3: 353–82.

40. See the section "Dialogue on Law" in *Shuihudi qinmu zhujian* [Bamboo slips found in Qin tombs at Shuihudi], ed. Research Team of Bamboo Slips Found in Qin Tombs at Shuihudi (Beijing: Wenwu Press, 1978). It reads: "Who are the persons known as *dianren*? They are those who guarded the *zhong* of Duke Xiao and Duke Xian" (何可谓旬人？守孝公、献公冢者也).

41. Li Daoyuan, *Shuijing zhu*, *juan* 18, in Chen Qiaoyi, *Shuijing zhu jiaozheng* [Annotated *Shuijing zhu*] (Beijing: Zhonghua Press, 2007), p. 440.

42. See He Qinggu, *Sanfu huangtu jiaoshi* [Annotated *Sanfu huangtu*] (Beijing: Zhonghua Press, 2005),

pp. 45 and 149. *Sanfu huangtu* [Yellow plans of the three capital commanderies] is a geographical description of the ancient capital region compiled during the Southern Dynasties period (300–600 CE).

43. Watson, *Records of the Grand Historian*, p. 44.

44. Epang Palace Archaeological Team, "Epanggong qiandian yizhi de kaogu yu fajue" [Survey and excavation of the site of the front hall of Epang Palace], *Kaogu xuebao*, 2005, no. 2: 211–38.

45. A different interpretation suggested that Palaces 1–3 were part of the complex Qin Shihuang built in imitation of palaces in the previous "warring states." See Gong Qiming and Hu Lingui, "Qin wenhua de kaogu gongzuo yu yanjiu" [The archaeological activities and research on the Qin culture], in *Qin wenhua luncong* [Qin Culture Studies Series], ed. Terracotta Warriors and Horses Museum, vol. 1, 1993, p. 58.

46. Xianyang Archaeological Team, "Qindu xianyang di yihao gongdian jianzhu yizhi jianbao" [A brief report on the excavation of palace architectural site no. 1 at the Qin capital Xianyang], *Wenwu*, 1976, no. 11: 12–24; Tao Fu [Yang Hongxun], "Qin xianyanggong diyihao yizhi fuyuan wenti de chubu tantao" [A preliminary discussion of several issues regarding the reconstruction of Xianyang palace site no. 1], *Wenwu*, 1976, no. 11: 31–41.

47. Xianyang Archaeological Team, "Qin xianyang gong di erhao jianzhu yizhi fajue jianbao" [A brief report on the excavation of architectural site no. 2 of the Qin Xianyang palaces], *Kaogu yu wenwu*, 1986, no. 4: 1–9, and Xianyang District Administration for Cultural Relics et al., "Qindu xianyang di sanhao jianzhu yizhi fajue jianbao" [A brief report on the excavation of palace architectural site no. 3 at the Qin capital Xianyang], *Kaogu yu wenwu*, 1980, no. 2: 1–13. See also Xu Weimin, *Qin ducheng yanjiu*, chap. 7, pp. 108–69.

48. See Wu Hung, *Monumentality*, pp. 102–3; Liu Yang, *Homage to the Ancestors: Ritual Art from the Chu Kingdom* (Sydney: Art Gallery of New South Wales, 2011), pp. 38–41.

49. Liu Qingzhu, "Lun qin xianyangcheng buju xingzhi jiqi xiangguan wenti" [On the urban plan of Xianyang city and other related issues], *Wenbo*, 1990, no. 5: 200–211.

50. Sima Qian, *Shiji* (Beijing: Zhonghua Press, 1959), pp. 289–90.

51. Anyang Team of the National Archaeological Institute, "Anyang yinxu wuhao mu fajue jianbao" [A brief report on excavating Tomb 5 at Yinxu in Anyang], *Kaogu xuebao*, 1977, no. 2: 57–98. Other Shang tombs of aristocrats such as those unearthed at Dasikong village also show no trace of tomb mounds. See Ma Dezhi et al., "1953 nian anyang da sikongcun fajue baogao" [A report on excavating tombs at Dasikong village in Anyang in 1953], *Kaogu xuebao*, 1955, no. 9: 25.

52. Such a view is shared by Chinese archaeologists. See Han Guohe, "Lun zhongguo fenqiumu de chansheng he fanzhan" [On the appearance and development of the Chinese tumulus], *Wenbo*, 1998, no. 2: 32–41.

53. Excavation Team of Tomb 1 at Hougudui in Gushi, "Henan gushi hougudui yihaomu fajue jianbao" [A brief report on excavating Tomb 1 at Hougudui in Gushi, Henan], *Wenwu*, 1981, no. 1: 1–8.

54. See Yang Kuan, "Zhongguo gudai lingqin zhidu de qiyuan jiqi yanbian" [The origin and innovation of Chinese ancient burial systems], *Fudan xuebao*, 1981, no. 5: 59–68.

55. It was mentioned in Liu Xiang's memo to Emperor Cheng of the Han dynasty (r. 32–10 BCE). See Ban Gu (32–92 BCE), *Hanshu* [History of the Han dynasty] (Beijing: Zhonghua Press, 1962), *juan* 36, p. 1954.

56. For the survey and examination of the Dongling tomb complex, see Shaanxi Provincial Institute of Archaeology and Lintong County Administration for Cultural Relics, "Qin dongling diyihao lingyuan kancha ji" [Record of a survey of tomb compound no. 1 at Dongling of Qin], *Kaogu yu wenwu*, 1987, no. 4: 1–14; idem, "Qin dongling dierhao lingyuan diaocha zuantan jianbao" [A brief report on the survey and excavation carried out at tomb compound no. 2 at Dongling of Qin], *Kaogu yu wenwu*, 1990, no. 4: 18–27; Qin Mausoleum Excavation Team of the Shaanxi Provincial Institute of Archaeology, "Qin dongling disihao lingyuan diaocha zuantan jianbao" [A brief report on the survey and excavation carried out at tomb compound no. 4 at Dongling of Qin], *Kaogu yu wenwu*, 1993, no. 3: 20–29.

57. Shaanxi Provincial Institute of Archaeology, "Shanxi changan sheheyuan zhanguo lingyuan yizhi tianye kaogu xin shouhuo" [A new gain in the field archaeology carried out at the Qin mausoleum site in Shenheyuang, Chang'an, Shaanxi], *Kaogu yu wenwu*, 2008, no. 5: 111–12.

58. In 1956 and 1966 two *ding* tripods bearing the inscription "siguan" were excavated at Zhiyang and Ta'erpo, respectively, and the latter was dated to the thirty-sixth year of King Zhaoxiang (r. 306–250 BCE). They were considered to be the belongings of two queens of the Qin state. See Shaanxi Provincial Museum, "Jieshao shaanxi sheng bowuguan shoucang de jijian zhanguo shiqi de qingtongqi" [An introduction to several Qin bronzes of the Warring States period], *Wenwu*, 1966, no. 1: 7–9; Xianyang Municipal Museum, "Shaanxi sheng xianyang taerpo chutu de tongqi" [Bronzes excavated at Ta'erpo in Xianyang], *Wenwu*, 1975, no. 6: 69–75.

59. For the different interpretations, see Duan Qingbo, "Guanyu shenheyuan damu muzhu ji xiangguan wenti de taolun" [A discussion on the tomb master of the grand tomb at Shenheyuan and related issues], *Kaogu yu wenwu*, 2009, no. 4: 53–61.

60. Shaanxi Provincial Institute of Archaeology et al., "Xianyang 'Zhouwangling' kaogu diaocha kantan jianbao" [A brief report on the archaeological survey and excavation of the "Zhou kings mausoleum" in Xianyang], *Kaogu yu wenwu*, 2011, no. 1: 3–10; Jiao Nanfeng et al., "Xianyang 'zhou wangling' wei zhanguo qin lingyuan buzhen" [Further evidence for the assumed "Zhou kings mausoleum" being actually the Qin mausoleum of the Warring States period], *Kaogu yu wenwu*, 2011, no. 1: 53–57.

61. Wang Xueli, *Xianyang didu ji* [A record of the capital city Xianyang] (Xi'an: Sanqin Press, 1990), pp. 219–23; Xu Weimin, *Qin ducheng yanjiu*, pp. 187–89; Liu Weipeng and Yue Qi, "Xianyangyuan shangde 'Qinling' de faxian he queren" [The discovery and affirmation of the "Qin mausoleums" located in the Xianyuan plain], *Wenwu*, 2008, no. 4: 62–72.

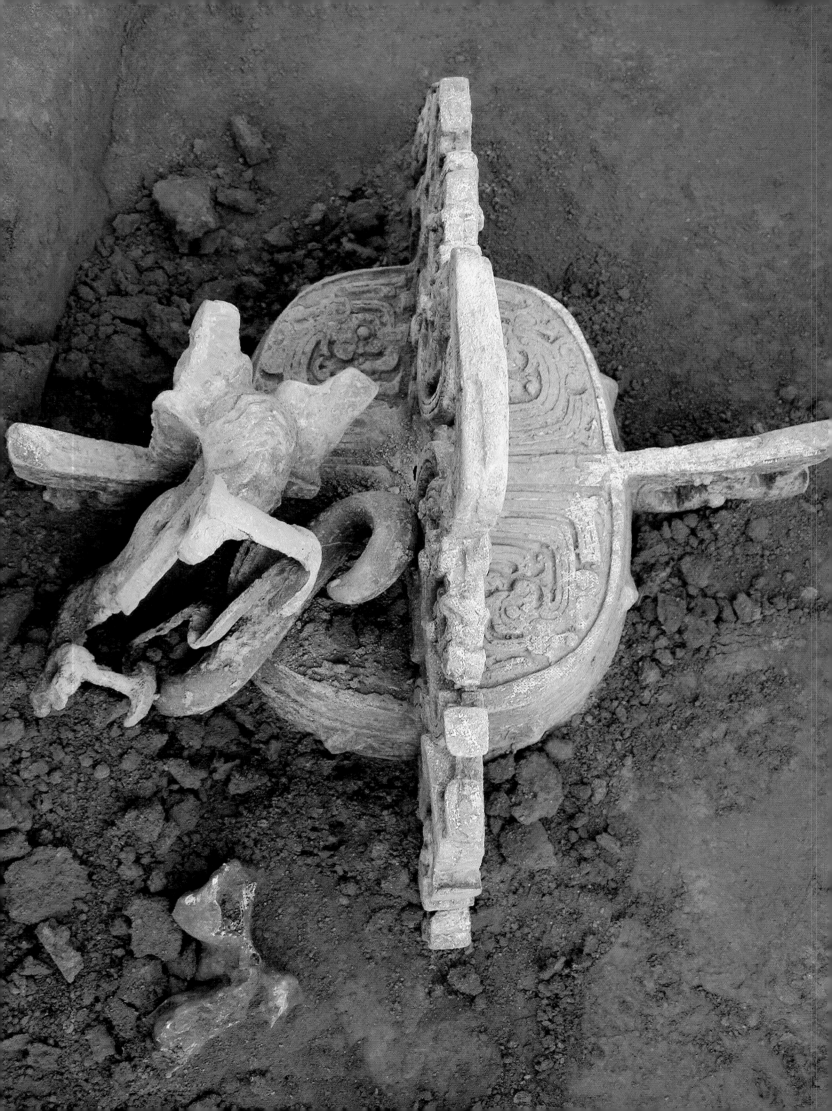

Objects from the Spring and Autumn and Warring States Periods

Ritual Bronzes

RITUAL AND CEREMONY WERE FUNDAMENTAL TO BRONZE AGE CHINA for maintaining order and for understanding the incontrovertible hierarchy that flowed from the heavens to the emperor to the courts to the people. An enormous, imaginative range of bronze vessels and musical instruments were made to acknowledge the power of that hierarchy. Inscriptions on many of these objects help us identify their function and the nature of those rituals: the celebration of a military success, a marriage, a plea for a good harvest, a largess from the ruler, or, most often of all, a sacrifice to assuage ancestral spirits. Many such inscriptions also identify the person for whom the vessel was made.

The Qin inherited ritual systems that had developed between the Shang and Zhou dynasties. From the early Spring and Autumn period onward, ritual bronzes became a central component of Qin burial practices. During this period, as made evident by archaeological excavations, a typical set of ritual bronzes buried with a ruler or noble was composed of a number of different types of vessels, including *ding* cauldrons, *gui* food vessels, *fanghu* wine vases, *yan* steamers, *pan* basins, *yi* water vessels, *he* kettles, and *dou* food vessels. Such groupings roughly followed the Western Zhou tradition. Interestingly, in terms of the manufacture and burial use of these bronzes, the Qin never rivaled previous dynasties or other contemporary states in the Central Plains.

By the late Spring and Autumn period, and until the early Warring States period, ritual bronzes in Qin were produced in fewer quantities than before, and their quality deteriorated. Many of these were crudely cast *mingqi*, or "spirit utensils," made strictly for funerary use. A trend that is particularly interesting to note is the emergence of ceramic *mingqi*. These either became components of the bronze-vessel groups or completely replaced the bronzes.

The mid–Warring States period witnessed a marked change in the type and form of Qin ritual bronzes. Smaller and finer handicrafts (using inlaid gold and silver) were now in fashion, and many vessels that were popular in the earlier period lost favor or disappeared entirely. These include the uncovered *ding* cauldron with its strong, turned-out legs, the *gui*, the *yan*, the *he* kettle with its flat body, and the square *fanghu*. New types of works emerged and became popular, including the bulbous-bodied *ding* (with cover), the ovoid *hu*-type vase also known as *zhong*, the garlic-mouthed *ping* bottle, the flat-bodied *bianhu* vase (also with a garlic-shaped mouth), and the *mou* cooking vessel. Bronze vessels now had minimalistic surface decoration or none at all.

Previous: View of the Musical
Instrument Pit at Mount Dabuzi
under excavation

1
Bo bell
秦公鎛

Spring and Autumn period, Duke Wu's reign (697–678 BCE)
Bronze, H. 69.6 cm (27⅜ in), W. (bell) 28.4 cm (11³⁄₁₆ in)
Excavated at Taigongmiao village, Yangjiagou in Baoji, Shaanxi, 1978

Baoji Bronze Museum, Shaanxi 02755/IA5.4

Percussion instruments played a significant role in ceremonial rituals in China's Bronze Age. They were always cast as a set and suspended on a wooden rack. There were a variety of bronze bells; those decorated with flamboyant flanges on the sides and top (as demonstrated by this example) are known as *bo* or *bozhong*.

This is one of a set of three *bo* bells discovered in 1978 in the region that served as the Qin capital from 714 to 677 BCE.[1] All three large *bo* share the same shape and decorative pattern, differing only in size, which ranges from 64.2 to 75.1 centimeters (25⅓ to 29½ in) high. Each was cast in a fanciful form with four openwork flanges. The two main flanges are composed of nine intertwined dragons. Each of the two lateral flanges represents a phoenix and five interlaced dragons. The body of the bell is adorned with two bands of stylized dragons bordered by two strips of geometric designs (including a cicada motif) interspersed by pyramidal knobs. This S-shaped design, known as *qiequwen*, is the most characteristic pattern of the Qin bronzes of this period.

Each of the three *bo* bears a 135-character inscription that documents the lineage of Qin dukes in order to verify the legitimacy of their rule. Like the smaller *yongzhong* bells (cat. no. 2), *bo* provided music to accompany rituals and ceremonies. The group of three matches the number of *bo* mentioned in the inscription; they also correspond with another group of three *bo* excavated in 2006 from the Musical Instrument Pit at Mount Dabuzi in Lixian, Gansu. It seems that such a grouping was the standard format in the Qin ritual system.

1. Lu Liancheng and Yang Mancang, "Shaanxi baojixian taigongmiao cun faxian qingong zhong, qingong bo" [The *bo* and *yongzhong* bells of the duke of Qin found in Taigongmiao in Baoji, Shaanxi], *Wenwu*, 1978, no. 11: 1–3.

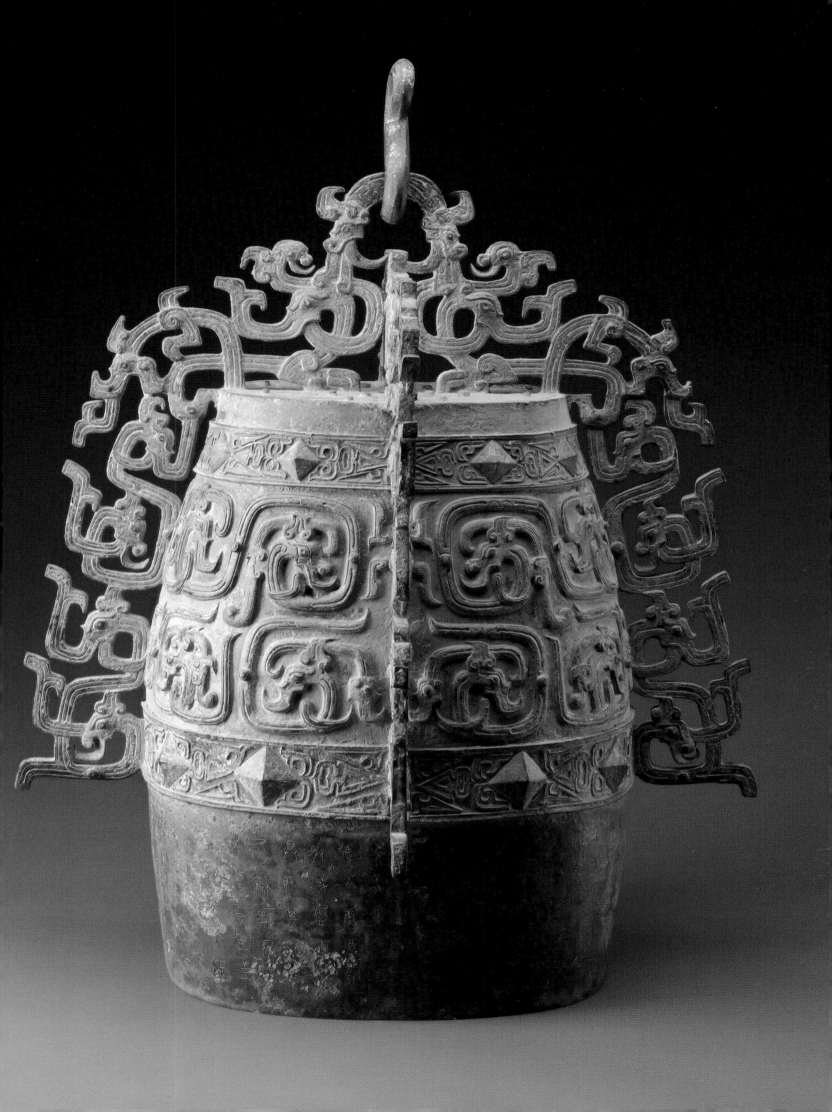

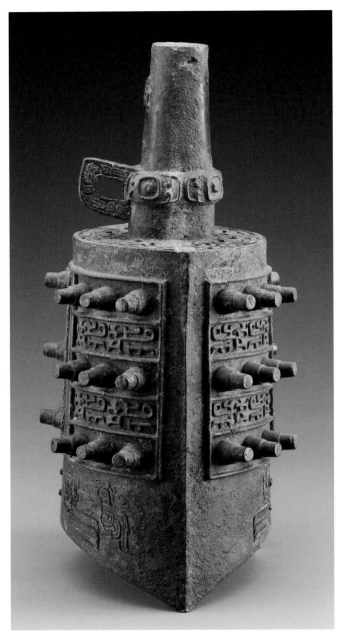

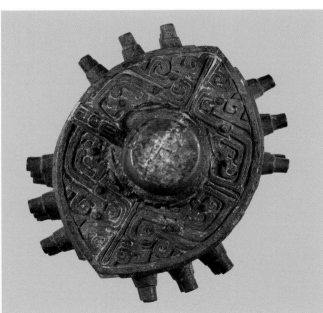

2

Yongzhong bell
秦公钟

Spring and Autumn period, Duke Wu's reign (697–678 BCE)
Bronze, H. 45.7 cm (18 in), W. 21.5 cm (8⁷⁄₁₆ in)
Excavated at Taigongmiao village, Yangjiagou in Baoji, Shaanxi, 1978

Baoji Bronze Museum, Shaanxi 02759/IA5.8

This bell, known as a *yongzhong*, has a long stem surmounting its flat top, with a loop attached to the stem's lower part. Like the *bo* bells, *yongzhong* have no clappers and are sounded by striking. Each bell could sound two different notes: one when struck on the side, another if struck at the center. The set is capable of producing a chromatic scale. On each face of each *yongzhong* is a panel containing eighteen bosses in three horizontal rows separated by stylized dragon designs; a plain trapezoidal section divides the panel in half vertically. Below this is the striking panel, which has asymmetrically arranged designs of stylized birds (there is one extra bird on the right-hand side).

This *yongzhong* is from a set of five excavated at Taigongmiao village in Baoji in 1978, along with three *bo* bells (see cat. no. 1). The five *yongzhong* have the same shape and decoration but vary in size. The largest is 48 centimeters (18⁷⁄₈ in) high, while the smallest measures only 27.6 centimeters (10⁷⁄₈ in). A cast inscription in the central vertical band continues onto the lower register.

The 135-character inscription is exactly the same as the inscription on the *bo* bells. However, it begins on the largest *yongzhong* and is completed on the second-largest. The same text, divided into four parts, appears on the other three bells (and a bell now missing). Because this set of three *bo* and five *yongzhong* is close in date to a group of three *bo* and eight *yongzhong* found at Mount Dabuzi, it is likely that it, too, originally comprised eight bells. The inscription would have been repeated again, in two parts, on two of the bells now missing. A set of eight was the standard *yongzhong* grouping from the middle to late Western Zhou dynasty, though sets of three had been more common earlier.[1]

1. Institute of Archaeology, Chinese Academy of Social Sciences, *Zhongguo kaogu xue: Liangzhou juan* [China's archaeology: the Zhou dynasty] (Beijing: Zhongguo Shehui Kexue Press, 2004), p. 217.

A scene of a performance on bronze and stone chimes depicted on a *hu* vessel of the Warring States period. (Collection Palace Museum, Beijing)

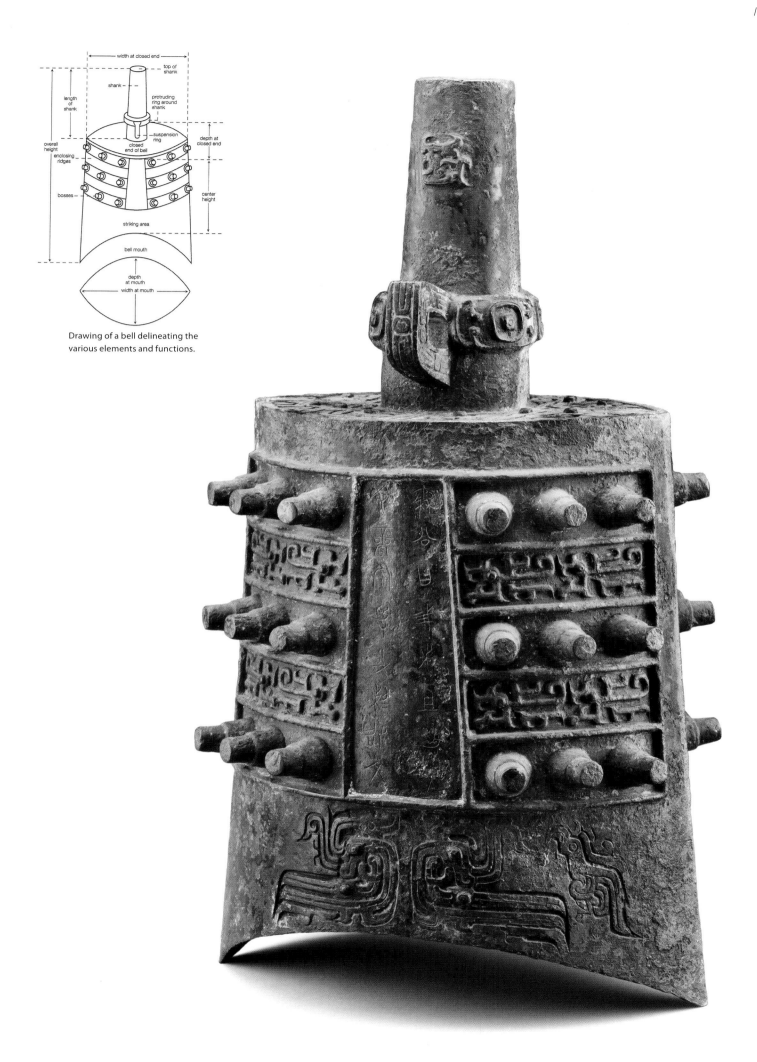

width at closed end

top of
shank

shank

protruding
ring around
shank

length
of
shank

suspension
ring

closed
end of bell

depth at
closed end

overall
height

enclosing
ridges

bosses

center
height

striking area

bell mouth

depth
at mouth

width at mouth

Drawing of a bell delineating the
various elements and functions.

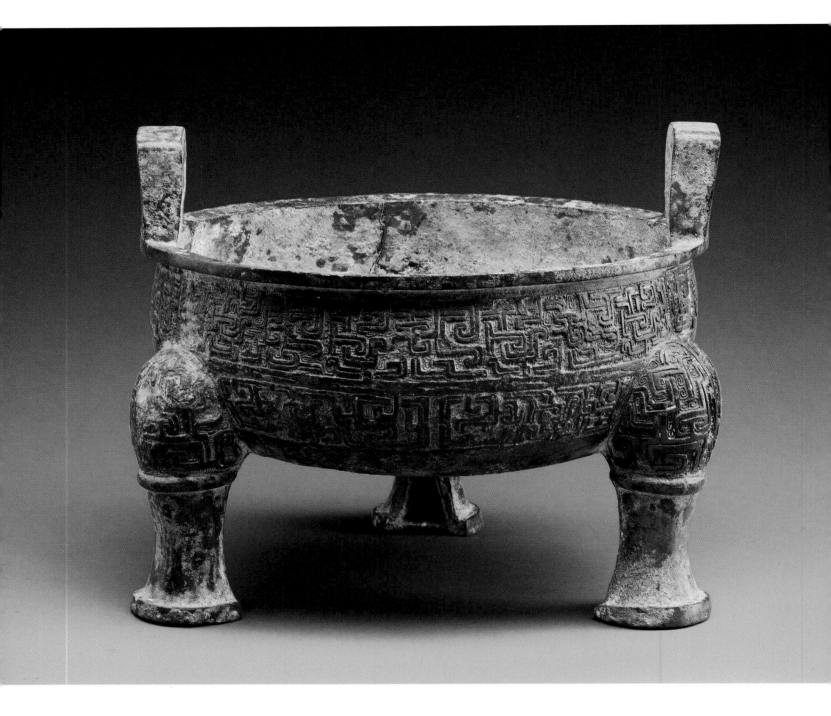

3

Ding cauldron

青銅蟠虺紋雙耳鼎

Spring and Autumn period (770–476 BCE)
Bronze, H. 19.6 cm (7¹¹⁄₁₆ in), Diam. 22.8 cm (9 in)
Excavated at Bianjiazhuang in Longxian, Shaanxi, 1981

Longxian Museum, Shaanxi 81L619

The *ding* food cauldron was the most prominent ritual vessel in China's Bronze Age. It was used to cook animal meat during the ceremony devoted to the ancestral spirits. The vertical handles allowed the vessel to be operated over a fire. In this example, excavated from Tomb 5 at Bianjiazhuang,[1] the densely arranged interlacing serpentine pattern is cast against a background of linear meanders, which imbues it with a mysterious power. In comparison with those cast earlier or those made in other regions, the Qin-style *ding* of this period has a shallower belly; the legs have become so thick and sturdy that the upper sections linking them to the belly swell out like knobs. The *taotie*, or monster-mask motif, dominant in earlier Shang and Western Zhou designs, has given way to the intricate, interlacing serpent-like motif. Another new and unique feature of the Qin *ding* of this period is the hoop found on its foot and sometimes in the middle of the leg.

1. Baoji branch of the Shaanxi Provincial Institute of Archaeology and Baoji Municipal Archaeological Team, "Shaanxi longxian bianjiazhuang wuhao chunqiumu fajue jianbao" [A brief report on the excavation of Tomb 5 at Bianjiazhuang in Longxian, Shaanxi], *Wenwu*, 1986, no. 11: 14–23, fig. 3:5.

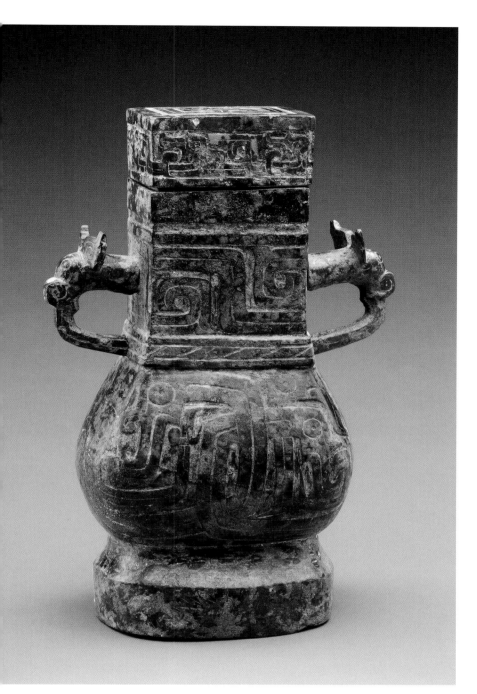

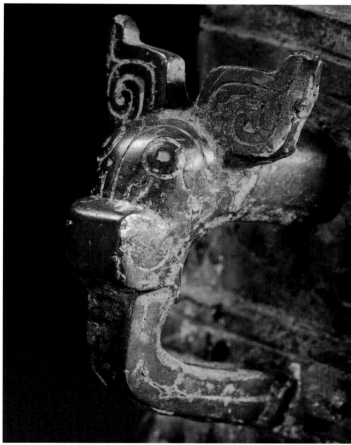

4

Covered *fanghu* square vessel
青銅蟠虺紋雙耳方壺

Spring and Autumn period (770–476 BCE)
Bronze, H. 23.6 cm (9⁵/₁₆ in), W. (mouth) 7.4 cm (2¹⁵/₁₆ in),
D. (mouth) 5.8 cm (2⁵/₁₆ in)
Excavated from Tomb 1, Bianjiazhuang in Longxian, Shaanxi, 1986

Longxian Museum, Shaanxi M12:84

Like the *ding* in the previous entry, this vessel is also from
Bianjiazhuang, located on the border of Gansu and Shaanxi. When
the Qin ruling class moved from Gansu into the former Western
Zhou's heartland, they established their capital there. Productive
archaeological excavations reveal a very sophisticated use of ritual
burial bronzes.

This wine vessel, one of a pair from the tomb,[1] is known as *fanghu* or
square *hu*. Its entire surface is decorated with interlacing serpents
and a pair of animal-head handles applied on the neck. The grouping
of the *hu* with other bronze vessels—such as *ding*, *gui*, *yan*, *he*, and
pan—in the tomb followed the tradition of the late Western Zhou.[2]

1. Ying Shengping and Zhang Tianen, "Shaanxi longxian bianjiazhuang yihao chun-
qiu mu" [Tomb 1 of the Spring and Autumn period excavated at Bianjiazhuang in
Longxian, Shaanxi], *Kaogu yu wenwu*, 1986, no. 6: 15–19; p. 17, fig. 3:7.

2. Baoji Branch of the Shaanxi Provincial Institute of Archaeology and Baoji Munici-
pal Archaeological Team, "Shaanxi longxian bianjiazhuang wuhao chunqiumu fajue
jianbao" [A brief report on the excavation of Tomb 5 at Bianjiazhuang in Longxian,
Shaanxi], *Wenwu*, 1986, no. 11: 14–23, plate 4:3.

5
Yi water vessel
青銅匜

Spring and Autumn period (770–476 BCE)
Bronze, H. 16.9 cm (6⅝ in), W. 29 cm (11⅜ in)
Excavated at Baoji in Shaanxi

Baoji Bronze Museum, Shaanxi IA4.19

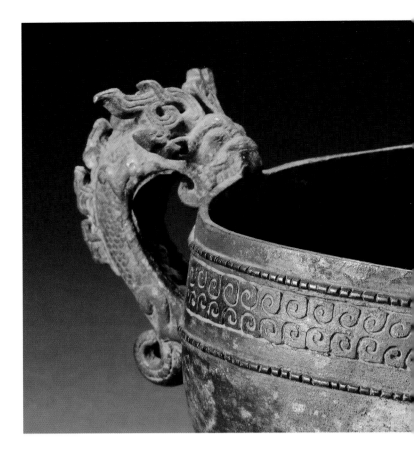

The *yi* vessel, which was used as a water container, first appeared
during the mid–Western Zhou dynasty, and was prevalent in the late
Western Zhou and Spring and Autumn period. Before conducting a
ritual activity or sitting down to a ceremonial feast, nobility would
wash their hands with water poured from a *yi* vessel like this one.
Like the *he* kettle, the *yi* was often paired with a *pan* basin (see cat.
nos. 7 and 8). The *yi* evolved from a footed vessel with rich decora-
tion and an animal-mask handle, to a simple flat-bottomed vessel
with restrained decoration and a ring handle. Although perhaps
made by Qin craftsmen, the current example is essentially a Western
Zhou type. The charming features include the handle, surmounted
by a horned dragon head; the legs, each one a stylized dragon; and
the frieze of swirling patterns that runs around the upper rim. Both
the beauty of its decoration and the refined casting technique imply
that it would have been the possession of an aristocrat, possibly the
Duke of Qin or a close member of his royal entourage.

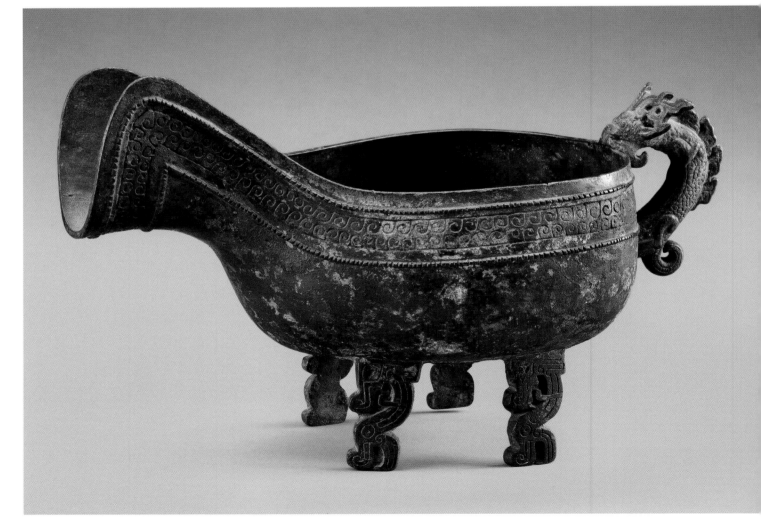

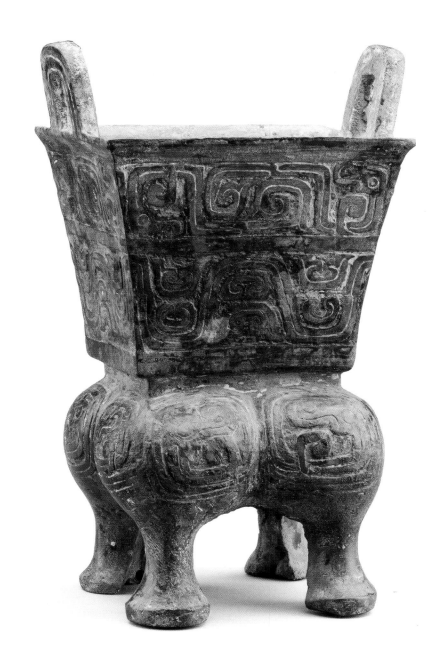

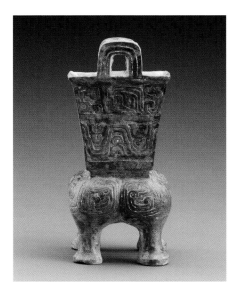

6

Yan **steamer**

青銅甗

Spring and Autumn period (770–476 BCE)
Bronze, H. 22.4 cm (8¹³⁄₁₆ in), W. 12.8 cm (5 in)
Excavated at Bianjiazhuang in Longxian, Shaanxi, 1986

Longxian Museum, Shaanxi 86LBM12:79

The bronze *yan* was a type of steamer or cooking vessel used chiefly
for grain. It consisted of a *zeng*, or deep upper bowl with a pierced
bottom, which was placed upon or attached to a lower, legged
vessel known as *li*. It first appeared during the Shang dynasty, and
the form became popular in the late Western Zhou and early Spring
and Autumn periods. This was an object that was crucial for burial
groupings. After the early Spring and Autumn period, the two parts
of the *yan* were generally cast separately, but this *yan*, adorned with
typical Qin-style serpentine meanders, was made for burial and still
follows the earlier fashion.

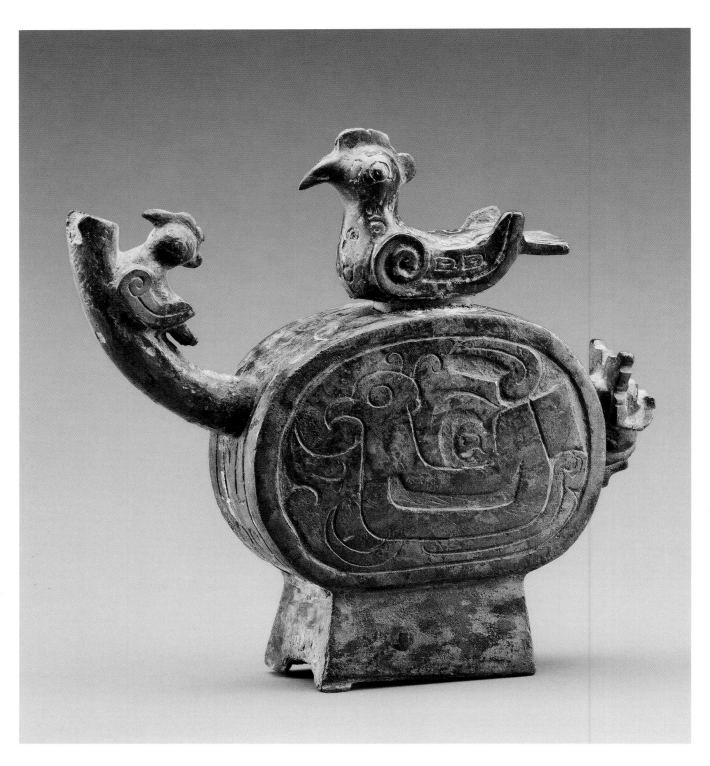

7
He **kettle**
鳳鳥紋銅扁盉

Spring and Autumn period (770–476 BCE)
Bronze, H. 14 cm (5½ in), W. 15 cm (5⅞ in)
Excavated at Bianjiazhuang in Longxian, Shaanxi, 1986

Longxian Museum, Shaanxi 86LBM114:67

8

Pan basin

青銅盤

Spring and Autumn period (770–476 BCE)
Bronze, H. 9 cm (3⁹⁄₁₆ in), Diam. 22.5 cm (8⅞ in)
Excavated at Bianjiazhuang in Longxian, Shaanxi, 1981

Longxian Museum, Shaanxi 81L1006

The *pan* basin was commonly paired with a *he* kettle (opposite),
not only in their ritual ceremonial context but also in burial. Both
began to appear in the early Shang dynasty and became prevalent
during the late Shang and the subsequent Western Zhou dynasty.
Although there is the popular opinion that the *he* was a vessel used
to heat wine, it is more likely that when it was paired with the *pan*, it
served as a water vessel for ceremonial ablutions. The *he* in its earlier
form was a three-legged vessel with a bulging body, but coming
into the Spring and Autumn period it evolved to become flatter and
thinner, like this example. This new, evolved shape was especially
prevalent in the Qin state. This *he* is heavily ornamented with a spout
and a handle, both in animal form, and a bird-shaped lid. The entire
exterior surface is embellished with a bird motif.

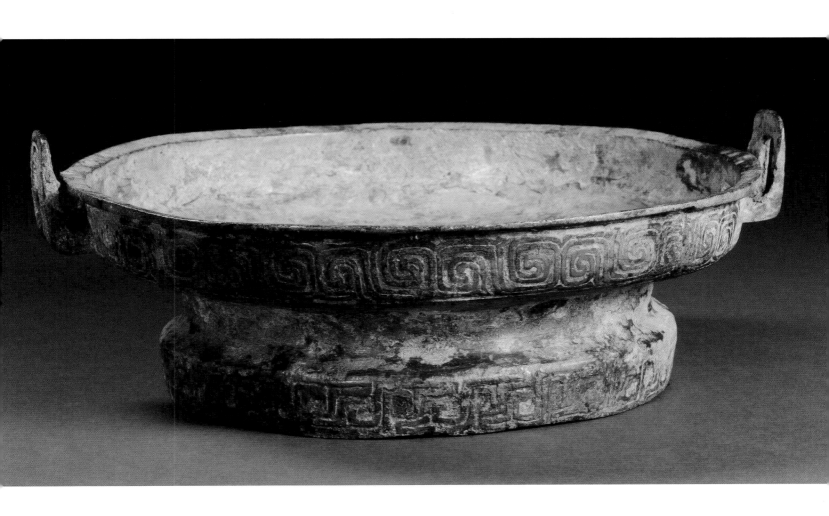

9
Dou food vessel
蟠虺紋帶蓋青銅豆

Spring and Autumn period (770–476 BCE)
Bronze, H. 20 cm (7⅞ in), Diam. 17.3 cm (6¹³⁄₁₆ in)
Excavated at Baoji in Shaanxi

Baoji Bronze Museum, Shaanxi 06927/IA1.162

This rounded bowl, raised on a thin-stemmed foot, is decorated
around the sides with four bands of interlacing serpentine scrolls;
the band encircling it is interrupted by a pair of ring handles. There
is a similar band on the domed cover's circular handle. This vessel,
known as a *dou*, was used in rituals for storing minced meat or
pickled vegetables. It appeared during the late Shang dynasty but
reached the pinnacle of its popularity in the Spring and Autumn
period, at which time, under the Qin state, it began to appear in
burial groupings.

10
Fanghu square vessel
青銅方壺

Spring and Autumn period (770–476 BCE)
Bronze, H. 22 cm (8⅝ in), W. (mouth) 9.5 cm (3¾ in),
D. (mouth) 9.5 cm (3¾ in)
Excavated at Gaozhuang in Fengxiang, Shaanxi, 1977

Shaanxi Provincial Institute of Archaeology 000232

The wine or water vessel known as *fanghu*, or square *hu*, was a new
type of ritual bronze that was popular during this period in the Qin.
It evolved from earlier models with smaller mouths, such as the
example excavated from the tomb at Bianjiazhuang (cat. no. 4). The
neck is now elongated and is crowned with an oversized rimmed
mouth. The exterior body, divided by plain wide strips, is adorned
with the popular interlocking serpentine motif. Its comparatively
crude quality suggests it was made for burial purposes.

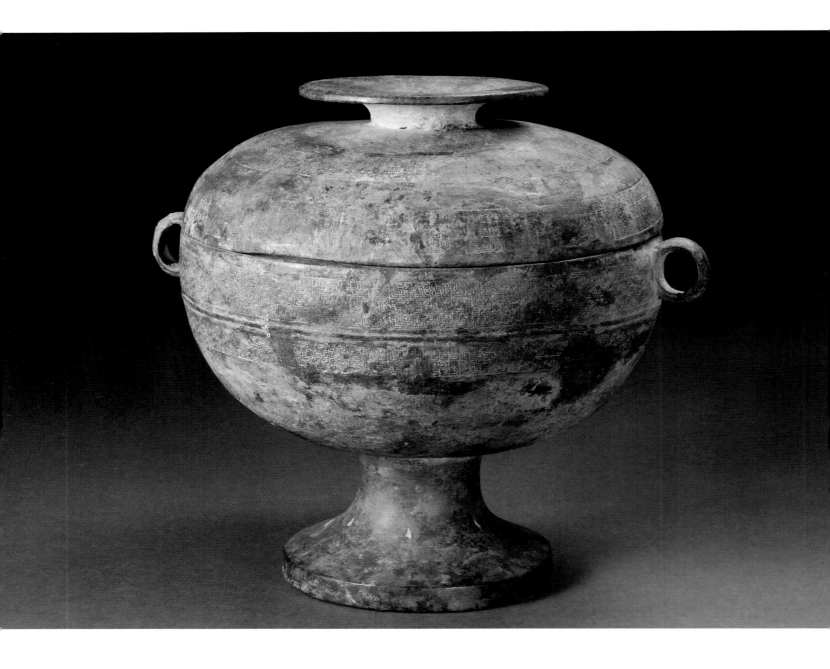

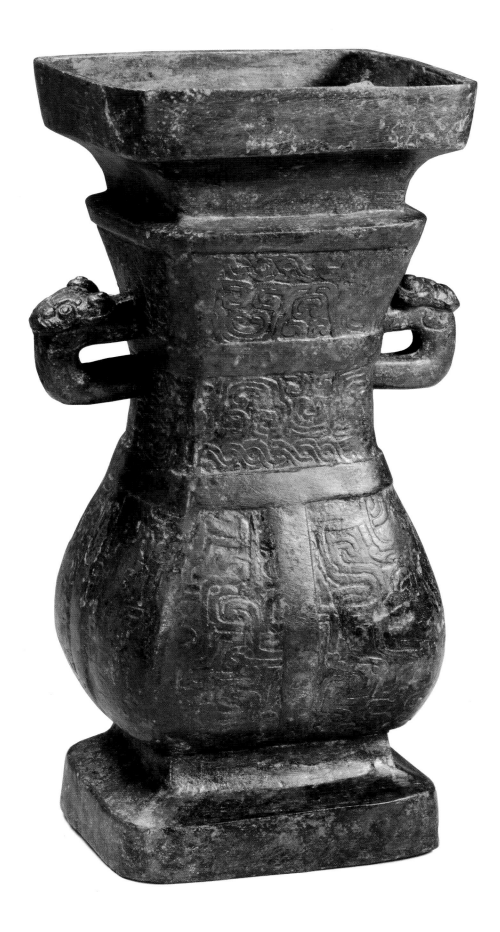

11
Covered *ding* cauldron
青銅帶蓋小圓鼎

Spring and Autumn period (770–476 BCE)
Bronze, H. 6.5 cm (2⁹⁄₁₆ in), Diam. (mouth) 6.1 cm (2³⁄₈ in)
Excavated at Shangguodian in Fengxiang, Shaanxi, 2001

Fengxiang County Museum, Shaanxi 1003

This *ding* tripod was excavated in the area of Yong, the former Qin
capital. On the domed lid, punctuated by three duck-shaped knobs,
is a circular band of three pairs of birds facing each other. This band
is encircled by a second band of fish near the rim. Below, on the top
half of the main register, there are two bands—one of beasts and
one of fish—all in incised lines. Although the vessel shares some
basic characteristics of the *ding* developed in the Qin, its unusual
richness of decoration is in contrast with the Qin tendency of the
late Spring and Autumn period toward less surface decoration. It is
therefore considered to be a product of another state.[1]

1. Fengxiang County Museum, "Shaanxi fengxiang shangguodian chutu de chunqiu
shiqi wenwu" [Cultural relics of the Spring and Autumn period excavated from
Shangguodian, Fengxiang, in Shaanxi], *Kaoku yu wenwu*, 2005, no. 1: 1–6, fig. 2.

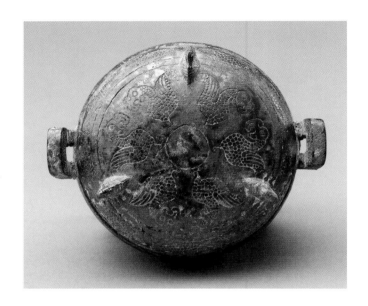

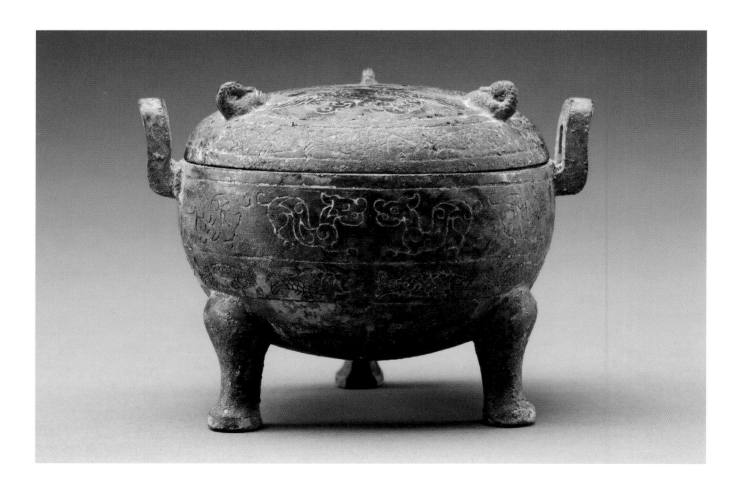

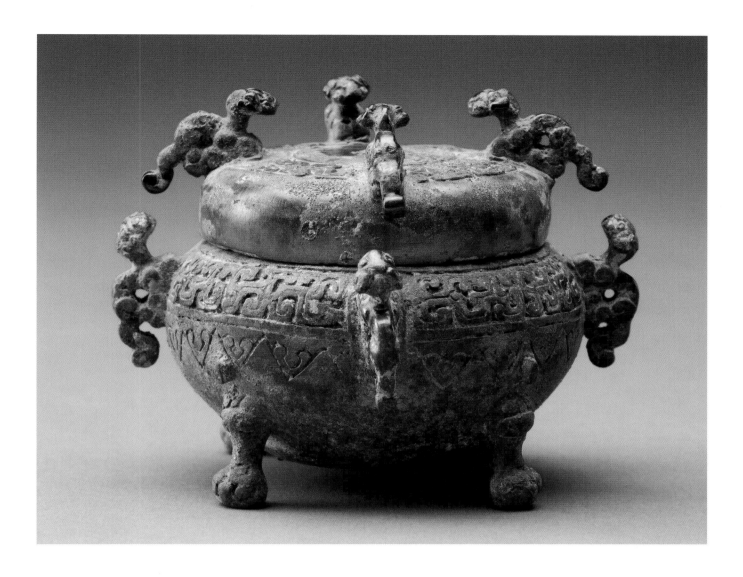

12
Covered *ding* cauldron with four legs
八獸帶蓋四足小銅鼎

Spring and Autumn period (770–476 BCE)
Bronze, H. 5.7 cm (2¼ in), Diam. (mouth) 4.5 cm (1¾ in)
Excavated at Shangguodian in Fengxiang, Shaanxi, 2001

Fengxiang County Museum, Shaanxi 1002

Compared to those cast in the Qin territory, this *ding* is unusual
for its shape and rich ornamentation. While the common *ding* of
this period displays a bulbous shape, this example has four legs, a
well-marked shoulder, and a short vertical neck and lid, which give
it the appearance of a covered jar. It is further adorned with eight
protruding animals on its exterior body, which were cast separately
and joined to the cauldron in a second cast. The uniqueness of the
piece makes it clear that it was the product of another state.[1] Like
the previous example (cat. no. 11), it was perhaps acquired by the
Qin as tribute or plunder.

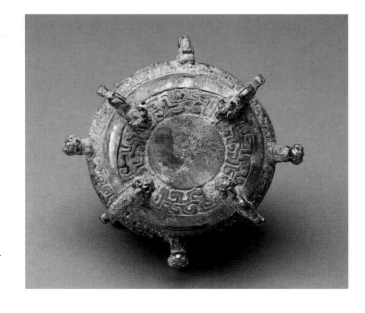

1. Fengxiang County Museum, "Shaanxi fengxiang shangguodian chutu de chunqiu
shiqi wenwu" [Cultural relics of the Spring and Autumn period excavated from
Shangguodian, Fengxiang, in Shaanxi], *Kaoku yu wenwu*, 2005, no. 1: 1–6, fig. 2.

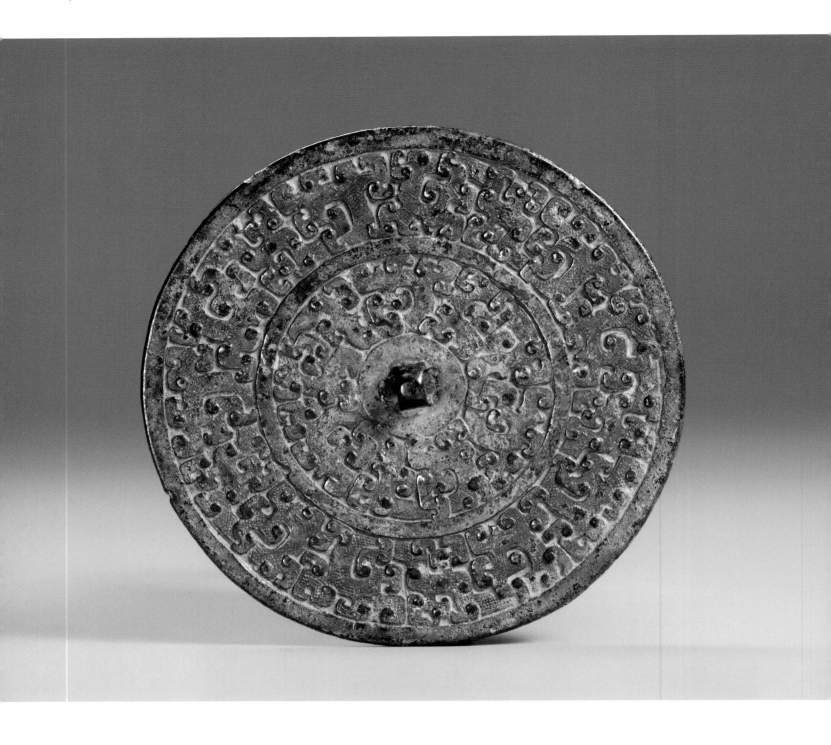

13
Mirror
青銅蟠虺紋鏡

Spring and Autumn period (770–476 BCE)
Bronze, Diam. 10 cm (3¹⁵⁄₁₆ in), D. 0.2 cm (¹⁄₁₆ in)
Acquired 1974

Fengxiang County Museum, Shaanxi 0032

This is a typical example of a Qin mirror from this period—circular in form, with the reflective side gently convex and polished, and the reverse side ornamented with symbolic motifs. Two raised bands, one on the outer perimeter and one in the middle section, separate the neatly arranged design. Its tightly interlaced serpentine motif is comparable to those on bronze ritual vessels from the same era. The prominent central knob allowed the mirror to be hung from a belt.

As evidenced by archaeological finds, Qin was less productive in mirror casting than other states. In other regions, mirrors were often buried with the deceased as a kind of talisman, and a group of some twenty-five mirrors unearthed from Qin tombs at Ta'erpo in Xianyang reveal that the Qin people also adhered to this belief. Nine of the mirrors were placed close to the top of the head, seven were found on the sides of the head, and three were located outside of the coffin on the head side.[1]

1. Xianyang Municipal Institute of Archaeology, Shaanxi, *Taerpo qinmu* [Qin tombs unearthed at Ta'erpo] (Xi'an: Sanqin Press, 1998), p. 136.

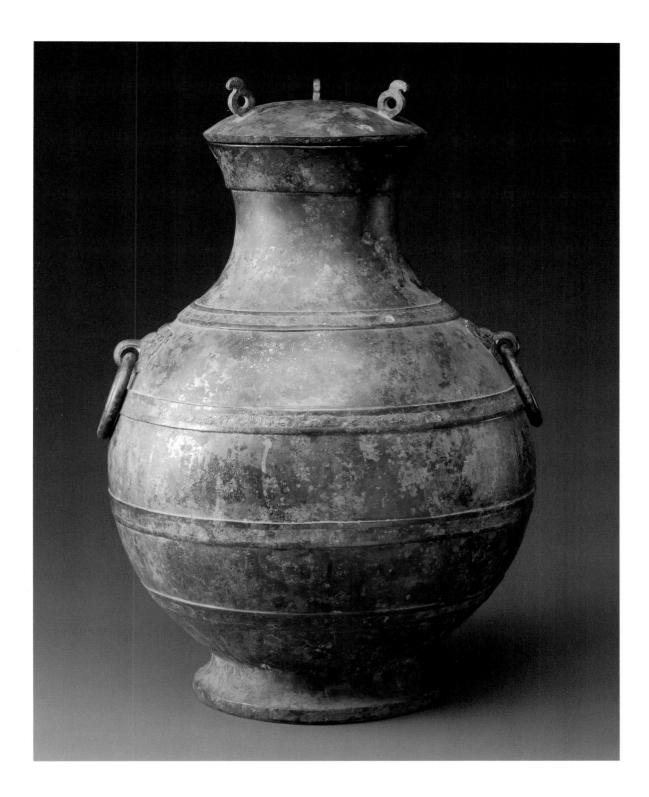

14

Hu vessel
青銅 "安邑下官" 鍾

Warring States period (475–221 BCE), Wei state
Bronze, H. 56 cm (22¹⁄₁₆ in), Diam. 36.9 cm (14.5 in)
Excavated at Ta'erpo in Xianyang, Shaanxi, 1966

Xianyang Municipal Museum, Shaanxi 5-1073

The *hu* wine or water vessel evolved from the Shang to the Han dynasties, and can be seen in a great variety of forms (see cat. no. 4). During the Warring States period, this type of round *hu*, with its bulging belly, tall neck, and rimmed foot, became one of the most popular bronze vessels in the Qin territory. In keeping with contemporary taste, it was relatively undecorated, with the exception of several raised bowstrings, or flat bands, encircling the body. Most have ring handles (often in the form of animal masks) on the shoulders and a slightly domed lid embellished with three knobs in stylized-animal form. A new type of *hu* that emerged during this period in the Qin shows a linked-chain handle. In some examples, as demonstrated by this vessel, the *hu* bears an inscription naming itself a *zhong*. Consequently, this type of *hu* was also known as *zhong*.

15
Ding cauldron
青銅鼎

Warring States period, dated 309–308 BCE
Bronze, H. 16.8 cm (6⅝ in), W. 22.4 cm (8³⁄₁₆ in), Diam. (mouth) 15.5 cm
(6⅛ in)
Excavated at Gaozhuang in Fengxiang, Shaanxi, 1977

Shaanxi Provincial Institute of Archaeology 007008

This simple and elegant piece is typical of the late Warring States
style of the popular *ding* vessel. In contrast to the *ding* of the Spring
and Autumn period (see cat. no. 3), it is smaller (in capacity) and
plainer (without exterior ornamentation), and its smooth, domed
lid has three looped knobs. An incised inscription indicates that it
was made in the neighboring state of Zhongshan in Hebei province,
which was conquered by Zhao troops in 296 BCE.[1] It was probably
later acquired by Qin soldiers as booty during the war of unification.

1. Shaanxi Provincial Archaeological Team at Yong, "Fengxiang gaozhuang zhanguo
qinmu fajue jianbao" [A brief report on the excavation of Qin tombs of the Warring
States period at Gaozhuang in Fengxiang], *Wenwu*, 1980, no. 9: 10–14, fig. 8:1.

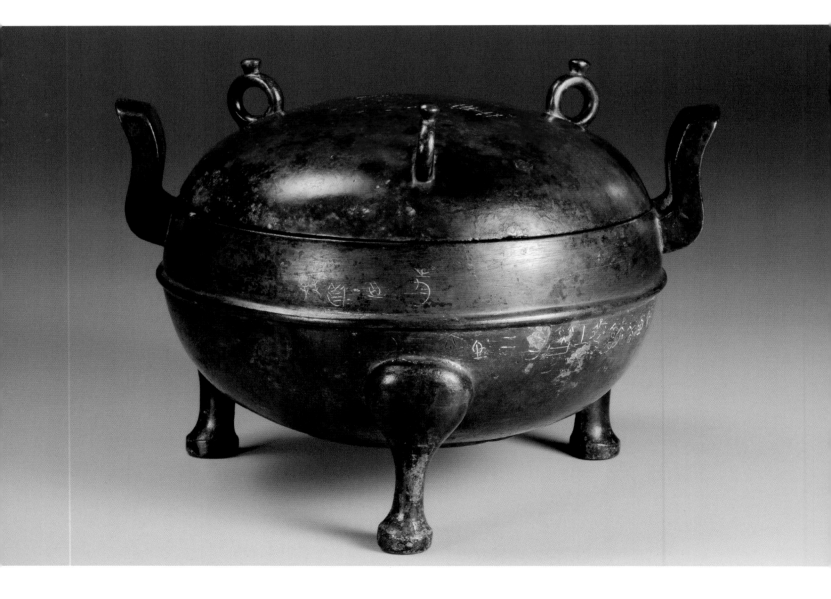

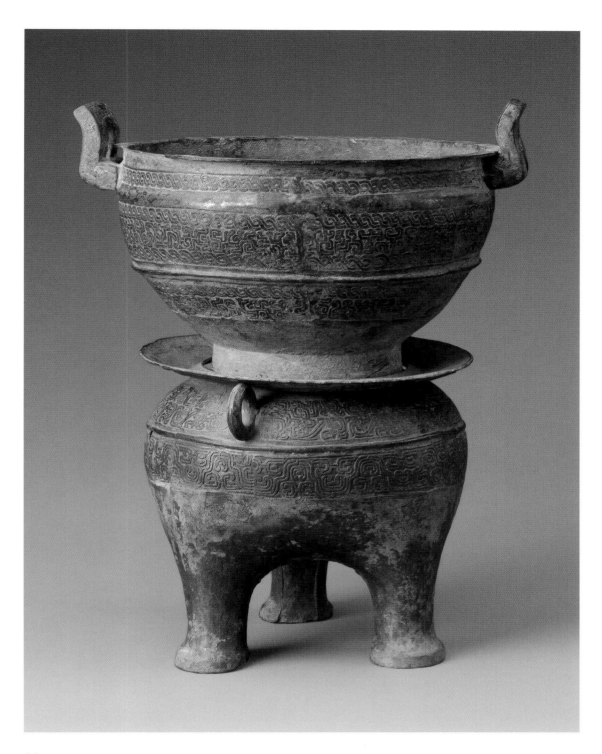

16

Yan **steamer**

青銅甗

Warring States period (475–221 BCE)
Bronze, H. 30.6 cm (12⅛ in), Diam. (mouth) 20 cm (7⅞ in)
Excavated at Gaowangsi in Fengxiang, Shaanxi, 1977

Fengxiang County Museum, Shaanxi 0322

This *yan* steamer was excavated from the storage pit at Gaowangsi in Fengxiang as was the *he* kettle with dragon-shaped spout (cat. no. 18). Although it is a combination of a *zeng* and a *li* like the vessel unearthed at Bianjiazhuang in Longxian (cat. no. 6), its upper and lower sections are separated. The upper vessel *zeng* is adorned with alternating strips of rope and serpent motifs, rather than the interlaced serpent ornaments that are ubiquitous on Qin bronzes. Below, the *li* vessel displays two ornamented strips around

its shoulder, each consisting of a series of pairs of mirror-image double-headed dragons, much like the design seen on the *he* kettle shown as cat. no. 18. Below, the wave-shaped band adorning its belly is alien to Qin bronze decoration. It is apparent that, like many works from the storage pit at Gaowangsi, this *yan* was manufactured in another state. In its general form, this *yan* shares an affinity with those produced in the former Jin state.[1]

1. See one example of the Eastern Zhou period excavated from a tomb at Siyu village in Yuanping, Shanxi province. Dai Zunde, "Yuanping siyu chutu de dongzhou tongqi" [Bronze vessels of the Eastern Zhou dynasty unearthed at Siyu in Yuanping], *Wenwu*, 1972, no. 4: 69–71, p. 69, fig. 2.

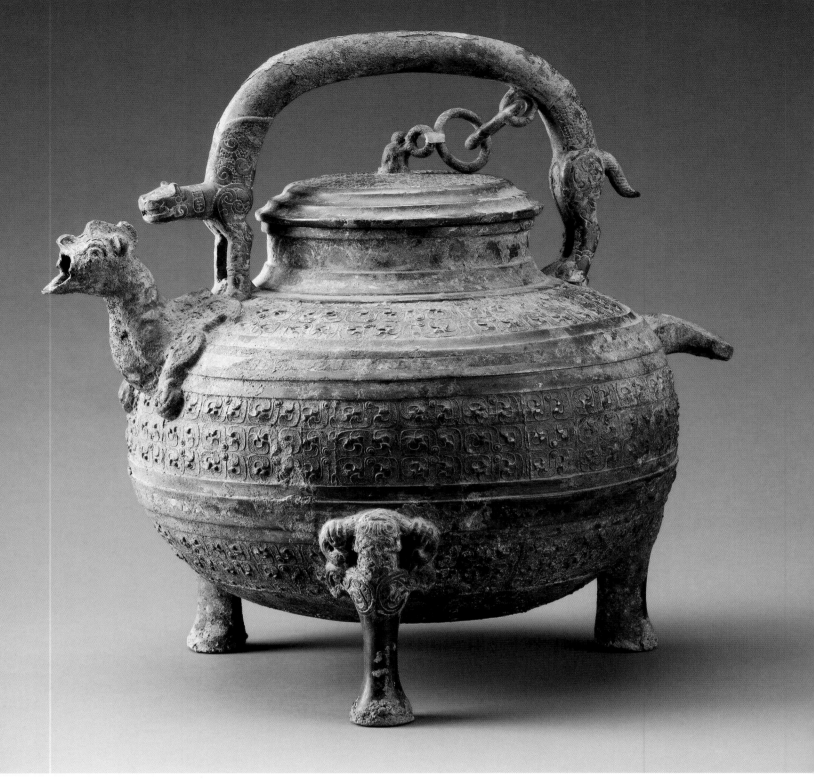

17
***He* kettle with phoenix-shaped spout**
青銅鳳流提梁盉

Warring States period (475–221 BCE)
Bronze, H. 25.5 cm (10¹⁄₁₆ in), Diam. 21.2 cm (8⁵⁄₁₆ in)
Excavated at Maopo in Xi'an, Shaanxi, 2002

Xi'an Municipal Museum, Shaanxi KG1

During this period, a new type of tripod *he* wine vessel—with a round mouth and lid and a bulging belly—became popular in the Qin, replacing the flat-bodied *he*, which eventually died out entirely. The stylized animal-shaped handle and a phoenix-like spout add charm to this ritual bronze vessel.

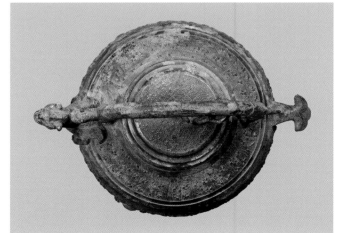

18
He kettle with dragon-shaped spout
青銅龍流提梁盉

Warring States period (475–221 BCE)
Bronze, H. 17 cm (6¹¹⁄₁₆ in), Diam. 9.2 cm (3⅝ in)
Excavated at Gaowangsi in Fengxiang, Shaanxi, 1977

Fengxiang County Museum, Shaanxi 0323

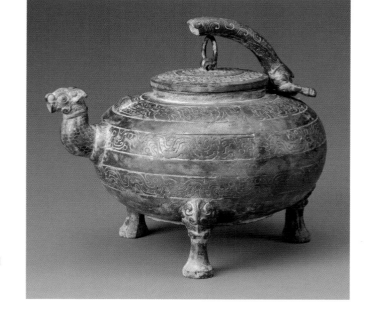

In 1977, a storage pit was unearthed at a location close to the Qin palace site at Majiazhuang in Fengxiang, in an area once known as Yong, the old capital of the Qin state. Archaeologists recovered twelve bronze vessels, including three *ding* tripods, a *dou* food vessel, two *hu* wine vessels, two *dui* vessels, a *pan* basin, a *yi* water vessel, a *he* kettle, and a *yan* steamer. Based on their varying forms and styles and one inscription, it is apparent that these twelve bronze vessels were cast in various states, including Qin in the west, Wu in the east, Chu in the south, and Jin in the Central Plains. Together, these vessels provide important evidence for the active cultural exchange and complicated relationships among the Qin and other states during the Warring States period.

In this example, although the general form is similar to those made in the Qin, the decoration is unique. Here, three bands comprise the main decoration of the exterior body. Each of the ornamental stripes consists of a series of two-headed S-shaped dragons (one dragon head is at the top right of each S, and the other is at the bottom left). Chinese archaeologists have suggested that it was made in the Central Plains, perhaps in the former Jin state.[1]

1. Han Wei and Cao Mingtan, "Shanxi fengxiang gaowangsi zhanguo tongqi jiaocang" [A storage pit containing bronze vessels of the Warring States period unearthed at Gaowangsi in Fengxiang, Shaanxi], *Wenwu*, 1981, no. 1: 15–17.

19
Ping vase with garlic-shaped head
青銅蒜頭瓶

Warring States period (475–221 BCE)
Bronze, H. 35 cm (13¾ in), Diam. 21.8 cm (8⁹⁄₁₆ in)
Excavated at Changling Railway Station, Xianyang, Shaanxi, 1962

Xianyang Municipal Museum, Shaanxi 5-1287

This wine vase has a mouth in the shape of a six-clove garlic bulb and is unique to the Qin state. Such vessels began to appear in the late Warring States period and soon became popular, spreading to other regions after the unification. As they were often found in the tombs of aristocrats, they may have served ritual purposes.

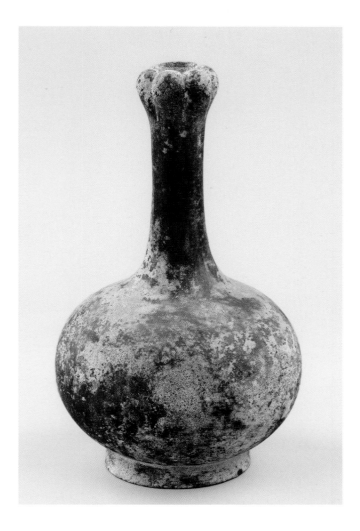

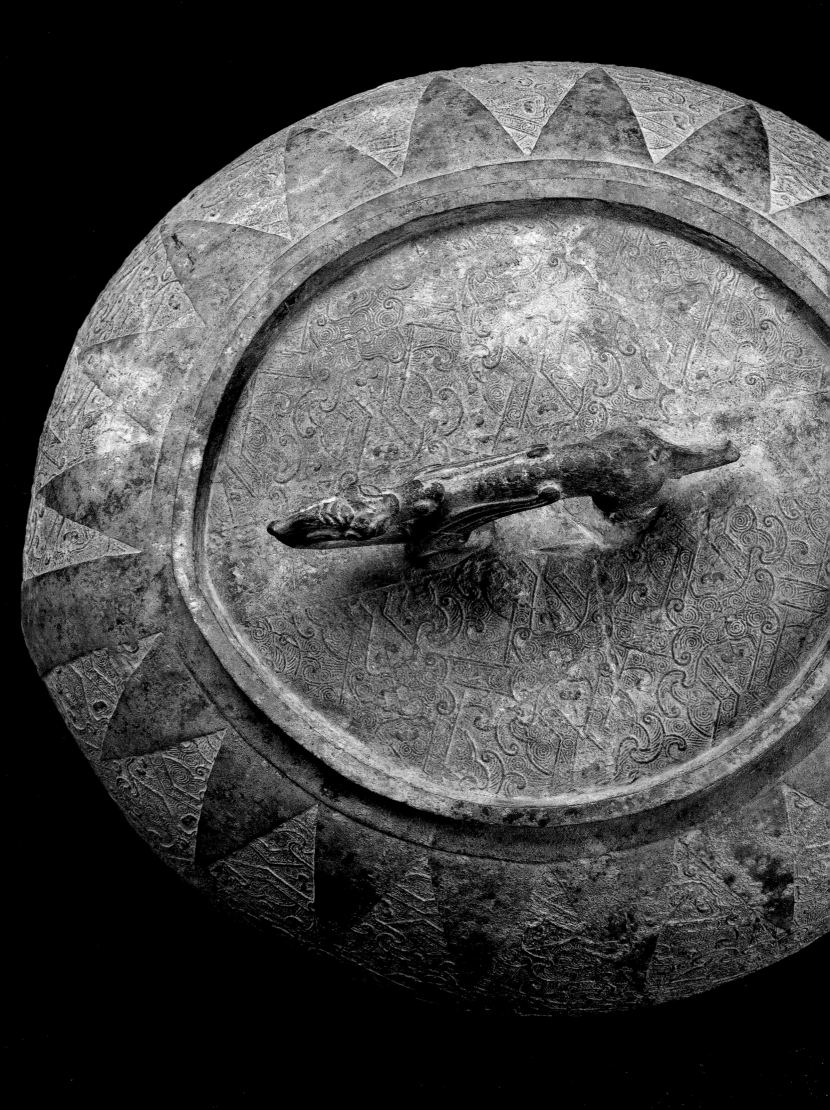

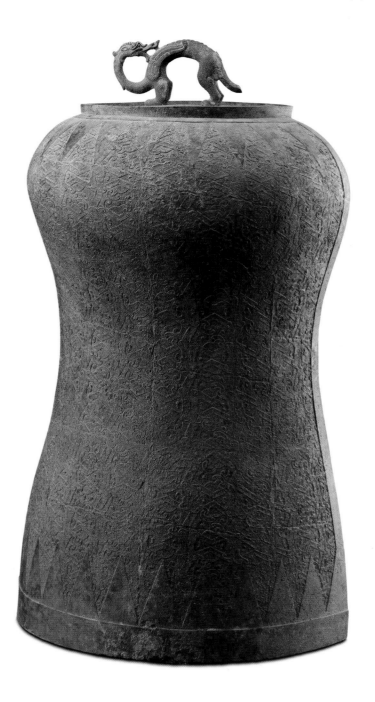

20
Chunyu percussion instrument
青銅淳于

Warring States period (475–221 BCE)
Bronze, H. 69.6 cm (27⅜ in), Diam. (foot) 37.6 cm (14¹³⁄₁₆ in)
Excavated at Ta'erpo in Xianyang, Shaanxi, 1979

Xianyang Municipal Museum, Shaanxi 5-1487

This percussion instrument *chunyu* is in the form of an upside-down vase with a dragon-shaped knob. Pendent triangles, or "hanging blades," encircle the foot and shoulder, and intertwined serpents embellish the main body. Musical instruments of this form are believed to have originated in the southwest, particularly in the Ba region (present-day Chongqing).[1] The *chunyu* became prevalent in many states during the Spring and Autumn period and until the Han dynasty, and probably served multiple functions both in warfare and in ritual ceremony. It is unclear whether the piece was made in Qin or taken as plunder from another state.

1. Li Chunyi, *Zhongguo shanggu chutu yueqi zonglun* [A study of ancient Chinese musical instruments] (Beijing: Wenwu Press, 1996), p. 345.

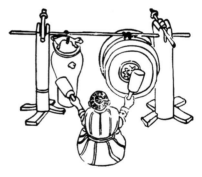

Line drawing of a man beating a *chunyu* and drum in ritual ceremony, depicted on a bronze vessel of the Han dynasty. After Zhang Zengqi, *Jinning shizhai shan* [Mount Shizhai in Jinning] (Kunming: Yunnan Meishu Press, 1998), p. 42.

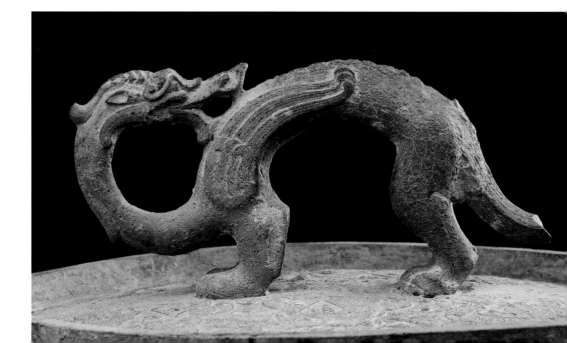

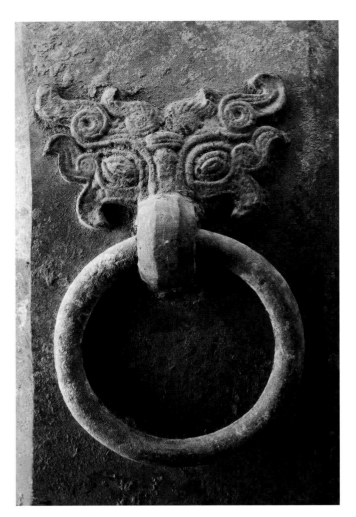

21
Bianhu vessel with garlic-shaped mouth
青銅蒜頭扁壺

Warring States period (475–221 BCE)
Bronze, H. 34 cm (13⅜ in), W. 29.5 cm (11⅝ in), D. 8.5 cm (3⅜ in)
Excavated at Belei village in Weinan, Shaanxi, 1987

Lintong County Museum, Shaanxi 00402

The prototype of this style of wine vessel, known as *bianhu*, was the pottery flask made in the Western Zhou dynasty.[1] It was not until the late Warring States period that a casting innovation allowed it to be adapted in bronze. With its garlic-shaped mouth and two loose rings suspended from a pair of *taotie*-mask escutcheons, it is one of the most characteristic forms of Qin bronze.

1. Two pottery *bianhu*, dating to the Western Zhou period, were excavated from Shuiguanyin in Xinfan, Sichuan, and are now in the collection of the Sichuan Provincial Museum.

22
Mou vessel
青銅鍪

Warring States period (475–221 BCE)
Bronze, H. 16.7 cm (6⁹⁄₁₆ in), Diam. (mouth) 12.3 cm (4¹³⁄₁₆ in)
Acquired in 1952

Shaanxi History Museum 3365

This *mou*-type vessel, with its pair of uneven ears, was more a cooking tool for boiling food and water than a ritual bronze. It originated in the regions of Ba and Shu (in present-day Sichuan), and was adopted by the people of Qin following their military triumph there during the mid–Warring States period. In the course of the Qin's campaign to eliminate the six states, the vessel became widespread throughout the nation.

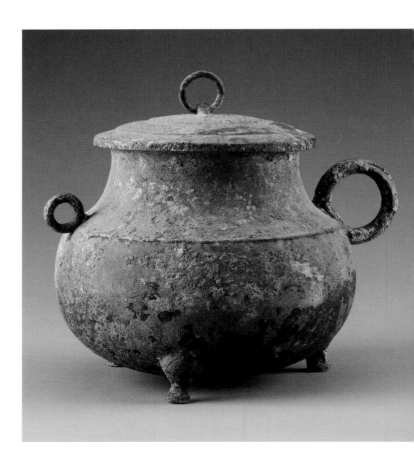

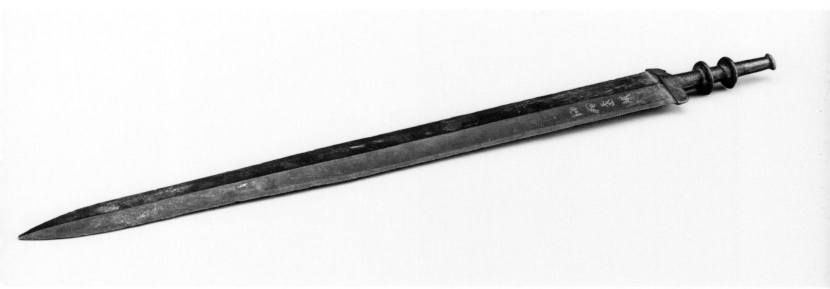

23
Sword
青銅劍

Warring States period (475–221 BCE)
Bronze, L. 53.8 cm (21³⁄₁₆ in)
Acquired in Baoji

Baoji Bronze Museum, Shaanxi IA8.223

This sword has a short guard and a grooved grip that would have been finished with a pommel (now missing). It is typical of the swords prevalent in the Qin and other states from the Spring and Autumn period through the Warring States period. It offers a clear contrast to the long-blade Qin-style sword that later armed the Qin soldiers who served as models for the terracotta warriors.

The sword is similar to one excavated from Tomb CM9 at Baqitun, Fengxiang. Researchers considered that sword to have been an "imported" object, with its origin in Liyu in Hunyuan, Shaanxi, the territory of the Jin state during that time.[1] Another sword unearthed from Tomb 74C1M4, which bears similar features, was identified as from the Chu state. In any case, the current sword was not a local product. It bears an inscription that reads, "Yin suowu yong" (for the use of Yin Suowu).

1. Teng Yuming, *Cong fengguo dao diguo de kaoguxue guancha* [Qin culture from an archaeological perspective: from a feudal state to the great empire] (Beijing: Xueyuan Press, 2003), pp. 86–87.

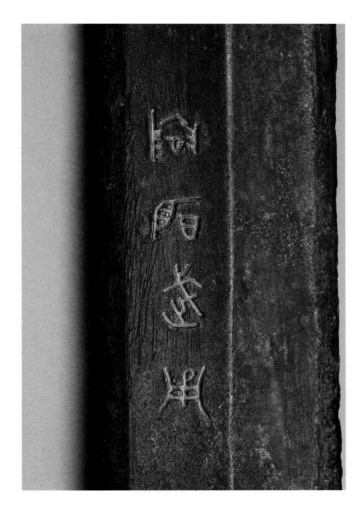

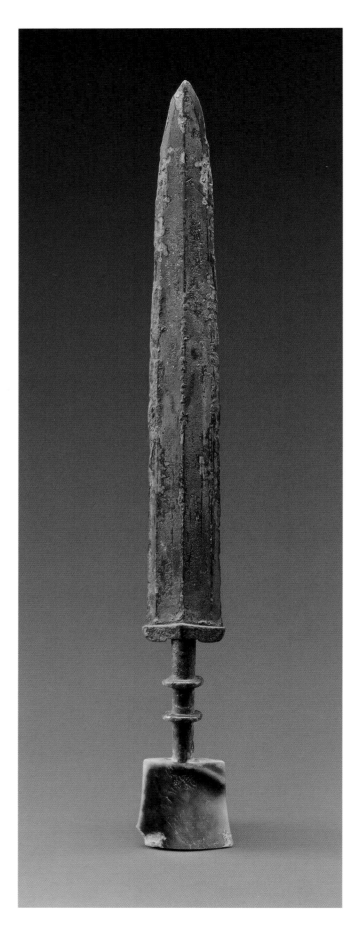

24
Sword with jade pommel
玉首青銅劍

Warring States period (475–221 BCE)
Bronze and jade, H. 43.3 cm (17 1/16 in), W. 5 cm (1 15/16 in)
Excavated at Wagangzhai, Biaojiaoxiang, in Fengxiang, 1995

Fengxiang County Museum, Shaanxi 0918

This sword is similar to others cast during this period, and differs only in its pommel, which is a piece of trapezoidal jade. The use of jade to adorn a bronze sword was an old tradition, as documented by a poem in *Shijing* (Book of Songs), a collection of Chinese poems dating from the ninth to the seventh century BCE. Dedicated to Duke Liu, the ancestor-founder of the Western Zhou dynasty, the poem contains these lines describing the hero's costume:

> What was it that he carried at his girdle?
> Pieces of jade, and *yao* gems,
> And his jade-ornamented scabbard with its sword.

This description suggests that as early as the Western Zhou period, decorative jade ornaments were added to swords and scabbards, a custom that continued through the Han dynasty. The earliest-known excavated jade sword finials date to the late Spring and Autumn period.[1] It was not until the Han dynasty that a complete four-part decorative set appeared on a sword and scabbard. The set included: a sword pommel; a sword guard; a scabbard chape (or cover); and a sword slide through which a baldric (or strap worn over the shoulder and across the chest) was threaded to allow the sword to hang from the belt.

Unlike the common jade sword pommel—a thin disc with a bevelled and decorated perimeter—this sword's pommel is a trapezoid. Such a form seems to have southern or Central Plains origins, as seen in one example from Tomb M2 at Liuhechengqiao in Jiangsu datable to the late Spring and Autumn period, and another example from a Warring States tomb at Baijiacun in Handan, Hebei province.[2]

1. See Sun Ji, *Zhongguo shenghuo: Zhongguo guwenwu yu dongxi wenhua jiaoliu zhong de ruogan wenti* [Chinese sacred fire: several issues in Chinese antiquities and in the east/west cultural exchanges] (Shenyang: Liaoning Jiaoyu Press: 1996), p. 15.

2. Nanjing Museum, "Jiangsu liuhechengqiao erhao dongzhou mu" [Tomb 2 of the eastern Zhou period at Liuhechengqiao in Jiangsu], *Kaogu*, 1974, no. 2: 116–20, p. 116, fig. 5:5; Cultural Relics Team of the Hebei Provincial Cultural Bureau, "Hebei handan baijiacun zhanguo mu" [Warring States tomb unearthed at Baijiacun village in Handan, Hebei], *Kaogu*, 1962, no. 12: 613–34, p. 623, fig. 14.

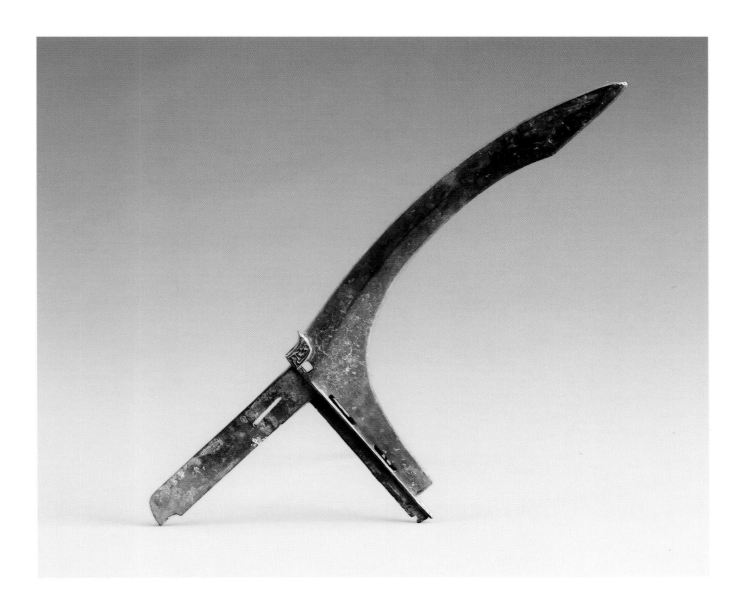

25
Ge dagger-ax
青銅三穿戈

Warring States period (475–221 BCE)
Bronze, L. 25.2 cm (9¹⁵⁄₁₆ in)
Excavated from Tomb M42 at Gucheng in Danfeng, Shaanxi, 1996

Shangluo Municipal Museum, Shaanxi 0297 D017

This *ge* dagger-ax was excavated from a tomb located at present-day Shangluo in eastern Shaanxi, an area that overlapped the territories of Qin, Jin (which was split into three successor states—Han, Zhao, and Wei in 453 BCE), and Chu, the three most powerful states during the Warring States period. The tomb, a rectangular vertical shaft, contained six pottery replicas of bronze vessels, a *ge* dagger-ax, and an arrowhead and sword, all of which were placed next to the left arm of a fifty-five-year-old deceased male. These objects identify the tomb occupant as a commoner who had served in the military.[1]

In comparison with the dagger-ax of the Qin dynasty (cat. no. 96), this *ge* has a much-longer crescent blade. Noticeable is the tiny wing-shaped finial decorating the corner of the right angle of the blade. Of the fifteen *ge* unearthed from fourteen tombs at Gucheng village in 1996, this is the only one decorated with the wing-like finial. The *ge* dagger-ax with this design was popular in the regions of Chu and Yue.[2]

1. Shaanxi Provincial Institute of Archaeology and Shangluo Municipal Museum, Shaanxi, *Danfeng gucheng chumu* [Chu tombs at Gucheng in Danfeng] (Xi'an: Sanqin Press, 2006), pp. 66–70, fig. 67:7, and p. 151, fig. 141.

2. See Jing Zhongwei, *Zaoqi zhongguo qingtong ge ji yanjiu* [A study of early Chinese bronze *ge* and *ji*] (Beijing: Kexuege Press, 2011), pp. 264–67, fig. 3-52, and pp. 348–51, figs. 5–19, 5–20.

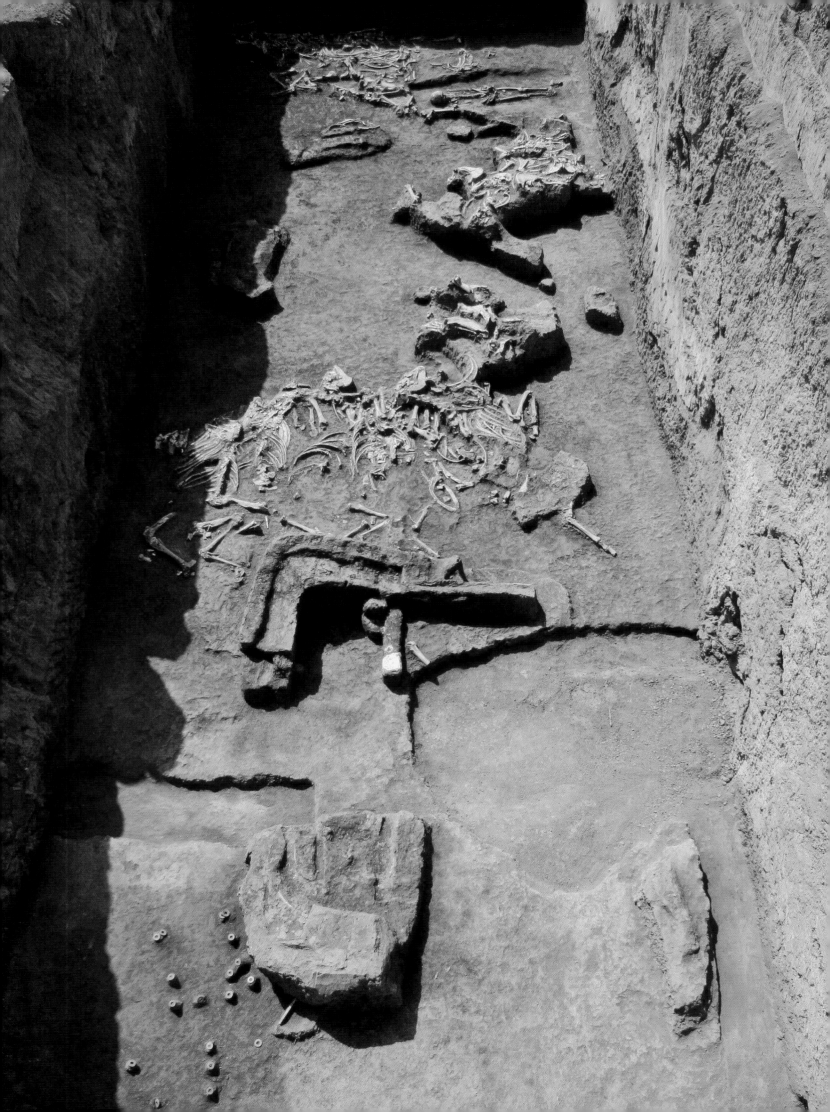

Chariot Fittings

THE PRACTICE OF BURYING WORLDLY GOODS SUCH AS CHARIOTS AND horses with deceased rulers and aristocrats began in the Shang dynasty and continued throughout the Bronze Age and the Qin dynasty. Such burial practices reflected the wealth and dignity of the deceased and their needs in the afterlife. During the early Western Zhou, chariots and horses were buried intact in a separate pit, a tradition inherited from the Shang dynasty. A new practice, however, occurred in the middle and late Western Zhou: the chariots would be disassembled and buried within the main tomb, but horses would be buried in a separate pit.[1] During the Eastern Zhou period, there were three different ways of dealing with the disassembled chariots and horses among the vassal states in the Central Plains: creating separate chariot-and-horse pits near the tomb; creating a side room for chariots along the entrance ramp; and placing chariot fittings within the tomb chamber to represent chariots and horses.[2]

The Qin ruling class carried on this tradition of entombing the deceased with their worldly goods, and the chariot-and-horse pits became part of a hierarchical order that manifested itself as much in death as in life. While chariots made of wood have long since perished, many of their fittings have survived. The archaeological excavations carried out in recent years in western and central Shaanxi where the Qin established their early centers of government have yielded numerous chariot components.

Bronze chariot fittings and horse accoutrements were ornamented with designs that coincide with those on bronze vessels of the period, confirming that there was an authentic decorative language to the bronze culture of ancient China. They are a testament to an enduring Qin tradition of ritual entombment that reached its apogee during Qin Shihuang's time, as demonstrated by the more than one hundred buried horses and kneeling terracotta stable boys or grooms excavated from his tomb complex. The two bronze chariots (cat. nos. 122 and 123) provide further examples of two variations of the Qin chariot, while excavations of the warrior pits have uncovered the remnants of more than one hundred life-size chariots and their bronze fixtures and fittings.

1. Institute of Archaeology, Chinese Academy of Social Sciences, *Zhongguo kaogu xue: Liangzhou juan* [China's archaeology: the Zhou dynasty] (Beijing: Zhongguo Shehui Kexue Press, 2004), p. 75.

2. See Ye Xiaoyan, "Zhongyuan diqu zhan'guo mu chutan" [A preliminary study of the tombs of the Warring States period in Central Plains], *Kaogu*, 1985, no. 2: 163.

Pit K10 at Shenheyuan under excavation

26
Pair of axle end caps and linchpins
青銅蟠虺紋車軎

Spring and Autumn period (770–476 BCE)
Bronze, L. 10 cm (3⅞ in), W. 3.2 cm (1¼ inches); L. 7 cm (2¾ in), W. 3.3 cm (1⁵⁄₁₆ in)
Excavated at Bianjiazhuang in Longxian, Shaanxi, 1986

Longxian Museum, Shaanxi 86LBMM11:18; 86M11:19

These two axle end caps are ornamented with motifs appropriated from bronze ritual vessels of the time. There are three bands of patterns on one end of each—one with a double-loop design and the others with stylized serpentine designs.

On the other side, a hidden rectangular slot accommodates the animal-head linchpin.

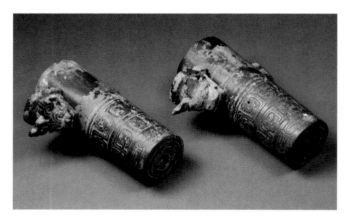

27
Axle head or end cap
青銅卷雲紋車轄

Spring and Autumn period (770–476 BCE)
Bronze, H. 6.8 cm (2¹¹⁄₁₆ in), Diam. 8.4 cm (3⁵⁄₁₆ in)
Excavated at Bianjiazhuang in Longxian, Shaanxi, 1978

Longxian Museum, Shaanxi 78L136

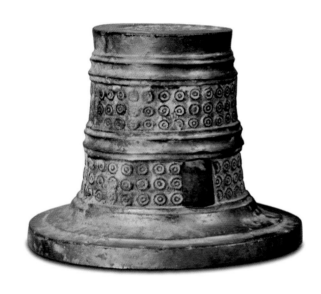

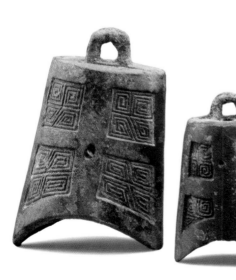

28
Horse's face masks
青銅獸面紋當盧

Spring and Autumn period (770–476 BCE)
Bronze, H. 8.7 cm (3⁷⁄₁₆ in) W. 16.8 cm (6⁵⁄₈ in)
Excavated at Bianjiazhuang in Longxian, Shaanxi, 1986

Longxian Museum, Shaanxi 86LBM1:36

These masks, known as *danglu*, resemble animal heads, with their
bulging eyes and large downward-turning horns. The two holes
between the two horns were used to attach the mask to a horse's
head as an ornament.

29
Horse bells
青銅馬鈴鐺

Spring and Autumn period (770–476 BCE)
Bronze, H. 8.2 cm (3¼ in), W. 4.3 cm (1¹¹⁄₁₆ in)
Excavated at Bianjiazhuang in Longxian, Shaanxi, 1986

Longxian Museum, Shaanxi 86M12:87/88/89/92/95/97/167/168

These bells—each with a clapper inside—would have been attached
to a horse's harness. A cross design separates the surface into four
panels, each filled with meander designs.

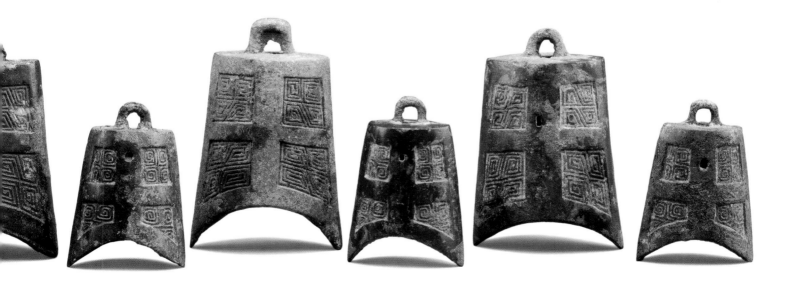

30
Animal-face harness ornaments
青銅獸面紋馬飾

Spring and Autumn period (770–476 BCE)
Bronze, H. 2.5–4.2 cm (1–1⅝ in), W. 2.6–4 cm (1–1⁹⁄₁₆ in)
Excavated at Bianjiazhuang in Longxian, Shaanxi, 1986

Longxian Museum, Shaanxi 86M12:6/7/8/10/11/17/36/106/107/108/110

These animal-face harness ornaments can be divided into three groups in accordance with their slightly different features and sizes. In general, they all have eyes, brows, coiling horns, and protruding noses. Some of them show tongues and teeth. At the back of each piece is a flat bar, through which a strap could be threaded to attach the ornament to a horse's harness. Similar designs are seen in contemporary works made of bronze and gold. Their prototype can

be traced back to bronze and gold animal-face ornaments of the late Western Zhou dynasty. Examples were excavated from Tomb 1 of the Guo state in present-day Sanmenxia, Henan, and from Tomb M508 of the Rui state at Liangdaicun in Hancheng, Shaanxi. In these two cases, however, the animal-face ornaments served as belt ornaments used by the deceased.[1]

1. Editorial Committee, *Zhongguo wenwu jinghua* [Gems of Chinese Cultural Relics] (Beijing: Wenwu Press, 1992), p. 123; Shaanxi Provincial Institute of Archaeology, "Shaanxi Hancheng liangdaicun mudi beiqu 2007 nian fajue jianbao" [A brief report on excavating tombs in the northern section of the cemetery at Liangdaicun in Hancheng, Shaanxi], *Wenwu*, 2010, no. 6: 10, figs. 15–16.

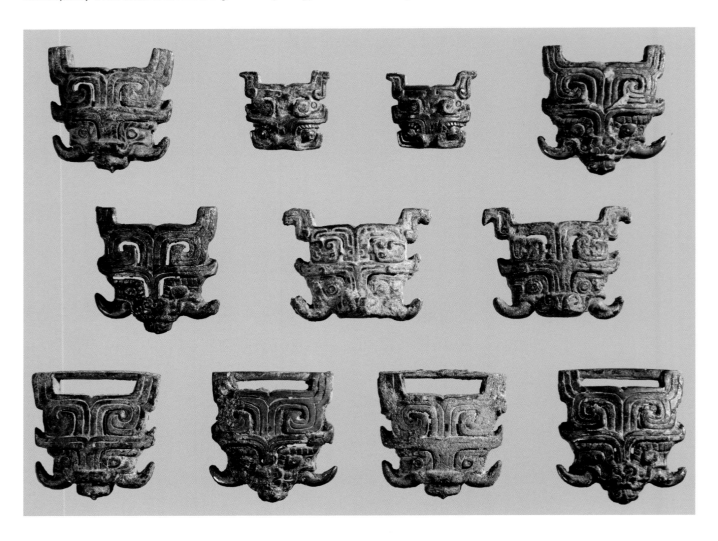

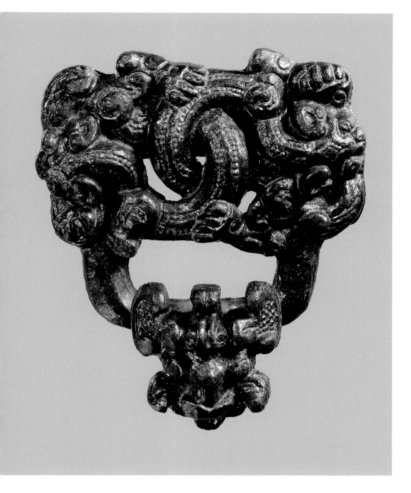
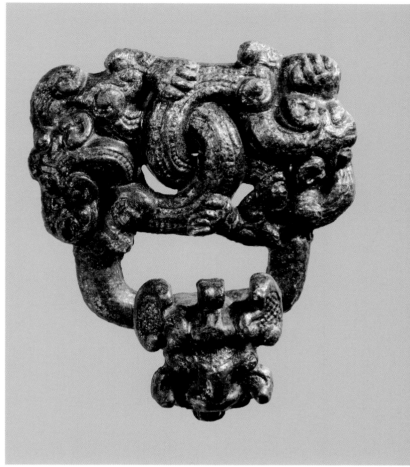

31
Horse's harness buckles
銅帶扣

Warring States period (475–221 BCE)
Bronze, H. 5.8 cm (2⁵⁄₁₆ in), W. 5 cm (1¹⁵⁄₁₆ in), D. 2.5 cm (1 in)
Excavated from Chariot Pit S1, Xicun village, Nanzhihui in Fengxiang, Shaanxi, 1980

Shaanxi Provincial Institute of Archaeology 000239; 000240

Two interlaced dragons are the primary motif of each of these buckles. The smaller projection on the other side of the oval ring is in the shape of a beast's head, which also can be seen in a gold ornament (cat. no. 36). These buckles were attached to the horse's harness with a strap.[1] When the two buckles were excavated, they were found near the head of a buried horse, confirming their function as harness buckles.

1. Li Zizhi and Shang Zhifu, "Shaanxi fengxiang xicun zhanguo mu fajue jianbao" [A brief report on the excavation of the Qin tombs of the Warring States period at Xicun in Fengxiang, Shaanxi], *Kaogu yu wenwu*, 1986, no. 1: 21, fig. 15:4.

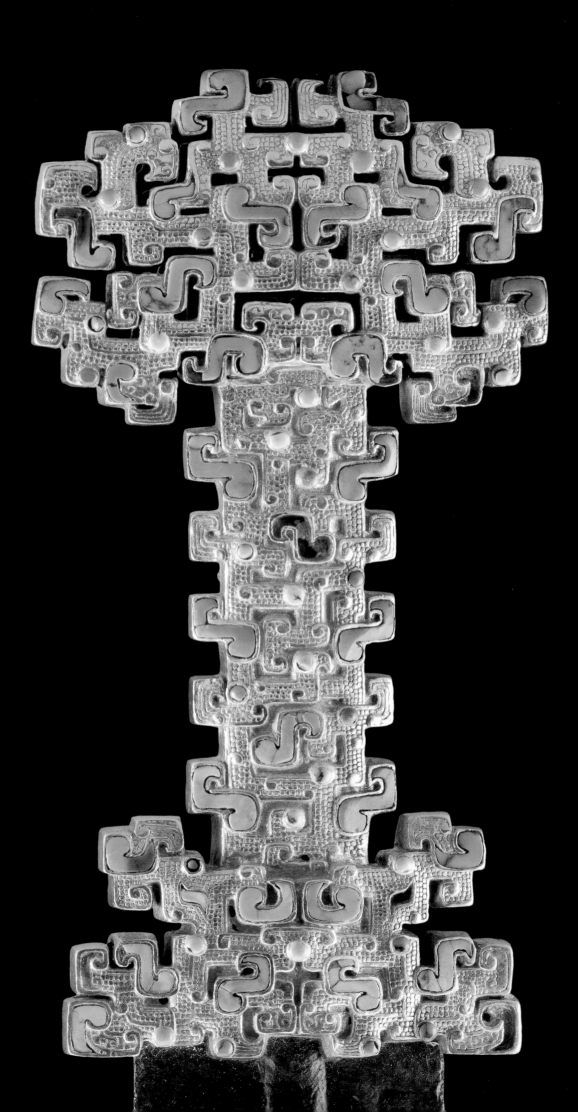

Gold, Silver, and Jade

WHILE THE ACHIEVEMENTS OF CHINA'S BRONZESMITHS—with their extensive production of sophisticated ritual and ceremonial vessels—have defined the art of China's Bronze Age, gold and silver were also employed, albeit more sparingly, for objects of special and often personal value, including ornaments, horse fittings, belt buckles, and ritual accoutrements.

Archaeological evidence shows that Qin aristocrats began to appreciate gold sometime during the early Spring and Autumn period. One of the most significant finds of gold objects was in 1992 at the village of Yimen in Baoji[1] and included refined works such as inlaid gold belt buckles, animal-mask ornaments, and spectacular swords with open-work hilts inlaid with turquoise (cat. nos. 32–34). In terms of style and ornament, these gold objects are consistent with the prevailing, contemporaneous Eastern Zhou bronze aesthetic, but have a heightened refinement and intricacy. Stylistically and technically, they also show the influence of the nomadic cultures of the western and northern steppe regions.

As the use of gold, silver, and precious stones became more prevalent, new technologies also emerged, including gold and silver inlay and mercury amalgam gilding. Although seen less often than gold, silver was used as an inlay on selected bronzes, such as the *hu*-type vessel and the bird-shaped finial (cat. nos. 40 and 41). Silver was also used occasionally for individual objects.

Since China's Bronze Age, jade has been held in the highest esteem as a stone of both subtlety and intensity. As such, it became an indelible symbol of purity, strength, nobility, and integrity. And because of its hardness and durability, it was associated with objects of special ritualistic, symbolic, and talismanic value. The Qin jades, while in many ways a continuation of the sophisticated Western Zhou jade tradition, exhibit unique forms, decorative designs, and carving techniques. The shapes are primarily geometric, and appear more often as flat plaques than round sculptures. The most common decorative surface pattern is incised meanders, or frets. These repeated and symmetrical geometric designs are reminiscent of earlier dragon or serpent motifs.

Gold and jade carving not only competed with each other, but also influenced one another. The result was the birth of a new type of ornament that paired both materials: gilt bronze belt hooks were now sometimes inlaid with jade; gold animal masks might hold jade rings. Such was the new fashion during this period. The juxtaposition of a very malleable metal and an extremely tough stone not only created a pleasing visual contrast but received praise for its heightened durability.

1. Baoji Municipal Institute of Archaeology, Shaanxi, "Baojishi yimencun erhao chunqiumu fajue jianbao" [A brief report on the excavation of Tomb 2 of the Spring and Autumn period at Yimen village in Baoji], *Wenwu*, 1993, no. 10: 1–14.

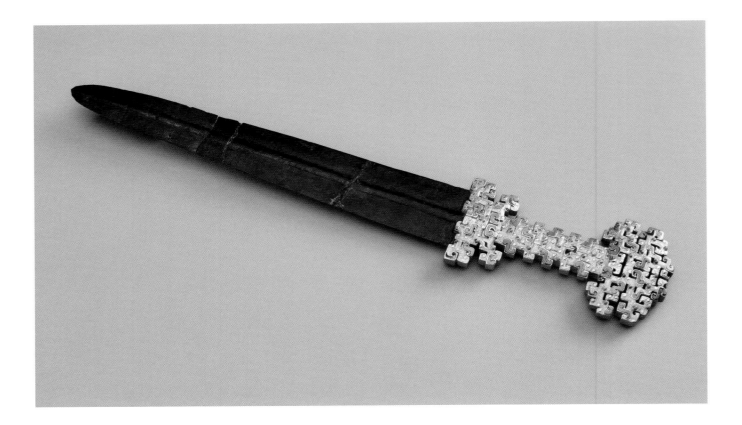

32
Sword with inlaid openwork hilt
金柄蟠虺紋鑲嵌寶石鐵劍

Spring and Autumn period (770–476 BCE)
Iron and gold with inlaid turquoise, L. 37.8 cm (14⅞ in), W. (blade) 4 cm
(1⁹⁄₁₆ in)
Excavated from Tomb 2 at Yimen in Baoji, Shaanxi, 1992

Baoji Municipal Institute of Archaeology, Shaanxi BYM2:1

Of the three swords with gold hilts discovered at Yimen, this is
the most splendid and the most significant. When the sword was
excavated there were remnants of fabric around it, as well as seven
small circular gold finials lying in a line nearby, which were most
likely part of the decayed scabbard. The iron blade and gold hilt were
cast separately and then joined with a rivet joint. The open-worked
hilt consists of interlaced serpents inlaid with round and S-shaped
turquoise, and is an exceedingly fine example of goldsmithing rarely
found in this period's burial sites. The serpentine designs on the hilt
are consistent with those used on Qin bronze and jade decorations,
but the granulated background was most likely influenced by the
fabrication techniques of other cultures, particularly those of the
steppe region. The blade, with a central cylindrical ridge, is also
unlike the common swords made in the Central Plains.

It should be mentioned that the blade is an early example of iron
production in the Qin. Although daggers made of meteoric iron from
the mid-Shang dynasty (c. 13th century BCE) were found at present-
day Beijing and Gaocheng in Hebei province, it was not until the
late Western Zhou period (c. 1046–771 BCE) that cast iron was first
produced in the Central Plains,[1] and it was barely produced in Qin
territory until the late Spring and Autumn period. Over twenty iron
objects were unearthed from Tomb 2 at Yimen, mainly knives and
blades, making the area quite advanced in terms of iron production.

1. Three iron weapons were unearthed from late Western Zhou tombs of the Guo
state at present-day Sanmenxia in Henan province. See Bai Yunxiang, *Xianqin liang-
han tieqi de kaoguxue yanjiu* [An archaeological perspective on the iron production
of the pre-Qin and Han dynasties] (Beijing: Kexue Press, 2005), p. 43.

33
Inlaid gold rosettes with animal-mask design
獸面金方泡

Spring and Autumn period (770–476 BCE)
Gold with inlaid precious stones, H. 3.3 cm (1⁵⁄₁₆ in), W. 3.9 cm (1⁹⁄₁₆ in),
D. 0.15 cm (¹⁄₁₆ in)
Excavated from Tomb 2 at Yimen in Baoji, Shaanxi, 1992
Baoji Municipal Institute of Archaeology, Shaanxi BYM2:26, BYM2:29

Each of these tiny ornaments takes the shape of an animal mask with
almond-shaped eyes, a design modeled on earlier bronze vessels'
decorations. Stylized serpentine patterns punctuated by inlaid
precious stones (perhaps representing the serpents' eyes) decorate
the surface, while a triangular head peeks out from the bottom edge
of each ornament in a surprisingly realistic way. In all, seven of these
ornaments were excavated together, some of them simpler in design
and without gems.

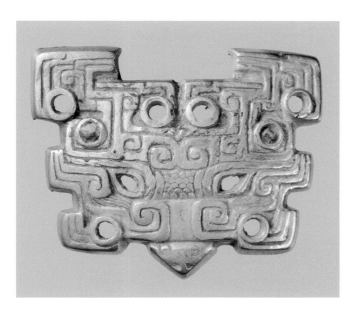

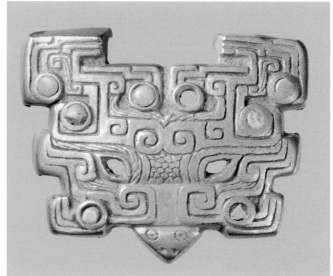

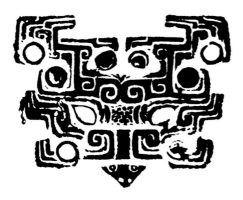

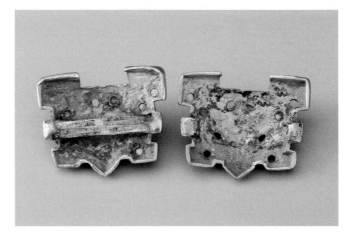

34
Duck-head buckles
鴨首金帶扣

Spring and Autumn period (770–476 BCE)
Gold, W. 1.9 cm (¾ in)
Excavated from Tomb 2 at Yimen in Baoji, Shaanxi, 1992

Baoji Municipal Institute of Archaeology, Shaanxi BYM2:33/34/35/36

These four buckles are part of a collection of seven gold and seven bronze duck-head buckles that were excavated together. Ring-shaped with duck-head prongs, they were perhaps used as strap buckles for a horse's harness. All have S patterns on their long beaks and heads.

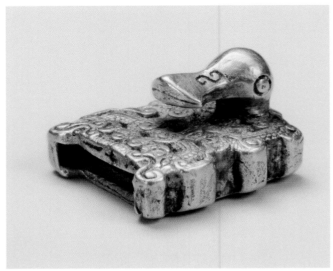

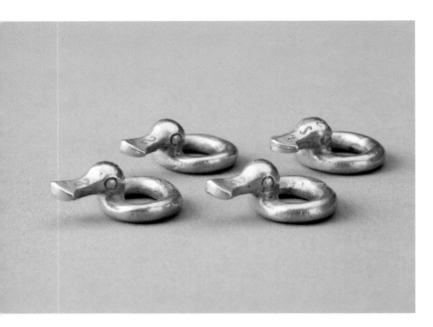

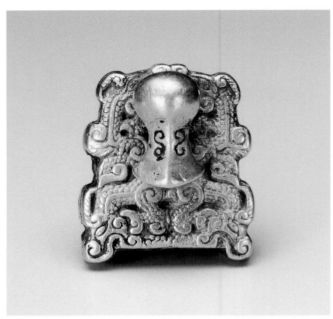

35
Duck-head belt hook
鴨首金帶扣

Spring and Autumn period (770–476 BCE)
Gold, W. 2 cm (¹³⁄₁₆ in), L. 1.2 cm (½ in)
Excavated at Yong in Fengxiang, Shaanxi, 1977

Shaanxi Provincial Institute of Archaeology 000001

During the Spring and Autumn period, the humble belt hook became a vehicle for opulent design and craftsmanship. This unusual example is in the form of a mandarin duck, admired for its great beauty and as a symbol of conjugal fidelity. The interlacing motifs are in the customary style, but are applied here with exquisite detail. The bottom of the duck is hollow; it has a vertical stem in the center to fasten a belt that would have been tucked in through a side slot. Such belt hooks were excavated from various locations in modern Shaanxi. Many of them (including this one) were originally adorned with turquoise inlay, which is now mostly missing.

36
Animal-face ornaments
金獸面紋泡飾

Spring and Autumn period (770–476 BCE)
Gold, H. 1.5 cm (⁹⁄₁₆ in), W. 2.5 cm (1 in), D. 0.32 cm (⅛ in)
Excavated from Sacrificial Pit K17, ancestral temple complex no. 1,
Majiazhuang in Fengxiang, Shaanxi, 1984

Shaanxi Provincial Institute of Archaeology 000916; 000915

The square ornament is one of eight rosettes excavated from the
building complex at the old capital Yong.[1] With a *taotie* animal-mask
design cast on one side, it was used as a harness ornament. On
the concave back there is a horizontal bar to which a leather strap
would have been attached. The frog-shaped ornament resembles a
monster mask with horns. Small holes at its top corners allow it to be
attached to other objects.

1. Shaanxi Provincial Yong Archaeological Team, "Fengxiang majiazhuang yihao
jianzhu yizhi fajue jianbao" [A brief report on the excavation of architectural com-
plex no. 1 at Majiazhuang in Fengxiang], *Wenwu*, 1985, no. 2: 1–29, p. 25, fig. 29.

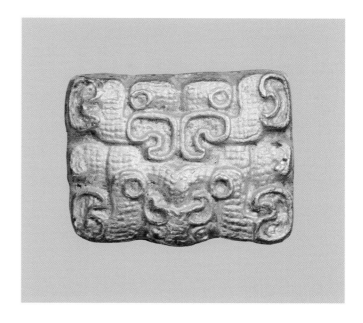

Drawing of a bronze harness ring with animal-face ornaments
from chariot pit S1 at Xicun in Fengxiang, Shaanxi.
After Li Zizhi and Shang Zhifu, "Shaanxi fengxiang xicun zhan-
guo mu fajue jianbao" [A brief report on the excavation of the
Qin tombs of the Warring States period at Xicun in Fengxiang,
Shaanxi], *Kaogu yu wenwu*, 1986, no. 1: 21, fig. 15:3.

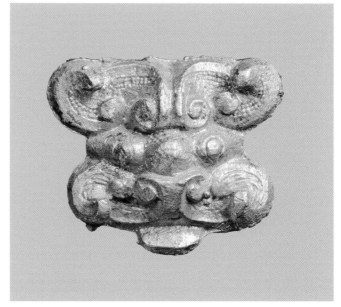

37
Animal-shaped ornament
金獸

Spring and Autumn period (770–476 BCE)
Gold, H. 2.5 cm (1 in), W. 3.7 cm (1⁷⁄₁₆ in)
Excavated from Duke of Qin Tomb 1, Nanzhihui in Fengxiang, Shaanxi,
1986

Shaanxi Provincial Institute of Archaeology 006909

This cast ornament shows a hybrid animal with goat's horns, hooves,
a pair of spirals on its body (possibly representing wings), and a
head resembling the animal masks (*taotie*) commonly seen on the
bronze vessels of the Shang and Western Zhou dynasties. The short
pins on the reverse, which would allow it to clasp another object,
suggest that it was likely an ornamental chariot fitting. A similar
animal-shaped ornament was unearthed along with twenty-nine
other pieces of gold from the ancestral temple site at Majiazhuang in
Fengxiang, the ancient Qin capital Yong.[1]

1. Han Jianwu, "Shaanxi chutu shoucang de zaoqi jinyinqi ji liujin wuyin qi" [Early
gold, silver, and gilt objects unearthed and collected in Shaanxi], *Shoucang jia*,
2003, no. 2: 36–40, fig. 2.

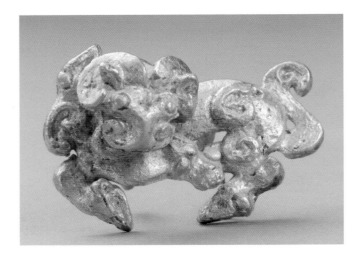

38
Dragon-shaped buckle
龍形金帶扣

Spring and Autumn period (770–476 BCE)
Gold, H. 4 cm (1⁹⁄₁₆ inches), W. 3.3 cm (1⁵⁄₁₆ in)
Excavated at Doufucun in Fengxiang, Shaanxi, 1979

Fengxiang County Museum, Shaanxi 0373

Curled horns dominate this gold buckle, which is recessed in an
oblong framework of twisting dragons or serpents. An animal head
protrudes from one end, and resembles the frog-shaped rosette
excavated from Sacrificial Pit K17 at Fengxiang (cat. no. 36). The granu-
lation along the body of the wriggling dragons is a characteristic
technique of Qin gold of this period. At the back of the buckle are
two buttons onto which leather straps would have been fastened.

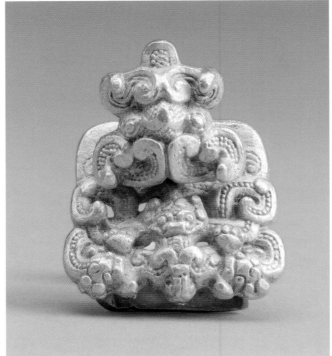

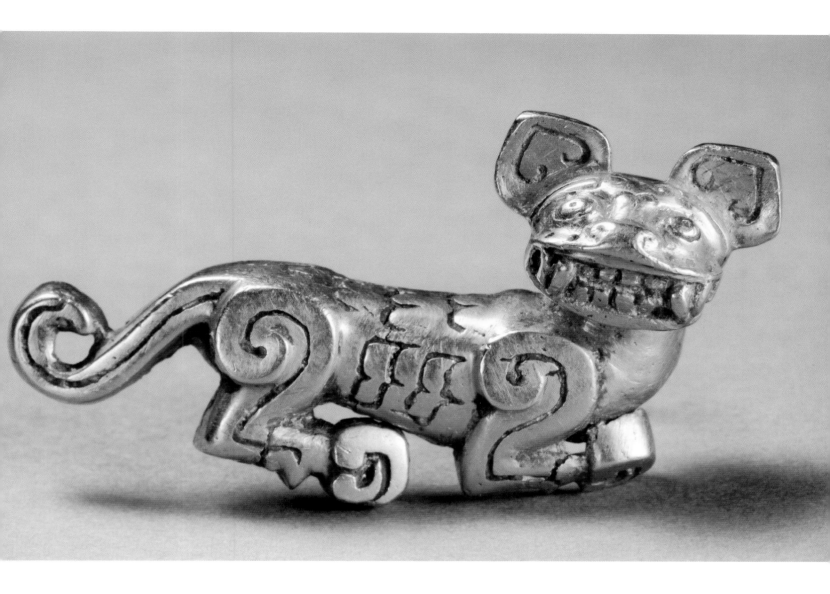

39
Tiger
金虎

Warring States period (475–221 BCE)
Gold, H. 2.3 cm (⅞ in), L. 4.8 cm (1⅞ in)
Excavated at Fengxiang, Shaanxi, 1979

Xi'an Municipal Museum, Shaanxi 3gj70

This gold tiger, which was cast from a mold, is vividly rendered with open mouth, bared teeth, bulging eyes, and pricked-up ears. The chevron motif seen on its body is a typical pattern favored by Qin artisans (cat. nos. 65–67).[1] Along the concave back is a horizontal bar through which a strap could be laced to tie it to other objects. A mirror image of a gold tiger was unearthed in 1992 at Weijiaya in Chencang, Baoji.[2]

1. See Han Wei, "An important cultural discovery: Pure gold decorative plaques from Li County, Gansu province," in Christian Deydier, *Qin Gold* (London: Christian Deydier Oriental Bronzes Ltd., 1994), p. 22, plates 3 and 10.

2. See Jane Portal, ed., *The First Emperor: China's Terracotta Army* (London: British Museum Press, 2007), p. 97.

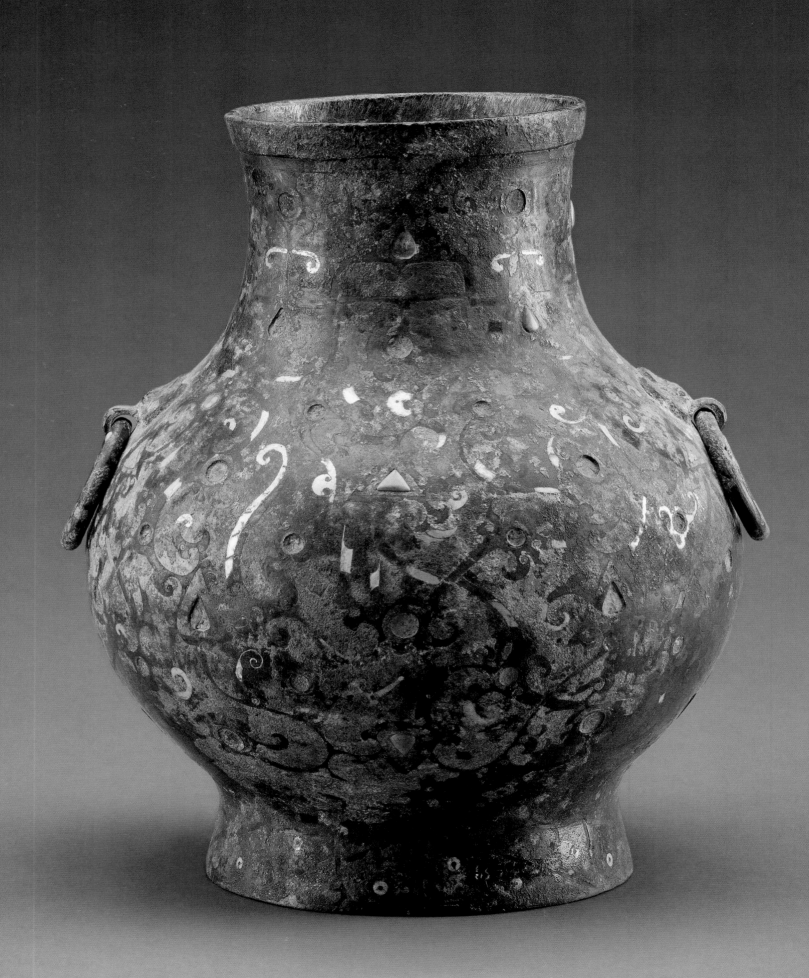

40
Hu vessel
錯金銀寶石雲紋雙耳壺

Warring States period (475–221 BCE)
Bronze with inlaid gold, silver, and precious stones, H. 18.8 cm (7⅜ in),
Diam. 15.3 cm (6 in)
Excavated at Liujiatai, Baoji

Baoji Bronze Museum, Shaanxi 02724

This wine vessel is similar in shape to other contemporaneous *hu* or *zhong* vessels of the Warring States period, but what sets it apart is its innovative spiral and triangle patterns, inlaid gold and silver slices (or threads), and its precious stones, now mostly missing. It is an excellent example of the era's interest in refined handicrafts. A similar *hu*, unearthed in 1973 at Shiyangmiao in Baoji, has a chain handle.[1]

1. See Liu Yang and Edmund Capon, *The First Emperor: China's Entombed Warriors* (Sydney: Art Gallery of New South Wales, 2010), p. 76, cat. no. 47.

41
Bird-shaped finial
錯金銀鳥形柲冒

Warring States period (475–221 BCE)
Bronze with inlaid gold and silver, H. 3 cm (1³⁄₁₆ in), L. 7.8 cm (3¹⁄₁₆ in)
Acquired 1983

Xi'an Municipal Museum, Shaanxi G97

This bird, decorated with geometric designs, turns its head as it rests upon an elliptical tub. Such an object was once considered by scholars to be a *jiushou*, or pigeon-shaped stick topper, and was associated with the ancient imperative to respect the elderly; it was customary for the ruler to bestow such a stick on an aged person to show his respect. Recent research and new archaeological finds, however, suggest that this type of object was used as a dagger finial, serving both as an ornament and to reinforce the end of the shaft. Known as *bimao*, it emerged during the late Shang dynasty. A complete example of a dagger with a bird-shaped finial (in a Macao private collection) is dated to the thirty-second year of King Zhaoxiang (274 BCE). That bird is almost identical to another example in the collection of the Xi'an Municipal Museum, which dates to the thirty-eighth year of King Zhaoxiang (268 BCE).[1] One other example of a shaft finial was excavated in 1968 in the tomb of Prince Liu Sheng at Mancheng, Hebei, and dates from the Western Han dynasty.[2]

1. Wang Hui and Xiao Chunyuan, "Zhenqinzhai cang qin tongqi mingwen xuanshi" [An interpretation of the selected inscriptions of the bronzes in the Zhenqingzhai collection], *Bulletin of the Palace Museum*, 2006, no. 2: 64–87, figs. 13–14.

2. William Watson, *The Genius of China* (London: Times Newspaper, 1973), pp. 105–6, fig. 161.

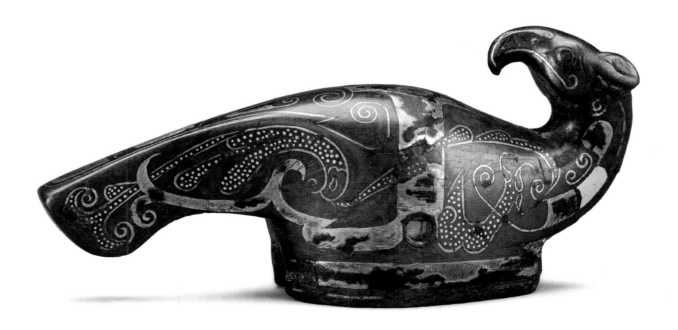

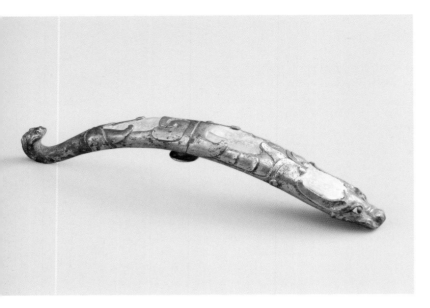

42
Belt hook
鎏金嵌蚌銅帶鉤

Warring States period (475–221 BCE)
Gilt bronze with inlaid shell and precious stones, L. 23.4 cm (9 3/16 in),
H. 5 cm (1 15/16 in), W. 3.5 cm (1 3/8 in)
Excavated from Tomb 20 at Youjiazhuang in Xi'an, Shaanxi, 1996

Xi'an Municipal Museum, Shaanxi 164

This is one of two belt hooks with inlaid decoration that were
excavated from an aristocrat's tomb of the late Warring States
period. It is elegantly arched and curled, and has a T-shaped stud
on the back that would have served to attach the hook to a belt.
The slender body terminates in two dragon heads (one at each
end), each crested and horned, but with different poses, features,
and scales. Each of the dragons has a pair of black pupils made
of inlaid precious stones. They are covered on their backs with
scales in low relief; the scales enclose three pieces of inlaid shell.
Two characters were inscribed in separate locations along the
hook, and although their meaning is unknown, they are written in
what is considered to be the Chu style of script, thus suggesting
that the belt hook was not a Qin product.[1] Belt hooks such as this
were extremely popular during the Warring States period, judging
by the sheer quantity and wide variety of forms known today.
Nevertheless, the inlaid shell ornamentation—versus the more
common jade—makes this piece unique.

1. Xi'an Municipal Institute of Archaeology, Shaanxi, "Xi'an bei jiao youjiazhuang
ershihao zhanguo mu fajue jianbao" [A brief report on the excavation of Tomb 20 of
the Warring States period at Youjiazhuang in the northern suburb, Beijing], *Wenwu*,
2004, no. 1: 4–16, fig. 17.

43
Bear-head harness button or rosette
鎏金熊頭銅馬飾

Warring States period (475–221 BCE)
Gilt bronze, Diam. 5.7 cm (2 1/4 in)
Excavated at Nan'ganhe in Fengxiang, Shaanxi, 1985

Fengxiang County Museum, Shaanxi 0702(1)

In November 1985, a farmer unearthed a bronze *guan* vessel while
working in the field at Nan'ganhe village in Fengxiang, the ancient
Qin capital of Yong.[1] The vessel contained seventy-five bronzes,
including weapons, tools, chariot fittings, and mirrors. Since these
works were a mixed bag of objects from the Warring States period
and the Han dynasty, archaeologists assumed that the bronze *guan*
was buried in the early Han dynasty.

Although excavated from the same bronze hoard as five other
rosettes, this rosette is distinctive in design. A round sculpture of a
relatively realistic bear head adorns the front side, and is encircled by
a double-floral rim. The reverse side has three semicircular buttons
to which leather thongs could be attached.

1. Zhao Congcang, "Shanxi fengxiang nan'ganhe chutu zhanguo handai jiaocang
qingqi" [A hoard of bronzes of the Warring States period and Han dynasty exca-
vated at Nan'ganhe in Fengxiang, Shaanxi], *Kaogu*, 1989, no. 11: 1045–47.

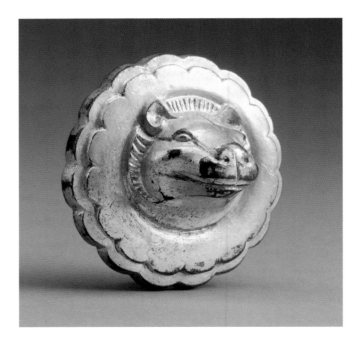

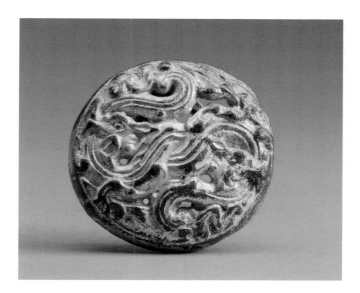

44
Harness buttons or rosettes
流雲蟠虺紋鎏金銅馬飾

Warring States period (475–221 BCE)
Gilt bronze, Diam. 5.1 cm (2 in)
Excavated at Nan'ganhe in Fengxiang, Shaanxi, 1985

Fengxiang County Museum, Shaanxi 0702(2–6)

These five gilt-bronze rosettes were unearthed from the hoard at Nan'ganhe village, and are all very similar. The fronts depict intertwined dragons—some with clearly portrayed heads—swirling among the curling clouds. On the reverse side of each harness button are four loops to which leather straps would have been tied. The two sets of bronze chariots and horses found at the First Emperor's mausoleum demonstrate how these harness buttons or rosettes would have been used (see illustration, cat. no. 109).

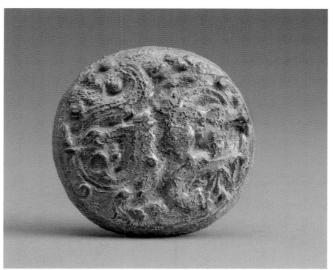

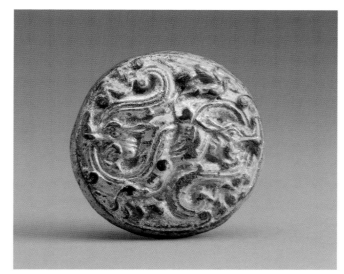

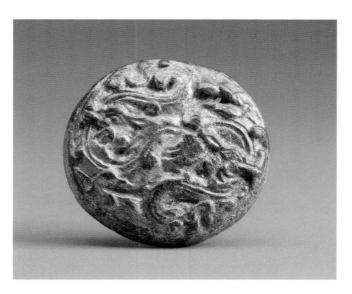

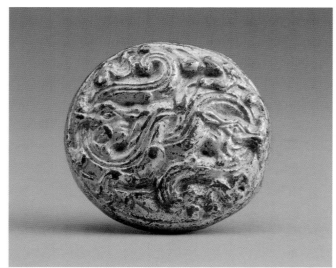

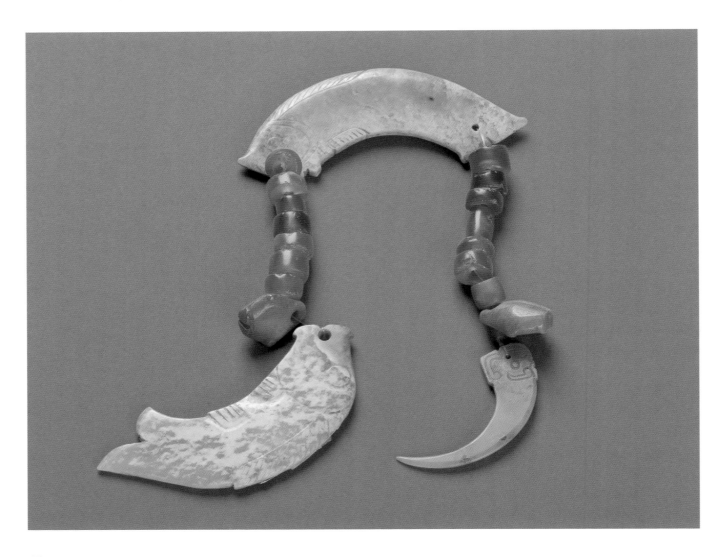

45
Necklace
玉瑪瑙串飾

Spring and Autumn period (770–476 BCE)
Jade and agate, L. (*xi* pendant) 4 cm (1⁹⁄₁₆ in); L. (fish) 7 and 7.3 cm
(2¾ and 2⅞ in)
Excavated from Tomb 9 at Bianjiazhuang in Longxian, Shaanxi, 1986

Longxian Museum, Shaanxi 86LBM9:44

New jade forms were developed during the Western Zhou era,
including jade necklaces made of multiple jade pendants. This
necklace from the Qin workshop of the early Spring and Autumn
period is an example of this new fashion.

The ornamental chain consists of two fish, two shell-shaped
pendants, and a *xi* pendant—all in jade—and fourteen agate beads.
The fish are modeled in arc shapes as if leaping up from a river. The
dorsal and ventral fins are incised in busy striations, in contrast with
the plain bodies. Each has two holes in its mouth and on the caudal
fin to allow suspension. They are so similar in style to the Western
Zhou fish pedant that one can't rule out the possibility that they

are from the Western Zhou workshop. The horn-shaped *xi* pendant
is carved on one side with a stylized dragon head in the typical
geometric shape of the Qin. The cleft represents its mouth, and the
flanges its horns. The entire body, however, is left plain here, unlike
the group of thirteen pieces of *xi* excavated from Tomb 2 at Yimen
village in Baoji, Shaanxi, in 1992, which were all embellished with
typical Qin-style meanders that resemble dragons or serpents.[1]

1. See Liu Yang and Edmund Capon, *The First Emperor: China's Entombed Warriors*,
(Sydney: Art Gallery of New South Wales, 2010), p. 81, plate 57; for the archaeologi-
cal report, see Baoji Municipal Institute of Archaeology, Shaanxi, "Baojishi yimencun
erhao chunqiumu fajue jianbao" [A brief report on the excavation of Tomb 2 of
the Spring and Autumn period at Yimen village in Baoji], *Wenwu*, 1993, no. 10: 8,
fig. 17: 5-6.

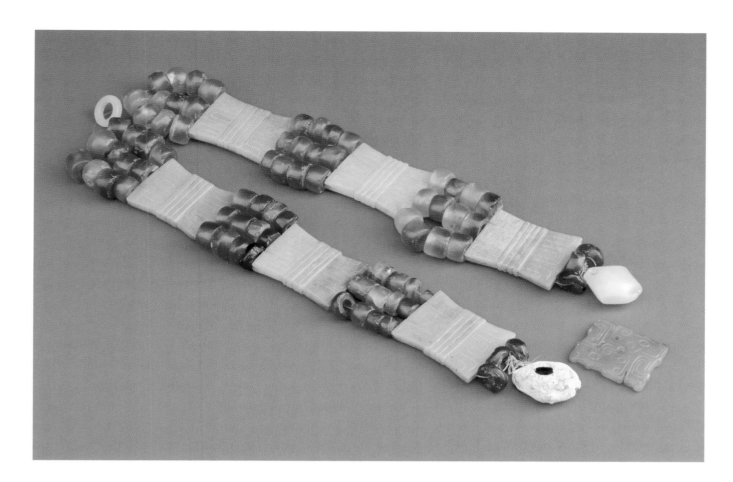

46
Necklace
玉瑪瑙串飾

Spring and Autumn period (770–476 BCE)
Jade, agate, and shell, L. (necklace) 30 cm (11¹³⁄₁₆ in); W. (each bowknot-shaped pendant) 1.8 cm (¹¹⁄₁₆ in)
Excavated from Tomb 9 at Bianjiazhuang in Longxian, Shaanxi, 1986

Longxian Museum, Shaanxi 86LBM9:41

This ornamental chain is formed of moveable parts joined by string. It consists of a ring, six bowknot-shaped pendants, and a square plaque—all of jade—and seventy-eight agate beads, as well as two shell-shaped pendants (one jade and one animal bone).

The square plaque bears a pair of engraved stylized dragons with intertwined bodies. Each bowknot-shaped pendant is embellished at its narrow waist with four bands and a petal-like design on each side. The back is plain, and there are three holes at the top and bottom for suspension. Although similar bowknot-shaped pendants have been found elsewhere, it is in the Qin territory that archaeological excavations have yielded the largest number; therefore such pendants are considered to be one of the most characteristic of the Qin-style jades.

47
Buckle in the shape of a stylized duck
鴨首玉帶扣

Spring and Autumn period (770–476 BCE)
Pale-green jade, L. 2.8 cm (1⅛ in), W. 2–2.2 cm (¹³⁄₁₆–⅞ in), H. 1.5 cm (⁹⁄₁₆ in)
Excavated from Tomb 2 at Yimen in Baoji, Shaanxi, 1992

Baoji Municipal Institute of Archaeology, Shaanxi BYM2:130

This belt buckle is in the form of a stylized duck with its head turned
back. Its body is entirely covered with decorative zoomorphic curls
and spirals in low relief. The low, rounded relief (as opposed to the
incising seen in earlier examples), carved against an incised net
ground, is a style that originated from other states in central China
and is characteristic of this period. Two circular piercings on the
bottom allow a belt to be fastened and tucked into the side slot. The
extensive traces of red coloring in the crevices of this buckle are from
the mineral cinnabar (also seen on other jade pieces from the same
excavation), suggesting that such jades were used in a ceremonial
context. When Tomb 2 at Yimen was excavated, a nearly two-inch-
thick layer of cinnabar was found inside the coffin.

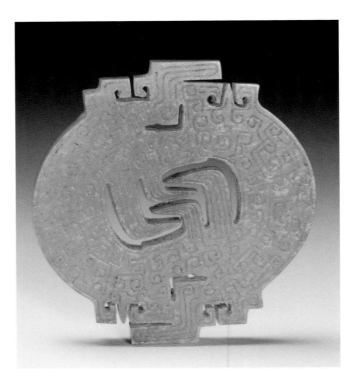

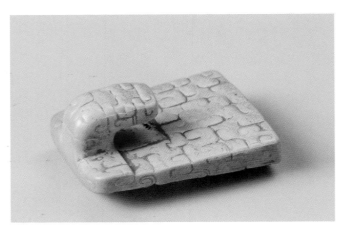

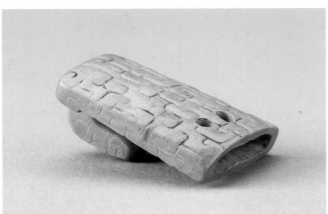

48
Circular pendant
蟠虺紋宮燈形鏤空玉佩

Spring and Autumn period (770–476 BCE)
Pale-green jade, Diam. 4.9 cm (1¹⁵⁄₁₆ in), D. 0.3 cm (⅛ in)
Excavated from Duke of Qin Tomb 1, Nanzhihui in Fengxiang, Shaanxi,
1986

Qin Shihuang Terracotta Warriors and Horses Museum, Shaanxi 002889

This jade is a typical Qin-style pendant with characteristic geometric
shapes. It is one of two identical lantern-shaped pendants excavated
from the tomb of Duke Jing (also known as Duke of Qin Tomb 1) in
the ancient Qin capital of Yong. The complicated openwork carvings
on the two opposite edges of the disc are formed as mirror images.
In the center, two pairs of protruding hooks are likewise composed
symmetrically. The surface of the disc is decorated on one side with
complex zoomorphic meanders, giving the pendant a mysterious
quality. Two gold circular ornaments of the Western Zhou period
that were unearthed from the tomb of Duke Bangfu of the Jin state
in present-day Quwo, Shaanxi, make it clear that this jade pendent
represents the fused bodies of two dragons each biting the other's
tail.[1] The protruding hooks in the center represent the dragons'
teeth. Two pairs of holes on the reverse side are used for suspension.

1. "Quwo fajue jinhou bangfu ji furen mu" [The tomb of Duke Bangfu of the Jin state
and his wife excavated at Quwo], *China Cultural Relics News*, January 30, 1994, p. 1.

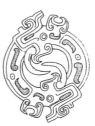

After "Quwo fajue jinhou bangfu ji furen mu," p. 1.

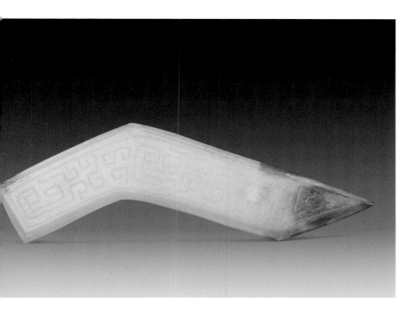

49
Triangle-shaped pendant
磬形玉佩

Spring and Autumn period (770–476 BCE)
Pale-green jade, L. 7.2 cm (2¹³⁄₁₆ in), W. 1.5 cm (⁹⁄₁₆ in), D. 0.3 cm (⅛ in)
Excavated from Duke of Qin Tomb 1, Nanzhihui in Fengxiang, Shaanxi, 1986

Shaanxi Provincial Institute of Archaeology 000456

This V-shaped jade pendant is another typical Qin-style pendant that is only seen in the Qin territory. Its entire surface is ornamented with a stylized serpent motif that resembles those of contemporaneous bronze vessels.

50
Strip-shaped *zhang* pendant
璋形玉佩

Spring and Autumn period (770–476 BCE)
Pale-green jade, H. 11.6 cm (4⁹⁄₁₆ in), W. 2 cm (¹³⁄₁₆ in), D. 0.4 cm (³⁄₁₆ in)
Excavated from Duke of Qin Tomb 1, Nanzhihui in Fengxiang, Shaanxi, 1986

Shaanxi Provincial Institute of Archaeology 000925

A handful of jade pendants of this form were excavated from Duke of Qin Tomb 1 at Fengxiang, the ancient capital of the Qin state. The irregular oblong pendants have flanges around two or three sides, and a slanted edge on one side. The entire surface of the plaque is decorated on both sides with a complex serpentine design. On some examples, a dragon's head—with eye, nose, and mouth—is clearly visible at the flat end.[1] This is another characteristic Qin-style pendant found only in the Qin territory; similar works also have been found at Tomb 2 at Yimen in Baoji, and at another tomb at Tongyu in Meixian, Shaanxi, both datable to the late Spring and Autumn period.[2]

1. Liu Yunhui, *Shaanxi chutu yuqi* [Eastern Zhou jades excavated in Shaanxi] (Beijing: Wenwu Press, 2006), pp. 129–32, plates 121: 1-b.

2. See Liu Yunhui, *Shaanxi chutu yuqi*, pp. 168–70, and 178.

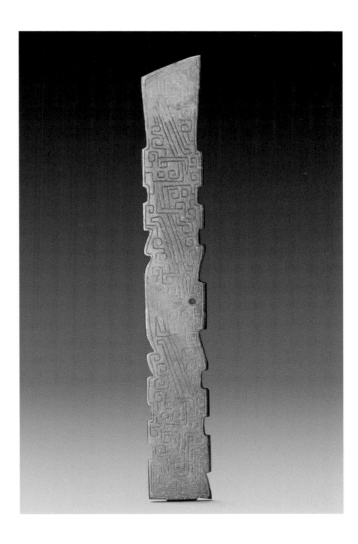

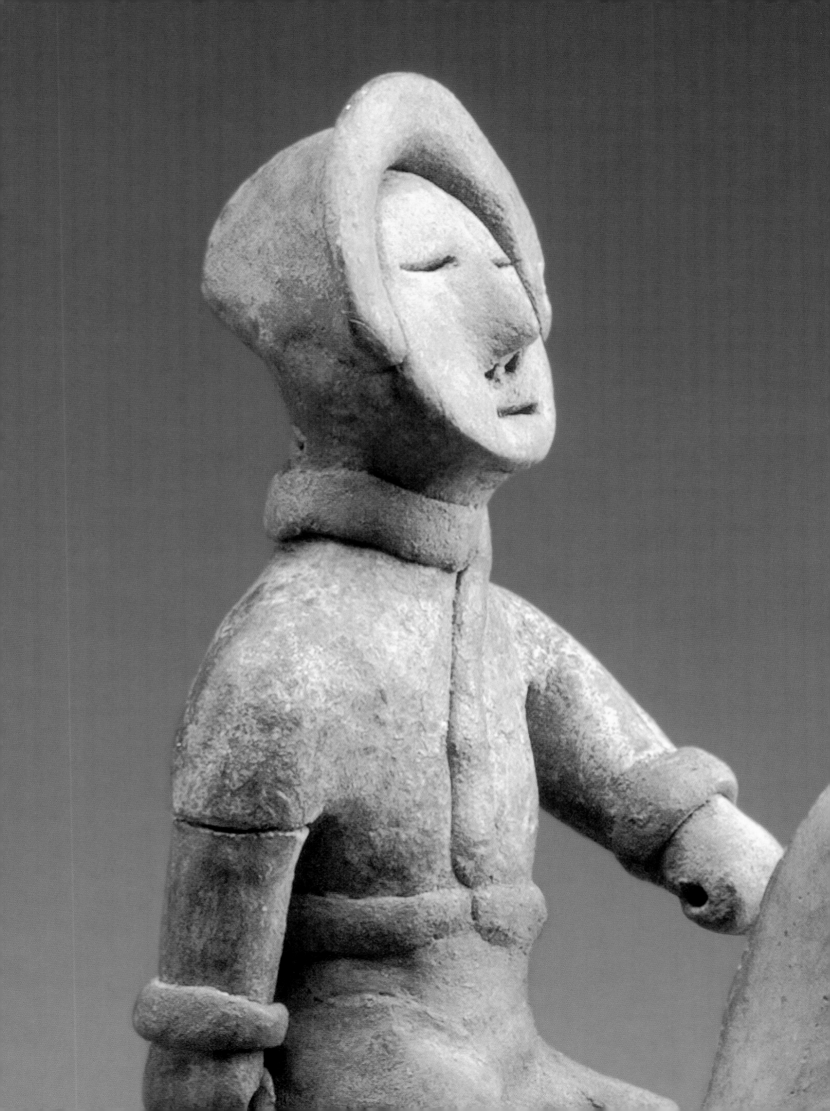

Ceramics

THE HIGH COST OF BRONZE RESTRICTED ITS USE TO ALL BUT THE UPPER
sectors of society. Consequently, starting in the mid–Spring and Autumn period,
pottery replicas of ritual bronzes became popular as burial items among the
middle and lower classes. The groupings included *ding* cauldrons, *gui* food
vessels, *hu* wine vases, *yan* steamers, *pan* basins, and *yi* water vessels, among
others. These were what were known as *mingqi* or "spirit utensils," made
strictly for funerary use. The Qin burial practice of using ceramic replicas of
ritual bronzes in sets began noticeably earlier than in other states of the
Central Plains, where the practice wasn't adopted until the early Warring
States period.[1] Qin funeral ceramic vessels of this period were elaborately
painted to mimic bronze patterns. The discovery of these ceramic replicas in
numerous burial sites bears testimony to the sophisticated design and variety
of form in *mingqi* pottery at that time.

The tradition of painted pottery fell into decline beginning in the mid–Warring
States period, and although there were sporadic revivals during subsequent
periods, it was not until the Han dynasty (206 BCE–220 CE) that it reemerged on
a large scale. This coincided with a stylistic change in ritual bronze vessels—
surface decoration was now either minimalist or completely absent. Likewise,
a general trend emerged toward plainness and simplicity in funeral ceramics.
The painted *fanghu* with luxuriously large ears disappeared completely. Instead,
only a small number of plain pottery replicas of bronze vessels—including
bulbous-bodied *ding* and ovoid *hu* vases with simple bow-string designs—have
been found in burials.[2] The Warring States period also saw an increase in the
funeral use of daily utensils such as cocoon-shaped or garlic-headed *hu*.

Toward the late Spring and Autumn period, at a time when the practice of
human sacrifice was on the decline, clay figurines appeared in the Qin state.
These freestanding statues were increasingly used as substitutes for actual
human victims, and served the same mortuary purpose. This is supported by
the fact that such figurines were often buried along with clay animals such
as horses, oxen, dogs, and birds, as well as chariots and granaries. Although
imperfectly made, the clay figurines may serve as early evidence of the Qin's
artistic ingenuity in realism, which led to the emergence of the terracotta
warriors and horses under the First Emperor's rule.

1. Teng Mingyu, *Qin wenhua: cong fengguo dao diguo de kaoguxue guancha* [Qin culture in the archaeological perspective: from a feudal state to the great empire] (Beijing: Xueyuan Press, 2003), p. 62.

2. See Liang Yun, "Cong Qin wenhua de zhuanxing kan kaoguxue wenhua de tubian xianxiang" [A thought on the sudden change in archaeological culture from the perspective of the cultural transformation of the Qin], *Huaxia kaogu*, 2007, no. 3, pp. 103–13.

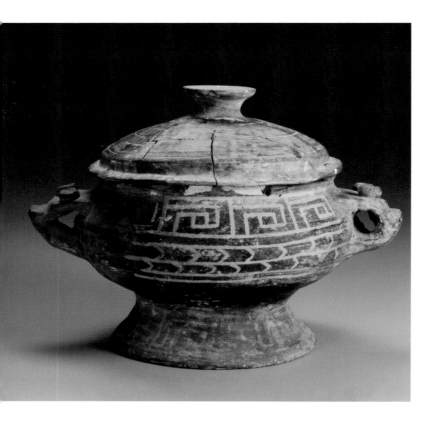

52

Painted *hu* vessel
彩繪陶獸面耳方壺

Spring and Autumn period (770–476 BCE) or early Warring States period (475–221 BCE)
Earthenware, H. 32 cm (12⅝ in), Diam. (mouth) 11.7 cm (4⅝ in)
Excavated at Bianjiazhuang in Longxian, Shaanxi, 1986

Longxian Museum, Shaanxi 86LBM32:4

This *hu* rises in a fluid line from its broad everted foot to its slim, elegant neck, which flares into a square mouth and rim. For this reason, it is sometimes called a *fanghu* or "squared *hu*." Two enormous ears in the form of stylized animal masks, each holding a ring in its mouth, are attached to the sides of the rim. Such *hu* evolved from an earlier style (with a strong, square neck and simple ears) first seen in the mid–Spring and Autumn period, to the shape seen here, which became one of the most characteristic ceramic types of the Qin state.[1]

1. See Shaanxi Provincial Yong Archaeological Team, "1981 nian fengxiang baqitun mudi fajue jianbao" [A brief report on the excavation of the cemetery at Baqitun, Fengxiang, in 1981], *Kaogu yu wenwu*, 1986, no. 5: 23–40.

51

Painted *gui* vessel
彩繪陶蓋簋

Spring and Autumn period (770–476 BCE)
Earthenware, H. 18.3 cm (7³⁄₁₆ in), W. 25.8 cm (10³⁄₁₆ in)
Excavated at Baqitun in Fengxiang, Shaanxi, 1976

Shaanxi Provincial Institute of Archaeology 000678

Gui, a food vessel that began to appear in the early Shang Dynasty, was the basic bronze ritual vessel and is commonly found in burials. This ceramic replica not only took the form of a bronze *gui*, but also imitated its surface decoration with painted patterns.

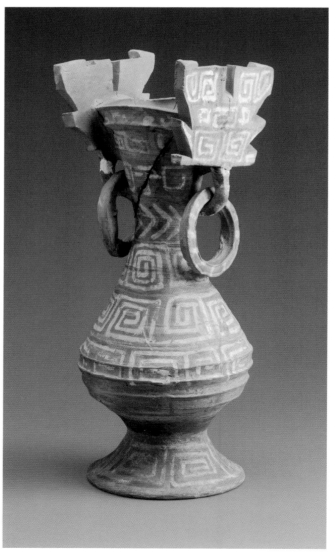

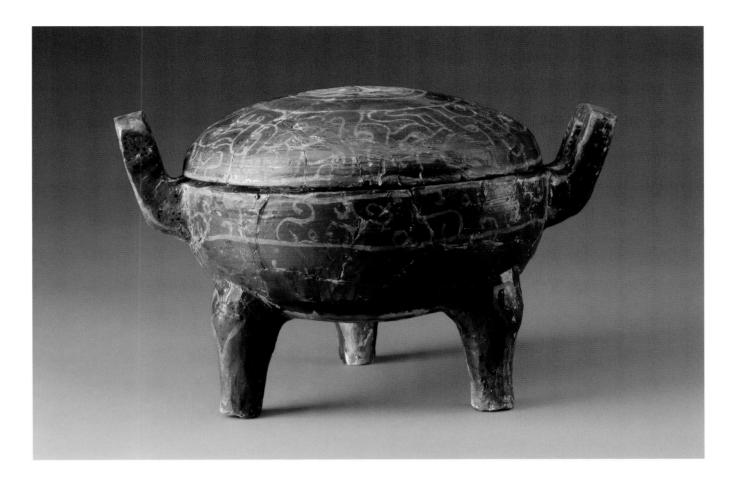

53
Painted *ding* vessel
彩繪漆衣陶鼎

Warring States period (475–221 BCE)
Lacquered earthenware, H. 17.4 cm (6⅞ in), Diam. 17.5 cm (6⅞ in)
Excavated at Jiyuan in Luonan, Shaanxi, 2001

Shangluo Municipal Museum, Shaanxi 0701 C355

In 2000, archaeologists excavated five tombs north of Luonan, a county located in eastern Shaanxi. The area was situated between present-day Shaanxi in the north and Henan in the south.[1] The structure of these tombs, with their north-south orientation, their burial groupings, and the style of the buried objects, are quite different from those unearthed in the Qin state, but are in line with those found in the neighboring southern Shaanxi province, which was the territory of the Wei state during the Warring States period. These tombs were thus identified as belonging to the Wei. The decorative style seen on a bronze *ding* from Tomb BLKM1 also points to a tie to the culture of the Wei. But because the use of inlaid black lacquer on the bronze *ding* was an exclusive technique of the Chu craftsmen, the *ding* found in a Wei tomb was either influenced by the Chu, or was booty taken from that kingdom.

Although lacquer-making (including lacquered ceramics) has a long history in China,[2] it was in the Warring States period that lacquer development peaked. The majority of lacquerware of this period was unearthed from Chu tombs, mostly located in present-day Hubei province. Although limited in popularity, lacquered pottery continued to be manufactured through the Warring States period. A number of Chu tombs contained lacquered pottery with surfaces painted in red, red-brown, and black. Tomb AXJM2 yielded six lacquered earthenware vessels, including *ding*, *hu*, and *dou*, all in pairs. These lacquered ceramics further confirm these tombs' connection to the Chu culture. As the Chu had led the field of the lacquer industry during the Warring States period, it would not be an overstatement to say that all lacquered ceramics of that time were inspired and influenced by the Chu.

This well-detailed ceramic *ding* is very much in the style of the early Warring States period, and was shaped in imitation of bronze *ding* tripods of the time (see cat. no. 15). The entire exterior is coated with a black lacquer and painted with decorations in vermilion and white. On the lid, a central roundel of whorls is encircled by a band of intertwined serpents. On the main body near the rim is a band of S-shaped designs. Leaf-shaped patterns adorn the upper sections of the three legs.

1. Shangluo Municipal Team of Archaeology and Luonan County Museum, "Luonan xisi jiyuan ji chengguan liangku dongzhou mu fajue jianbao" [A brief report on excavating Eastern Zhou tombs at Jiyuan in Xisi, Luonan, and at the city's granary], *Kaogu yu wenwu*, 2003, no. 5: 15–23.

2. A trumpet-shaped wooden vessel painted with red lacquer was excavated from the Neolithic site at Yudun in Changzhou, Jiangsu, datable to 3000 BCE. See Wu Su, "Yudun xinshiqi shidai yizhi fajue jjianbao" [A brief report on the excavation of the Neolithic site at Yudun], *Kaogu*, 1978, no. 4: 223–40; Two pottery jars from the late Neolithic site at Meiyan in Wujiang, Jiangsu, datable to 2500 BCE, were decorated with geometric patterns in gold and brownish red lacquers. See Rui Guoyao, "Jiangsu wujiang meiyan xinshiqi shidai yizhi" [Neolithic site at Meiyan in Wujiang, Jiangsu], *Kaogu*, 1963, no. 6: 308–19.

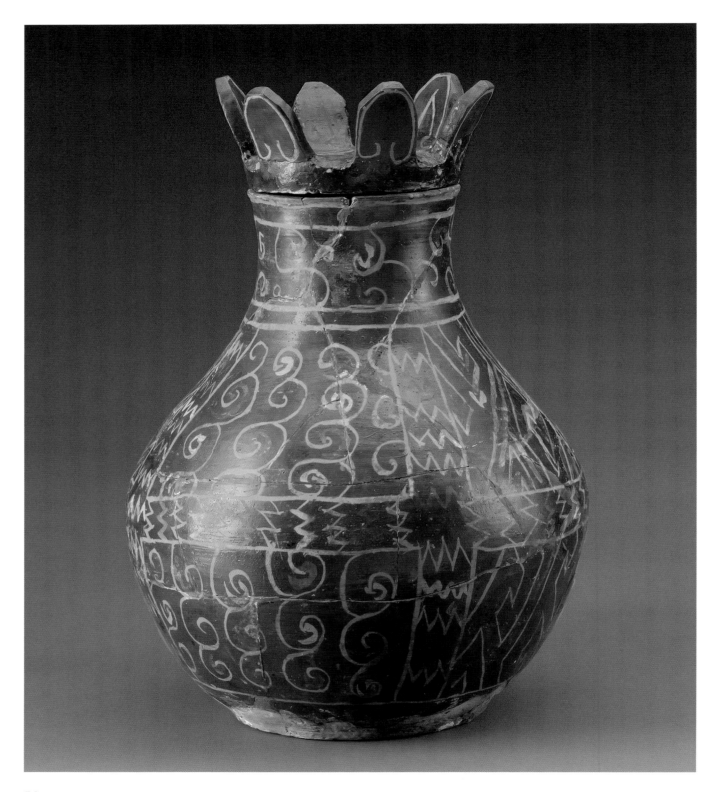

54
Painted *hu* vessel
彩繪漆衣陶壺

Warring States period (475–221 BCE)
Lacquered earthenware, H. 33 cm (13 in), Diam. (mouth) 10.8 cm (4¼ in),
Diam. (foot) 13.3 cm (5¼ in)
Excavated at Jiyuan in Luonan, Shaanxi, 2001

Shangluo Municipal Museum, Shaanxi 0703 C357

This exquisitely shaped vessel is slender and elegant, rising in a fluid line from its flat base to its lotus-blossom-shaped lid. Cross strips divide the main body into eight areas, each filled with spirals and meanders, while chevron patterns fill the inside of the strips.

This vessel imitates the form of the circular bronze *hu*, also from the Warring States period (see cat. no. 14), but differs in the addition of the lotus-blossom decoration on its lid. That innovative form appeared in its bronze version much earlier—in the Spring and Autumn period—and was particularly popular in the Central Plains.

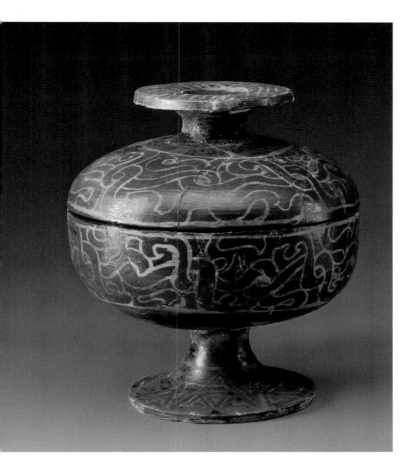

55
Painted *dou* vessel
彩繪漆衣陶豆

Warring States period (475–221 BCE)
Lacquered earthenware, H. 20.5 cm (8⅟₁₆ in), Diam. (belly) 16.3 cm (6⁷⁄₁₆ in)
Excavated at Jiyuan in Luonan, Shaanxi, 2001

Shangluo Municipal Museum, Shaanxi 0703 C359

This vessel, with its intricate, stemmed, cup-like profile, was inspired by the contemporary bronze form *dou* (see cat. no. 9), and the potter's effort to match the bronze model is clearly evident. The most striking aspect of this piece is the meticulously painted ornamentation, which covers the entire body. The knob is adorned with a net pattern. A band with intertwined serpents encircles both the lid and the main body. The foot is decorated with a strip of triangular patterns. The colored decoration raises the object beyond a mere imitation to an imaginative amplification of the bronze prototype.

56
Incense burner
馬形陶熏

Warring States period (475–221 BCE)
Earthenware, H. 17 cm (6¹¹⁄₁₆ in), L. 21 cm (8¼ in)
Excavated at Huangjiagou in Xianyang, Shaanxi, 1984

Shaanxi Provincial Institute of Archaeology 001081

This unique incense burner is in the form of what looks like a horse carrying a cylindrical vessel on its back. The horse's legs, which most likely broke long ago, perhaps in use, have been tinkered with to make the censer stable. The cylinder is encircled by several flat bands embellished with an incised net design. Inside the cylinder, the chamber walls are decorated with a fish pattern; a grate sits at the bottom. A seated toad (facing a smaller dog) forms the handle of the burner. The animals' bodies are hollow and connected internally to the burner chamber. Incense smoke would have escaped from the animals' open mouths and from the twelve tiny holes on the toad's back.

Incense burners became popular during this period and were made in bronze and ceramic. Often they were shaped like *ding* tripods and had perforated lids. This censer, though apparently not from the royal workshop, stands out as a vivid work of art. The unique design—the toad and dog appear to be much interested in each other—makes it quite appealing.

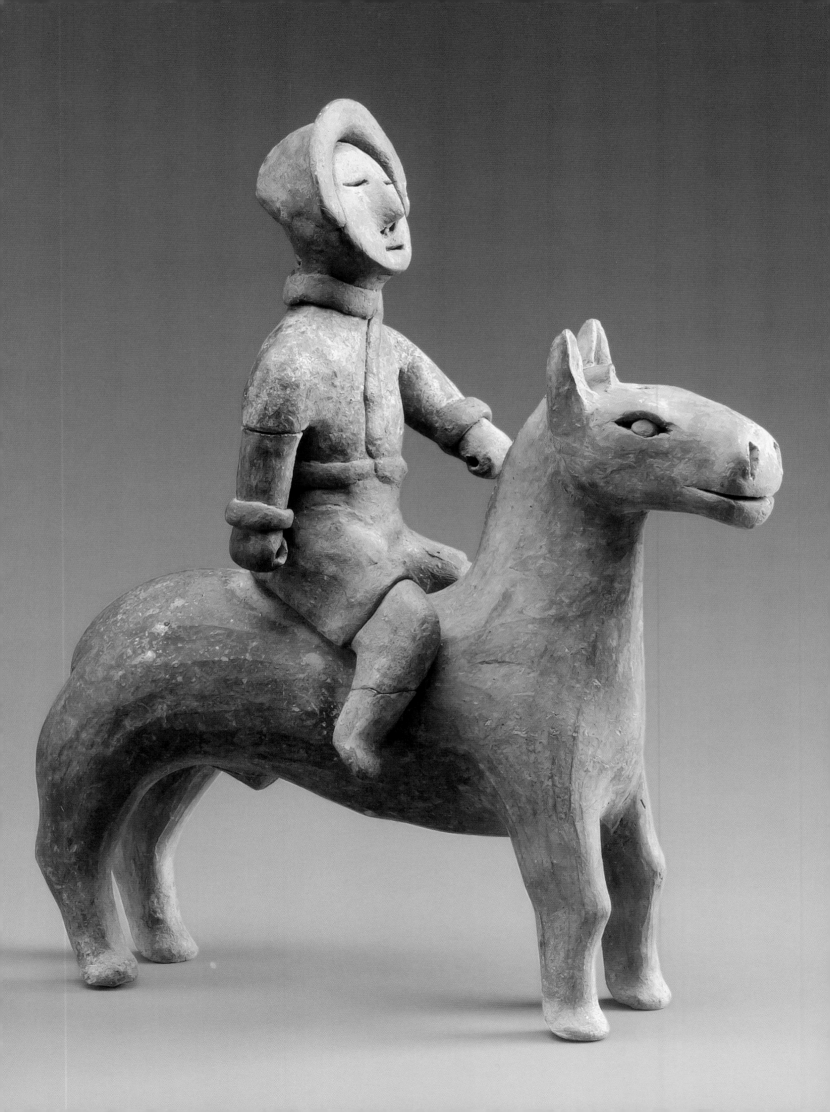

57
Cavalryman and horse
彩繪騎兵陶俑

Warring States period (475–221 BCE)
Earthenware, H. 22.6 cm (8⅞ in), W. 7 cm (2¾ in), L. 18.4 cm (7¼ in)
Excavated from Tomb M28057 at Ta'erpo in Xianyang, Shaanxi, 1995

Xi'an Municipal Institute of Archaeology, Shaanxi M28057:6

This is one of a pair of figures excavated from a Warring States period tomb at Ta'erpo, Shaanxi.[1] The tomb is datable to the reigns of King Huiwen (r. 337–311 BCE) and King Wu (r. 310–307 BCE) of the Qin state. They were placed side by side, facing the deceased, while a set of four pottery copies of bronze vessels (including a *ding*, a *hu*, and two boxes) were stored within a niche along the side wall underneath the coffin. The rider raises his left hand to hold the reins, which can be seen painted on the horse's neck, while his right hand seems to be positioned in a way that would have held a weapon.

The ceramic figures appear to have been made in imitation of the contemporary cavalryman and horse, though the representation has primitive characteristics. For instance, the horse is featured without a saddle, and the bridle is painted on. The attire of the cavalryman is simple in comparison with those excavated from the terracotta warriors pits. Here the cavalryman wears only a tunic that folds toward the left (differing from the right-folding garments of the cavalrymen of the Qin dynasty), trousers and boots, and a close-fitting riding cap with upturned brim tied under his chin. In addition, unlike the terracotta warriors from the First Emperor's tomb complex, this pair of figures is rendered in a stylized manner rather than realistically. Nevertheless, the figures are unique and significant; they are the earliest-known examples of a cavalryman and horse, created nearly one hundred years prior to the First Emperor's terracotta army.

1. Xianyang Municipal Institute of Archaeology, *Ta'erpo qinmu* [Qin tombs in Ta'erpo] (Xi'an: Sanqin Press, 1998), pp. 125–28, fig. 96.

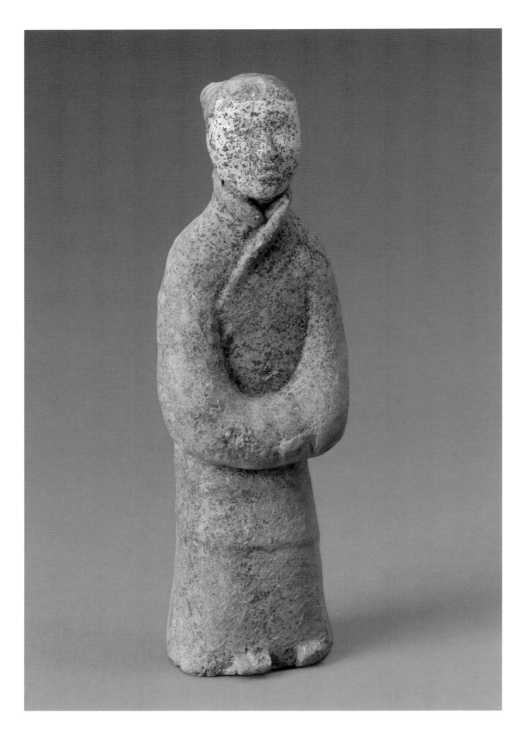

58
Standing female attendant
彩繪陶女俑

Warring States period (475–221 BCE)
Clay, H. 12.5 cm (4¹⁵⁄₁₆ in)
Excavated at Maopo in Xi'an, Shaanxi, 2002

Xi'an Municipal Institute of Archaeology, Shaanxi 123:8

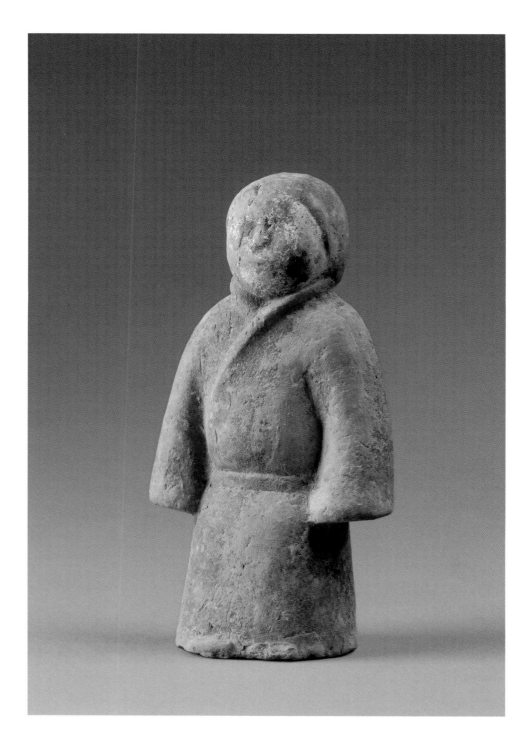

59
Standing male attendant
彩繪陶男俑

Warring States period (475–221 BCE)
Clay, H. 7.7 cm (3¹⁄₁₆ in)
Excavated at Maopo in Xi'an, Shaanxi, 2002

Xi'an Municipal Institute of Archaeology, Shaanxi M123:7

These two clay figures are from a recently excavated group that also includes a horse, a rider, and stable attendants. They are among a handful of figurines unearthed in Shaanxi that were made prior to the creation of the terracotta warriors. These figurines, of which more than two dozen are known to us, were made of clay, stone, and wood, with the earliest datable to the late Spring and Autumn period.[1] As demonstrated by these two examples, they are all small-scale figurines; none of them exceeds ten inches (10 to 25 cm) in height. The clay figures were evidently sculpted by hand and

with tools. A variety of colorful pigments was employed to decorate them, including white, black, red, and vermilion. Their hair is mostly painted black, and only a few were sculpted with details. The standing pose seems to have been the most preferred; the figurines are exclusively clad in long robes folded toward the right, some of which are decorated with painted designs along the hems.[2]

1. See Hu Lingui, "Zaoqi qinyong jianshu" [A brief introduction to the early Qin tomb figures], *Wenbo*, 1987, no. 1: 23–25.

2. A figure excavated from tomb M5:3 at Zaomiao in Tongchuan, Shaanxi, was painted with diamond-shaped decorations along the hem. See Shaanxi Provincial Institute of Archaeology, "Shanxi tongchuan zaomiao qinmu fajue jianbao" [A brief report on the excavation of a Qin tomb at Zaomiao in Tongchuan], *Kaogu yu wenwu*, 1986, no. 2: 7–17.

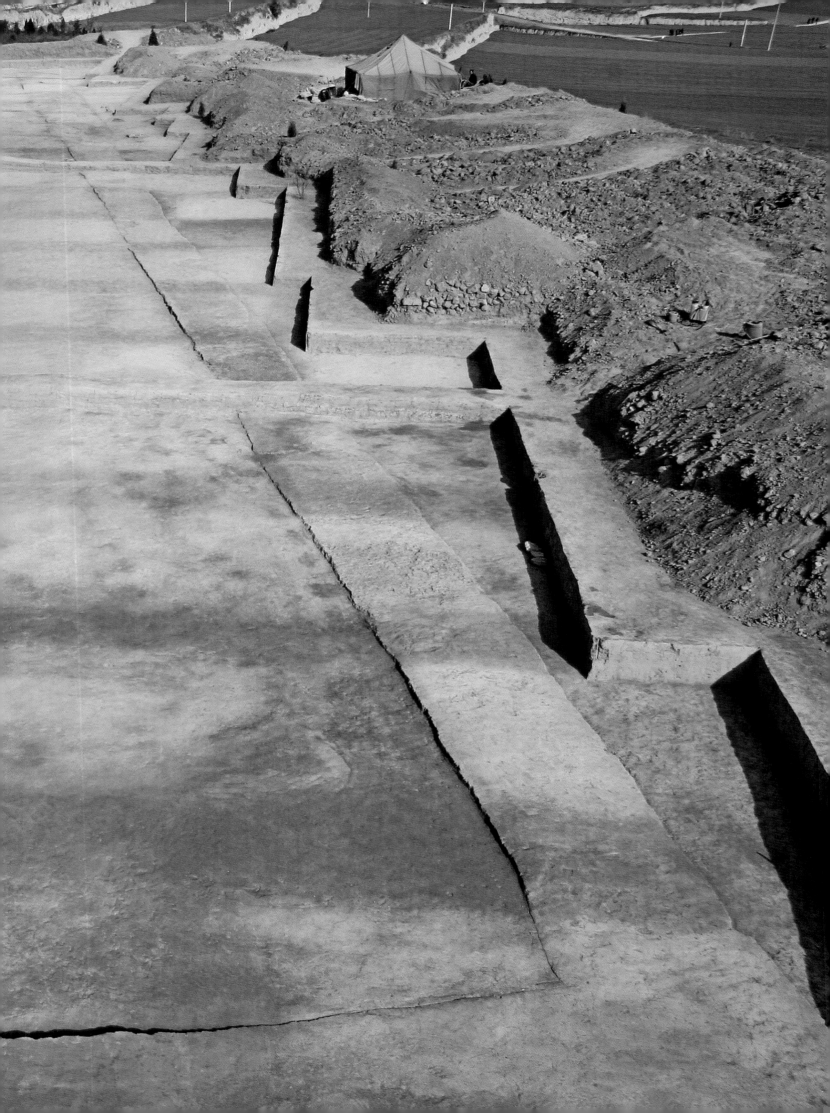

Architecture

THE *SHIJI* (RECORDS OF THE GRAND HISTORIAN) NOTES THAT DURING Duke Mu's time (r. 659–621 BCE), an ambassador from the western region of Xirong who was visiting the Qin capital of Yong (present-day Fengxiang in Shaanxi) was so impressed by the scale and opulence of what he saw that he remarked, "If it was built by ghosts, then it would have exhausted their energy; if it was built by people, then it would have caused them great suffering." Since most of the buildings of ancient China were built largely of wood and tamped earth, the material evidence for the existence of Yong—and for any of the great buildings and palaces of the Qin—resides in fragments: bronze architectural fixtures, pottery bricks, and most numerous of all, roof tile ends. Archaeological work since the 1960s has confirmed the plan and scale of this once-great metropolis, capital of the Qin state for nearly three centuries.

Among the architectural fragments, the tile ends, with their rich variety of molded patterns, are the most distinctive. Long, curved pottery roof tiles overlapped to form a waterproof barrier, and circular or semicircular tile ends were placed at the end of each line of tiles, as protection for the eaves and as decoration.

The tile ends of the early Western Zhou period (c. 1046–771 BCE) found in Shaanxi are all semicircular (known as *ban wadang* or "half tile end") and either blank or decorated with geometric patterns.[1] More elaborate decoration began to appear during the mid–Western Zhou period. Qin tiles ends remained semicircular in the Spring and Autumn period, but in the early Warring States period circular tile ends came into use and ultimately predominated during the Qin dynasty. There was also a rare two-thirds-size circular mold.

Unlike earlier and contemporary bronze and jade decoration, in which mythical animals proliferated, tile-end imagery portrayed real-life animals. There are depictions of individual beasts, and also assemblages of various species, all often shown in dynamic motion. Enthusiasm for this utterly faithful reproduction of animal forms can be traced to the origins of the Qin people. Feizi, a Qin chief of the early Western Zhou period, had a reputation as someone "skilled at rearing and breeding" horses and other domestic animals.

After China's unification, depictions of living creatures became more restrained. Animals were often confined within well-proportioned grids, and abstract designs prevailed. Whatever the composition, lively, rhythmic designs were subject to rules of proportion, harmony, and balance. This new desire for order reflected the new political reality of the central government's powerful control.

Less commonly seen as tile-end decorations are inscriptions that identify the buildings for which the tile ends were made and provide invaluable information about the existence and the locations of those long-gone structures.

A tile end of the Western Zhou period excavated in Shaanxi. Photo courtesy Beilin Museum, Xi'an.

Ink rubbing of a tile end excavated from Qin Palace 1 at Xianyang. After Xu Xitai et al., *Zhou qin han wadang* [Tile ends of the Zhou, Qin, and Han dynasties] (Beijing: Wenwu Press, 1988), plate 29.

Building site no. 21 at Mount Dabuzi under excavation

1. See Shen Yunyan, *Zhongguo gudai wadang yanjiu* [A study on Chinese tile ends] (Beijing: Wenwu Press, 2006), pp. 9–10.

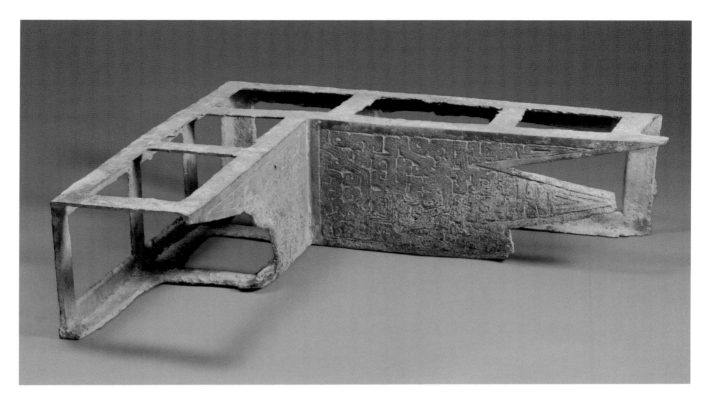

60
Architectural fixture
曲尺形雙齒銅建築構件

Spring and Autumn period (770–476 BCE)
Bronze, H. 16 cm (6⁵⁄₁₆ in), W. (each end) 16 cm (6⁵⁄₁₆ in),
L. (each side) 42.5 cm (16¾ in)
Excavated at Yong site in Fengxiang, Shaanxi, 1973

Fengxiang County Museum, Shaanxi 0056

In 1973, sixty-four pieces of structural bronze fragments with ornamentation were unearthed from three separate storage pits at the palace site at Yaojiagang in Fengxiang, the ancient Qin capital of Yong.[1] Varying in shape, these fixtures served to ornament and reinforce the joints of wooden beams. On one or two faces of these fixtures, the familiar stylized serpentine or dragon pattern is cast in shallow relief. The decorative language of interlaced zoomorphic motifs derives from ritual bronzes of the era. These bronze structural fixtures are testaments to the grandness and lavishness of the Qin palaces of Yong. Although such fixtures were no longer used after the Northern Song dynasty (960–1127 CE), their outlines can still be seen, painted by craftsmen as decorative motifs on wooden beams in Chinese architecture of the later period.[2]

Drawing after Yang Hongxun, "Fengxiang chutu chunqiu qingong tonggou—jin'gang," p. 103, fig. 1.

1. Fengxiang County Museum and Shaanxi Provincial Administration for Cultural Relics, "Fengxiang xianqin gongdian shijue jiqi tongzhi jianzhu goujian" [A preliminary excavation of the pre-Qin palaces at Fengxiang and the bronze structural fittings found there], *Kaogu*, 1976, no. 2: 121–28.

2. Yang Hongxun, "Fengxiang chutu chunqiu qingong tonggou—jin'gang" [The Qin palace bronze structural fittings *jin'gang* of the Spring and Autumn period excavated at Fengxiang], *Kaogu*, 1976, no. 2: 103–8.

61
Roof tile end with phoenix motif
鳳鳥紋瓦當

Warring States period (475–221 BCE)
Earthenware, Diam. 15 cm (5⅞ in)
Excavated at Yong site in Fengxiang, Shaanxi, 1982

Shaanxi Provincial Institute of Archaeology 000931

Qin potters chose to decorate their tile ends with a variety of creatures, subjects primarily taken from the natural world. The phoenix and the dragon were the only two mythological creatures frequently featured on the tile ends. The reason for this may have had something to do with the legend of Xiao Shi and his lover, Nongyu, the daughter of Duke Mu of Qin (r. 659–621 BCE), both skilled flautists whose delightful melodies were so touching that they attracted phoenixes to their garden. Duke Mu took it as an auspicious omen and built a phoenix pavilion for them to live in at the capital, Yong. In the end, Xiao Shi and Nongyu became immortal and ascended to heaven riding on a dragon and a phoenix.

63
Semicircular roof tile end with phoenix motif
鳳紋半瓦當

Warring States period (475–221 BCE)
Earthenware, Diam. 14.5 cm (5¹¹⁄₁₆ in), D. 1.5 cm (⁹⁄₁₆ in)
Excavated at Doufucun in Fengxiang, Shaanxi, 2005

Shaanxi Provincial Institute of Archaeology T1102:187

With its long beak, crest, and S-shaped wing that crosses a forked tail, this phoenix is similar to those on the circular tile end and mold (cat. nos. 61 and 62). The difference lies in the shape of the tile end: this is what is known as ban wadang ("half tile end"), the only form of tile end used during the Western Zhou before the circular tile end emerged to dominate in the Warring States period. The half tile ends produced during this period are distinguished from those of the Western Zhou by their vivid animal designs.

62
Tile-end mold with phoenix motif
鳳紋瓦當模

Warring States period (475–221 BCE)
Earthenware, Diam. 15 cm (5⅞ in), D. 2 cm (¹³⁄₁₆ in)
Excavated at Doufucun in Fengxiang, Shaanxi, 2005

Shaanxi Provincial Institute of Archaeology T1202:66

In 2005 and 2006, an excavation carried out by archaeologists at Doufucun in Fengxiang uncovered what may have been a tile-workshop district from the Warring States period. These workshops produced roof tiles and bricks for the capital city of Yong. Among the significant finds were intaglio molds used to produce designs in relief on tile ends. It is interesting to note that the phoenix depicted on the tile end above (cat. no. 61) shares similarities with the phoenix on this mold.

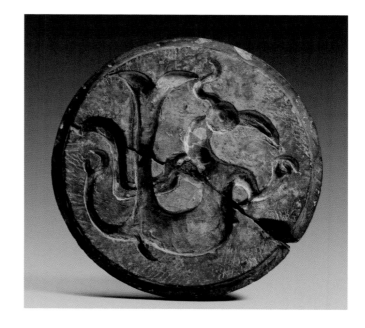

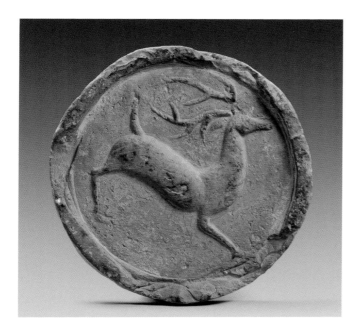

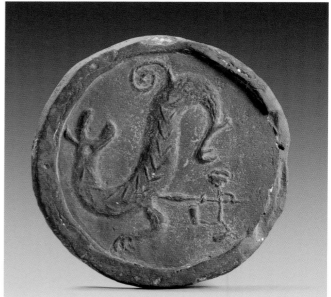

64
Roof tile end with running-deer motif
奔鹿紋瓦當

Warring States period (475–221 BCE)
Earthenware, Diam. 13.3 cm (5¼ in), D. 1.97 cm (¾ in)
Excavated at Yong site in Fengxiang, Shaanxi, 1982

Shaanxi Provincial Institute of Archaeology 000932

Deer were a favorite motif used to decorate tile ends. They were depicted both running and standing, some of them with their heads turned.

65
Roof tile end with scene of a man fighting a tiger
斗獸紋瓦當

Warring States period (475–221 BCE)
Earthenware, Diam. 14.9 cm (5⅞ in)
Excavated at Dongshe in Fengxiang, Shaanxi, 1982

Shaanxi Provincial Institute of Archaeology 000930

The tiger was a favored motif in Qin art, first seen in early bronze vessels found in eastern Gansu, and in gold ornaments and jades. In early Qin art, the tiger was used mainly as a decorative motif, but the image molded on this tile end is a pictorial scene: a man attacking a tiger with a spear. It is unique, not only because of the tiger itself, and in particular its chevron-patterned body, but because the combat scene between man and beast reflects the period's zeitgeist. In the early art of the Shang and Western Zhou dynasties, animals were often represented as a revered and dominant force, and images more likely depicted men being forcibly subdued by animals. This concept is seen in two famous bronze ritual vessels (*you*) of the Shang dynasty in the form of a tiger gripping a boy in its teeth (now in the collection of the Cernuschi Museum, Paris, and the Sumitomo collection in Kyoto; see p. 204). In the late Spring and Autumn period, and particularly in the Warring States period, man emancipated himself from the mythical dominance of animals and, at times, became the challenger or even the victor.[1]

1. See K. C. Chang, *Early Chinese Civilization* (Cambridge, Mass.: Harvard University Press, 1976), chap. 9.

66
Roof tile end with scene of a tiger attacking a wild swan
虎雁紋瓦當

Warring States period (475–221 BCE)
Earthenware, Diam. 15.5 cm (6⅛ in)
Excavated at Yong site in Fengxiang, Shaanxi, 1982

Shaanxi Provincial Institute of Archaeology 000929

This tile end, excavated at the Yong site,[1] is part of the remains of the Qin palaces. The tiger, a ubiquitous motif in Qin art, is arranged with its head turned back, attacking the airborne swan. The S shape formed by the composition of the two figures brings movement to the design. Again, the tiger is decorated with a chevron pattern.

1. Liu Liang and Wang Zhouying, "Qindu yongcheng yizhi xin chutu de qinhan wadang" [Newly excavated tile ends of the Qin and Han period from the Qin capital Yong city site], *Wenbo*, 1994, no. 3: 53–55, fig. 1.

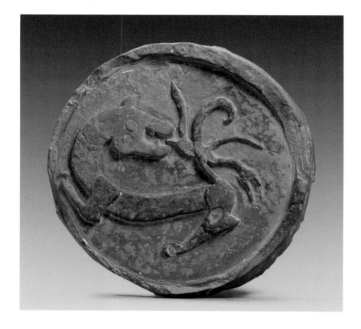

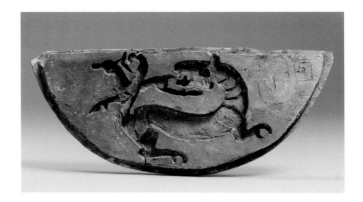

67
Semicircular tile-end mold with tiger-and-deer motif
虎襲鹿紋半瓦當模

Warring States period (475–221 BCE)
Earthenware, Diam. 15.5 cm (6⅛ in), D. 2 cm (¹³⁄₁₆ in)
Excavated at Doufucun in Fengxiang, Shaanxi, 2005

Shaanxi Provincial Institute of Archaeology T1102:190

The design on this mold has similarities to that of the previous entry (cat. no. 66). Here, the tiger, with its head turned back, is attacking a running deer. Its neck is decorated with a familiar chevron pattern that can be seen in many pictorial images of tigers created in the Qin territory. Interestingly, an incised image of a phoenix appears near the tiger's neck. With the design carved in intaglio, it is apparent that the piece was used as a mold.

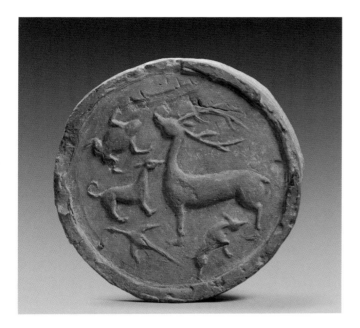

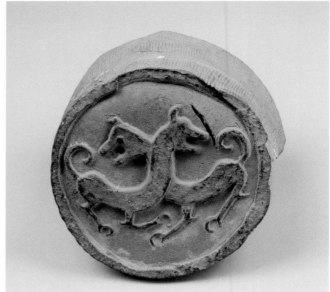

68
Roof tile end with deer, frog, dog, and wild swan motifs
鹿犬雁蟾蜍紋瓦當

Warring States period (475–221 BCE)
Earthenware, Diam. 16.7 cm (6⁹⁄₁₆ in)
Excavated at Yong site in Fengxiang, Shaanxi, 1982

Shaanxi Provincial Institute of Archaeology BE000578

While many tile ends depict a single animal, sometimes several creatures are assembled with one dominantly displayed. Here a frog, a dog, a wild swan, and one unidentified animal all surrounding a large deer concoct a wild world of different species capable of running, flying, and swimming.

69
Roof tile end with canine motif
雙獾紋瓦當

Warring States period (475–221 BCE)
Earthenware, Diam. 14 cm (5½ in)
Acquired 1998

Qin Shihuang Terracotta Warriors and Horses Museum, Shaanxi 002957

The innovative decoration on this tile end presents an arrangement of more than one animal within the narrow confines of a circular space. A pair of what appear to be jackals forms a cheerful composition.

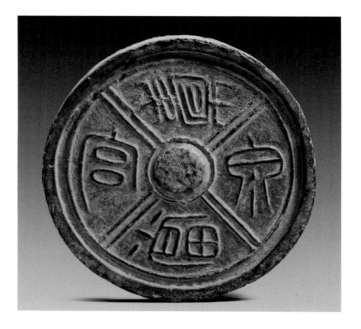

70
Roof tile end with stylized floral motif
葵紋瓦當

Warring States period (475–221 BCE)
Earthenware, Diam. 15.3 cm (6 in), D. 2.4 cm (¹⁵⁄₁₆ in)
Excavated at Baoji, Shaanxi, 1998

Qin Shihuang Terracotta Warriors and Horses Museum, Shaanxi 002959

Qin tile ends from the Warring States period were sometimes
decorated with floral motifs—some depicted rather realistically,
others in a more stylized manner. In this example, the design
seems to have derived from the stylized floral form that Chinese
scholars call *kui*, or sunflower,[1] but developed into a highly abstract
pattern. Although the movement and arrangement of lines are still
reminiscent of the original organic motif, the visual connection
to the vegetal form has been lost, and abstract and geometric
characteristics play the major part.

1. See Shen Yunyan, *Zhongguo gudai wadang yanjiu* [A study on Chinese tile ends]
(Beijing: Wenwu Press, 2006), chap. 1.

71
Roof tile end inscribed "Tuoquan Palace"
橐泉宮當

Warring States period (475–221 BCE)
Earthenware, Diam. 16.5 cm (6½ in), D. 3 cm (1³⁄₁₆ in)
Excavated at Sunjia-Nantou in Fengxiang, Shaanxi, 1997

Shaanxi Provincial Institute of Archaeology 004439

This roof tile end bears four characters written in the Qin "small seal"
script, which read *Tuoquan gongdang*, or "tile end of Tuoquan Palace."
Such tile ends were once thought to be from the Han dynasty. But
in 1996, dozens of such tile ends, along with others bearing the
inscription *Qinian gongdang* ("tile end of Qinian Palace"), were
excavated from the stratum of the Warring States period at a palatial
site in Sunjia Nantou village, some twelve miles (20 km) southwest of
the ancient Yong city site, proving that they belonged to two famous
Qin palaces.[1] The palace of Qinian (literally, "praying for harvest") was
built by Duke Hui (r. 399–387 BCE) to offer sacrifices to Houji, or the
earth deity for the harvest. (King Zheng, the future First Emperor,
would choose this palace to hold his coronation.)[2] Tuoquan Palace
was built later, during Duke Xiao's reign (361–338 BCE). The palaces
were used continuously during the Han dynasty.

1. Jiao Nanfeng et al., "Qin wenzi wadang de queren he yanjiu" [The affirmation and
study of Qin tile ends bearing inscriptions], *Kaogu yu wenwu*, 2000, no. 3: 64–71.

2. Sima Qian, *Shiji* (Beijing: Zhonghua Press, 1963), *juan* 6, p. 227.

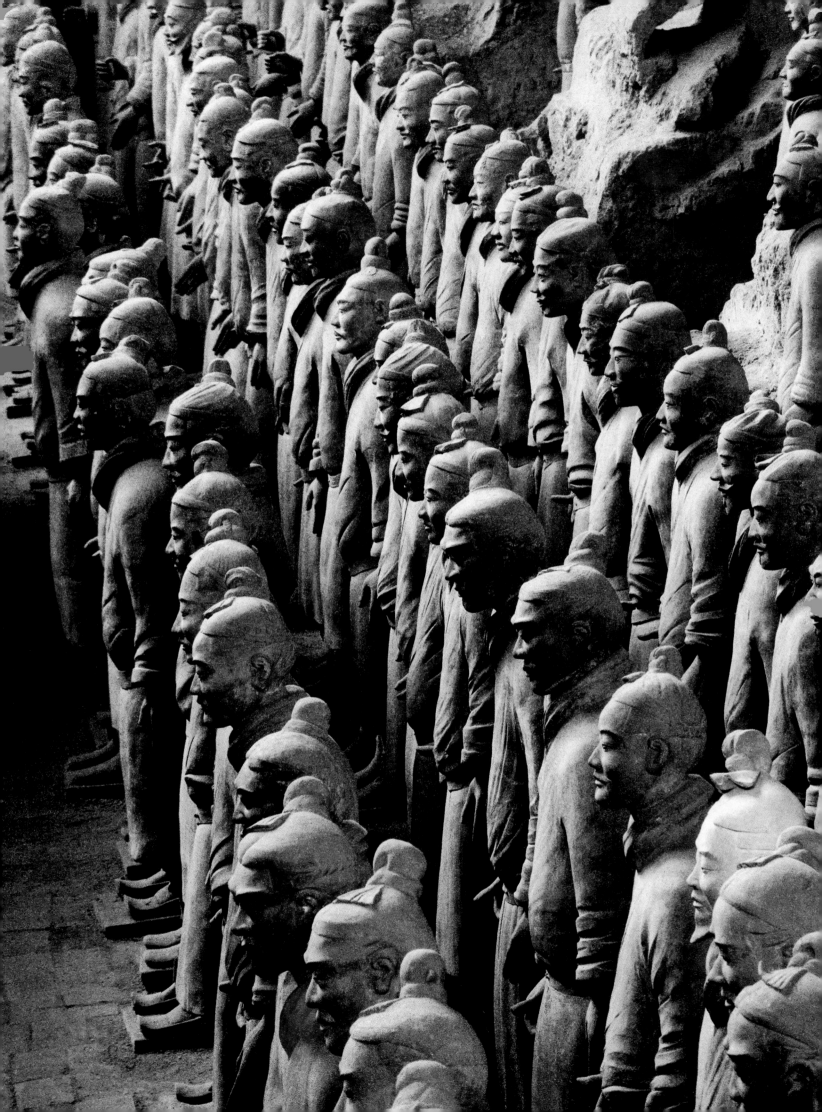

Unified under Heaven: The First Emperor and the Qin Dynasty

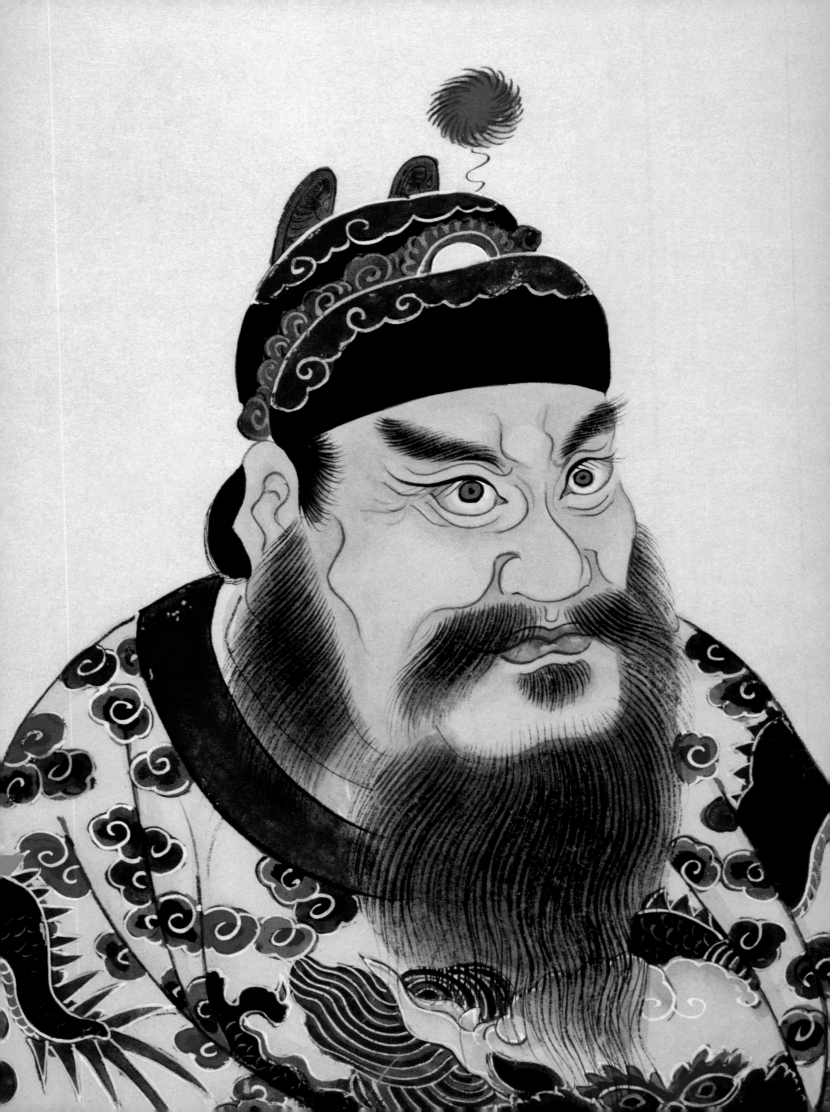

The First Emperor: His Life, Achievements, and Vision

LIU YANG

The Rise of Zheng, the Future Emperor

Sometime around 265 BCE, the young prince Yiren, grandson of King Zhaoxiang of the Qin state (r. 306–250 BCE), took up residence in Handan (in present-day Hebei), the capital of the Zhao state, as a political hostage to guarantee pledges of good faith (a common practice at that time). His father, Anguo, the crown prince, had more than twenty sons, and Yiren was among the middle-ranking ones.[1]

China was by then in the later Warring States period (475–221 BCE). The conception of the state had undergone fundamental changes since the Shang dynasty (c. 1600–c. 1046 BCE)—the second Chinese dynasty, after the Xia, and the earliest archaeologically verified dynasty with written documentation. The Shang had ruled in the northeast of what is considered China proper, in the Yellow River valley. Surrounding the Shang were the *fangguo*, groups of "barbarians" outside of the civilized *wangji*, or capital regions, that made up the Shang center. Between the Shang king and the *fangguo* chiefs there was a very loose relationship.

About 1040 BCE, the ruler of the Zhou (Western Zhou, c. 1046–771 BCE; Eastern Zhou, 770–256 BCE) conquered the Shang and began a feudal form of governing. In elaborate ceremonies, land was given to relatives, clan members, and those who had rendered outstanding service. The landowners became vassals of the king. At its peak, this feudal system included some eight hundred vassals. As the vassals grew stronger and the royal line was broken, the power of the Zhou court gradually diminished and the fragmentation of the kingdom accelerated. From King Ping's reign (770–720 BCE) onward, the Zhou kings ruled in name only, with true power in the hands of the nobles. Toward the end of the Zhou dynasty, one sign of the shift in power was the change in the title used by the rulers of the states. Initially they were addressed as *gong*, or duke, signifying they were vassals of the king of the Zhou. But later they took the title *wang*, or king, putting themselves on par with the Zhou sovereign.[2] As the name Warring States indicates, the regional warlords of this period began to annex the smaller states around them and consolidate their power.

It was against this historical backdrop that Yiren found himself trapped in a foreign land. Dismayed and helpless, he encountered Lü Buwei, a rich merchant from the state of Wei (in present-day north Henan and south Hebei), who considered Yiren "a rare piece of merchandise that should be saved for later."[3] Using Machiavellian bribes and machinations, Lü induced Lady Huayang, the leading wife of Anguo, to adopt Yiren as her son, so that Yiren became Anguo's heir and returned to Qin. She changed his name to Zichu, or Prince Chu, because she was from the southern state of Chu. In 250 BCE, when King Zhaoxiang died after ruling for fifty-six years, Anguo became King Xiaowen but

A portrait impression of the First Emperor from the eighteenth-century album *Lidai diwang xiang* (Portraits of emperors throughout dynasties). No images of the First Emperor survive from his time.

Previous: Rows of light infantry in Pit 1 at the First Emperor's tomb complex

died after only three days, leaving Zichu to ascend the throne as King Zhuangxiang (r. 249–247 BCE). Lü Buwei finally had his day: in 249 BCE the new king made Lü prime minister of Qin, with twelve counties in the capital area as his manor.

Zheng, the future First Emperor, was born in Handan in 259 BCE, the eldest son of Zichu. It was rumored that Zheng was not actually Zichu's son. Allegedly, by the time Lü Buwei introduced the dancing girl Zhao Ji to the future king, she was already Lü Buwei's lover and pregnant by him. However, scholars today are skeptical of this claim by Sima Qian (c. 145–c. 86 BCE), the Western Han historian.[4]

In 247 BCE King Zhuangxiang died after reigning just three years, and his thirteen-year-old son ascended the throne. At that time, the Qin state was still waging war against the neighboring six states. Zheng's mother and Lü Buwei served as regents. As King Zheng grew older, Lü Buwei became fearful that the boy king would discover Lü's liaison with his mother. He decided to distance himself and introduced to Queen Zhao Ji a particularly licentious man named Lao Ai. The two got along so well that Lao Ai became ennobled as a marquis and was showered with riches.

In 238 BCE, the twenty-one-year-old Zheng held a grand ceremony at the old capital, Yong (present-day Fengxiang, Shaanxi), to mark the moment when he began taking personal control of the state affairs of Qin. While the ceremonial chime was still echoing, messengers informed the young king that Lao Ai had mobilized an army and meant to attempt a coup. However, the rebellion was quickly put down by the king's loyal troops. Zhao Ji was placed under house arrest at a palace in Yong until her death many years later. Lü Buwei was dismissed as prime minister of Qin and ordered into exile. In 235 BCE Lü Buwei was again ordered into exile in Shu (modern Sichuan); rather than comply, he committed suicide by taking poison. Zheng then assumed full power as king of the Qin state and appointed Li Si (c. 280–208 BCE) as his new prime minister. Li Si was from Shangcai, in the state of Chu. A talented statesman, he espoused the ruthless but efficient ideas of the political philosophy of Legalism.

Unification of the Country

According to legend, the ancient overlord Yu the Great, in the second millennium BCE, had nine *ding*, or cauldrons, cast during his reign, symbolizing the nine states of ancient China. Depicted on each were the famous mountains, rivers, and rare animal species of the state it represented. The nine *ding* were gathered in the capital city of the Xia dynasty, Yangcheng (modern Dengfeng, Henan), suggesting that the king of Xia, Yu the Great, was lord of the nine states and that the country had been unified. Thereafter, the nine *ding* became the symbol of the Mandate of Heaven, signifying the supremacy of the imperial power as well as the unification and prosperity of the country.

Possessing the nine *ding* was associated with power and dominion over the land. In 606 BCE, when Duke Zhuang (d. 591 BCE) of the Chu state moved his troops northward and approached the Yellow River, King Ding (r. 606–586 BCE) of the Zhou sent an envoy to express his regard. Duke Zhuang could not help but inquire about the *ding*, their size, weight, and so on. His ambition to replace the Zhou king was obvious, and the term *wending*, meaning "inquire about the *ding*," was thereafter understood as an attempt to seize power.

Next it was the Qin rulers who felt the time had come to overthrow the Zhou king and take the nine *ding*.[5] Early in 290 BCE, Zhang Yi, the prime minister of Qin, proposed an attack on two strategic towns in central China.

> Once this is done, our troops will reach the outskirts of the Zhou capital. . . . The Zhou's only way to survive would be to submit its secret nine *ding* and other precious symbols. With the nine tripods in our control, official maps and documents in our possession, and the Zhou king himself as hostage, the Qin can give orders to all under Heaven and no one would dare disobey.[6]

In 256 BCE, King Zhaoxiang of Qin launched a campaign against the Zhou king that ended the Zhou dynasty. According to Sima Qian, the Qin army removed the nine *ding* to the Qin capital, Xianyang.[7] With possession of the *ding*, the Qin had supremacy over the land. In 254 BCE, the vassals all sent special envoys to the Qin court,

offering congratulations to the Qin ruler.[8] Eight years later, when Zheng came to the throne, the dream of many generations was handed over to him, the young king of this rising state.

In 238 BCE, when Zheng took personal control, conditions were favorable for Qin to realize its ambition. Zheng adopted Li Si's strategy for achieving unification and set out to conquer the remaining independent states. He attacked them one by one, beginning nearby and gradually going farther as he consolidated his strength. The first state to fall was Han, in 230 BCE. Then the Qin took advantage of an earthquake that occurred in Zhao in 229 BCE to invade Zhao. Handan, the capital, where Zheng was born, fell the year after.

With the enemy at the gates, Crown Prince Dan of the Yan state, the neighbor of Zhao, became frightened and plotted to stop Zheng by having him assassinated. In 227 BCE the assassin Jing Ke embarked on a mission impossible. At the river Yi (in present-day Yixian, Hebei), inspired by drinking wine with those seeing him off, Jing Ke shouted out an impromptu poem: "Whistling wind, piercing water of Yi. The warrior fords, and he never returns!" Such heroism, which reflects the temper of the times, also informs the story of Fan Wuqi, a former Qin army general who had defected amd escaped to Yan. Learning of Jing Ke's plot, and knowing that Zheng

wanted his head, Fan Wuqi without hesitation decapitated himself to aid Jing. With Fan's head and a map of Yan, Jing Ke approached the king of Qin. While the map was being unrolled, a dagger was revealed, and Jing Ke grabbed it to stab Zheng. But he failed and was killed immediately (fig. 1). One year later the Yan capital, Ji (near modern Beijing), fell.

Zheng and his troops proceeded to take over the rest of the states, conquering the small state of Wei in 225 BCE, and Chu—the largest state and greatest challenge—in 223 BCE. In 222 BCE, the last remnants of Yan and its royal family were captured in Liaodong in the northeast. The only independent state left was Qi, in the far east (in present-day Shandong). Invading from the north in 221 BCE, the Qin armies captured the king and annexed Qi. For the first time, all of China was unified under one powerful ruler. Within a span of only ten years, Zheng had achieved the complete unification of China.

Establishing Supreme Sovereignty

Before the Qin, the rulers were addressed as *wang*, or king. Zheng, however, thought "king" fell short of conveying the reverence due the victor's supreme status. He adopted instead the title *huangdi*, or emperor, a designation previously reserved for deities and the mythological sage-emperors. Within the year, he had proclaimed himself

Fig. 1. Ink rubbing of a relief carved on the Wu Liang Offering Shrine in Jiaxiang, Shandong, Eastern Han dynasty, c. 151 CE, depicting Jing Ke's attempt to assassinate King Zheng, the future First Emperor

Shihuangdi (First Emperor) or Qin Shihuang (First Emperor of Qin). In appropriating the terms *huang* and *di* (both mean "sovereign"), Zheng did more than change his title. It was as if he put on a divine robe and thereby acquired the authority of a revered "high god" and the right to govern all things and exercise ultimate power. By taking such a title, he hoped to attain something of the divine status and prestige of the sage-emperors. And by calling himself First Emperor, he implied that his successive heirs would be called Second Emperor, Third Emperor, and so on down the generations. Although the Qin dynasty lasted only fourteen years, *huangdi* remained the title of reigning Chinese emperors until the early twentieth century.

As his political ideology, Zheng adopted the *wude*, or Five Powers theory, of the Warring States period philosopher Zou Yan (c. 305–240 BCE). This gave him a powerful basis for legitimizing his conquest of other states. According to Zou, the Five Powers (earth, wood, metal, fire, and water) supplant each other in the following order: earth is replaced by wood, wood by metal, metal by fire, and fire by water. The sequence of the Five Powers correlates with the yearly cycle of the four seasons, in which the *yang* of spring and summer is inevitably replaced by the *yin* of autumn and winter. The rise and fall of a given dynasty can be explained in terms of its affinity with the prevailing power in a specific historical time. For example, the Shang dynasty was dominated by the power of metal and hence was inevitably conquered by the Zhou, which was ruled by the power of fire.

When his regime began, the First Emperor declared the supremacy of the power of water. He renamed the Yellow River *deshui*, or "virtue water." Since in the complex *yin-yang* and *wu-xing* (Five Phases) correlation water is associated with the color black and the seasons of autumn and winter, the First Emperor selected black as his royal color, and his imperial robes, ceremonial flags, and banners were all fashioned in black. Also, because water, the *yin* power, is associated with the number six (according to the *Zhouyi*, or *Classic of Change*), six was taken as a number of special importance. For instance, by regulation the ceremonial scepter and cap had to be six *cun* (about 13.86 cm, or 5½ in) and the width of a chariot, six *chi* (about 138.6 cm, or 4½ ft); one *bu*, or fathom

(a unit of length), was changed from eight *chi* to six.[9] Similarly, multiples of six were significant: the empire was divided into thirty-six *jun*, or prefectures; the altar built for the *fengshan* ceremony held on Mount Tai in 219 BCE measured twelve *zhang* long and three *chi* high; the palaces constructed in Xianyang comprised 270 building complexes. Even the inscriptions carved on monuments commemorating the First Emperor's inspection tours followed the same rule and were either 144 or 288 characters, and the Yangling tiger tally (a military tally) contained three sentences, totaling twelve words.[10]

New Administration and Law

With his new prime minister and chief adviser Li Si, Qin Shihuang began a program of major political and economic reform, aiming to bring all the new territories under the direct control of the central government and curb anti-Qin activities instigated by aristocrats from the conquered six states.

Abolishing the role of the old aristocracies and feudal structures, Qin Shihuang established an autocratic network of administrative and political control. At the heart of this new system were the *sangong*, or Three Lords: the prime minister (*chengxiang*), the highest administrative official; the chief military commander (*taiwei*), who advised the emperor on military affairs but without the power to move troops; and the general supervisor (*yushi-dafu*), responsible for taking the public census and supervising officials' behavior and morals. Below the Three Lords were the *jiuqing*, or nine high officials, whose major responsibilities included seeing to various state and palace affairs (their number was not in fact confined to nine). Fundamental to the system was the absolute power of the emperor.

As early as Shang Yang's reforms of the fourth century BCE,[11] the Qin court had experimented with exerting direct control on the local administration of its territories by dividing them into prefectures called *jun*, with subdivisions called *xian*. The First Emperor now adopted this system of administrative districts throughout the country. There were thirty-six *jun*, or prefectures (later there were approximately forty-eight),[12] subdivided into *xian*, or counties, with a number of *xiang*, or towns, in each county. Under each town were a number of *ting*,

and under each *ting* were ten *li,* consisting of groups of individual families. Ten families constituted one *shi,* and five families made up one *wu,* the smallest rural administrative unit. These families were held accountable for each other's actions and behavior. Besides being a means of policing, this system served as a way to organize emergency relief and to collect taxes and impose corvée. The *jun* and *xian* were governed by nonhereditary officials appointed by the central government, with fixed salaries, who were subject to recall or removal by the emperor. The Qin empire's pyramid-like hierarchical system of administration, with the emperor occupying the pinnacle, achieved political unification and strongly reinforced the central government.

To solidify his rule, the First Emperor applied Qin laws to the whole empire. Following the Shang Yang reforms, the Qin had established a complicated legal code that helped centralize state power. The sophisticated system of traditional and largely unwritten rules known as *li,* which had regulated people's conduct in the Zhou dynasty, was replaced with written, codified law. Successive Qin leaders continued to value what was known as *yuanfa erzhi,* or rule-by-law policy. Once a law was issued by the central administration, everyone, including the king, had to abide by it. Rule-by-law and centralized control were part and parcel of an authoritarian regime, ushering in a new era.

The Qin law code is known to have been highly complicated and extremely cruel, yet the details of its enforcement remained a mystery. In December 1975, some 1,155 bamboo slips and 80 fragments, most of them well preserved, were unearthed at Shuihudi ("sleeping tiger place") in Yunmeng county, Hubei province. Their contents dealt mostly with Qin politics and legal systems from 359 to 217 BCE, that is, from the period of the Shang Yang reforms until after the unification. Though far from complete, this is the most comprehensive documentation of the Qin legal code discovered to date. Recorded on the slips are different types of codes (penal, civil, administrative, litigation, etc.); various imperial edicts; explanations of the codes; and guidelines for legal proceedings and documentation (such as crime scene investigation, inspection by legal medical experts, inventory of a criminal's possessions, interrogation, and testimony

retraction).[13] The materials from Shuihudi also show that many of the Qin laws were concerned with keeping the vast array of officials in check and with meting out rewards and punishments.

Standardizing Script, Measures, and Currency

Qin Shihuang ordered the standardization of writing, weights and measures, and currency throughout his newly unified realm. These changes were beneficial for trade and communication, and they helped promulgate the idea of a unified empire among the population at all levels.

Although all Chinese characters originated in the script of the early Zhou dynasty, known as *dazhuan,* or large seal script (commonly used in bronze inscriptions), the upheavals of the Warring States period brought political, economic, and cultural changes that resulted in regional differences in the writing of characters, even within the same state. For instance, there were three different forms for the character *ma* (horse) in the Qi state and two in the states of Chu, Yan, Zhao, Wei, and Han.[14] On Li Si's advice, Qin Shihuang instituted reforms leading to the standardization of the Chinese writing system. He adopted the so-called *xiaozhuan,* or small seal script, which had evolved from the Zhou *dazhuan* script starting in the Spring and Autumn period (770–476 BCE). Simpler and more regular in appearance than *dazhuan,* and therefore easier to write and more practical, this standardized script became universal throughout the Qin empire.[15]

During the Warring States period, the weights and measures used in the different states varied considerably, as evidenced by modern archaeological finds. For example, the precise length of one *chi* (a basic unit) as defined by a standard bronze ruler from Jingchun, in Luoyang, Henan (where the Eastern Zhou capital was), measures 23.1 centimeters (9⅛ in); a ruler from Shou county, in Anhui (a territory of the Cai state, conquered by Chu in 447 BCE), measures 22.5 centimeters (8⅞ in); and two from the Chu state in Changsha measure 22.7 centimeters (8¹⁵⁄₁₆ in) and 22.3 centimeters (8¾ in).[16] Likewise, the units for measuring cereal grains were not consistent. In the Wei state, these included *yi, dou,* and *hu.* In the Qi state, they were *sheng, dou, qu, fu,* and

zhong. The ratios between these units also altered over time, even within a single state. In the Qi state, for instance, four *sheng* constituted one *dou*, but later there were five *sheng* to one *dou*.[17] Units of weight were also confusing, with names and values differing from state to state, both for objects and for monetary metals such as gold and silver.[18]

Weights and measures were important for trade and also for determining the amount of taxes the state collected. The Qin, who had standardized their weights and measures during the Shang Yang reforms,[19] now imposed Qin standards throughout their territories. A short imperial edict (forty characters) promulgated in 221 BCE decreed unity in the measuring system. All officially accepted measuring instruments were required to bear this edict, which was also inscribed on everyday tools and utensils. Archaeological finds in the provinces of Shaanxi, Gansu, Jiangsu, Shandong, and Shanxi include examples of Qin's standard weights and measures carved with the imperial edict, reflecting the prevalence of the Qin system.

At the time of China's unification under the First Emperor, currencies and monetary systems differed from region to region (fig. 2). The Qin and Chu states had developed centralized monetary systems, whereas in Zhao, Wei, and Han there was less government control and hence more local autonomy in issuing money. Using coins of different shapes, sizes, weights, values, and units was detrimental to trade and tax collection, so Qin Shihuang standardized the coinage, adopting the existing Qin round coin in

221 BCE.[20] The main currency reform measures were (1) the central government became responsible for minting coins, and private money production was outlawed, and (2) two types of legal tender, gold (*shangbi*) and copper (*xiabi*), were introduced. *Shangbi*, or upper currency, had *yi* as its unit; *xiabi*, or lower currency, took the form of round coins with a square hole, with a par value of half a *liang* and therefore known as *banliang* (fig. 3).

Infrastructure and Major Works

Six years into the unification, in 215 BCE, the First Emperor launched a series of military campaigns against the hostile Xiongnu, or Huns, a confederation of nomadic tribes from Mongolia. The Xiongnu were the dominant power on the steppes north of China and had caused great problems for the rulers of the Central Plains. They were expert horsemen who carried out raids on villages and towns and often intruded into Zhao and Yan to abduct commoners as slaves. Leading an army of three hundred thousand strong, the Qin general Meng Tian regained control of a vast area on both sides of the Yellow River and the Ordos region, forcing the Xiongnu tribes farther north. To secure control and prevent the Xiongnu from again encroaching on the northern frontier, the First Emperor ordered that many convicts and commoners be resettled in the newly conquered border areas. Then in 214 BCE he commanded Meng Tian to undertake one of the biggest defensive military projects in the history of China—the construction of the Great Wall (figs. 4 and 5).

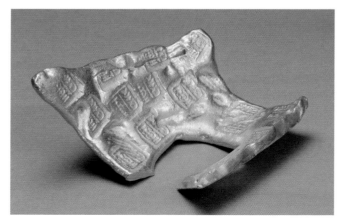

Fig. 2. Gold *chenyuan* block currency, late Warring States period (475–221 BCE), excavated at Lujiapo village, Yaodian, in Xianyang, Shaanxi, in 1972, Xianyang Municipal Museum 11-0009

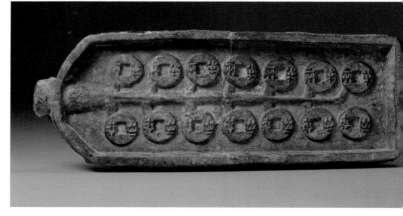

Fig. 3. Bronze mold for the Qin half-*liang* coins, Qin dynasty (221–206 BCE), excavated at Lintong in Shaanxi, in 1983, Shaanxi Provincial Institute of Archaeology 000223

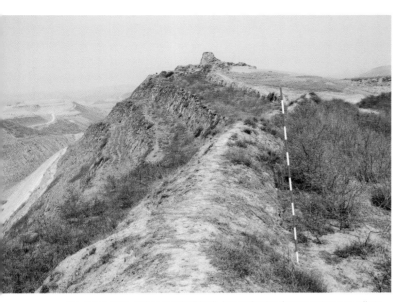

Fig. 4. A section of the Great Wall built during the Qin dynasty at Yangxin village in Wuqi, Shaanxi

Fig. 5. The Great Wall of China today

During the Warring States period, several states bordering the Xiongnu territory had built a series of interconnected fortresses. Meng Tian proceeded to connect the remaining fortifications, building new walls and trenches and incorporating natural barriers such as hills and rivers to form a continuous defensive barricade along the empire's new northern frontier. The Great Wall comprised three main sections, starting from present-day Min county in Gansu province in the northwest and stretching to Liaodong in the east (in present-day east Liaoning province).

In 219 BCE, as military expansion in the south continued with the annexation of various regions in what are now Guangdong and Guangxi provinces, the emperor had a major canal dug to transport supplies to the army. Known as Lingqu, the twenty-one-mile-long canal linked the Xiang River (which flows into the Yangzi River) and the Li River (which flows into the Pearl River), connecting two of China's major waterways and allowing water transport between north and south China. In addition to aiding the Qin's expansion into the southwest, the canal facilitated economic and cultural exchanges between the Central Plains and the southern region.

To better control his vast territorial conquests and enable him to make periodic inspection tours, Qin Shihuang improved transportation throughout the empire with construction of the imperial road networks known as Chidao (literally, "speed way") and Zhidao (literally, "direct road"). Chidao, built in 220 BCE, radiated from Xianyang eastward to today's Shandong, Hebei, and the Liaodong Peninsula; southward to Hubei and Hunan; and

southeast to Anhui, Jiangsu, and Zhejiang. It was made for vehicles, with pedestrian paths on both sides, separated from the main roadway by trees. In 212 BCE, Qin Shihuang ordered Meng Tian to construct the Zhidao, from Yunyang (in present-day Chunhua, in Shaanxi province), near Xianyang, to Jiuyuan on the northern border (in present-day Jiuyuan, Inner Mongolia). This road stretched for 1,800 *li* (about 435 miles) across mountains, valleys, and desert plains (fig. 6). A standard wheel gauge, established in 221 BCE, ensured that vehicle wheels would fit the cart ruts of roads throughout the empire.

The First Emperor also set about expanding his capital, Xianyang, transforming it from a state capital into the imperial center of politics, commerce, and culture. To boost prosperity (and enable him to watch over powerful subjects), he forced 120,000 rich and influential families from the former six states to move to the city. In 212 BCE, building of the famous Epang Palace began, requiring an estimated 700,000 or more workers. However, the First Emperor would not live to see the palace completed.

Qin Shihuang's most ambitious project was his lavish mausoleum near the capital, containing his terracotta army. Driven by his eagerness for immortality, from the moment he ascended the throne of the Qin state, at the age of thirteen, the First Emperor began to construct his burial. The site's outer wall extended over a mile from north to south and more than half a mile from east to west. The complex plan and symbolic contents of the mausoleum—as gradually revealed by ongoing archaeological excavations—far exceed what anyone could have imagined.

Fig. 6. View of the Zhidao, or "direct road," at Zhaizishan in Fuxian, Shaanxi

Inspection Tours

Beginning in 220 BCE, one year after the unification, the First Emperor made a series of inspection tours to ascertain the adequacy of the empire's border protection. The first one took him to the prefectures of Longxi and Beidi, in present-day Gansu and Ningxia provinces—Qin's northwest frontier, inhabited by the Rong tribes.

A year after completion of the Chidao, in 219 BCE, the First Emperor embarked on his second inspection tour, this time to the eastern and southern portion of his empire, the former states of Qi and Chu. At Mount Tai, in Shandong, he performed an ancient rite known as the *fengshan* sacrifices, paying homage to Heaven on the summit and Earth at the foot of the mountain. Since the Spring and Autumn and Warring States periods, *fengshan* had been the most important rite in the state religion and the sole prerogative of sovereigns. By performing these sacrifices, rulers received solemn investiture and blessing from Heaven.[21] Qin Shihuang was the first ruler to perform the *fengshan* ceremony on Mount Tai (fig. 7).

On Shandong Peninsula, Qin Shihuang encountered a *fangshi*, or necromancer, named Xu Fu, who advised him that the elixir of immortality was to be found on the three divine isles of Penglai, Fangzhang, and Yingzhou, in the Eastern Sea. Xu Fu volunteered to obtain the elixir on condition that three thousand boys and girls accompany him to the Faraway Land. Xu Fu was given a small fleet of his own with which to conquer death, and Qin Shihuang headed south to the former state of Chu.

The third inspection tour, to the empire's eastern region (present-day Shandong, Hebei, and Shanxi), took place in

218 BCE. At Bolangsha in Wuyang (in present-day Zhongmou, Henan), the First Emperor survived an assassination attempt. It was plotted by Zhang Liang, an aristocrat of the Han state who had sworn revenge when his homeland was conquered by Zheng in 230 BCE. Zhang Liang hired a strong man, and the two hid among the bushes along a mountain route to kill Qin Shihuang as his entourage passed by. The muscular assassin hurled a heavy metal cone weighing 120 *jin* (about 214 pounds), shattering the first carriage. However, the emperor was in the second carriage. Thus the attempt failed. Despite a huge manhunt, both men escaped.

Heading north in 215 BCE, the First Emperor inspected the border defenses in anticipation of attacking the Xiongnu. When traveling to lands of former vassals, he ordered the leveling of city walls and other obstructions of military importance, a policy consonant with the destruction of arms and the removal of the aristocracy of former vassal states. On his return to Xianyang, the campaign to drive the Xiongnu out of the lands south of the Ordos River began.

On his journeys, the First Emperor set up stone stelae with inscriptions testifying to his influence and power, for example: "I have personally inspected the people of the distant lands, and ascended this Mount Tai, to comprehensively oversee the Eastern Limit" and (on Mount Langya) "The Emperor's virtue has preserved and fixed the Four Limits . . . all within the six cosmic divisions is the land of the Emperor." Six such stelae were erected in the course of five expeditions, all on mountains.

Burning of the Books and Execution of the Necromancers and Literati

In 213 BCE there was a debate in the court on whether to restore the feudal hierarchy that had been abolished eight years previously. Some scholars thought the new system of prefectures and counties was not as good as the old system of enfeoffment. They advocated the idea of *shigu*, or learning from the past, claiming that a government that did not model itself on its predecessors never lasted long. But Li Si, the prime minister, argued that rulers in the past never repeated each other—not because they tried to be different, but because times had changed. He reprimanded his scholar opponents for

Fig. 7. Present-day view of Mount Tai in Shandong

learning from the past instead of the present and for confusing ordinary people with their criticisms. Li Si advised the First Emperor to burn all books of literature and the writings of the various schools of thought, except those on medicine, divination, forestry, and the history of Qin. He also advised that permitted copies of the burned writings be kept in the bureau of the academicians. The First Emperor took Li Si's advice, and books were burned across the empire.

The following year, according to Sima Qian, the First Emperor committed his second major "excess": the execution of 460 necromancers and scholars. This occurred as a consequence of incidents involving several necromancers. On his fourth inspection tour, Qin Shihuang had consulted the necromancers Lu Sheng, Han Zhong, Hougong, and Shi Sheng about the secret of immortality. They all claimed they could find the elixir of life, so he dispatched them to do so. When their promises were revealed as empty and deceitful, they plotted to flee. Before going into exile, they criticized the emperor as "violent, cruel . . . and greedy for power," asserting that such a tyrant was not worthy of obtaining the secret of immortality. Qin Shihuang was furious and ordered a thorough investigation. More than 460 necromancers and scholars were believed to have been associated with the detractors, and Qin Shihuang had them all buried alive in the capital (fig. 8). For opposing

Fig. 8. Scene from an eighteenth-century album showing the First Emperor ordering necromancers and scholars to be buried alive, as recounted in Sima Qian's *Shiji* (Records of the Grand Historian)

Present-day view of the First Emperor's tomb mound in Lintong, Shaanxi

their execution, Crown Prince Fusu was sent away to command an army unit under General Meng Tian.

Death and Aftermath

In 210 BCE, the First Emperor made his fifth inspection tour, to the south and the east coast. In Langya, on Shandong Peninsula, he summoned Xu Fu and again inquired about the elixir of life. Xu claimed he could not reach the isle of Penglai because it was guarded by huge fish. So the emperor himself, along with archers, set out to slaughter the sea beasts. He finally killed a huge fish with his crossbow and, satisfied, continued his tour.

Upon reaching Shaqiu (in present-day Hebei province), Qin Shihuang became seriously ill. Aware that he would soon die, he named his eldest son, Fusu, as his successor. Li Si feared that news of the emperor's demise might spark an uprising, so the death was kept secret during the months-long journey back to Xianyang. To mask the foul smell of the decomposing body, carts of rotten fish were positioned immediately before and after the emperor's wagon. Meanwhile, Zhao Gao, the chief eunuch and tutor of the emperor's second son, Huhai,

suppressed the emperor's choice of Crown Prince Fusu, causing Fusu to commit suicide, and placed Huhai on the throne. During the tumultuous aftermath, Zhao Gao persuaded the new emperor to install his followers in official positions. With his power base secure, Zhao Gao had Li Si killed in 208 BCE. One year later, the Qin empire was toppled by a rebellion.

What caused the rapid collapse of the Qin Empire? First, the huge amount of labor invested in constructing public works—such as the Great Wall, roads, and canals—and the palaces and burial complex of the First Emperor. These monumental projects required hundreds of thousands of workers, an unknown number of whom died. Second, the extreme cruelty of the legal code. Rule-by-law was necessary for establishing an empire. But even as circumstances changed, brutal punishments and forced labor continued, preventing people from resuming peacetime work such as rebuilding their homes and their lives. And the First Emperor went on to impose yet harsher rules and regulations, forcing all officials and civilians to comply with his personal wishes, in effect turning the nation into a massive prison. In his insightful essay "Faults of the Qin," the Western Han thinker Jia Yi

(200–168 BCE) states that the Qin thrived and rose because of the "complicated laws and strict punishments," and fell for the same reason.[22]

Qin Shihuang remains a controversial figure in Chinese history. Despite the tyranny of his autocratic rule, he is regarded as a pivotal figure because he unified the country. But this is only a superficial evaluation. The Tang dynasty thinker Liu Zongyuan (773–819 CE) considered the First Emperor's greatest achievement to be the abolishment of the old system of feudal investiture and the establishment of a new system of administrative districts throughout the country.[23]

When Qin Shihuang came to the throne, unification of the country was almost inevitable. For over half a century, the rulers of the Qin state had played their indispensable parts in developing a small kingdom into a superpower. Shang Yang's numerous reforms helped transform Qin from a peripheral state into a militarily powerful, strongly centralized kingdom capable of annexing all the other warring states. Qin Shihuang was the ruler fated to accomplish this. Though his reign was brief, the system of state bureaucracy which he built became a legacy that, after elaboration and consolidation by the Han, persisted in successive dynasties over the next two millennia with only gradual modification.

Notes

1. The account of the First Emperor's life and the history of Qin presented here are based primarily on Sima Qian's *Shiji* [Records of the Grand Historian]. The relevent chapters were translated into English by Burton Watson in *Records of the Grand Historian: Qin Dynasty* (Hong Kong: Chinese University of Hong Kong, 1993).

2. In 334 BCE, the rulers of the Qi state and the Wei state addressed each other as *wang*; in the state of Qin, the ruler assumed the title of king in 325 BCE, to be known as King Huiwen (r. 337–311 BCE).

3. *The Annals of Lü Buwei*, trans. John Knoblock and Jeffrey Riegel (Stanford, Calif.: Stanford University Press, 2001), p. 4.

4. For instance, Knoblock and Riegel call the story "patently false, meant both to libel Lü and to cast aspersions on the First Emperor" (*Annals of Lü Buwei*, p. 9).

5. In 325 BCE, when Duke Si of Qin changed his title from "duke" to "king," becoming known as King Huiwen, it was a bold sign that he considered himself the equal of the Zhou king.

6. Sima Qian, *Shiji* (Beijing: Zhonghua Press, 1959), vol. 7, *juan* 70, p. 2282.

7. Watson, *Records of the Grand Historian: Qin Dynasty*, p. 32.

8. Sima Qian mentioned that the vassals all sent special envoys to the Qin court in this year but did not elaborate on why. Modern historians think they did so to celebrate the possession of the nine *ding*. See Watson, *Records of the Grand Historian: Qin Dynasty*, p. 32; Yang Zhigang, *Qianqiu xingwang: Qinchao* [Rise and fall of dynasties in one thousand years: Qin dynasty] (Changchun: Changchun Press, 2000), p. 217.

9. Sima Qian, *Shiji*, vol. 1, *juan* 6, pp. 236–37.

10. The Yangling tiger tally (8.9 cm long and 3.14 cm high) was excavated at Lincheng in Shandong and is now in the collection of the National Museum in Beijing.

11. Shang Yang (390–338 BCE) was an important statesman of the Qin during the Warring States period. With the support of Duke Xiao (r. 361–338 BCE) he enacted numerous reforms that contributed to Qin's emergence as a militarily strong, centralized kingdom.

12. See Bai Shouyi et al., eds., *Zhongguo tongshi* [A general history of China] (Shanghai: Shanghai Renmin Press, 1989–99), vol. 4, bk. 1, p. 188.

13. Editorial Team, *Shuihudi qinmu zhujian* [Bamboo slips from the Qin tombs in Shuihudi] (Beijing: Wenwu Press, 1990).

14. Bai Shouyi et al., *Zhongguo tongshi*, pp. 207–8.

15. In comparison with *dazhuan*, small seal script was vertically elongated with a regular appearance. It was systematized through the elimination of most variant structures and repetitive parts and became much neater and rectangular in proportion. For example, the character *qin* 秦, which stands for the name of the Qin state, was written in the oracle bones of the Shang dynasty in a form resembling two hands holding a wooden stick pounding two cereal plants (*he* 禾). The big seal script kept the same structure, but in small seal script the character was simplified, retaining only one plant.

16. Bai Shouyi et al., *Zhongguo tongshi*, p. 210.

17. See *Zuozhuan* [Commentary of Zuo], compiled fifth to fourth century BCE, annotated by Yang Bojun (Beijing: Zhonghua Press, 1990), "Third year of Zhaogong," p. 1235.

18. Gao Zhixi, "Hunan chumu zhong chutu de tianping yu fama" [The balance and weight excavated from a Chu tomb in Hunan], *Kaogu*, 1972, no. 4: 42–45.

19. Several measures of Shang Yang's period have been excavated, including a well-known bronze *sheng*, or pint, inscribed with his name and a date corresponding to the year 344 BCE, now in the Shanghai Museum collection.

20. As attested by archaeological finds, such round coins had appeared in the fourth century BCE in the states of the Central Plains and subsequently came to be used in all major states except Chu, in the south. Presumably modeled on earlier circular jade disks (*bi*) with small holes in the center, these coins were cast according to regional weight standards and often inscribed with their denomination or the name of the issuing city. The state of Qin followed the *liang* standard, casting *banliang* (i.e., half *liang*) coins. They were introduced in a period of profound state-sponsored changes, and it is possible that a state monopoly was established or at least claimed in connection with the sweeping Legalist reforms of Shang Yang in the 340s and 330s BCE.

21. See Sima Qian, *Shiji*, vol. 4, *juan* 28, pp. 1355–1404.

22. Jia Yi, *Xinshu* [New book], "Guo qin lun" [Faults of the Qin] (Shanghai: Shanghai Guji Press, 1988), pp. 6–9.

23. Liu Zongyuan, "Fengjian lun" [On the enfeoffment system], in *Liu Zongyuan ji* [Complete works of Liu Zongyuan] (Beijing: Zhonghua Press, 1975), pp. 69–76.

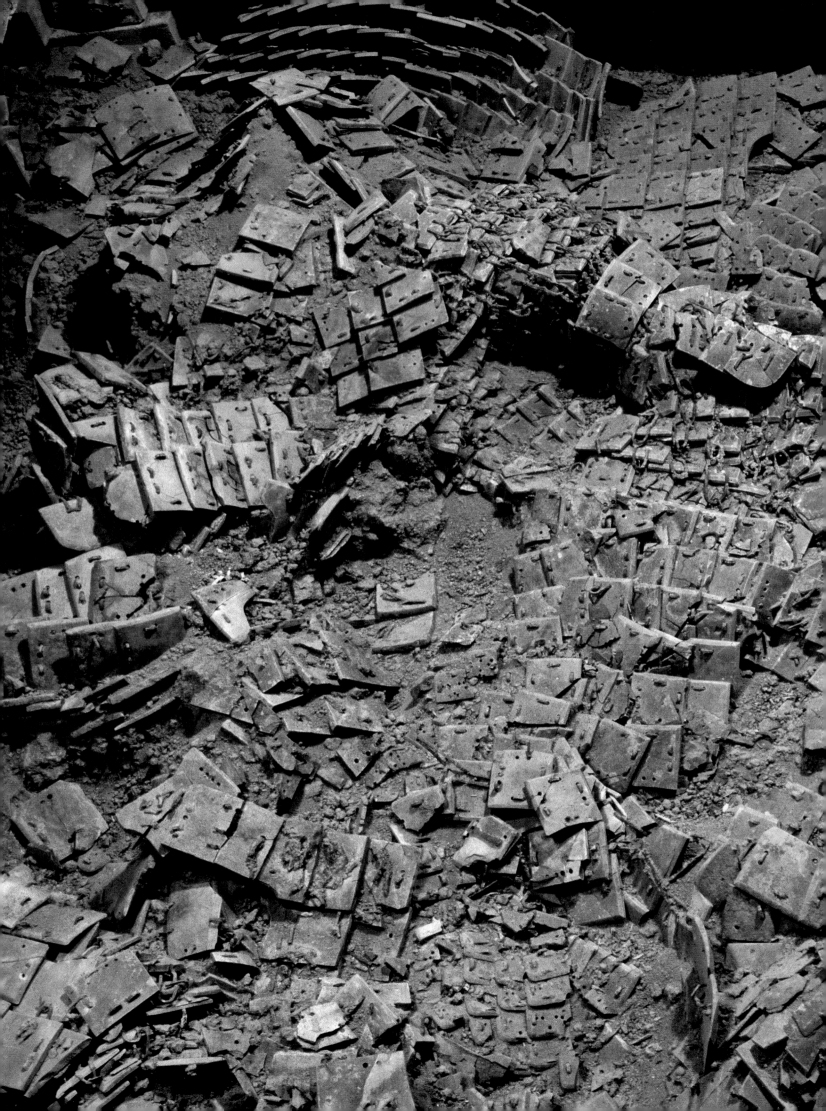

The Qin Army and Its Antecedents

Albert E. Dien

The armor and weapons of the Qin army were the culmination of a long history of experimentation and development in China that can be traced back to the earliest known military forces, those of the Shang dynasty of the middle second millennium BCE, some one thousand years earlier. Bronze first appeared in China at that time and was used not only for magnificent ritual vessels, but also for weapons. Chief among them was the dagger-ax, or *ge*, a hacking or chopping blade hafted onto a handle, which long remained the chief armament in Chinese antiquity (fig. 1). In addition, bronze was used for arrowheads and spearheads. Knives also occur but swords do not. The warrior elite rode into battle on chariots, accompanied by their troops on foot. Armor was probably made of tough leather and has not survived, but bronze helmets with animal-head motifs, worn by the upper echelons, have been found (fig. 2). From the evidence of the oracle bone inscriptions, Shang armies usually numbered in the low thousands, but there is mention of an army of ten thousand and even more.

The Zhou dynasty, which succeeded the Shang in the mid-eleventh century BCE, in general took over the Shang technology, but some changes were made. The chariots improved: a smaller wheel lowered the center of gravity, increasing mobility. Whereas the Shang chariot had perhaps served primarily as a platform for observation and signaling (with drums and flags), the chariot as an attack vehicle now came into its own. Each chariot carried three men—the driver, the bowman, and the wielder of a particularly long-handled dagger-ax. As the Zhou began to lose its authority and independent states emerged, acknowledging the leadership of the Zhou in name only, individual states were ranked in significance by the number of chariots they could mount, ranging into the hundreds and thousands. There were changes in the weaponry as well. The helmets lost that fearsome appearance, featuring only a slight crest, perhaps to hold a plume. The dagger-ax was still the most common weapon, but some now included a spear point at the top, so that thrusting was added to the hacking function. This new weapon was called a *ji*, or halberd. By the eighth to seventh century the sword finally appeared among the array of weapons. With a blade only some four inches in length, it resembled a long knife and was shaped like a slender willow leaf. Over time, the weapon became much longer.

We are much better informed about the armor of this period because of the discovery in 1977 at the modern Suixian, in Hubei, of the tomb of Marquis Yi of Zeng, a small state subordinate to the large state of Chu. Dated to 433 BCE or shortly after, the tomb contained thirteen suits of lacquered leather armor and helmets; although the leather had decomposed, the layer of lacquer remained and allowed some of the outfits to be reconstructed (fig. 3). These handsome suits were of leather plates covered with a layer of black lacquer with red trim. In one of the suits, the armor for the upper body is made up of 23 plates forming

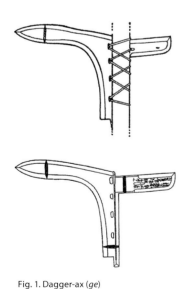

Fig. 1. Dagger-ax (*ge*)

Clusters of armor fragments in Pit K9801 of the First Emperor's tomb complex

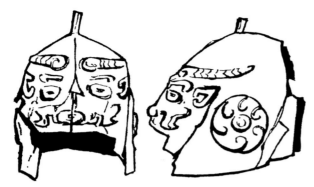

Fig. 2. Shang dynasty helmet

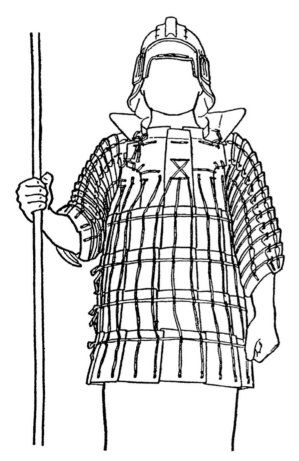

Fig. 3. Warring States armor from Suixian

a collar, chest, and back; that for the lower body is a kind of skirt of 56 plates (four rows of 14 each); and articulated armor for the arms brings the total to 131 pieces. Some of the cords that held these plates together still survived, demonstrating that the plates were imbricated—that is, one overlapped the other—with the final seam at the back. The other suits, not all of which could be completely restored, had differences in detail. The helmets, also made of lacquered leather, had a sort of brim at the front, rows of plates that protected the side and back of the head, and a distinctive crest. These

elaborate outfits were most probably worn by those who rode in the chariots.

The fiction of a Zhou state was thrown off in what is termed the Warring States period (475–221 BCE), a name that well describes the tenor of the time. We can see scenes of warfare incised into bronzes from that time (fig. 4). In the competition for survival in this multistate development, the larger states swallowed the smaller, armies grew enormously, large investments were made in defensive and offensive gear, and new technologies brought warfare to an entirely new level of intensity.

The heyday of chariot warfare came to an end during this period. The arena of warfare began to include southern China, where the terrain, wet and boggy, was unsuited to the use of chariots. But more important, two new developments augured the end of the chariot as a tactical weapon. These were the introduction of cavalry and the invention of the crossbow.

There is a long-standing and fierce debate among scholars about when people began riding horses rather than using them for traction. Though there may have been occasional instances of riding as far back as some claim, the widespread use of mounted horsemen among the nomads of Inner Asia—enabling them to control far larger herds of animals and facilitating their raiding of enemies, both settled and nomadic—probably emerged in the tenth century BCE. This new culture of the mounted nomad spread across Asia, but in the Chinese textual sources available to us, no note was taken of it until the end of the fourth century BCE. The king of Zhao, a northern state, is said to have ordered his warriors, in 307 BCE, to abandon their gowns for trousers and to ride horses in order to meet the threat from the nomad enemy on their northern frontier. Greater mobility, and the capacity to operate on all sorts of terrain, made cavalry clearly superior to the chariot.

The other innovation of this period was the crossbow. Attaining skill with the composite, reflexive bow, made of cattle sinews and horn, required much training and experience. The crossbow, on the other hand, had an extended range and could be handled without much training; it became the Chinese infantry's chief weapon against the nomads in the field. The Chinese never developed the gear mechanism that was added in the

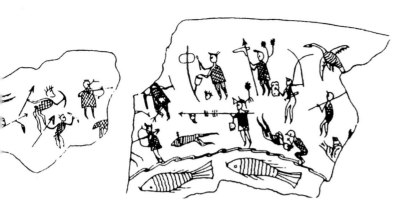

Fig. 5. Warring States helmets

Fig. 4. Depiction of a battle scene, Warring States period

West once the crossbow came into use there, but with some effort the weapon could be cocked.

The introduction of cavalry and crossbow largely spelled the end of the chariot as a tactical weapon. Removed from the front line of battle, the chariot became, as it probably had been in the Shang, an observation station that also sent signals to the troops—while no doubt remaining a prestige symbol.

The military obsolescence of the chariot also had a significant social impact. Chariots had been manned by the aristocrats, whose status and power were associated with the dominance of the chariot. Here we may draw a parallel with a similar situation in the West. After the stirrup was introduced, from the eighth century CE on it became possible for a man in armor to retain his seat on a horse, and armored knights became the major fighting force. The cost of outfitting such an army was beyond the European rulers of the time, so grants of land were made in return for a guarantee to provide specified numbers of knights when called on. Subinfeudation was repeated on down the line under the same conditions, resulting in what we call the feudal system. Then the longbow made mounted knights ineffective, and power accrued to the center, which could mobilize the new sort of army on its own. The knights were now extraneous, and the feudal system itself became an anachronism. It is quite possible that the squads of chariots were financed in a similar way in early China. Once they became obsolete as a military force, a similar decline of the aristocratic warriors occurred, along with a growing centralization of power in the individual states. The rulers of these states then drew on a new set of officials, of bureaucrats, to administer the affairs of the state, and these men became the new elite, but without hereditary claim to that position. The term for the elite, *shi*, which had formerly designated the

aristocratic warriors, now referred to these men who served at the behest of the ruler.

Metal weaponry, too, underwent changes. Bronze keeps an edge as well as any metal, can be molded to fine tolerances (important in the crossbow mechanisms), and does not rust. But by the late Warring States period, iron, which was less expensive, began to make an appearance in the armaments. Two Yan state sites containing military equipment were found at Yanxiadu, Yixian, Hebei. One of the sites included nineteen spearheads, twelve halberds, eleven mace heads, fifteen swords, and one knife, all of iron, and one dagger-ax, one sword, ten mace heads, and nineteen arrowheads of bronze. The second, an ancient ash pit, yielded two iron mace heads, two bronze arrowheads, and a remnant of a bronze sword. More striking, an iron helmet was found at each site, revealing complicated structures unlike anything seen before. Each was made up of small iron plates, sixty-six (originally sixty-nine) and eighty-nine, respectively, bound so that they overlapped. One helmet left the face exposed, while the other almost entirely covered the face (fig. 5). These would not have been for general issue, but it is not clear who would have worn them in battle.

Warfare had been taken to a new level, and the need to mount larger armies, eventually in the hundreds of thousands, required efficient utilization of resources, also conducing to centralized administration within each state. In place of the confused melees of aristocrats in chariots accompanied by untrained mobs of conscripted peasants, one now saw trained corps of crossbowmen and cavalry led by career officers. Along with this professionalization, manuals on warfare, such as Sunzi's well-known *Art of War*, appeared. There was no longer any place for the chivalry of the past, when warriors did not strike at a wounded enemy or one who was elderly.

It is estimated that in the eighth century BCE there had been over a hundred states, and by the third there were only three: Qin in the northwest, Qi in the northeast, and Chu in the south. By 221 BCE, under the redoubtable Qin Shihuang, the First Emperor, Qin had united the whole of China and imposed a centralized administration, dividing the country into thirty-six commanderies, each under a governor appointed from the center. The Qin state had achieved this feat by outdoing its opponents in carrying through the systems of centralization and militarization that were emerging at the time.

There is an interesting description of the Qin state by the famous Confucian philosopher Xunzi (c. 335–c. 238 BCE).

> Since the people of Qin must be provided a living within a narrow defile, the use of the people in obligatory service is stern and harsh. The people are coerced with authority, restricted to a narrow life by deprivation, urged on with incentives and rewards, and intimidated with punishments and penalties. Persons in subordinate and humble positions are made to understand that only by success in combat can they seek benefits from their superiors. Men must endure deprivation before they are employed, and some degree of accomplishments must be achieved before any benefits are obtained, but as accomplishments increase so do the rewards. Accordingly a man who takes the heads of five enemy soldiers has five households placed under his supervision. Because of this policy, soldiers have become exceedingly numerous, the fighting strength of the army is formidable, its ability to stay in the field has been greatly extended, and Qin's territories yielding taxation greatly increased. Thus, that there have been four consecutive generations of victories is due not to mere chance good luck but to method and calculation. (John Knoblock, *Xunzi: A Translation and Study of the Complete Works*, vol. 2 [Stanford, Calif.: Stanford University Press, 1990], p. 223)

The militarized society described by Xunzi is confirmed by the Qin law code recovered from a burial, in which the amounts of fines are expressed in terms of suits of armor or shields.

The momentous discovery beginning in 1974 of the three pits containing the terracotta warriors, about three-quarters of a mile from the mausoleum prepared for the First Emperor of the Qin when he died in 210 BCE, reveals an image of the army that made Qin an invincible force. In Pit 1, six thousand figures appear to be arranged in battle formation, with lines of men at the flanks and back facing outward to guard against attacks. Fully painted in bright colors (now mostly lost), they must have been an awesome sight.

The men in the first three rows in front, who do not wear armor, are crossbowmen. Each stands at attention, as do all the figures in this pit, the arms stiff at the sides, but the fingers of the right hand are curled, with the thumb out, indicating they held a crossbow. As the first line got off a volley of bolts, the second line was prepared to move up, and the third would have been loading their weapons. The first line would then fall back, the second line advancing to the front, and so on, so that a constant stream of bolts was released against the enemy. The figures are depicted wearing thick robes (see cat. no. 74), the collars and sleeve ends emerging from a thin robe cover that comes across to the right, where it is buttoned below the right arm; such covers are still used today. A belt—more or less a strap with some sort of catch, not a buckle—holds the whole in place. The hair, partly braided, is neatly arranged in a topknot; possibly such elaborate coiffures were thought to be apotropaic, that is, a protection against harm. In many figures, the leggings of short trousers show just below the hem of the robe. The square-toed shoes were perhaps of cloth, with a prominent seam up the center and an upper part that covered the ankle and was neatly fastened at the top.

Although some robed figures are placed behind the three front rows, the rest of the formation consists for the most part of armored warriors. The armor (see cat. no. 75), termed a cuirass, was worn over robes like those described above. The lamellae, or plates, that composed the cuirass were probably of the same lacquered leather seen in the past. Such armor is light, and the smooth surface allows a missile hitting at any angle to simply glance off. It differs from scale armor, characteristic of the West, in which the individual plates are attached only at the top to a backing, each row hanging over the one below. In the lamellar armor here, the individual plates overlap or are overlapped, that is, imbricated, on all four sides to the

Fig. 6. Armor plate binding, Han dynasty

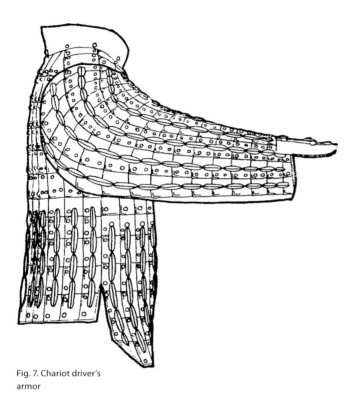

Fig. 7. Chariot driver's armor

surrounding plates, by means of cords of leather or silk, through a series of double holes that allow the attachments to go in and out, resulting in what on the surface look like knots. The central or vertical line overlaps the rows to the sides. Thus the central line at the back is overlaid on both sides. The top four rows imbricate downward, while the four lower rows imbricate upward. This allows for easier movement of the body as it bends at the waist. To prevent the lower rows from having gaps, double cording appears on the surface; connections on the inside holding the plates together would have been quite complex. We cannot know from these pottery figures how the plates were connected on the undersides, but actual armor from the following Han dynasty may suggest how it was done (fig. 6). The shoulder guards are also imbricated

upward, permitting easier movement of the arms. Interestingly, Western medieval armor presents the same patterns of imbrication. The gap in the cording at the neck reveals where the armor plates at the top opened to allow the cuirass to be donned or removed. The fastener at the right side closes that opening. Most of the figures in this sort of armor represent those who would have held handled weapons such as *ge* or spears; their right arms are bent and the fingers shown as if grasping a handle.

Scattered through the corridors of Pit 1 had been wooden chariots, which have not survived, but their locations are marked by the teams of four pottery horses that drew each. Since very few bronze parts were found, the chariots most likely were simulations. They clearly were meant to represent command posts, probably of squads or platoons of the infantry, and behind each chariot was placed its three-man crew. They all wear small caps which mark them as charioteers. One wielded a long-handled weapon. The other two, including the driver, who is easily identified because he has both hands extended to hold the reins (see cat. no. 80), do not have shoulder guards and so may have been of higher rank.

Pit 2 forms the left flank of Pit 1, with the various components of the army grouped together. These included 89 chariots with 356 horses, 116 cavalry horses, and over 900 warriors of various sorts. The realism of the terracotta army is unlike anything that had been done in China before, with the finest details sculpted, down to fingernails and strands of hair, but all the figures are facing forward in a static pose. Even more startling is the group of 160 archers from Pit 2. The realistic twisted and kneeling posture, with heads raised slightly as if viewing the enemy at a distance, demonstrates the high level of artistry achieved by the craftsmen of that time (see cat. no. 77). One interesting detail of such figures is that the soles of their shoes, revealed as they kneel, are stippled with small knots, the result of layers of cloth closely stitched together, just as in the *buxie*, or cloth shoes, still made in China. The presence of some swords nearby suggests that these men were also prepared for hand-to-hand combat, which would explain their armor.

The detailed representation of cavalry here is the first found in China since the adoption of cavalry a century earlier (see cat. nos. 78 and 79). The saddle is a simple

pad, and there are no stirrups (stirrups would not be invented for another five hundred years). Because the headstall and reins were simulated in bronze, they have survived. The cavalryman himself is depicted wearing a minimal suit of armor that would not compromise the agility needed to maintain his seat on the horse. Cavalrymen probably were armed with lances or with composite bows, since it would not have been possible to cock a crossbow while astride a horse.

At the other extreme in protective armor is that worn by some of the chariot drivers (fig. 7). These suits feature a standing collar and, in place of shoulder guards, sleeves of articulated plates almost encircling the arms and extending down to the wrists, with an extension to cover the fingers holding the reins, so that no hit by an arrow would cause the driver to lose control of the vehicle.

The final innovation in Pit 2 is the presence of some 120 standing figures, without armor, whose stances reminded some archaeologists of taijiquan poses (see cat. no. 76). From the position of the hands it is clear that these were bowmen, stationed so they could move quickly to discharge harassing fire, while behind them the cavalry would move up to outflank the enemy. What is surprising is the large number of chariots massed as for an attack. If these pits to any extent simulate actual battle formations, it would seem that the chariot still had a place in the military forces.

Pit 3 represents the headquarters of this army. Much smaller than Pits 1 and 2, it contains sixty-five warriors making up a guard unit and one chariot with a crew of four. The armor of one of the charioteers here has a front that resembles the standard armor, but the back consists of broad cross bands, elaborately decorated. As the literature suggests, the commanding officer is not present; it is surmised that the unit awaits the arrival of the emperor himself.

Finally there are the officers, scattered through the ranks of the three pits (see cat. nos. 72 and 73). These men appear older. Their fancier headdress, called a "pheasant-tail," which was probably lacquered to keep its shape, and the scarf and ribbons on their overgarment all indicate their ranks. Their armor is made up of lamellae smaller than that of the other warriors, with a curious

V-shaped pattern of corded linkages. Along the top and sides of the suit of armor is a representation of what seems to be cloth edging, adorned with tassels and an elaborate decorative pattern. One officer holds his hands crossed in front of him, as if resting on the pommel of a sword. At this period swords averaged about thirty-six inches long, including the hilt. The blades were thin and slightly tapered and appear to have undergone a process of chromotizing to inhibit rusting, a remarkable achievement in those times.

No helmets were found in the pits, but many of the figures have some sort of cap over their elaborate hairdos, perhaps serving as a helmet liner. The question of the use of helmets during the Qin was solved by the discovery of a large pit, K9801—part of the mausoleum complex surrounding the burial mound—that contained an enormous number of suits of armor made of limestone lamellae (see cat. nos. 91 and 92). The armor is of the same construction as that of the pottery army but with the individual lamellae joined by flat strips of copper. The helmets closely resemble those found at Yanxiadu, mentioned above. Scholars speculate that this stone armor was meant to be worn by the First Emperor's bodyguard in the afterlife, since stone may have been considered better protection from the demons encountered there.

The small size of the lamellae in the officers' armor may indicate that their armor was made of metal; lamellae of similar size are seen in suits of iron armor from the following Han dynasty. In the manner of its construction, however, metal armor of the Han and following periods closely resembles Qin leather armor. Lacquered leather continued to be used, as it was lighter and cheaper than metal, and effective. Some lacquered leather lamellae of the third to fourth century CE were found at Miran and Niya, in Xinjiang to the west. There is a story that perhaps reveals the envy felt by those who could not afford the more expensive metal armor. A military force wearing metal armor in a mountainous region became immobilized by powerful lodestones in the cliffs about them and fell victim to warriors wearing leather armor. A likely story!

Rows of warriors and horses in Pit 1 at the First Emperor's tomb complex

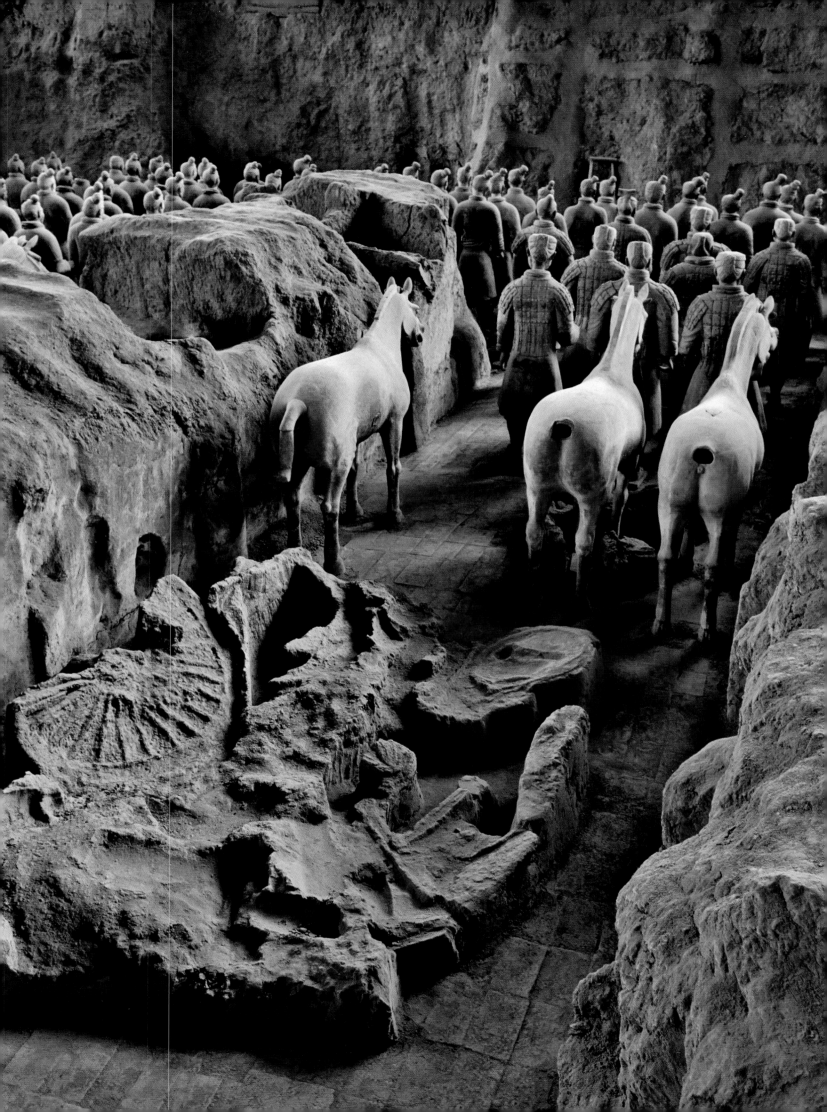

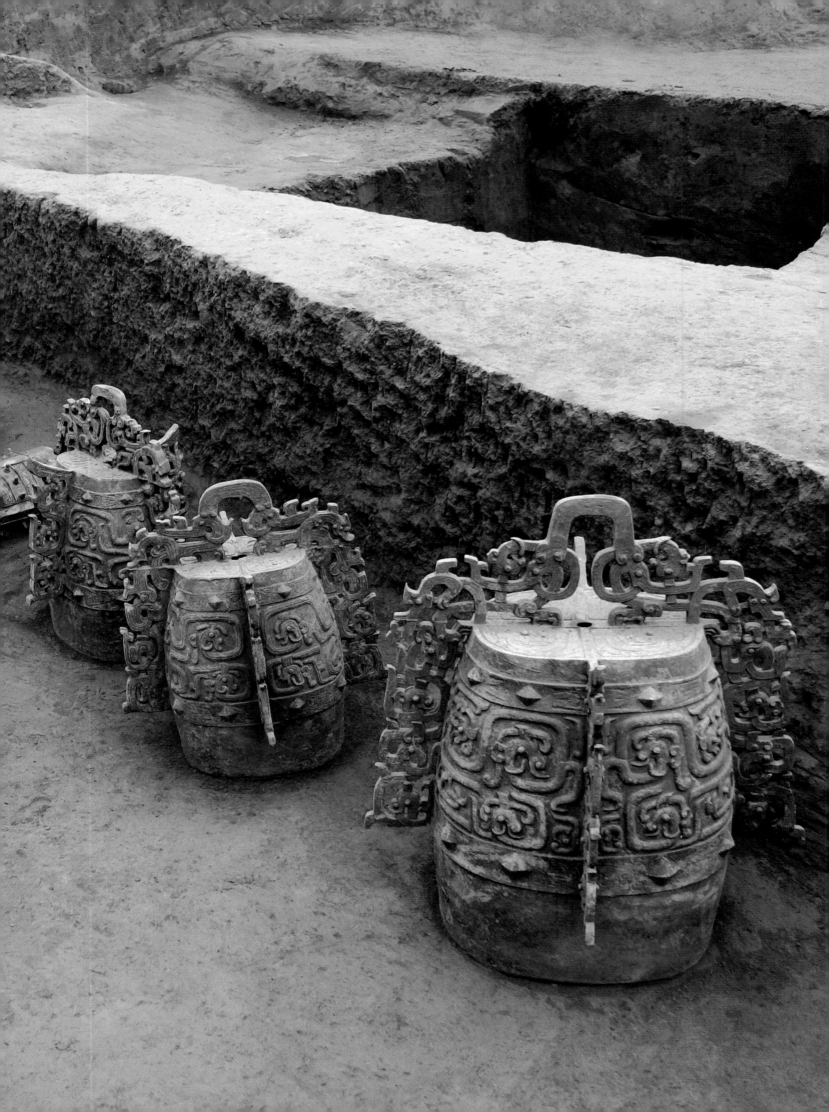

Inheritance and Innovation: Qin Bronze, Gold, and Jade

LIU YANG

Bronzes

Although Qin arose as an independent state on China's western frontier, the Qin cultural attitude was very much in line with mainstream Shang and Zhou dynasty systems. This is particularly apparent in the use of ritual bronzes.

In the Shang and Zhou dynasties, ritual was the mechanism that generated social cohesion and statecraft; it was considered crucial to the maintenance of hierarchical order. This was the reason for making an enormous and imaginative range of bronze vessels and musical instruments. These bronzes were used in ceremonies and sacrifices performed to please ancestors and heavenly deities, to maintain the incontrovertible order from the heavens to the rulers to the courts to the people, and to acknowledge the powers invested in the various levels of hierarchy.[1] Bronze ritual vessels and paraphernalia, even those used in earthly ritual and ceremony, were also placed in the tombs and burial sites of rulers and nobility. These furnishings, particularly vessels used for food and drink, were intended to sustain the deceased in the afterlife. The bronzes were always grouped, with variously shaped vessels fulfilling different functions. The number and style of vessels and accoutrements was strictly regulated in accordance with the deceased's rank.

Since the late 1970s, a number of aristocrats' tombs datable to the early Spring and Autumn period (770–476 BCE) were excavated at Bianjiazhuang in Longxian, Baoji, the earliest Qin political center after Qin's ruling class moved eastward into the region of modern Shaanxi.[2] The remains from these burial sites reveal a highly sophisticated use of ritual bronzes, intended to reflect the dignity with which the deceased persons had lived and to re-create their earthly life, albeit in symbolic form.

Many tombs were unearthed by accident when local farmers were digging in the ground. In the winter of 1986, archaeologists excavated twenty-eight tombs, and some three thousand objects were gathered. The most important tomb was M5 (fig. 1), not only because of its rich contents (over 780 sets of objects), but also because it was scientifically excavated, revealing important data on early Qin aristocratic mortuary practice. The tomb was 5.2 meters long and 3.5 meters wide (17 x 11½ ft) and contained a smaller pit 2.2 meters by 1.2 meters (7 x 4 ft) in the center of its base, in which was nested a lacquered coffin. The main chamber held a chariot with two charioteers (the earliest Qin human sculptures found to date) and a typical grouping of bronze vessels, including five *ding* cauldrons, four *gui* food vessels, two *hu* wine vessels, a *pan* basin, a *he* kettle, and a *yan* steamer. There were also bronze objects in other forms: bells, fish, rabbits, and various chariot fittings.[3]

View of the Musical Instrument Pit at Mount Dabuzi under excavation

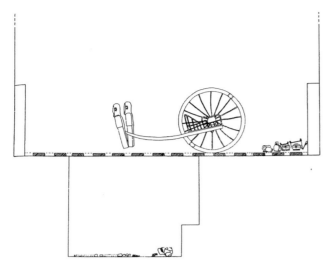

Fig. 1. Drawing of the structure of Tomb M5 in Bianjiazhuang, Longxian

Among some thirty-three tombs excavated from 1977 to the late 1980s, eleven contained bronze ritual vessels. In general, the assemblages included *ding, gui, hu, pan, he,* and *yan.* The grouping of five *ding* and four *gui* seen in eight tombs suggests that the tomb occupants had been high-ranking officials. Three tombs show a slightly lower rank with a grouping of three *ding* and two *gui.* These tombs also contained shells used as currency (the tomb excavated in 1982, for instance, had 546 shells) and chariot fittings. Such groupings reflect a strong Western Zhou influence, seen also in the shape of the tombs, which were vertical shafts, usually larger at the base, or with base and opening of equal size.[4]

Qin artistic output was also very much in accord with mainstream Western Zhou styles. When the Qin ruling class moved into the former Western Zhou heartland in Shaanxi, they must have inherited many bronze vessels left behind by the Zhou aristocrats, which would have served as models for Qin artisans. In 1978, Chinese archaeologists excavated a number of bronze vessels from tombs of the early Spring and Autumn period at Xigaoquan in Baoji. Bronze vessels such as *hu* and *dou* cast during King Xuan's reign (827–782 BCE) were found buried with the Qin vessels.[5]

The most typical bronze vessel forms of the Shang and Zhou periods—*ding, gui, fanghu,* and *he*—are all familiar in the repertoire of Qin bronzes. However, while adhering to the previous dynastic tradition in fundamental bronze forms, even the earliest Qin work also exhibits a regional style. The *ding,* for instance, is the most common form of Bronze Age ritual vessel and is often seen in Qin ritual paraphernalia. A fine example was excavated from Tomb 5

at Bianjiazhuang (cat. no. 3). The spherical body, bulbous legs, and vertical handles are typical features of the type. Although the intricate interlaced patterning on the body derives ultimately from the familiar serpent-like designs of Western Zhou, it has been developed into a character-istic decorative pattern ubiquitous on all types of Qin bronzes of this period. Stylistic innovation also appears in the vessel's form. Compared with Western Zhou *ding* or those cast in other regions, the Qin-style *ding* has a shallower belly and thick, strong legs that swell out at the top. Another unique feature is a hoop on the foot and sometimes in the middle of the legs.

From the sheer number of finds at archaeological excavations carried out in eastern Gansu and western Shaanxi, it is clear that percussion instruments were an important element of ceremonial musical ensembles of the Qin aristocratic society, a tradition inherited from the Western Zhou.[6] Chimes, when in use, were arranged according to size and tone and suspended as a set on a substantial multi-tiered wooden rack.

In 2006, archaeologists discovered a group of bronze and stone musical instruments in a sacrificial pit on Mount Dabuzi in Lixian, Gansu province. There were three huge *bo* bells, 53.3 to 66 centimeters (21 to 26 in) high, and eight *yongzhong* bells, 23.4 to 53.71 centimeters (9 3/16 to 21 1/8 in) high, datable to the late eighth or early seventh century BCE (fig. 2).[7] An earlier important find, made in 1978, was a set of three *bo* and five *yongzhong* bronze bells, unearthed

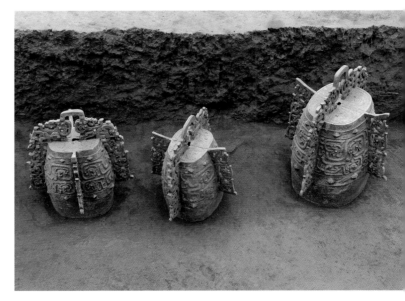

Fig. 2. View of the Musical Instrument Pit in Mount Dabuzi under excavation

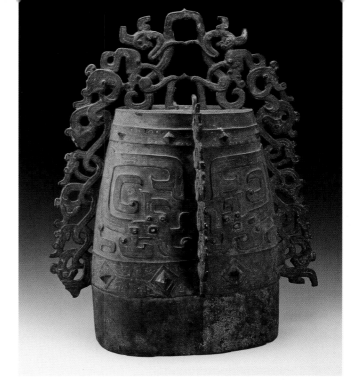

Fig. 3. Bronze *bo* bell, Western Zhou dynasty, dated to the sixteenth year of King Xuan's reign (827–782 BCE), excavated at Ren village, Fufeng, Shaanxi, in 1890, Tianjin Art Museum

north of Taigongmiao in Chencang, Baoji (see cat. nos. 1 and 2).[8] These, however, were not a complete set. The inscriptions cast on them suggest that the standard Qin chime set consisted of three *bo* and eight *yongzhong* bells (three *bo* was also the Western Zhou standard).

Each of the three *bo* excavated at Taigongmiao bears a long inscription of 135 characters proving that these bells were important musical instruments cast during Duke Wu's reign (697–678 BCE).

> The Duke of Qin states: My foremost ancestor [Duke Xiang] received the heavenly mandate, was rewarded with a residence, and received his state. The gallant and courageous Dukes of Wen, Jing, and Xian followed Heaven's will, discreetly commandeered barbarians from various tribes, and therefore they are favored by Heaven and are on the side of God. I, as their descendant, pay homage to Heaven day and night with profound reverence, hoping to receive more blessings. Now, from the duke to his officials, we all strive together to make a concerted effort to govern the state. The tribes surrounding our kingdom are also endeavoring to serve the Qin. Therefore I made this set of treasurable bells, to express our gratitude to Heaven with harmonious music in order to gain more favor. I, Duke of Qin, will obey the mandate and pray for the longevity and expansion of our territory.[9]

It is apparent that, as with Western Zhou bronzes, such inscriptions became a means of communicating to the clan ancestors and recording for posterity some honor or achievement of a living aristocrat, thereby proclaiming his power and prestige. As Lothar von Falkenhausen has pointed out, the rhetorical formulas derived from Western Zhou royal inscriptions also abound in the text inscribed on these bells.[10]

This inscription, however, also expresses a tendency inharmonious with the Zhou tradition. In the inscriptions carved on bronzes owned by Western Zhou aristocrats, the history of a noble lineage was often deliberately interwoven with the history of the Zhou royal house, mentioning how their ancestor received the lineage fief from the Zhou king and emphasizing that the vessel was made to honor both their ancestors and the Son of

Heaven (inscriptions on a group of bronzes unearthed from Zhuangbai in Shaanxi provide the best example).[11] But here, the Duke of Qin mentions nothing about the linkage with the Zhou king that legitimated Qin's status within the Zhou bureaucratic network, emphasizing instead the Mandate of Heaven.

The inscription also calls attention to the deeds of Duke Wu himself. As Wu Hung has noted, toward the end of the Western Zhou, ritual objects underwent a transformation from *liqi* (ritual vessels) devoted to one's ancestral deities to objects that one dedicated to oneself. The living members of the lineage had gradually lost interest in their past and were eager to demonstrate their power straightforwardly by presenting their personal deeds in the temple.[12] This tendency resulted in the division of the traditional temple into twin centers: a temple for religious purpose and a palace for administrative functions, as seen in the layout of the Qin capital at Yong, in present-day Fengxiang, Shaanxi.

Such characteristics of tradition and innovation are also seen in the form and decorative style of the bronze bells. Though apparently from the workshop of the Qin, the bells appear to have been modeled on Western Zhou prototypes. With the *bo*, for example, the openwork flanges and the design on the body are similar to those on earlier *bo*. A comparative example is the famous *bo* of the Western Zhou dated to the sixteenth year of King Xuan's reign, now in the Tianjin Art Museum (fig. 3). Known as the Ke *bo* (because it bears its owner's name, Ke), it was

unearthed in 1890 at Fufeng in Shaanxi.[13] It is 63 centimeters (24³⁄₁₆ in) high and 35.3 centimeters (13⅞ in) wide and weighs 38.25 kilograms (84 lb).

Each of the three large *bo* bells from Taigongmiao was cast in a fantastical form with four openwork flanges. The two primary flanges are composed of nine intertwined dragons; the lateral flanges, of a phoenix and five interlaced dragons. Two bands of meandering stylized dragons adorn the main register, which is bordered by geometric designs (including a cicada motif) interspersed with pyramidal knobs.

From the early to the middle Spring and Autumn period, the form of the *bo* bell was undergoing changes in other vassal states of the Central Plains. The general tendency was to reduce the flanges or omit them completely.[14] The flaring flanges of the Qin *bo* bell reflect Qin's adherence to the Zhou tradition. Nonetheless, Qin artisans showed an interest in change: the flanges became even larger and showier and the phoenix-like bird more prominent. Besides appearing on the flanges, a phoenix is engraved back-to-back with a dragon on the top of the bell.

The bird motif appears frequently in the decorative schemes of early Qin bronze vessels, and the possible reasons for this are interesting. It seems to allude to the genealogical myth concerning the origins of Qin's rulers and people, in which Lady Xiu, the forebear of Qin, swallows the egg of a dark bird and gives birth to Grand Undertaking, the ancestor of Qin. A story told by Mozi (468–376 BCE) confirms such totemic worship among the Qin people. One day Duke Mu of Qin (r. 659–621 BCE) saw a deity in black clothing, and he was terrified. The deity comforted him, saying: "You needn't be afraid. I am Goumang, sent by God to protect you. I can help your country to be prosperous and your people to thrive."[15] Goumang was the name of a bird deity commonly worshiped by people in the east. Some scholars even suggested that the family name of the Qin clan, Ying, had the same etyma as *yan*, meaning "swallow."[16] In Sima Qian's account of early Qin history, we read that one of the early Qin chiefs, Boyi or Dafei, who received the family name Ying from the legendary emperor Shun, was a master at training and communicating with wild birds and animals. One of his two sons, called Dalian,

according to Sima Qian "was the founder of the Bird-custom family." Two of his grandsons, Mengxi and Zhongyan, had bird bodies but spoke human language.[17]

The Chinese archaeologist Zhou Heng cross-checked the relevant historical records against the oracle texts associated with the Qin. He thought the type of bird pictorial sign often seen on late Shang and Western Zhou bronzes found in Shaanxi and Gansu might be connected with the Qin clan emblem.[18] Though birds played an important role in many vassals' genealogical myths, it does seem there could be a link between Qin ancestral worship and the vogue for birds in Qin art.

The ornamental patterns and designs on Qin bronzes of the early Spring and Autumn period were pretty much identical with those on late Western Zhou bronzes. Basic patterns included *chuilin wen* (downward fish-scale pattern), *qiequ wen* (S-shaped serpentine pattern), *wanleng wen* (parallel tile-ridge-like pattern), *bodai wen* (continuous wave pattern), and *chonghuan wen* (double-loop pattern). Arrangements of several primary motifs also correspond to Western Zhou designs.

The middle Spring and Autumn period saw the establishment of characteristic Qin styles. The most notable new feature was the *goulian panhui wen*, or interlocked serpentine pattern (see cat. no. 3). Designs with two entwined dragons or serpents had already appeared in Western Zhou art, but the intertwining of several dragons or serpents to form a repeating unit of decoration, this was new.[19] It gradually became the predominant motif on bronze vessels and was also frequently seen on bronze chariot fittings and even architectural fixtures. The sophistication and wide use of *goulian panhui wen* distinguishes Qin bronzes at the height of their development. Though the interlocked serpents or dragons are markedly similar in contour, structure, and orientation, variations occur; notably, the head and eyes of the serpents are sometimes shown and sometimes not (fig. 4).[20]

With the passage of centuries from the early Spring and Autumn period to the Warring States period, the form and decorative style of Qin bronzes evolved from the architectonic Shang and Western Zhou idiom to a more restrained surface ornamentation. This is demonstrated by a bronze *ding* excavated at Gaozhuang in Fengxiang,

Fig. 4. Interlocked serpentine-dragon pattern cast on a bronze *ding* of the Spring and Autumn period, excavated at Bianjiazhuang in Longxian, Shaanxi, in 1981, Longxian Museum, Shaanxi 81L619

the region of the ancient Qin capital of Yong (cat. no. 15). With its spherical lidded body, three small legs, and the usual prominent handles, this simple and elegant form contrasts sharply with the more highly decorated and architectonic *ding* vessels of the Western Zhou dynasty and the Spring and Autumn period (see cat. no. 3). An incised inscription indicates that it was perhaps made in the neighboring state of Zhongshan in Hebei province,[21] and it is plausible that the casting of ritual bronzes in a restrained style or with simple decoration originated in other states in the Central Plains.

Some typical bronze forms current during the Spring and Autumn period disappeared while new types became fashionable. Those that fell from favor or died out included the uncovered *ding* cauldron with richly ornamented body and strong, bulgy legs (see cat. no. 3), the *gui*, the *yan* (see cat. no. 6), the *he* with a flat body (see cat. no. 7), and the square *fanghu* (see cat. no. 10). Among the new types that emerged were the bulbous-bodied *ding* with a cover (see cat. no. 15), the ovoid *hu* vase (see cat. no. 14), the *ping* vase with garlic-shaped head (see cat. no. 19), the four-sided *fang* wine vessel (see cat. no. 90), the *chunyu* percussion instrument (see cat. no. 20), and the *mou* cooking vessel (see cat. no. 22). Apparently many new types, like the *ding* with round body and short animal feet and the round *hu*, were adopted from styles current in the east and south, while others, such as the *chunyu* and *mou*, came from Ba and Shu in Sichuan.

The primary impetus for these stylistic changes was Qin's openness following Shang Yang's reforms in the mid-fourth century BCE, which set Qin on the road to becoming a superpower. Numerous bronzes from other

states were brought to Qin through trade or warfare, and many skilled craftsmen were attracted or coerced to the Qin territory. All of this contributed to dramatic changes in how ritual bronzes were cast and used.[22]

An ovoid *hu* vase (cat. no. 14) provides evidence of such exchange. On its belly are two inscriptions. The first identifies this *hu* (or *zhong*) as once owned by the city of Anyi, which was under the administration of the Wei state at the time the vessel was cast. In 287 BCE, the ruler of Wei was forced to cede Anyi to Qin. Ownership of the *hu* then somehow passed to the state of Han. In Han, officials from *fu*, the official warehouse, noticed a discrepancy between the required and actual capacity of the *hu* and added a second inscription on its belly in 263 BCE plus an engraved line on the neck, annotated "to here," likely indicating the designated volume.[23] Some years later, the *hu* ended up in the hands of Qin aristocrats, who added an inscription along the mouth ring to indicate the Qin standard capacity. The *hu* was buried with other valuables in a tomb at Ta'erpo in Xianyang, the Qin capital.[24]

Although surface decoration on bronze vessels from this period tends to be minimalistic or completely lacking, a remarkable feat of ornamentation is an incense burner with unusual intricate interlacing and openwork designs (fig. 5). This spectacular object was discovered one day in March 1995 by a boy on his way home from school at Yaojiagang in Fengxiang.[25] It is 35.5 centimeters (14 in) high and consists of three sections: base, hollow pillar, and burner with a flying phoenix on the top. The ball-shaped burner has two chambers, the outer being composed of interlaced serpents in an openwork design

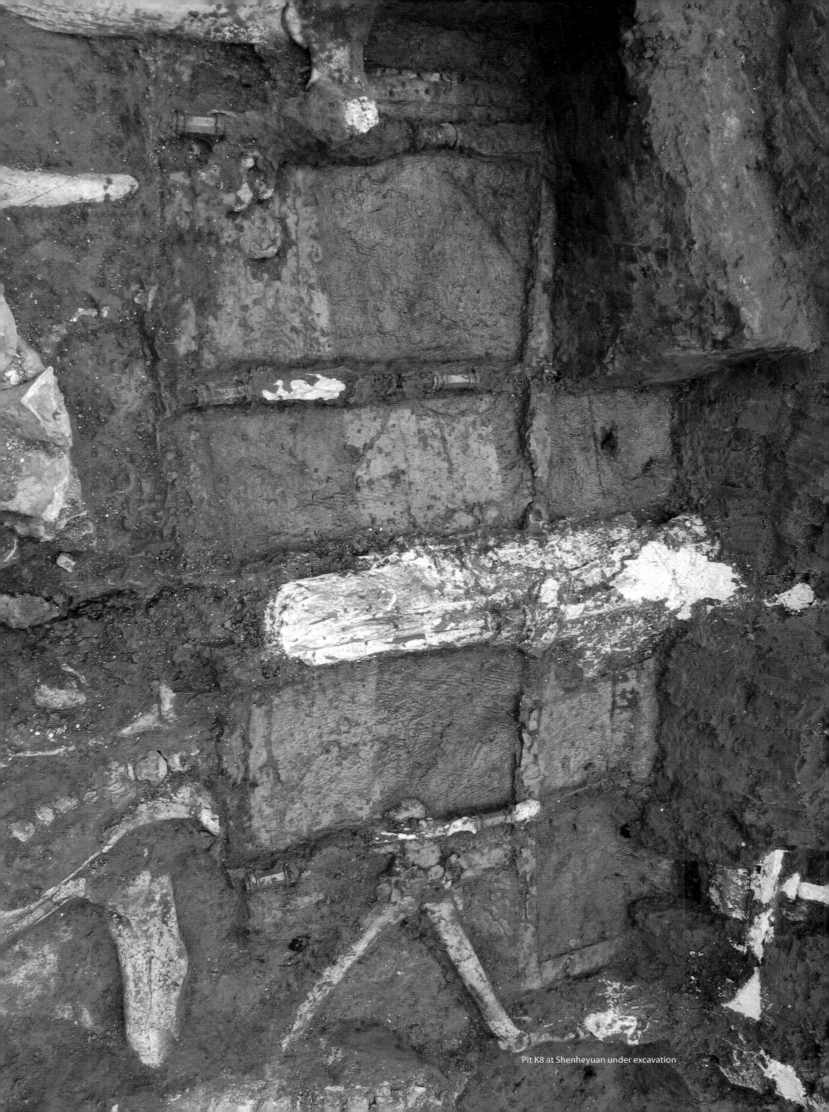

Pit K8 at Shenheyuan under excavation

with four *pushou*, or animal-faced ring holders, attached to the edge of the lid. The four rectangular panels of the base each have a tiger at the top center, flanked by two warriors holding a shield and spear, and below this a pair of upside down tigers flanking a warrior. Tiny flying phoenixes and climbing animals adorn the outermost edge. The trapezoidal panels repeat this design, minus the phoenixes and animals.

The feature of curling and intertwining serpents hollow-cast in three dimensions suggests either very sophisticated section-mold assembly techniques or a different casting procedure altogether, such as the lost-wax method, which allows for irregular, convoluted shapes. Apparently the incense burner was made in a state other than Qin. A comparable work is a *ding*, 50 centimeters (19½ in) high, of the Warring States period, excavated in 1980 at Liuquan in Xinjiang, Shanxi province, that has a semicircular double-decked body whose exterior is formed of interlaced hydras in openwork.[26] A *hu* vessel with inlaid gold ornament of the middle or late Warring States period excavated at Yuyi in Jiangsu also has interlaced openwork meshes on the exterior.[27] Although bronze vessels of similar design and technique were found in many places, a possible southern influence from the state of Chu is tenable. Bronzes unearthed from a series of Chu tombs dating from the mid-sixth century BCE, including those at Xiasi in Xichuan, southern Henan, and the tomb of Prince Wu (d. 552 BCE) in particular, prove that by the middle of the Spring and Autumn period lost-wax technology had become quite advanced. A famous bronze *jin* stand, for instance, consists of surface ornament and the many layers of bronze sticks in the interior. All these Chu bronzes with intricate surface openwork were cast with the lost-wax method.[28]

The mid–Warring States period also witnessed the emergence of ritual bronzes of a new type, cast in Qin. These were small in scale with refined decoration requiring great skill in techniques of inlaying gold and silver. A *ding* tripod cauldron 13.7 centimeters (5⅜ in) high excavated from Lady Qi's tomb at Zhengyang in Xianyang, Shaanxi, in 1971, attests to this new trend (fig. 6). Although sharing the features of other *ding* popular at this time—depressed bulbous body, hoof tripod, two upright ears, and three knobs (see cat. no. 15)—it differs in having spiral or triangle patterns inlaid in gold and silver segments or thread over the entire body. Another example is a *hu* wine vessel (cat.

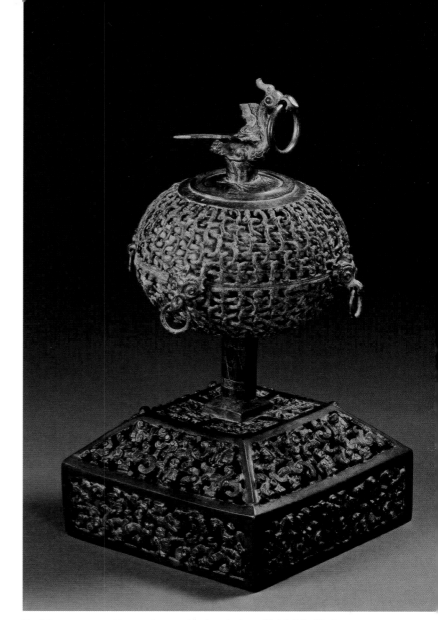

Fig. 5. Bronze openwork incense burner with phoenix-shaped finial of the Warring States period, discovered at Yaojiagang, Doufucun, in Fengxiang, Shaanxi, in 1995, Fengxiang County Museum 0838

no. 40), shaped like popular *hu* of the time but decorated with inlays of gold, silver, and precious stones.

The technique of embellishing bronze with decorative inlays, usually turquoise or more rarely malachite in the early period, dates to the later Shang dynasty. However, it was during the Eastern Zhou that the technique came into wider use and the most refined vessels and accessories, such as belt hooks, were made. Inlaying involved inserting very thin gold or silver foil thread into a fine line scored on the surface of the bronze.

An important innovation in Qin bronzes was the sudden appearance of realism. Startling changes occurred during the First Emperor's era. While the casting of ritual vessels on a much smaller scale continued, there was a tendency to produce bronze sculpture that reflected the everyday experiences of contemporary life.

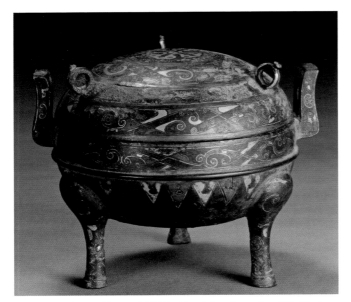

Fig. 6. Bronze *ding* cauldron with inlaid gold and silver decoration of the Warring States period, excavated from Lady Qi's tomb at Zhengyang in Xianyang, Shaanxi, 1971, Xianyang Municipal Museum 5-0062

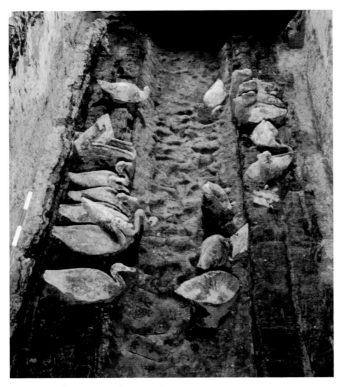

Fig. 7. View of Pit K0007 under excavation

In 2001–3 a pit (K0007) was discovered in the northeast corner of the First Emperor's mausoleum some 900 meters (½ mi) from the outer wall. It contained fifteen terracotta figures, twenty life-size bronze swans, six cranes, and twenty wild swans (*yan*) lining the banks of an artificial watercourse (fig. 7).[29]

Eight of the terracotta figures are seated (leaning slightly forward) and wear soft caps, right-fold robes fastened at the waist by a belt, and long trousers. Their hands are resting on their knees, one palm facing up and the other down, suggesting to archaeologists that they originally held an object. The remaining seven figures are kneeling and are attired similarly to the seated figures. One notable difference is their hand positions, with the left palm naturally dropping down while the right hand is raised as if holding onto something.

Archaeologists think the scene in this pit may represent musicians training birds in the royal park. That would fit in well with the First Emperor's plan for his tomb complex, since the Royal Park and *yuefu*, or Music Bureau, were government offices that provided entertainment for the emperor (see cat. no. 105). Supporting this speculation are findings of remains of small bone objects, bronze rods, and silver nails, all assumed to be associated with musical instruments. The seated figures may be musicians, using music as a means to train the birds, and the kneeling figures could be dancers.[30]

While it is agreed that the pit likely represents the royal park, scholars differ as to whom the terracotta figures represent. Some have thought they might be the park keepers, that their gestures show they are throwing food to the birds and that the seated figures are weaving nets for catching small fish for the birds.[31] Others think the figures could be archers working at the royal park, trying to catch birds for the ritual feast.[32] While these arguments may continue, everyone agrees it is not the symbolic meaning but rather the artistic conception of the birds that is most important. The bronze waterbirds display a realism previously unknown in Chinese art.

The life-size waterbirds are all faithfully rendered, none identically. Meticulous, busy lines on some areas of their bodies indicate feathers. Their poses are especially charming. Some birds are portrayed as if gliding gracefully on the pond; others are stretching their long necks toward the water, looking for food (see cat. nos. 82–85). A crane is sculpted as a lively bird lifting its beak from the water the moment after catching a fish (fig. 8). Like the terracotta warrior figures, the bronze birds were painted in detail to appear lifelike, although little of the paint survives. Archaeologists reported obvious burn traces along both side walls of the pit except on the lowest edge of the watercourse, where a water mark is visible, and they detected

Fig. 8. Bronze crane from the Qin dynasty, excavated from Pit K0007 at Qin Shihuang's tomb complex in 2001–3, Qin Shihuang Terracotta Warriors and Horses Museum K0007T3:33

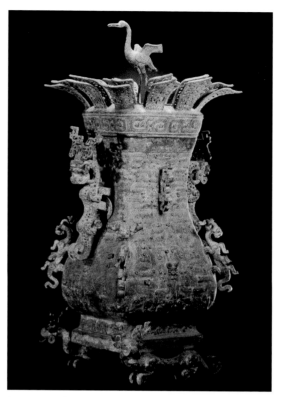

Fig. 9. Square *fanghu* wine vessel of the Eastern Zhou dynasty, late 7th–6th century BCE, excavated from a tomb of the Duke of Zheng in Xinzheng, Henan, in 1923, Henan Provincial Museum

footprints along the watercourse. All of which suggests that the natural surroundings of waterbirds were reproduced with vivid verisimilitude. This also explains why the pit was located far away from the tomb mound but close to Yuchi—a "fish pond" formed by the removal of soil for building the mound—which would have supplied water.[33]

The bronze waterbirds, like the terracotta army, are remarkable not only for their life-size scale but, above all, for their authenticity and realism. Created on the scale and with the detail of real animals, without the distortions of ritual and symbolism, these sculptures have no precedent in the history of early Chinese art.

Animals and birds were ubiquitous motifs in Chinese art of the Bronze Age as well as in Qin bronzes. But their depiction was bound to ritual and ceremony, and no attempt was made to define or represent a fixed world. Rather, the world was seen as symbolic, in the shadow of divinity, and artistic imagery lacked the qualities central to the realist mode of expression.

During the Eastern Zhou dynasty, animals began to be portrayed in a more realistic way, but still only as an adjunct to the divine presence. An excellent example is seen in a bronze *fanghu* (fig. 9), one of an identical pair excavated in 1923 from the tomb of the Duke of Zheng in present-day Xinzheng, Henan, datable to the late seventh to sixth century BCE, and now in the Palace Museum and the Henan Provincial Museum collections of wine vessels. Above the lid of this monumental vessel, which stands 124 centimeters (49 in) tall, a strikingly realistic crane is poised with half-spread wings among blossoming lotus petals. Yet this bird image is still an element of a ritual vessel and not an independent subject. The realism here

is overwhelmed by a flurry of fantastical animal forms: interlacing bird-dragons around the vessel's body; on its sides, winged creatures with spiraling trumpet-shaped horns; and, crouching at the base, slinking horned felines.

During the Warring States period, realistic animal figures appeared ever more frequently as subjects rather than symbols. These figures were sculpted to serve as a finial, handle, or foot attached to a vessel, or even as independent sculptures in the round. But though such representations became dissociated from the ritualistic function they had served in the Shang and Western Zhou periods, there is nothing in Chinese art before the Qin dynasty on the same scale, or displaying the same intent to replicate a living being, as the life-size bronze waterbirds of the First Emperor's burial. The miniature bronze birds attached to ritual vessels (exemplified by the crane poised on the *fanghu* from Xinzheng) may have been prototypes for the Qin waterbirds, yet the differences are obvious. The life-size waterbirds perform a real-life rather than a symbolic role within the confines of the ritual scheme. While they may have played a symbolic role in Qin Shihuang's eternal life, they are not fantastical creatures but lively sculptures based on real birds.

One of the more remarkable finds at the site of the First Emperor's burial was the discovery in 1980 of two

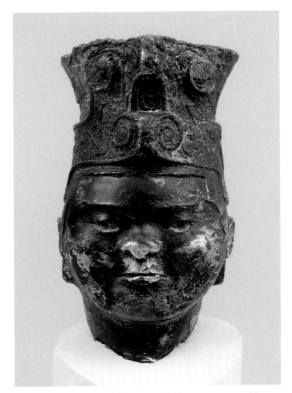

Fig. 10. Gilt bronze head of a warrior, Qin dynasty, excavated from a bronze hoard near Changling railway station in Xianyang, in 1982, Xianyang Municipal Museum 5-1166

half-life-size cast bronze chariots, each pulled by four horses (cat. nos. 122 and 123). They are meticulously detailed and richly embellished with paint and with gold and silver accoutrements. Chariot 1 is driven by a chari-oteer standing beneath a round canopy and holding the reins with outstretched arms. He is armed with a sword, a crossbow, a shield, and a quiver of arrows. Clearly a piece of military equipment, this light chariot—known as a *qiandaoche*, or "preceding chariot"—is one of the chariot types found in Pits 1 and 2 of the pits containing the emperor's buried army but is more elaborate in design and construction. Chariot 2 is driven by a single kneeling charioteer armed only with a sword. This type of enclosed carriage with small windows would have carried a passenger, presumably the emperor, in comfort. As faithful models of the full-size versions, these two bronze chariots represent a new level realism in the material arts of ancient China.

What accounts for the extraordinary realism of Qin bronze art? Without doubt, the First Emperor gave fresh impetus to this revolution in art. The quest for realism was driven by the political expediency of emphasizing certain aspects of representation in an effort to enhance Qin imperial authority. It was also driven by the First Emperor's desire to mimic the earthly world in his afterlife abode.

In 221 BCE, after unifying the country, Qin Shihuang ordered that all arms in the empire be collected and brought to his capital at Xianyang. The spears, arrowheads, and other weapons were melted down to make twelve "gold men," gilt bronze colossi each over 11 meters (36 ft) high and weighing 34 tons. They were placed in the front hall of his new palace.[34]

The giant "gold men" must have been realistically rendered, with individual finishing and detail. Although those colossi are long gone, their features can be glimpsed in a small gilt bronze statue of a warrior, of which only the head survives (fig. 10). Excavated in 1982 from a bronze hoard near Changling railway station in Xianyang,[35] the head measures 11.5 centimeters (4½ in) high, so the complete statue was probably 70 to 80 centimeters (28 to 32 in) high. This is indeed a rare example of a secular and naturalistic human statue cast in bronze, possibly dating from the same time as the terracotta army. The facial features display a distinct human individuality. As with the bronze waterbirds and terracotta warriors, what is so striking here is a striving for realism never before seen in Chinese art.

Both Jia Yi (200–168 BCE) and Sima Qian (c. 145–c. 86 BCE), two great thinkers of the Western Han dynasty, commented on the First Emperor's act of casting the twelve colossi as being politically motivated, "all in order to weaken the people of the empire."[36] That such sculp-tures were not traditional exalted the militarism and supremacy of the emperor and his imperial government. They were monuments celebrating the First Emperor's triumphs. The public display of these lavish "gold men" was a way of asserting his prestige before his people, his allies, and even potential rivals and rebels, as were the magnificent palaces built upon high terraces. The visual impact of these immense statues would have been an impression of sovereignty that reinforced social stratifi-cations and turned beholders into submissive subjects owing obeisance and loyalty to the imperial power.

The move toward representation of the real world in Qin bronze art was also stimulated by the First Emperor's eagerness for immortality. His objective was to create a facsimile of the real world in the afterlife. Following the initial discovery and excavation of the terracotta army pits, remarkable discoveries continued to be made in the

immediate vicinity: the exquisitely made bronze chariots, an armory with thousands of stone armor suits and helmets, civil service officials, stables and stableboys, and acrobats, as well as the life-size bronze waterbirds. It is clear that the First Emperor planned his tomb as an elaborate subterranean palace, a parallel world that would extend his rule into the afterlife. Without doubt it was this aspiration that inspired the naturalism of his buried bronze waterbirds and chariots. These objects are more than masterworks of bronze casting. In their realism and naturalism they, along with the terracotta warriors, heralded a new era in the material arts of China.

Gold and Jade

The earliest gold artifacts of the Qin known to us are a batch of thin gold sheets in the form of stylized animals and various geometric shapes, now in European private collections. They are thought to be from the tombs of the Dukes of Qin at a cemetery on Mount Dabuzi, in Lixian, Gansu province.[37] Datable to the early Spring and Autumn period, these gold sheets were used to embellish coffins. Their sophistication and exquisiteness suggest that the Qin love of gold may have begun earlier than previously supposed.

After their early conquests of Zhou territory in Shaanxi, the Qin continued to maintain contacts with nomadic tribes in the northwestern steppe regions. Hence, it is possible that the Qin aristocrats' taste for gold and their huge demand for it were in part the result of influence from the nomadic peoples of the steppe, who prized gold highly.[38] During the late Spring and Autumn period and the early Warring States period, Qin rulers and aristocrats possessed large quantities of gold ornaments, and goldsmithing was more refined and advanced in Qin than in other contemporary states of the Central Plains.

Gold artifacts have been found in many tombs of Qin rulers and aristocrats. Particularly stunning and significant are those discovered in Tomb 2 at Yimen village, south of Baoji, excavated in 1992. Of the more than 200 relics from that tomb, 104 were made of gold. These include belt hooks and buckles, chained ornaments, sword hilts, rosettes, and ornaments for horses, chariots, reins, and harnesses; the combined weight of the all the gold was reported to be 3,000 grams (6½ lb).[39] The sheer

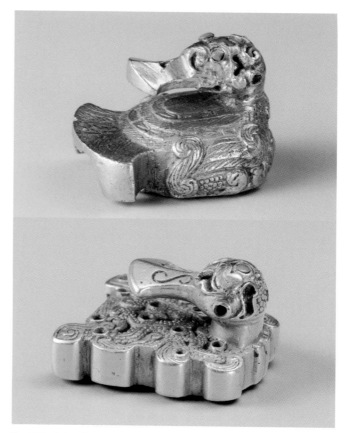

Fig. 11. Duck-head belt buckles, gold with inlaid turquoise, Spring and Autumn period, excavated from Tomb 2 at Yimen village in Baoji, Shaanxi, in 1992, Baoji Municipal Archaeological Institute BYM2:24 and BYM2:25

quantity and quality of gold objects from this tomb testifies to the very high technical standards of Qin artisans. Many of these gold objects were fabricated by means of casting. The decorative designs employed include animal-mask and serpentine patterns similar to those seen on bronzes and jades. The use of openwork with inlaid precious stones and granulated patterning is characteristic of gold ornaments manufactured by the nomadic peoples of the north and northwest.[40]

An excellent example of Qin work is an iron sword with an openwork gold hilt ornamented with inlaid turquoise (cat. no. 32). Of three swords with gold hilts discovered at Yimen Tomb 2, this is the most impressive. When the sword was excavated, there were remnants of fabric around it, and seven small gold circular finials in a line were apparently part of the decayed scabbard. The blade features a cylindrical central ridge. The eye-catching hilt is of rare quality and craftsmanship. Its design of interlaced serpent-like motifs is consistent with the sophisticated carvings on contemporary bronzes and jades, but the granulation may be an influence from the steppe region. A sword such as this, clearly not an effective weapon, was made for ceremonial and ritual use.

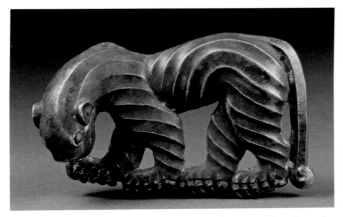

Fig. 12. Silver tiger plaque of the Warring States period, excavated from the tomb of a Xiongnu aristocrat at Gaotu village in Shenmu, Shaanxi, in 1957, Shenmu County Administration for Cultural Relics 080-5

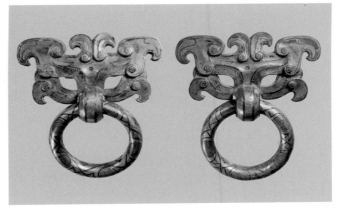

Fig. 13. Silver *pushou* animal-mask ring holders of the Warring States period, excavated from a tomb at Shenheyuan, a southern suburb of Xi'an, Shaanxi, in 2004, Shaanxi Provincial Institute of Archaeology

Among the most exquisitely crafted ornaments from the same tomb are three gold belt buckles with turquoise inlay. One is in the form of seven coiled serpents; the other two are shaped like stylized mandarin ducks with the head facing back and the long beak serving as the belt hook (fig. 11). One of the ducks has a comparatively realistic body, its wings and feathers being clearly delineated with lines, dots, and spirals. The eyes and other areas of the head are filled with precious stones. The other duck's body is more stylized and highly patterned, with two intertwined serpents stretching their heads toward the tail. Originally, precious stones filled the tiny dots, representing the serpents' eyes. This duck's elongated beak, with a tapering middle section, is decorated with two S-shaped designs, a characteristic Qin pattern seen on many duck-shaped buckles (see cat. nos. 34 and 35). The ducks measure 1.7 centimeters (¹¹⁄₁₆ in) and 2.3 centimeters (⁷⁄₈ in) long, respectively, and both have hollow bases and a vertical stem in the center to fasten a belt tucked through the side slot.

The humble belt buckle thus became an object of opulence, and examples were crafted in jade as well as gold, as seen in another duck-shaped buckle (cat. no. 47). The choice of the mandarin duck motif may reflect the traditional view that this was a bird of great beauty (it later became an emblem of conjugal fidelity). The archaeological finds show ducks or other waterbirds to be the most common form for belt buckles in the Qin state during this period.[41]

An unusual and humorous representation in gold is a diminutive tiger whose round eyes, open mouth, and erect ears give it a startled look (cat. no. 39). While overall the beast shows influences of the "animal style" art of western Asia and southern Siberia, the chevron motifs link it to tigers represented over the centuries in various mediums but with the same patterning on their bodies (see cat. nos. 65–67). The prototype of this gold tiger can be found in the bronze vessel finials of the Spring and Autumn period, seen in works excavated from Mount Yuanding in Lixian, Gansu.[42]

Several silver plaques in the form of tigers fall outside the mainstream Bronze Age style in their realism and distinctive ornamentation (fig. 12). In both respects they are closer to the artistic styles of western Asia and southern Siberia. They were found in a tomb of the nomadic Turkic-speaking Xiongnu people in Shenmu county, northern Shaanxi province, in the Ordos region north of the Great Wall and on the edge of the Gobi desert near Inner Mongolia. The Xiongnu were a constant threat to the outer northern regions of the traditional Chinese homelands in the later Bronze Age and again in the Han dynasty. But in 215 BCE the Qin drove them northward, out of the Ordos area, regaining control over a vast area. These tigers, which are 11 centimeters (4⁵⁄₁₆ in) and 14 centimeters (5½ in) in length, have the distinctive ribbing and robust animal forms typical of the so-called Ordos style.

Although in many Qin gold and silver ornaments the steppe influence is strong, the Shang and Western Zhou tradition remained ubiquitous. Two small gold rosettes of animal-mask design inlaid with precious stones, from Yimen Tomb 2, have stylized serpentine patterning on the surface and a triangular serpent head protruding from the bottom edge (cat. no. 33). Their animal-mask form clearly derives from designs on earlier bronze vessels.

A pair of silver *pushou*, or animal-mask ring holders, dating from the late Warring States period are further

evidence that the Shang and Western Zhou tradition endured (fig. 13). The prototype of such ring holders would seem to be the *taotie* animal mask, the most striking motif of the early bronze period. It featured a pair of beast's eyes projecting from the bronze surface and fixing the viewer with a forceful stare. Later on, animal-mask fixtures were used to hold rings on bronze vessels and stone coffins and on doors of architectural elements and tomb chambers. These two, each 7.7 centimeters (3 1/16 in) wide, were excavated in 2004 from a grand tomb at Shenheyuan, a southern suburb of Xi'an. Constructed with four entrance ramps and surrounded by thirteen burial pits, some containing chariots drawn by six horses, this would have been a royal tomb. A plausible suggestion is that it belonged to Lady Xia, the grandmother of Qin Shihuang.[43]

The early Qin inherited a rich legacy of jade carving from the Shang and Western Zhou dynasties while also absorbing influences from contemporary states in the Central Plains. A strip-shaped *pei* pendant, 12.5 centimeters (4 15/16 in) long, from Yimen Tomb 2 (one of nine similar pendants of various sizes) is entirely covered with decorative zoomorphic curls and spirals in low relief (fig. 14). The form and patterns—bulging reliefs against a background of incised busy striations—show the strong influence of jadework from the states of Jin and Chu. This is clear from many examples excavated from Zhao's tomb in present-day Taiyuan in Shanxi and from Tomb 1 at Xiasi in Xichuan, Henan, all dated to the late Spring and Autumn period.[44]

The Qin also made their own distinctive types of jade pendants, as demonstrated by a rectangular plaque and a circular pendant, both excavated in 1986 from Tomb 1 of Duke Jing of Qin at Nanzhihui village in Fengxiang, the ancient Qin capital Yong. The irregular oblong plaque, 9.9 centimeters (3 7/8 in) long, has flanges around three sides, and the entire surface is decorated with complex incised and pierced meanders (fig. 15). The circular pendant has two complex mirror-image openwork designs carved opposite each other along the edge and two symmetrically composed pairs of protruding "hooks" in the center (cat. no. 48). A stylized serpent motif adorns the surface. Two gold circular ornaments of the Western Zhou period unearthed from the tomb of Duke Bangfu of the Jin state

Fig. 14. Jade strip-shaped *pei* pendant of the Spring and Autumn period, excavated from Tomb 2 at Yimen village in Baoji, Shaanxi, in 1992, Baoji Municipal Archaeological Institute BYM2:168

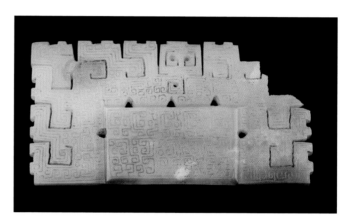

Fig. 15. Jade rectangular plaque of the Spring and Autumn period, excavated from Tomb 1 at Nanzhihui village in Fengxiang, Shaanxi, in 1986, Qin Shihuang Terracotta Warriors and Horses Museum 002888

in present-day Quwo, Shanxi, make clear that this jade pendant represents the fused bodies of two dragons holding each other's tails in their mouths (cat. no. 48, illustration).[45] Qin-style jades such as these typically tend to be geometrically shaped and flat rather than three-dimensional.

As the use of gold and silver and jade for luxuries became more prevalent, new forms and techniques emerged, including gold (or gilt bronze) objects with inlaid decoration of jade, shell, or precious stones (see cat. no. 42). A *pushou* ring holder of the Warring States period, excavated at Qianhe, Baoji, in 1972, is an outstanding example (fig. 16). In this tiny object, only 2.8 centimeters (1 1/8 in) long, the symbolic and decorative vernacular of Chinese bronzes has been rendered in the precious materials of gold and jade. It consists of two *taotie* monster masks in gold, one above the other, the jaw of the lower one extending to hold a jade ring. This *pushou* would have been an appendage to a ritual or ceremonial object (a bar at the back allows suspension).

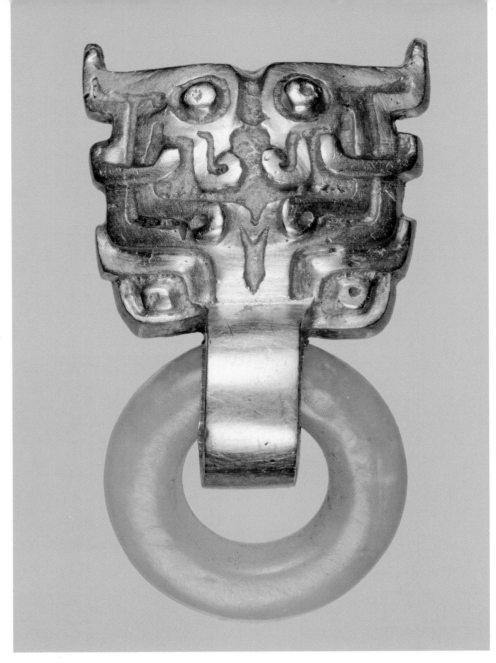

Fig. 16. Gold and jade *pushou* ring holder of the Warring States period, excavated at Qianhe, in Baoji, in 1972, Chencang Museum 364

The juxtaposition of two enduring materials may have signified the idea of eternity.[46]

∴ ∴ ∴ ∴ ∴ ∴ ∴ ∴

Throughout its history, Qin assimilated whatever aspects of other cultures could profit its own population. As shown by archaeological finds, during its earliest stage, in the middle of the Western Zhou dynasty, Qin had absorbed the pottery crafts of the Zhou people and the nomadic Rong tribes. After becoming a vassal state, Qin extensively adopted practices of the Zhou and the other states in the Central Plains and in the south—in agriculture; bronze, gold, and jade crafts; script; and ritual code. In music, as Li Si once commented, the Qin court gave up its traditional drum music of *weng* and *fou*, as well as plucking music, for the music of the states of Zheng and Wei. In politics, the recruitment of many outstanding

ministerial talents (including Shang Yang, Lü Buwei, and General Meng Tian),[47] from all the states of the east, and the adoption of Legalism, a utilitarian political philosophy which originated in the Central Plains, completed Qin's metamorphosis from a marginal state to a superpower that accomplished the unification of China.

The fortunes of Qin seem to have rested on a capacity for innovation as well as assimilation. To the people of Qin, inheritance and adaptation meant transformation, change, and, ultimately, the creation of new forms. Indeed, throughout Qin history, both tradition and innovation drove development and led to the establishment of a system responsible for the underlying unity that characterized Qin culture and art. Early developments and innovations reached maturity during Qin Shihuang's era, culminating in a revolution in art that is manifested in the discoveries excavated at his tomb complex.

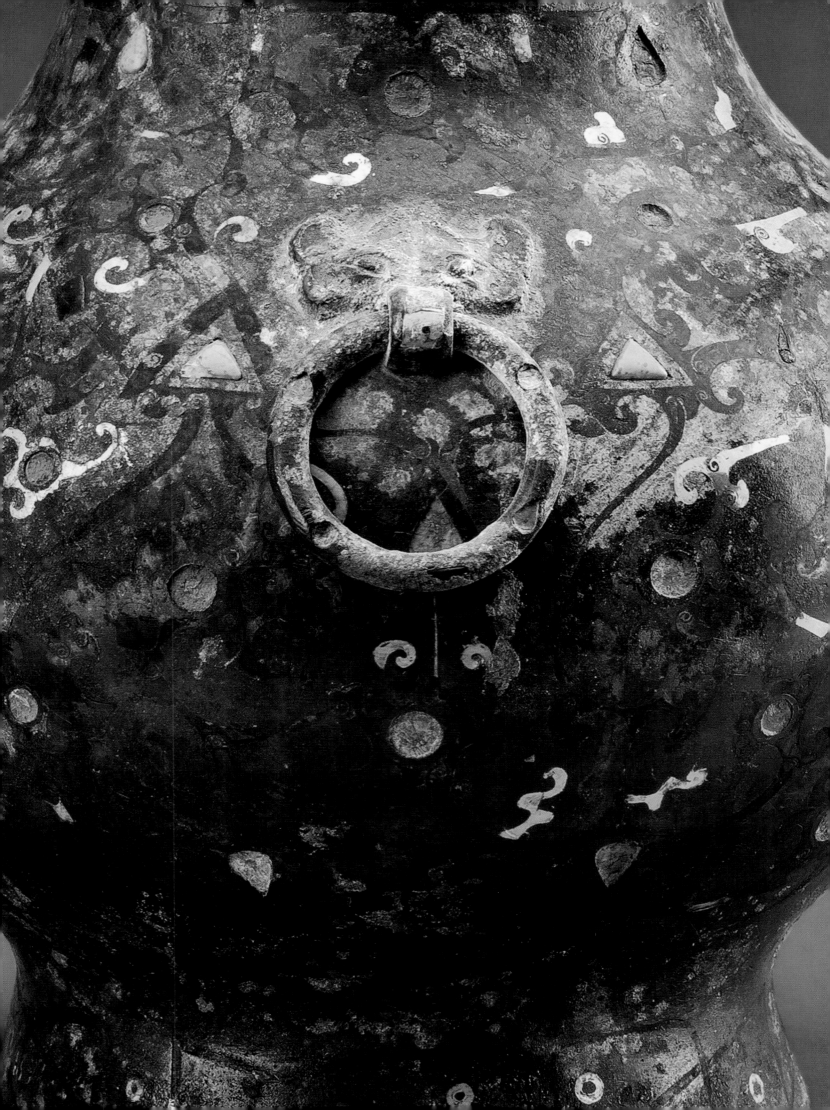

Notes

1. For a discussion of the evolving role of bronze vessels in the ritual context during the Eastern Zhou period, see Liu Yang, "Homage to the Ancestors," *Apollo*, March 2011, pp. 122–27, and idem, *Homage to the Ancestors: Ritual Art from the Chu Kingdom* (Sydney: Art Gallery of New South Wales, 2011).

2. Yin Shengping and Zhang Tianen, "Shaanxi longxian bianjiazhuang yihao chunqiu qin mu" [Qin Tomb 1 of the Spring and Autumn period at Bianjiazhuang in Longxian, Shaanxi], *Kaogu yu wenwu*, 1986, no. 6: 15–19; Baoji Branch of the Shaanxi Provincial Archaeological Institute and Baoji Municipal Archaeological Team, "Shaanxi longxian bianjiazhuang wuhao chunqiumu fajue jianbao" [A brief report on the excavation of Tomb 5 at Bianjiazhuang in Longxian, Shaanxi], *Wenwu*, 1988, no. 11: 14–23; Xiao Qi, "Shaanxi longxian bianjiazhuang chutu chunqiu tongqi" [Bronzes of the Spring and Autumn period excavated at Bianjiazhuang in Longxian, Shaanxi], *Wenbo*, 1989, no. 3: 79–81; Shaanxi Provincial Institute of Archaeology, *Longxian dianzi qinmu* [Qin tombs at Dianzi in Longxian] (Xi'an: Sanqin Press, 1998).

3. Shaanxi Provincial Institute of Archaeology et al., "Shaanxi longxian bianjiazhuang wuhao chunqiumu fajue jianbao" [A brief report on the excavation of Tomb 5 at Bianjiazhuang in Longxian, Shaanxi], pp. 14–23.

4. See Zhang Tianen, "Bianjiazhuang chunqiu mudi yu qianyi diwang" [The cemetery of Spring and Autumn period in Bianjiazhuang and the location of Qian], *Wenbo*, 1990, no. 5: 227–51.

5. Lu Liancheng and Yang Mancang, "Baojixian xigaoquan cun chunqiu qinmu fajueji" [Excavation of the Qin tombs at Xigaoquan village in Baoji], *Wenwu*, 1980, no. 9: 1–9.

6. In addition to those unearthed from Mount Dabuzi in Lixian and Taigongmiao in Baoji, a set of nine *niuzhong* bells of the Spring and Autumn period in the collection of the Gansu Provincial Museum are reported from Lixian. See Li Yongping, "Gansu sheng bowuguan xitong suocang qingtongqi xuanjie" [An introduction of the selected bronzes in the museums' collections in Gansu], *Wenwu*, 2000, no. 12: 69–71, fig. 1.

7. Joint Archaeological Team on Early Qin Culture, "2006 nian gansu lixian dabuzi shan jisi yiji fajue jianbao" [A brief report on the excavation of the sacrificial remains at Mount Dabuzi in Lixian, Gansu, in 2006], *Wenwu*, 2008, no. 11: 14–29; Joint Research Team on Early Qin Culture, "Gansu lixian dabuzi shan zaoqi qin wenhua yizhi" [The early Qin cultural site at Mount Dabuzi in Lixian, Gansu], *Kaogu*, 2007, no. 7: 38–46; Zhao Huacheng, Wang Hui, and Wei Zheng, "Lixian dabuzi shan qinzi yueqi keng xianguan wenti tantao" [A discussion of the Qinzi "musical instrument pit" in Mount Dabuzi, Lixian, and related issues], *Wenwu*, 2008, no. 11: 54–65.

8. Lu Liancheng and Yang Mancang, "Shaanxi baojixian taigongmiao cun faxian qingong zhong, qingong bo" [The *bo* and *zhong* bells of the Duke of

Qin found in Taigongmiao in Baoji, Shaanxi], *Wenwu*, 1978, no. 11: 1–3.

9. Institute of Archaeology of China Academy of Social Science, *Yinzhou jinwen jicheng* [Corpus of Shang and Zhou bronze inscriptions] (Beijing: Zhonghua Press, 1984–94), vol. 1, nos. 262–69; Gilbert L. Mattos offers another translation of the inscription in "Eastern Zhou Bronze Inscriptions," in *New Sources of Early Chinese History: An Introduction to the Reading of Inscriptions and Manuscripts*, ed. Edward L. Shaughnessy (Berkeley: Society for the Study of Early China and the Institute of East Asian Studies, University of California, Berkeley, 1997), pp. 111–14.

10. Lothar von Falkenhausen, "The Waning of the Bronze Age: Material Culture and Social Development, 770–481 B.C.," in *The Cambridge History of Ancient China: From the Origins of Civilization to 221 B.C.*, ed. Michael Loewe and Edward L. Shaughnessy (Cambridge: Cambridge University Press, 1999), p. 487.

11. See Wu Hung, *Monumentality in Early Chinese Art and Architecture* (Stanford, Calif.: Stanford University Press, 1995), pp. 92–100.

12. Ibid.

13. See Zhang Zhi, ed., *Tianjin bowuguan jinghua* [Gems of the Tianjin Art Museum] (Tianjin: Tianjin Yangliuqing Press, 2005), pl. 39.

14. Li Chunyi, *Zhongguo shanggu chutu yueqi zonglun* [A study of the excavated Chinese ancient musical instruments] (Beijing: Wenwu Press, 1996), p. 151.

15. See *Mozi jiaozhu* [Annotated Mozi] (Beijing: Zhonghua Press, 1993), *juan* 8, p. 337.

16. See Lin Jianming, *Qin shigao* [The Qin history] (Shanghai: Shanghai Remin Press, 1981), p. 21.

17. See "Basic Annals of Qin," in *Records of the Grand Historian: Qin Dynasty*, trans. Burton Watson (New York: Columbia University Press, 1993), p. 2.

18. Zhou Heng, *Xia shang zhou kaoguxue lunwen ji* [Selected essays on the archaeology of Xia, Shang, and Zhou periods] (Beijing: Wenwu Press, 1980), pp. 326–27, fig. 5.

19. See Li Xueqin, *Eastern Zhou and Qin Civilizations*, trans. K. C. Chang (New Haven, Conn.: Yale University Press, 1985), p. 267.

20. See Chen Ping, "Shilun guanzhong qinmu qingtong rongqi de fengqi wenti" [A preliminary discussion of the periodization of bronze vessels excavated from Qin tombs in Shaanxi], *Kaogu yu wenwu*, 1984, no. 3: 69.

21. Shaanxi Provincial Archaeological Team at Yong, "Fengxiang gaozhuang zhanguo qinmu fajue jianbao" [A brief report on the excavation of Qin tombs of the Warring States Period at Gaozhuang in Fengxiang], *Wenwu*, 1980, no. 9: 10–14, fig 8:1.

22. Cf. Chen Ping, "Shilun guanzhong qinmu qingtong rongqi de fengqi wenti," *Kaogu yu wenwu*, 1984, no. 3: 58–73, and 1984, no. 4: 63–73; Wang

Xueli and Liang Yun, *Qin wenhua* [The Qin culture] (Beijing: Wenwu Press), pp. 175–85.

23. See Li Xueqin, "Xingyang shangguan min yu anyi xiaguan zhong" [The *min* vessel with inscription of Xingyang and the *zhong* vessel with Anyi *shangguan* inscription], *Wenwu*, 2003, no. 10: 79–80; idem, *Wenwu zhong de gu wenming* [Ancient civilization reflected in the cultural relics] (Beijing: Shangwu Press, 2008), pp. 321–27.

24. Xianyang Municipal Museum, "Shanxi xianyang ta'erpo chutu de tongqi" [Bronze vessels excavated at Ta'erpo in Xianyang], *Wenwu*, 1975, no. 6: 69–72, figs. 4 and 5.

25. Jing Hongwei and Wang Zhouying, "Fengxiang faxian zhanguo fengniao xianhuan tongxunlu" [Incense burner with phoenix-shaped finial of Warring States period found in Fengxiang], *Wenbo*, 1996, no. 1: 57.

26. Editorial Committee of "Gems of China's Cultural Relics," *Zhongguo wenwu jinghua 1992* [Gems of China's cultural relics 1992] (Beijing: Wenwu Press, 1992), plate 109. Two bronze vessels with similar design and technique are a two-layered *fou* vessel in Harvard Art Museums/Arthur M. Sackler Museum (1943.52.70) and a globular two-layered tripod in the Metropolitan Museum of Art (47.27a.b); see Jenny So, *Eastern Zhou Ritual Bronzes from the Arthur M. Sackler Collections* (Washington, D.C.: Arthur M. Sackler Foundation in association with the Arthur M. Sackler Gallery, Smithsonian Institution, 1995), p. 28, figs. 23 and 24.

27. Editorial Committee of "Gems of China's Cultural Relics," *Zhongguo wenwu jinghua 1990* [Gems of China's cultural relics 1990] (Beijing: Wenwu Press, 1992), plate 73.

28. For the excavation of these tombs and bronzes, see Henan Provincial Institute of Archaeology, *Xichuan xiasi chumu* [Chu tombs in Xiasi, Xichuan] (Beijing: Wenwu Press, 1991); the *jin* stand is illustrated in plates 49–51. For a discussion of the Chu bronzes, see also Liu Yang, *Homage to the Ancestors: Ritual Art from the Chu Kingdom*, pp. 46–105.

29. Shaanxi Provincial Institute of Archaeology and Qin Shihuang Terracotta Warriors and Horses Museum, "Qinshihuang lingyuan K0007 peizang keng fajue jianbao" [A brief report on the excavation of Pit K0007 at Qin Shihuang's tomb complex], *Wenwu*, 2005, no. 6: 16–37.

30. Shaanxi Provincial Institute of Archaeology and Qin Shihuang Terracotta Warriors and Horses Museum, *Qin Shihuangdi lingyuan kaogu baogao 2001–2003* [Qin Shihuang tomb complex: An archaeological report 2001–2003] (Beijing: Wenwu Press, 2007).

31. Yuan Zhongyi, "Guanyu qinshihuang ling tongqinkeng chutu yijiyiwu de chubu renshi" [A preliminary discussion of the remains from the bronze waterbird pit in Qin Shihuang's tomb complex], in *Qin wenhua luncong* [Qin Culture Studies Series], ed. Terracotta Warriors and Horses Museum, vol. 12 (Xi'an: Sanqin Press, 2005).

32. Jiao Nanfeng, "Qinshihuang ling peizangkeng xingzhi lice" [A preliminary discussion of the purpose of the burial pits in the Qin Shihuang tomb complex], *Wenwu*, 2005, no. 12: 44–51.

33. Shaanxi Provincial Institute of Archaeology and Qin Shihuang Terracotta Warriors and Horses Museum, *Qin Shihuangdi lingyuan kaogu baogao 2001–2003.*

34. This was first mentioned by Jia Yi (200–168 BCE) in his famous essay "Guo qin lun" [Faults of the Qin], in his book *Xinshu* [New book] (Shanghai: Shanghai Guji Press, 1988), p. 2. See also Sima Qian, *Shiji* (Beijing: Zhonghua Press, 1959), p. 281.

35. Shaanxi Provincial Institute of Archaeology, *Qindu xianyang kaogu baogao* [A report on the archaeological excavation at the Qin capital Xianyang] (Beijing: Kexue Press, 2004), p. 198, color plate 3; Liu Yang and Edmund Capon, *The First Emperor: China's Entombed Warriors* (Sydney: Art Gallery of New South Wales, 2010), p. 174, plate 112.

36. See Jia Yi, "Guo qin lun," p. 2, and Sima Qian, *Shiji*, p. 281.

37. *Qin Gold* (London: Christian Deydier/Oriental Bronzes, 1994); Han Wei, "Lun gansu lixian chutu qin jinbo shipian" [On the Qin gold foils unearthed in Lixian, Gansu], *Wenwu*, 1995, no. 6: 1–11.

38. Cf. Emma C. Bunker, "Gold in the Ancient Chinese World: A Cultural Puzzle," *Artibus Asiae* 53, no. 1/2 (1993): 27–50.

39. Baoji Municipal Institute of Archaeology, "Baojishi yimencun erhao chunqiumu fajue jianbao" [A brief report on the excavation of Tomb 2 of the Spring and Autumn period at Yimen village in Baoji], *Wenwu*, 1993, no. 10: 1–14.

40. Zhang Tianen, "Qinqi sanlun" [Three discussions on Qin gold objects], *Wenwu*, 1993, no. 10: 20–39; Li Xueqin, "Yimencun jinyin yuqi wenshi yanjiu" [A study on the ornaments of the gold and jade objects excavated at Yimen village], *Wenwu*, 1993, no. 10: 15–19.

41. Wang Renxiang, "Daigou gailun" [A general discussion of belt hooks], *Kaogu xuebao*, 1985, no. 3: 267–312.

42. See Lixian Museum and Lixian Qin Xichui Cultural Research Association, *Qin xichui lingqu* [The Qin necropolis at Xichui] (Beijing: Wenwu Press, 2005), pp. 78–85; Jenny So, *Eastern Zhou Ritual Bronzes from the Arthur M. Sackler Collections*, p. 30, fig. 29a.

43. Shaanxi Provincial Institute of Archaeology, "Shaanxi chang'an shenheyuan zhanguo qin lingyuan yizhi tianye kaogu xin shouhuo" [New achievements in the field archaeological excavation carried out at the Qin cemetery of the Warring States period at Shenheyuan in Chang'an, Shaanxi], *Kaogu yu wenwu*, 2008, no. 5: 111–12; Ding Yan, "Shenheyuan zhanguo lingyuan zhuren shitan" [An exploration of the tomb occupant at the Qin cemetery of the Warring States period at Shenheyuan], *Kaogu yu wenwu*, 2009, no. 4: 62–66.

44. Cf. Yang Boda et al., eds., *Zhongguo yuqi quanji* [The complete collection of jades in China], vol. 3, *Qunqiu zhanguo shiqi* [Spring and Autumn and Warring States period] (Shijiazhuang: Hebei Fine Arts Press, 1993), plates 42, 43, 46, 74, and 78.

45. "Quwo fajue jinhou bangfu ji furen mu" [The tomb of Duke Bangfu of the Jin state and his wife excavated at Quwo], *China Cultural Relics News*, January 30, 1994, p. 1.

46. For a brief survey of Qin gold and silver, see also Liu Yang, "Inheritance and Innovation: An Archaeological Perspective of Qin Art," *Arts of Asia*, January/February, 2011, pp, 80–93.

47. Lin Jianming has counted nearly sixty such persons. See his article "Cong qinren jiazhiguan kan qin wenhua de tedian" [Characteristics of the Qin culture, view from the perspective of Qin peoples' value judgment], in *Qin wenhua luncong* [Qin Culture Studies Series], Terracotta Warriors and Horses Museum, vol. 1 (Xi'an: Northwest University Press, 1993), pp. 1–20.

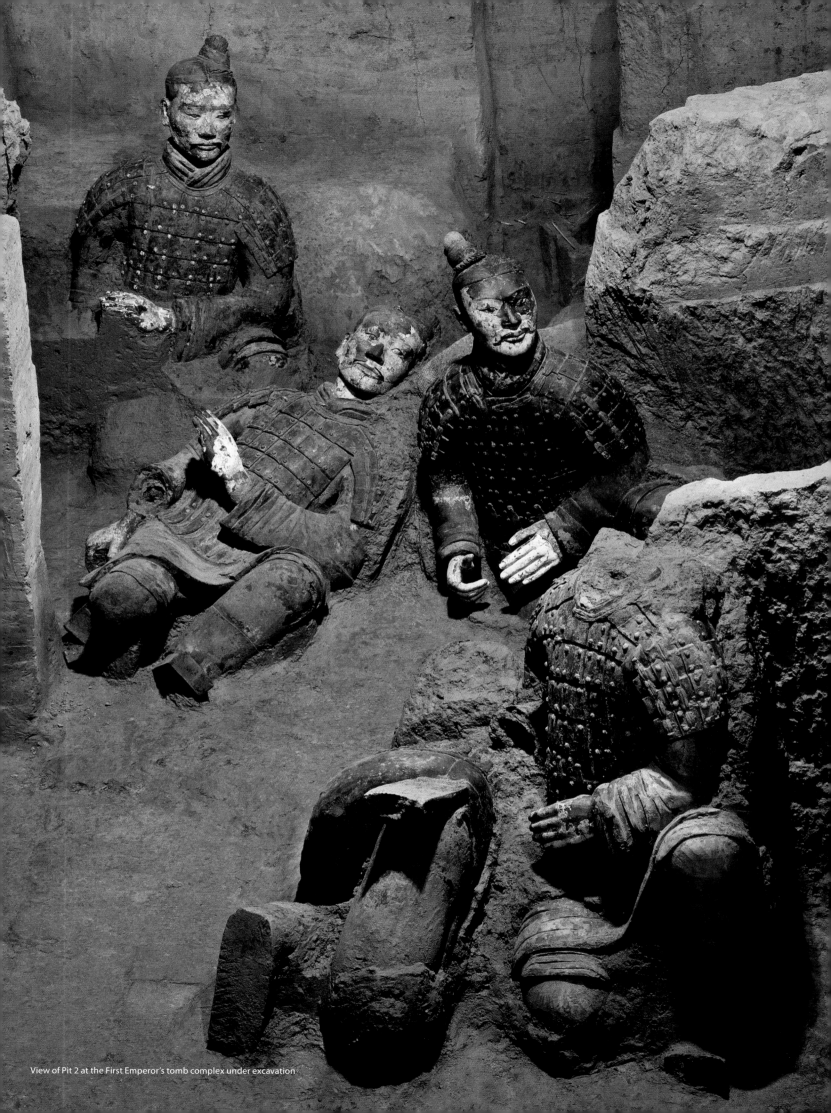

View of Pit 2 at the First Emperor's tomb complex under excavation

Quest for Immortality: The First Emperor's Tomb Complex and Terracotta Army

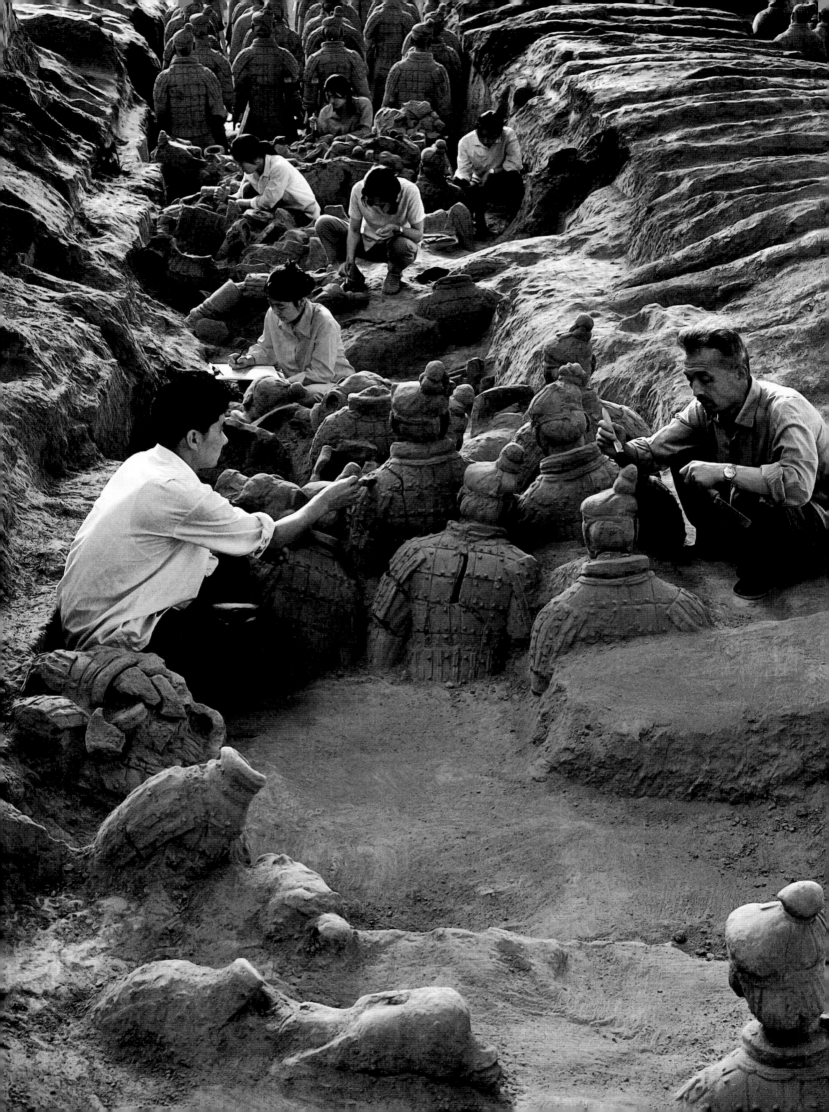

The Discovery and Excavation of the Terracotta Army

YUAN ZHONGYI

Years of drought during the early 1970s threatened the lives of the people in the village of Xiyang in Lintong, Shaanxi province, at the foot of Mount Li. Finding a solution to the water shortage became imperative. In the afternoon of March 24, 1974, a few members from the commune under the leadership of Yang Peiyan and Yang Wenxue arrived in the south of the village to begin digging a well. Reaching a depth of three meters (10 ft), on March 29, a pit below was revealed through an opening similar in size to an earthenware container.

As the digging continued, fragments of terracotta heads, legs, arms, and other pieces were continually uncovered. Some of the people working on site believed they were the "Washenye" (tile deity), or that the dig had uncovered the Temple of the Washenye. When the digging reached a depth of 4.5 meters (15 ft), bronze arrowheads, bronze crossbows, and other weapons, as well as a tiled floor area, were uncovered.

News that the peasants had dug up the Washenye quickly spread to the villages of Xiyang and Xiahe. Some elderly women came to light incense and pray to the Washenye for blessings for their families. Others believed this was the God of Plagues, and proceeded to smash the already fragmented pieces.

Fan Shumin, a county water conservancy supervisor, usually traveled to the various villages to make inspections and organize repairs in relation to water conservancy matters. On arriving in Xiyang to check progress of the well-digging project, he immediately stopped the digging and rushed back to Lintong to inform the County Museum. Three museum staff hurried to the site, where they saw several near-complete but headless terracotta figures with fragments of terracotta pieces scattered around. They halted the digging and gathered the objects unearthed so far to take back to the museum.

Meanwhile, a journalist working for the Xinhua News Agency heard about the discovery of terracotta figures while visiting family in Lintong and stopped by the museum to see for himself the two terracotta warriors as well as the fragments of heads, torsos, and limbs that were awaiting restoration. Amazed by the sight, he submitted an article to his news agency. The article was published the following day in the 2,396th issue of the "Collection of Internal Reports" (a news service available only to ranking government officials), attracting the attention of Chairman Mao, Premier Zhou, and leading personnel in the State Council. Upon the approval of the Ministry of Cultural Affairs, an archaeological team and excavation groups were promptly set up in Shaanxi, and I was appointed head of the excavation team. The State Administration for Cultural Relics required us to finish the excavation in a week.

Pit 1 at the First Emperor's tomb complex under excavation in the late 1970s

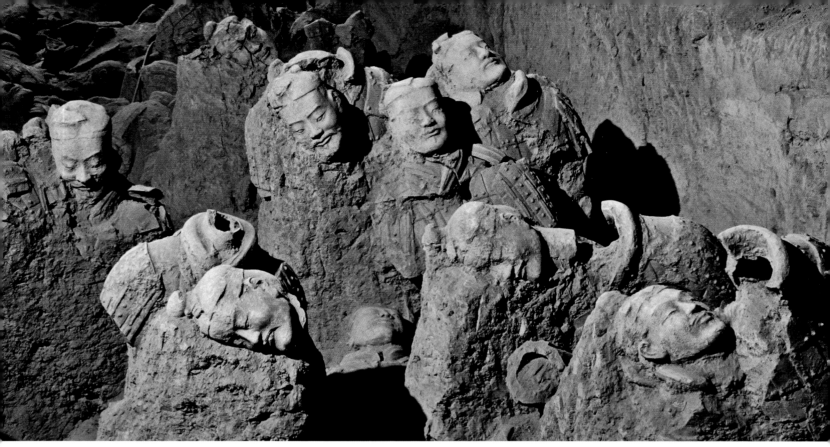

Pit 1 under excavation

Preliminary test excavation of terracotta warrior Pit 1 began on July 17, 1974. Our first task was to determine the boundary of the pit. The result astonished everyone, its scale larger than any of us could have imagined. We quickly realized that this was a task that could take our whole career.

By end of June of 1975, we had gathered enough information to ascertain the size, shape, and contents of Pit 1. From the style and period of the artifacts, as well as the proximity to the Qin Shihuang Mausoleum, a calculated assumption was made to name the site the Qin Shihuang Mausoleum Terracotta Army Pit.

In the month of February 1976, after starting construction of a building to protect the warriors in Pit 1, we turned our attention to explore the possibility of finding other pits nearby. As Pit 1 was located 1.5 kilometers (nearly a mile) east of the Qin Shihuang Mausoleum, we began test excavation of a site 1.5 kilometers west of the mausoleum. After about a month of excavation work, the site proved to be futile. Next, we turned our attention to a site north of the mausoleum. Likewise, the dig produced no results. Just when the excavation works seemed in vain, news of a potential discovery emerged on April 21, 1976, when a construction worker discovered an area of tamped earth east of Pit 1. By April 23, fragments of terracotta figures had been uncovered from the site, heralding the discovery of Pit 2.

After the discovery of Pit 2, our team was split into two groups: one working on the test excavation of Pit 2 and the other surveying for other sites in the surrounding area. The rationale was, if east of Pit 1 was Pit 2, then west of Pit 1 may be another similar pit. On May 11, 1976, we successfully uncovered another pit, subsequently named Pit 3. Test excavations for this site began in March 1977 and the excavation works were completed by December of that year.

After the discovery of Pit 3, we continued to survey the surrounding area, and in an afternoon in June 1976, I uncovered another pit west of Pit 2. This pit was subsequently named Pit 4. Its southern boundary had already sustained much damage. Unlike the other pits, this one was empty—suggesting it was never finished.

Over the next four years, a series of excavations carried out in the surrounding area unearthed more than 80 horse stall pits in various sizes, 31 precious bird and animal pits, 17 human burial pits, and a bronze chariot pit. Today excavation at the Qin Shihuang Mausoleum continues. Although a new generation of archaeologists has now taken over the task, I am always proud of being one of the first to uncover the secrets of the "Eighth Wonder" of the ancient world.

Translated from the Chinese by Lim Chye Hong

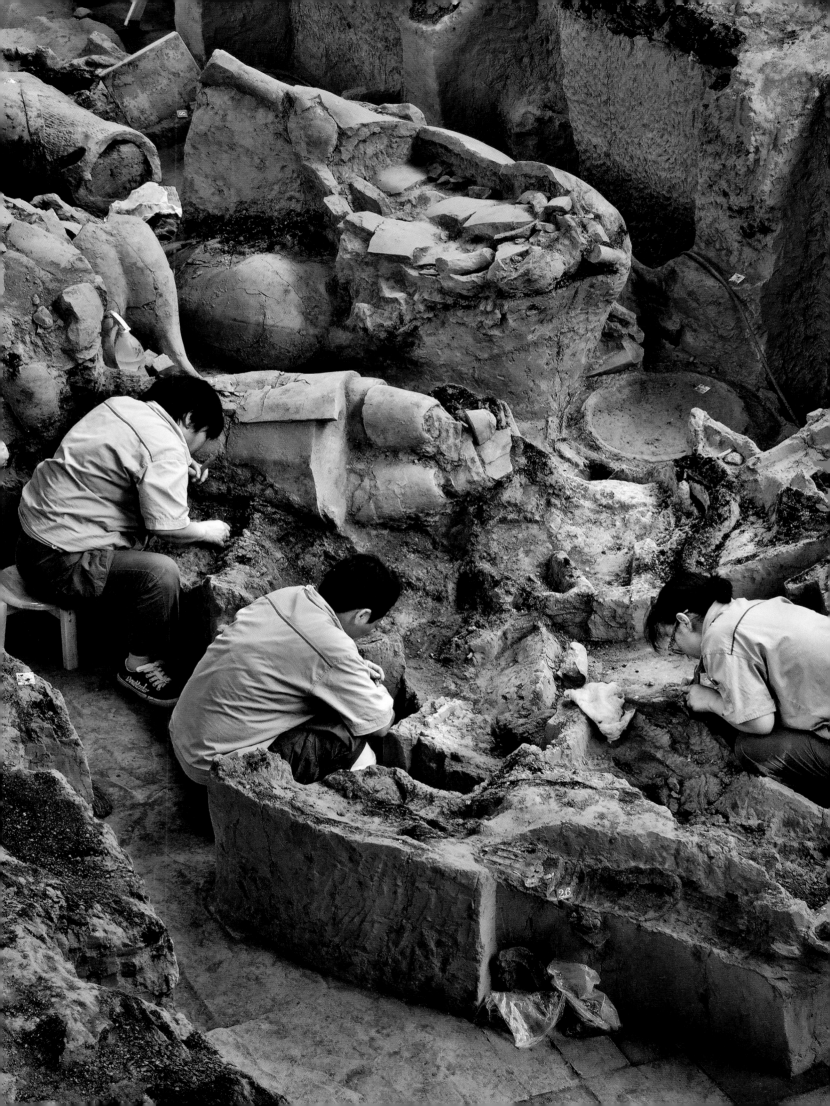

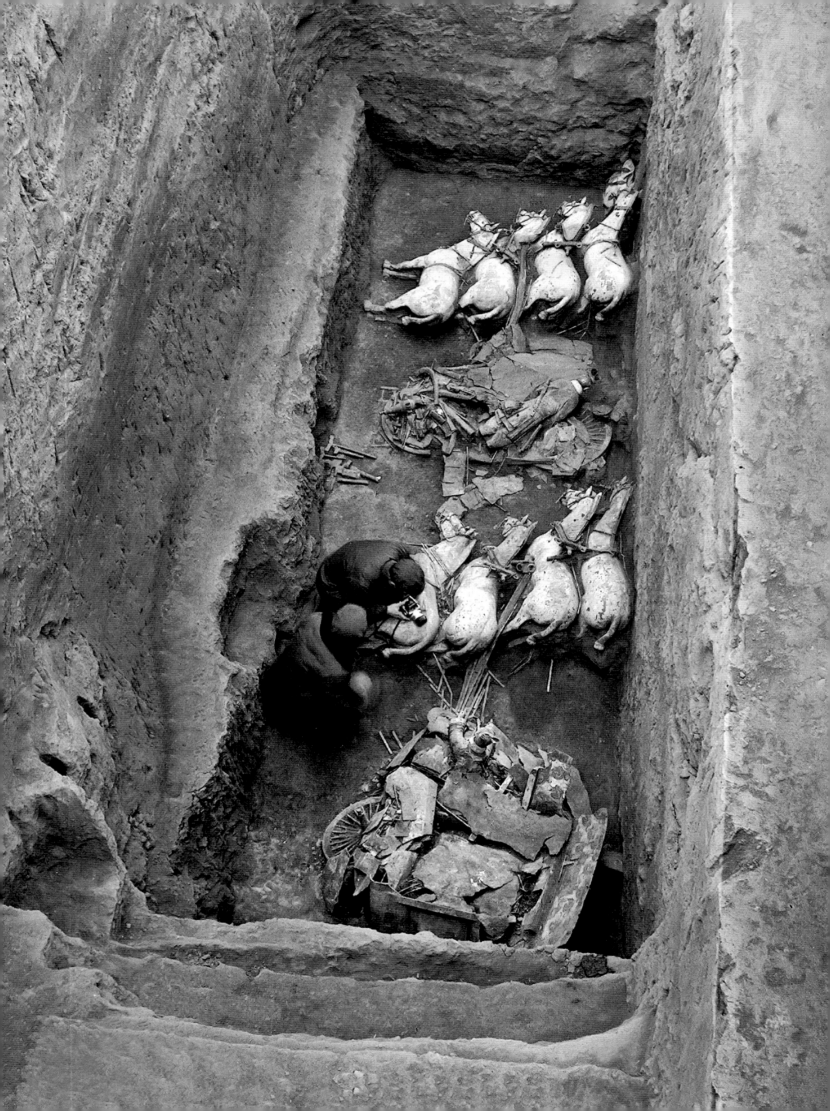

The First Emperor's Tomb Complex

Liu Yang

Qin Shihuang's mausoleum is located about twenty-two miles east of present-day Xi'an, between Mount Li in the south and the Wei River to the north. According to traditional Chinese geomancy, the area between Mount Li and Mount Hua is shaped like a dragon, and the mausoleum is positioned at the dragon's eye. The site was apparently chosen in the belief that invisible energy currents, or "dragon veins," run from the sky down into the mountain peaks and then along the earth, blending heavenly and earthly energies, creating auspiciousness, and being beneficial to the deceased and his offspring.

Work had begun on the mausoleum as soon as Zheng, the future First Emperor, became king of the Qin state in 246 BCE. As recorded in the *Shiji* (Records of the Grand Historian), by Sima Qian—a great historian who lived during the early Han dynasty—more than seven hundred thousand conscripts from all parts of the empire labored at the site.[1] Since the complex was only completed during the reign of the Second Emperor, estimates are that its construction took thirty-eight or thirty-nine years in all.

Bounded by a protective outer wall extending over a mile from north to south and about half a mile from east to west, the burial mound, situated in the southern half of the compound, is surrounded also by an inner wall. This above-ground inner barrier replaces the moat and ditches used in the earlier Qin rulers' mausoleum in the old capital Yong. The walled complex is a replica of the capital city of Xianyang and its palaces, serving to suggest the continuous presence of the First Emperor.

The most obvious statement of the emperor's presence, however, is the mound above his tomb (fig. 1). Looking today like a hill overgrown with trees, it was originally an earthen pyramid with a wide base and flat top, a terrace upon which pavilions were built. In the course of more than two thousand years, the 330-foot-high hill has weathered down to about 150 feet. It is about 1,690 feet from north to south and 1,590 feet from east to west. Beneath the tumulus and within the mysterious huge chamber, Alhambraesque buildings housing numerous precious treasures are said to be buried. Sima Qian's brief description hints at dazzling contents. According to him, molten copper was used to seal the tomb. The underground palace was a gem-studded replica of imperial housing above ground. To deter anyone who might try to break in, booby traps with automatic-shooting arrows were installed.

As his urban plan for the capital city, Xianyang, makes plain, the First Emperor had never viewed building as a random affair. Structures on earth inevitably related to those thought to be in heaven, and symmetry was crucial. Therefore heaven and earth were said to be represented in the tomb's central chamber. The

Left: Bronze Chariot Pit under excavation in 1980

Previous:
The First Emperor's tomb mound, photographed in 1914 by the French explorer Victor Segalen

Plan of the First Emperor's tomb complex

Bronze birds and terracotta musicians pit K0007

Yuchi site

Outer wall

Xiajiaocun

Inner wall

Remains of offices

Remains of secondary palace

Accompanying cemetery

Retiring hall

Sacrificial pits

Remains of offices

Accompanying cemetery

Bronze chariots and horses pits

Sacrificial animal pits

Horse stable pits

Tomb mound

Stone armor pits K9801

Shangjiaocun

Tombs of craftsmen

Stable pits

N

Officials pit K0006

Acrobats pit K9901

Dike

0 1 km

Linma Road

Pit 3 Pit 4 ● Xiayangcun

Pit 2

Pit 1

Terracotta warriors
and horses pits

Unexcavated
tomb

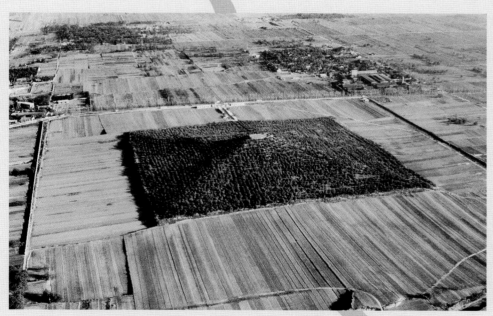

Fig. 1. Aerial view of the First Emperor's tomb complex, which covers about twenty-two square miles

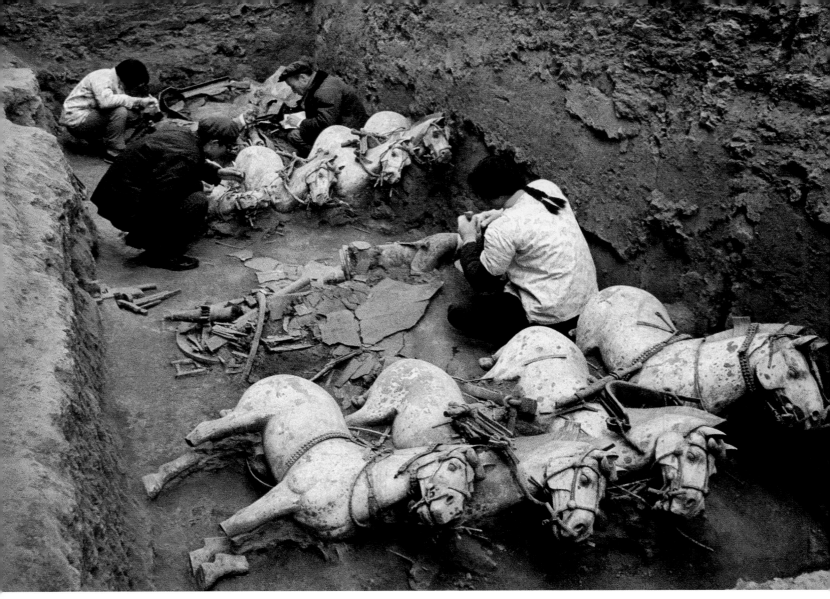

Fig. 2. Bronze Chariot Pit under excavation in 1980

ceiling was shaped into sky, with inlaid pearls and gems symbolizing sun, moon, and stars; in the ground beneath, flowing mercury resembling China's rivers signified the earth. The underground palace was supposed to be brightly lit for eternity by whale oil lamps. Although this main chamber, containing the emperor, has yet to be opened, scans of the earth atop the tomb have shown unusually high concentrations of mercury, adding credibility to Sima Qian's description.[2]

For over two thousand years, the tumulus surrounded by two walls attracted people's interest. But no one had ever imagined that the complex plan and symbolic content of the mausoleum extended far beyond the protective walls. This was not known until 1974, when local farmers drilling a well discovered fragments of terracotta figures approximately three-quarters of a mile east of the emperor's tomb. Shortly thereafter, Chinese archaeologists excavated three pits containing an estimated eight thousand or more life-size terracotta warriors of different ranks, together with horses and chariots, all designed to protect the emperor in his afterlife.

In the third century BCE, when these burial pits were constructed, the soil covering them was probably noticeably higher than the surrounding ground. Like the First Emperor's tumulus, they would have been obvious and identifiable in the landscape. At the end of the Qin dynasty, when peasant armies rose against the stringencies of Qin rule, literary records suggest that the emperor's burial site was attacked.

In 207 BCE there were two principal rebel forces. One was led by Liu Bang (c. 256–195 BCE), who later founded the succeeding Han dynasty and became its first emperor under the title of Gaozu, and the other by Xiang Yu (232–202 BCE), who came from a family distinguished by generations of generals in the former state of Chu. They acted in concert against the Qin hierarchy until, with victory in sight, the two leaders evidently took

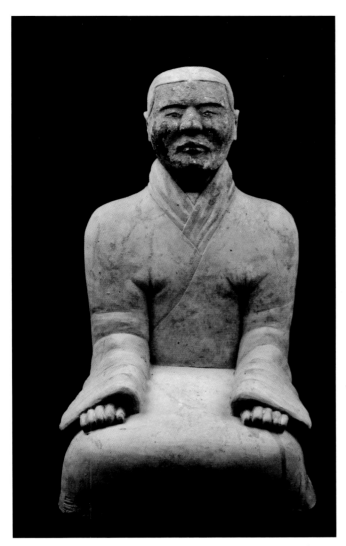

Fig. 3. Terracotta stableboy excavated from the pits that represent the royal stables in the First Emperor's tomb complex

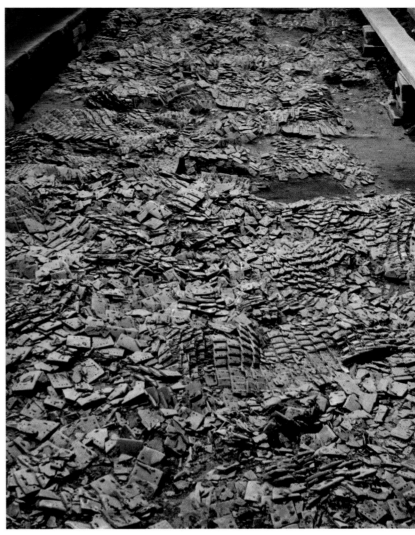

Fig. 4. Detail of Pit K9801 showing clusters of armor fragments

independent courses that eventually led to conflict. Although historical records suggest that Liu Bang entered the Qin capital at Xianyang first, it was Xiang Yu who killed Ziying, the short-lived successor to the Second Emperor of Qin, and then ransacked the capital. It was probably at this time, in 206 BCE, that an assault was made on the guardian army burial pits and Qin Shihuang's tomb. This is mentioned in Sima Qian's *Shiji*, Ban Gu's *Hanshu* (History of the Han dynasty), and, in more detail, in Li Daoyuan's *Shuijing zhu* (Commentary on the Waterways Classic).

> After Xiang Yu entered the pass, he opened the mausoleum. After thirty days of plundering they still could not exhaust the contents of the mausoleum. Bandits from east of the pass melted the coffins for bronze as well as setting fire to it. The fire burned for more than ninety days.[3]

Since the First Emperor's tomb itself has not yet been excavated, the accuracy of these reports of its plundering

cannot be verified. However, the burial pits of the guardian army do show signs of having been set on fire by intruders, for charred timbers and pottery fragments and scorched earth are clearly visible in the excavated areas, particularly in Pit 1. Although Pit 3 was not burned, it was purposely damaged, with many terracotta figures broken and even missing their heads. Many weapons were also taken from the pits. It may well have been during Xiang Yu's assault that the protective timber framework was set on fire, causing the construction to collapse and resulting in most of the damage evident today.

Following the initial discovery and excavation of the warrior pits in the 1970s, remarkable discoveries continue to be made in the immediate vicinity. Two magnificent bronze chariots were found on the western side of the tomb complex in 1980, in a location originally covered by the tomb mound (fig. 2). Also during the early 1980s, archaeologists excavated more than a hundred pits in an area east of the tomb mound, approximately 380 yards

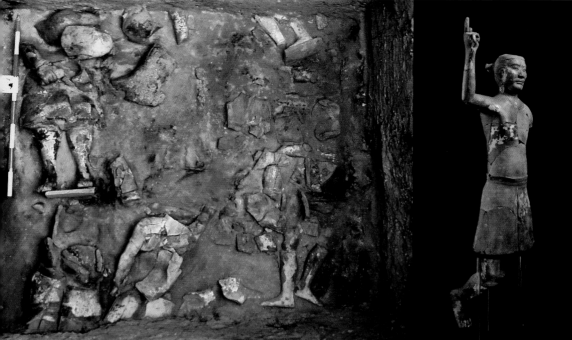

Fig. 5. View of Pit K9901 under excavation in 1999 and a terracotta acrobat

Fig. 6. Terracotta civil service official from Pit K0006

beyond the outer wall. Thought to represent the royal stables, many of these pits contained a dead horse slaughtered before burial, others held a seated terracotta figurine (fig. 3), and some contained both. Objects such as lamps, tools, and jars holding traces of seeds and hay were placed around the horses and figures. Inscriptions on the pottery, such as "dajiu" (grand stable), "zhongjiu" (medium stable), and "zuojiu" (left stable), suggest that the imperial stables were of considerable size. Similar pits with standing terracotta figures were found between the inner and outer walls, west of the tomb mound, along with some thirty-one pits containing various animals, including deer and muntjacs, possibly representing a royal zoo.[4]

Another important find, made in 1997–98, was the so-called stone armor pit (K9801), 220 yards to the southeast of the tomb mound. Covering almost three and a half acres, only slightly smaller than Pit 1, it has so far yielded eighty-seven sets of armor, forty-three helmets, and three sets of horse armor, all made of limestone (fig. 4).[5] In 1999 a pit (K9901) with eleven figures believed to be acrobats, modeled in various postures, was excavated only 44 yards south of the stone armor pit (fig. 5).[6] A pit (K0006) with twelve terracotta figures and twenty horse skeletons was found in 2000 in the southwest corner of the tomb mound. Eight of the standing figures wear official robes, with a knife and grindstone (used to make records) hanging from their belts (fig. 6). They are thought to represent civil officials working in government departments.[7]

In 2001, about half a mile beyond the northeast corner of the outer wall, a pit known as K0007 was discovered, containing fifteen seated terracotta figures (fig. 7), twenty life-size bronze swans, six cranes, and twenty wild swans (yan), all lining the banks of an artificial watercourse (fig. 8; see cat. nos. 82–85). This is thought to be a scene of court musicians training birds in the royal park.[8]

Clearly, the First Emperor planned his tomb as an elaborate subterranean palace, a parallel world that would provide for him and perpetuate his rule into the afterlife. The contents of the various pits in the tomb's immediate vicinity present an account of his daily life and needs, including accommodation, entertainment, travel, and bureaucratic assistance. The terracotta army represents Qin military prowess. The burial pits containing stablemen, prized animals, bronze birds, and acrobats give a glimpse of palace, stables, and royal gardens. The "civil officials" pit represents the centralized government, with courtiers assisting the emperor in promulgating law and order throughout the empire. The bronze chariots and horses from the mausoleum display the formation of the guard of honor that attended the emperor on his tours. All these are meant to ensure a posthumous existence with all of life's luxuries. To provide for Qin Shihuang's soul and perpetuate his rule, the living world is mirrored in the mausoleum.

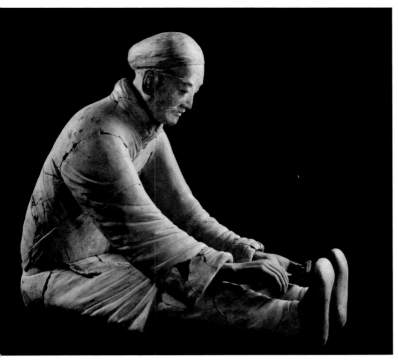

Fig. 7. Seated terracotta figure excavated from Pit K0007

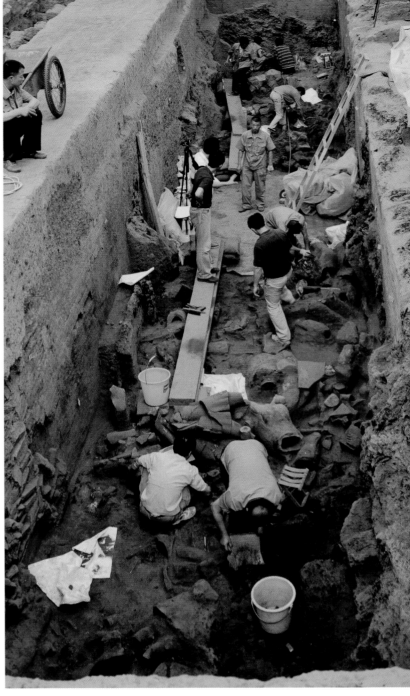

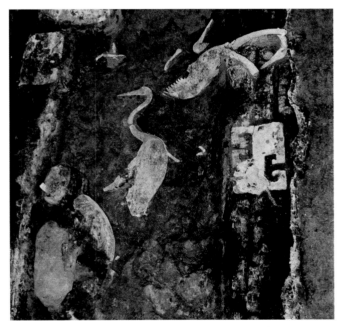

Fig. 8. View of Pit K0007 under excavation

Excavation at Pit K9901 in 2012

Notes

1. Sima Qian, *Shiji* (Beijing: Zhonghua Press, 1959), vol. 1, *juan* 6, p. 265.

2. Duan Qingbo, "Scientific Studies of the High Level of Mercury in Qin Shihuangdi's Tomb," in *The First Emperor: China's Terracotta Army*, ed. Jane Portal (London: British Museum Press, 2007), pp. 204–7. See Sima Qian, *Shiji*, vol. 1, *juan* 6, p. 265, and also Ban Gu (c. 32–92 CE), *Hanshu* [History of the Han dynasty] (Beijing: Zhonghua Press, 1962), vol. 7, *juan* 36, p. 1954.

3. Li Daoyuan (c. 470–527 CE), *Shuijing zhu* [Commentary on the Waterways Classic] (Beijing:

Zhonghua Press, 2007), *juan* 19, p. 622. And see Sima Qian, *Shiji*, vol. 2, *juan* 8, p. 376, and Ban Gu, *Hanshu*, *juan* 36, p. 1954.

4. Yuan Zhongyi, *Qin shihuang ling de kaogu faxian yu yanjiu* [The archaeological discovery and research of Qin Shihuang's tomb complex] (Xi'an: Shaanxi Renmin Press, 2002), pp. 198–222, 136–48.

5. Ibid., pp. 149–78.

6. Ibid., pp. 179–96.

7. Shaanxi Provincial Institute of Archaeology and Qin Shihuang Terracotta Warriors and Horses

Museum, *Qinshihuangdi lingyuan kaogu baogao 2000* [Qin Shihuang mausoleum archaeological report 2000] (Beijing: Wenwu Press, 2002).

8. Shaanxi Provincial Institute of Archaeology and Qin Shihuang Terracotta Warriors and Horses Museum, "Qinshihuang lingyuan K0007 peizang keng fajue jianbao" [A brief report on the excavation of Pit K0007 at the First Emperor's tomb complex], *Wenwu*, 2005, no. 6: 16–37.

Battle formation of the terracotta army

PIT 1

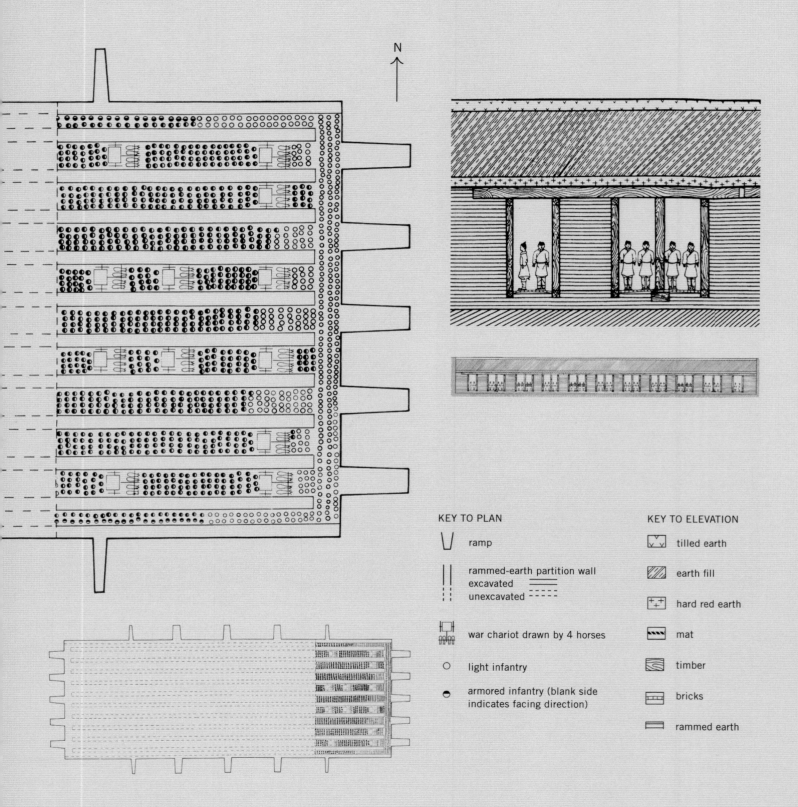

KEY TO PLAN

⋁ ramp

‖ rammed-earth partition wall
excavated ⎯⎯⎯
unexcavated - - - -

war chariot drawn by 4 horses

○ light infantry

◐ armored infantry (blank side indicates facing direction)

KEY TO ELEVATION

tilled earth

earth fill

hard red earth

mat

timber

bricks

rammed earth

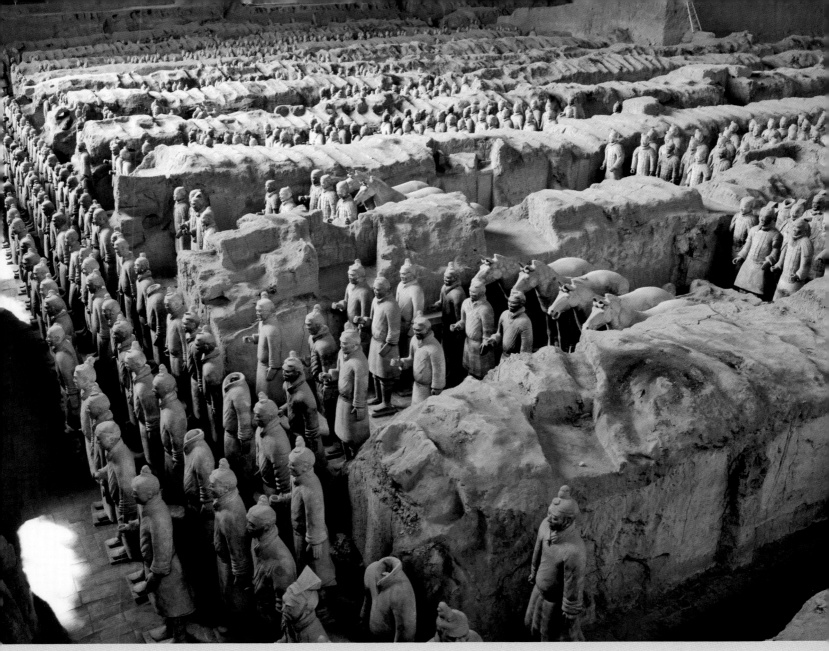

Rows of warriors and horses in Pit 1

Roughly 15 to 20 feet deep and covering 3½ acres, Pit 1 is estimated to contain 6,000 terracotta warriors and horses and 50 chariots, representing the main army. So far, 1,900 terracotta figures, 22 wooden chariots, and 88 chariot horses have been unearthed. They are arranged in typical combat formation. Guarding the perimeter on all sides are rows of infantry, some armored and others not, most with crossbows. The outermost row or two on each side faces outward, and the others face east. Inside the perimeter are nine tunnels, each with 36 rows of warriors four abreast, chariots and horses; the warriors carry mainly long-handled weapons. This battle formation, with long-range weapons in front and short-range ones at the back, accords with the classical treatises on war of that time. Infantry had replaced the chariot as a key strength, though chariots continued in use until the time of Emperor Wu of the Han dynasty (r. 141–87 BCE).

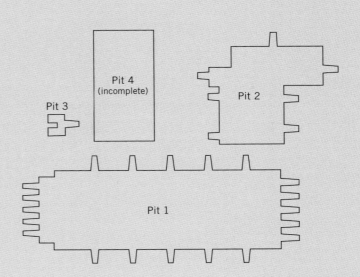

PIT 2

Pit 2 occupies 1½ acres and like Pit 1 is only partially excavated. Based on the types of figures, it has four sections. Section 1, the eastern end, contains 332 infantry including standing and kneeling archers and soldiers holding long-handled weapons. Section 2, the southern end, holds 64 chariots, each drawn by four horses and manned by a charioteer and two assistants. In Section 3, the center, are 19 chariots, 264 infantry, and 8 cavalry, with 8 more cavalry forming the rear guard. A command chariot is stationed in the northwest corner, a departure from the centrally positioned command of a conventional Warring States formation. The deployment of chariots in front of the infantry accords with the *yuli* combat formation mentioned in classical treatises on war. In Section 4, the northern end, a formation of 6 chariots and 108 saddled horses with riders shows that cavalry units had an important role in the war of unification. All four sections together make up an integrated combat formation that ancient treatises on war call *quzhen* (bent, or L-shaped), with both offensive and defensive capabilities.

N

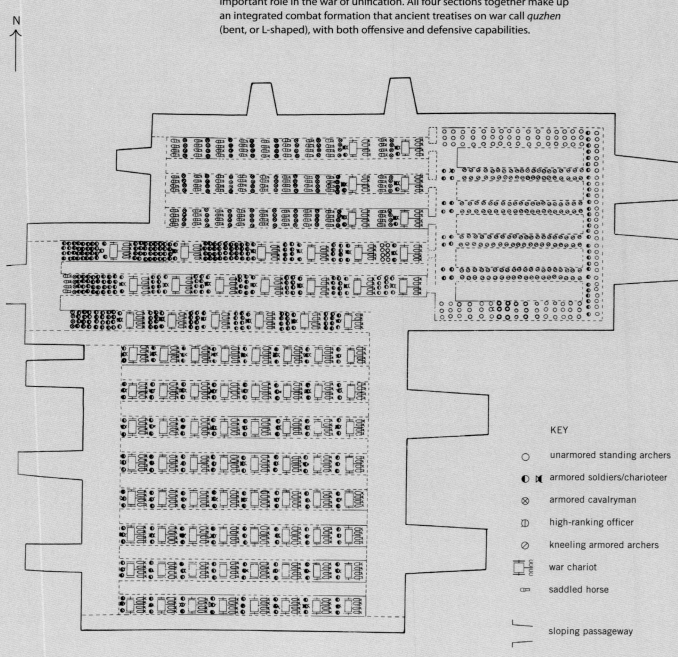

KEY

○ unarmored standing archers

◐ ⋈ armored soldiers/charioteer

⊗ armored cavalryman

⪽ high-ranking officer

⊘ kneeling armored archers

⊞ war chariot

⊏⊐ saddled horse

⌐ sloping passageway

Smaller than the other pits, Pit 3 is U-shaped, with the opening facing west. It comprises a central stable with wings on the north and south that contain, respectively, 22 and 42 armored infantry. The stable houses a four-horse wooden chariot, magnificently painted (unlike the chariots in Pits 1 and 2), with the usual charioteer and two assistants, plus a middle-ranking officer. Whereas the figures in Pits 1 and 2 are in combat formation, the infantry here are lined up facing each other, as if guarding or greeting, and though armored, they hold ceremonial weapons (*shu*). It is thought Pit 3 may be a command post for Pits 1 and 2. But if so, where is the commander? An unexcavated tomb nearby, its main chamber shaped like the character 甲 (a configuration usually reserved for kings), may hold the answer. Another explanation is that in Qin tradition commanders were appointed by the emperor only temporarily, in time of war, and since the warriors in the three pits are not engaged in a war, the First Emperor himself is their commander in chief.

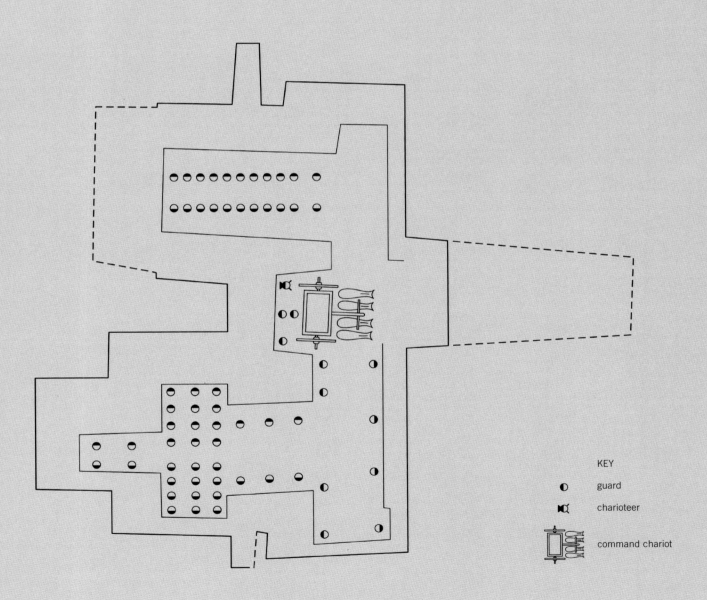

KEY

◐ guard

◄◙ charioteer

command chariot

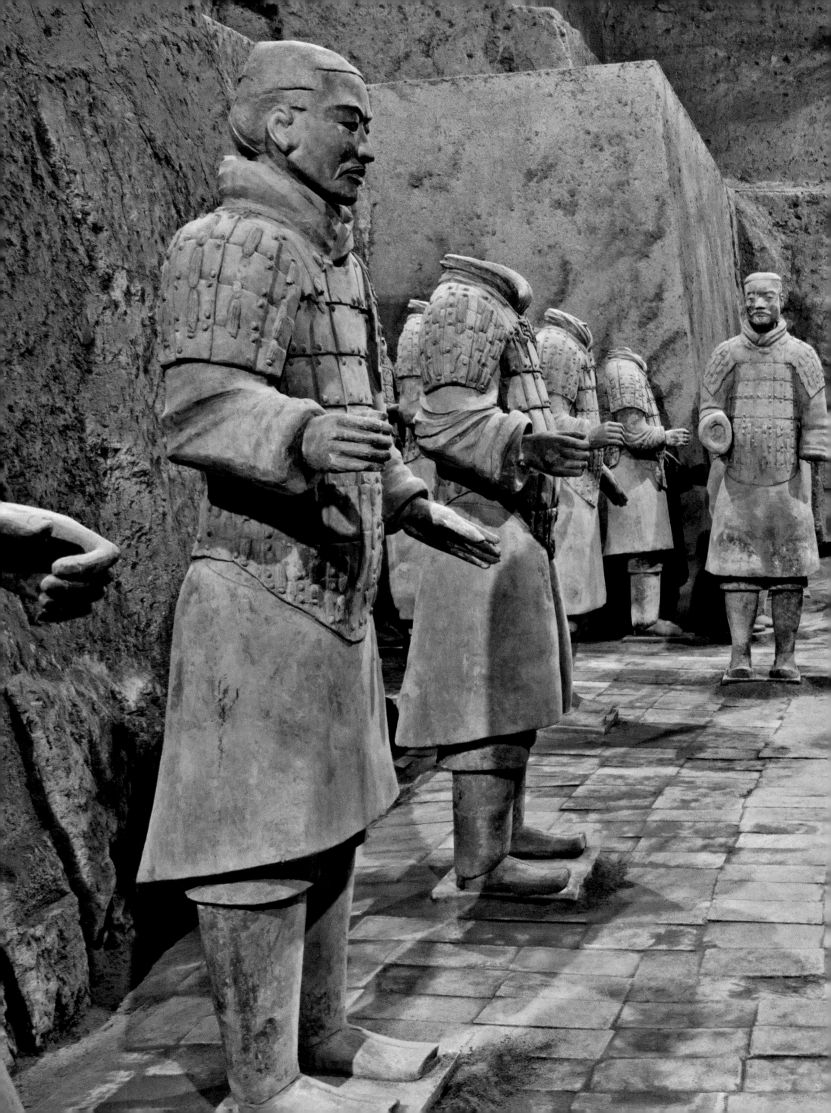

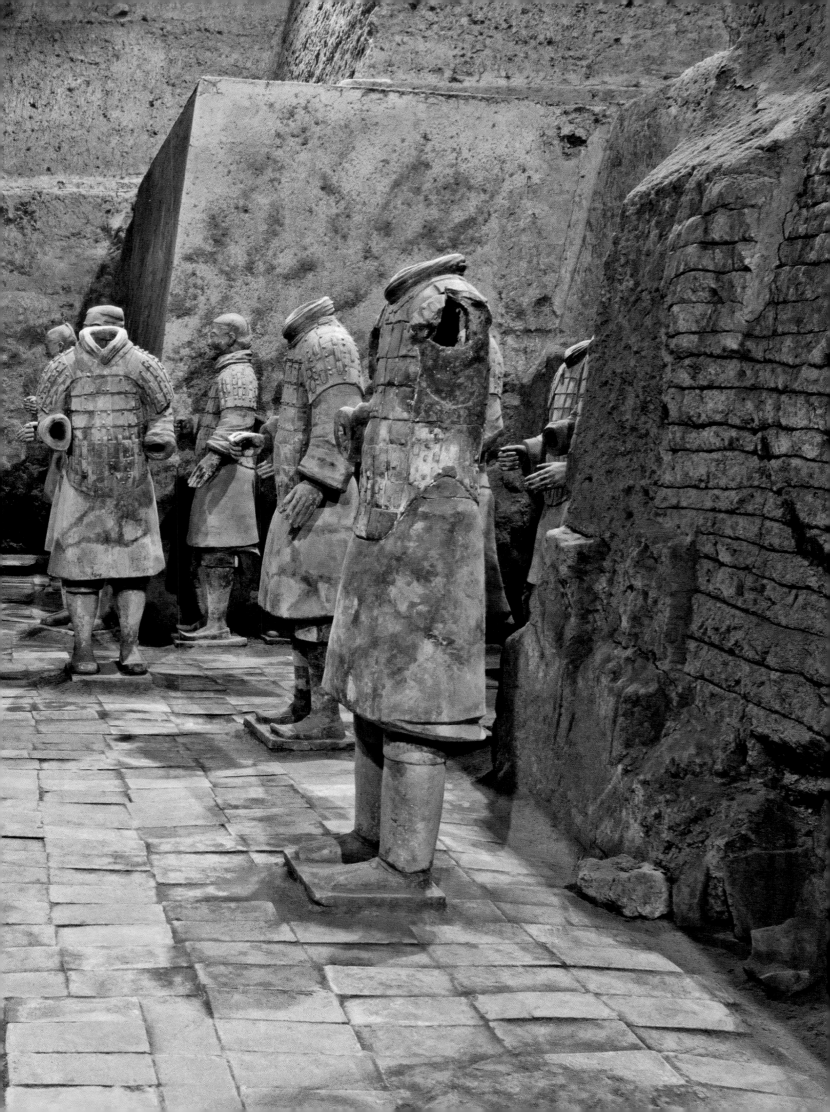

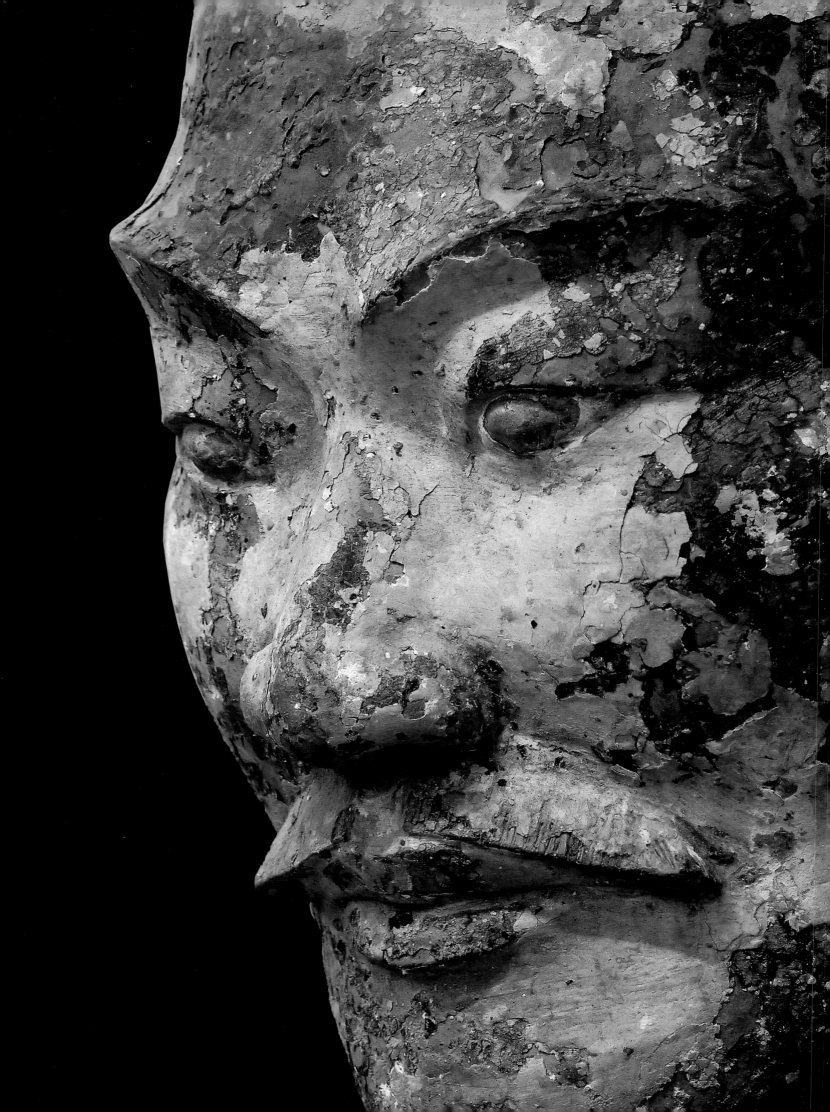

The Making of the Terracotta Army

Liu Yang

Materials and Techniques

The terracotta army figures were apparently manufactured in workshops by government laborers and craftsmen. All the figures, humans and horses alike, were made from a gray pottery. Investigation into their construction has shown that each warrior figure generally consists of seven modeled or molded segments—platform, foot, leg, torso, arms, hands, and head/neck—made separately, allowed to dry, and then luted together (fig. 1). All the joints would have been sealed and strengthened with clay coils.

The platforms, cast from a mold, are of three shapes—rectangular, near-square, and pentagonal—and about an inch to an inch and a half thick. Platform and foot were sometimes cast in one piece and sometimes made as separate segments, joined with glue after firing.

The legs, some hollow and others solid, were fashioned in four ways: from solid clay cylinders, from clay coils, from flat clay sheets shaped into cylinders, or from hollowed-out solid cylinders.

The torsos, all hollow, were made with coiled clay in two steps: first, up to the waist, and then, once that had dried, from waist to shoulders. To give strength, the coils were beaten with a wooden hammer to compact the clay and remove air bubbles.

The arms are either hollow or solid, hollow being more common. Usually, for hollow arms, coiled clay was added until the right shape was achieved. Arms were made separately and then attached to the torso. The hands were either molded or hand-built and attached to the sleeves by means of wet clay, clay nails, or some type of adhesive.

The heads were molded or sculpted in two parts (front and back) and then joined. The neck section is either solid or hollow. Hollow examples were sometimes reinforced with a clay bar.

After completion of the base figure, a thin layer of clay was applied all over and incised, stamped, or embellished to detail individual features with meticulous precision. While there is a certain consistency to the faces, no two are identical, confirming that each was indeed given an individual final finish. The hair and hairdos received great attention, with details sculpted and incised (fig. 2). The variety and complexity of the braiding techniques are amazing to the modern eye. Similarly, features such as the armor plates, pins, belt hooks, shoe ties, and costume details—even the tread pattern on the sole of a kneeling archer's shoe—could only have been achieved through meticulous hand finishing (fig. 3).

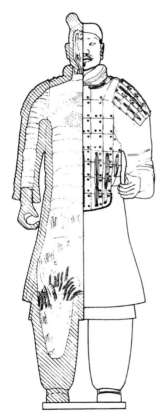

Fig. 1. Diagram showing the internal structure of a terracotta figure

Left: Detail of a warrior's face

Previous: View of Pit 3 at the First Emperor's tomb complex

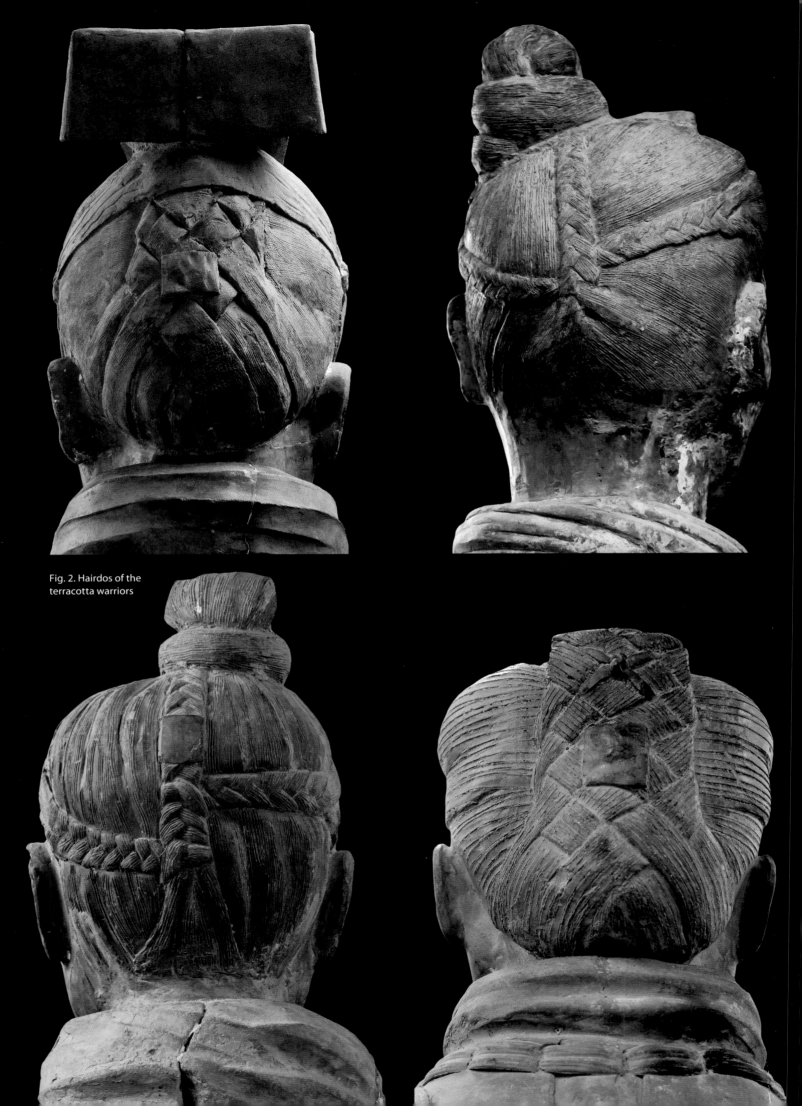

Fig. 2. Hairdos of the terracotta warriors

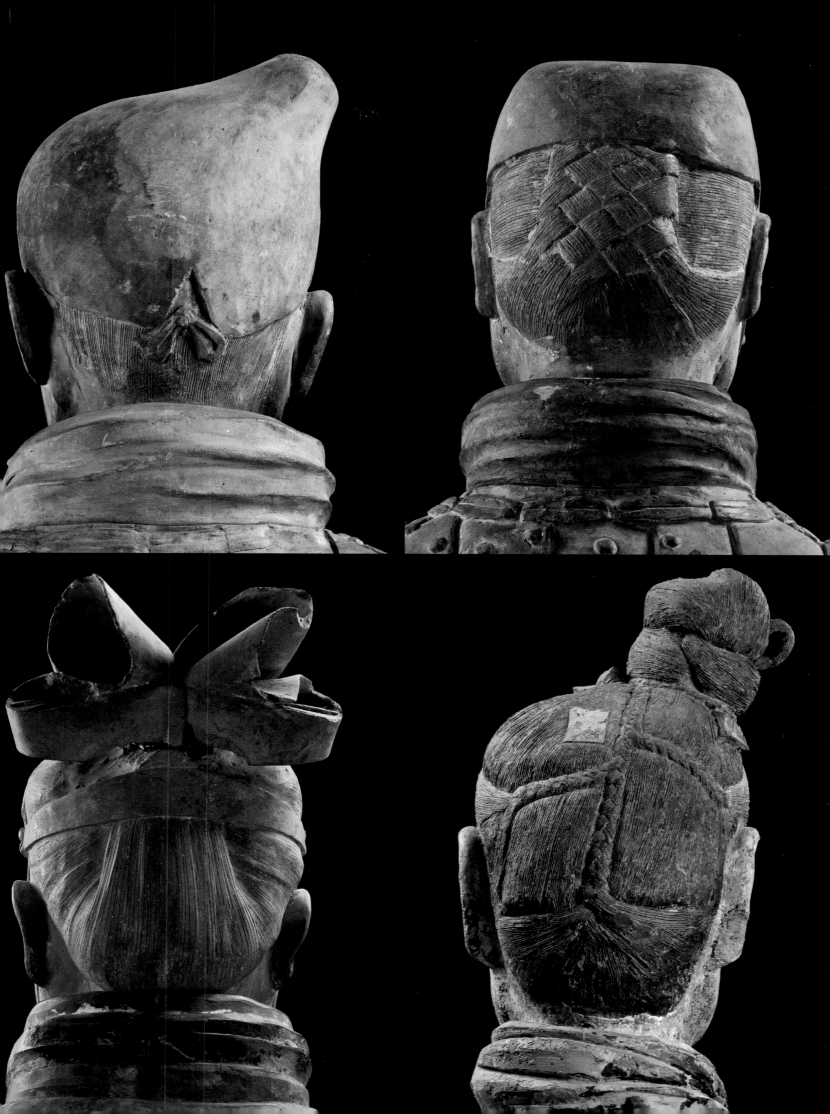

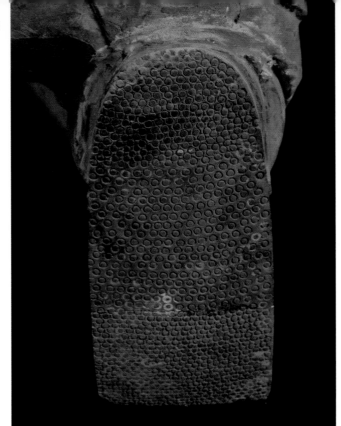

Fig. 3. Tread pattern on the sole of a kneeling archer's shoe

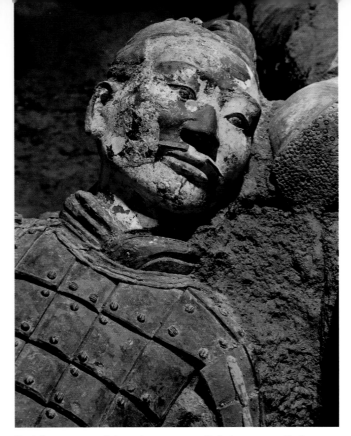

Fig. 4. Better-preserved pigments on an armored infantryman unearthed from Pit 2

This detailing has helped identify the varying ranks within the army while also providing a wealth of information concerning the development of style, fashion, and armor in early China.

The horses were made in five parts—head, neck, torso, legs, and tail. Because of their larger volume, the horses were more difficult than the human figures to construct and fire.

The head was made with two molds (the joining line is visible in the middle), with the ears made separately and attached. The neck was made from two pieces of flat clay about an inch and a half to three inches thick, joined to form a cylinder and reinforced with hammering. Due to its size, the torso was made in three segments—chest, belly, and rear—joined and reinforced with linen cloth on the inside and then hammered on the outside for added strength. For the legs, the clay was piled up layer by layer and then pounded vigorously to remove any air bubbles. The tail was made separately, then joined to the rear.

When the assembly process was completed, a thin layer of clay was applied over the top. Then more clay was added to the chest and shoulder area to fashion the muscles, and to the head to form facial features. As with the human figures, the horses display an overall consistency in size, shape, and style, which again suggests that mass production methods were employed. However, the varying detail in the finish of the eyes, nostrils, and

mouth in particular suggests that each was finished by hand. Stirrups were not, on the evidence of these figures, in use in China during Qin times.

The finished warrior and horse figures were then fired in a kiln. The hardness of the fired bodies indicates that they are earthenware and thus were fired at temperatures of 1,742 to 1,922 degrees Farenheit. To prevent distortion or cracking, a small hole about an inch and a half in diameter was made in many of the horses. Variation in clay color suggests that the clay was not necessarily from a single source—hardly surprising given the enormous number of figures—and that several factories and kilns were involved, although no convincing evidence for these factories has yet been found.

After firing, color pigments were applied to add further detail and enliven the figures. A distinction between officers and soldiers can be observed in the costume ornamentation: the warriors' armor is painted only with colors, while the edge of the generals' armor is decorated with leaf and diamond-shaped designs. Deterioration over time and damage from fire have made it impossible to see the full glory of the original color of the warriors from Pit 1, though traces of pigment remain. Fortunately, a number of figures with much better preserved pigments, unearthed from Pit 2, provide evidence of the coloring technique (fig. 4).

Fig. 5. Various color pigments, including Han purple, found in Pit 2

Rendering of a general from Pit 1 showing how brilliant the coloring would originally have been

First, a primer followed by an application of white pigment formed an undercoat. Colored pigment was then applied in at least two to three layers in areas such as the hands, face, and legs, forming a thick but even texture over the terracotta surface. Different colors were applied to different parts of the figures. The faces and hands of most warriors were painted pink. Colors such as bright red, vermilion, burgundy, dark green, pastel green, and sky blue were used for the robes worn by the infantry. Colors for the trousers included dark green, pastel green, sky blue, and burgundy, and for the shoes and boots, reddish brown, vermilion, dark green, purple, and ocher. The hair ribbons and shoelaces were painted vermilion. The horses were painted a deep red (Chinese date red), with red tongues, white teeth, black hair, black tails, and white hooves.[1]

Chemical analysis reveals that the purple pigment found on the terracotta warriors is barium copper silicate ($BaCuSi_2O_6$). To date, scientists have yet to discover its source, but its presence implies that Chinese artisans were performing inorganic chemistry by that time. This synthetic inorganic color is known as Han purple (fig. 5).

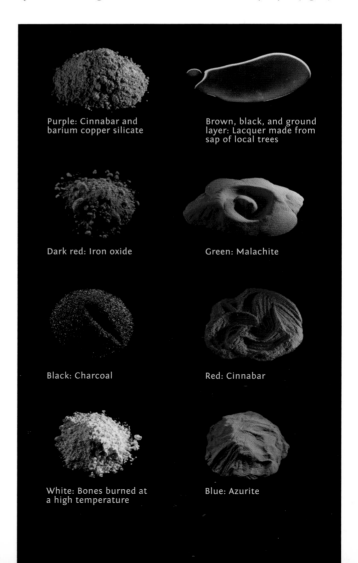

Purple: Cinnabar and barium copper silicate

Brown, black, and ground layer: Lacquer made from sap of local trees

Dark red: Iron oxide

Green: Malachite

Black: Charcoal

Red: Cinnabar

White: Bones burned at a high temperature

Blue: Azurite

Fig. 6. Detail of a terracotta figure showing several inscriptions

Finally, the painted figures were baked at a low temperature to help the paint adhere well to the clay's surface.[2]

The Craftsmen

An undertaking on such a grand scale required considerable material resources and manpower. Who made the terracotta army, and where were these craftsmen and laborers from? Throughout the Qin dynasty, the tight imperial control of the central government required craftsmen and workshops across all state-owned industries to inscribe their names on the items they produced, to ensure quality control. This has aided modern historians in verifying who participated in making the terracotta army.

To date, Chinese archaeologists have found 382 inscriptions from Pit 1, including 192 that contain incised or seal characters (the rest are numbers). Sixteen of these inscriptions have the character *gong* (literally, "palace") or *gong* along with a person's name, suggesting some of the sculptures were made by the court craftsmen (fig. 6).[3] Another group of inscriptions includes names of places,

mainly Xianyang, along with personal names, perhaps indicating that potters from Xianyang and other cities in present-day Shaanxi worked on those figures. A third group seems to be names of craftsmen from elsewhere.[4] All told, the inscriptions reveal the names of some sixty-four master potters and verify that the craftsmen responsible for making the terracotta warriors came from various towns. A mass grave discovered a short distance to the southwest of the mausoleum contains a large quantity of human bones, presumably those of laborers who died during the construction work. Names and birthplaces of nineteen of them, engraved on tile fragments, show that they came from various towns in the present-day provinces of Shandong, Hebei, and Henan, areas that belonged to the former eastern warring states conquered by the First Emperor.

From this evidence, it is apparent that the craftsmen and laborers involved in sculpting the terracotta army came from all parts of the empire. Furthermore, those from Xianyang may not have been native to that city. Given that Qin Shihuang forced 120,000 families from the former six states to move to Xianyang, many craftsmen working at the tomb complex might have been among those immigrants. Some of the names engraved on the terracotta figures are also found on tiles and bricks unearthed from the First Emperor's tomb complex, so it appears likely that workshops producing tiles and other mundane items were commandeered to work on the terracotta army.

Notes

1. For studies of the application of color pigments on the terracotta figures, see Li Yadong, "Qin yong caihui yanliao ji qindai yanliaoshi kao" [A study of the color pigments on the terracotta figures and the history of using color pigments in the Qin dynasty], *Kaogu yu wenwu*, 1983, no. 3; Zhang Zhijun, *Qin shihuang ling bingmayong wenwu baohu yanjiu* [A study of the preservation of terracotta warriors, horses, and other cultural relics from the Qin Shihuang tomb complex] (Xi'an: Shaanxi Renmin Jaoyu Press, 1998).

2. For the making of the terracotta army, see Yuan Zhonghi, *Qin shihuang ling de kaogu faxian yu yanjiu* [The archaeological discovery and research of Qin Shihuang's tomb complex] (Xi'an: Shaanxi Renmin Press, 2001), pp. 259–70.

3. Yuan Zhongyi, "Qinling bingmayong de zuozhe" [The sculptors of the Qin mausoleum terracotta warriors and horses], *Wenbo*, 1986, no. 4: 56–62.

4. Shaanxi Provincial Institute of Archaeology et al., *Qin shihuang ling bingmayong keng yihao keng fajue baogao, 1974–1984* [Report on the excavation of Pit 1 at the Qin Shihuang tomb complex] (Beijing: Wenwu Press, 1988), pp. 433–43.

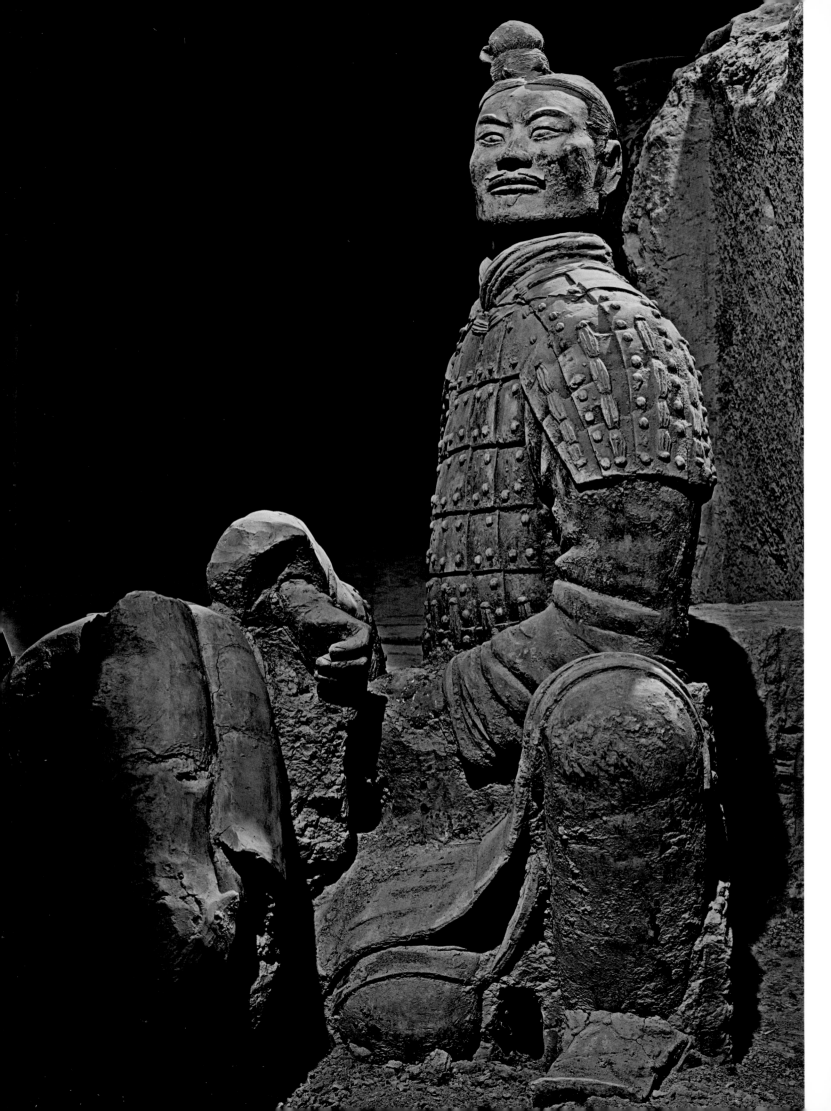

The First Emperor's Army: Realism, Naturalism, Symbolism

EDMUND CAPON

The sheer scale of Qin Shihuang's terracotta army has galvanized the imagination of people around the world. In the very early days of the discovery, in March 1974, nobody had the remotest idea of its magnitude. The renowned historical records of Sima Qian, which so vividly describe the First Emperor's actual burial nearby, make no mention of the massed ranks of this long-buried and silent army. It lay hidden and unknown for two millennia.[1]

When the breathtaking scale of the discovery became apparent, it was that, above all, on which everybody's attention focused. Only after digesting the overwhelming fact of its size could one stand back and look at the individual figures in a dispassionate and objective way. Then it began to dawn how truly unusual they are. It was not only a matter of scale, although their ever so slightly larger than human size is impressive enough. It was the conception of the human figure with an intent toward realism hitherto completely unknown in the history of Chinese art. It struck me, too, that the fidelity to the real appearance of soldiers and horses was such that even in the succeeding Han dynasty there was something of a reversal to symbolic as opposed to realistic representation of the human figure. Any fleeting comparison of a typical Han dynasty pottery tomb figure and one of the personalized figures from the First Emperor's entombed army demonstrates that realism took a step back in the early Han period. For though the typical Han figure may be more beautiful, subtle, and svelte, those qualities were attained at the sacrifice of attention to realism. The intention was indisputably to represent the human figure—but interpreted to suit a role rather than depicted as an earthly reality.

To see the Qin Shihuang figures as revolutionary in terms of realism in early Chinese art, we must look at what preceded them. In pre–Qin dynasty China the defining tradition was the bronze culture, and the function of art was overwhelmingly in the service of ritual and ceremony. Faithful or even marginal realism was largely irrelevant. Qin Shihuang's quest to represent the earthly life in the afterlife brought a new requirement to the role of art—a vision of realism. This was achieved on a monumental scale with his serried ranks of life-size terracotta soldiers. These are no mere tokens. They may have symbolic value in their role as guardians of the entrance to the emperor's burial, but they are determinedly realistic facsimiles, just as the more recently discovered figures of officials, acrobats, musicians, and bronze birds are true to their earthly counterparts.

To appreciate this radical new vision, we must understand how the human figure was perceived and represented in the art of pre–Qin dynasty times, when there was really no attempt, or indeed need, to replicate the reality of the human presence.

An armored kneeling archer from Pit 2 at the First Emperor's tomb complex

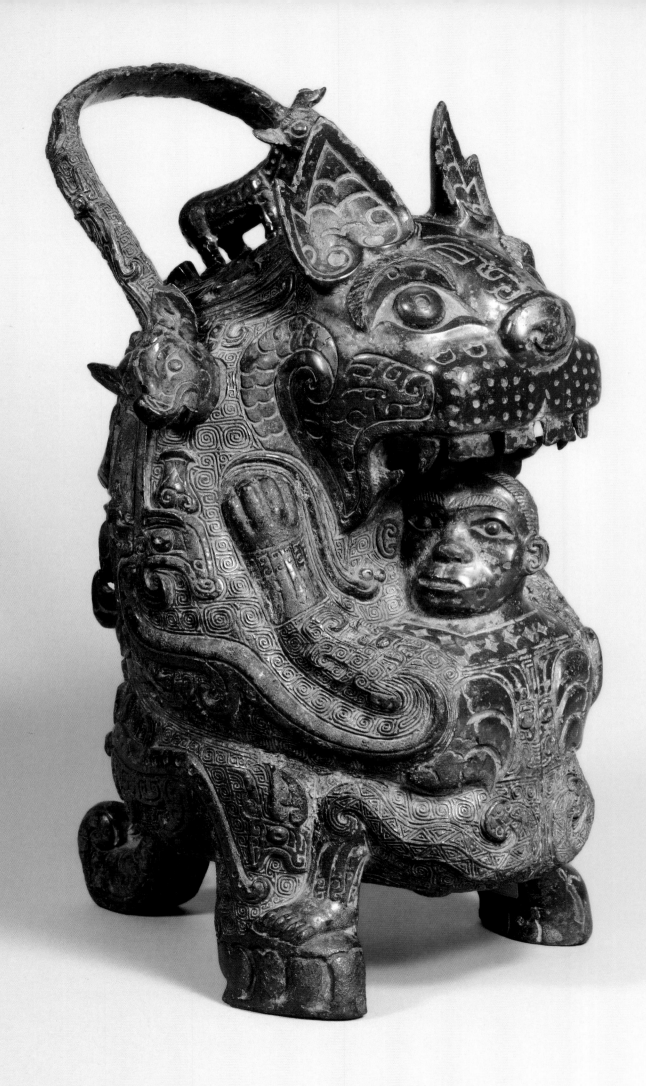

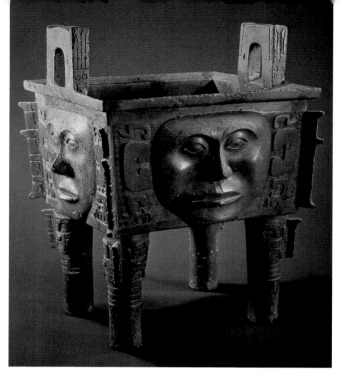

Fig. 2. Bronze *ding* vessel, Shang dynasty, c. 12th–11th century BCE, excavated in 1959 at Ningxiang, Hunan province

Tracing the image of the human presence in art of the Shang and Zhou periods reveals that verisimilitude was not an objective. Whatever human figure or face appears is surely fulfilling a symbolic role. Typical are the images on two similar *you*-type vessels in the form of a tiger devouring a boy, one in the Cernuschi Museum in Paris and the other in the Sumitomo collection (fig.1);[2] a variation is the masklike human face on the lid of a *he*-type vessel in the Freer Gallery. All such heads and faces have a stylized anthropomorphism, but they represent no known human face.[3] They also assume a primitive form, not so much the face of a local courtly ruler as the face of what might have been perceived as a "barbarian"—a force beyond the normal human dimension. There are a small number of like bronzes bearing symbolic and ritualistic images based on the human face, of which the best known is probably that on the rectangular *ding* vessel excavated in 1959 at Ningxiang, Hunan province (fig. 2).[4] Arguably even more removed from the real world of the human presence are, of course, the almost demonic, otherworldly images from Sanxingdui, which have all the hallmarks of visitors from another planet. These dramatic and strangely ominous masklike faces bear little resemblance to anything in Shang dynasty art—or to any other vaguely human-inspired image in the history of Chinese art.[5]

Interest in the idea of the human face and form was not, it would seem, much greater in the succeeding Western Zhou period. One of the rare sightings of the human figure in Western Zhou bronzes is a rudimentary type serving as feet to a group of early *pan* vessels from Shandong (examples in the Sackler, Buckingham, and Pillsbury collections); however, functioning as vessel feet and appearing as nothing more than humble servants, such figures barely qualify as human.[6] Later, in the Eastern Zhou era, the human figure began making a tentative appearance, not of course as the subject, but as an emblem of the human presence. The gradual assertion of the human figure as subject rather than symbol gathered pace, the figure becoming more detached from the ritualistic role it had fulfilled in the Shang and Western Zhou periods.

In the Warring States period, the human figure continued to be a component of ritual objects and was seldom if ever

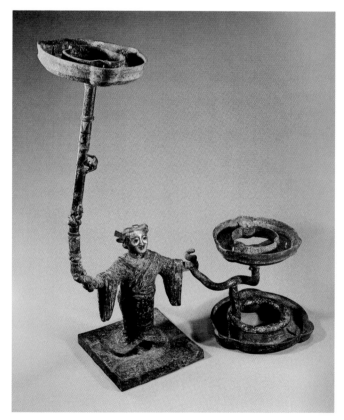

Fig. 3. Bronze lamp holder with head of male figure in silver, Warring States period, from the tomb of a king of Zhongshan, Pingshan, Hebei province

a subject in its own right. Perhaps in the role of a domestic or courtly servant, the human figure was depicted as a lamp holder in a number of distinctive works, among them an example from Sanmenxia, in Henan province, that was discovered in 1975, and a more resplendent version with a silver head, excavated from the tomb of the king of Zhongshan, in Hebei province, in 1976 (fig. 3).[7] An unusual form of a human figure holding a tray and standing on the

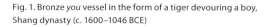

Fig. 1. Bronze *you* vessel in the form of a tiger devouring a boy, Shang dynasty (c. 1600–1046 BCE)

Fig. 4. A soldier (left) and a general (right) from the buried army

back of a tapir was discovered in 1965 in Shaanxi. These represent a marked step toward regarding the human figure as an independent subject and not merely an appendage to a ritualistic object; furthermore, their visages display a degree of sophistication that suggests we are no longer dealing with notional barbarians or emblems of evil. The Zhongshan figure's imposing demeanor (standing as opposed to the more familiar kneeling type) and its clothing, which appears to be a fairly opulent court costume, may be seen as more evidence of a move toward representation of the real world. Nonetheless, in the art of the Warring States era the human figure remained a feature of marginal significance playing a supporting role in an essentially symbolic world.

The intentionally lifelike images produced in the Qin dynasty seem to me far from an evolutionary step and more like a quantum leap, so strikingly do they differ from any representation of the human face or figure that we see from Bronze Age China. The very first finds associated with Qin Shihuang were not the terracotta warriors but several slightly less than life-size figures of kneeling grooms (originally identified as servant women it seems), one of which was unearthed, way back in 1932, just sixty-five feet or so from the base of the burial mound and only six feet below the current ground level. A similar figure discovered in 1964 was included in the revelatory "Genius of China" exhibition shown in Paris (at the Petit Palais) and London (Royal Academy) in 1973.[8] In retrospect it is surprising how little interest those figures seemed to generate at the time. They were rather lonely

representatives, but I recall looking at that solitary figure in the Paris and London shows and thinking that it was something of a revelation and that even the great panorama of Han dynasty figurines really offered nothing quite so human in scale or presence.

Those very first discoveries of Qin realism now of course are seen to bear a strong resemblance to a range of types found since 1974. In terms of style, detail, and presence, they may be specifically compared with the seated musicians found in the year 2001 adjacent to the bronze birds located a little under two miles to the northeast of the burial mound itself. This discovery is further evidence of the quest for realism and the remaking of the First Emperor's earthly life. The location of the musicians and their promise of Arcadian pleasures some distance from the actual burial does raise the question of what they were doing there if, as is generally accepted, they are part of the emperor's burial. Perhaps such idyllic pleasures had to be well beyond the pragmatic confines of the administration. The musician figures are noticeably larger, at about ninety centimeters (35½ in) in height, than the less than life-size stable attendants. Nonetheless, the two figure types have in common a genuine verisimilitude to living human beings.

Which brings us to all those soldiers with no precedent in the long history of the art of Bronze Age China. That commitment to an earthly human reality is reinforced by the recent discovery of pits containing similarly life-size court officials, impassive in their stoic duty, and acrobats

and entertainers in poses of slightly unusual and contrived animation. While it might be argued that the figure with his right arm raised bears a resemblance to those miniature bronze figures holding a lamp, such comparisons merit little credence, for the life-size figures perform a real-life rather than a symbolic role in the service of their emperor.

The objective of re-creating the reality of the First Emperor's earthly world and its people—soldiers, entertainers, acrobats, officials—in the afterworld launched a quest for realism that, at the time, was as remarkable as it was revolutionary. The quest for immortality continued unabated in the Han dynasty but on a lesser scale; nothing compares with the First Emperor's burial. The impressive burials of the Han dynasty emperor Jing at Yangling and the Han general Zhou Bo at Yangjiawan, both in the vicinity of Xi'an, are furnished with thousands of military figurines; however, their modest scale makes these massed ranks seem like little more than toys in comparison with the First Emperor's army.[9] Such burials and their furnishings represent not the real world but a metaphoric world, as indeed the whole tradition of tomb figures would continue to do in successive eras. The art of the facsimile of the real world reached its zenith in the Tang dynasty, and there is no denying the hugely varied and colorful imagery represented in the Tang tomb figure tradition. Yet this is a miniature world that can barely be compared with the First Emperor's extraordinary life-size re-creations.

Much has been made of the individual finish given each and every one of the Qin Shihuang figures, and it is tempting to see the faces of such images as portraits. However, in those engaging but vacant stares we are looking at a number of stereotypes, although a clear attempt was made to acknowledge and represent differing physiognomies and racial types (fig. 4). For example, comparing the face of the general, an image of stern, natural authority, to the face of a mere soldier reveals hierarchy demonstrated through the subtle means of expression (and scale, too, for the figure of the general is noticeably grander and larger). In the impressive range of faces in the emperor's buried army it is possible to see the diversity of peoples from all reaches of the empire, who were evidently conscripted or employed in the imperial armies. Those intriguing heads with their uniquely finished details may represent generalities, but

each has its own presence—an individuality with the substance, but not quite the psychological and interpretative specifics, of portraiture.

The legitimate question has been raised as to what model or models the craftsmen and artisans responsible for these figures had access to. The huge workshops established for producing the terracotta figures were not centrally located, as the varying qualities of the clay indicate, and must have drawn upon a diverse labor force. Given this situation, it seems entirely plausible that the final, individual touches of facial details were not necessarily prescribed and may indeed have been taken from the very visages of fellow workers. Details of shoe types, armor types, even perhaps hairstyles, could reflect the standard repertoire of military personnel, but the faces have the semblance of once real people.

If the tomb figure was meant to transform imagination and belief into concrete visible form, then the First Emperor's army succeeds spectacularly. Without doubt it constitutes the first major instance of figuration in the history of Chinese art. But the question may be asked, Why did the Han dynasty not follow the grandeur of Qin Shihuang's example? Frugality perhaps, or maybe they did not wish to emulate the lavishness of their defeated predecessors, or the image of a man who has gone down in the history of China as a despot.

Both the *Liji* and the *Zhouli* identify objects accompanying the deceased into the next world as *mingqi*, or spirit vessels, therefore not substitutes for sacrificial victims but ethereal equivalents of humans, and that, it seems, is how tomb furnishings for the afterlife of rulers and the aristocracy were considered in the Han and Tang dynasties. Not so for the First Emperor, who, as we know so well, dismissed the classics and would take no notice of such writings and their advice. He was not interested in mere substitutes or symbolic equivalents; he wanted the real thing or, if not that, then something on the same scale and realistic to the last detail. Hence the uniqueness of his buried army. China has seen nothing like it before or since. For all his fame and infamy, it is something of an irony that the First Emperor was the catalyst for a revolution in art.

Notes

1. Yang Hsien-yi and Gladys Yang, trans., *Selections from Records of the Grand Historian, Written by Szuma Chien* (Peking: Foreign Languages Press, 1979). Pages 186ff describe the construction of the First Emperor's burial but without any mention of the buried guardian army.

2. The Cernuschi example is collection no. M.C. 6155; the Sumitomo example is in Kyoto and illustrated in William Watson, *Ancient Chinese Bronzes* (London: Faber and Faber, 1977), plate 36a.

3. Freer Collection no. 42.1, illustrated and described in John A. Pope et al., *The Freer Chinese Bronzes* (Washington, D.C.: Smithsonian Institution, 1967), 1:222–27.

4. *The Genius of China: An Exhibition of Archaeological Finds of the People's Republic of China*, exh. cat. (London: Times Newspapers, 1973), cat. no. 79.

5. The Sanxingdui finds have been widely published. A special exhibition was held at the Art Gallery of New South Wales, December 2000–March 2001, with a fully illustrated catalogue, *Masks of Mystery: Ancient Chinese Bronzes from Sanxingdui*.

6. There are numerous examples of the *pan*-type vessel supported on human-figure feet, including many recently excavated. Typical of the type are one in the Buckingham collection at the Art Institute of Chicago (*Chinese Bronzes from the Buckingham Collection* [Chicago: Art Institute of Chicago, 1946], pp. 68–69), acc. no. 1929.647, and one in the Pillsbury collection in the Minneapolis Institute of Arts (Bernhard Karlgren, *A Catalogue of the Chinese Bronzes in the Alfred F. Pillsbury Collection* [Minneapolis: University of Minnesota Press, 1952], pp. 127–28).

7. The example discovered at Sanmenxia is now in the Henan Provincial Museum, Zhengzhou, and is illustrated in *Trésors d'art de la Chine* (Brussels: Palais des Beaux-Arts, 1982), cat. no. 19. The Zhongshan lamp holder is illustrated in a number of publications, including *Treasures from the Tombs of Zhong Shan Guo Kings*, exh. cat. (Tokyo: Tokyo National Museum, 1981), cat. no. 41; the catalogue accompanying the exhibition "Das Alte China" (shown in Essen, Munich, and Zurich in 1996), *Das Alte China: Menschen und Götter im Reich der Mitte* (Zurich: Kunsthaus, 1996), cat. no. 65; and in *China's Cultural Relics* (Beijing: Cultural Relics Publishing House, 1992), no. 111.

8. *Genius of China*, cat. no. 136.

9. The majority of the figures from the burial of General Bo are in a special display in the Xianyang Museum; the burial of Emperor Jing at Yangling is now a site museum.

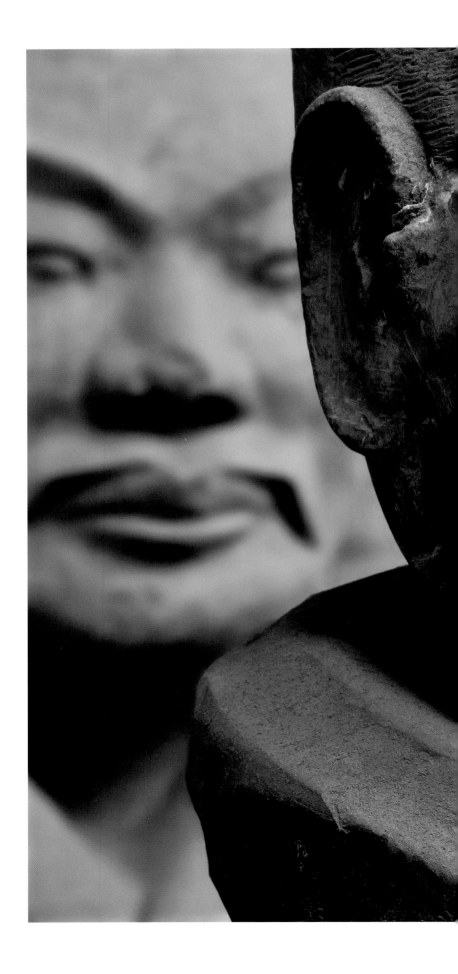

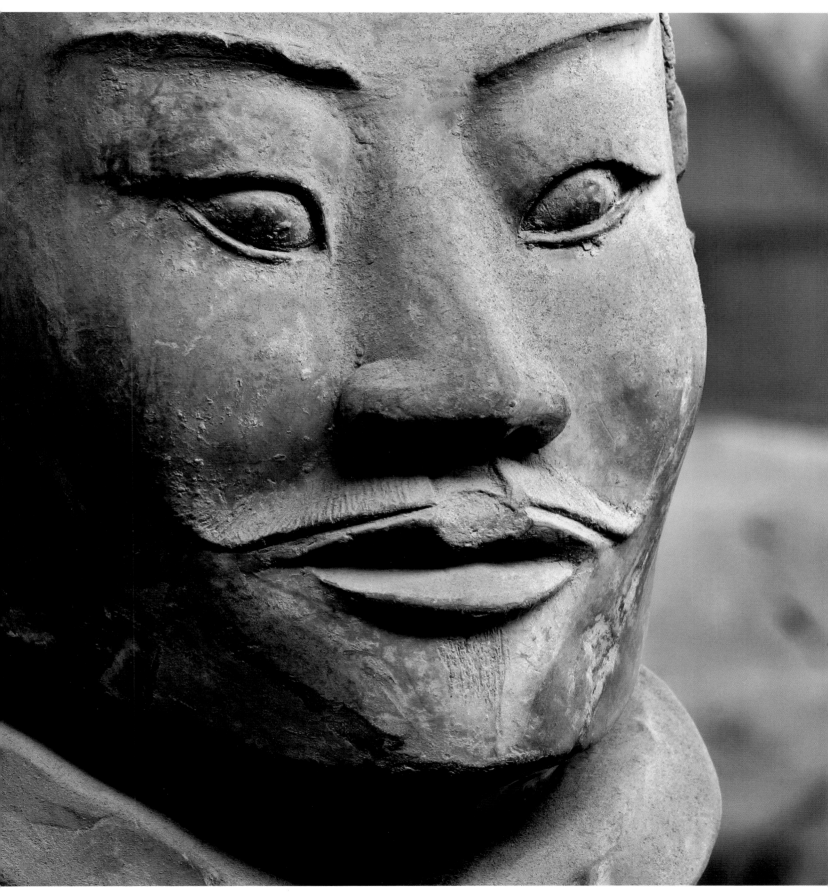

Face of a warrior from Pit 1

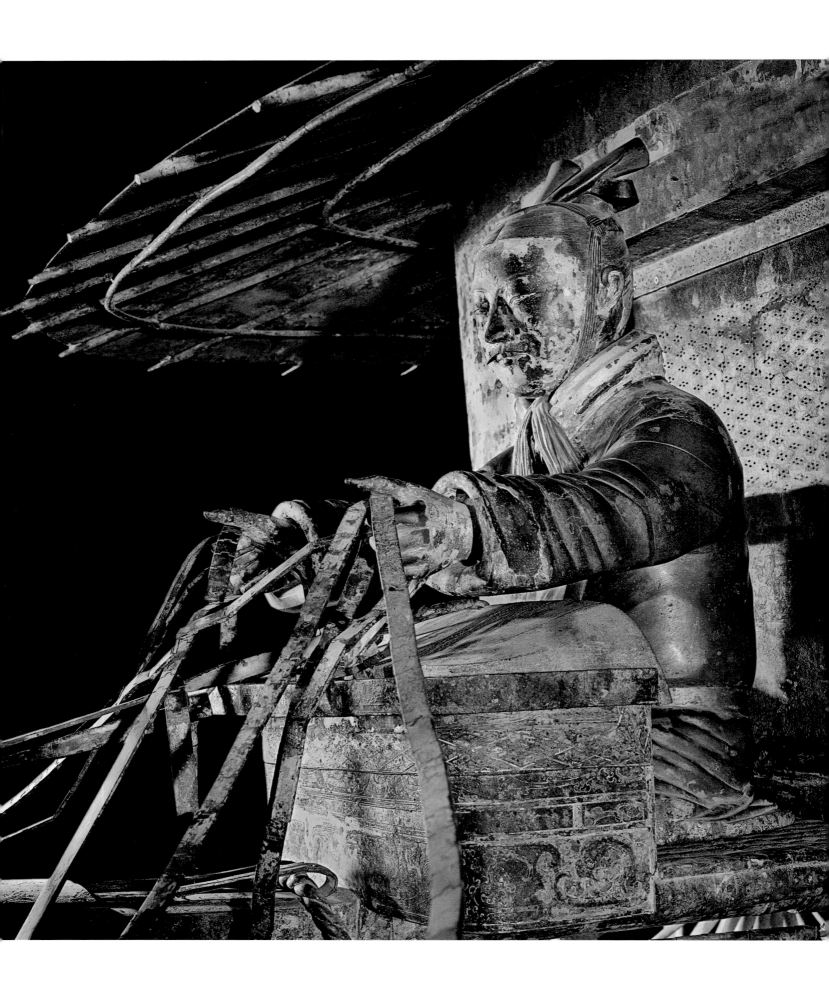

What Happened to the First Emperor's Afterlife Spirit?

Eugene Wang

Although we may imagine the First Emperor commanding the underground terracotta army in his afterlife, his spirit appeared to show little interest in doing so. The pits containing the army are located nearly a mile east of the tomb.[1] The six thousand or so terracotta soldiers in Pit 1,[2] the largest of the cluster of four pits, all face east. But the emperor's afterlife spirit did not seem to be in sync. The bronze carriages unearthed west of the tomb,[3] one of which is now commonly known as the emperor's "spirit carriage,"[4] decidedly face west. If the terracotta army's role was to safeguard the eternal peace of the emperor's tomb, the commander in chief's spirit—presumably ready to climb into the bronze carriage—seems to have turned his back on his afterlife army.

Formulated thus, the matter is apparently fraught with problems. But these problems are rooted in our own notion of an afterlife "spirit." Does our imagined scenario of a spirit riding in a carriage have a historical basis in the third century BCE context? For this scenario to work, the spirit needs to have a figural form that behaves much like a living person,[5] and this being would need to know how to get into the vehicle and ride off into the sunset—be it the west or heaven. In the third century BCE, the Chinese imagination had not yet conceived notions of this kind regarding modes of existence in the afterlife. That would come later.

Life and death, in the third century BCE, were defined largely with regard to the condition of breath. Human existence was understood as part of a cosmos made up of all-permeating "breath," or *qi*. Everything in the universe was conceived in terms of *qi*. Concentration of breath meant life; dispersion spelled death. Existence after death was understood as an amorphous state, a nebulous mass of scattered breaths that tended to fly around aimlessly. "That the bones and flesh should return again to the earth is what is appointed. But the spirit in its energy can go everywhere; it can go everywhere."[6] Thus sighed a wise man, resignedly, in an ancient text. However, the spirit's waywardness was of less concern than its dispersion. What we know of the burial practices of the third and second centuries BCE suggests that prevention of spiritual dispersion was the governing principle in the care of the dead.[7] An effective way to counteract dispersion, so it was believed, was simply to collect and reconcentrate those scattered breaths. It is precisely this notion that informs the unusual decorative design on the First Emperor's "spirit carriage."

In 1980, Chinese archaeologists discovered an accessory pit, about twenty yards west of the First Emperor's tomb mound, containing two half life-size bronze carriages, each drawn by four bronze horses (fig. 1). The front vehicle, commanded by a standing figure, is historically termed a "standing carriage"; the rear one is a "sedan carriage" (*anche*). They served different purposes, the standing carriage heading up the caravan and the sedan carriage conveying a seated dignitary.

Detail of the bronze sedan carriage

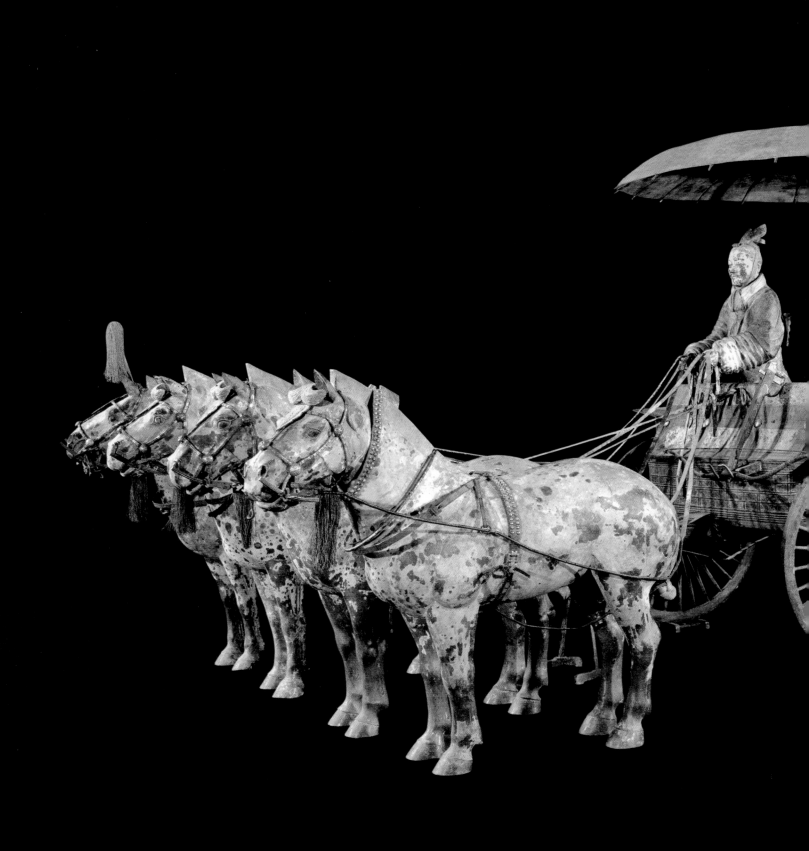

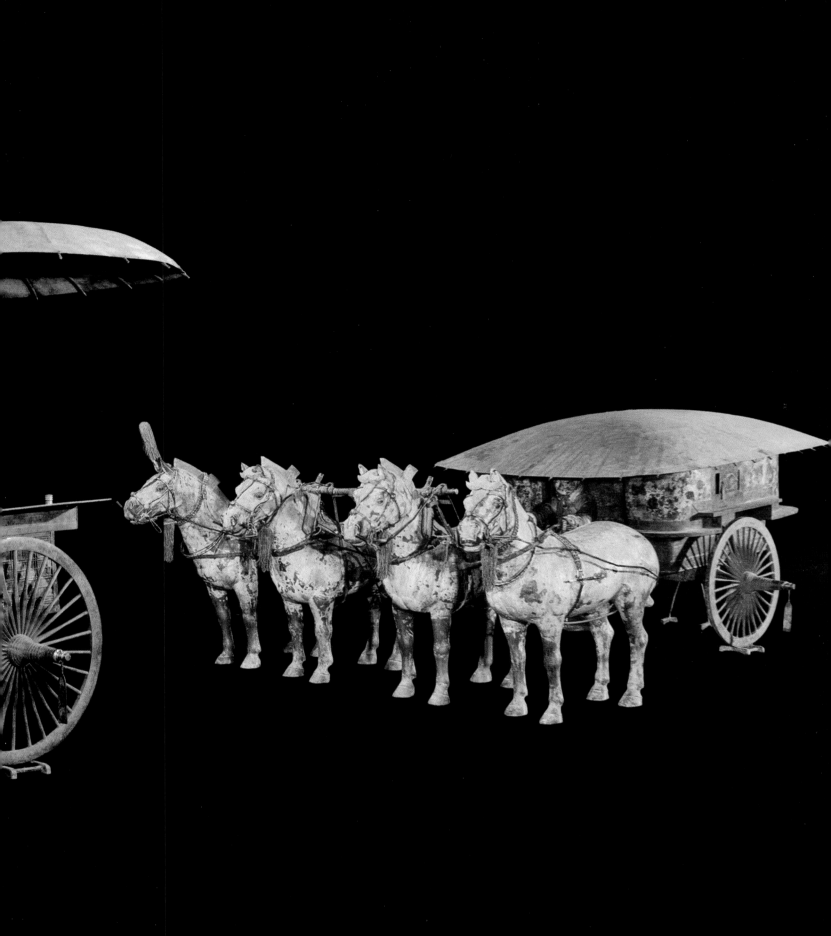

Fig. 1. Bronze "standing carriage" (left) and "sedan carriage" (right) from the First Emperor's tomb complex (cat. nos. 122 and 123)

Fig. 2. Drawing of a standard sedan carriage from a Han tomb carving

The design of this sedan carriage is unprecedented. Normally the passenger sat alongside the driver. To accommodate a female passenger or a dignitary, a back seat was created by drawing a curtain behind the driver, but driver and passenger still shared one compartment (fig. 2). The sedan carriage from the First Emperor's tomb, however, places the driver outside the passenger compart-ment. Historically known as the "all-season carriage" (*wenliangche*), the vehicle is completely enclosed, with three windows and a back door. It preserves the design of the notorious real-life all-season carriage used by the emperor in the final days of his life.

In 210 BCE, the emperor embarked on a tour of the country—his fifth and, as it would prove, his final one. His entourage included his youngest son, Huhai (221–206 BCE); the minister Li Si (c. 280–208 BCE); Huhai's former tutor, the chief eunuch Zhao Gao (d. 207 BCE); and other eunuchs. The emperor died on the road, leaving an edict to summon Prince Fusu (d. 210 BCE), his trusted eldest son and heir apparent, to return from the northern frontier and supervise the emperor's funeral in the capital. The top-level party accompanying the emperor on his tour kept the death secret and continued to act as if the emperor were still alive. They placed the coffin in the all-season carriage, escorted by the eunuchs close to the emperor. Wherever they arrived, they pretended to present food to the occupant of the carriage. As the emperor's death occurred in summer, the decomposing body began to reek, so dried fish were loaded on the escorting officials' carriages to disguise the odor.[8]

Though half life-size, the bronze carriage unearthed from the tomb site appears to be a faithful replica of the all-season vehicle that transported the emperor's coffin. As such, it presents a problem. Being half life-size, it

would have been considered a "model carriage" (*ouche*), or a "send-off carriage" (*qianche*), normally crude in design and made of wood as a "spirit article" which would have been buried in the tomb chamber.[9] The bronze carriage is anything but crude, nor was it interred in the tomb chamber.

The two-carriage set was crated in a completely sealed wooden compartment with no hint of any passageway to the tomb chamber.[10] Even allowing for some peculiar behavior associated with the imaginary denizens of the netherworld, we are hard pressed to explain why the wooden chamber contains no doorway—not even a symbolic one—for the emperor's spirit, if there was one, to access. The tightly sealed carriage pit's isolation and insulation from the tomb chamber are striking.

The problem stems from our assumption that the dead emperor's spirit would have had a distinct form that would move about, doing things the way living humans do. Was the emperor imagined to have a figural spirit capable, in the afterlife, of riding in the carriage as he would have in life? As mentioned earlier, death in third century BCE meant simply a state of scattered breaths. Any hope of reversing the deadening course—often symbolically—relied on collecting and concentrating those breaths.

The pictorial decoration of the bronze sedan carriage registers a symbolic program for reconcentrating the breaths. The various painted patterns that adorn the carriage, both inside and out, take two significant basic forms: cloud-scrolls and hard-edged geometrical shapes with lozenge patterns predominating (fig. 3).[11] Their arrangement across the carriage is revealing, and a distribution pattern is immediately discernible. Regardless of the motif, however, the decorated field is rimmed by bands of hard-edged geometrical patterns.

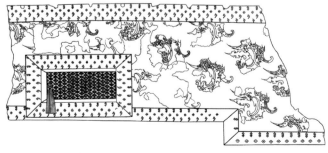

Fig. 3. Decorative design on the interior of the bronze sedan carriage

Fig. 4. Design on the inner (left) and outer (right) faces of the bronze sedan carriage door

Fig. 6. Cloud motifs on the headboard of the second coffin from Mawangdui Tomb 1 (left); lozenge patterns on the innermost coffin of Mawangdui Tomb 1 (right)

The deliberate ordering of the motifs is most strikingly apparent on the ornamentation of the back door (fig. 4). The inside panel features cloud-scrolls exclusively, whereas the outer face is covered with hard-edged lozenge patterns. While this comes as a bit of a surprise, since we would expect the clouds to be outside, there is a good reason for it. We can, in fact, detect a deliberate spatial demarcation: cloud patterns are meant to be rimmed in from the edges or, as with the door, contained inside the carriage.

What do the flowing cloud-scrolls and hard-edged lozenges represent then? If each is taken on its own, the precise symbolic significance and function is hard to determine. But when they are considered in relation to each other, as opposites, their significance begins to emerge. The two motifs appear to play off each other. Together, they spell out a transformative process through which breaths, signified by the cloud-scrolls, harden into some sort of quintessential spiritual permanence signaled by hard-edged lozenges.[12]

A tomb built some four decades after the First Emperor's death elucidates this process. Mawangdui Tomb 1, dated sometime after 168 BCE, contains a set of four nesting

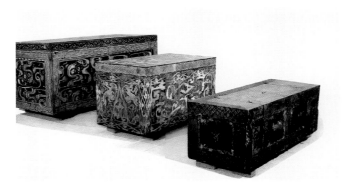

Fig. 5. The inner three nesting coffins from Mawangdui Tomb 1, c. 168 BCE, lacquer painting on wood, Hunan Provincial Museum

coffins, all with painted surfaces (fig. 5). A symbolic logic of transformation governs the decorative program, which proceeds from the outside in. The subject is the tomb occupant's postmortem spirit, and the program is tantamount to a roadmap or itinerary for the spirit, running in stages the gamut of afterlife transformation.[13] In the initial stage, the breaths of the deceased are scattered. Through various symbolic efforts concentrating and refining the breaths, the spirit "flows into form" (*liuxing*); that is, the scattered breaths are gathered into a cohesive, momentary "born-again" figural form that has enough energy to levitate. The final stage envisioned for the afterlife metamorphosis is the subliming of the reconstituted bodily form:[14] its dissolution, followed by crystallization into a heightened state of permanence that transcends time.[15]

Most notable is the role different types of decorative motifs play in this transformation scenario. The interplay of design motifs (cloud-scrolls vs. lozenges) on the First Emperor's bronze carriage reappears in the second-century BCE tomb in a more complex form, in which the two motifs bookend the transformation (fig. 6). The cloud-scrolls start the process on the second coffin. The program then goes through a convoluted metamorphosis in which the cloud patterns intermingle with—and gradually morph into—lozenge patterns. The grand finale occurs in the innermost coffin. Opening the coffin lid reveals a decorative panel covered with lozenge patterns. The significance of the two design motifs thus becomes clear. They mark the beginning and the end of the metamorphosis of scattered breaths into crystalline hardness. Mawangdui Tomb 1 spells out this process with a full pictorial program. The Qin bronze carriage elliptically

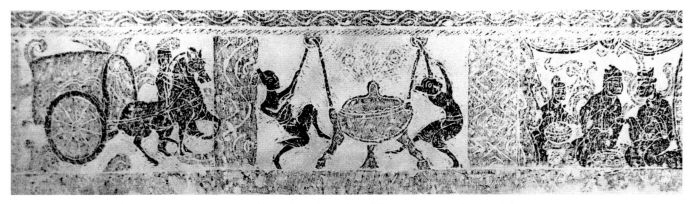

Fig. 7. Concentrating and refining the postmortem spirit. Ink rubbing of sarcophagus bas-relief, Eastern Han period, Luzhou, Sichuan

telegraphs the process by simply juxtaposing the beginning and the end, omitting what occurs in between.

Represented on the Mawangdui coffins (and implicit in the Qin carriage design) is a set of symbolic regimens associated with ancient Chinese life-prolonging macrobiotic practices: physiological alchemy,[16] dietetics, breathing exercises, and sexual practices.[17] These were part of an overall macrobiotic regimen that gained currency in the third century BCE. The underlying principle is the gathering of scattered breaths and conjugation of their *yin* (earth, night, winter, cold, etc.) and *yang* (heaven, day, summer, warm, etc.) elements in a refining process. Similar principles inform the symbolic ritual of revitalizing the dead. As the dead could not be expected to practice macrobiotic exercises, symbolic means—in the form of pictorial decoration, arrangement of objects, and so on—were used to effect the "revivification of the entombed dead."[18] Codified visual motifs became key elements of such programs. Cloud patterns, signifying scattered breaths, tend to be the starting point. The culmination of the collecting and refining process of transformation is marked by diamond- or lozenge-shaped patterns, suggesting hardened permanence (alternatively described in ancient texts as the crystalline, jadelike topography of the immortality-conferring Mount Kunlun in the imaginary west).

A bas-relief on an Eastern Han (25–220 CE) sarcophagus presents the transformation from cloud shape (scattered breaths) to lozenge pattern (hardened, jadelike state of sublimation) most succinctly (fig. 7). A funerary carriage transports the spirit of the newly dead, a mass of breaths, into the picture from the left. The breath-stuff is placed in a tripod for alchemical refinement. Good things start to happen. The ethereal breaths are consolidated and refined into hefty substance, so heavy that two strong men have a hard time lifting the vessel.

What takes place here is no ordinary alchemy. The refining process sends sparks flying, which form a pair of disembodied eyes, hovering above the vessel. Ancient texts typically describe such a manifestation as the "arrival of the spiritual intelligence" following a successful macrobiotic regimen. The columns flanking the tripod scene clearly register the before-and-after conditions bracketing the alchemical process. On the left, wavy lines similar to cloud-scrolls suggest the scattered and nebulous breaths "before"; on the right, angular geometrical forms, those lozenge- or diamond-shaped patterns, signal the "after" moment. The scene at the right denotes *yin-yang* harmony, either the prescribed *yin-yang* breath conjugation that leads to the alchemical condensation of breaths, or the bliss which follows. In any case, what we have here is the cloud-to-lozenge or breath-to-consolidation transformation—registered in the First Emperor's bronze sedan carriage as well.

With the parallel examples of the Mawangdui coffins and the Han sarcophagus in mind, we can better appreciate the decorative program of the sedan carriage. Now the distribution patterns start to make sense: the dominance of the cloud and lozenge patterns, the enclosure of a field of cloud-scrolls with lozenge patterns, and the back door that keeps the cloud-scrolls inside and the lozenge patterns outside. The purpose was apparently to circumscribe and rim in the scattered breath.

The scale of the carriage, at half life-size, is also significant. There would seem to be no expectation of a figural, humanlike spirit—the emperor's spiritual doppelgänger—showing up and crawling inside. Its size implies that the carriage is no more than a symbolic container whose contents, as the cloud decoration suggests, are merely a mass of nebulous scattered breaths. The vehicle was designed to contain the breaths until their eventual hardening.

Detail of the bronze standing carriage

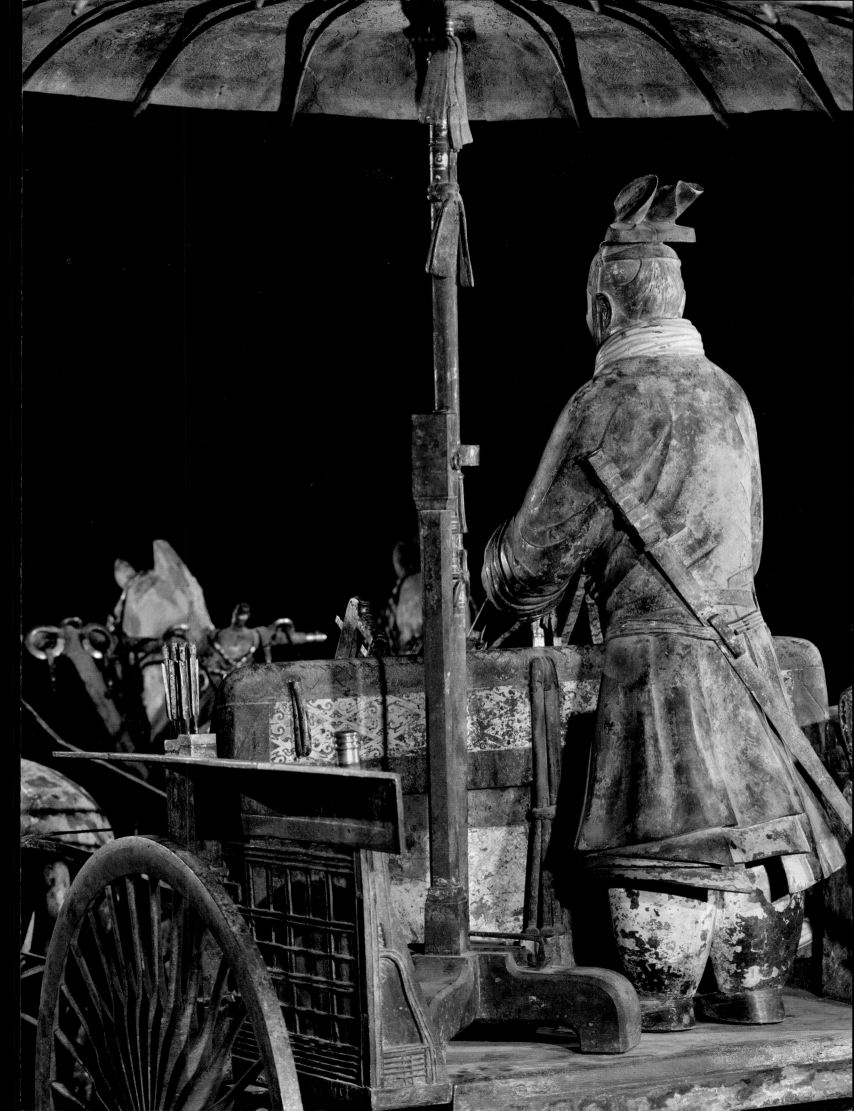

A telltale detail reinforces this impression. Clearly, the bronze carriage mimics the all-season sedan carriage used in the emperor's final days. But does the replica retain accommodation for a human form to be seated inside? Its reduced scale already says no. Furthermore, when a dignitary of that time rode in a sedan carriage, a pair of armed guards of honor or senior officials flanked the driver to escort the distinguished vehicle. Yet here there is only the driver, alone on the front seat. This implies that the design did not presume a dignified passenger, in his figural form, inside the compartment. In fact, the compartment of the bronze carriage has been stretched into an oblong shape to hold a casket—or a nebulous mass of breaths.

From the well-wishing viewpoint of the living, what should happen to the deceased person's mass of breaths? A simple answer has already been given: they should be gathered and consolidated. Symbolic means were devised to make that happen. One way was to refine the breaths in a crucible (real or imaginary). That process is demonstrated in the bas-relief on the Han sarcophagus discussed above. The tripod in the middle, attended by two bare-chested strong men, is the crucible in which the scattered breaths are refined into consolidated substance.

The process depicted in this scene is an instance of both physiological and physical alchemy. Its rationale was derived from macrobiotic therapies practiced by the living with the aim of revitalization. These included breathing exercises and various other activities, all united by a basic governing principle. The goal was, invariably, consolidation of scattered breaths, and this was achieved through alchemy. In this macrobiotic context, the alchemy was sometimes metaphorical and sometimes literal. It might involve a physiological activity (such as a breathing exercise), or it might denote the physical refinement of alchemical substances. In ancient texts, it is not always clear whether "alchemy" is of the physiological or the physical kind. What matters for us is the principle underlying both: the conviction that the nebulous breaths—or elements (e.g., mercury) embodying breaths—could be transmuted into a magical crystalline substance that is transcendent and permanent.

Two seventeenth-century prints illustrate the concept and the process. One print demonstrates the equivocal space in which the alchemical process occurs (fig. 8).

Fig. 8. Illustration of universal radiance. From *Direction for Endowment and Vitality*, dated 1615, woodblock-illustrated book, ink on paper, Harvard-Yenching Library Rare Book Collection

Fig. 9. Copulation of the dragon and tiger. From *Direction for Endowment and Vitality*, dated 1615, woodblock-illustrated book, ink on paper, Harvard-Yenching Library Rare Book Collection

Here the crucible—which could be a physical entity or simply a trope—is located somewhere near the abdomen of the meditation practitioner, who is holding the sun and moon. The human body is thus correlated with the cosmos. The figural space in question oscillates between body and cosmos. The other print demonstrates how the *yin-yang* alchemical conjugation takes place (fig. 9). The *yin* and *yang* breaths, pictured here as a boy and a girl respectively riding a tiger and dragon, converge in the alchemical crucible. The symbolic *yin-yang* copulation will result in a condition of regenerated vitality.

If there are doubts about the relevance of seventeenth-century prints to third-century BCE practice, a bas-relief on a Han sarcophagus (fig. 10) will help dispel them. It contains all the essential elements of the physiological alchemy diagrammed in the print: the dragon and tiger embodying the *yin* and *yang* breaths converging on the cauldron. The circle signals the union, and the pair of eyes on the cauldron indicates the arrival of spiritual illumination following the *yin-yang* conjugation. This is similar to the bas-relief of a tripod on the Han sarcophagus from Luzhou (fig. 7), only there the eyes appear in midair. The theme is the same: conjoining of the *yin* and *yang* breaths leads to revitalization.

With regard to the First Emperor's tomb site, the Luzhou bas-relief is doubly suggestive and revealing. First of all, it graphically illustrates the metamorphosis induced by physiological alchemy: nebulous breaths (cloud patterns) harden into consolidated substance (hard-edged lozenges). But that is just the beginning. It also radically redefines for us the nature of another burial pit near the

Fig. 10. Conjugation of *yin* (dragon) and *yang* (tiger) breaths. Ink rubbing of of sarcophagus bas-relief from the cliff tomb of Mount Gongzi, Yibin, Sichuan, Later Han period (25–220 CE), Institute of Cultural Artifacts, Yibin County, Sichuan

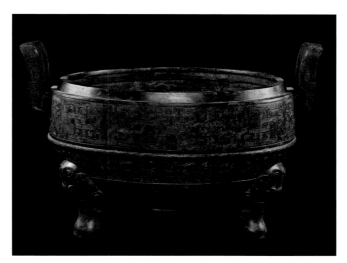

Fig. 11. Bronze *ding* vessel, Eastern Zhou period, from Pit K9901 of the First Emperor's tomb complex

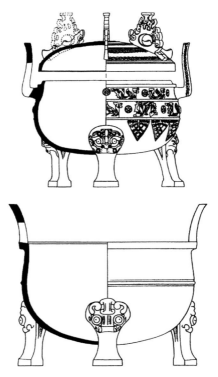

Fig. 12. *Ding* vessel from Yanxiadu, Warring States period

First Emperor's tomb. The bas-relief's most prominent features are the bare-chested strong men attending the tripod and the crucible that refines the nebulous breaths into quintessential forms of permanence. If such was the way the living cared for the dead, efforts to this effect must have been made in stage-managing the First Emperor's death. And if so, there ought to be some traces of them. Indeed, there are.

A bronze tripod (fig. 11) was uncovered in burial pit K9901, southeast of the tomb mound.[19] Pottery vessels have been found in a number of accessory burial pits of the tomb complex, but this is the only bronze vessel discovered on the site. This bronze tripod is now commonly regarded as a ceremonial vessel signifying the emperor's august status. But the characterization is problematic. Bronze vessels were indeed interred in tombs, in numbers proportional to the tomb occupant's social status. According to ancient Chinese ritual decorum, the emperor was entitled to a set of nine.[20] However, archaeological evidence indicates that officials and aristocrats of lesser status often transgressed the hierarchical rule and had numerous bronze vessels placed in their tombs, in ostentatious acts of pretension to higher status. It would confound logic to think that the First Emperor was entitled to only one. So, if the tripod is not there to fulfill the status-signifying ceremonial function, what is it doing in the pit?

The tripod's design points us in the right direction. It can be traced back to the Spring and Autumn period (770–476 BCE), but it also recalls a Central Plains prototype prevalent in the Warring States period (475–221 BCE). Its owl-faced legs bear a striking resemblance to those of the pottery tripods from the Warring States tombs at Yanxiadu, in the state of Yan (present-day Hebei) (fig. 12).[21] It is hardly surprising that the state of Yan should enter the picture here. Occult or magical recipe specialists (*fangshi*) of the Yan and Qi regions were particularly influential advocates of life-prolonging techniques. The First Emperor was evidently rather beholden to their expertise.[22] His quest for transcendence was motivated in part by the widely circulating lore of transcendence that the occult specialists of the Yan and Qi perpetuated. Central to their technique was the theory of harnessing breaths as part of macrobiotic therapies.

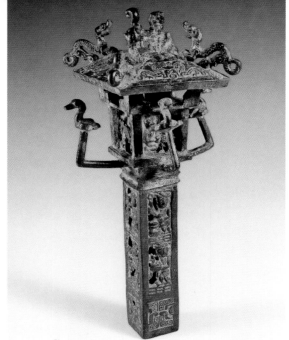

Fig. 13. Bronze cosmological model from Yanxiadu, Warring States period, Research Institute of Cultural Artifacts, Hebei

Fig. 14. Life-size terracotta figure in Pit K9901 of the First Emperor's tomb complex

A bronze object from the Yan region (fig. 13) serves as a model for this breath-conjugation process.[23] It is apparently a cosmological model, consisting of a pillar surmounted by a superstructure with four birds—presumably signaling the four directions. A succession of three scenes, one above the other on the column's shaft, suggests a transformative process structured as an upward aspiration. In the first (lowest) scene, two nebulous serpentine motifs are set against hard-edged geometric patterns; the other two scenes picture a nude figure working on a vessel of some kind. While the precise meaning of these images is unclear, the significance of the progression emerges at the superstructure. There, a kneeling figure attends a legged vessel. This scene occupies the same level as the four branching birds. Farther up, paired facing dragons and birds meet, echoing the serpentine motifs at the base, as if the nebulous breaths have now morphed into distinct shapes signifying exalted transformation in a heavenly state. The tripod apparently plays a key role in transforming the breaths.

The Yan model's scene of a figure attending a legged vessel is recapitulated in later times. The Han sarcophagus bas-relief of two strong men attempting to raise a tripod is but one example. To see a variation on the same theme from the First Emperor's tomb site, we need look no further than Pit K9901, which yielded the bronze tripod. The pit contains eleven terracotta male figures with bare torsos, in skirtlike pants (fig. 14). They are now dubiously identified as acrobats engaged in a sort of variety show to supply the emperor with afterlife entertainment.[24] If this is correct, there is an oddity that

is hard to explain. Acrobat figurines are typically smaller than life-size. Examples from tombs both before and after the First Emperor's mausoleum attest to that established convention.[25] The terracotta figures from Pit K9901, however, are all life-size. But even allowing for the Qin taste for colossi, we are still hard pressed to explain another peculiarity. Entertainment figures found in ancient tombs are generally shown doing what they are supposed to do: performing acrobatics (body contortions, flips, etc.), dancing, or playing music. That is not the case here; nor do we find any musical instruments, which typically accompany such figures.

Some notable visual facts about these figures have, however, caught the attention of scholars despite their settling for the acrobat identification. For instance, one figure's taut and bulging belly suggests the summoning up of "abdominal breath" (*dantian zhi qi*).[26] This observation is right on. The figures may well be engaged in breathing exercises just like those in the energy-guiding diagram from Mawangdui Tomb 3 (fig. 15). Interestingly, some of the figures in the diagram have bare torsos and wear short, skirtlike pants.

Even if they are not practitioners of breathing exercise or "energy-guiding" (*daoyin*), the terracotta figures certainly play a vital part in a transformative alchemical process. To begin with, they look remarkably like their counterparts in the sarcophagus bas-relief (fig. 7), with bare torsos, short pants, and all. Also suggestive is the geometrical design on their skirtlike pants. It is mainly of two kinds, wavy scrolls and angular lozenges (fig. 16),[27] precisely the opposition of forms seen on the bronze sedan carriage.

The presence in Pit K9901 of the alchemically significant tripod, with its implied function of transforming and refining the scattered breaths, calls to mind a key passage from the *Records of the Grand Historian* that pertains to what lies inside the First Emperor's tomb.

> In the ninth month the First Emperor was interred at Mt. Li. When the emperor first came to the throne he began digging and shaping Mt. Li. Later, when he unified the empire, he had over 700,000 men from all over the empire transported to the spot. They dug down to the third layer of underground springs and

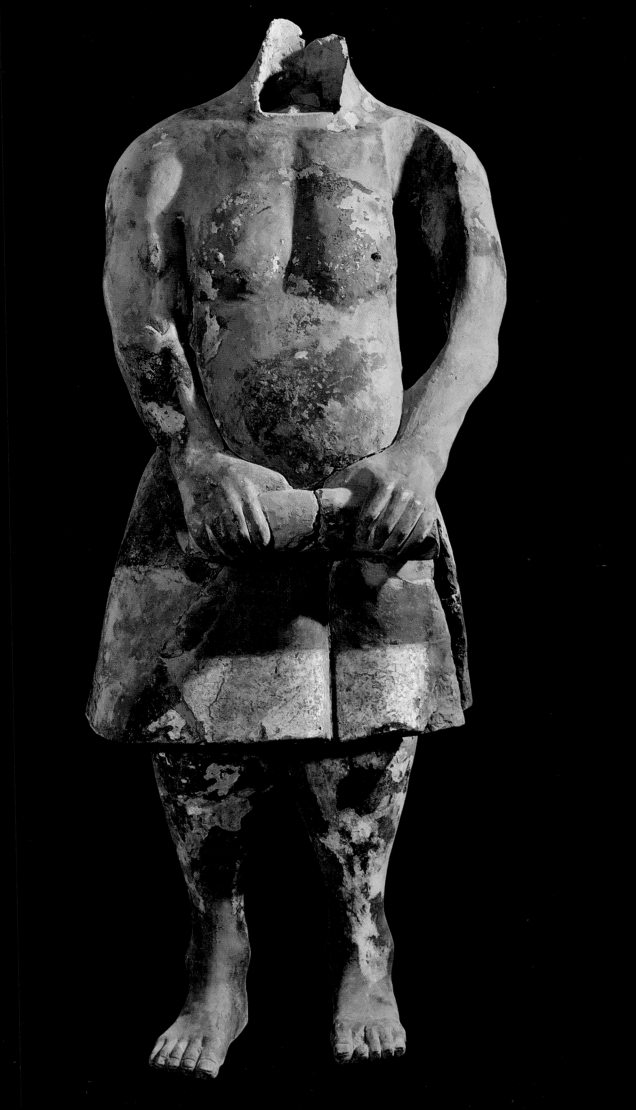

Fig. 15. Illustration of the energy-guiding exercise, painting on silk, Mawangdui Tomb 3, c. 168 BCE

Fig. 16. Decorative designs on the pants worn by the terracotta strong men in Pit K9901

poured in bronze to make the outer coffin. Replicas of palaces, scenic towers, and the hundred officials, as well as rare utensils and wonderful objects, were brought to fill up the tomb. Craftsmen were ordered to set up crossbows and arrows, rigged so they would immediately shoot down anyone attempting to break in. *Mercury* [italics mine] was used to fashion imitations of the hundred rivers, the Yellow River and the Yangtze, and the seas, constructed in such a way that they seemed to flow. Above were representations of all the heavenly bodies, below, the features of the earth. "Man-fish" oil was used for lamps, which were calculated to burn for a long time without going out.[28]

The grand historian's mention of mercury is significant. It may be no coincidence that a high level of mercury has been detected at various spots in the First Emperor's tomb. Mercury and lead are the two key components required for physiognomic and physical alchemy. In the seventeenth-century print cited above (fig. 9), they are represented by the dragon (mercury) and tiger (lead).[29] The mercury in the tomb chamber may well function beyond the simulacra of rivers; it may have been deployed as one of the elements indispensable for the conjugation of the *yin* and *yang* breaths to achieve the desired "transcendence." The cosmological model described by the grand historian Sima Qian may well be akin in concept to the bronze pillar from the Yan region.

It is likely that the terracotta strong men in Pit K9901 were there to attend the bronze cauldron from the same pit. Various early texts contain versions of cauldron lore, some involving strong men, others not. Peeling off the narrative overlays, we can see that the cauldron is not necessarily linked to political symbolism. Instead, during

Qin and Han times, it was associated more with the quest for transcendence[30] and the refinement of dietetic recipes.[31] That cauldron scenes are depicted in Han tombs strongly suggests an iconographic interest in their regenerative overtones. The sarcophagus bas-relief from Luzhou is the most explicit and self-explanatory evidence in this regard. The cauldron pit from the First Emperor's tomb complex should be viewed in a similar light.

It is well documented that, from the First Emperor's time on, bronze cauldrons became associated with the practice of alchemy aimed at attaining longevity.[32] Sima Qian's account of the molding of the Yellow Emperor's cauldron says more about the aspiration to transcendence underlying care of the dead in the third and second centuries BCE than about the legendary Yellow Emperor's time.[33]

With all that effort to accommodate the mass of the First Emperor's scattered breath, what might have happened to it? The emperor gasped his last in the seventh month of 210 BCE at the Ping Terrace of Sand Hill (now Guangzhong County, Hebei), in the former state of Zhao. He was allegedly interred in Mount Li in the ninth month, but the tomb was not sealed until the fourth month of the following year.[34] There is now a growing revisionist suspicion among modern scholars that the emperor's body may not have been returned to the capital. The scorching summer heat would have made it impossible for Li Si's party to preserve the corpse for two or three months on the road. It is not inconceivable that the emperor's body was secretly buried in the former state of Zhao rather than being carried back to the Qin capital.[35] Given the early Chinese understanding of the post-mortem condition, care for the scattered breaths, not the body, would have been the more pressing concern: "That the bones and flesh should return again to the earth is what is appointed. But the spirit in its energy can go everywhere; it can go everywhere."[36]

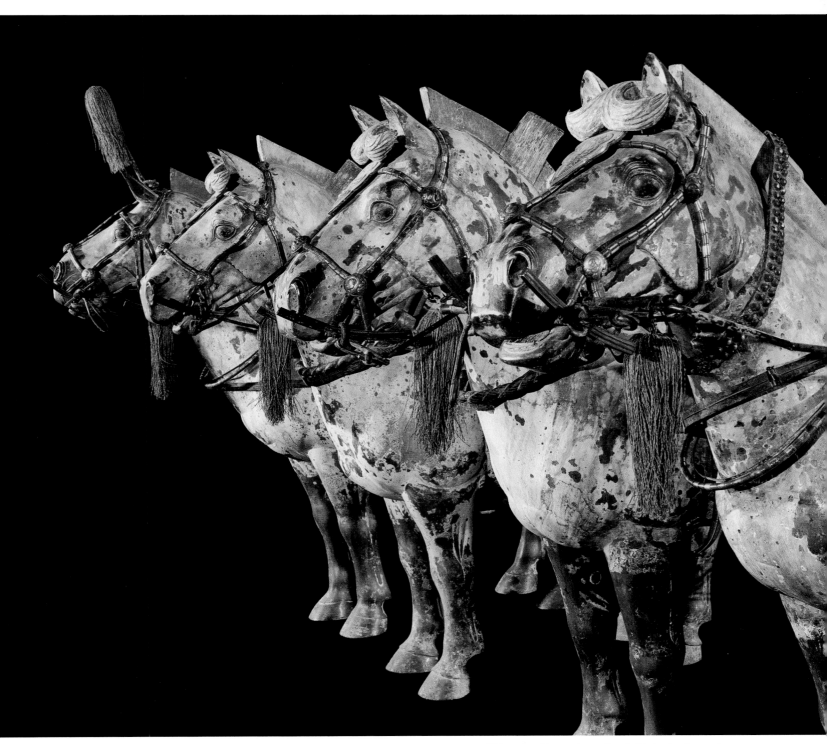

White-painted bronze horses found with the standing carriage

There is no way of knowing—before the tomb is opened—whether the emperor's body was brought back to his mausoleum in Mount Li. At this point, the bronze carriage excavated west of the tomb provides our best clue. It registers a deliberate effort to replicate the all-season sedan carriage which carried the emperor in his last days and held his body after he expired. Inside the carriage are three bronze objects: a container, a folded sheet, and a strap.[37] The container (fig. 17)—with its realistically modeled string and cover, creased to create the effect of pliable material—has been identified as a bronze replica of a *chiyi*, a tightly sealed leather pouch used as a wine vessel in ancient China.[38] Early sources also record the use of *chiyi* sacks to contain human remains.[39] For Li Si's party, bringing back the First Emperor's body in a leather sack may have been a practical solution.

It is, however, questionable whether the bronze pouch was intended primarily to document the undignified use of a leather sack to bring back the emperor's body. The plain and pedestrian sack carried far more symbolic weight in ancient China than our modern perception would credit. Whereas human beings have "seven orifices for the purpose of seeing, hearing, eating, and breathing," the sack has none.[40] Its featureless plainness embodies and models "primordiality" (*hundun*), an embryonic condition that was the original state of existence prior to the birth of the *yin* and *yang* breaths and the creation of the universe and varieties of life.[41] Cultivation of this condition was known as the "arts of the Embryonic Age."[42] Embodying primordiality, the transcendent "true being" (*zhenren*) was said to be free of bodily form[43] and therefore capable of "entering water without getting wet, entering fire without getting burned, soaring over the clouds and air, and enduring as long as heaven and earth."[44] During his life, the First Emperor openly aspired to the status of a "true being."[45] Now that he had become indeed a "free spirit" unshackled by a bodily frame, his postmortem condition, consisting in pure breaths, could be conceived as in the undifferentiated "embryonic state." The leather sack—symbolized by the bronze vessel—best embodied this condition. That the "content" of the carriage is the imaginary breath in "embryonic condition" reinforces the point made earlier. The decorative patterns diagram the optimum condition of the breath.

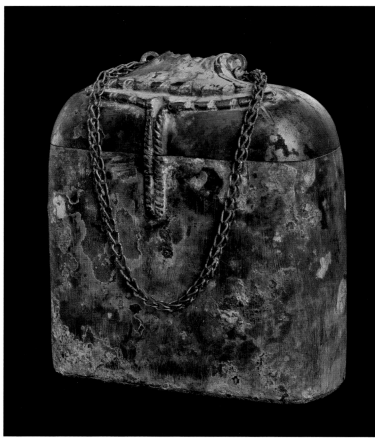

Fig. 17. Bronze container in the bronze sedan carriage

The bronze sack enclosing the "embryonic condition" has further significance. Primordiality is inextricably linked, both linguistically and conceptually, to the legendary Yellow Emperor (Huangdi) and to Mount Kunlun,[46] the pristine jade-covered magical mountain in the west, a ladder to heaven. King Mu of Zhou (r. 976–922 BCE) allegedly went there in a carriage to catch a glimpse of the residence of the Yellow Emperor, the apotheosis of primordiality, and became rejuvenated.

Such associations bring into focus the distinctiveness of the bronze carriages. The two-carriage set is commonly considered part of the emperor's afterlife caravan. However, the discovery near the tomb of three other burial pits—called "stable pits" by Chinese archaeologists—strains this theory. The stable pits are located south, southwest, and east of the tomb. They all contain real horses, unlike the west-side pit holding the small bronze carriages. The south-side stable pit has three horses in one wooden compartment. The east-side pits—so far eighty have been found—each have one horse per pit, some of them encased in wooden compartments. All the horses face west. If these horses are indeed, as Chinese archaeologists believe, part of the imperial court caravans serving the emperor,

Fig. 18. The Plough (Big Dipper) vehicle carrying a celestial god on a sky tour. Drawing based on a bas-relief from the Wu Family Shrines, c. 147 CE

the imperial family, and the imperial court in their afterlife world,[47] that leaves the bronze carriages decidedly the odd ones out.

A host of significant traits make the bronze carriages distinctive. Each is drawn by four half-size bronze horses painted white. The tunnel containing the bronze carriages is one of a set of five identical tunnels.[48] A medieval imperial ceremonial guide speaks of the "five imperial carriages," each keyed to one of the five quarters (east, south, west, north, and center), five colors (green, red, white, black, and yellow), and five seasons (spring, summer, third-month summer, autumn, and winter).[49]

The fivefold division of space applies equally to heaven and earth—the two were strictly correlated.[50] The sky ecliptic was divided into a "central palace" and four other "palaces" that each contained seven "mansions" (groups of stars). The four palaces were each associated with an animal. The Western Palace, which figured as the White Tiger and was exemplified by the constellation Xianchi (also known as the Five Celestial Ponds), served as the garage for the carriages of the Five Gods.[51]

Primordiality (hundun), apotheosized as a god figure, was the central deity among the Five Gods in heaven.[52] If the bronze sack in the sedan carriage embodies Primordiality, it signals the projection of the embryonic condition into the terrestrial (or subterranean) imitation of heaven. The bronze horses and carriages were clearly not meant to be used by any afterlife semblance of a real human being in a this-worldly manner. Rather, their reduced size and bronze medium signal their abode in celestial alterity as opposed to terrestrial reality.

The First Emperor's court had a propensity to construct earthly simulacra of heaven. The Xin Palace, built south of the Wei River in 220 BCE, for example, was soon renamed "Apex Temple in imitation of the Heavenly Apex."[53] It is likely that the set of five tunnels in the First Emperor's tomb—one holding the bronze carriages—is the garage for the Five Gods' carriages. A Han carving of a god touring the sky in his astral "god's carriage" (diche) (fig. 18) helps us visualize how the bronze carriage may have played its part.[54]

The heavenly Western Palace is central to this scenario. Amid its seven mansions—Legs, Bond, Stomach, Hairy Head, Net, Turtle Beak, and Three Stars—the Heavenly Street intervenes between the Hairy Head and the Net. It is a numinous dividing line: to its north is the yin realm, to its south the yang realm. The Hairy Head hosts the White Clothing Assembly, in charge of funerary matters.[55] Occult specialists of the time spoke of the west as "the tomb for the spiritual luminescence."[56] The white-painted bronze carriage parked near the Heavenly Street is thus richly suggestive. It could mean the crossing of that yin-yang boundary. The decorative patterns on the carriage suggest that the end result had already been diagrammed. Cloudlike forms were to dissolve. The scattered breath was expected to harden into transcendent qualities in the form of pristine lozenge patterns. No matter what the scenario might be, one thing becomes clear: the bronze carriage is not there waiting for the emperor's figural spirit—there wasn't any such thing at the time—to sneak out of the tomb chamber and climb into it. The carriage had already arrived at the Heavenly Street, in perfect conformity with the ways of heaven. And in accord with third-century BCE notions about the postmortem condition and with the historical circumstances, the carriage simply remained empty, as it was meant to be, except for a pouch's worth of breaths in an "embryonic state."

Notes

1. For an introduction to the site, see Lothar Ledderose, *Ten Thousand Things: Module and Mass Production in Chinese Art* (Princeton, N.J.: Princeton University Press, 2000), and Jane Portal, ed. *The First Emperor: China's Terracotta Army* (Cambridge, Mass.: Harvard University Press, 2007).

2. Wu Yongqi, *Qinshihuangling ji binmayong* [Mausoleum of the First Emperor and its terracotta warriors] (Xi'an: Sanqin Chubanshe, 2004), p. 22.

3. Even though the current plan of the tomb shows the bronze chariot pit outside of the tumulus, archaeologists confirm that the tumulus, in its original condition, covered the pit. *Qinshihuangling tongchema fajue baogao* [The bronze carriages from the First Emperor of Qin: Excavation report], Qin Shihuang bingmayong bowuguan, Shaanxisheng kaogu yanjiusuo [Qin Shihuang Terracotta Warriors and Horses Museum; Shaanxi Provincial Institute of Archaeology] (Beijing: Wenwu Chubanshe, 1998), p. 6.

4. Wang Xueli, *Qinling caihui tongchema* [Painted bronze carriages from the Qin mausoleum] (Xi'an: Shaanxi Renmin Chubanshe, 1988), p. 11. For a survey of literature and critique of the characterization of the bronze carriage as "spirit carriage," see Liu Jiusheng, "Qinshihuang diling tongchema yu Zhongguo gudai wenming" [The First Emperor's bronze carriages and the ancient Chinese civilization], *Tangdu xuekan* 27, no. 2 (2011): 1–34.

5. Wang Xueli, for instance, states that the carriage's empty seat indicates that it is waiting for the emperor's soul to sit and roam the mountains and rivers in the tomb. See Wang Xueli, *Qinling caihui tongchema*, p. 11.

6. Sun Xidan, *Liji jijie* [Variorum edition of the Record of the Rites] (Beijing: Zhonghua Shuju, 1989), p. 294. Legge translates *hunqi* as "soul." I have replaced it with "spirit," which captures more the sense of the ancient Chinese notion of *hunqi*. For Legge's translation, see James Legge, trans., *Li Chi Book of Rites*, 2 vols. (New York: University Books, 1967), 1:192.

7. Eugene Wang, "Why Pictures in Tombs? Mawangdui Once More." *Orientations* 40, no. 2 (March 2009): 27–34, and Eugene Wang, "Ascend to Heaven or Stay in the Tomb? Paintings in Mawangdui Tomb 1 and the Virtual Ritual of Revival in Second-Century B.C.E. China," in *Mortality in Traditional Chinese Thought*, ed. Amy Olberding and Philip J. Ivanhoe, pp. 37–84 (Albany: State University of New York Press, 2011).

8. Burton Watson, trans., *Records of the Grand Historian*, by Sima Qian (New York and Hong Kong: Columbia University Press, 1993), pp. 62–63.

9. Zheng Luanming, "Xi Han zhuhouwangmu suojian de chema xunzang zhidu" [The sacrificial burial system of the carriages and horses seen in the tombs of Western Han princes], *Kaogu*, 2002, no. 1: 71.

10. *Qinshihuangling tongchema fajue baogao*, p. 12, fig. 6.

11. Zhang Weixing has proposed a tripartite taxonomy of the design patterns: (1) lozenge, (2) geometrical designs, and (3) cloud-scrolls. Zhang Weixing, "Qinshihuangling tongchema wenshi de chubu kaocha" [A preliminary study of the decorative patterns on the bronze carriages from the mausoleum of the First Emperor], *Zhongyuan wenwu*, 2005, no. 3: 47–53.

12. The hard-edged geometric patterns were initially designs woven into openwork silk (*qi*). They are known in ancient texts as "cup pattern." Liu Xi (2nd/3rd century) states that wearing clothes with such cup patterns enables one to enjoy longevity. He did not spell out the reason. In light of my analysis of the decorative designs on Mawangdui coffins, Liu's statement makes perfect sense. See Liu Xi, *Shiming* [Explanation of Names], Sibu congkan chubian jingbu [Reprint of collectanea of the four categories: Confucian classics] (Shanghai: Shangwu Yinshuguan, 1922), p. 19; Sun Ji, *Handai wuzhi wenhua ziliao tushuo* [Illustrated history of the material culture of the Han dynasty] (Shanghai: Shanghai Guji Chubanshe, 2008), pp. 72–73.

13. Eugene Wang, "Why Pictures in Tombs?" and "Ascend to Heaven or Stay in the Tomb?"

14. The period term is "dissolution of bodily form and sublimation" (*xinjie xiaohua*). See Sima Qian, *Shiji* (Beijing: Zhonghua Shuju, 1959), p. 1368.

15. For the most recent study of the tomb, see Eugene Wang, "Why Pictures in Tombs?" and "Ascend to Heaven or Stay in the Tomb?"

16. Joseph Needham, *Science and Civilisation in China*, vol. 5, pt. 5, *Spagyrical Discovery and Invention: Physiological Alchemy* (Cambridge: Cambridge University Press, 1983).

17. Donald Harper, *Early Chinese Medical Literature: The Mawangdui Medical Manuscripts* (New York: Kegan Paul International, 1998).

18. Joseph Needham, *Science and Civilisation in China*, vol. 5, pt. 3, *Spagyrical Discovery and Invention: Historical Survey, from Cinnabar Elixirs to Synthetic Insulin* (Cambridge: Cambridge University Press, 1976), p. 533.

19. Yuan Zhongyi, *Qinshihuangling kaogu faxian yu yanjiu* [The mausoleum of the First Emperor: Archaeological discoveries and studies] (Xi'an: Shaanxi Renmin Chubanshe, 2002), color plate 7. Portal, *First Emperor*, p. 47, fig. 39.

20. He Xiu's (129–182 CE) annotation of the *Chunqiu Guliang zhuan* [The Guliang commentary on the Spring and Autumn Annals], in *Chongkan Songben Shisanjing zhushu fu jiaokanji* [Reprint of the Song edition of the Thirteen Classics with commentaries and annotations], ed. Ruan Yuan (1764–1849) (Taipei: Yiwen Yinshuguan, 1965), p. 49a.

21. Similar tripods are found in Jiunütai Tomb 16, Xinzhuangtou Tomb 30, and Langjingchun Tomb 31. *Yanxiadu* [Secondary capital of the state of Yan], Hebeisheng wenwu yanjiushuo [Research Institute of Cultural Relics, Hebei Province] (Beijing: Wenwu Chubanshe, 1996), p. 687. *Zhongguo kaoguxue liang Zhou juan* [Studies in Chinese archaeology: The Zhou dynasty] (Beijing: Zhongguo Shehuikexue Chubanshe, 2004), pp. 336–37. Guo Dashun and Zhang Xingde, *Dongbei wenhua yu youyan wenming* [Northeastern culture and the You-Yan civilization] (Nanjing: Jiangsu Jiaoyu Chubanshe, 2005), pp. 564–72.

22. Sima Qian, *Shiji*, p. 1368.

23. *Yanxiadu*, pp. 842–47. Guo Dashun and Zhang Xingde, *Dongbei wenhua yu youyan wenming*, p. 578.

24. Yuan Zhongyi, *Qinshihuangling kaogu faxian yu yanjiu*, pp. 179–97.

25. See Hu Lin'gui and Liu Hengwu, *Tidai xunzang de suizangpin—Zhongguo gudai taoyong yishu* [Burial objects as sacrificial substitutes—Ancient Chinese art of pottery figurines] (Chengdu: Sichuan Jiaoyu Chubanshe, 1998).

26. Yuan Zhongyi, *Qinshihuangling kaogu faxian yu yanjiu*, p. 185; plate 32.

27. Ibid., p. 191, fig. 77; p. 192, fig. 78.

28. Watson, *Records of the Grand Historian*, p. 63.

29. See Su Shi, "Longhu qiangong lun" [Treatise on dragon, tiger, lead, and cinnabar], in *Tang Song badajia quanji* [Complete works of the eight masters of the Tang and Song dynasties], ed. Yu Guanyin (Beijing: Guoji Wenhua Chuban Gongsi, 1998), pp. 3701–2.

30. See Yuan Ke, *Zhongguo shenhua tonglun* [Survey of Chinese mythology] (Chengdu: Ba Shu Shushe, 1993), pp. 140–44.

31. The lore of the cooking cauldron of Yi Yin, the legendary adviser to a Shang king, provided a basis for later ideas about cooked soup in a cauldron as a recipe for refining and transformation. A chef of humble origins, Yi Yin offered political advice when serving the king food from the cooking cauldron. Recognizing Yi Yin's talent, the king made him a minister. For the lore of Yi Yin's cauldron, see Sima Qian, *Shiji*, pp. 94, 3182.

32. Ying Shao noted that "the theory of alchemical crucible for breath refinement started in the times of the [First] Emperor of Qin and Han Wudi." Ying Shao, *Fengsu tongyi yiwen* [Common meanings in customs], cited in Zhang Zhengli, *Zhongyuan gudian shenhua liubian lunkao* [Study of the origins and development of the classical mythology of the Central Plains] (Shanghai: Shanghai Wenyi Chubanshe, 1991), p. 119.

33. Sima Qian, *Shiji*, p. 468.

34. *Qinshihuangling tongchema fajue baogao*, p. 375. Watson, *Records of the Grand Historian*, p. 63.

35. Chen Jinyuan, "Qinshihuang mizang Hebei zhishuo" [The secret burial of the First Emperor of Qin in Hebei: A hypothesis], *Zhishi jiushi liliang*, 2007, no. 2: 74–75.

36. Sun Xidan, *Liji jijie*, p. 294. Legge, *Li Chi Book of Rites*, 1:192.

37. *Qinshihuang tongchema fajue baogao*, p. 374.

38. Nie Xinmin, "Qinling tongcheyu nei chutu wenwu shimin" [Notes on the artifacts from the bronze carriages], in *Qinyong bowuguan lunwen xuan* [Collection of essays from the museum of the Qin terracotta soldiers], ed. Yuan Zhongyi and Zhang Wenli (Xi'an: Xibei Daxue Chubanshe, 1989), pp. 314–18.

39. Examples include the sackings respectively of Guan Zhong and Wu Zixu. See *Lüshi chunqiu zhushu* [Mr. Lü's Spring and Autumn Annals with annotations], ed. Wang Liqi (Chengdu: Bashu Shushe, 2002), 4:2887. For a survey of the use of the *chiyi* sack, see Zang Shouhu, "Huangdi, chiyi, huntuo, hundun hukao" [Notes on the Yellow Emperor, *chiyi*, *huntuo*, primordiality], in *Zhongyi wenhua luncong* [Studies in Chinese medicine culture], ed. Wang Xinlu (Jinan: Qilu Shushe, 2005), pp. 214–15.

40. The *Zhuangzi* contains a parable of the god of *hundun* (chaos, primordiality, embryonic state): "The Normal Course for Rulers and Kings: The Ruler of the Southern Ocean was Shu, the Ruler of the Northern Ocean was Hu, and the Ruler of the Centre was Chaos [i.e. Primordiality]. Shu and Hu were continually meeting in the land of Chaos, who treated them very well. They consulted together how they might repay his kindness, and said, 'Men all have seven orifices for the purpose of seeing, hearing, eating, and breathing, while this (poor) Ruler alone has not one. Let us try and make them for him.' Accordingly they dug one orifice in him every day; and at the end of seven days Chaos died." *Zhuangzi jishi* [Variorum edition of Zhuangzi], annotated by Guo Qingfan, ed. Wang Xiaoyu, vol. 1 of *Xinbian zhuzi jicheng* [New variorum edition of the classical masters] (Beijing: Zhonghua Shuju, 1995), p. 309; translation from Legge, *The Texts of Taoism* (New York: Dover, 1962), 1:266–67.

41. David Hall, "Process and Anarchy: A Taoist Vision of Creativity," *Philosophy East and West* 28, no. 3 (July 1978): 271–85.; N. J. Girardot, *Myth and Meaning in Early Taoism: The Theme of Chaos (hun-tun)* (Berkeley: University of California Press, 1983); Eugene Eoyang, "Chaos Misread: Or, There's Wonton in My Soup!" *Comparative Literature Studies* 26, no. 3, East-West Issue (1989): 271–84.

42. *Zhuangzi jishi*, p. 438.

43. *Huainan honglie jijie* [Variorum edition of the Great Brilliance of Huainan], comp. Liu Wendian, 1st series of Xinbian zhuzij icheng (Beijing: Zhonghua Shuju, 1989), p. 463.

44. Sima Qian, *Shiji*, p. 257.

45. Sima Qian, *Shiji*, pp. 257, 259.

46. Zang Shouhu, "Huangdi, chiyi, huntuo, hundunhukao," p. 218.

47. Yuan Zhongyi, *Qinshihuangling kaogu faxian yu yanjiu*, p. 217.

48. *Qinshihuangling tongchema fajue baogao*, p. 9.

49. Du You, *Tongdian* [Comprehensive institutions] (Beijing: Zhonghua Shuju, 1988), pp. 1288, 1796. See also Wang Xueli, *Qinling caihui tongchema*, pp. 88–89.

50. For a compelling account of the celestial-terrestrial interconnectedness with regard to the First Emperor's tomb mound, see Jessica Rawson, "The Power of Images: The Model Universe of the First Emperor and Its Legacy," *Historical Research* 75, no. 188 (May 2002): 123–54.

51. Sima Qian, *Shiji*, p. 1304. See also Xia Nai, "Luoyang Xi Han bihuamu zhong de xingxiangtu" [Astral pictures in the Western Han mural tombs at Luoyang], in *Kaoguxue he kejishi* [Archaeology and history of science] (Beijing: Kexue Chubanshe, 1979), p. 54.

52. *Zhuangzi jishi*, p. 438.

53. Sima Qian, *Shiji*, p. 241. Watson, *Records of the Grand Historian*, p. 45.

54. For exposition of this relief carving and the notion of "god's carriage" (*diche*), see Joseph Needham, *Science and Civilisation in China*, vol. 3, *Mathematics and the Sciences of the Heavens and the Earth* (Cambridge: Cambridge University Press, 1959), 3:240–41; Xia Nai, "Luoyang Xi Han bihuamu zhong de xingxiangtu," p. 54.

55. Sima Qian, *Shiji*, p. 1305. The "White Clothing Assembly" refers to the protocol observed by court officials who were expected to attend the court in white during the observation of funerary rites of the imperial family. See *Bajia Hou Han shu jizhu* [Compendium of eight commentators on the History of the Later Han], ed. Zhou Tianyou (Shanghai: Shanghai Guji Chubanshe, 1986), p. 450.

56. Sima Qian, *Shiji*, pp. 1213, 1382. *Bajia Hou Han shu jizhu*, p. 4.

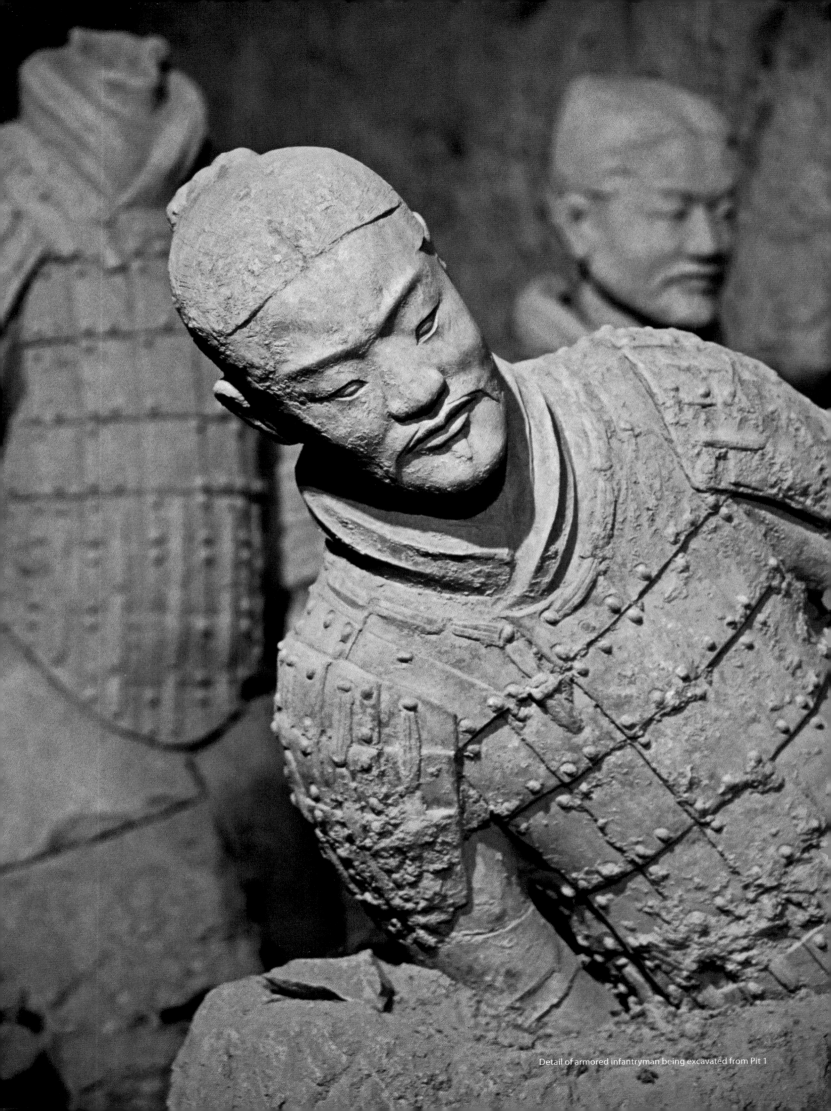

Detail of armored infantryman being excavated from Pit 1

OBJECTS FROM THE QIN DYNASTY

Terracotta Figures

72
Armored general
鎧甲將軍俑

Qin dynasty (221–206 BCE)
Terracotta, H. 198 cm (77¹⁵⁄₁₆ in)
Excavated from Pit 1, Qin Shihuang tomb complex, 1980

Qin Shihuang Terracotta Warriors and Horses Museum, Shaanxi 000847

Most impressive of all the terracotta warriors, the general is distinguished by his size, his headdress, his armor—which extends down his front and ends below his waist in a triangular form—and his ribbons, assumed to be emblems of rank, and tied in bows on his upper front and attached to his armor at the back. His headgear in real life would have been a cap adorned with tail feathers from a type of pheasant known as *he* (giving the cap the name *heguan*). Feathers of the *he* were chosen because of the bird's brave nature— it was common for them to fight to the death. It became customary later in the Han dynasty for ranking military officials to wear such headgear, yet the tradition can be traced back to the Warring States period. Representations of warriors wearing such costumes can be seen in other art forms in addition to the terracotta figures of the Qin dynasty (see image on right).

The general also wears long trousers and square-toed shoes. His hands are posed as if resting on a sword. He assumes an imposing stance, while his expression of intense concentration and his carefully groomed moustache and sideburns convey an aura of impassive authority, solemnity, and dignity.

To date, nine general figures have been excavated from the pits, two of which are without armor. They were positioned standing to the left side of a chariot, upon which bronze bells and drums were often installed to function as command signals.

A combat scene depicted on a bronze mirror of the Warring States period unearthed from a tomb in Jincun, Luoyang, showing an armored warrior wearing a *heguan*. After Wang Bomin, ed., *Zhongguo meishu tongshi* [A History of Chinese Art] (Jinan: Shandong Jiaoyu Press, 1996), vol. 1, plate 119.

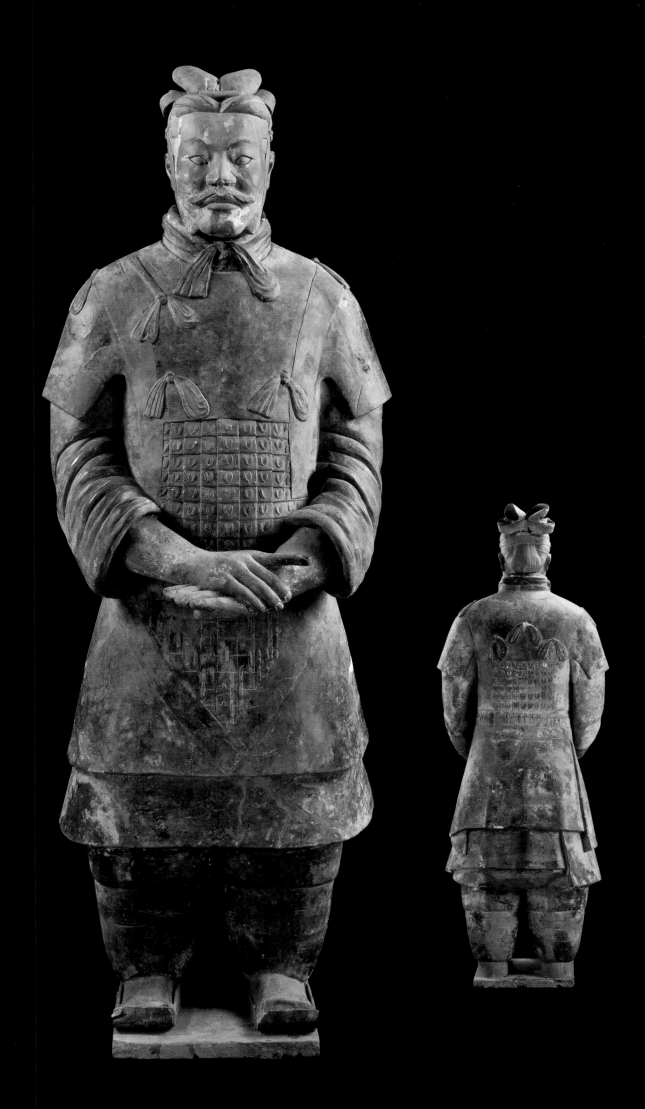

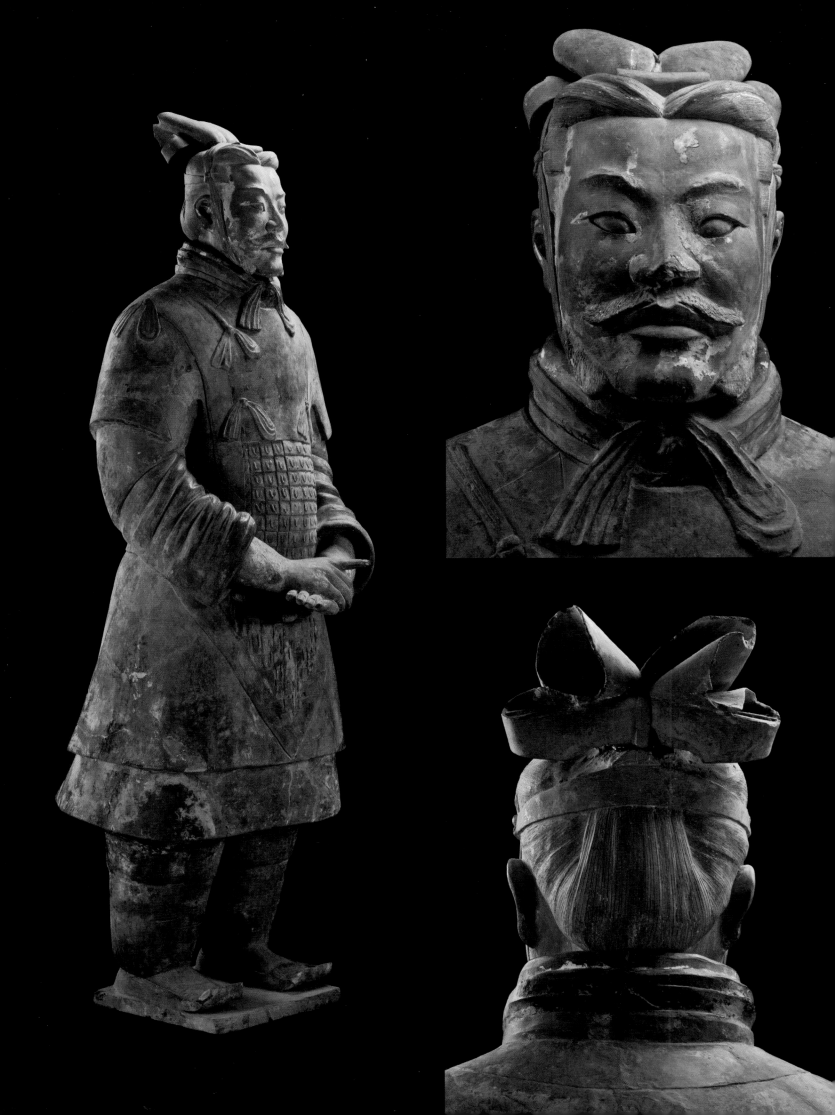

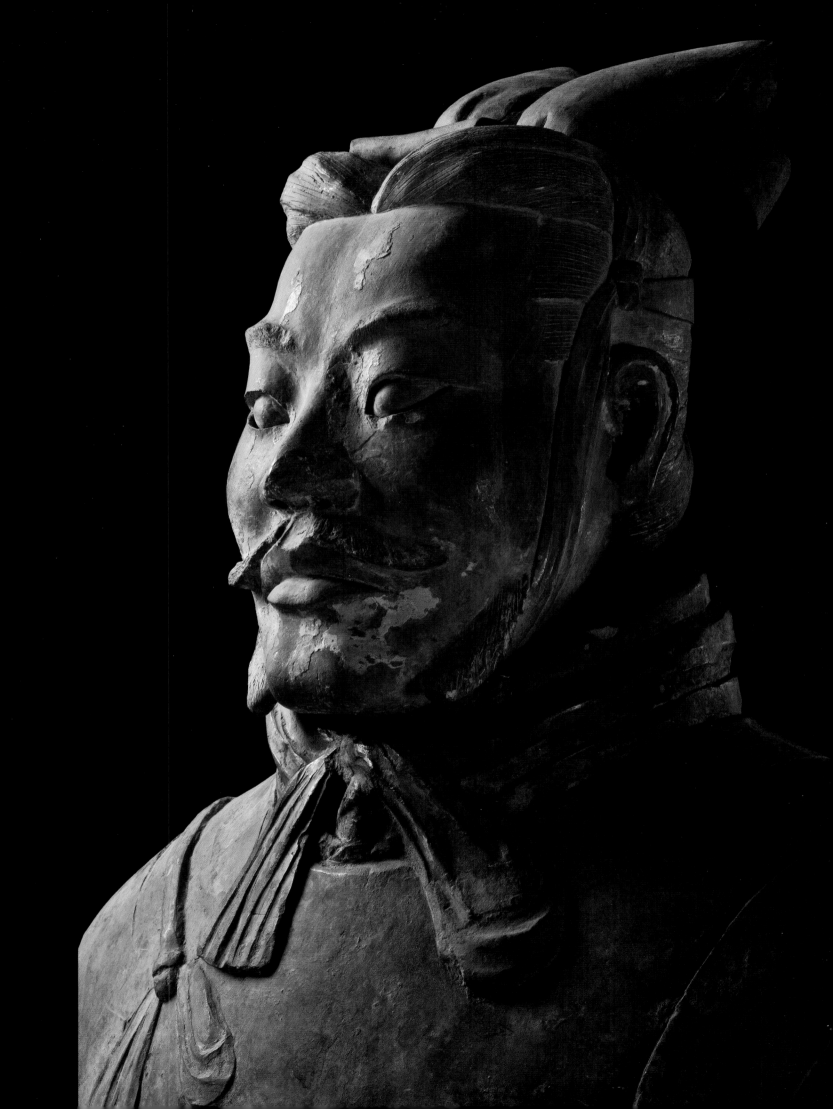

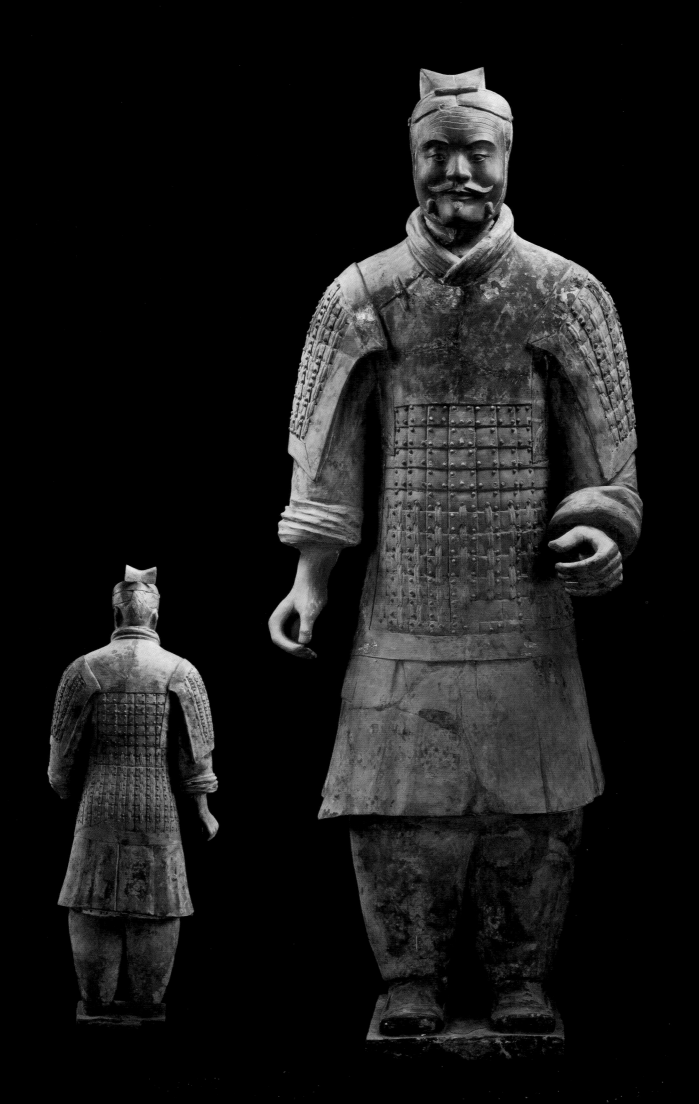

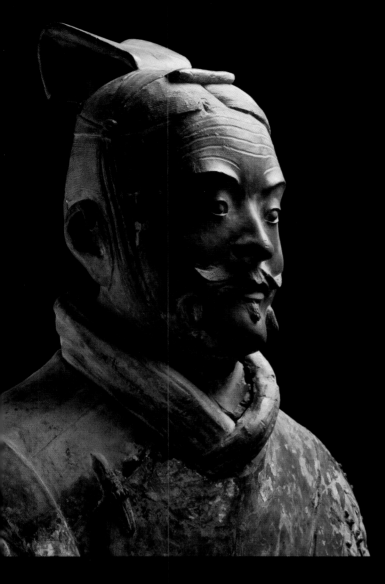

73
Armored military officer
中級軍吏俑

Qin dynasty (221–206 BCE)
Terracotta, H. 189 cm (74⁷⁄₁₆ in)
Excavated from Pit 1, Qin Shihuang tomb complex, 1976

Qin Shihuang Terracotta Warriors and Horses Museum, Shaanxi 00849

The hat, tied under the chin, identifies this warrior as a member of the officer class. It is interesting to compare this figure with the preceding general, for there is a clear intent to establish a hierarchy based on size, detail, and power of expression. The officer is smaller of stature, his facial expression less severe, and his raised left hand—originally holding a weapon—hints at a slightly hesitant pose, creating an overall impression of lesser authority than that accorded the general.

There are two types of ranking military officers excavated from the pits: armored and unarmored. Yet, each wears a cap with a flattened headdress set at an angle on the head and tied under the chin. Known as *zhaiguan*, the cap is believed to have originated in the Chu state during the Warring States period. The same headdress with a vertical line down the center would indicate a higher rank.

This officer wears armor, with epaulettes covering his shoulders and upper arms. Both hands are half clenched, indicating he once held a long-shafted weapon in his left hand and a sword in his right hand.

Some ranking military officers excavated from Pit 1 have been found aboard the decayed remains of chariots, acting as commanding officials.

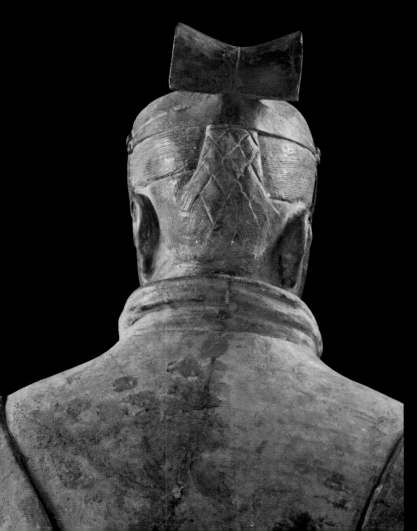

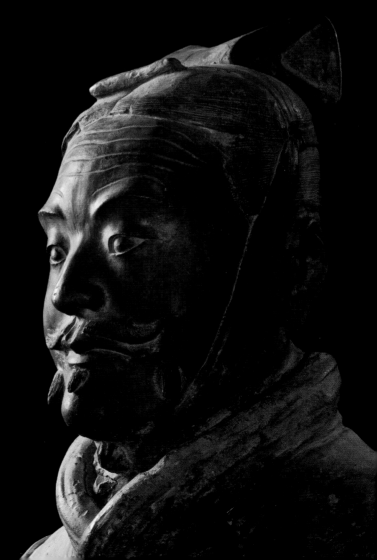

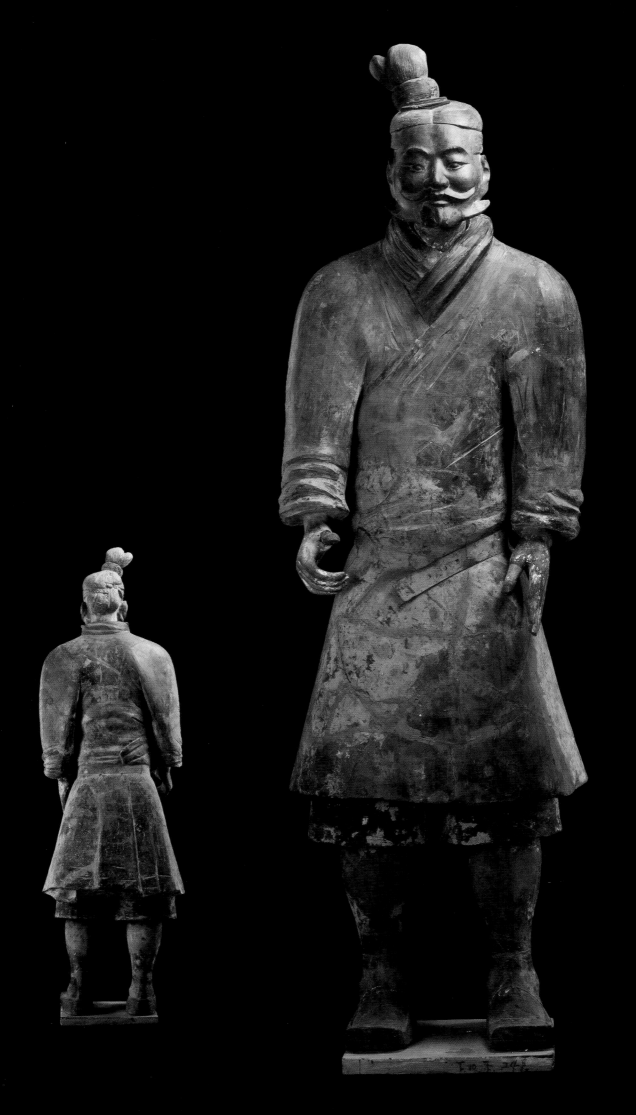

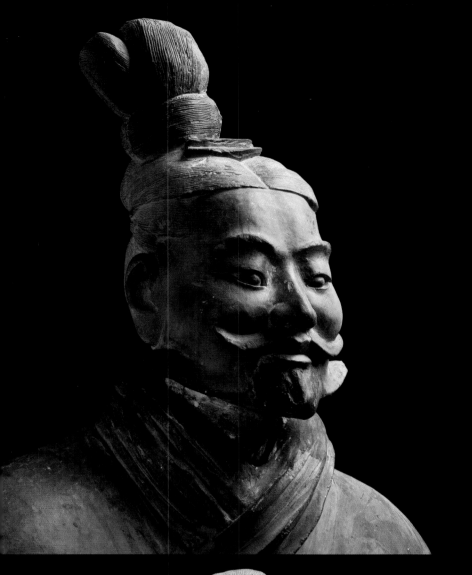
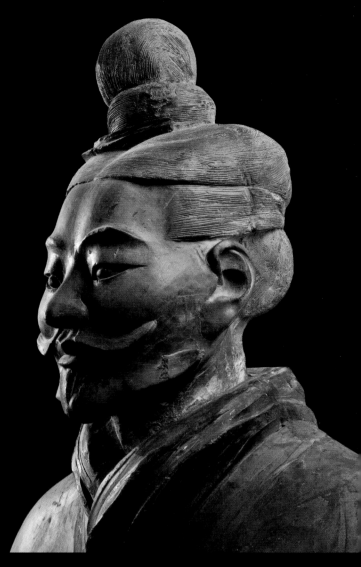
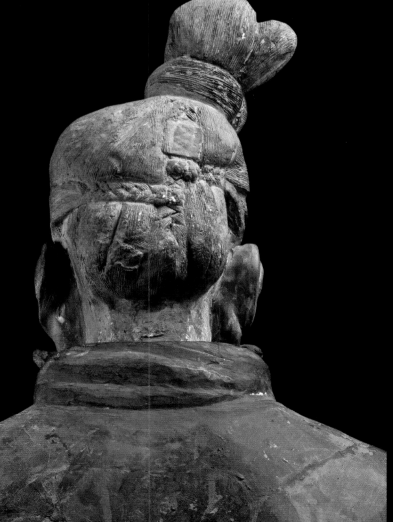

74
Light infantryman
輕裝步兵俑

Qin dynasty (221–206 BCE)
Terracotta, H. 193 cm (76 in)
Excavated from Pit 1, Qin Shihuang tomb complex, 1980

Qin Shihuang Terracotta Warriors and Horses Museum, Shaanxi 00085

So far, some 1,900 infantrymen have been excavated from the three pits, including unarmored light infantry, armored infantry, and archers. The light infantry are distinguished by the absence of suited armor, and their hair is tied in various forms of topknot. This figure wears what appears to be a simple folded robe that flares at the hem, with full sleeves and a low-waisted belt—seemingly more everyday than military in style. However, his short trousers are indicative of military personnel, and his wide shoes are similar to those that appear on many of the other warrior figures. Such infantrymen have various hairstyles. This one shows strands of hair taken from the sides and nape of the neck and plaited, while the main bulk of the hair is gathered into a topknot. Each infantryman would have held a weapon in his hands: a long-shafted weapon or a crossbow.[1]

In the pits, the light infantrymen such as this one were deployed to the front or the edge of a formation. They were sometimes attached to the chariots to form a special unit.

1. Yuan Zhongyi, *Qin bingmayong keng* [The Qin terracotta warriors and horses pits] (Beijing: Wenwu Press, 2003), p. 48.

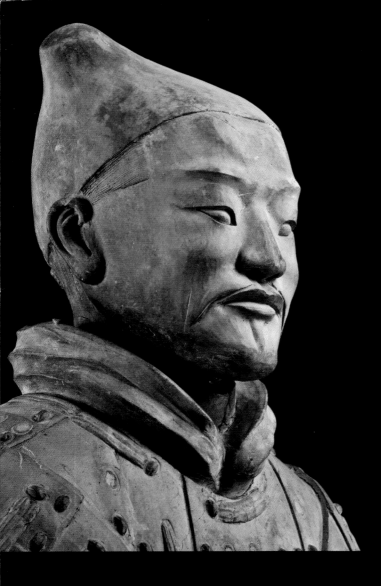

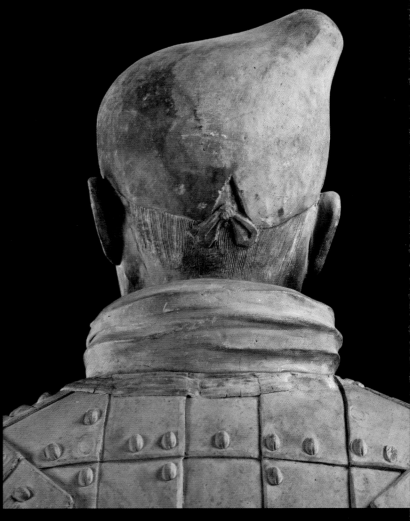

75
Armored infantryman
鎧甲步兵俑

Qin dynasty (221–206 BCE)
Terracotta, H. 187 cm (73⅝ in)
Excavated from Pit 1, Qin Shihuang tomb complex, 1978

Qin Shihuang Terracotta Warriors and Horses Museum, Shaanxi 2778

Armored infantry (including armored archers) are the predominant
type of soldier found in the pits. So far, some 1,300-odd figures have
been excavated from three pits.[1] They each wear the same costume
as the light infantryman, but with an added armor suit over a long
tunic, which protects the upper body and shoulders. Unlike other
warriors, who wear their hair up to form a topknot to the side, or
braid their hair at the back without a piled topknot, this figure
wears a soft cloth cap over a topknot, which is tied at the back for
easy adjustment. Both hands are positioned to hold a weapon. The
pi lance heads often found next to infantrymen indicate that he
originally held such a long-shafted weapon. His right hand would
have grasped a crossbow.

1. Yuan Zhongyi, *Qin bingmayong keng* [The Qin terracotta warriors and horses pits]
(Beijing: Wenwu Press, 2003), p. 49.

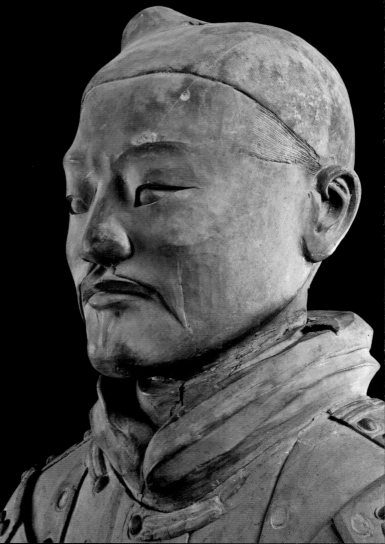

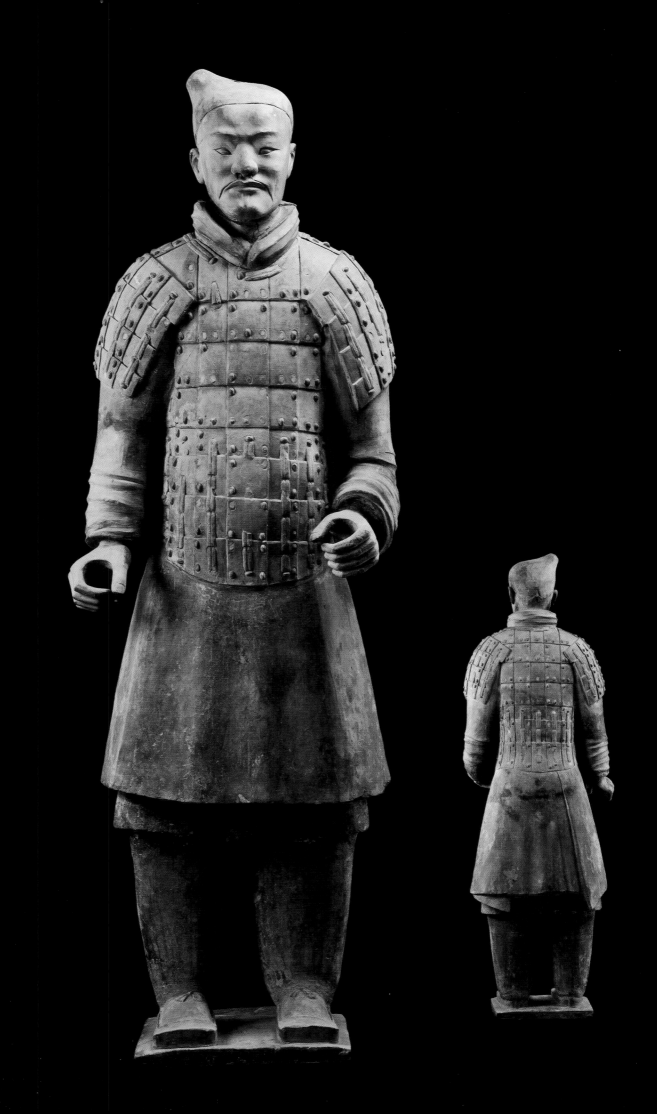

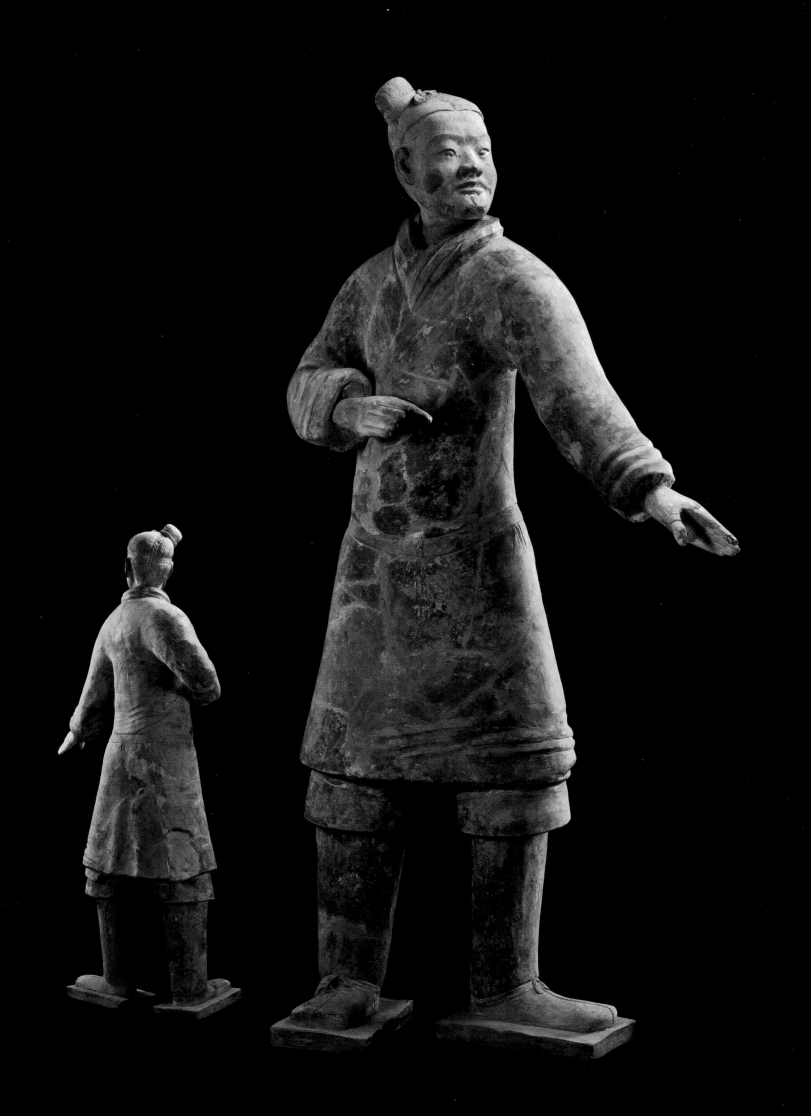

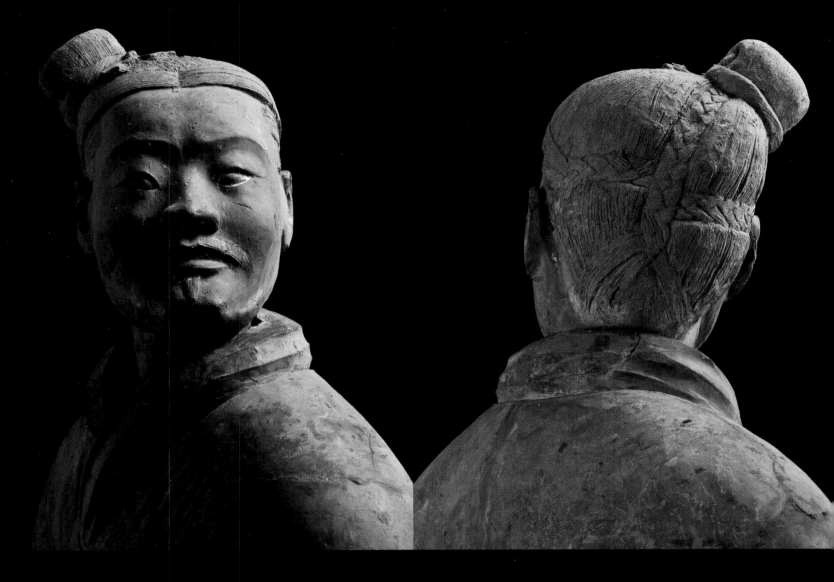

76
Standing archer
輕裝立射俑

Qin dynasty (221–206 BCE)
Terracotta, H. 184 cm (72⁷⁄₁₆ in)
Excavated from Pit 2, Qin Shihuang tomb complex

Qin Shihuang Terracotta Warriors and Horses Museum, Shaanxi 002816

Adopting one of the more animated poses, the standing archers—as well as the kneeling archers—come exclusively from Pit 2, where approximately 139 standing archers have been found. They wear the standard unarmored long robe, puttees, and a pair of square-front shoes, or short boots in this case. Their hairstyle is uniformly braided on the sides and piled into a topknot. The garments of such figures are lightweight and unrestrictive. The position of the arms indicates that the standing archer originally would have held a crossbow. He has been captured at a particular moment in time: with his legs in a steady stance, his upper body held straight, his gaze toward the front, his left arm pendent, and his right arm tightly held, he is in the act of shooting a crossbow. The posture is in accordance with the ancient treatises of war and is described thusly: "To shoot [a crossbow], the torso [should be straight] as if wearing a wooden board on one's back, and the head should be held high; the left foot should be positioned vertically and the right horizontally. The left hand should be positioned as if placed upon a tree branch, and the right hand should be positioned as if holding an infant . . ."[1] It seems that the standing archers occupied the outer perimeters of the large phalanxes as a defensive force.

Drawing of two archers shooting with crossbows. After Wang Xueli, *Qinyong zhuanti yanjiu* [Issues on Qin Terracotta Figures] (Xi'an: Sanqin Press, 1994), p. 222.

1. Zhao Ye (2nd century CE), *Wuyue chunqiu* [The Spring and Autumn Annals of Wu and Yue], a historical record of the states of Wu and Yue during the Spring and Autumn period (Shanghai: Shanghai Guji Press, 1997), *juan* 9, pp. 153–54.

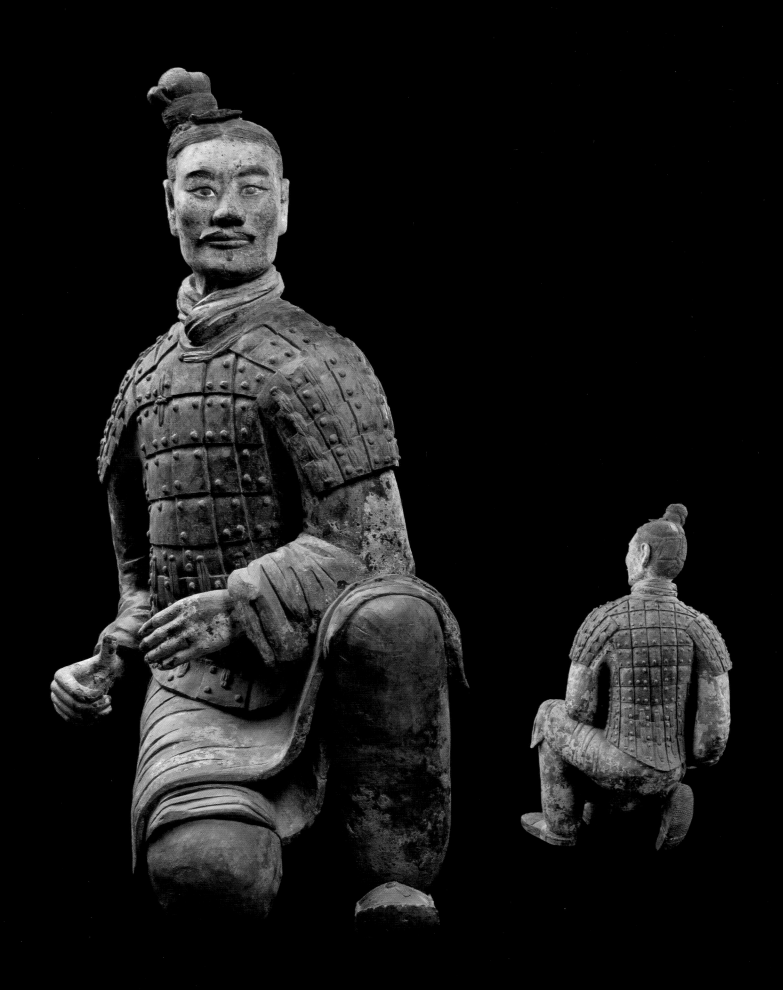

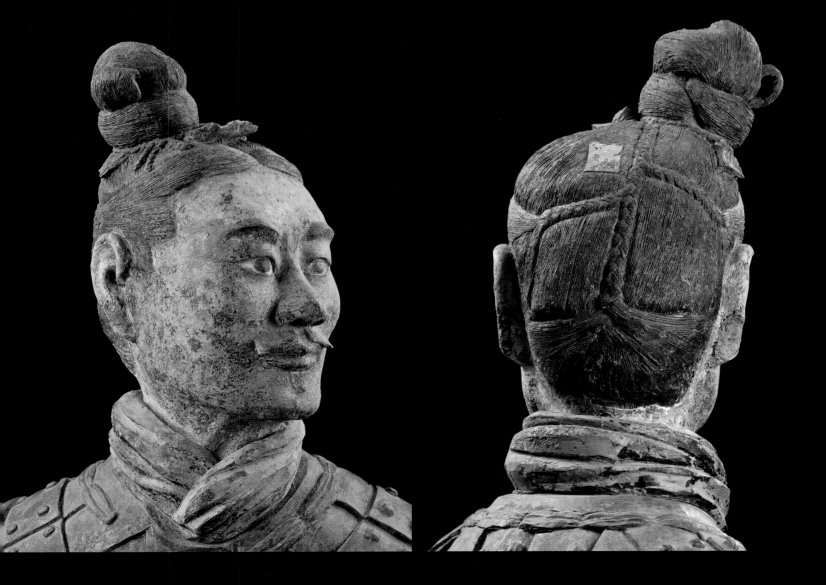

77
Armored kneeling archer
鎧甲跪射俑

Qin dynasty (221–206 BCE)
Terracotta, H. 218 cm (50⅜ in)
Excavated from Pit 2, Qin Shihuang tomb complex, 1977

Also found only in Pit 2, these figures were clearly part of the core defensive army that consists of some 332 warriors, including 139 standing archers, 160 kneeling archers, 31 armored infantry, and 2 commanders. The kneeling archers are positioned at the center of the force surrounded by standing archers; all are equipped with body and shoulder armor. Such an arrangement suggests that during the battle, the standing and kneeling archers would strike in turn.

The level of surviving detail on this group includes the articulation of the grip on the soles of the shoes, the careful positioning of the hands to hold the crossbow, the ribbons holding armor plaques, the alert facial expressions, and an unusual plaited hairstyle. All kneeling archers show an upright torso, with head and eyes positioned to gaze toward the left, and the hands placed near the lower right of the chest. Like many examples of this type, this archer retains much of its painted detail.

Each kneeling archer in this formation is featured wearing armor over a tunic and a pair of square-toed shoes. The folds on the robe correspond with the movement of the body. The figure's hair represents one of the most characteristic styles of the warriors from the pits: it is parted down the middle and combed backward where all the hair is gathered and then divided into several strands and plaited. The plaits are then coiled into a topknot on the left side of the head and are fixed with a vermilion cloth strip.

This figure is unique because of the well-preserved pigments on his face—the only figure with a green face among more than a thousand terracotta warriors excavated to date. The unnatural color has aroused curiosity. Some have speculated that the green paint might be a soldier's camouflage. It is more plausible that the figure may represent a military necromancer.[1]

1. Different opinions were summarized in Wang Rui, "Lulianyong yingwei junzhong nuoren zhiyi" [Questioning the interpretation of the terracotta warrior with green face being the military necromancer], *Wenbo*, 2006, no. 6: 33–35.

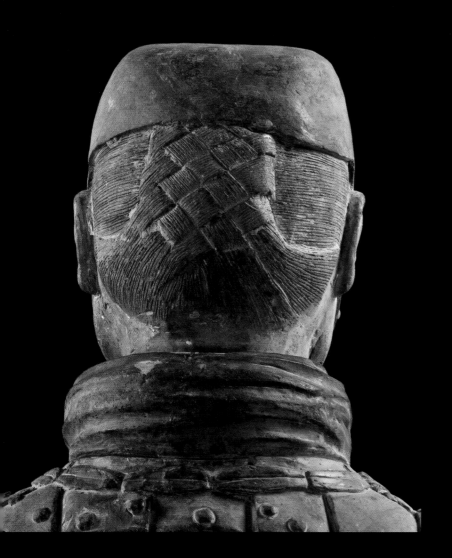
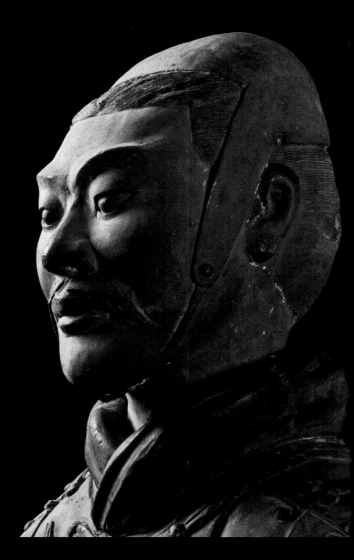

78
Cavalryman
騎兵俑

Qin dynasty (221–206 BCE)
Terracotta, H. 180 cm (70⅞ in)
Excavated from Pit 2, Qin Shihuang tomb complex, 1977

Qin Shihuang Terracotta Warriors and Horses Museum, Shaanxi 02531

The attire of the cavalryman is distinctively different from that of the infantrymen and charioteers. The cavalry figure wears short armor over a robe with pleated skirt to permit ease of riding, and a soft cap tied under the chin. His clasped right hand originally held the reins of his horse; the position of his left hand suggests it may have held a crossbow. This figure type has been found only in Pit 2, where it was placed in a neat formation that consisted of 116 horses and cavalrymen.

The emergence of the cavalry reflected a revolutionary shift in early warfare. The Qin, believed to have originated in the northwestern region, may have been influenced by the horse-riding culture of the nomadic tribes in that area who used mounted soldiers for warfare. The Qin was the earliest state to establish a cavalry. According to

Han Feizi (c. 281–233 BCE), Duke Mu (r. 659–621 BCE) dispatched five hundred chariots, two thousand cavalrymen and fifty thousand infantrymen to escort the exiled Prince Chong'er to ascend the throne in his motherland of the Jin state.[1] Compared to the infantry and chariot forces, the fast and nimble Qin cavalry played an important role in the unification war. In 260 BCE, for instance, in the famous battle of Changping, the Qin staged a feigned retreat in the face of the Zhao offensive, while at the same time deploying five thousand cavalry to cut off their rear. The Zhao army was thus split into two parts and its supply lines cut, forcing them eventually to surrender.

1. Han Feizi, *Han Feizi*, annotated by Wang Xianshen (Beijing: Zhonghua Press, 2003), *juan* 3, p. 76.

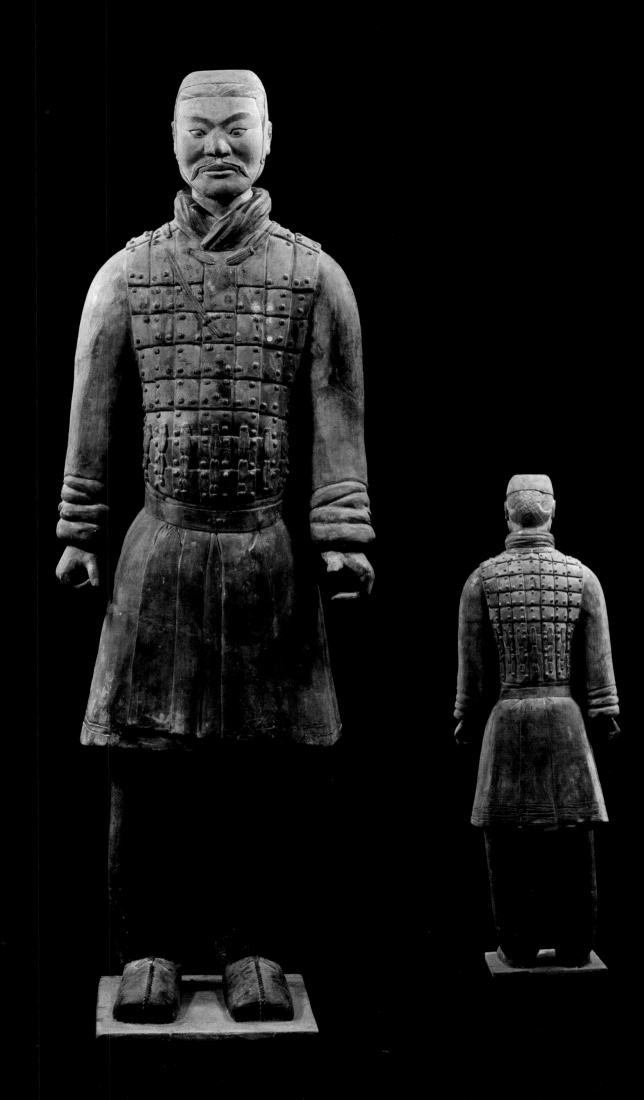

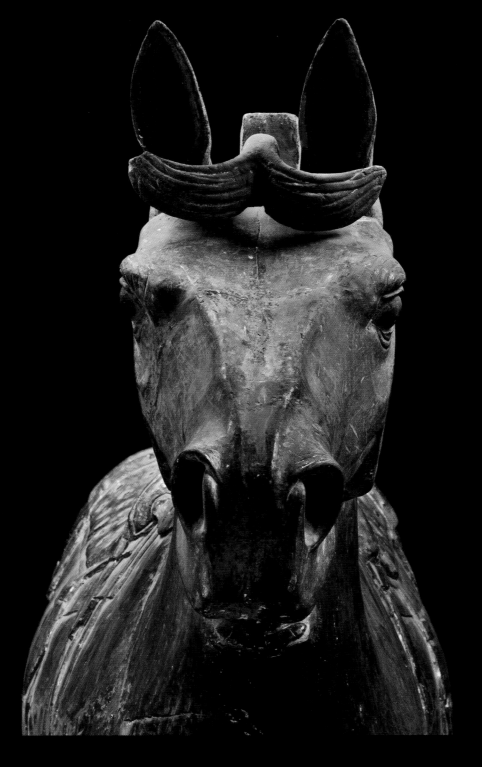

79

Cavalry horse
鞍馬俑
Qin dynasty (221–206 BCE)
Terracotta, H. 213 cm (83⅞ in), L. 174 cm (68½ in)
Excavated from Pit 2, Qin Shihuang tomb complex, 1978

Qin Shihuang Terracotta Warriors and Horses Museum, Shaanxi 003161

Readily identified by its saddle, the cavalry horse was found only in Pit 2, part of a neat cavalry formation that consisted of 116 horses and cavalrymen. Remnants of harnesses and fittings have also been recovered from Pit 2. The cavalry horses are slightly taller and longer than their chariot counterparts, and are approximately life-size. The depiction of six teeth in its mouth indicates that the horse is in its prime. Some fine details are also noticeable: skin creases around the flared nostrils, wide-open eyes, ears pitched forward and alert, mane neatly trimmed, and tail carefully plaited (as opposed to the tied-up tail of the chariot horse). While the use of horses to drive chariots dates back to the early Bronze Age, mounted cavalry appear

to have been introduced centuries later in the Warring States period. Based on the evidence of this model, stirrups were not used at the time. The earliest representation of stirrups appears in a ceramic cavalryman dated to 302 CE, excavated from a Western Jin tomb in Changsha, Hunan.[1]

The Qin were renowned for their skill in horse breeding. Feizi, the early Qin chief, was granted an aristocratic title for his work raising horses for the king of the Western Zhou. Duke Mu of Qin recognized the importance of the cavalry and hired Bole, the supreme master of horse physiognomy, to select excellent horses to serve the Qin cavalry. Bole was able to assess with unfailing accuracy hidden traits that a lesser judge of horses would have overlooked.

1. See Yang Hong, "Zhongguo gugai maju de fazhan he duiwai yingxiang" [The development of horse gear and its influence], *Wenwu*, 1984, no. 9: 45–54.

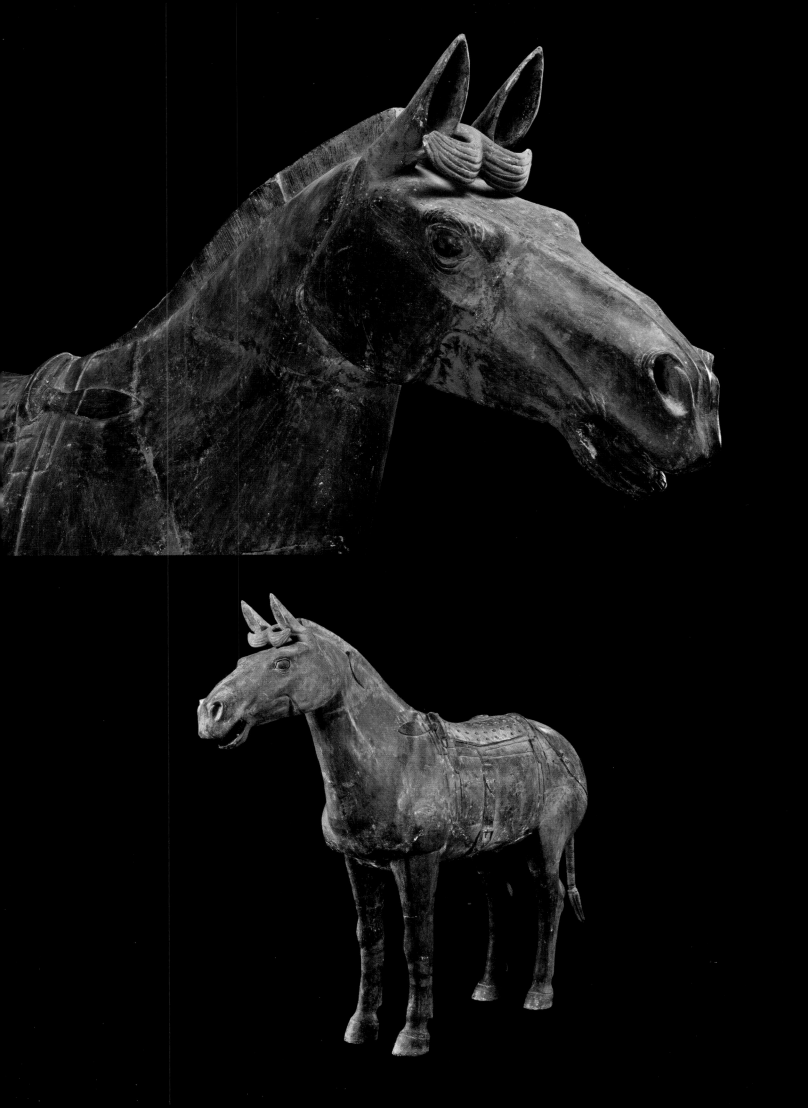

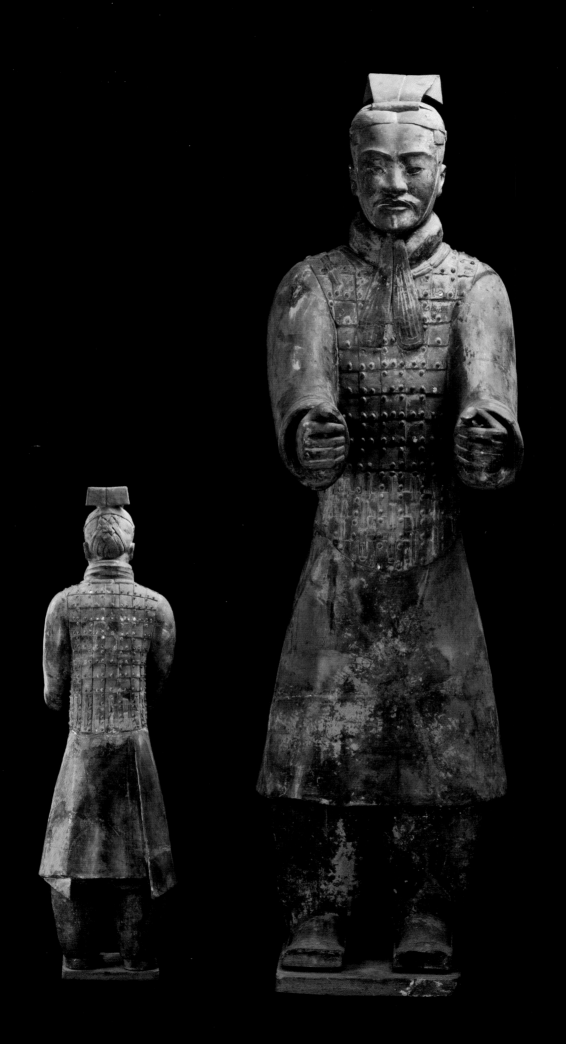

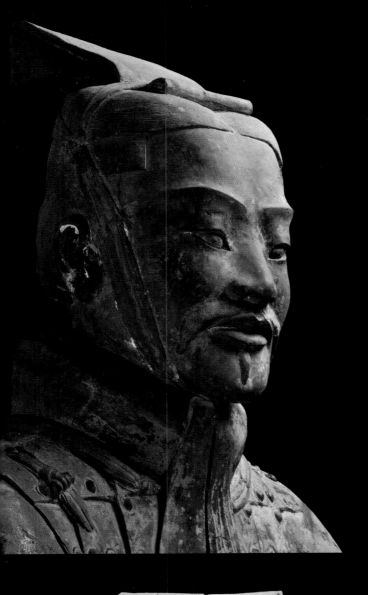

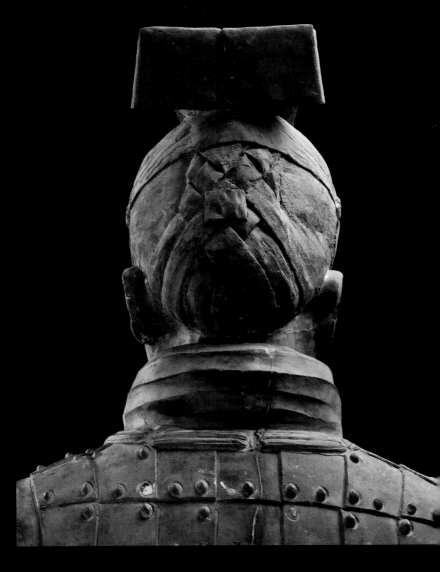

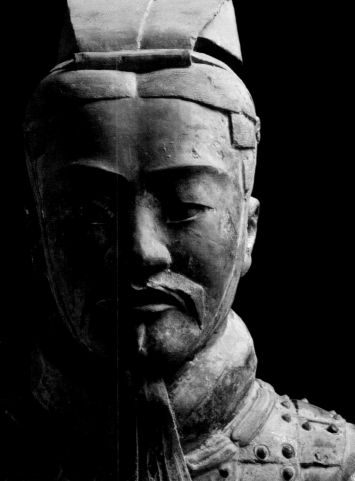

80
Charioteer
鎧甲禦手俑

Qin dynasty (221–206 BCE)
Terracotta, H. 194 cm (76⅜ in)
Excavated from Pit 1, Qin Shihuang tomb complex, 1983

Qin Shihuang Terracotta Warriors and Horses Museum, Shaanxi 02550

War chariots, each pulled by four horses, were found in all three of the pits—although just a single example was found in Pit 3. It is estimated that there were more than 140 wooden war chariots in the three pits. They can be divided into four types: the common chariot; the commander's chariot with painted ornaments and hanging bell and drum; *zuoche*, or assisting chariot (with two charioteers, deployed in the front of the cavalry formation in Pit 2); and *sichengche*, or special commanders' chariot (with four ranking officers, found in Pit 3). The most common group is accompanied by a single charioteer and two guards on each side, each holding a long-shafted weapon.[1] The charioteers are all sculpted with arms outstretched to hold the reins. All are equipped with body armor and headdresses, which identify them as officer class. A variant has extended armor covering outstretched arms.

The charioteers assumed a very important role in the Qin state before the unification of the Qin dynasty, and there were strict requirements for training a charioteer. It took four years to gain mastery of manning a chariot. If the charioteer failed, both he and his drill master would be punished.

1. Yuan Zhongyi, *Qin bingmayong keng* [The Qin terracotta warriors and horses pits] (Beijing: Wenwu Press, 2003), p. 39–43.

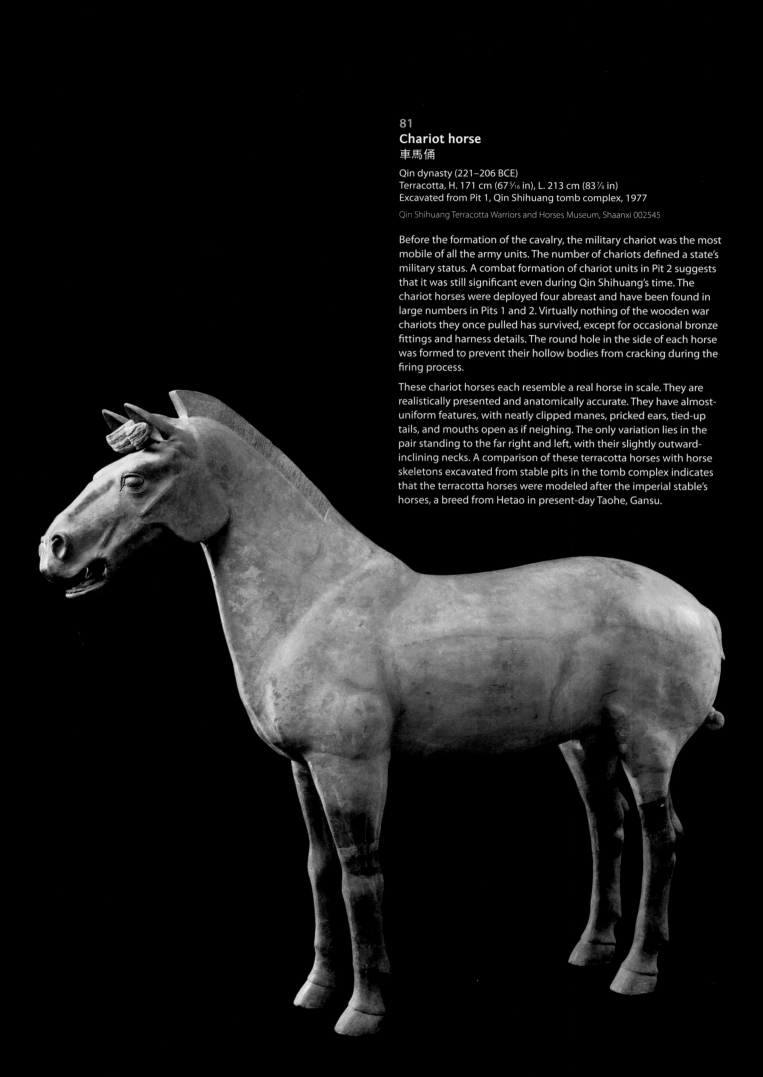

81
Chariot horse
車馬俑

Qin dynasty (221–206 BCE)
Terracotta, H. 171 cm (67 5/16 in), L. 213 cm (83 7/8 in)
Excavated from Pit 1, Qin Shihuang tomb complex, 1977

Qin Shihuang Terracotta Warriors and Horses Museum, Shaanxi 002545

Before the formation of the cavalry, the military chariot was the most mobile of all the army units. The number of chariots defined a state's military status. A combat formation of chariot units in Pit 2 suggests that it was still significant even during Qin Shihuang's time. The chariot horses were deployed four abreast and have been found in large numbers in Pits 1 and 2. Virtually nothing of the wooden war chariots they once pulled has survived, except for occasional bronze fittings and harness details. The round hole in the side of each horse was formed to prevent their hollow bodies from cracking during the firing process.

These chariot horses each resemble a real horse in scale. They are realistically presented and anatomically accurate. They have almost-uniform features, with neatly clipped manes, pricked ears, tied-up tails, and mouths open as if neighing. The only variation lies in the pair standing to the far right and left, with their slightly outward-inclining necks. A comparison of these terracotta horses with horse skeletons excavated from stable pits in the tomb complex indicates that the terracotta horses were modeled after the imperial stable's horses, a breed from Hetao in present-day Taohe, Gansu.

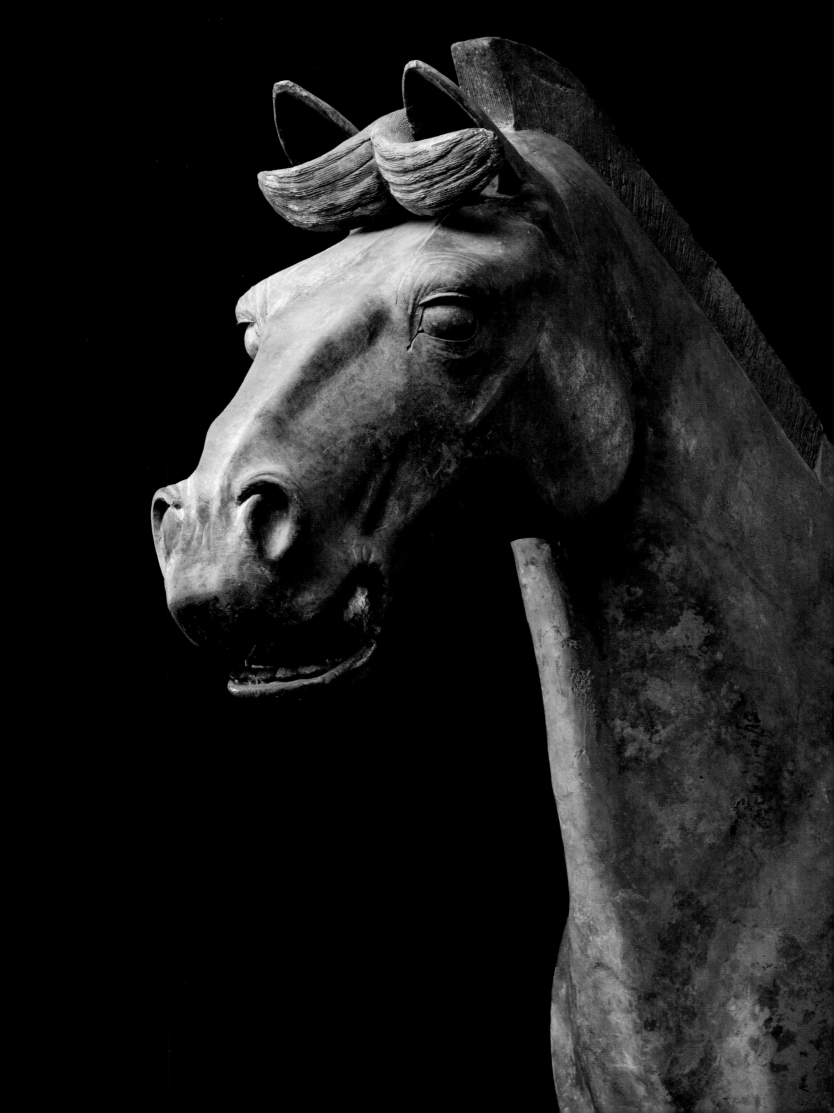

A bronze *pushou* ring holder in the grand tomb at Shenheyuan

Bronzes

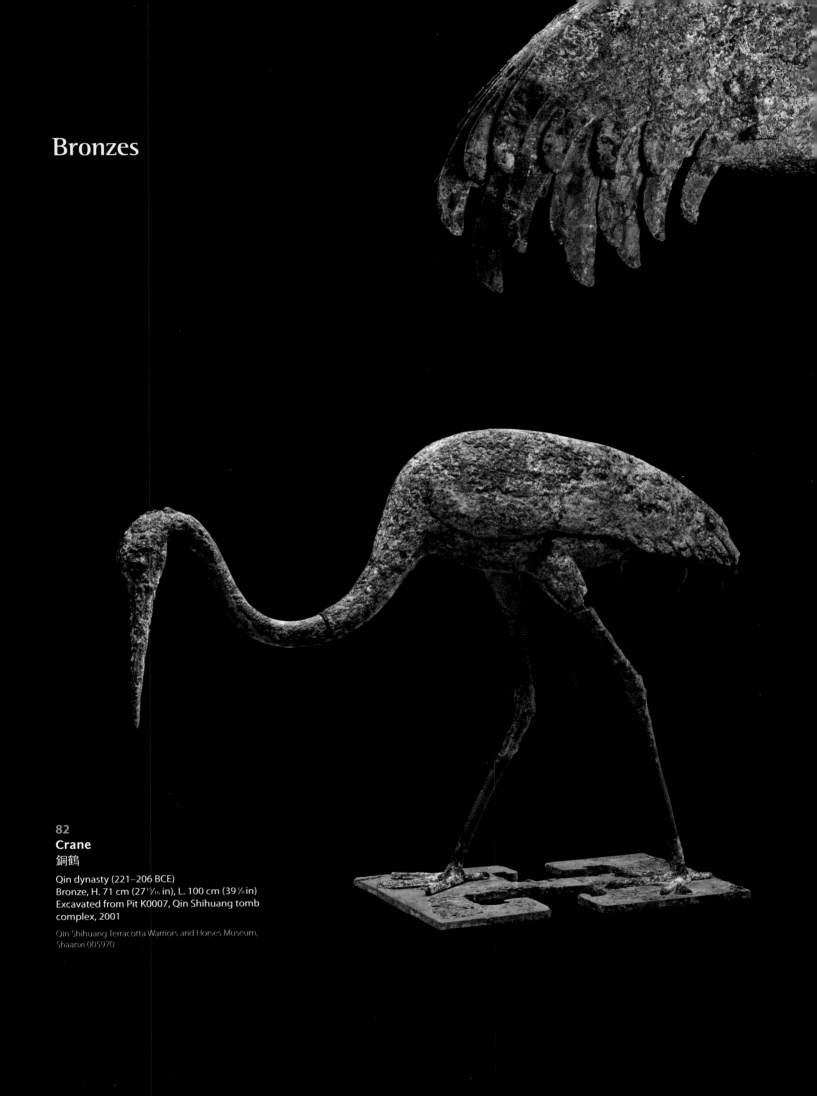

82
Crane
銅鶴

Qin dynasty (221–206 BCE)
Bronze, H. 71 cm (27¹⁵⁄₁₆ in), L. 100 cm (39⅜ in)
Excavated from Pit K0007, Qin Shihuang tomb
complex, 2001

Qin Shihuang Terracotta Warriors and Horses Museum,
Shaanxi 005970

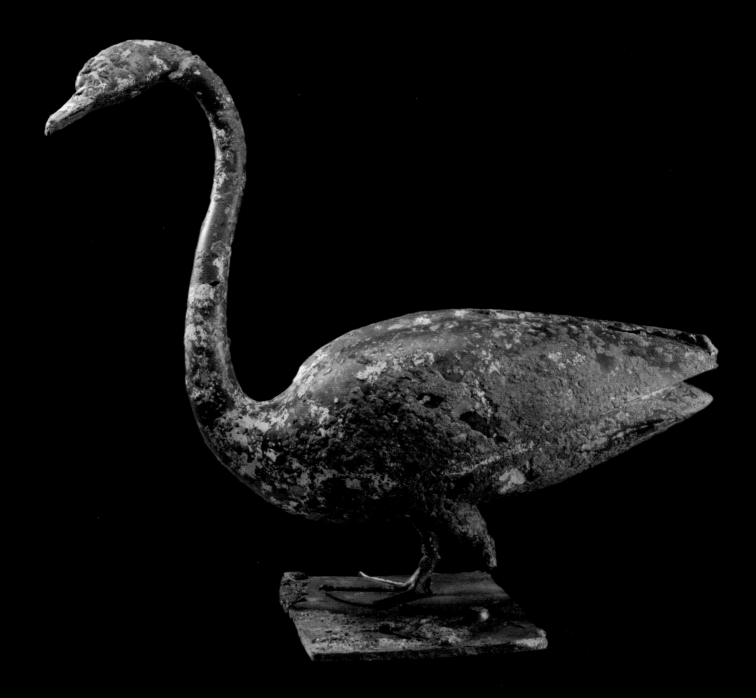

83
Swan
銅天鵝

Qin dynasty (221–206 BCE)
Bronze, H. 100 cm (39⅜ in), L. 90 cm (35⁷⁄₁₆ in)
Excavated from Pit K0007, Qin Shihuang tomb complex, 2000

Qin Shihuang Terracotta Warriors and Horses Museum, Shaanxi K0007T3:33

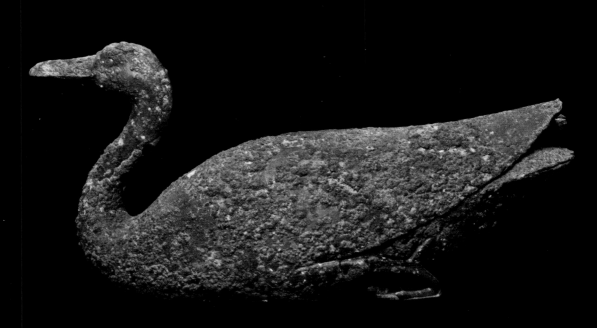

84
Wild swan
銅雁

Qin dynasty (221–206 BCE)
Bronze, H. 30 cm (11¹³⁄₁₆ in), L. 60 cm (23⅝ in)
Excavated from pit K0007, Qin Shihuang tomb complex,
2001

Qin Shihuang Terracotta Warriors and Horses Museum, Shaanxi
DM:015/005969

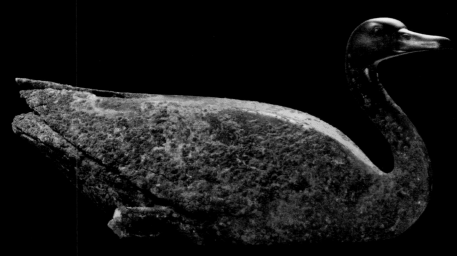

85
Wild swan
銅雁

Qin dynasty (221–206 BCE)
Bronze, H. 17 cm (6¹¹⁄₁₆ in), L. 53 cm (20⅞ in)
Excavated from Pit K0007, Qin Shihuang tomb complex, 2000

Shaanxi Provincial Institute of Archaeology K007T3:54

In 2001, a most unusual discovery was made within the burial city of the First Emperor's tomb. Almost two miles northeast of the burial mound lay an F-shaped pit measuring more than ninety-six hundred square feet, within which a fanciful scene—what may be described as a symbolic haven for the emperor in his afterlife—had been constructed. The scene was composed of a group of fifteen life-size seated pottery figures and forty-six life-size bronze water birds: twenty swans, six cranes, and twenty wild swans—none of them identical.[1] The water birds were arranged as if congregated along a riverbank. Like the warrior figures, they were painted in detail to appear lifelike, although little of the paint survives. It is speculated that the scene in the pit represents musicians training birds for the institute of the royal park and music—the office that provided entertainment for the emperor. As such, it's a fitting component of the First Emperor's tomb complex.

1. Shaanxi Provincial Institute of Archaeology and Qin Shihuang Terracotta Warriors and Horses Museum, "Qinshihuang lingyuan K0007 peizang keng fajue jianbao" [A brief report on the excavation of the burial pit K0007 at the First Emperor's Mausoleum], *Wenwu*, 2005, no. 6: pp. 16–37.

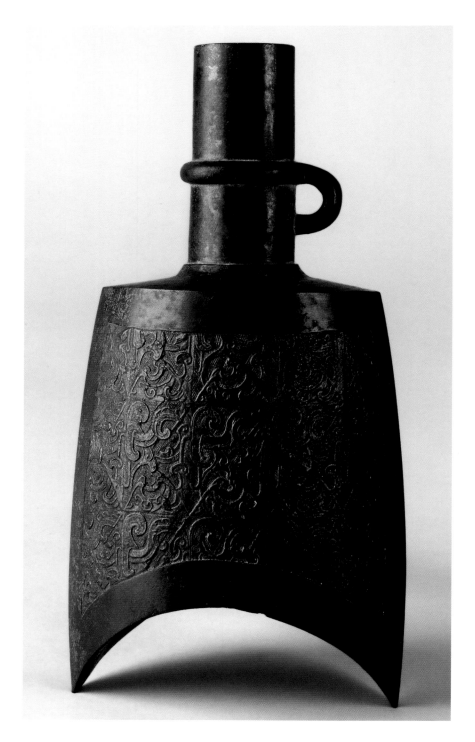

86
Yongzhong bell
青銅甬鈡

Qin dynasty (221–206 BCE)
Bronze, H. 25.9 cm (10³⁄₁₆ in), W. 10.8 cm (4¼ in)
Excavated from Pit 1, Qin Shihuang tomb complex, 1976

Qin Shihuang Terracotta Warriors and Horses Museum, Shaanxi 000879

This bell, embellished on its exterior surface with an interlaced serpentine design, was excavated from Pit 1 near the remains of a commander's chariot. Traces of decayed drums and drumsticks were also found at that location. It is believed that bells were suspended in the commander's chariots during battle to send out command signals. The sound of the drum would direct troops to make an assault, while the sound of the bell signaled a pause and retreat. The lack of a clapper suggests that the bell was struck, as were the drums.

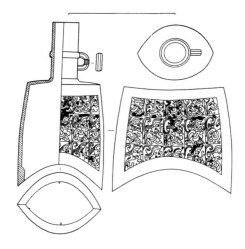

Drawing of the *yongzhong* bell. After Shaanxi Provincial Institute of Archaeology and the Excavation Team for the Terracotta Warriors Pits of the First Emperor Tomb Complex, *Qinshihuang ling binmayong keng yihaokeng fajue baogao 1974–1984* [A Report on the Excavation of Pit 1 of the Terracotta Warriors and Horses at Qin Shihuang's Tomb Complex, 1974–1984] p. 230, fig. 137.

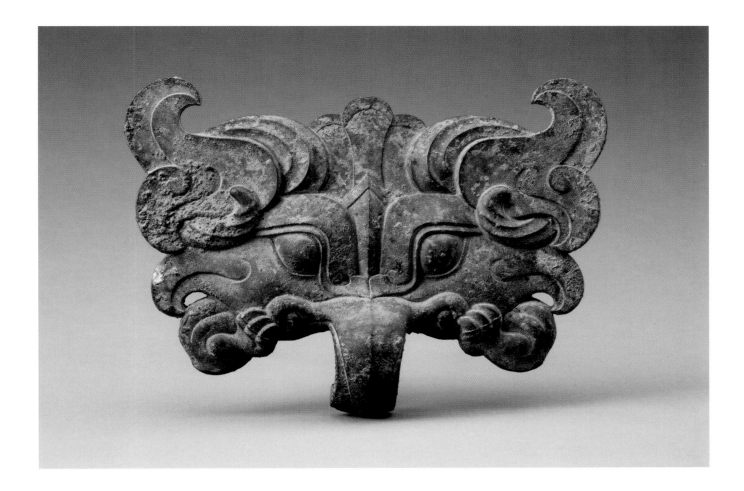

87
Pushou animal-mask ring holder
青銅鋪首

Qin dynasty (221–206 BCE)
Bronze, H. 15 cm (5 ⅞ in), W. 16 cm (6 ⁵⁄₁₆ in)
Excavated from Palace 1, Xianyang, Shaanxi, 1974–75

Xianyang Municipal Museum, Shaanxi 5-1349

The prototype of the *pushou* ring holder can be traced back to the *taotie* animal mask, the most stunning imagery of the early Bronze Age. Later on, these types of animal-mask fixtures were used to hold rings on bronze vessels and stone coffins, or on the doors of houses and tomb chambers.

This *pushou* ring holder has a face with coiled horns rising from its brows. Dominating the face is a pair of round, slightly bulging eyes.

The beast stares at the viewer with a bewitching force. Nevertheless, the most unusual and charming feature of this mask is the pair of muscular arms and claws supporting the cheeks. The trunk-like mouth or mandible served to hold a ring, which was unearthed along with the *pushou* during the excavation from the Palace 1 site at Xianyang.[1] On the reverse side there is a pair of loops for affixing it to the door of the palace.

1. Liu Qingzhu and Chen Guoying, "Qindu xianyang diyihao gongdian jianzhu yizhi jianbao" [A brief report on the excavation of palatial architectural site no. 1at the Qin capital Xianyang], *Wenwu*, 1976, no. 11: 12–24, plate 2:1.

88
Mirror
獸紋銅鏡

Qin dynasty (221–206 BCE)
Bronze, Diam. 6.6 cm (2⅝ in)
Excavated at Bianjiazhuang in Longxian, Shaanxi, 1987

Longxian Museum, Shaanxi 87LBM23: 9

The rarity of Qin mirrors has led scholars to believe that they occupy only a transitional place between those of the Warring States and Western Han periods, bridging the two styles yet possessing few distinctive characteristics of their own.[1] While the majority of Qin mirrors follow the familiar stylistic patterns and currents of other regions of that time, this example surprisingly possesses unique characteristics heretofore unknown to us. In this example, four beasts full of lively, sinuous movement writhe around with their tails vigorously twisting upward, all against a background decorated with a meander design.

1. Li Xueqin, *Eastern Zhou and Qin Civilizations*, trans. K. C. Chang (New Haven: Yale University Press, 1985), p. 313.

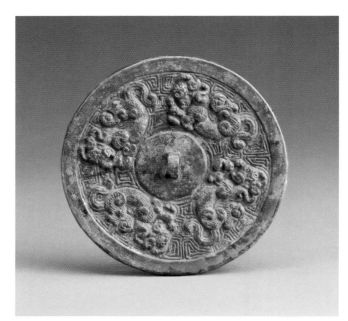

89
Mirror
獸紋銅鏡

Qin dynasty (221–206 BCE)
Bronze, Diam. 8.5 cm (3⅜ in)
Excavated at Dianzi in Longxian, Shaanxi, 1991

Longxian Museum, Shaanxi 91M49:1

This is another Qin bronze mirror with a unique design. Here, a plain band divides the decoration into two divisions. On the inner ring, three recumbent beasts with curving tails and long tongues turn their heads to look over their backs. Their bodies are each decorated with tiny circular bulges and an S pattern. Eight figures of the same beast occupy the outer registry and differ only in their heads, which are pitched forward. An almost-identical mirror was unearthed from a Warring States period tomb in Changye, Shanxi, thus providing further evidence of an increasing cultural interaction between Qin and the other states.[1]

The bronze mirror was an implement used in daily life; the superstitious beliefs attached to it, however, led people to believe that mirrors reflected true forms and hence could be used to detect illusions that might deceive the senses. Literary record has it that Qin Shihuang placed huge bronze mirrors in his palace and killed those whose reflections were suspicious.[2] This mirror was unearthed from a commoner's tomb (M49:1) at Dianzi in Longxian.[3] The deceased was accompanied only by ceramic vessels and a few bronzes. This mirror demonstrates that people across the boundaries of social status believed in the talismanic qualities of the bronze mirror.

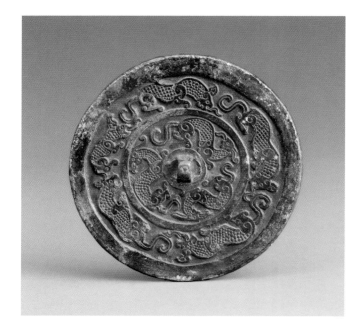

1. Shanxi Provincial Administration for Cultural Relics and Shanxi Provincial Institute of Archaeology, "Shanxi changye fengshuiling zhanguo mu dierci fajue" [The second excavation of the Warring States period tombs at Fengshuiling in Changye, Shanxi], *Kaogu*, 1964, no. 3: 111–36, p. 134, fig. 27.

2. It was recorded in *Xijing Zaji* [Miscellaneous notes about the western metropolis], a book attributed to Liu Xin (d. 23 CE) or Ge Hong (284–363 CE). *Han Wei Liuchao biji xiaoshuo daguan* [Comprehensive collection of *biji* and stories from the Han, Wei, and Six Dynasties periods], annotated by Wang Genlin et al. (Shanghai: Guji Press, 1999), vol. 3, p. 97.

3. Shaanxi Provincial Institute of Archaeology, *Longxian dianzi qinmu* [Qin tombs at Dianzi in Longxian] (Xi'an: Sanqin Press, 1998), p. 105, plate 74:4.

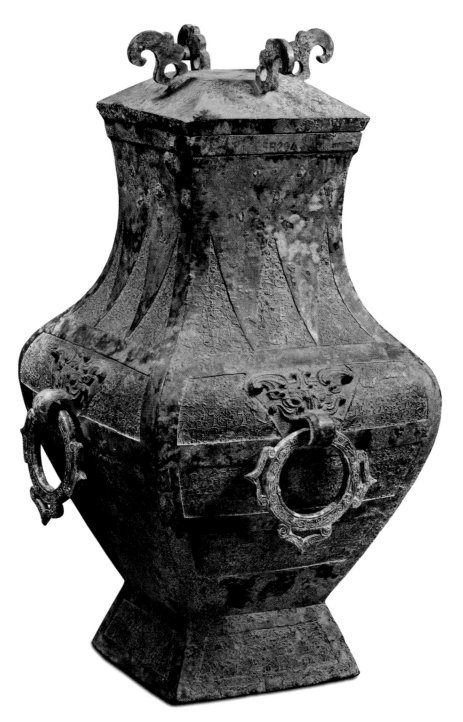

90
Fang vessel
青銅蟠虺紋鈁

Qin dynasty (221–206 BCE) or later
Bronze, H. 45 cm (17¹¹⁄₁₆ in), W. 23 cm (9¹⁄₁₆ in)
Excavated at Sanyao in Yanta, Xi'an, Shaanxi, 1972

Xi'an Municipal Museum, Shaanxi 3gtA131

The four faces of the body and the highly truncated pyramidal foot are adorned in low relief with panels of a fine abstract curl pattern; these panels lie within plain border strips on the body and foot, and alternate with pendent triangles on the neck. The tightly curled designs are characteristic of Warring States bronze designs but the "hanging blade" motif on the neck is a relatively rare decorative device that first appeared on Shang dynasty vessels in the second millennium BCE. Four S-shaped bird-form finials straddle the flat top and canted sides of the cover. On each side of the vessel a loose ring held in the mouth of a *taotie* mask is cast with spirals and with three projecting pierced flanges.

Known as *fang*, this vessel is a variation of the *hu*-type wine vessel, and began to appear in the mid–Warring States period in some states such as Han, Zhao, and Wei, but not in the Qin territory.[1] A similar *fang* in the Arthur M. Sackler Collections, New York (V-149), is reported to have an incised inscription dating to 1 BCE.[2] It proves that this type of vessel continued well into the Western Han period; furthermore, it cannot be ruled out that the current example may be dated later.

1. One *fang* vessel was excavated from a Warring States period tomb at Liulige (at present-day Huixian in Henan) which was the Wei state territory during that time. See *Guo Baojun, Shanbiaozhen yu liulige* [Shanbiaozhen and Liulige] (Beijing: Kexue Press, 1959), plate 89. Another similar pair is now in the Poly Art Museum collection. See Editorial Committee, *Baoli cangjin* [Selected bronzes in the collection of the Poly Art Museum] (Guangzhou: Linnan Meishu Press, 1999), pp. 199–200.

2. See Jenny So, *Eastern Zhou Ritual Bronzes from the Arthur M. Sackler Collections* (Washington D.C.: Arthur M. Sackler Foundation in association with the Arthur M. Sackler Gallery, Smithsonian Institution, 1995), p. 283, fig. 50.5.

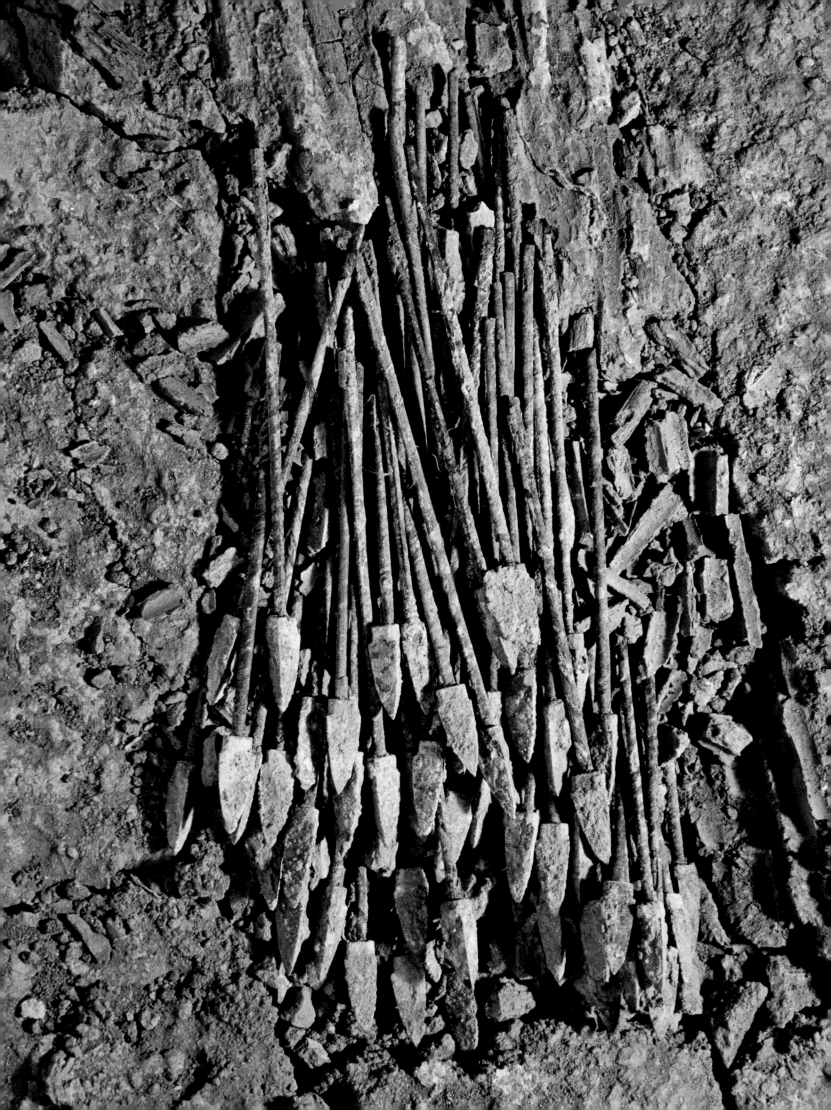

Weapons and Armor

AS MANY TOMB SITES OF THE STATE OF QIN AND THE BURIAL SITE OF the First Emperor attest, bronze was the preferred material for weapons in Bronze Age China until the Qin dynasty. Bronze spears, swords, daggers, and arrowheads have been recovered from countless tombs in the traditional Qin homelands of Gansu and Shaanxi provinces and, indeed, in Shang and Zhou dynasty sites across north China. All confirm the technological sophistication and resources that were necessary for the production of arms and weaponry.

The Qin made weapons in great quantity during the Warring States period for the purpose of continuous military engagement. The inscriptions found on many such weapons provide invaluable information about the Qin weaponry industry. It is apparent that many weapons were manufactured by the central government and that others were made locally. Those made in government workshops were manufactured under supervision of a specific department, and sometimes the Qin prime minister. Many of them were located in the capital cities such as Yueyang, Yong, and Xianyang.

Numerous bronze weapons were unearthed from the terracotta warriors pits. These included familiar objects in the traditional repertoire of ancient weapons such as the *mao*, or spear; *pi*, or lance head; *ge*, or dagger-ax; and *ji*, or halberd (a composite weapon made from the *mao* and *ge*). A less-familiar weapon is the Qin style of *jian*, or sword, which was much longer than swords produced and used by the other states. Certain weapons of unusual quality or effect were evidently made purely for ceremonial use, the sword with a gold hilt being one such example (cat. no. 32). The enigmatic object described as a ritual mace head (cat. no. 99) is a weapon of uncertain use but evidently served a ceremonial function, and can be compared with clearly effective weapons such as *mao* spears, *ji* halberds, *pi* swords, and daggers of more conventional form.

Another effective weapon was the bronze crossbow mechanism that was first introduced in the Warring States period (cat. no. 98) and revolutionized military warfare. It was said to have the capacity to fire bronze arrowheads, like those found in large quantities in the terracotta warrior pits (cat. no. 97), a distance of about a half mile (800 m). A range of weapons has been found in the terracotta warrior pits, indicating that many of the figures originally were furnished with weapons.

A cluster of bronze arrows
unearthed from Pit 1

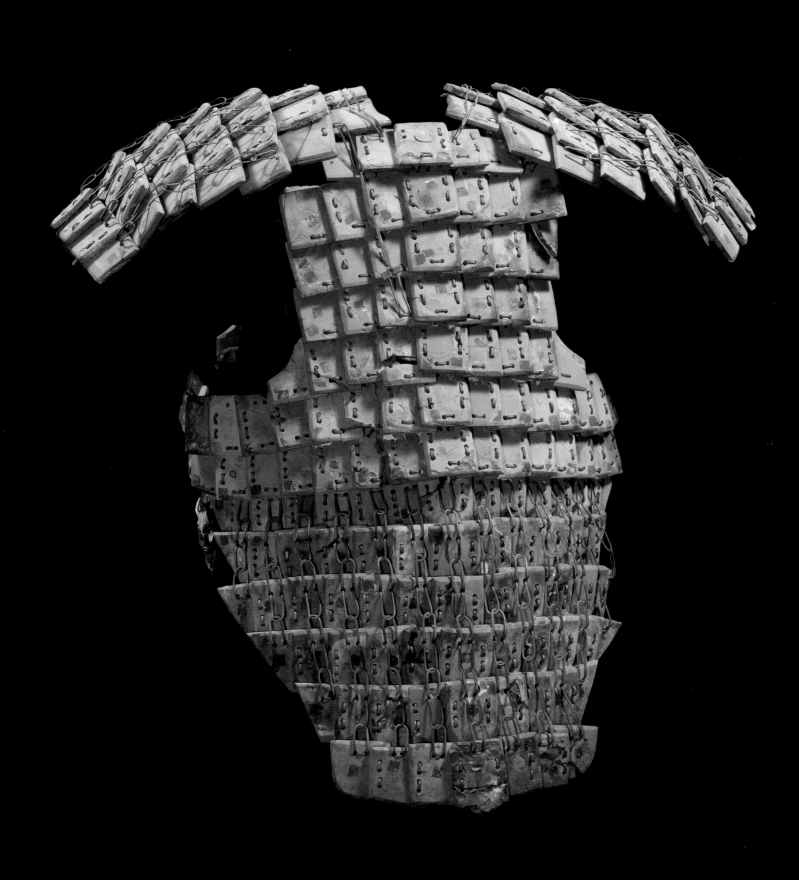

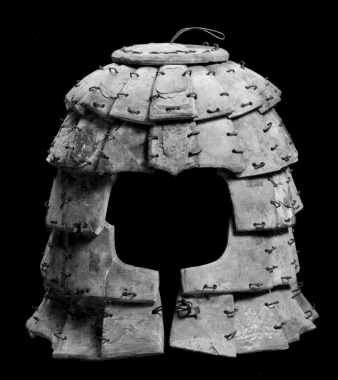

91
Suit of armor
石甲

Qin dynasty (221–206 BCE)
Limestone, H. 77 cm (30�516 in), W. 50 cm (19¹¹⁄₁₆ in)
Excavated from Pit K9801, Qin Shihuang tomb complex, 1999

Shaanxi Provincial Institute of Archaeology 007094

In 1997, a pit (K9801) just over two hundred yards (200 m) southeast of the First Emperor's tomb mound was found containing countless limestone suits of armor and helmets. This pit, which to date has not been fully excavated, is estimated to cover an area of 140,000 square feet (13,000 sq m). Exploratory excavation of approximately one-eightieth of the area of the whole pit has revealed more than 130 suits of armor with helmets.

This limestone armor (and the helmet at right, cat. no. 92) was reconstructed from the clusters of fragments excavated from the pit. The armor consisted of more than six hundred stone plaques of various shapes laced together with copper wire. The sheer weight of these stone armor suits indicates that they were solely for burial purposes, possibly comprising an armory for the First Emperor in his afterlife. They do, however, emulate the structure of real armor of the time, which was made of leather or metal, and can be seen in examples worn by the terracotta warrior figures.

92
Helmet
石盔

Qin dynasty (221–206 BCE)
Limestone, H. 38 cm (14¹⁵⁄₁₆ in), W. 21 cm (8¼ in)
Excavated from Pit K9801, Qin Shihuang tomb complex, 1998

Shaanxi Provincial Institute of Archaeology JZ10-1

Although historical records indicate that Qin army uniforms included helmets,[1] the warriors in all three pits appear without them. It has been postulated that the Qin were particularly admired for their martial might and brute strength, and thus, the practice of eschewing protective gear in war was deemed valorous. As a frontier state engaged in conflicts with non-Chinese "barbarians," the Qin acquired a wealth of military experience, which no doubt served it well when directing its armies against other states. Shang Yang's reforms had encouraged the Qin soldiers to fight even more bravely to gain in rank. This exaltation of the manly virtues was accounted for by Zhang Yi, a military strategist of the Warring states period, who commented on the Qin servicemen saying, "The Qin established an army with over a million armored warriors, a thousand chariots, and tens of thousands of horses. The soldiers are all brave and strong warriors. In the battle, those who dash ahead with bare heads regardless for their safety, shooting the enemy with crossbows, are countless."[2]

1. Bamboo slips unearthed in 1975 at Shuihudi in Yunmeng, Hubei province, contained such information. See also Zuo Qiuming (c. 502–422 BCE), *Zuozhuan* [Zuo's Commentary on the Spring and Autumn Annals], annotated by Yang Bojun (Beijing: Zhonghua Press, 1990), "Thirty-third year of Duke Xi," p. 494.

2. *Zhanguo ce* [Intrigues of the Warring States], compiled during the late Warring States period to Western Han, annotated by He Jianzhang (Beijing: Zhonghua Press, 1990), *juan* 26, p. 974.

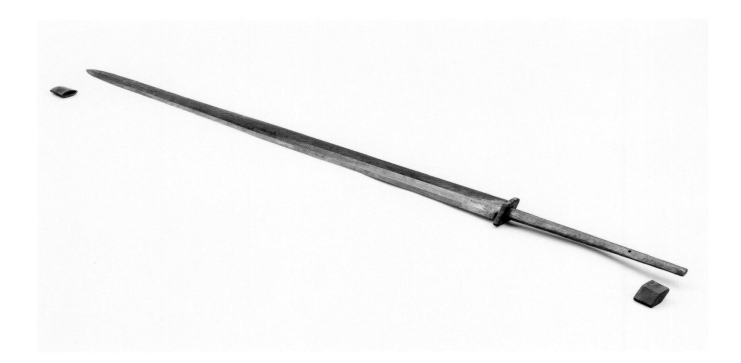

93
Sword
青銅劍

Qin dynasty (221–206 BCE)
Bronze, L. 93.4 cm (36¾ in)
Excavated from Pit 1, Qin Shihuang tomb complex, 1983

Qin Shihuang Terracotta Warriors and Horses Museum, Shaanxi 00857

According to Sima Qian's account of Jing Ke's failed assassination of the future First Emperor, the assassin chased the king of Qin around the audience hall with a poisoned dagger, while the king tried unsuccessfully to unsheathe his sword, which was slung at his side. After being advised by the court officials, he pushed the scabbard toward his back and drew the sword across his shoulder, stabbing Jing Ke with it. The discovery of some twenty-two swords from Pits 1 and 2 shed light on the question as to why King Zheng was unable to readily draw his sword and thus seize the advantage. Qin swords, like this example, were, on average, twenty-five to thirty centimeters (9⅞ to 11¾ in) longer than the average sword produced and used by the other states (50 to 65 cm or 19⅝ to 25⅝ in), making them unwieldy.

Each of the swords was exquisitely cast with precisely three ridges along both sides of each blade (for a total of six ridges), providing a great penetrating force. A coating of chromium oxide applied on the blade's surface helped resist tarnish and corrosion. During this period, the key to sword casting was the amount of tin used: too little would lead to softness in the weapon, but too much would make it brittle and prone to breaking. A scientific examination of the Qin sword has revealed that the percentage of bronze to tin created a perfect ratio of toughness to flexibility.

94
Pi lance head
銅"十七年"鈹

Qin dynasty (221–206 BCE)
Bronze, L. 35.6 cm (14 in)
Excavated from Pit 1, Qin Shihuang tomb complex, 1976

Qin Shihuang Terracotta Warriors and Horses Museum, Shaanxi 00855

This weapon, known as *pi*, resembles a sword, but is distinct in that it has a long handle. When it was in use, the *pi* would be hafted onto a pole, creating a composite weapon with the blade of a sword and the shaft of a *mao* spear. The shaft was usually made of wood or bamboo, and often lacquered. The upper section was approximately thirty to forty centimeters (11 to 15 in) in length and often engraved with inscriptions. At the end of the handle was a bronze protection cap. An inscription incised on the blade identifies the *pi* as being cast in the seventeenth year of King Zheng, the future First Emperor (235 BCE). In all, sixteen bronze *pi* were found in Pit 1.

Recent archaeological findings date the *pi* to the late Western Zhou period. The design of the *pi* continued to evolve until the Spring and Autumn period, when it reached its mature form as shown in this exhibition. The *pi* lance heads were also unearthed in the regions of Hubei, Shandong, and Henan. With the advancement of metallurgical technology in the late Spring and Autumn period, bronze weapons such as the *pi* began to be phased out in favor of weapons made of other metals. By the middle of the Western Han period, the *pi* was obsolete.

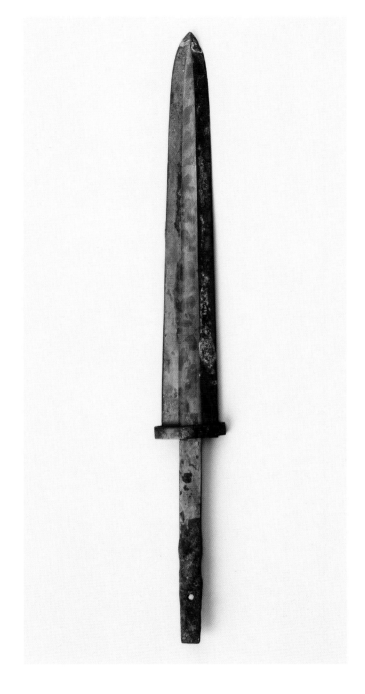

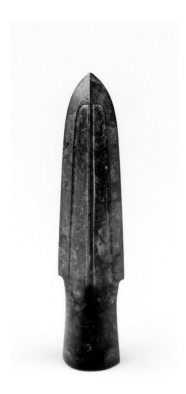

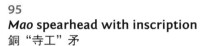

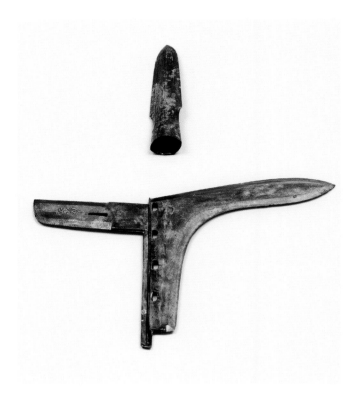

95
Mao spearhead with inscription
銅 "寺工" 矛

Qin dynasty (221–206 BCE)
Bronze, L. 15.7 cm (7⅝ in), W. 3.2 cm (1¼ in)
Excavated from Pit 1, Qin Shihuang tomb complex, 1987

Qin Shihuang Terracotta Warriors and Horses Museum, Shaanxi 000875

The *mao* spear is one of the most common long-shafted weapons of ancient Chinese warfare. This *mao* spearhead, from Pit 1, has a ridge in the middle that forms a concave surface, allowing it to inflict serious injury or death.

The inscription *sigong* engraved on this spearhead transmits important information regarding the state's management of the weapons industry during the Qin dynasty. *Sigong* is the name of the department supervising the manufacture of weaponry. As early as Shang Yang's reforms of the mid-fourth century BCE, the Qin state had implemented a policy known as *wulei gongming* (literally, "the name of the maker [should be] attached to [the manufactured] object"). This was done for quality control. Upon unification in 221 BCE, the First Emperor enforced this policy throughout the empire. Under this system of regulation, the names of the workshop, craftsmen, and administrators or department supervising the manufacture were engraved on the weapons.

96
Ji halberd
銅 "寺工" 戟

Qin dynasty (221–206 BCE)
Bronze, L. (spearhead) 15.1 cm (5¹⁵⁄₁₆ in); L. (dagger-ax) 27 cm (10⅝ in)
Excavated from Pit 1, Qin Shihuang tomb complex, 2005

Qin Shihuang Terracotta Warriors and Horses Museum, Shaanxi 005803

This weapon is composed of a *ge* dagger-ax and a *mao* spearhead. When the two were used as a composite, they became a *ji*, or halberd (four such weapons were excavated from Pit 1). Attached to wooden poles, the bronze *ge* and *ji* were two of the principal weapons in both the Warring States and Qin periods. Based on the numbers found in ancient burials of the Eastern Zhou and Qin periods, the *ge* was probably the primary weapon of the time.

This example bears an inscription identifying the weapon as being made by the official workshop. Inscriptions on similar weapons recovered from Pit 1 record that they were produced under the supervision of the Qin prime minister, Lü Buwei, from 249 to 246 BCE. Other information includes the name of the workshop, the supervisor, and the worker. By extension, the information tells the level of organization and proficiency of weapons production, and shows that the manufacturing of weapons was strictly controlled and accounted for in the Qin state.

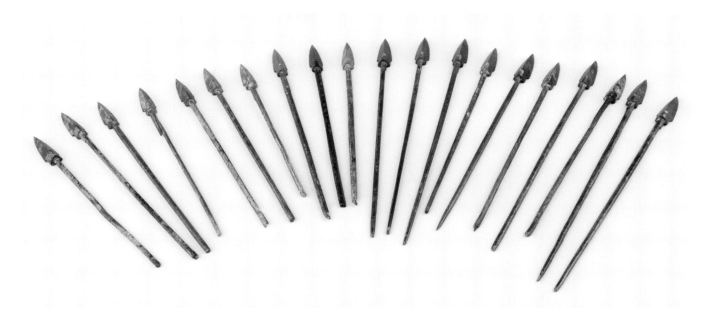

97
Twenty arrows
銅箭頭

Qin dynasty (221–206 BCE)
Bronze, L. 11.3–16.3 cm (4⁷⁄₁₆–6⁷⁄₁₆ in)
Excavated from Pit 1, Qin Shihuang tomb complex, 1983

Qin Shihuang Terracotta Warriors and Horses Museum, Shaanxi 001464

Approximately 280 clusters of arrows were excavated from the pits. Each cluster, consisting of one hundred arrows, originally would have been contained within a quiver and carried on the back of an archer. In addition, more than ten thousand arrowheads, all made of bronze, were unearthed in the pits.

Each of these arrowheads has three sides and is shaped like a prism. That each side of the prism is fairly uniform reflects the exceptional quality of their production. This style of arrowhead, an innovation of the Qin dynasty, was designed to pierce through armor, and is far superior to the two-sided arrowhead commonly seen in the earlier period, which was also more susceptible to the wind. In some examples, the short tapering circular stem would have been inserted into a wooden or bamboo shaft of sixty-eight to seventy centimeters (26 to 27 in), exposing just the tripartite tip. They were fired from crossbows in batches, with fletching attached to the lower section of the shaft.

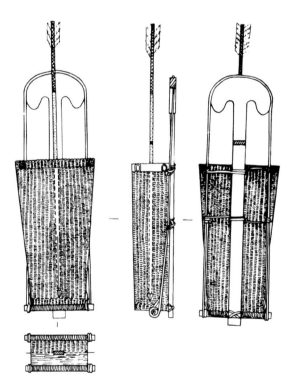

Drawing of the reconstruction of a hem-woven quiver, excavated from Pit 1. After Shaanxi Provincial Institute of Archaeology and the Excavation Team for Terracotta Warriors Pits of the First Emperor Tomb Complex, *Qinshihuang ling binmayong keng yihaokeng fajue baogao 1974–1984* [A Report on the Excavation of Pit 1 of the Terracotta Warriors and Horses at Qin Shihuang's Tomb Complex, 1974–1984] (Beijing: Wenwu Press, 1988), p. 286, fig. 174.

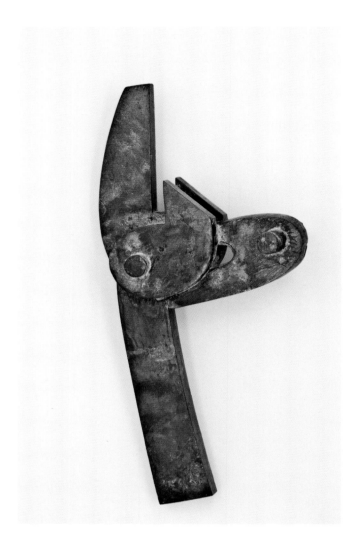

Line drawing of a crossbow.
After Yang Hong, *Weapons in Ancient China* (New York and Beijing: Science Press, 1992), p. 98

98
Crossbow trigger mechanism
銅弩機

Qin dynasty (221–206 BCE)
Bronze, L. 16 cm (6⁵⁄₁₆ in)
Excavated from Pit 1, Qin Shihuang tomb complex, 1983

Qin Shihuang Terracotta Warriors and Horses Museum, Shaanxi 000945

The *nu*, or crossbow, revolutionized military warfare and proved to be one of the most effective and widely used long-range weapons from the late Warring States period through the Han dynasty. It was said to be able to fire a bronze arrow over a distance of about a half mile (800 m), but required less strength to use than a composite bow.

This bronze trigger mechanism, *nuji*, is made from four separately cast pieces and includes the "tooth" that holds the bowstring as well as the sighting device.

Although the *nu* is generally accepted as an invention of the Chu state during the Warring States period, the Qin craftsmen improved the *nu* by lengthening the curved elastic frame, refining the trigger mechanism, and setting it within a bronze frame, which greatly improved its range and capacity.

Remnants of actual crossbows have been recovered from Pit 1, and reconstruction of the *nu* has been possible using those remnants. In the 1980s, two bronze chariots were found in the tomb complex, one of which contained a complete set of reduced-size crossbows. They provide a vivid example of crossbows in use at the time.

99
Shu ritual mace head
銅殳

Qin dynasty (221–206 BCE)
Bronze, H. 10.6 cm (4³⁄₁₆ in), Diam. 2.7 cm (1¹⁄₁₆ in)
Excavated from Pit 3, Qin Shihuang tomb complex, 1977

Qin Shihuang Terracotta Warriors and Horses Museum, Shaanxi 001925

This simple cylindrical weapon with a chisel-shaped top was fixed to a long shaft. *Shu* have been found only in Pit 3 (some thirty pieces), which was the command center of the buried army. In that pit, the *shu*, attached to their long shafts, were held in the hands of the terracotta guards who stood in a line facing each other. This led Chinese archaeologists to surmise that this weapon was used by the honor guard for ceremonial purposes. A *mao* spear—a weapon of a similar form—that was excavated from the tomb of Marquis Yi of the Zeng state at present-day Sui in Hubei province, bears an inscription that identifies itself as *shu*. It is apparent that a weapon of the same genre evolved into diversified forms in different regions.

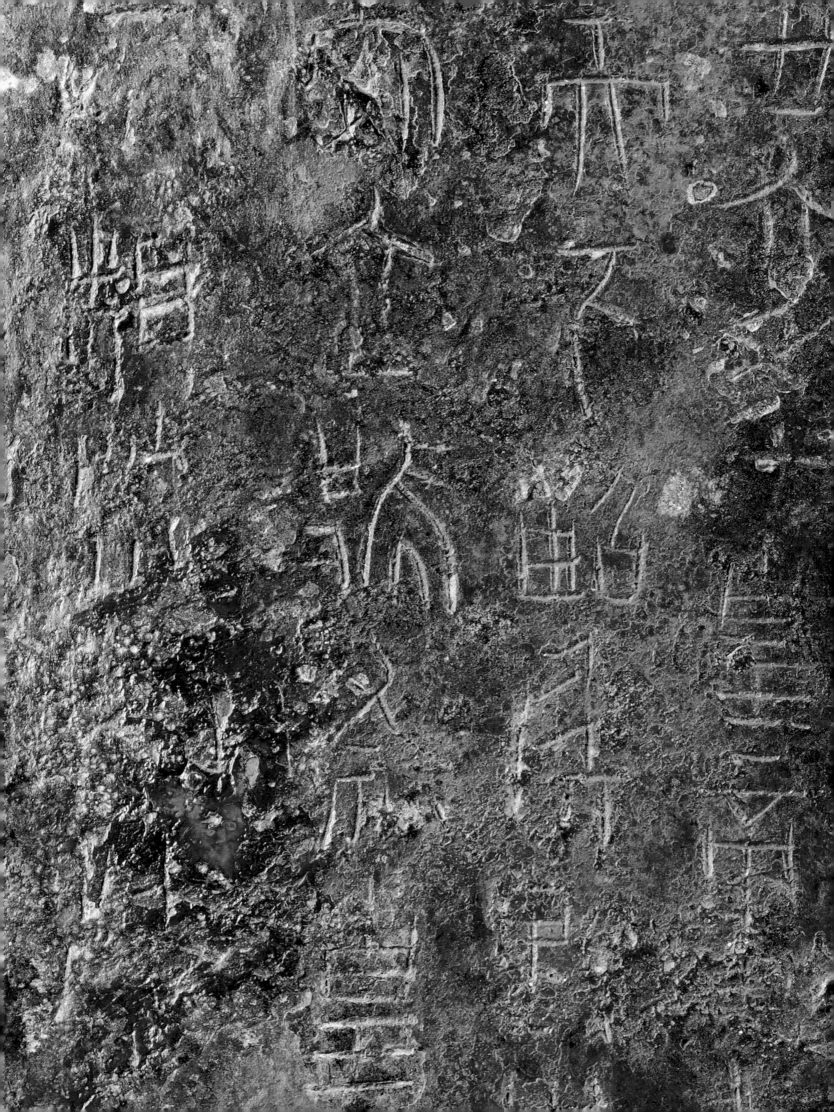

Tools for Governing

THE FIRST EMPEROR IS CREDITED WITH UNIFYING NOT ONLY THE EMPIRE, but also a number of its governmental and administrative tools. After the unification, all scripts, currency, weights, and measures were standardized within the empire for the first time, as were the size and gauge of all carriages. The First Emperor issued a decree requiring compliance with the new standardizations. It reads: "In the twenty-sixth year of his rule the emperor conquered all the vassal states under heaven, brought peace to the people, and declared himself the emperor. He ordered Prime Ministers Kui Zhuang and Wang Wan to unify all inconsistent and incorrect weights and measures in accordance with the law." The decree was inscribed on bronze plaques, standard weights, and other measuring instruments, which were placed in governmental departments and in public areas such as markets and at the city gates, where they served to publicize the new law. Later, upon his succession, Qin Shihuang's son Huhai had an additional edict inscribed on these bronze weights and measures calling for continued compliance with the system introduced under the First Emperor: "In the first year [of the Second Emperor], [the emperor] issued this edict to Prime Ministers [Li] Si and [Feng] Quji: All the legal measurements were created by the First Emperor, and they were all inscribed. Now we have inherited these designations . . . and all successors will implement these policies without taking credit for them. Now this edict will be engraved next to the First Emperor's earlier decree, in order to allay any doubts."

Standard weights made of bronze and iron have been unearthed over a broad area in China, suggesting that the implementation of the policy was quite efficient. Most of them bear the First Emperor's edict, while in some examples his successor's decree is also included.

Another of Qin Shihuang's significant administrative reforms was the standardization of currency. He first abolished all existing forms of currency, and introduced a round coin with a circular hole called *banliang*, or half *liang* (a unit of weight), based on a Qin example. Inconsistencies in the weight and size of these coins, however, have cast doubt over the effectiveness of the centralized controls on currency.

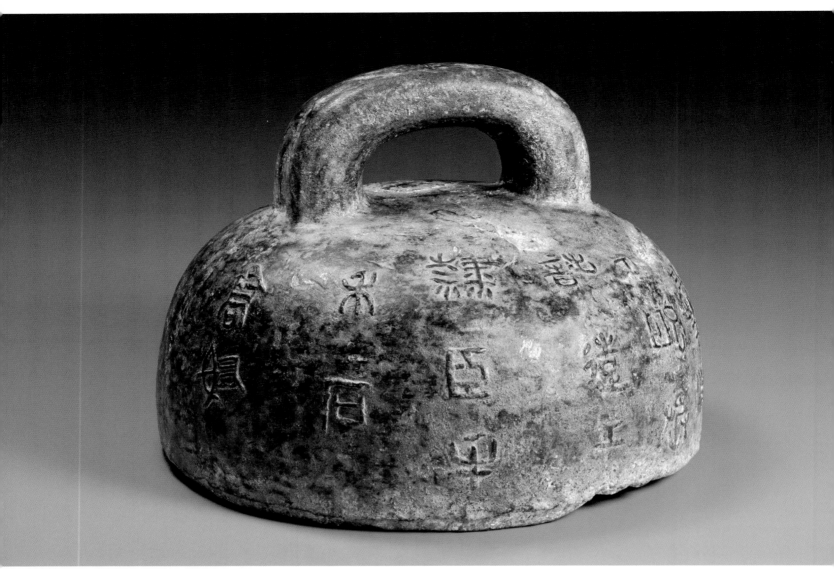

100
Standard weight with *Gaonu* inscription
"高奴" 權

Warring States period (475–221 BCE), dated 244 BCE
Bronze, H. 17.2 cm (6¹¹⁄₁₆ in), Diam. 23.6 cm (9¼ in)
Excavated at Gaoyao village, Sanqiao in Xi'an, Shaanxi, 1964

Shaanxi History Museum 64.65

On one side of this standard weight measure, a cast inscription states that it was issued by the central government at a place called Gaonu (present-day Yanchuan, Shaanxi), as the standard weight.[1] The date mentioned, "the third year," could refer to the third year of King Zhaoxiang (304 BCE), King Zhuangxiang (247 BCE), or King Zheng, the future First Emperor, (244 BCE). This is evidence that the will for a unification of such systems existed before unification of the empire in 221 BCE.

On the other side of the weight, the First Emperor's edict of 221 BCE, requiring compliance with the standardization of weights and measures, was later incised. A second inscription of a decree by

Huhai, the First Emperor's son and successor, issued in his first year on the throne (209 BCE) was added still later, and reiterated his father's requirement of compliance. The weight was in use from the year it was cast until the fall of the Qin—more than thirty years. This proves that the standardized weights in the Qin dynasty were based on the system that had been in use in the Qin state for years, and remained stable.

Standard weights were mostly semispherical in form and had knobs on top. Variations include examples that are octagonal in shape and hollow inside. Inscriptions on the weights were either cast or incised.

1. Shaanxi Provincial Museum, "Xianshi xijiao gaoyaocun chutu qin gaonu tong shiquan" [Gaonu bronze/stone weight of the Qin state excavated at Gaonu village, western suburb of Xi'an], *Wenwu*, 1964, no. 9: 42–45.

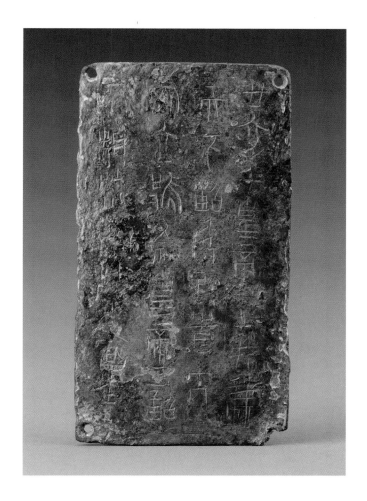

101
Plaque cast with an imperial edict
秦昭版

Qin dynasty (221–206 BCE), dated 221 BCE
Bronze, H. 12.2 cm (4¹³⁄₁₆ in), W. 6.6 cm (2⅝ in), D. 1.5 cm (⅝ in)
Collected in 1957

Shaanxi History Museum 57.176

In 221 BCE, a short imperial edict was promulgated calling for the compliance of standardized weights and measures introduced under the First Emperor. The decree was cast on bronze plaques such as this, and on weights and other measuring instruments to make it widely known. This plaque bears most of the edict's content, but is missing the last two sentences (ten characters). A similar bronze plaque was found at the Qin capital Xianyang, which bears the complete edict of Qin Shihuang with forty Chinese characters.[1] The holes on the four corners of the current example suggest that such plaques were originally affixed to other objects.

1. It is now in the collection of the Shaanxi Provincial Institute of Archaeology. See Shaanxi Provincial Institute of Archaeology, *Qindu xianyang kaogu baogao* [A report on the excavation of the Qin capital Xianyang] (Beijing: Kexue Press, 2004), p. 153, fig. 138.

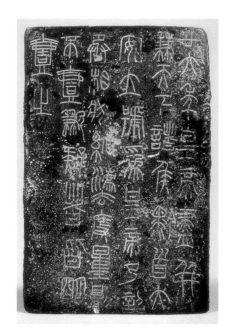

Ink rubbing of a bronze plaque unearthed at the Qin capital Xianyang, bearing the complete edict of Qin Shihuang calling for compliance with standardized weights and measures. After Shaanxi Provincial Institute of Archaeology, *Qindu xianyang kaogu baogao* [A report on the excavation of Qin capital Xianyang] (Beijing: Kexue Press, 2004), p. 153, fig. 138.

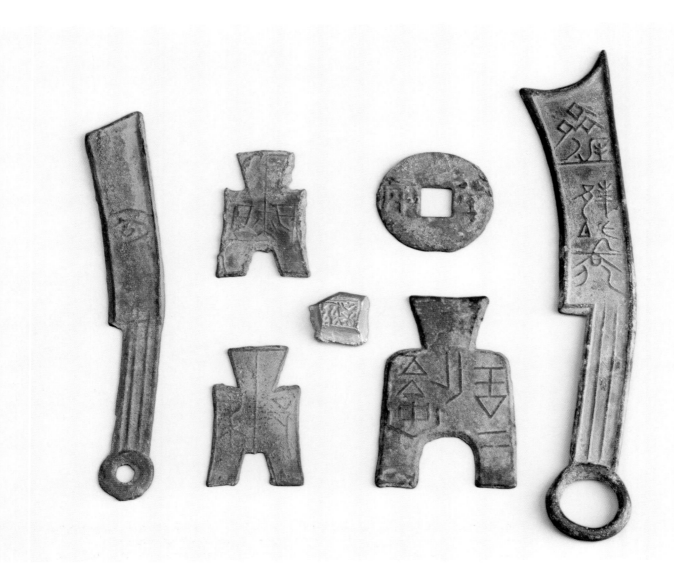

102
Coins from seven states
Warring States period (475–221 BCE)

Shaanxi History Museum

Clockwise from left:

Yan knife-shaped coin with *ming* inscription
燕 "明" 刀幣

Bronze, L. 13.7 cm (5⅜ in), W. 2 cm (¹³⁄₁₆ in)
Excavated at Pingshan, Hebei, 1999
99.1.1

Zhao spade-shaped coin with *lin* inscription
趙 "藺" 字銅布幣

Bronze, H. 4.6 cm (1¹³⁄₁₆ in), W. 2.9 cm (1⅛ in)
Acquired in 1957
58.16

Qin circular coin with *banliang* inscription
秦 "半兩" 圓錢

Bronze, Diam. 3.7 cm (1⅜ in)
81.149.2

Qi knife-shaped coin
齊刀幣

Bronze, L. 17.5 cm (6⅞ in), W. 3.1 cm (1³⁄₁₆ in)
65.211

Wei spade-shaped coin with *anyi erjin* inscription
魏 "安邑二釿" 銅布幣

Bronze, H. 6.6 cm (2⅝ in), W. 4.2 cm (1⅝ in)
72.73

***Yingyuan* block currency**
楚 "郢爰" 金版

Gold, H. 1.8 cm (¹¹⁄₁₆ in), W. 1.7 cm (¹¹⁄₁₆ in), D. 0.4 cm (³⁄₁₆ in)
Acquired in 1972
72.31

Han spade-shaped coin with *liangyi* inscription
韓 "梁邑" 銅布幣

Bronze, H. 4.7 cm (1¹³⁄₁₆ in), W. 2.9 cm (1⅛ in)
Acquired in 1981
81.146

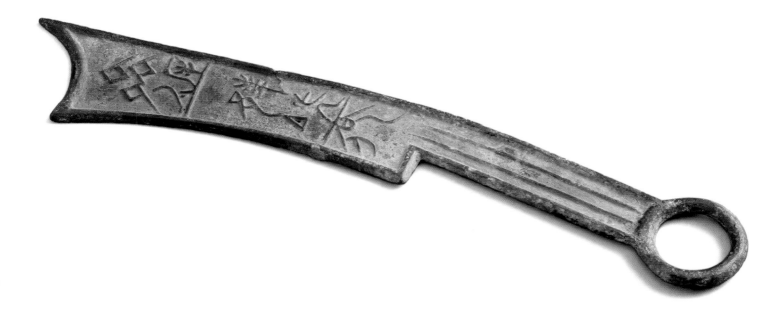

During the Warring States period there were three main shapes of bronze currency. States such as Wei, Zhao, and Han (formerly Jin, which was split into three successor states in 453 BCE) all used spade-shaped coins called *bubi*. The Qi and Yan used knife-shaped coins known as *daobi*. The Eastern Zhou capital, the Qin state, and parts of the districts of Zhao and Wei that were near the Yellow River, used round coins with either a circular or square hole in the center. A divergent monetary system in the southern state of Chu involved the use of bronze cowries, usually called *yibiqian* or "ant-nose coins." Chu was also the only vassal state at that time to issue gold coins. These were block or disk-shaped, and each bore twelve to seventeen punch marks with two characters (*yingyuan*) denoting the name of the currency (*yuan*, a weight unit) and the name of the Chu capital Ying (689–278 BCE, at present-day Jiangling, Hubei). The gold coins cast after 278 BCE at its later capital Chen (in present-day Huaiyang, Henan) were known as *chenyuan* (again, bearing the characters for weight and capital city). Archaeological finds prove that the punch marks were guides that enabled the gold block to be cut into small pieces for use, with each piece bearing a mark.

As part of the unification of China, Qin Shihuang abolished all forms of local currency and introduced a national currency. This was based on the round coins with circular or square holes—known as *banliang*, or half *liang* (a weight unit)—already in use by the Qin. It is presumed that the circular shape symbolized heaven, and the square in the center represented the earth, following a traditional cosmological concept. This type of coin remained the common design for most Chinese copper coins until the nineteenth century.

This group of coins includes spade-shaped money of the Zhao, Han, and Wei states; the knife-shaped money of the Qi and Yan; the *yingyuan* gold currency of the Chu; and the *banliang* coins of the Qin.

103
Qin official seal
秦 "器府" 官印

Qin dynasty (221–206 BCE)
Bronze, H. 2.4 cm (⅞ in), W 1.3 cm (½ in)
Excavated at Gengzhen in Gaoling, Shaanxi, 1964

Shaanxi History Museum 64.87

Seals in ancient China can be traced back as far as the Shang dynasty, and several extant bronze examples—all flat-shaped and with knobs—have been datable to that era.[1] During the Warring States period there were no strict rules regarding the material of seals, but with the First Emperor's standardization program, all official seals that previously may have been made of bronze, jade, silver, opal, stone, paste, bone, antlers, or clay, were now to be made of bronze. In addition, whereas before the unification all seals were called *xi*, now only imperial seals were to be called *xi* (and were required to be made of jade), and all other official seals were to be referred to as *yin*. An officer in the Department of Shaofu (the administration for the handicraft industry) was appointed to oversee the use of official seals.

Official seals are seen in two forms: square and oblong. Characters are often engraved in intaglio and placed within a grid or on either side of a single horizontal line. The official Qin "small seal" script was the standard for such seals. Unlike the official seals of pre-Qin times, with knobs shaped in various animal forms such as dragons and tigers, official Qin seals had simple knobs, often taking the form of a loop or—as in this example—a bulge with a piercing, known as *biniu* or "nose knob"; the dragon-shaped knob was now exclusively reserved for the ruler's seal.

Qin seals are easy to identify because of the distinctive style of the script. This seal bears the two characters *qifu*, meaning "department of implements."

1. Yu Xingwu, *Shuangjianyi guqiwu tulu* [The illustrated catalogue of artifacts in Shuangjianyi studio] (Beijing: Zhonghua Press, 2009), pp. 127–32.

104
Qin imperial inscription carved on a stele on Mount Yi
峄山刻石拓本

Qin dynasty (221–206 BCE), dated 219 BCE; re-carved in 933 CE, Northern Song dynasty

Ink rubbings

H. 155 cm (61 in)

Minneapolis Institute of Arts

On his five empire-wide inspection tours, the First Emperor erected stelae inscribed with encomiums to his achievements. In this example, the text was originally carved in 219 BCE on a stele on Mount Yi in present-day Zhouxian in Shandong province. Written by the emperor's prime minister Li Si in standard "small seal" script, the inscription consists of two texts: the first, composed of 144 characters, was written at the time of his tour; the second was written by his son and successor, Huhai, who in his first year on the throne (209 BCE) followed in his father's footsteps and ascended Mount Yi.

The original stele was destroyed by fire in the Tang dynasty. The existing monument, from which this rubbing was taken, was re-inscribed by the Song dynasty scholar and official Zheng Wenbao in 993 CE, and is preserved in the Beilin Museum ("Museum of Forest of Steles") in Xi'an.

View of the stele bearing the Qin imperial inscriptions, re-carved in 993 CE, now in the collection of the Beilin Museum in Xi'an. Photo by Liu Yang.

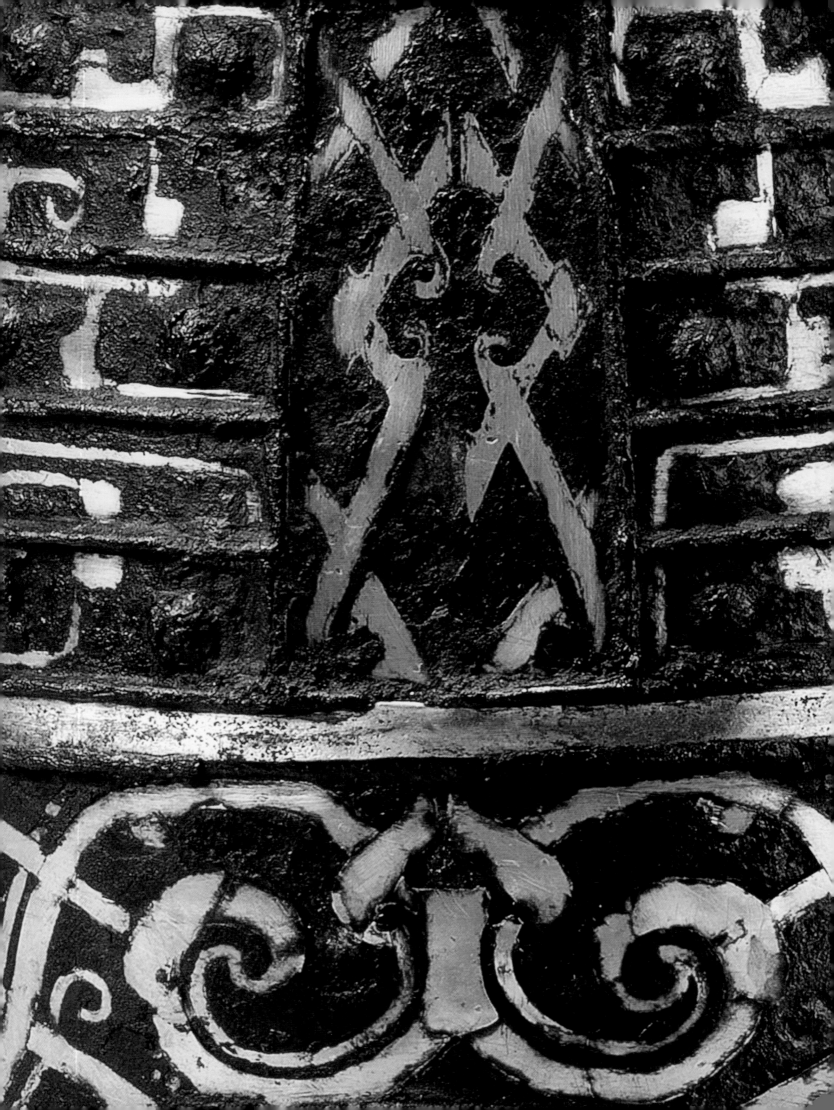

Gold and Silver

105
Niuzhong bell with inlay design
錯金銀樂府鈡

Qin dynasty (221–206 BCE)
Bronze, gold, and silver, H. 13.3 cm (5¼ in), W. 7.2 cm (2¹³⁄₁₆ in)
Excavated from the Qin Shihuang tomb complex, 1976

Qin Shihuang Terracotta Warriors and Horses Museum, Shaanxi 002823

Like the *yongzhong* (see cat. no. 2), this *niuzhong* bell is almond shaped in cross section, but it has a U-shaped loop (rather than a long stem) surmounting its flat top. The bosses on its face are much smaller, and it is uniquely ornamented with inlaid gold and silver designs of stylized serpentine motifs. It would have been from a set of chimes suspended from a wooden rack and used in performances.

The significance of the bell lies not only in the fact that it is the only extant bronze bell with inlaid gold and silver designs, but also in the two-character inscription cast along the surface of the loop, which reads *yuefu*. The term literally means "music bureau," a reference to the imperial Chinese governmental organization charged with collecting or writing song lyrics. The music bureau flourished under Emperor Wu of the Western Han (r. 141–87 BCE). This bell and its inscription, however, prove that the music bureau existed during the Qin dynasty, if not earlier.

The story surrounding this bell is quite dramatic. One late afternoon in 1976, Yuan Zhongyi, the head of the archaeological team, was strolling alone alongside the field in the Qin Shihuang tomb complex. In a location some 110 meters (360 ft) to the northwest of the tomb mound, a bell, lying slightly exposed in the ground, caught his attention. He ventured to dig it out and found with astonishment that his discovery was an extremely rare Qin bell with inlaid designs. He handed it over to what was then known as the Shaanxi Provincial Museum. Ten years later, in 1986, a thief broke into the museum and stole the bell from the gallery. After ten years of fruitless searching, the bell resurfaced and passed into the hands of a Hong Kong collector; it eventually was returned to Shaanxi.

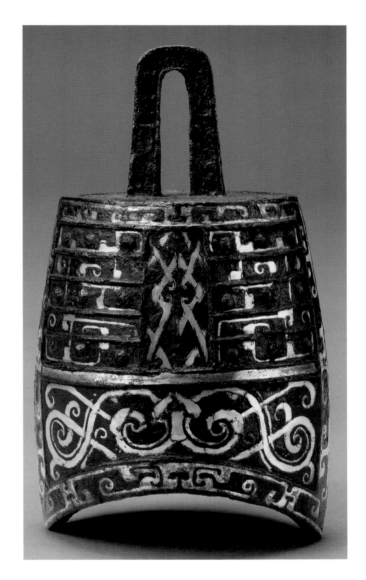

106
Base for a lacquer object
青銅漆器座

Warring States period (475–221 BCE)
Bronze inlaid with silver, H. 3.9 cm (1⁹⁄₁₆ in), L. 36.3 cm (14⁵⁄₁₆ in),
W. 22 cm (8⁵⁄₈ in)
Excavated at Shenheyuan, Xi'an, 2005

Shaanxi Provincial Institute of Archaeology 05XCJH5

This unusual object was recovered from what is believed to be
the tomb of the First Emperor's grandmother. The tomb was badly
robbed a number of times, and the coffin was completely burned.
Despite the severe plundering, archaeologists were able to collect
a handful of artifacts from the tomb, including a pair of magnificent
silver *pushou* ring holders, a gilt bird finial, and this unusual object.[1]
Based on the lacquer remains, this bronze structure is assumed to be
the pedestal for a lacquer chest. The G-shaped structure is

ornamented on its exterior walls with geometric designs in inlaid
silver. Five rows of denticulation on its bottom serve to prevent it
from slipping.

1. The full archaeological report on the excavation is yet to be published. A brief
report is seen in Shaanxi Provincial Institute of Archaeology, "Shaanxi changan
shenheyuan zhanguo qin lingyuan yizhi tianye kaogu xin shouhuo" [A new archaeo-
logical achievement in excavating the Qin mausoleum site of the Warring States
period at Shenheyuan in Chang'an, Shaanxi], *Kaogu yu wenwu*, 2008, no. 5: 111–12.
For the *pushou* ring holders and bird finial, see Liu Yang and Edmund Capon, *The
First Emperor: China's Entombed Warriors* (Sydney: Art Gallery of New South Wales,
2010), p. 79, plates 52–53.

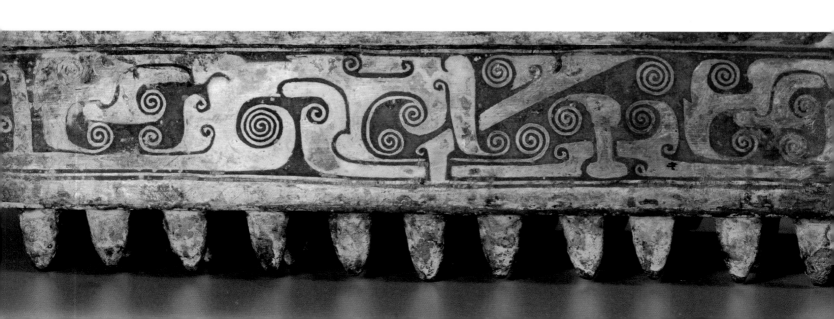

107
Danglu horse's brow ornament
金當盧

Qin dynasty (221–206 BCE)
Gold, H. 9.7 cm (3¹³⁄₁₆ in), W. 4.75 cm (1⅞ in), D. 0.2 cm (¹⁄₁₆ in)
Excavated from the Bronze Chariot Pit, Qin Shihuang tomb complex, 1980

Qin Shihuang Terracotta Warriors and Horses Museum, Shaanxi 004493

This leaf-shaped plaque, known as *danglu*, is an ornament for a horse's brow. It was a component of the bronze chariot-and-horse set no. 2. Its surface is decorated with clouds or abstract patterns, and on its back there are four loops through which strips could be laced to affix the plaque to the halter.

108
Rosette
蟠虺紋金泡飾

Qin dynasty (221–206 BCE)
Gold, Diam. 2.44 cm (¹⁵⁄₁₆ in), D. 1.58 cm (⅝ in)
Excavated from the Bronze Chariot Pit, Qin Shihuang tomb complex, 1980

Qin Shihuang Terracotta Warriors and Horses Museum, Shaanxi 004477

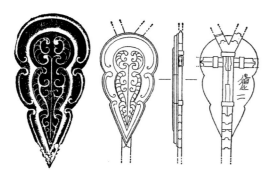

Line drawing of the *danglu*. After Terracotta Figure Excavation Team, "Qinshihuang ling erhao tongchema qingli jianbao" [A brief report on the excavation of Bronze Chariot 2 from the Qin Shihuang tomb complex], *Wenwu*, 1983, no. 7: 10, fig. 23:1.

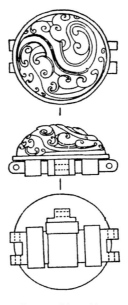

Line drawing of the gold rosette. After Terracotta Figure Excavation Team, "Qinshihuang ling erhao tongchema qingli jianbao" [A brief report on the excavation of Bronze Chariot 2 from the Qin Shihuang tomb complex], *Wenwu*, 1983, no. 7: 15, fig. 44.

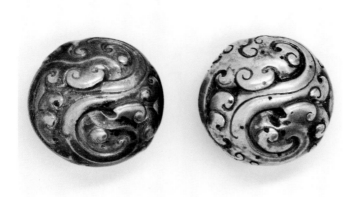

109

Rosettes

蟠虺紋銀泡飾

Qin dynasty 221–206 BCE
Silver, Diam. 2.44 cm (¹⁵⁄₁₆ in), D. 1.6 cm (⅝ in)
Excavated from the Bronze Chariot Pit, Qin Shihuang tomb complex, 1980

Qin Shihuang Terracotta Warriors and Horses Museum, Shaanxi 004505, 004506

The harness buttons, or rosettes, in this and the previous entry, are similar in function to those excavated in Fengxiang from the Warring States period (see cat. no. 44), but are made of pure gold or silver. They are components of the bronze chariot-and-horse sets excavated from the First Emperor's tomb complex. On the reverse of each rosette there are three loops through which two gold strips could be crossed and fixed. The cloud and serpentine motifs—in comparison with those made in the Warring States period—have evolved into a refined and fluent design.

110

Chained bridle ornament

金節

Qin dynasty (221–206 BCE)
Gold, L. (each tube) 0.87 cm (⁵⁄₁₆ in), W. (each tube) 0.95 cm (⅜ in)
Excavated from the Bronze Chariot Pit, Qin Shihuang tomb complex, 1980

Qin Shihuang Terracotta Warriors and Horses Museum, Shaanxi 003917

This gold bridle ornament is made up of fifteen segments strung together. Viewed from above, the pieces appear to be double tubes, but on the reverse they are flat, and the interior of each is a single hollow. Because of the softness of the metal, it is apparent that such tubing, rather than protecting the reins from damage, served only as ornament.[1]

1. Some 130 gold tubes dating from the late Spring and Autumn period were unearthed from Tomb 2 at Yimen in Baoji. They belonged to two chained bridle ornaments, each consisting of sixty-five pieces of tiny tubes. See Liu Yang and Edmund Capon, *The First Emperor: China's Entombed Warriors* (Sydney: Art Gallery of New South Wales, 2010), p. 72, cat. no. 40.

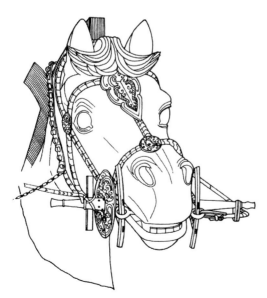

Drawing of a bronze horse showing positions of the *danglu* and rosettes.
After Yuan Zhongyi, *Qin shihuang ling de kaogu faxian yu yanjiu*
[The archaeological discovery and research of Qin Shihuang's tomb complex] (Xi'an: Shaanxi Renmin Press, 2002), p. 120, fig. 43.

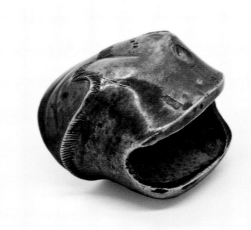

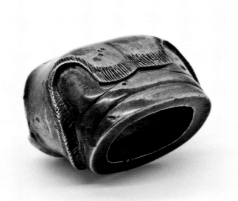

111
Animal-head ornament
獸頭銀飾件

Qin dynasty (221–206 BCE)
Silver, H. 2.5 cm (1 in), W. 2.7 cm (1¹/₁₆ in)
Excavated from the Bronze Chariot Pit, Qin Shihuang tomb complex, 1980

Qin Shihuang Terracotta Warriors and Horses Museum, Shaanxi 004531

This is another silver ornament from the bronze chariot-and-horse sets. The overall form is simple and exaggerated, yet contains meticulous details such as the representation of hairs along the slanting ridges on both sides of the head.

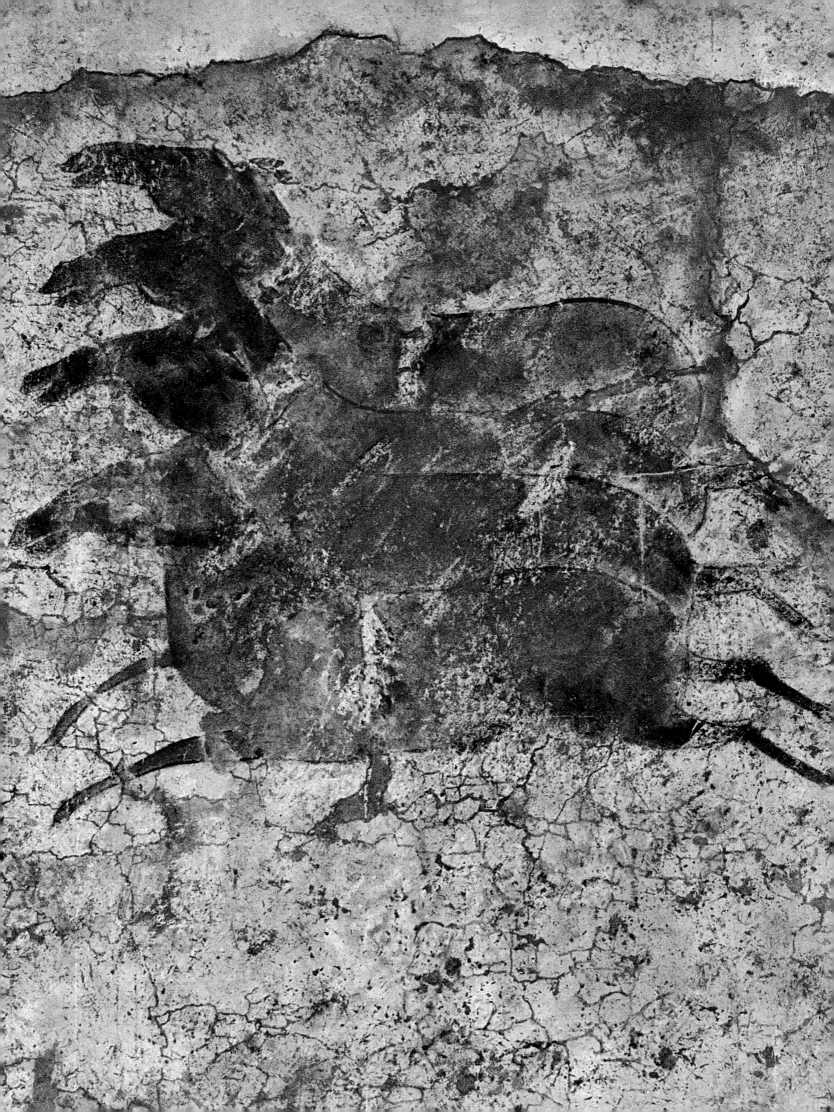

Architecture

IN THE MID-FOURTH CENTURY BCE, THE QIN CAPITAL WAS MOVED TO Xianyang near Xi'an, where it remained for more than 140 years until the demise of the Qin dynasty in 206 BCE. It was here that the First Emperor expanded what was already a grand capital covering about seventeen square miles by adding, it is believed, more than 270 palaces. Recent excavations have determined that the major palace buildings were constructed on raised-earth platforms of up to six meters in height (about 20 ft). Based on the evidence of these foundations, it is estimated that Palace 1 measured some sixty by forty-five meters (150 x 200 ft). Architectural fragments, such as decorated brick floor paving and large ornamented roof tiles, hint at the grandeur of the palaces and buildings that once graced the city. At both the Qin Shihuang tomb complex and Xianyang palace site, large earthenware pipes have been recovered and are evidence of an advanced drainage system. A rare fragmentary wall painting was recovered from the Palace 3 site at Xianyang (see detail at left).

Chariot procession, detail from a mural fragment
excavated from Palace 3 at Xianyang in 1979

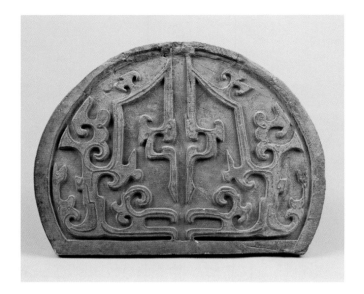

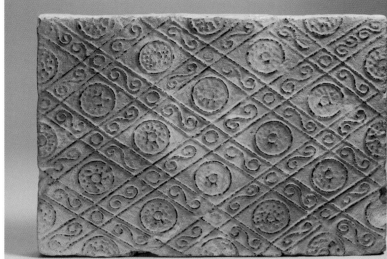

112
Roof tile end with dragon design
夔紋大瓦當

Qin dynasty (221–206 BCE)
Earthenware, Diam. 51 cm (20¹⁄₁₆ in), D. 40 cm (15¾ in)
Excavated at the Huangshan palace site, Hou village, Xingping, Xianyang, Shaanxi, 1993

Shaanxi Provincial Institute of Archaeology 003002

The geometric design on this unusually large semicircular roof tile end depicts stylized dragons facing each other. It can be compared with the serpentine design seen on the Qin bronzes from the Spring and Autumn period, such as the *bo* bell and *ding* cauldron (cat. nos. 1 and 3). It was used for the Huangshan palace that once stood at Xingping in the Qin capital Xianyang. An even larger tile end with the same ornamental pattern was excavated at the Qin Shihuang tomb complex. With a diameter of sixty-one centimeters (24 in), that giant piece was regarded as the "king of tile ends."[1] The scale of both tile ends is a testimony to the majesty and splendor of the Qin palaces built during Qin Shihuang's time.

1. Lintong County Museum, Shaanxi, "Qin Shihuang ling xinchutu de wadang" [Newly excavated tile ends at Qin Shihuang tomb complex], *Wenwu*, 1974, no. 12: 87–88.

113
Rectangular paving tile with sun design
太陽紋長方鋪地磚

Qin dynasty (221–206 BCE)
Earthenware, L. 44 cm (17⁵⁄₁₆ in), W. 32 cm (12⁵⁄₈ in)
Excavated at Palace 1, Xianyang, Shaanxi, 1974–75

Xianyang Municipal Museum, Shaanxi 14-1039

A number of such bricks excavated from the Palace 1 site in Xianyang would have been used to pave the floors of the palace.[1] The sun pattern with geometric and curlicue designs was molded or stamped onto the bricks before firing.

1. Shaanxi Provincial Institute of Archaeology, *Qindu xianyang kaogu baogao* [An archaeological report on the Qin capital Xianyang] (Beijing: Kexue Press, 2004), p. 310.

114
Rectangular paving tile with geometric design
方塊米格紋磚

Qin dynasty (221–206 BCE)
Earthenware, L. 16 cm (6⁵⁄₁₆ in), W. 14.8 cm (5¹³⁄₁₆ in), D. 3.7 cm (1⁷⁄₁₆ in)
Excavated at Palace 1, Xianyang, Shaanxi, 1974–75

Xianyang Municipal Museum, Shaanxi 14-0769

The checkerboard-like design on this paving tile consists of seventy equal-sized squares; each blank square is alternated with a concave square made up of sixteen asterisks.

115
Hollow brick with geometric design
幾何紋空心磚

Qin dynasty (221–206 BCE)
Earthenware, L. 118 cm (46⁷⁄₁₆ in), W. 39 cm (15³⁄₈ in), D. 16.3 cm (6⁷⁄₁₆ in)
Excavated at Palace 1, Xianyang, Shaanxi, 1974–75

Xianyang Municipal Museum, Shaanxi 14-758

Pottery bricks such as this (and cat. no. 116) have been found in some quantity at the Qin palace site in Xianyang. Hollow inside, and ornamented with molded or incised geometric designs or imaginary beasts and birds, they were invariably used to pave the steps of the corridors within the palace.

116
Hollow brick fragment with dragon design
龍紋空心磚

Qin dynasty (221–206 BCE)
Earthenware, L. 71 cm (27¹⁵⁄₁₆ in), W. 39 cm (15³⁄₈ in), D. 16.3 cm (6⁷⁄₁₆ in)
Excavated at Palace 1, Xianyang, Shaanxi, 1974–75

Xianyang Municipal Museum, Shaanxi 0-40

This hollow brick was used as a paver for the palace steps. The deco-
ration visible on the fragment shows a vigorous dragon wriggling
in a graceful S shape. On the center of the intact examples shown
below (figs. 1 and 2), one can discern a circular design resembling
a jade disc, or *bi*.[1] One of the most familiar jade ritual objects in
ancient China, the *bi* was considered an offering to the heavens,
according to Western Zhou ritual texts. In addition to the dragon,
the phoenix was also a common motif for brick decoration.[2] In the
succeeding Han dynasty, both the dragon and the phoenix (or the
vermilion bird)—along with the white tiger and the black tortoise—
were well-established as cosmological symbols of the four cardinal
directions, and appeared on tile ends at the eastern and southern
gates of the palaces. As Qin Shihuang ordered that his network of
palaces in Xianyang be built to embody the theme of earth as the
mirror of heaven, the appearance of dragons and phoenixes on
the Qin paving bricks suggests that these motifs could have been
imbued with cosmological meaning during the Qin dynasty.

The dragon exhibits a fierce head, four legs (each with three claws),
and fins that extend from its body. In some examples the head
resembles a giant salamander, an image that had never before been
seen in Qin art. It is most likely one of the many design elements
appropriated by the Qin from other states, and inspired by the
replica palaces of conquered states that Qin Shihuang ordered to
be built along the northern bank of the Wei River.

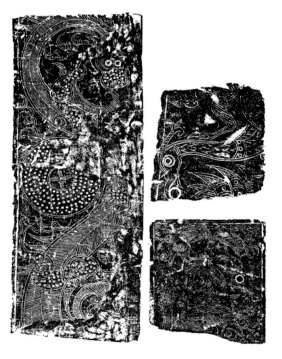

1. See Liu Yang and Edmund Capon, *The First Emperor: China's Entombed Warriors*
(Sydney: Art Gallery of New South Wales, 2010), p. 179, plate 119.

2. Liu Qingzhu and Chen Guoying, "Qindu xianyang diyihao gongdian jianzhu yizhi
jianbao" [A brief report on the excavation of Palace 1 at the Qin capital Xianyang],
Wenwu, 1976, no. 11: 12–24, plate 2:1. See also Shaanxi Provincial Institute of
Archaeology, *Qindu xianyang kaogu baogao* [An archaeological report on the Qin
capital Xianyang] (Beijing: Kexue Press, 2004), pp. 384, 390, fig. 321.

Fig. 1. Earthenware hollow brick with dragon design (117 x 39 cm), excavated at
Palace 2 in Xianyang, 1982, Xianyang Municipal Museum, Shaanxi 005444.
Photo courtesy Shaanxi Cultural Promotion Center.

Fig. 2. Ink rubbings of designs on the earthenware hollow bricks
excavated at Palace 1 in Xianyang, 1974–75. After Liu Qingzhu
and Chen Guoying, "Qindu xianyang diyihao gongdian jianzhu
yizhi jianbao" [A brief report on the excavation of Palace 1
architectural site at the Qin capital Xianyang], *Wenwu*, 1977,
no. 11, p. 20, fig. 12.

117
Pentagonal-shaped drainpipe
五角形陶管

Qin dynasty (221–206 BCE)
Earthenware, H. 46.5 cm (18⁵⁄₁₆ in), W. 45.5 cm (17¹⁵⁄₁₆ in),
L. 67.3 cm (26½ in)
Excavated from the Qin Shihuang tomb complex, 1979

Xianyang Municipal Museum, Shaanxi 14-0162

The use of drainpipes can be dated to the early Qin settlement in east Gansu during the early Spring and Autumn period. They were also found at the palace site in Yong, the old Qin capital. They were mostly cylindrical, but a number of pentagonal pipes were excavated at the Qin Shihuang tomb complex and at the Qin palace site in Xianyang, where they were linked to form a complex underground drainage system. The Qin drainpipes used in Xianyang and in the Qin Shihuang tomb complex were almost standard in size, ranging from 130 to 150 centimeters long (50 to 60 in) and 40 to 50 centimeters in diameter (15 to 20 in). The size of one end of cylindrical pipe was larger than the other, allowing them to be joined. A type of L-shaped drainpipe was also unearthed, as were funnel-shaped drains, all of which suggests that an underground drainage system with unprecedented sophistication was established in Xianyang during Qin Shihuang's time.

118
Bronze plaque mold with motif of a mother holding her son
陶人物紋飾牌模

Qin dynasty (221–206 BCE)
Earthenware, L. (each side) 6–7 cm (2⅜–2¾ in)
Excavated at the Lebaishi building site, Beikangcun, Xi'an, Shaanxi, 1999

Shaanxi Provincial Institute of Archaeology M34: 15

From 1999 to 2000, Chinese archaeologists conducted a survey in a location at Beikangcun, a northern suburb of Xi'an, where a factory was to be constructed by Lebaishi Food Co. Ltd. The excavation yielded some fifty-seven tombs, with thirty-four from the Warring States period to the Qin dynasty. They were mostly commoners' tombs, originally outfitted with wooden coffins. Some of them contained small portions of bronze vessels and ceramic copies of bronze vessels. Mirrors and belt hooks, as well as jade and animal-bone ornaments, were also found.

Among the tombs, M34 is the most interesting and unusual. Here the deceased was buried in an east-west oriented *dongshi mu*, or catacomb tomb, in which the coffins were placed in a lateral chamber adjacent to a vertical shaft. Six pottery vessels were placed within a niche built along the side wall; next to his head was a bronze seal with the character *cang* (which may stand for his name), a bronze ring, an iron knife, and a lacquer *zhi*, or wine cup. Twenty-five clay pictorial plaques of various shapes were placed on both sides of him and at the end of his feet.[1] These are all positive clay models of bronze plaques. Designs were carved into the sides of these models with a carving tool. There is one mold depicting human figures, four with designs of animals, and ten bearing abstract patterns. The rest are molds of chariot fittings, rings, crossbow trigger mechanisms, legs of the *ding* vessel, ear cups, and candlesticks, each in the form of a goose's foot. The deceased was most likely a craftsman skilled in bronze casting.

In this example, there are four bulges at regular intervals along the perimeter, which might have served as spacers to maintain a consistent distance between the positive and negative molds. Within a double-roped, diamond-shaped frame, a mother with a smiling face is shown holding her son. She wears a headscarf, a jacket with a round collar and tight sleeves, and a pleated skirt. The costume is ethnic (non-Han Chinese) in style.

1. Shaanxi Provincial Institute of Archaeology, *Xi'an beijiao qinmu* [Qin tombs at the northern suburb of Xi'an] (Xi'an: Sanqin Press, 2006), pp. 120–22, fig. 84: 1.

119
Bronze plaque mold with design of a galloping horse
陶馬紋飾牌模

Qin dynasty (221–206 BCE)
Earthenware, H. 7 cm (2¾ in), W. 9.4 cm (3¹¹⁄₁₆ in), D. 2.5 cm (1 in)
Excavated at the Lebaishi building site, Beikangcun, Xi'an, Shaanxi, 1999

Shaanxi Provincial Institute of Archaeology M34: 13

This mold depicts a galloping horse whose hind legs are rather
fancifully articulated; while its tail whisks the ground, its hind legs
are raised high into the air.[1] A wave-shaped band decorated with five
birds' heads runs along the top edge of the double-roped frame.

1. Shaanxi Provincial Institute of Archaeology, *Xi'an beijiao qinmu* [Qin tombs at the
northern suburb of Xi'an] (Xi'an: Sanqin Press, 2006), p. 123, fig. 85:1.

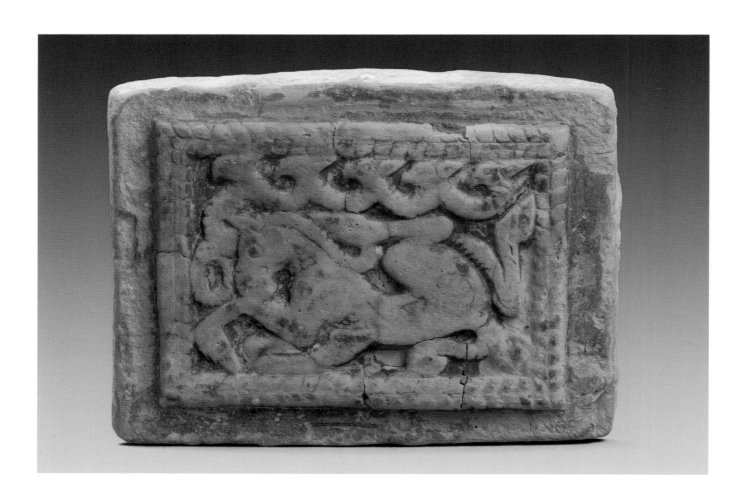

120

Bronze plaque mold with design of running sheep
陶雙羊紋飾牌模

Qin dynasty (221–206 BCE)
Earthenware, H. 7.9 cm (3⅛ in), W. 6.7 cm (2⅝ in), D. 1.4 cm (⁹⁄₁₆ in)
Excavated at the Lebaishi building site, Beikangcun, Xi'an, Shaanxi, 1999

Shaanxi Provincial Institute of Archaeology M34: 12

Two running sheep, each the mirror image of the other, are confined within two triangles. One hind leg kicks out at an acute angle, while the other is raised high into the air. Each sheep has an inward-curving horn and an open mouth.[1] There are grooves on four edges that allows molten bronze to be poured into the mold.

1. Shaanxi Provincial Institute of Archaeology, *Xi'an beijiao qinmu* [Qin tombs at the northern suburb of Xi'an] (Xi'an: Sanqin Press, 2006), pp. 124–25, fig. 86:1.

121

Bronze plaque mold with design of eagle and tigers in combat
陶鷹虎搏斗紋牌模

Qin dynasty (221–206 BCE)
Earthenware, H. 5.2 cm (2¹⁄₁₆ in), W 4.2 cm (1⅝ in), D. 0.6 cm (¼ in)
Excavated at the Lebaishi building site, Beikangcun, Xi'an, Shaanxi, 1999

Shaanxi Provincial Institute of Archaeology M34: 25

An elaborate scene of an eagle fighting two tigers is depicted in high relief on this elliptical tablet.[1] The bird's huge body sits firmly atop the two tigers, which are seen in profile; they, in turn, bite the eagle's wings. Above and below this main image, symmetrical birds positioned back-to-back render the scene more complex.

1. Shaanxi Provincial Institute of Archaeology, *Xi'an beijiao qinmu* [Qin tombs at the northern suburb of Xi'an] (Xi'an: Sanqin Press, 2006), p. 124, fig. 85: 2.

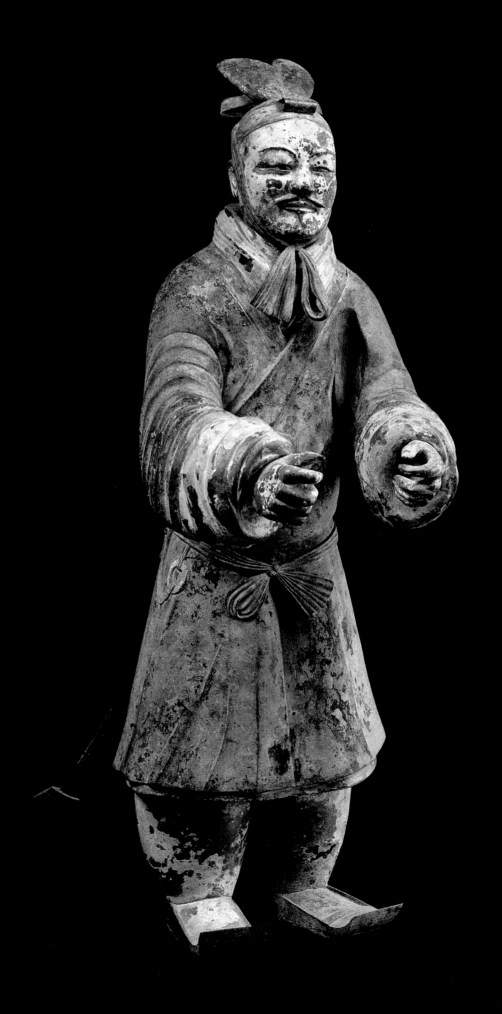

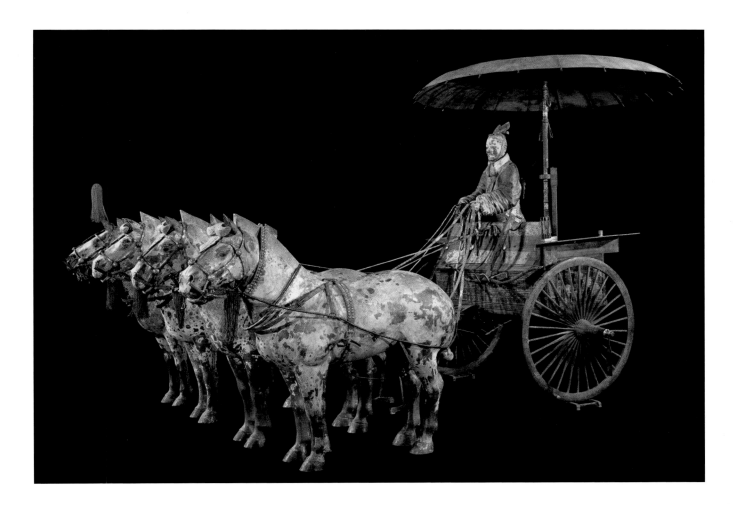

122
Chariot 1
一號銅車馬
Qin dynasty (221–206 BCE)
Bronze, gold, and silver, H. 160 cm (63 in), W. 185 cm (72¹³⁄₁₆ in), L. 265 cm (104⁵⁄₁₆ in)
Excavated from the Bronze Chariot Pit, Qin Shihuang tomb complex, 1980

Qin Shihuang Terracotta Warriors and Horses Museum, Shaanxi qy2012-1

In 1980, two half-life-size chariots, each drawn by four horses, were excavated from one section of a larger pit located about sixty-five feet (20 m) west of Qin Shihuang's tomb mound. They were cast from bronze and embellished with paint and gold and silver ornaments. This one, named *liche*, or "standing chariot" (because the charioteer rides in *li*, or standing, pose), is an example of what is known as *qiandaoche*, or "preceding chariot." Each of the horses was cast from a single mold. The horse on the outermost right wears a semispherical bronze finial in the middle of its head, and from its center protrudes a twenty-two-centimeter-long (9 in) bronze cylinder surrounded by sixteen golden beads; a tassel, known as *dao*, issues from the cylinder. This type of headdress is an emblem of the imperial chariot. Each wheel on the chariot has thirty spokes, which represent the thirty days in a month.

The charioteer, measuring about ninety centimeters tall (35⅜ in) and wearing a long tunic, holds the reins in his hands as if concentrating on manning the horses. He is protected from the sun and rain by a canopy, whose twenty-eight spokes symbolize the twenty-eight constellations in the sky. His pheasant-feather headgear and the jade pendant hanging from his belt indicate his high rank. He is

armed with a sword, a crossbow, an arrow quiver, and a magnificently embellished shield.

The entire grouping—chariot, horses, and charioteer— weighs 2,339 pounds (1,061 kg) and consists of 3,064 components, including 1,720 pieces of gold and silver ornaments that weigh 15½ pounds (7 kg).

Line drawing of Chariot 1. After Shaanxi Terracotta Figure Excavation Team, "Qinshihuang ling yihao tongchema qingli jianbao" [A brief report on the excavation of Bronze Chariot 1 from the Qin Shihuang tomb complex], *Wenwu*, 1991, no. 1: 2–3, fig. 1.

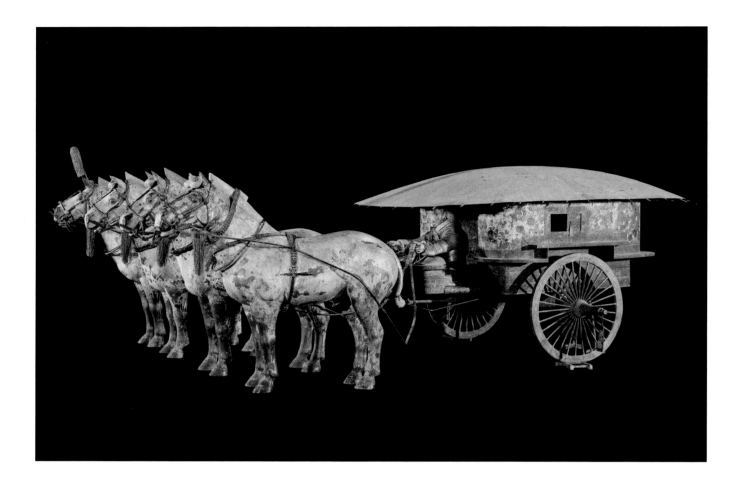

123
Chariot 2
二號銅車馬

Qin dynasty (221–206 BCE)
Bronze, gold, and silver, H. 104 cm (40¹⁵⁄₁₆ in), W. 190 cm (74¹³⁄₁₆ in), L. 328 cm (129⅛ in),
Excavated from the Bronze Chariot Pit, Qin Shihuang tomb complex, 1980

Qin Shihuang Terracotta Warriors and Horses Museum, Shaanxi qy2012-2

Chariot 2 is known both as *anche* (sedan carriage), the name that is engraved on the end of one rein, and *wenliangche* (all-season carriage), named because the carriage is entirely enclosed except for two small windows that can be opened on both sides, and a rear access door. It is an example of the chariot in which Qin Shihuang toured the country, and which later carried his body back to the capital after his sudden death during his inspection tour. Painted diamond and cloud motifs on the exterior and interior walls of the carriage are reminiscent of contemporary textile patterns.

The kneeling charioteer wears general-style headgear, and is armed with a short sword that is tucked into his belt at the side. The sword was cast separately and could be displayed independently, although it cannot be drawn from its scabbard. Chinese archaeologists believe this "false sword" actually represents a reality of the First Emperor's time: those who were close to him were not allowed to carry real weapons.[1]

The chariot's manufacture involved amazingly complex techniques. In total, the set weighs 2,736 pounds (1,241 kg) and is made up of 3,462 components, including 737 gold finials and 983 silver ornaments. The carriage is protected by a turtle-shell-like cover with an area of 2.3 square meters (25 sq ft). It was cast in one mold, with the thinnest area being 0.1 cm (¹⁄₁₆ in), and the thickest 0.4 cm (³⁄₁₆ in). The horses' manes are made of hollow bronze threads with diameters ranging between 0.1 and 0.5 millimeters (the hollow section has a diameter of 0.02 mm). The horse chaplet consists of forty-two pieces of gold and forty-two pieces of silver, all of which were soldered together; the welding seam is only observable under a microscope. As different metals have different melting points, it is still a mystery how the craftsmen managed to create this piece at that time.

1. Ma Qingyun, "Tongchema yuguanyong peijian zhi wojian" [My opinion of the swords worn by the charioteers of the bronze chariots], *Wenbo*, 1995, no. 1: 73–74.

Line drawing of Chariot 2. After Shaanxi Terracotta Figure Excavation Team, "Qinshihuang ling erhao tongchema qingli jianbao" [A brief report on the excavation of Bronze Chariot 2 from the Qin Shihuang tomb complex], *Wenwu*, 1983, no. 7: 2–3, fig. 3.

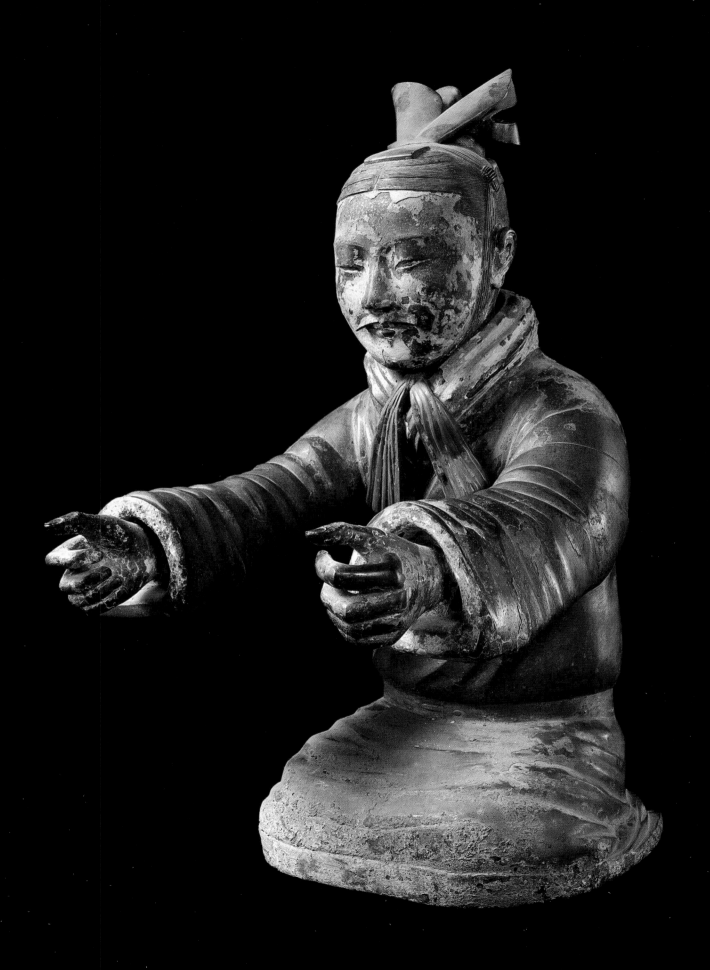

Glossary of Chinese Characters

anche 安車
ban wadang 半瓦當
beigong 北宮
Beiling 北陵
biniu 鼻紐
bodai wen 波帶紋
bozhong 鎛鐘
bu 步
Cang 蒼
chanjiao daizu li 鏟腳袋足鬲
Chaogong 朝宮
chengxiang 丞相
chenyuan 陳爰
Chidao 馳道
chiyi 鴟夷
chonghuan wen 重環紋
chuilin wen 垂鱗紋
Dabuzi 大堡子(山)
dajiu 大廄
dao 纛
daoyin 導引
Dazhenggong 大鄭宮
dazhuan 大篆
deshui 德水
dianren 甸人
Dongling 東陵
dongshi mu 洞室墓
Dongyi 東夷
dou (measurement) 斗
dou (vessel) 豆
dui 錞
Epanggong 阿房宮
ercengtai 二層臺
fangguo 方國
fengshan 封禪
fou 缶
fu (measurement unit) 釜
fu (the official warehouse) 府
gong (duke) 公
gong (palace) 宮
goulian panhui wen 勾連蟠虺紋
guan (vessel) 罐
guan (coffin) 棺
gui 簋
guo 椁
heguan 鶡冠
hou 侯
hu 斛

Huang 黃
huang 璜
huangchang ticou
　　黃腸題湊
huangdi 皇帝
Huangdi 黃帝
hundun 渾沌
jian 劍
Jiang 江
Jimiao 極廟
jin 禁
jiuqing 九卿
jiushou 鳩首
jue 玦
jun 郡
Ke bo 克鎛
kui 葵
Laigugong 來谷宮
li (vessel) 鬲
li (administrative unit) 里
li (rules) 禮
liche 立車
ling 陵
lingyin 淩陰
liqi 禮器
Liuyinggong 六英宮
ma 馬
Maojiaping 毛家坪
mingqi 明器
mumiao 穆廟
Niangong 年宮
niuzhong 鈕鐘
pei 佩
pen 盆
pingyang fenggong
　　平陽封宮
pushou 鋪首
qi 氣
Qian 汧
qianchao houqin 前朝后寢
qiandaoche 前導車
Qiang 羌
qiequwen 竊曲紋
qing 磬
qingong zuozhu yong ding
　　秦公作鑄用鼎
qingong zuozhu yong gui
　　秦公作鑄用簋

qinian gongdang
　　蘄年宮當
Qin-Rong 秦戎
Qinzi 秦子
qu 區
quan 權
Quanrong 犬戎
quzhen 曲陣
Rong 戎
sangong 三公
shangbi 上幣
Shaofu 少府
Shaohao 少昊
sheng 升
Shenheyuan 神禾塬
shi (elite) 士
shi (administrative unit) 什
shigu 師古
Shihuangdi 始皇帝
sichengche 駟乘車
sigong 寺工
siguan 私官
tai 臺
Taihao 太暤
Taiwei 太尉
tang 堂
taotie 饕餮
ting 亭
Tuoquangong 橐泉宮
wang 王
wangji 王畿
wanleng wen 瓦棱紋
wending 問鼎
weng 甕
wenliangche 輼輬車
wu 伍
wude 五德
wuku 武庫
wulei gongming 物勒工名
xi (seal) 璽
xi (jade pendant) 觿
xiabi 下幣
xian 縣
xiang 鄉
xiaozhuan 小篆
Xichui 西陲
Xinglegong 興樂宮
Xingong 信宮

Xiquanqiu 西犬丘
Xu 徐
ya 亞
Yan 奄
yan (bronze vessel) 甗
yan (swallow) 燕
yan (wild swan) 雁
yao 瑤
yaokeng 腰坑
yi 鎰
yibiqian 蟻鼻錢
yin 印
yin suowu yong 陰所武用
Ying 嬴
Yiren 異人
Yong 雍
Yuanding 圓頂(山)
yuanfa erzhi 緣法而治
Yuchi 魚池
yuefu 樂府
yueyang gong (shi)
　　櫟陽工(師)
yuli 魚麗
yun 勻
yushi-dafu 禦史大夫
Yuyanggong 豰陽宮
zeng 甑
zhaiguan 齋冠
zhang 丈
Zhangtaigong 章臺宮
zhaomiao 昭廟
Zheng 政
Zhenren 真人
zhi 巵
zhidao 直道
zhong (tomb) 冢
zhong (measurement unit) 鍾
zhong (bronze vessel) 鍾
zhongjiu 中廄
zhongting 中庭
Zhouwangling 周王陵
Zhuanxu 顓頊
Zhuquangong 竹泉宮
Zichu 子楚
zumiao 祖廟
zuoche 佐車
zuojiu 左廄

Further Reading

Bagley, Robert W. *Shang Ritual Bronzes in the Arthur M. Sackler Collections.* Washington D.C. and Cambridge: Arthur M. Sackler Foundation and Arthur M. Sackler Museum, Harvard University, 1987.

—————, ed. *Ancient Sichuan: Treasures from a Lost Civilization.* Princeton, N.J.: Princeton University Press, 2001.

Bai Shouyi, ed. *Zhongguo tongshi* [A general history of China]. 12 vols. Shanghai: Shanghai Renmin Press, 1995.

Bunker, Emma C. "Gold in the Ancient Chinese World: A Cultural Puzzle." *Artibus Asiae* 53, no. 1/2 (1993): 27–50.

Chang, Kwang-chih. *Early Chinese Civilization: Anthropological Perspectives.* Cambridge, Mass.: Harvard University Press, 1976.

Chen Ping. "Shilun guanzhong qinmu qingtong rongqi de fengqi wenti" [A preliminary discussion of the periodization of bronze vessels excavated from Qin tombs in Shaanxi]. *Kaogu yu wenwu,* 1984, no. 3: 58–73, and 1984, no. 4: 63–73.

Ciarla, Roberto, ed. *The Eternal Army: The Terracotta Soldiers of the First Chinese Emperor.* Vercelli, Italy: White Star Publishers, 2005.

Dien, Albert, ed. *Terracotta Warriors: Guardians of China's First Emperor.* Santa Ana, Calif.: Bowers Museum, 2008.

Falkenhausen, Lothar von. *Chinese Society in the Age of Confucius (1000–250 BC): The Archaeological Evidence.* Los Angeles: Cotsen Institute of Archaeology, University of California, 2006.

—————. *Suspended Music: Chime-Bells in the Culture of Bronze Age China.* Berkeley and Los Angeles: University of California Press, 1993.

—————. "The Waning of the Bronze Age: Material Culture and Social Development, 770–481 B.C." In Loewe and Shaughnessy, *Cambridge History of Ancient China,* pp. 450–544.

Fong, Wen, ed. *The Great Bronze Age of China: Treasures from the Bronze Age of China.* New York: Metropolitan Museum of Art, 1980.

Furniss, Ingrid. *Music in Ancient China: An Archaeological and Art Historical Study of Strings, Winds, and Drums during the Eastern Zhou and Han Periods (770 BCE–220 CE).* Amherst, N.Y.: Cambria Press, 2008.

Han Wei and Christian Deydier. *Ancient Chinese Gold.* Paris: Les Éditions d'Art et d'Histoire ARHIS, 2001.

Hayashi Minao. *Shunshū sengoku jidai seidōki no kenkyū. In Shū seidōki sōran,* 3 [A study of bronze from the Spring and Autumn and Warring States periods. A survey of Chinese bronze from Shang to the Zhou dynasties, 3]. Tokyo: Yoshikawa Kōbunkan, 1989.

Hulsewé, A. F. P. *Remnants of Ch'in Law: An Annotated Translation of the Ch'in Legal and Administrative Rules of the 3rd Century B.C. Discovered in Yün-meng Prefecture, Hu-pei Province, in 1975.* Leiden: E. J. Brill, 1985.

Institute of Archaeology of China Academy of Social Science. *Yinzhou jinwen jicheng* [Corpus of Shang and Zhou bronze inscriptions]. Beijing: Zhonghua Press, 1984–94.

—————. *Zhongguo kaoguxue: Liangzhou juan* [Chinese archaeology: Western Zhou and Eastern Zhou]. Beijing: China Social Science Press, 2004.

Kern, Martin. *The Stele Inscriptions of Ch'in Shih-huang: Text and Ritual in Early Chinese Imperial Representation.* New Haven, Conn.: American Oriental Society, 2000.

Kesner, Ladislav. "Likeness of No One: (Re)presenting the First Emperor's Army." *Art Bulletin* 77, no. 1 (March 1995): 115–32.

Lagerwey, John, ed. *Religion and Chinese Society.* Vol. 1, *Ancient and Medieval China.* Hong Kong and Paris: Chinese University Press and École Française d'Extrême-Orient, 2004.

Lawton, Thomas. *Chinese Art of the Warring States Period: Change and Continuity, 480–222 B.C.* Washington, D.C.: Freer Gallery of Art, Smithsonian Institution, 1982.

Ledderose, Lothar. *Ten Thousand Things: Module and Mass Production in Chinese Art.* Princeton, N.J.: Princeton University Press, 2000.

Lewis, Mark Edward. *The Early Chinese Empires: Qin and Han.* Cambridge, Mass.: Harvard University Press, 2007.

Li County Institute for the Study of Qin Culture at Xichui and Li County Museum. *Qin xichui wenhua lunji* [A collection of essays on Qin culture at the western frontier]. Beijing: Wenwu Press, 2005.

—————. *Qin xichui lingqu* [The Qin necropolis at the western frontier]. Beijing: Wenwu Press, 2005.

Li Xueqin. *Eastern Zhou and Qin Civilizations.* Translated by K. C. Chang. New Haven, Conn.: Yale University Press, 1985.

Liu Yang. *Homage to the Ancestors: Ritual Art from the Chu Kingdom.* Sydney: Art Gallery of New South Wales, 2011.

—————. "Inheritance and Innovation: An Archaeological Perspective of Qin Culture." *Arts of Asia,* January/February 2011, pp. 80–93.

—————. "Qin Bronze: From Symbolic Art to the Quest for Realism." *Orientations,* September 2012, pp. 111–17.

Liu Yang and Edmund Capon. *The First Emperor: China's Entombed Warriors.* Sydney: Art Gallery of New South Wales, 2010.

Liu Yunhui. *Shaanxi chutu dongzhou yuqi* [Jades of the Eastern Zhou dynasty excavated from Shaanxi]. Beijing: Wenwu Press, 2006.

Loehr, Max. *Ritual Vessels of Bronze Age China.* New York: Asia Society, 1968.

Loewe, Michael. *The Government of the Qin and Han Empires, 221 BCE–220 CE.* Indianapolis and Cambridge: Hackett Publishing, 2006.

Loewe, Michael, and Edward L. Shaughnessy, eds. *The Cambridge History of Ancient China: From the Origins of Civilization to 221 B.C.* Cambridge: Cambridge University Press, 1999.

Lü Buwei. *The Annals of Lü Buwei.* Translated by John Knoblock and Jeffrey Riegel. Stanford, Calif.: Stanford University Press, 2001.

Mattos, Gilbert L. "Eastern Zhou Bronze Inscriptions." In Shaughnessy, *New Sources of Early Chinese History,* pp. 85–123.

Needham, Joseph, and Robin D. S. Yates. *Military Technology: Missiles and Sieges.* Vol. 5, pt. 6 of *Science and Civilisation in China.* Cambridge: Cambridge University Press, 1994.

Pankenier, David W. "The Cosmic Center in Early China and Its Archaic Resonances." In *Archaeoastronomy and Ethnoastronomy: Building Bridges between Cultures,* edited by Clive L. N. Ruggles, pp. 298–307. Cambridge: Cambridge University Press, 2011.

Pines, Yuri. "The Question of Interpretation: Qin History in the Light of New Epigraphic Evidence." *Early China* 29 (2004): 1–44.

Portal, Jane, ed. *The First Emperor: China's Terracotta Army.* London: British Museum Press, 2007.

Rawson, Jessica. *Chinese Bronzes: Art and Ritual.* London: British Museum Press, 1987.

Image Credits

————. *Western Zhou Ritual Bronzes from the Arthur M. Sackler Collections*. Washington D.C. and Cambridge, Mass.: Arthur M. Sackler Foundation and Arthur M. Sackler Museum, Harvard University, 1990.

Shaughnessy, Edward L., ed. *New Sources of Early Chinese History: An Introduction to the Reading of Inscriptions and Manuscripts*. Berkeley: Society for the Study of Early China and the Institute of East Asian Studies, University of California, Berkeley, 1997.

Sima Qian. *Records of the Grand Historian: Qin Dynasty*. Translated by Burton Watson. New York: Columbia University Press, 1993.

So, Jenny F. *Eastern Zhou Ritual Bronzes from the Arthur M. Sackler Collections*. Washington, D.C.: Arthur M. Sackler Foundation in association with the Arthur M. Sackler Gallery, Smithsonian Institution, 1995.

————, ed. *Music in the Age of Confucius*. Washington, D.C.: Freer Gallery of Art and Arthur M. Sackler Gallery, Smithsonian Institution, 2000.

Teng Mingyu. *Qin wenhua: cong fengguo dao diguo de kaoguxue guancha* [Qin culture from an archaeological perspective: From a feudal state to the great empire]. Beijing: Xueyuan Press, 2003.

Thote, Alain. "Burial Practices as Seen in Rulers' Tombs of the Eastern Zhou Period: Patterns and Regional Traditions." In Lagerwey, *Religion and Chinese Society*, pp. 65–107.

Twitchett, Denis, and Michael Loewe, eds. *The Ch'in and Han Empires, 221 B.C.–A.D. 220*. Vol. 1 of *The Cambridge History of China*. Cambridge: Cambridge University Press, 1986.

Wang Xueli. *Qin shihuang ling yanjiu* [A study on Qin Shihuang's tomb complex]. Shanghai: Shanghai Renmin Press, 1994.

————. *Qinyong zhuanti yanjiu* [A study on the terracotta warriors]. Xi'an: Sanqin Press, 1994.

Wu Hung. "Art and Architecture of the Warring States Period." In Loewe and Shaughnessy, *Cambridge History of Ancient China*, pp. 651–744.

————. *Monumentality in Early Chinese Art and Architecture*. Stanford, Calif.: Stanford University Press, 1995.

————. "On Tomb Figurines—the Beginning of a Visual Tradition." In *Body and Face in Chinese Visual Culture*, edited by Wu Hung and Katherine R. Tsiang, pp. 13–47. Harvard East Asian Monographs 239. Cambridge, Mass.: Harvard University Asia Center, 2005.

Wu Yongqi, ed. *Shaanxi chutu jinying qi* [Qin gold and silver ornaments excavated in Shaanxi]. Xi'an: Shaanxi Renmin Jiaoyu Press, 2004.

Yang, Xiaoneng, ed. *New Perspectives on China's Past: Chinese Archaeology in the Twentieth Century*. 2 vols. New Haven, Conn.: Yale University Press with the Nelson-Atkins Museum of Art, Kansas City, 2004.

Yuan Zhongyi. *Qin shihuang ling de kaogu faxian yu yanjiu* [The archaeological discovery and research of Qin Shihuang's tomb complex]. Xi'an: Shaanxi Renmin Press, 2002.

Zhongguo qingtong quanji [A Complete collection of Chinese bronzes]. Beijing: Wenwu Press, 1993–98.

Bibliothèque Nationale de France: p. 143 (fig. 8)

© **The British Library Board:** pp. 20 (105024.a.1), 134 (2231.f.24)

Photo by Kwang-chih Chang from *The Formation of Chinese Civilization*, ed. Sarah Allan (Beijing: Yale University Press in association with New World Press, 2005): p. 183 (fig. 1)

Photo by Robert Clark: p. 200 (right)

Photo by Duan Qingbo, Northwest University: p. 141 (fig. 4)

Gansu Provincial Institute of Archaeology: pp. 16, 18, 26, 29 (fig. 1), 30, 31 (fig. 6), 32, 33 (figs. 8, 9), 34, 35, 38–39, 62, 124, 154, 156 (fig. 2)

Harvard-Yenching Library Rare Book Collection: p. 218

Photo courtesy Henan Provincial Museum: p. 163 (fig. 9)

Photos courtesy Hunan Provincial Museum: pp. 205 (fig. 2), 215 (figs. 5, 6), 222 (fig. 15)

Institute of Cultural Artifacts, Yibin County, Sichuan: pp. 216, 219 (fig. 10)

iStockphoto: pp. 6, 141 (fig. 5)

From *Jinshisuo* (1821), *Shi* section, chap. 3: p. 225

After *Kaogu*, 1975, no. 4: 21, fig. 5: p. 149 (fig. 5, left)

After *Kaogu*, 1979, no. 6: 551, fig. 9: p. 148 (fig. 3)

After *Kaogu xuebao*, 1963, no. 2: 35, fig. 27: p. 151 (fig. 6)

After *Kaogu xuebao*, 1976, no. 1: 24, fig. 5.1: p. 148 (fig. 2)

After *Kaogu yu wenwu*, 2011, no. 1: 5, fig. 3: p. 56 (fig. 11)

After *Kaogu yu wenwu congkan*, 1983, no. 3: 114, fig. 16.1: p. 151 (fig. 7)

With permission from Librairie Orientaliste Paul Geuthner, Paris: pp. 178–79

Photo by Liu Yang: p. 201

After Lixian Museum and Lixian Qin Xichui Cultural Research Association, *Qin xichui lingqu* (Beijing: Wenwu Press, 2004), pp. 45, 51: p. 31 (fig. 5)

© **Lowell Georgia/CORBIS:** p. 143 (fig. 7)

Minneapolis Institute of Arts, The William Hood Dunwoody Fund, 39.26.1: p. 137

Pure Rendereing Gmbh/National Geographic Stock: p. 200 (left)

Qin Shihuang Terracotta Warriors and Horses Museum: pp. 146, 174, 180, 184

Qin Shihuang Terracotta Warriors and Horses Museum (photos by Xia Juxian and Guo Yan): pp. 5, 8, 10, 50, 132, 140, 144, 153, 163 (fig. 8), 172, 176, 177, 185 (fig. 3), 186 (figs. 5 [acrobat], 6), 187 (fig. 7, right), 189, 192–93, 194, 196–97, 198, 199, 202, 208–9, 210, 212–13, 217, 219 (fig. 11), 221, 223, 224, 228, 260, 284, 292–95

Research Institute of Cultural Artifacts, Hebei: pp. 205 (fig. 3), p. 220

Courtesy Shaanxi Cultural Heritage Promotion Centre and Shaanxi Provincial Cultural Relics Bureau: pp. 50 (fig. 4), 64, 67–91, 94–98, 100–114, 116–20, 122, 123, 126–31, 159, 161, 162 (fig. 6), 164–69, 206, 214, 215 (fig. 4), 219 (fig. 12), 222 (fig. 16), 231–51, 253–59, 262–70, 272–76, 278–83, 286–91, 304

Shaanxi Provincial Institute of Archaeology: pp. 40, 45, 46, 50 (fig. 5), 53, 54, 55, 56 (fig. 10, photo by Jiao Nanfeng), 57, 58–59, 92, 141 (fig. 4), 142 (photo by Xiao Jianyi), 160, 162 (fig. 7), 185 (fig. 4), 186 (fig. 5 [Pit K9901]), 187 (fig. 8), 195, 252

Courtesy Shaanxi Provincial Institute of Archaeology, illustration Art Gallery of New South Wales: pp. 14, 182–83, 188–89, 190–91

Photo courtesy Sumitomo Museum, Kyoto: p. 204

After *Wenwu*, 1985, no. 2: 4, fig. 6: p. 44

After *Wenwu*, 1988, no. 11:15, fig. 2: p. 156 (fig. 1)

After *Wenwu*, 2005, no. 2: 6, fig. 3: p. 36

After *Wenwu*, 2008, no. 11: 25, fig. 27: p. 33 (fig. 7)

After *Wenwu*, 2011, no. 4: 32, fig. 3.1: p. 149 (fig. 5, right)

After Yuan Zhongyi, *Qin Shihuang ling bingmayong yanjiu* (Beijing: Wenwu Chubanshe, 1990), p. 193, fig. 104

Zhang Zhi, ed., *Tianjin bowuguan jinghua* (Tianjin: Tianjin Yangliuqing Press, 2005), plate 39: p. 157

Index